FICTIONS OF THE POSE

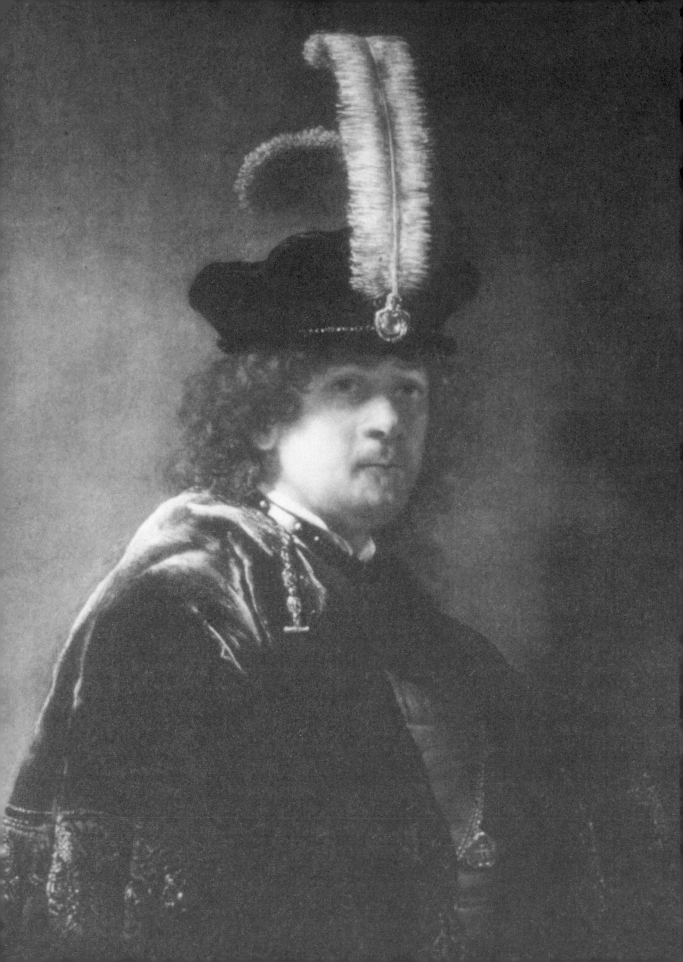

HARRY BERGER, JR.

FICTIONS OF THE POSE

Rembrandt Against the Italian Renaissance

STANFORD UNIVERSITY PRESS STANFORD, CALIFORNIA 2000

FRONTISPIECE

Rembrandt Workshop (?), *Half-Length Figure of Rembrandt*, ca. 1638. Oil on wood. Private Collection.

Stanford University Press Stanford, California

© 2000 by the Board of Trustees of the Leland Stanford Junior University

Printed in the United States of America
CIP data appear at the end of the book

Book jacket and interior design by Janet Wood
Typeset by James P. Brommer in 11/15 Bembo

For Beth Pittenger

Acknowledgments

I'm surprised this book got finished. I'm even more surprised to see it published. I wasn't trained as an art historian and don't consider myself one. In the fall of 1958 I returned frustrated to New Haven after spending six months of a sabbatical leave in Florence: frustrated because I had wasted most of my time—when I wasn't driving my children to the Cascine pool or walking blank-eyed around the city streets eating Alemanni ice cream bars—writing notes for a study of Edmund Spenser's poetry, and as a result I never bothered to think hard about or even look hard at everything there I could have seen or thought about. My timing was bad, my planning was dumb, and that particular Spenser book never got written. Back in New Haven I began to miss both Florence and what I had missed in Florence. Partly to cure nostalgia, partly to apologize to myself, I audited some classes in Renaissance art history offered by Charles Seymour, Jr., and Helmut Wohl. For two or three weeks I just stared mistily at images of the old familiar places. And then I got hooked. I began to take copious notes—I still have and occasionally consult the notebooks—and to look hard at pictures of the originals I had missed. Pretty soon I stopped apologizing to myself. Like Uccello (as reported by Vasari), I fell in love with and stayed up nights and thought about and, in short, started a romance with—of all things—the theory and practice of perspective. That was probably because it is in some ways easier to look and think about perspective in the confined academic world of reproductions and diagrams and comparative analysis made possible by the convenience of adjacent images on a wall, a convenience that depends on seeing things

out of scale and all the same size within the kind of square and imaginary space perspective theorists wrote about. Although I still feel a strong residual attachment to that cloistered culture and to the lantern magic that opens up the wall or screen to disclose the virtual vistas buried within it, my interest was diverted long ago from transparencies to opacities: during the 1970s it shifted to Vermeer's opacities of meaning, and during the 1980s to Rembrandt's opacities of paint. What finally emerges in the form of this book are thus the meanderings and musings of some forty years of longing, the impossible longing to transform into words images that strike me dumb.

During the years in which I was struggling toward some understanding of the issues engaged in this book, a few friends helped me with criticisms, suggestions, and encouragement at crucial moments, making it possible for me to go on. I'm deeply grateful to Mary Price, whose quiet but steady and bracing impatience with my early flights of nonsense many years ago—in 1976—gave me a new start, and to Svetlana Alpers and Beth Pittenger for ideas and criticism that helped damp more recent flights of nonsense. Svetlana's work introduced me to Rembrandt studies and oriented my own responses, but my debt goes far beyond the work. Without her spirited generosity, her unstinting frankness and encouragement, and the example of her combined passion and integrity, I could never have taken my first baby steps toward this project. Beth was by my side during the late 1980s and early 1990s, when the project began to take shape. The four months we spent in Florence in 1989, along with our brief visits to Amsterdam in 1989 and 1991, were crucial to its formation. There are traces of her suggestions, her insights, her interpretations, throughout the book, traces also of her cool, witty, firm, and loving resistance. She saw things I didn't see and tempered my sense of what I saw.

Many of the ideas and interpretations that ultimately came together in and as this book were developed in conversation with undergraduates in courses in Italian painting and Rembrandt I taught at the University of California, Santa Cruz, from the early 1970s through the middle 1990s. Twice during that period I co-taught a seminar in the literature and anthropology of the ancient world with my colleague Richard Randolph, of the anthropology department. Our experience teaching and thinking about Tacitus's *Germania* almost twenty years ago planted the seed that eventually grew into the thesis of this book, *Rembrandt against the Italian Renaissance*. Richard may or may not recognize his contribution in much

ACKNOWLEDGMENTS ix

of the bizarre exfoliation that follows, but he is likely to discern it pretty clearly in my discussion of Tacitus in Chapter 21. On two occasions I had the pleasure of collaborating with colleagues in art history: a seminar in portraiture with Donna Hunter in 1996 and a seminar in Renaissance art and literature with Catherine Soussloff in 1992. These were not only enjoyable and instructive experiences in themselves, but they also forced me to think harder about—and to clarify—concepts and interpretations that found their way into the book. I'm additionally grateful to Professor Soussloff for her careful commentary on an earlier version of the Introduction. During the last five years or so, my thinking about some of the issues raised in the book—especially those considered in Chapters 3 through 9—has benefited from the challenging scrutiny of several graduate students in our literature program. I thank Robin Baldridge, Kristen Brookes, Scott Davis, Valerie Forman, and Catherine Newman for their consistently helpful, critical, and perceptive responses to this material.

With the deepest pleasure and the fondest memories, I now turn to thank the participants of the Folger Summer Seminar I directed in 1994. I retired in June of that year, and the day after I taught my last class as an active faculty member I flew to Washington and began a new life under the reanimating influence of the following sixteen breaths of fresh air: David Baker, Ellen Caldwell, John Cunningham-Crowther, Alexander Dunlop, Graham Hammill, Joan Hartman, Katie King, Laura Levine, Pam Long, Terry Murphy, Dora Polachek, Michael Shea, Steve Shelburne, Mark Sherman, Bette Talvacchia, and Lawrence Wheeler. I shall never forget the enthusiasm, intelligence, skepticism, rigor, good humor, and (occasionally) amusement with which they tolerated and improved on the ravings of a self-confessed amateur in the field of art history. We spent a considerable amount of our time together learning how to talk and write about portraits, and it was one of the great and joyous experiences of my life. I also want to thank those members of the Folger Institute who made it possible—Lena Cowen Orlin, Barbara Mowat, Kathleen Lynch, Carol Brobeck, and Rebecca Willson—and the four visiting lecturers whose stimulating presentations and discussions greatly enhanced the value of the seminar—David Lee Miller, Margreta de Grazia, Margaret Carroll, and Elizabeth Bellamy.

In recent years a host of friends and students have helped me with later stages of the book. I'm particularly grateful to three good friends who have shown me by their example how it is possible to fuse the discipline

of responsible scholarship and critical rigor with the fire of imagination: Margreta de Grazia, Tyrus Miller, and Judith Anderson. I thank my stars that they're in the profession. Their example is always before me as an ideal for all those who, like myself, need to be encouraged to do more and better than we do. In addition, the detailed, challenging, and stimulating commentaries on drafts of the manuscript by Professors de Grazia and Miller have been invaluable to me. Over the years I've also profited much from discussions with or the comments of many other friends and colleagues: Leonard Barkan, Geoffrey Batchen, Michael Baxandall, Stephen Campbell, Margaret Carroll, Linda Charnes, Janina Darling, Lynn Enterline, Angus Fletcher, Catherine Greenblatt, Stephen Greenblatt, Catherine Gimelli-Martin, Thomas M. Greene, Graham Hammill, Timothy Hampton, Richard Helgerson, Elizabeth Honig, Donna Hunter, Virginia Jansen, Elinor Windsor Leach, Marsh Leicester, Diane Manning, Richard Martin, David Lee Miller, Louis Montrose, Sheldon Nodelman, Stephen Orgel, Gordon Osing, Patricia Parker, Seth Schein, Edward Snow, Catherine Soussloff, Deanna Shemek, Don Wayne, and Sarah Whittier.

Though I mention it in the text (see notes 9 and 12 of the Introduction), I would like to acknowledge briefly here the importance to my project of the three Rembrandt studies on which I've relied most heavily: Svetlana Alpers, *Rembrandt's Enterprise*; H. Perry Chapman, *Rembrandt's Self-Portraits*; and Gary Schwartz, *Rembrandt, His Life, His Paintings*. The nature of the debt is not simple, however, and in today's critical climate it isn't even simple to describe. To say that it includes the opportunity to disagree with and make adjustments in certain aspects of their readings of Rembrandt that I can't fully accept—to say this is to invite the charge that so courtly a way of phrasing an introduction to the critic's favorite pastime, trashing precursors, is snide at best. And indeed this charge may be partially substantiated by my hostile treatment of another critic in Chapter 12. Although I offer no apology for the treatment, I think the charge reflects simplistic assumptions about critical encounters. It reflects, for example, the assumptions that such encounters should be zero-sum and two-dimensional affairs dominated by agon and epideixis, that they should either be a central form of action in the polemical genres classified as theory or else be relegated to footnotes in more workaday jobs of interpretation, and that footnotes are the appropriate environment—cramped, marginal, of modest nine-point stature, in a word, adequate—for listing credits, briefly thanking creditors, and compactly (if less briefly) dismiss-

ing competitors. Conventions of this sort make it harder for those work-
ing in interpretive genres to do in public what most of them do in their
preparatory negotiations: map the traces of the continuous exercises in tri-
angulation that involve critics in often complex journeys as they circulate
back and forth between "secondary" and "primary" works. This whole
negotiatory process constitutes the proper sphere within which to define
indebtedness and express gratitude, and to do so with no implication of
irony. My reading of Rembrandt portraits did not emerge from long ses-
sions of mute and rapt gazing at the objects of desire. It was mediated by
my encounters chiefly with the work of Alpers, Chapman, and Schwartz.
I thank them for that.

I have greatly benefited from and enjoyed disagreeing with the impres-
sively detailed, scrupulous, controversial, and monumental reassessment of
Rembrandt's paintings in J. Bruyn, B. Haak, S. H. Levie, P. J. J. van Thiel,
and E. van de Wetering, *A Corpus of Rembrandt Paintings*, trans. D. Cook-
Radmore, five volumes (The Hague: Martinus Nijhoff, 1982–). I con-
sulted and comment on entries in the first three volumes. Volume 1 ap-
peared in 1982, Volume 2 in 1986, Volume 3 in 1990. Since this work is
the product of the Rembrandt Research Project, it will be cited in future
references as RRP. And since the RRP can be thought of both as a group
of individuals and as a collective project, my references to them/it will be
singular on some occasions and plural on others, depending on the needs
of particular grammatical contexts.

During the final and most onerous stage of preparation, the securing of
permissions and reproductions, several scholars and curators went out of
their way to help me locate paintings that were in private collections or
whose whereabouts were unknown. For their generosity, patience, and
helpfulness in this matter, I wish to thank Lideke Peese Brinkhorst and
Michiel Franken of the RRP, Simon Taylor of Art Resource, Cynthia
Altman, Barbara Thompson of the Witt Library in the Courtauld Insti-
tute of Art, Sophie Seebohm of the Bridgman Art Gallery in London,
and Quentin Buvelot, Curator of the Koninklijk Kabinet van Schilderi-
jen in The Hague.

An earlier draft of Chapters 1 and 18 and an essay subsequently ex-
panded into Chapters 4 through 9 were published in *Representations*, the
first two as "The System of Early Modern Painting," *Representations* 62
(Spring 1998): 31–57, and the third as "Fictions of the Pose: Facing the
Gaze in Early Modern Portraiture," *Representations* 46 (Spring 1994): 87–

119. I'm grateful to the editors and readers of the journal for their criticism and support. Versions of the latter essay were delivered before audiences at: Stanford University; the Marcus W. Orr Center for the Humanities at Memphis State University; the University of California, San Diego; Indiana University; and the Folger Institute. Versions of Part 3 were delivered in lecture form for occasions sponsored by the Committee for Lectures and Colloquia of the Literature Department of the University of California at Santa Cruz and by the Program for Early Modern Studies in October and December 1997, and at Notre Dame University in April 1998. I'm very grateful to members of these audiences for suggestions and criticisms that helped me with my revisions. Thanks also to Professor Kay Easson, Director of the Marcus W. Orr Center, to Professor Lena Cowen Orlin, former Executive Director of the Folger Institute, and to her staff—especially to Kathleen Lynch, the present Executive Director, and Carol Brobeck—and to Professor Lois Potter, for courtesy, interest, and support that made the lectures I gave under their auspices a pleasurable and instructive occasion.

I feel strangely compelled to acknowledge a failure or inability properly to engage with the work of a critic I deeply respect: Mieke Bal's *Reading "Rembrandt."* This is a bold and compelling experiment in the semiotic approach to visual art, but with different agendas from mine, agendas that lead Bal too often—for my taste—to use her interpretations of paintings to exemplify themes and issues at a different level of interpretation. I've found Bal to be a wonderful presence on the critical scene: generous, constructive, and positive in her reviews and critiques of others, courageous in her willingness to experiment. Certainly neither she nor her contribution to visual semiotics is deserving of the dismissive tone some art historians take toward her work, and this in part causes me to be disappointed by my own failure to address some of the important issues *Reading "Rembrandt"* raises.

It's with pleasure and gratitude that I thank Marianna Alves and Lisa Leslie, of the Cowell College Steno Pool, for all the support, moral as well as stenographic, they've given me in recent years. I appreciate, for example, the patience with which they repeatedly had to teach an aging technophobe how to do simple tasks like sending faxes, and I want them to know that I detected the amusement, the humiliating alacrity, with which they often finished the jobs I had walked stoop-shouldered away from after fumbling.

For the second time in two years, it gives me pleasure to acknowledge

the help and support I have received from the Committee on Research of the University of California at Santa Cruz and from the staff of the campus Word Processing Center, especially Cheryl Van De Veer, its supervisor, and Zoe Sodja. I thank Cheryl and Zoe not only for indispensable help in floppifying some thirty years of typescript, but also for the wonderfully cooperative spirit and careful attention that have made the Center an invaluable resource for so many members of our campus community. During those thirty years all the typescripts were prepared by Charlotte Cassidy, whose skill and devotion produced the fairest copy in the world. I also wish to thank the Millard Meiss Publication Fund Committee of the College Art Association for its award of a generous subsidy that enabled the author and the Stanford University Press to achieve a higher level of quality in production than would otherwise have been possible.

Also for the second time in two years, I'm delighted to acknowledge how important Helen Tartar's sustained and active support has been to the completion of this project. Helen encouraged me to submit the manuscript to the Stanford University Press when I had just about given up on it; she oversaw its production as Humanities Editor of the Press; and as copy editor she suggested an embarrassingly large number of revisions— major and minor, technical and conceptual—that substantially strengthened both the style of the book and its argument. Without her supervision, without her participation at every level and phase of production, *Fictions of the Pose* would never have gotten off the ground. In addition, I want to thank the Stanford Press reader of the manuscript for his/her encouraging report and helpful suggestions for improvement. And finally, my gratitude to Dr. Kasey Hicks, who agreed to prepare the indexes on short notice and went on to do a wonderful job, at once analytically rigorous and cross-referentially imaginative.

I reserve my deepest thanks for the last. During the final stages of writing and the preparation of the manuscript, Sarah Whittier was a constant source of encouragement, support, constructive criticism, and interpretive suggestions. In addition to these vital if relatively intangible gifts of companionship, she volunteered to perform an immensely tangible, not to say tedious and terrifying, task, one that had to be done and that no one else— including me—was capable of doing: the monstrous task of securing permissions and acquiring reproductions for over eighty illustrations. Confronting the chaos of this difficult, maddening, and in itself unrewarding job, which took the better part of seven months, she organized the files,

mastered the idiosyncratic *modi operandi* of more than forty museums and collections, took responsibility for every phase of an endless correspondence, and with marvelous efficiency turned a tangled nightmare into a gallery. But her contribution didn't stop there. Sarah patiently read and discussed with me drafts of the last section I wrote, the chapters on Dutch art in Part 3, and in return I gladly stole and used several of her stimulating suggestions about particular portraits, suggestions we plan to develop in a collaborative study of seventeenth-century Dutch group portraits. Still, I happily admit that something else was more important to me if a little less labor intensive: her companionship in a difficult time, and the loving care with which she grew our garden and waters the flowers.

Contents

Frontispiece. Rembrandt Workshop (?), *Half-Length Figure of Rembrandt*, ca. 1638. Oil on wood. Private Collection.

Plates

Figures

FICTIONS OF THE POSE

What kind of a work is a self-portrait by another hand? How can there be a copy of a self-portrait? Can one still call it a self-portrait or is it now a portrait?[1]

Consider the silliness of the ostrich plumes dominating and dwarfing the courtly sitter in the frontispiece to this book. Or at least consider the silliness they add to the expression on his face as he displays himself over-dressed and a little overstuffed for the benefit of the painter or the observer, whose gaze he doesn't quite return. His eyes would meet ours more squarely were it not for the plumes and the fancy beret—bejeweled and bechained—into which they are, as the members of the Rembrandt Research Project (RRP) straightforwardly put it, "stuck."[2] The plumed jewel presses the front edge of the beret down over the courtier's forehead and thereby affects the message sent by his eyebrows. They appear raised, pushed up as if to stave off the imminent forward lurch of the beret; the courtier's gaze shifts up to join them in their worry; and the lower part of his face follows suit and forms itself into a concerned pucker. None of this would happen without the burden and the splendor of the plume-laden hat. This is the portrait of a courtier struggling with his hat and struggling—manfully, one would like to say—to prevent that struggle from overshadowing the performance of the impressive pose he and his painter had obviously planned to commemorate.

The intention is obvious because he is dressed to the hilt. Judging from the following inventory of his trappings, he must have emptied out a sizable armoire to assure the observer of his noble and warlike demeanor:

> He wears a short black velvet cloak with a broad gold-embroidered edge and fringe. Above this can be seen a gorget and the collar of a white shirt; a short gold chain hanging down from this and terminating in a

crossbar is probably the loose clasp for the cloak. At the front, where the cloak hangs open, one can see an ochre garment . . . over which [are] three thin gold chains running diagonally and supporting a medallion with a swastika-like motif. (Ibid.)

Nor is this the end of it. The RRP goes on to note that the cloak on the sitter's left—our right—"stands away from the body, giving the impression of the man's left elbow being pushed out somewhat, with the hand perhaps resting on his hip" (ibid.). This is the famous Renaissance elbow, which we shall meet more than once in this study, for it is an indicator of noble manliness reproduced in countless portraits of the time.[3] The RRP identification of the gesture is tentative because they find "the arms hidden beneath the cloak" unclearly delineated (3.594), yet they might have noted that the sitter stands with not one but possibly two arms akimbo. Though poorly defined and muffled by the cloak, what looks like the forward elbow pushes up against the picture plane before dropping helplessly down like a broken wing. If our interpretation takes its point of departure from the elbow rather than from the plumed beret, we may respond a little less to the sitter's capital insecurity and a little more to his interest in looking truculent. But both arms akimbo? Twice the manliness? Too much, or, not enough. At this point one is forced to agree with the RRP that the sitter is pudgy. The show of truculence inflates the air of insecurity.

The pudginess is nevertheless comfortingly recognizable. It is Rembrandt's. Is the painting also his? Signed and dated (1635), the picture was long considered to be a self-portrait because it resembles many other works called Rembrandt self-portraits that date from the late 1620s, especially those in which the sitter poses in fancy dress. During the last thirty years or so its authenticity has been questioned, however. The current consensus is that the features are Rembrandt's but the facture is another's. A product of Rembrandt's workshop, it is painted in his style but not up to his speed. It has been decided, then, that this is a portrait of Rembrandt probably executed by a pupil during the late 1630s, perhaps in 1638.[4] But we shouldn't let ourselves be so humbled by the wonders of the new science of attribution that we close the door on this decision prematurely. For even if we concede that it isn't a self-portrait, the alternative designation, "portrait of Rembrandt," isn't our only option. In the current holdings and judgments of the Rembrandt archive a very large

number of painted, etched, and drawn self-portraits predate the frontispiece figure. In several cases there are two versions of the same self-portrait, one of which has been identified as a copy by another hand. At least in Rembrandt's workshop and neighborhood, the Rembrandt self-portrait seems to have established itself before 1640 as a distinctive and authoritative category of portraiture. A copy is not the only possible parasite on this category. It's easy to imagine that by the late 1630s Rembrandt's pupils (and others) might be motivated or encouraged to try not mere portraits of Rembrandt, nor mere copies, but portraits that imitate Rembrandt self-portraits. And it's easy to imagine the frontispiece image is just that: the portrait of a Rembrandt self-portrait.

What kind of difference does this proliferation of categories—self-portrait, portrait, copy, imitation—make to those of us who are neither dealers nor buyers in the art market? In responding to this question, I shall ignore copies and begin with the difference between self-portrait and portrait. For interpreters if not for connoisseurs, whether the painting is by Rembrandt or by one of his pupils will matter less than whether we choose to "read" it as a portrait or a self-portrait. If I read it as a self-portrait I assume that the painter painted some version of the figure he saw in a mirror.[5] And we can take this a step further: we can suppose that the painting represents not merely the image of the man the painter saw in the mirror but also his reaction to that image. In other words, we can suppose that the painting offers its observers the image of the painter looking at himself in the mirror while painting, or while preparing to paint; an image of the painter checking himself out and trying to monitor the impression he plans to transmit through his art to posterity; an image, then, of the act of self-portrayal. To frame the frontispiece image within this supposition is to subject it to a strange but predictable metamorphosis: the attitude I referred to above as truculence yields pride of place to capital insecurity, and we confront the image of a sitter nervously eyeing the plumes and assessing their possible impact on the pose he aspires to deliver. At first, when we approached the painting with more innocent eyes, the plumes seemed visually to unbalance the picture; now they do so thematically as well. In that respect the image assumes the status of a meta-portrait, that is, a portrait of or about the act of (self-)portrayal.

Yet what gives us permission to read this painting in terms of self-portrayal even when we accept the theory that Rembrandt's likeness was painted by someone else? Suppose we hypothesize that it is the product of

a studio exercise or game in which Rembrandt has his pupils paint him in the act of showing how one should, or should not, pose (as if) for one's self-portrait. What would the point of such an exercise be? The point, implicit in the preceding sentence's distinction between "Rembrandt" and "one," is that Rembrandt could be posing as a particular kind of sitter, the kind we call "patron," and demonstrating how that sitter should or should not pose for the painter. A patron who commissions a portrait doesn't simply roll over and hold still while the painter portrays him; he *gets himself portrayed*; he participates in what, for him, is an act of self-portrayal, or self-presentation, or self-representation. To pose is by definition to portray oneself, and painters must learn how to influence the acts of self-portrayal they are commissioned to represent. They must, for example, learn tactfully to resist the patron's tendency toward sartorial excess, his desire to put the insignias of his lineal, military, seigneurial, and official preeminence too ostentatiously on parade. They must be prepared to discourage his proclivity for oversized ostrich plumes. In this picture, then, Rembrandt shows his pupils how patrons should not be allowed to portray themselves. So it isn't surprising to find the following two observations in the RRP commentary: first, in this work "more than in other representations of Rembrandt by himself or his pupils the emphasis is . . . placed on the notion of *Vanitas*," and second, it was understood as such in the seventeenth century (3: 595–96).

The idea that in this pose Rembrandt offered his pupils a parody of patronal self-portrayal as self-betrayal is a fine fantasy, but it can't be right, or at least it can't be the whole story. Whether this painting is a portrait or a self-portrait, it accords tonally with his practice of self-portraiture throughout his career. Nobody who takes it as a likeness of Rembrandt raises an eyebrow at the ostrich plumes or the other bits of fashionable nonsense. A preference for fancy dress is a well-documented Rembrandtian idiosyncrasy, and we have come to expect it of him. Horst Gerson, who doesn't challenge the 1635 date, notes that "[i]n 1632–3 Rembrandt compared himself with his fashionable patrons; in 1634–5 with the characters created by his imagination."[6] But this distinction between fashionable patrons and imaginary characters is too sharply and quickly drawn. However exotic and bizarre the examples of fancy dress may be, however varied in their allusions (occidental, oriental, military, seigneurial, haute-bourgeois, baroque, Batavian, belligerent and boorish, effete, Italianate), they home in on a relatively small circle of reference. They represent the

power, privilege, status, and honors that some of Rembrandt's fashionable patrons may have aspired to even if they prudently applied the reins and kept their sartorial fantasies from galloping away with them. In some cases they suggest the international courtly tastes dominant in the Orangist court at The Hague, which was not only the political hub of the Dutch Republic but also a cultural emporium into which fashions filtered from imperial, national, ducal, and civic centers in Flanders, France, Italy, and even, ironically, in the United Provinces' arch-enemy, Spain.

Rembrandt often posed in elegant but out-of-date attire as if to portray an old-fashioned aristocrat, but portray him outlandishly enough to add an exclamation point to his fashion statement. He also posed in costumes that conveyed the dandified bravura of possessors of newer wealth. The self-portraits are thus a picture book of more than a century's worth of European high fashion. Any one image in the picture book is liable to be a miscellany or pastiche of items that, drawn from different contexts, have the common function of signifying modishness. But to call this collection a picture book scarcely does it justice. It's a comic book. Its contents consist in self-portraits in which Rembrandt imitates portraits of patrons, courtiers, aristocrats, bravos, and burghers. In each case, what we confront is always and indubitably the features of the figure we have come to identify as Rembrandt Harmensz van Rijn—always, indubitably, and incongruously. This is to say that he does more than imitate patrons and portraits of patrons. He parodies them. But at the same time he parodies the sitter as artist whose fancy getup lays bare his desire for patronal commissions, status, and style. Thus, to summarize this discussion, we began with a self-portrait of Rembrandt that turned first into a portrait of Rembrandt, then into a portrait of self-portrayal that imitates a Rembrandt self-portrait, and finally into a portrait that imitates self-portraits in which Rembrandt parodies both himself and the patron he impersonates.

The foregoing meditation contains in small compass all the themes and topics to be developed in this book. It illustrates the claim implied in my title, *Fictions of the Pose*, that portraits can be viewed as imitations or likenesses, not of individuals only, but also of their acts of posing. Perhaps the idea that portraits portray acts of (self-)portrayal doesn't throw much light on the first term of the title—In what sense are these acts fictions?—but I'll get to that before this introduction is over. The hypothe-

sis that the painting with the ostrich plume delivers a parody or critique
of artist/patron relations and desires anticipates the argument implied in
my subtitle, which is intended to evoke and challenge the view of Rem-
brandt put forth many years ago in Kenneth Clark's *Rembrandt and the
Italian Renaissance*.[7]

Although I don't explicitly confront Clark's book until Chapter 21, my
study as a whole is deeply if perversely indebted to it, for it provoked me
many years ago to begin to rethink the relation between Rembrandt and
the Renaissance in terms of a set of theoretical, methodological, and inter-
pretive principles that grew progressively different from his. Granted that
this is the normal consequence of three decades of intellectual and ideo-
logical changes, the revisionary project has been driven by more specific
motives. First, I've approached the Rembrandt/Renaissance relation not as
an art historian but as an interpreter trained in literary studies, taunted by
the challenge of extending the practice of "close reading" from verbal to
visual media, and fascinated by the way this practice can show how indi-
vidual works "talk back" to their contexts. Second, my sense of the rele-
vant contexts and of the methodologies by which one constructs them has
been influenced by authors whose attitude toward "civilization" is crankier
than Clark's in part because they prefer a worm's-eye to a bird's-eye view:
Elias, Foucault, Lacan.[8] Third, my own responses to many of the paintings
Clark and I both discuss are not merely different from but radically op-
posed to his.

Rembrandt Against the Italian Renaissance: the subtitle may be misleading
because from the Introduction through Chapter 10—more than half the
book—hardly a word appears about Rembrandt. Those chapters comprise
an interpretive study of the technical and sociopolitical conditions within
which, in early modern Europe, portraiture becomes an important if prob-
lematic medium of self-representation.[9] During this discussion the em-
phasis on patronal self-representation and its importance is the core, the ar-
mature, of my argument, and its two most important implications are
those I just unpacked in my account of our frontispiece. The first is the
shift of attention from the painter's to the sitter's part in the act of (self-)
portrayal. Not that I ignore the painter's part, but I want to compensate
for a tendency among art historians—who are understandably more in-
terested in artists than in sitters—to understate the sitter's part. In this I
follow—at least superficially—Gary Schwartz, who has criticized Rem-
brandt scholars for ignoring the *patron's* part.[10] The second is a correlative

shift in the conception of the primary object the portrait imitates: its primary object or referent is not the likeness of a person but the likeness of an act, the act of posing.

I can most economically outline the limits and special conditions these shifts impose on my argument by contrasting its focus to the one announced by Richard Brilliant in the opening pages of his wide-ranging discursive and interpretive study of portraiture as a genre. Brilliant makes a point of distancing himself from both the historian's interest in "how individual portraits can be identified" and the collector's preoccupation with attribution and dating. For him, "the oscillation between art object and human subject . . . is what gives portraits their extraordinary grasp on our imagination. Fundamental to portraits as a distinct genre . . . is the necessity of expressing . . . [the] intended relationship between the portrait image and the human original." Thus his approach centers on "the vital relationship between the portrait and its object of representation," on "the concepts that generate ideas of personal identity and lead to their fabrication in the imagery of portraits," and on "the relationship between the presentation of the self in the real world and its analogue in the world of art."[11]

I don't for a minute think the student of portraiture can or should dodge these topics, but I plan to give them a spin that differs from Brilliant's in at least one respect: the portrait's primary "object of representation" is not the "human subject" or "human original" *tout court* but its (his, her) act of posing. For me, to vary Brilliant's phrasing, it is "the imagery of portraits" that fabricates; what it fabricates are poses; and poses as self-presentations generate or appeal to received ideas of personal identity that the very performance and representation of the pose—either by sitter or by painter or by both—may throw into question. My accent will be on fabrication—in the particular sense of making up, producing a fiction—and on problematization. Portraits, Brilliant reminds us, present "the fundamental assertion that their images have a legitimate, intentional, and purposeful connection with the persons represented" (43). The connection is given in the definition of the genre. But it's neither fixed nor static. In Brilliant's more dynamic expression, cited above, it is an "oscillation between art object and human subject." And as a referential gesture, the oscillation is never-ending. It always makes and always breaks the promise of reference.

Fictions of the Pose is a discursive study, in the sense of "discursive" as

opposed to "cursive." That is, it oscillates. Like these brief encounters with Clark and Brilliant, the discussions that follow frequently make their way by backlooping and sidewinding through the arguments of other authors in order both to capitalize on their insights and to vary or reshape them in accordance with the direction I want my argument to take. I'm often reluctant to relegate my intellectual creditors to footnote mentions when in fact their work was indispensable to my thought and essential to the admittedly different body of my project. I have no anxiety about influence—so long as I can destroy and resurrect it under the sign of allusion. It's probably under the influence of *that* anxiety that I take the trouble to stage these occasionally palimpsestuous relations with precursors and even, at times, to wear them like ostrich plumes.[12]

The initial version of this study consisted only of Part 4, an essay on several self-portraits by Rembrandt. Though this is a topic I had been thinking about for a long time, not until I went to school to Svetlana Alpers's *Rembrandt's Enterprise* and H. Perry Chapman's *Rembrandt's Self-Portraits* did I learn how to organize these thoughts into an argument that would allow me to say something that hadn't already been said.[13] Alpers's book was the chief catalyst of the present version. The basic structure of my argument derives from her emphasis on theatricality and posing, her account of the domination of the workshop as the mise-en-scène of the dramas Rembrandt portrays, and her explanation of Rembrandt's resistance to and independence of patrons. The effort to funnel these general insights into a study of self-portraiture could not have proceeded without Chapman's help, which involved not only my reliance on her impressive command of early modern conventions of dress, pose, iconography, and ethnopsychology, but also my encounter with the many passages of stimulating, fine-grained, and original interpretation enabled by that command. Occasionally I disagree with Alpers and Chapman on issues of interpretive method and in "readings" of particular works. But the opportunity to disagree and thus find my own bearings and position in the ongoing discourse about Rembrandt, portraiture, and self-portraiture is a gift that only increases the generosity (in the literal sense) of their work and my debt to it.

As my study grew its center of gravity shifted, so that what began as an interpretation of Rembrandt's self-portraits modulated into a larger pro-

ject that reconceived portraiture and self-portraiture as forms or genres within the set of emergent early modern technologies of representation—a set that includes changes in systems of notation, symbolism, and material expression in a variety of practices and media: in writing and printing, in the visual arts and cartography, in mathematical thought and scientific method, in commercial instruments and bookkeeping, in methods of taxation, in the institutionalization of theater, in the proliferation of manuals of conduct, in the motives, styles, and practices of patronage, and in experiments in representative or parliamentary government. To consider portraiture in this context involves exploring its interconnections with at least some of the other technologies in the set, and Parts 1 and 2 of the present study make rudimentary gestures in that direction.

My ultimate objective, however, remains what it was in the beginning, even if its role in the overall project has diminished: to demonstrate the ironic, polemical, and political force of Rembrandt's self-portraits. A force of this kind must have a target in view, though "target" is perhaps too aggressive a term for what may more accurately, if blandly, be called a field of allusion. Establishing the existence and character of this field was therefore essential to the thesis that the self-portraits engage in social, cultural, or institutional as well as aesthetic critique. At first I underestimated the complexity of that task, and although the addition of material in Parts 1 and 2 still doesn't adequately respond to the complexity, it suggests the extent of the underestimation.

This complexity becomes evident as soon as we recognize that what the painter(s) characterized by Rembrandt's self-portraits *saw* differed from what they *were looking at*, and that the second question has to be considered before dealing with the first. The field of allusion is one thing; the precursor it refers to and imitates is another, and here I use the word "precursor" to denote the general scene of patronage and painting—the practices, discourses, and institutional apparatuses—I construct as the anterior conditions the self-portraits index and comment on. The field of allusion elicited from a reading of the images will always be a simpler, more distilled, version of the precursor it alludes to and represents, which means that my representation of the precursor—although itself correspondingly simplified by my own project—will have to convey something of its complexity. Thus in order to prepare for the reading of the self-portraits, which unfolds in the fourth part of this study, Parts 1 through 3 articulate and examine some basic constituents of the precursor represented by the

field of allusion within and against which Rembrandt paintings display and situate themselves.

Chapter 1 considers a system of techno-material practices and conventions, Chapters 2 and 3 consider the structure and consequences of a system of social practices and conventions, and Chapters 4 through 9 consider the structure and consequences of a system of practices and conventions that govern poses in commissioned portraits. In Part 3 the scene shifts from Italian to Dutch portraiture. Part 4 is devoted to self-portraits by Rembrandt that I interpret as responses to the conditions depicted in Parts 1 through 3 and as varied expressions of something that I shall call—after Alpers—*the Rembrandt look*. I use this phrase to denote both the characteristic appearance of works attributed to (or deattributed from) Rembrandt—the way they look to us—and also the way they "look" at other paintings, by which I mean the way they represent their relations to other paintings by conspicuous allusion and revision. I shall argue that they combine a critique of the scopic regime dominating early modern painting with a critique of the politics of representation reflected in the traditional poses mandated by the purposes and demands of commissioned portraiture. This regime and its politics are described in Parts 1 and 2, whose arguments are profiled below, followed by some rudimentary theoretical distinctions essential to the analyses undertaken in the body of this book.

The first chapter contains a generalized account of the interplay among several modes used by painters in early modern Europe to organize the visual data and materials of artistic performance and representation; modes of organization that I treat as bound variables within a changing system of pictorial practices that include, for example, the uses and representations of paint, brush-strokes, paint supports, linear and "painterly" emphases, *disegno* and *colorito*, and space-making (or space-inhibiting) schemes. As some of the terms in the preceding sentence make clear, this presentation will go over old ground. Something like the modes of organization I shall describe have often been discussed in the art-historical literature, but I have packaged them in a slightly different way to bring out features of the field of allusion that seem important to the understanding of Rembrandt. Nor is there anything new in the basic idea informing my account of the modes, the idea that formal, visual, and aesthetic values along with their technical and material "infrastructures" may be correlated with social, political, and ideological values. Whether the correlations are purely associative or reinforced by formal resonances, they make it possible to imagine

that the aesthetic and ideological values were fused together, so that regardless of what motivated painters to make a given set of aesthetic choices and formal moves, the choices and moves themselves convey social meanings.

Chapter 2 develops a generalized model of the politics of portraiture in which most painters submitted happily enough to the co-optation of the patrons who employed them. I place much emphasis on the collaborative character of patron-painter interactions because it is as important for an understanding of Rembrandt's critique as is the ideology of portraiture that governs patrons' conventions of self-representation.[14] This ideology and the collaboration that produces it and is reflected—and strengthened—by it constitute a well-defined scopic regime. Its social, aesthetic, and cultural parameters varied with changes in time and place, but the basic regime that developed in the republican and courtly societies of Renaissance Italy spread northward to Baroque Europe and, *mutatis mutandis*, to the Dutch Republic along the trails of a network of influences.

I contend that the dialectical energies of the Rembrandt look are mobilized in response to this regime, and in Part 4 I shall try to show how they are channeled into self-portraits that perform a critique, a sometimes bumptious and hilarious parody, of the regime. I add as an afterthought that what I refer to as a scopic regime may also be called a discourse.[15] It comprises not only tacit practices, technical routines, and aesthetic trends, not only social conventions, politico-economic interests, and an informal technology of patronage, but also ways of talking, writing, and thinking about them that helped reproduce or modify the system. The discourse serves to harmonize if not mystify the structural differences between the interests of patrons and those of painters. It provides the normative framework within which artists and their works are preferred or rejected. And it is inscribed in the style and meaning of the works themselves. To this discourse, and the ideology it embodies, I give the name *mimetic idealism*.

Chapter 3 contains a brief interpretation of a sixteenth-century discussion I consider to be a sophisticated critique of the social, aesthetic, and representational aspects of mimetic idealism: the account of *sprezzatura* developed in Castiglione's *Il libro del cortegiano* (*The Book of the Courtier*). It has often been demonstrated that the account responds to and dramatizes the new instability of social elites and the growing political impotence of one of the few "professions" available to aristocrats, service in the prince's court. My analysis of the various aspects of sprezzatura yields two

conclusions: first, its structure as a behavioral technology, a theatrical art in which the performer presents a normative self-representation, is depicted by Castiglione's text as reproducing and even intensifying the problems it is intended to solve; second, this depiction of sprezzatura illuminates the structural problems inherent in the practices of commissioned portraiture influenced by the norms of mimetic idealism.

In the six chapters of Part 2 I explore these problems in a set of discussions intended to contextualize and characterize the practice of portraiture in early modern Italy. The central aim of the discussions is to develop a methodological framework within which portraits may be approached as presentations of acts of self-presentation, or representations of acts of self-representation. More specifically, the act in question, the act the painting represents, the act I shall refer to as performing the fiction of the pose, is the act of sitting for one's portrait. This act is not merely a means to an aesthetic or social end. It is itself a privilege, and therefore auto-referential. As Lisa Jardine suggests concerning Bellini's portrait of Doge Leonardo Loredan, that the painting is "itself a luxury commodity" reinforces "its role in confirming the identity and importance of its owner" and in testifying to his "wealth and absolute power."[16] In Chapters 4, 5, 8, and 9, I formulate and illustrate an approach designed to situate portraiture among new technologies in verbal and visual media that contribute to the theatricalization of public expressions of identity and, in doing so, create problems of self-representation. The paradoxes of theatricality explored in the *Cortegiano* illuminate those problems, and, as we'll see, they also illuminate and anticipate similar phenomena in Rembrandt's portraits. They arise as a general function of developments in the technologies of self-representation, which in turn affect how people are socialized to represent themselves to themselves and to each other. In Chapters 6 and 7 I explore the historical and structural matrices of those problems through a critical reconsideration of Norbert Elias's approach to the history of manners, which, once again, I situate within the history of self-representation in order to unsettle some of Elias's formulations by giving them a mildly Lacanian spin.

Part 3 redirects attention from Italian to Dutch portraiture and begins by looping back to Chapter 2 in order to sketch the similarities and differences between their respective contexts. The pressures affecting the apparatus of patronage and the conventions of self-representation in the Dutch Republic are then discussed in terms of the cultural problematic

condensed in the titular pun of Simon Schama's *The Embarrassment of Riches* and the political problematic analyzed by Marjolein C. 't Hart in *The Making of a Bourgeois State*. This provides the framework for readings of several individual portraits in Chapter 11 and group portraits in Chapters 12 and 13. Part 3 thus supplies the transition to the chapters on Rembrandt's self-portraits that comprise Part 4.

My concern with the theatricality of portraiture was initially aroused and remains influenced by Michael Fried's studies of absorption and theatricality, though the different body of evidence I examine leads me to re-arrange the relation between those two categories. Once again I am in-debted to the passages in *Rembrandt's Enterprise* in which Alpers extends the idea of performance from the act of painting to the characteristic look of Rembrandt's subjects: figures are represented theatrically as if their gestures were "performed or acted," as if the models and sitters were actors performing roles.[17] In the self-portraits the artist, like an actor, per-forms before himself, indeed, performs himself, "presenting himself as a model in the theatrical mode" (39), and in general "the relationship be-tween artist and model/sitter was theatrically construed" (58). Not only was the artist "called on to perform as an actor," he was also "the specta-tor of the performances of others in the studio."[18] This interest, Alpers in-sists, is spectatorial rather than voyeuristic because Rembrandt often in-cludes witnesses in his works in order to "call attention to the observed and, because observed, consciously performed nature of human events" (44–45), to which I would add that his representations of models, or ac-tors, also produce the same effect.

To insist on the theatricality of portraits and self-portraits is to stipu-late that they represent acts of self-representation. The theatrical inten-tionality of the genre is expressed by Richard Brilliant in the statement that "the portrait . . . presents a person to the viewer," where "presents" connotes display rather than presence—as in "Ladies and gentlemen, we proudly present . . . "[19] But Brilliant's word "person" tends to mask the complexity of the relation he is getting at. As he puts it a little later, the persons represented by artists "also represent themselves to themselves, to their contemporaries, and to those who take their portraits" (43), and to anyone else who may materialize as a viewer of the image. So it would be better to say that the portrait presents—performs, displays, stages—not a person but a representation, and the representation not of a person but of an act of self-representation.

Since I have casually been running together the vexing terms "presentation" and "representation" in the preceding paragraphs, and since these terms play a central role in the study that follows, I want to make a brief attempt—pragmatic and stipulative rather than philosophical—to distinguish them from each other and from a related term that currently suffers from overexposure and fuzzy usage, *self-fashioning*. After this I'll conclude by introducing a set of semiotic terms borrowed from C. S. Peirce that will enable me to classify different modes of representation at play in portraiture.

"Ladies and gentlemen, we proudly present . . . !" This expression is used to introduce performances of various kinds, and it is also itself a performance, an act of self-presentation. In this context, "presentation" and "performance" are synonymous. But what about "Ladies and gentlemen, we proudly represent . . . !"? That doesn't have the same ring. Let's fill these phrases out with the examples of The Royal Shakespeare Company (RSC) and *King Lear*. We could easily and proudly present the RSC if we knew they were present, waiting in the wings dressed up to perform *Lear*. But I don't see how we could claim to represent them unless they were absent and being replaced by some other company waiting to present an RSClike production of *Lear*. Representation in this case differs from presentation in that it presupposes a determinate absence, the absence of the original company. And just what is it the company is preparing to present or perform? Is it *King Lear* per se—or, to be more precise, a particular text of *King Lear* (Quarto, Folio, conflation, abridgment)—or is it a representation of *King Lear*? Don't we think of a particular performance or production of *Lear* as the presentation of one version we distinguish both from past, future, and possible other versions, and from the set of *Lear* texts they are all based on and refer to? In this case, the representation is the content of a presentation and begins to move toward the semantic territory occupied by "interpretation," whereas "presentation" seems to designate a strictly rhetorical or deictic act performed before others, without implying anything about its content. But the distinction can't be kept that clean.

To present is to make oneself present to the others who are directly or indirectly present to the presenter, others who include the presenter insofar as he or she imagines and rehearses and monitors the presentation "be-

fore" himself or herself. Presentation is always presentation-to, either presentation directly before or indirectly for others. Yet one never simply, unconditionally, presents oneself. Rather, one presents oneself *as*—as a man, a woman, an actor, a character, a professional, a victim, a noble, a monarch, a martyr, a merchant, a figure of authority, a figure of fun, an allegorical embodiment, a presenter, etc.—or, as oneself. In all these cases one performs a "role," that is (speaking more properly), a language-game or discourse which, being a cultural ready-made, is a pre-existing interpretation of the role, a representation of it that may vary from culture to culture. To perform that interpretation is, in turn, to interpret it.[20] Presenting-as is thus interpreting, and both are synonymous with "representing." "Presentation-as" overlaps these terms while "presentation-to" picks out the demonstrative or performative aspect of representation/interpretation: the address to empirical spectators, the construction or mobilization of virtual spectator positions. Having made this distinction I should add that unless otherwise noted future occurrences of the term "presentation" in this study will be instances of the demonstrative or performative notion, presentation-to.

To assimilate presentation to performance in the theatrical sense is to distinguish it not only from representation but also from what Judith Butler defines as *performativity*, which "must be understood not as a singular or deliberate 'act', but, rather, as the reiterative and citational practice by which discourse produces the effects that it names."[21] This definition is based on Derrida's critique of the residual voluntarism that besets the account of linguistic performativity developed in speech act theory, and Butler's use of the concept may be illustrated by the following passage:

> Consider the medical interpellation which . . . shifts an infant from an "it" to a "she" or a "he," and in that naming, the girl is "girled," brought into the domain of language and kinship through the interpellation of gender. But that "girling" of the girl does not end there; on the contrary, that founding interpellation is reiterated by various authorities and throughout various intervals of time to reinforce this naturalized effect,

which is secured by the continuous behavioral repetition of regulatory norms of heterosexuality (7–8). Performativity in this sense is opposed to (theatrical) performance because it is a mode of agency that "cannot be conflated with voluntarism or individualism . . . and in no way presupposes a choosing subject." Rather, it consists in "identificatory processes by which norms are assumed or appropriated, and these identifications pre-

cede and enable the formation of a subject, but are not, strictly speaking, performed by a subject" (15). I should note here that my concerns in the present essay lead me to exclude from the notion of performativity the limiting conditions—the enabling power of institutional authority—still presupposed in Butler's example and fundamental to Austin's notion of performatives as socially efficacious speech acts. For me the performativity of language, like that of any other medium, consists in what it says and does "on its own," regardless of what speakers mean to say or do, though the scare quotes are intended to suggest that the autonomy is not unconditioned: what language does and says on its own may be overdetermined by the play of discursive forces that motivate interlocutory exchanges and events.[22] These comments also apply to the performativity of other media, those, for example, that distinguish the visual arts.

The argument that one is made, not born, a girl presupposes a revised understanding of constructedness. Why is it, Butler asks,

> that what is constructed is understood as an artificial and dispensable character? What are we to make of constructions without which we would not be able to think, to live, to make sense at all, those which have acquired for us a kind of necessity? Are certain constructions of the body constitutive in this sense: that we could not operate without them, that without them there would be no "I," no "we"? . . . And if certain constructions . . . have this character of being that "without which" we could not think at all, we might suggest that bodies only appear, only endure, only live within the productive constraints of certain highly gendered regulatory schemas. (xi)

I suggest that what Butler calls construction may without much strain be rewritten as representation, and thus that performance is to performativity as presentation is to representation (or presentation-*to* to presentation-*as*). To be constructed as a girl is to be shown to oneself and others as a girl, to be inculcated into a performative and citational practice through which one is represented and represents oneself as a girl; one "gives oneself to be seen" as a girl. But representation adds two notions to construction: it implies mediation through some sort of perceptible schema, and it implies a relation to some prior construction. These differentiae make representation a particular class of constructive practices, and Butler's rhetorical questions remind us that although discussions of representation often focus on artificial and voluntary constructions in science, the arts,

and politics, there is a more "constitutive" activity of representation without which "there would be no 'I,' no 'we,'" the activity psychoanalysis designates as "primary"—primary process, primary identification, primary narcissism.

"Representation" is less easily circumscribed and defined than "presentation." The term changes like a chameleon as it wanders about from one context of usage to another. It does, however, carry a passport, a founding sense or identity that lets it move freely and flexibly across discursive boundaries: "representation" generally denotes the practice or product of depicting, imitating, replacing or displacing, symbolizing or signifying, something—call it the "representatum"—that the practice or product claims to stand for or to act on behalf of.[23] It may or may not claim to resemble its representatum (according to one or another set of criteria of resemblance); models in arts and sciences may explain or interpret but need not resemble their representata.

> How do representations act in society? Representations both interpret and replace the objects they represent. Overlapping cumulative representations of "woman" select certain characteristics to "stand for" women, enabling me to "handle" the women to whom they must relate. The social function of representations, then, is to stabilize assumptions and expectations relating to the objects or persons represented.
>
> Image-making, E. H. Gombrich has said, "is the creation of substitutes"; an image represses by producing its symbolic representation.[24]

What makes a representation a representation is that it displays an anaclitic and mimetic relation to a representatum, a relation that is in fact constitutive and repressive, since the representation interprets its referent and cannot, by definition, be identical with it.

"Representation, stressing and registering itself as representation, calls up and evokes as something absent the truthful presentation it confesses truly it is not."[25] It secures its status by distancing itself from its representatum, which it constitutively marks as an absent referent or original, an other. In that sense representation is always—as phenomenologists used to say of consciousness—representation-of.[26] Both representation and presentation should be kept distinct from presence, self-presence, self-identity, and related notions of immediacy, notions encouraged by such couplings of inside to outside, body to soul, as we find in physiognomic and related discourses that articulate theories of corporeal transparency. (See Chap-

ter 5 below.) Presence, thus understood, is on the thither side of representation from presentation, even though the latter is sometimes misrepresented or misconstrued as presence because in presentation the content is identical with the referent: both are here, within the presentation. Where representation says, "Here is a sign or image of something absent from my body (of print, paint, marble, etc.)," presentation says, "Here it is, present before you, part of my body," and the "it" may itself be a representation, as when an actor presents to an audience his representation of a character. For those who resist the postulate of transparency and view the body as a system of discourse that masks itself in prediscursive forms like nature and organism, presence is a mode of representation, the mythic object of desire, the object lost when the subject suffers the distortion of the media through which it passes.

How big a difference is there between actors, who present themselves representing themselves as others, and hypocrites, who represent themselves as others but try to conceal the signs of performance or presentation so as not to appear to be acting? Does "try to conceal" itself denote a presentational act? If hypocrites habituate themselves to conceal the signs of performance, they won't have to try so hard. They will become able not to be aware of—not to watch themselves—performing their representations of themselves as others. Freed from their presentational burden, they will become like children, pure and simple agents of representation unmediated by presentation. But aren't children, even babies, already like hypocrites? Infant majesties give themselves to be seen and represent themselves to others; in responding mimetically they represent themselves *as* others; and it is a psychoanalytic commonplace that they represent themselves to themselves. Can they also be said to present themselves representing themselves? Is presentation wrapped tightly inside representation like a chrysalis in its cocoon? Can speakers of any age be characterized by their speech as unwittingly, tacitly, performing like actors and hypocrites, presenting their representations of themselves to others? Can speech be rhetorically marked as presentational regardless of what the speaker seems to intend? Don't representations present themselves to their agents? Don't media and sign systems emit signals on their own that transgress even as they transmit their users' messages and intentions? These questions are not intended to kick off a serious philosophical inquiry. They're offered only as exercises aimed at bringing out—and getting used to—the distinction between presentation and representation, and they are also meant to sug-

gest that different levels of presentational intensity or distinctness may be keyed to different kinds and levels of representation. Presentation emerges and splits off from representation, announces itself as the frame or vehicle for representations, at the level of what may very loosely be called technologies of "image"-making in different media.[27]

Discussion of representation in its reflexive form, self-representation, has, in the past decade or two, become mixed up with an activity called "self-fashioning" in a manner that I think is more confusing than helpful. I wish I could declare a moratorium on the use of the phrase "self-fashioning" and the concept(s) it denotes because it has a flaw built into it that not even Stephen Greenblatt has been able to avoid. Consider the difference between these two statements: "Rembrandt fashioned himself"; "Rembrandt fashioned his self." In the first, the reflexive shifter circles back and disappears into the subject; in the second, the noun phrase that is the object of the verb splits off from the subject and moves forward in search of the reification promised by the verb.[28] The first illustrates the diathetical relation expressed in Greek by middle-voice constructions; it implies no claims about the separate existence of an object called "the self." But in the second, reification doubles our trouble: two referents instead of one have to be considered, not to mention the relation between them. An ontic rather than reflexive signifier, "[the] self" denotes an independent entity and thus carries theoretical commitments that are lacking—or at most implicit—in the first locution.[29]

These commitments of course vary. Just what is this self that gets fashioned, molded, formed, shaped, invented, or discovered, as if it were the creation of sculptors, painters, and poets (which in a certain way it is, at least in the sixteenth-century field of cultural production mapped out by Burckhardt, Greenblatt, and others)? Is it "a sense of personal order, a characteristic mode of address to the world, a structure of bounded desires," "a distinctive mode of personality, . . . a consistent mode of perceiving and behaving"?[30] Is "selfhood" synonymous with "individuality," "authenticity," "distinctive identity," "unique sense of identity," "nature or temperament," "the deepest recesses of the human psyche," "vital psycho logical presence, nature, or character"?—All these terms are phrases used by Perry Chapman in her study of Rembrandt's self-fashioning.[31]

As a work of art, the object of metaphors of shaping and fashioning, the self is made to seem comfortably thinglike. But the bounded entity evoked by those metaphors conceals a vague, fluid, and protean potpourri

of aspects as hard to pin down as The Old Man of the Sea and perhaps more frustrating because, as Butler puts it in *Gender Trouble:* the "figure of the interior soul understood as 'within' the body is signified through its inscription *on* the body"; "the effect of an internal core or substance" is produced "*on the surface* of the body, through the play of signifying absences that suggest, but never reveal, the organizing principle of identity as a cause."[32] So if there is no there there, if the self is a simulation, we might as well take Occam's razor to it.

Problems of another sort announce themselves as soon as we recognize that both "self-fashioning" and "self-presentation" are syncopated expressions; they occlude complex features of the activities they denote. If Butler is right, why not shave or slice off "fashioning" along with "the self" and replace "self-fashioning" with "self-representation"? Unless whatever goes on within "the deepest recesses of the psyche" between the fashioner and his or her self gets represented or, as Butler would say, performed, there is nothing to see or interpret apart from the fantasies of the "internal core" we inscribe on the surface of the representations we interpret. By definition, self-representation is something you show about yourself and something you do with yourself, but not something you do *to* or *for* yourself, which may happen but is contingent to the definition. By definition, self-fashioning is something you do to yourself and with yourself (and, if you're lucky, for yourself) but not something you show about yourself. The showing per se may be a kind of doing, but the doing per se isn't a kind of showing. How, then, do we determine whether or not people are engaged in fashioning themselves—or, possibly, their selves— if they don't represent themselves fashioning themselves? And if they do, how can we tell whether the self-fashioning they represent to others is actually going on "inside" the performers? So I call for a moratorium on the unqualified use of the term "self-fashioning" unless it is preceded by some form of "represent."

How does representation constitute and present (its relation to) its referent? Though I ask the question primarily with a view toward developing a framework for the interpretation of portraits, I would like to place this project within the context of a more general semiotic of representation, and for this I—like many others before me—find C. S. Peirce's famous second trichotomy of signs the simplest and most flexible system. The

three sign-referent relations Peirce distinguishes are: *the icon*, the sign that denotes by resemblance (for example, a visual imitation); *the symbol*, the sign that denotes by convention (language); and *the index*, the sign that points not merely to a referent but to some dynamic relation between itself and its referent (example: smoke is an index of fire).[33] Although Peirce's theory is simple, it isn't this simple, and we must explore it further.

Consider the following three examples: smoke is a sign of fire; the photograph is a sign of the scene it resembles; the (human) creature is an image of its Creator (*imago dei*). The first is an indexical but not an iconic sign; it signifies its referent neither by the formal qualities "that it has *qua* thing" and shares with the referent nor by the arbitrary conventional coupling Peirce calls "symbolic" and locates primarily in linguistic signs (2.157, 159); rather, when smoke appears, as St. Augustine puts it, "observation and memory of experience with things bring a recognition of an underlying fire."[34] The photograph is an iconic but not an indexical sign of the scene it refers to. It is not an index of the scene per se because the scene didn't cause it in the way fire causes smoke. It is dynamically related, causally and contiguously connected, not to the scene but to the photographic act and apparatus of which it is the material imprint or trace. This makes it a potential index, a sign interpretable as the effect of the camera and the act.[35] Its indexicality is realized in the interpretive act informed by "observation and memory of experience with things" photographic, and specifically by the viewer's lay knowledge that "the meaning-bearing surface of the sign—the photosensitive plate—came into direct contact with the world at the moment of exposure."[36] Furthermore, the same lay knowledge assures the viewer that "if a photograph is a photograph of a subject, it follows that the subject exists" and "is, roughly, as it appears in the photograph."[37]

The example of *imago dei* combines the direct causal linkage of the first example with the ontological assurance of the second. *Imago dei* activates both the subjective and objective genitive: "image *of* God because image *by* God"; iconic because indexical. Our lay knowledge or faith that the divine referent is the cause of the human sign guarantees the belief in some kind of strategically indeterminate resemblance that is flexible enough to lend itself to different, and often competing, specifications. Peirce emphasizes the formal structure that makes an object potentially iconic, the opacity that conditions the form its subsequent transparency will take: an icon "refers to the Object it denotes" by virtue of "a quality

that it has *qua* thing"—not, that is, *qua* sign—and this quality "renders it fit to be . . . a *Substitute* for anything that it is like"—"whether any such Object actually exists or not."[38] The concluding disjunction glances at the blasphemous specter theologies defend against, the specter that Baudrillard has baptized the "simulacrum," whose traditional form the theologians control by stigmatizing it as the hypericonicity (not hyperreality) of anthropomorphism. But they do this in order to safeguard the category of iconicity for their own appropriation of it in the more indirect and powerful form of *analogy*, "the bond of being."[39] In this form, the *imago dei* is understood as "a sign determined by its . . . object by virtue of being in a real relation to it," and this determination motivates the attribution to the index of a quality—iconicity—that "renders it fit to be" an image of if not "a *Substitute* for" its referent.[40]

The question—and questionability—of the indexical icon as a cultural construct comes up in Chapter 4 in the context of the basic formula of physiognomic discourse, "the face is the index of the mind," or, in one variant, "the face is the index *to* the mind." The variant is more specific because "of" in the first version introduces the directional ambiguity built into the genitive construction. With "to," the formula denotes only the modest ostensive functions of *indication* or *deixis* that are etymologically and logically connected to *index*. "To" brackets out the ontologically less modest and more problematical relations—the partitive, possessive, and causal relations encoded in the genitive "of" and potentially implicated in issues of hierarchy, control, and agency. "The face is the index *of* the mind": a part of it, the mind's possession or servant, its effect, the medium on which it acts and through which it discloses itself.

Of course, if all this is presupposed and taken for granted in the more modest variant, it supports the truth claims of physiognomic discourse. To say that the possibility of deixis presupposes those relations, takes them for granted, brackets them out, is to confer an ideological truth function on even so casual an act as pointing or drawing attention to the referent of the face. Indeed, the function is enhanced by the casualness of the gesture. But what is enhanced by casualness may be jeopardized by the appearance of deliberateness—the deliberateness apparent, for example, in such technologically mediated acts of self-representation as the acts of portraiture I discuss in this book. To stipulate that a portrait pretends to be an image or semblance of the act of portrayal—posing and painting— that produced it is to treat it as an indexical icon. However, as we'll see

(and as "pretends" in the preceding sentence suggests), the indexical iconicity of a portrait is an explicit fiction. Therefore it is diametrically opposed to the truth claims encoded in the indexical iconicity of the proposition that the face is the index of the mind.

In discussing the importance of Peirce during a short survey of semiotics, Kaja Silverman emphasizes his insistence

> that our access to and knowledge of ourselves is subject to the same semiotic restrictions as our access to and knowledge of the external world. In other words, we are cognitively available to ourselves and others only in the guise of signifiers, such as proper names and first-person pronouns, or visual images, and consequently are for all intents and purposes synonymous with those signifiers.[41]

Silverman and many others have commented on the way Peircean semiotics anticipates the work of Benveniste and Lacan, but I want to turn for a moment to another aspect of Peirce's theory that illuminates the close bond between an act of mediation and its self-representation.

Note that in each of the three examples I discussed above (smoke, the photograph, the *imago dei*) the critical factor governing the interpretation of sign functions is the context of understanding, the fabric of presuppositions, within which signs are exchanged. Woven into this fabric are not only the factors already mentioned—"observation of memory and experience," lay knowledge, faith—but also awareness of the categorical distinctions among *types* of sign function: the ability to use and recognize icons, indexes, symbols, and their combinations presupposes culturally inscribed norms and markers of iconicity, indexicality, and symbolicity. Thus if the actual signs that instantiate those types—their *tokens*, as Peirce calls them—are to be exchanged, they must be self-referential. That is, an icon has to be presented and recognized *as* an icon, has to signify and communicate its iconicity, before it can signify the referent it denotes by resemblance. This means that icons are not simply signs that denote by resemblance but signs *that denote that they denote* by resemblance. The first "denote" is contingent on a cultural interpretation of semiotic categories, and iconicity is therefore a product of convention. Inasmuch as the exchange of tokens is both enabled and constrained by the typology of sign functions prevailing at any given moment of culture, icons, or signs that denote by resemblance, are at that meta-level symbols, Peirce's term for signs that denote by convention. The same holds true for indexes: they are

signs that denote by convention that they are in dynamical relation to their referents.

Properly defined, then, an icon is a sign that denotes by convention that it denotes by resemblance. Thus in the transhistorical structure of discourse every category of sign function is a variant of the arbitrary sign, the symbol. To conceive of semiosis in this constructivist way is to grant the producer or user of signs access to a form of semiotic power that operates mainly at the level of historical change: since any token refers not only to its object (meaning or referent) but also to itself as an instance of its type, acts of sign use can affect and modify typological assumptions about what counts as an icon, an index, a symbol, an indexical icon, etc. Such power may not belong to individual sign-users per se; it may operate through them and be, relative to them, a level of *their* semiosis from which they are divided, an agency identifiable with the unconscious of their discourse. But to conceive of it as grounded in the arbitrariness of the symbolic mode is to encourage a view of it as a medium open to continuous intervention. Methodologically, then, classifying the icon and the index as variants of the symbol produces two complementary and interdependent interpretive outcomes. First, it enables us to postulate an essential or transhistorical signifying matrix (patrix?), which, if we give it the upper-case dignity of the rubric the Symbolic (Order), nudges it cautiously toward the watered-down version of Lacanian analysis I shall flirt with in Chapter 7. Second, it establishes the conditions of minimal variability—the parameters—that make possible the interpretation of the systemic changes we associate with historical specificity.

What I have variously called the context of understanding, the metalevel of categorical construction, and the fabric of cultural presuppositions corresponds roughly if reductively to the multi-faceted concept to which Peirce gives the name *interpretant*, though my sense of it is in accord with Umberto Eco's revised formulation: "The interpretant is that which guarantees the validity of the sign, even in the absence of the interpreter," and the "that" can only be

> another sign which in turn has another interpretant to be named by another sign and so on. At this point there begins a process of *unlimited semiosis* . . . [in which language] is clarified by successive systems of conventions that explain each other. . . . In fact . . . culture continuously translates signs into other signs, and definitions into other definitions, words into icons, icons into ostensive signs, ostensive signs into new

definitions, new definitions into propositional functions, propositional functions into exemplifying sentences and so on; in this way it proposes to its members an uninterrupted chain of cultural units composing other cultural units, and thus translating and explaining them.[42]

"Chain" is not the best image for what Eco describes here and elsewhere as unlimited semiosis: a better one would be a rhizomatic network of interconnecting branches that changes continuously as some grow and others die off.

The interpretant may be any state or sector of the network, any of the "successive systems of conventions" that circumscribe the sign in question and can be used to clarify it and guarantee its validity. Understood in this way, interpretants "can be complex discourses which not only translate but even *inferentially* develop all the logical possibilities suggested by the sign" (70). But since I am persuaded by Eco's thesis that the basic units of experience (including not only unit-meanings but also unit-percepts) are *cultural* units stabilized or focalized as signs, and that semiotics "*is mainly concerned with signs as social forces*" (65), my interest is less in the logical than in the ideological possibilities developed by discursive interpretants, and less in the logical than in the ideological force by which the interpretant "guarantees the validity of the sign"—or, in more openly political terms, the force by which it *legitimates* the sign. For the interpretant is the context not only of understanding but also of the legitimation of privileged sites of interpretation; it is a social and political as well as a semiotic and semantic function. Mimetic idealism, the legitimating discourse of early modern portraiture I discuss in Chapters 2 and 4, is an example of an interpretant. The apparatus of patronage is another.

Eco divides semiotics into two areas: the theory of codes or signification and the theory of sign production or language use. To the first he allocates the analysis of relations between signifier and signified within the sign or, in his terminology, the relations of "sign vehicle" and "content" within the "sign-function." The analysis of sign/referent relations ("the use of signs in order to mention things or states of the world"; 3) is among the phenomena taken into account by the second. In principle, even though his focus on the synchronics of code structure leads him to assign it what appears to be strictly methodological priority, Eco construes the relation between code and language use as dialectical. But as Teresa de Lauretis points out in a trenchant critique, he defines creative sign use in a manner prejudicial to the embodied subject of semiosis, the ordinary

sign user in the street: he "seems to exclude all practices which do not re-
sult in actual texts, or 'physically testable cultural products.'"[43]

De Lauretis argues that Peirce's "concepts of the interpretant and un-
limited semiosis . . . usher in a theory of meaning as a continual cultural
production that is not only susceptible of ideological transformation, but
materially based in historical change" (172), and she goes on to criticize
Eco's reformulation of Peirce because it elides the material basis of change
in the semiotic process—elides the "psychological, psychic, and subjective"
traces of the embodied and gendered individual that Peirce took into ac-
count, even if in rudimentary form (176, 168–82). She proceeds to reha-
bilitate Peirce's "less restrictive" view of "the varieties of possible semio-
sis" because it allows for substantive interventions by "political or more
often micropolitical" practices that may, "by shifting the 'ground' of a
given sign," alter "codes of perception as well as ideological codes." Since
these practices "produce, in Peirce's terms, . . . a habit-change," they func-
tion as interpretants that result in 'a modification of consciousness'" (178).
The examples of interpretants I gave above—mimetic idealism, the appa-
ratus of patronage—work in this way. They are not only the structural
"ground" but also an interpictorial effect of practices of sign production.[44]
This sense of the interpretant informs my approach to the set of chang-
ing technologies of (self-)representation that includes portraiture.

The concept of the interpretant formulated by Peirce and successively
modified by Eco and de Lauretis is crucial to the study of portraiture
that follows, but I also want to emphasize the importance to my project
of the way Peirce formulates the distinction between icon and index.
That distinction will be the basis of the interpretive framework devel-
oped in Part 2 under the rubric of the fictions of the pose. I argue there
that it is necessary to articulate the distinction between these two func-
tions of the portrait sign in order to explore the effect of their interplay.
Here is a condensed preview of the argument: a portrait presents itself as
a sign that denotes its referent by resemblance; the referent it denotes is
not simply a person but a person in the act of posing; and since posing is
part of the causal event that produced it, the portrait as a sign is indexi-
cal as well as iconic.

I use the term "iconic" in a fairly restrictive and simplistic way to de-
note the relation between the portrait as a sign and the act of portrayal it
depicts as its putative referent. A more complex and perhaps more Peirc-
ean version is put into play by Mieke Bal, who defines iconicity as "a

ground of meaning production, a code, . . . that establishes a relation be-
tween sign and meaning on the basis of analogy—of a common prop-
erty."[45] In keeping with her stated effort to get "beyond the word-image
opposition," she distinguishes "Peircean iconicity" from "visuality, " asso-
ciates it with such other forms of analogy as metaphor and allegory, and
on occasion treats it as a deceptive mode inferior to indexicality.[46] I have
a particular reason for wanting to stay clear of so diffuse and evaluative an
interpretation of iconicity, whether in Peirce or in Bal, and to insist on a
narrow construal of the portrait as a visual icon.

This reason stems from my desire to situate my reading of portraits
within the framework provided by some of Eco's more perverse *doxai*:

> [S]emiotics is in principle the discipline studying everything which can be used
> in order to lie.

> In a sentence mentioning something, that is, referring to an actual state
> of the world, what happens at the source is the so-called "referent."

> The problem . . . of the referent . . . [is] the problem of the possible
> states of the world supposedly corresponding to the content of a sign-
> function. . . . *Every time there is possibility of lying, there is a sign-function*,
> which is to signify (and then to communicate) something to which no
> real state of things corresponds.

> The semiotic object of a semantics is the *content*, not the referent, and the
> content has to be defined as a *cultural unit*. . . . The referential fallacy
> consists in assuming that the "meaning" of a sign-vehicle has something
> to do with its corresponding object.[47]

I define a portrait as a sign that denotes by resemblance, a sign whose con-
tent purports to refer to some possible state of the world that corresponds
to it but is absent from it.[48] Since the possible state the portrait sign de-
notes and resembles is the prior act of portrayal that produced it, its rela-
tion to what it denotes and resembles is indexical as well as iconic. But the
basic premise behind the fiction of the pose is that we can't assume the
activity of posing and painting to have transpired exactly in the way it is
represented. Rather, as I shall argue in Chapter 8, we must assume that
much of the actual process of producing the portrait was different from
and is thus unrepresented in the final product. We assume, in short, that
the portrait is lying—is encouraging the referential fallacy—and that its
claims to iconicity and indexicality are fictitious.

The portrait, however, may bear indexical significations that are not

fictive in this manner because they denote the work self-representation does in the sociopolitical and economic context of the apparatus of patronage. This work can be concisely illustrated by considering the genealogical relation of portraits and posing conventions to donor figures in religious paintings. According to Vasari, Giotto was the first painter to express "gli affetti" so that one could recognize and distinguish "fear, hope, anger, and love." As Vasari's descriptions in the life of Giotto show, he is referring to history painting, religious narrative, where familiarity with the story is presupposed in any judgment about the rendering of states of mind or feeling. Without the cues or justifications of narrative, such rendering becomes difficult and presents the challenge in whose terms the criteria for judging portraiture emerged.

The actual story of this emergence, as told by John Pope-Hennessey, in fact begins within putative history painting, religious or civic. He is at his most engaging when he expresses his animus against the conversion of "the choirs of so many churches" in Florence to "a civic portrait gallery."[49] In Venice the collective portrait struck like the plague:

> Status and portraiture became inextricably intertwined, and there was almost nothing patrons would not do to intrude themselves in paintings; they would stone the woman taken in adultery, they would clean up after martyrdoms, they would serve at the table of Emmaus or in the Pharisee's house. The elders in the story of Susannah were some of the few figures whom respectable Venetians were unwilling to impersonate. (22–23)

Because the portraits in history paintings were commissioned primarily for their documentary and social value, their "emphasis is generally descriptive" and few painters succeeded in producing more than recognizable transcriptions (23). The subjects do, however, pose, adopting conventional attitudes as pious donors, conversing observers, and more active participants. In many cases they are represented as poor actors who, adjacent to each other and supposedly engaged in the event or conversing about it, fail to convince observers that they are more interested in playing historical parts than in leaving their likenesses to posterity. Thus examples of the category or genre of history painting may be rendered ambiguous by the interpolation of portraits that intrude the issue of posing—getting represented—into a primary emphasis on sacred history. In the eyes of more skeptical contemporaries, did the effect of historiation as role performance

rub off on representations of the scene's feature players—Christ, the Marys, the saints, and their Old Testament precursors?—Would it make them seem more aware of performing their salvific deeds before spectators?

Pope-Hennessey was hardly the first to vent his spleen at these performances. In "Aretino" (1557), Lodovico Dolce interrupts praise of Raphael and Titian as history painters to castigate the nameless painter of a mural in the Doge's Palace who "exceeded the bounds of propriety . . . when he put in so many Venetian senators, and showed them standing there and looking on without any real motivation. For the fact is that there is no likelihood that all of them should have happened to be there simultaneously in quite this way, nor do they have anything to do with the subject."[50] This is true of many earlier Venetian extravaganzas. One of the most fetching examples of an attempt to avoid the sin against propriety is to be found in Gentile Bellini's *Miracle at the Bridge of San Lorenzo*, in which the miracle is both witnessed and venerated by a row of men kneeling in profile on the right and a row of women standing in profile on the left. They are, in effect, multiple donors, or representatives of a corporate donor.

The fiction and function of the donor profile are interesting in this context. According to Rab Hatfield, the profile view was dictated by the necessity for donors "to appear intent upon the sacred scene and for their faces to be visible at the same time."[51] Hatfield's explanation of this motif is worth quoting because it suggests, albeit in jumbled form, the ambivalent structure of the donor portrait:

> The importance of the sitters themselves is not the expressed [*sic*] subject of such portrayals. One realizes that they have earned the right to be shown only because they or their relatives [or, e.g., confraternity] have paid for the painting in which they have only the subordinate role of onlookers. Hence they are to be admired for having contributed to the devotion and edification of the community. Of course, one deduces from the portrait that the donor had achieved social prominence, or at least the wealth to pay for the painting. Moreover, he is shown in a zone that opens onto that of the sacred beings. . . . But the power and influence that he had are not shown. Rather, the qualities that one is given to read from the context in which he is placed are those of reverence and humility. By implication it was these qualities, rather than his high position or the uniqueness of his position, which made the donor socially deserving of fame. (320)

The donors conspicuously yield pride of place to "an event of significance for the social body to which they have contributed by their participation" (ibid.).

Yet it is misleading to say that "the power and influence . . . are not shown." Within the context of the politics of patronage, history painting has both use value and exchange value for those who invest in it as a means of accumulating symbolic capital. From this standpoint, the reputation of the painter, the conspicuousness of expenditure, and the allegorical reference may be more important than the iconic content of the painting. As an indexical sign of power and generosity, the particular "event of significance" the painting represents is ancillary to the display of *invenzione* that makes it a slant allusion to the occasion of patronage. When the act of commission or donation enters into the content through donor portraits, when the indexical sign becomes an indexical icon of donor power, the traces of that power already emanating from every material inch of the sign are merely redistributed, not concealed. They are evacuated only from the figure of the donor. In its trans-iconic totality, the painting is an index of power and influence because it celebrates and, by being installed, perpetuates the act of donation as itself the "event of significance" allegorically shadowed by the narrative selected to serve it up. Reduced to an embodiment of reverence and humility, the donor portrait provides a formulaic index of the spirit, the motivation, that caused—and that legitimizes—the act.

In Bellini's *Miracle*, the prominent size and position of the male donors (one of whom is thought to be the painter), and the rich detail of the inventory that displays the material wonders of both the painter's brush and the Venetian state, proclaim the miracle of donation and painting to be the real event. The profile of the pious donor is thus a "dead image" in several senses: a good likeness; a likeness reduced to the status of a personification of virtue; an idealized commemoration bequeathed to posterity. As Hatfield notes, the sharply outlined profile view minimizes the "transitory changes to which a face is subject" and conveys a "sense of permanence" (322), a permanence which, like that of the profiles inscribed in coins and medallions, signifies or predicts (or solicits) posthumous fame, and thereby signifies death.

On the other side of the generic interpenetration between history and portraiture, the visual and conventional signs of power and influence are re-collected, condensed, within the posing figure. Many portraits show

sitters who, while pretending only to display their physiognomies, strike the historical poses or assume the expressions assigned to the protagonists in classical and religious painting. The commissioned portrait is an act of self-donation. The sitter is a donor in the weak sense that he gives himself to be seen in an icon. But in a strong sense, the icon is an embodiment, a representation, and a reminder both of his power of donation and of his gifts to the community. I conclude by returning to Lisa Jardine's comments on Bellini's portrait of Doge Loredan because they offer a beautifully compact example of this. Jardine suggests that the portrait as a luxury commodity testified to Loredan's wealth and power, including the power of commission and the privilege of posing. Such wealth and power may have derived from membership in a patrician family and order, but, as she makes clear, they weren't guaranteed. They were affected by the fluctuations of the civic economy and by related political pressures that made patrician families continually compete and negotiate with each other even as the patrician state was engaged in competing and negotiating with other polities. If the responses to these challenges are classified under the general rubric of acts of self-representation, then it becomes clear that portraiture bears an indexical relation to economic, social, and political contingencies. As Jardine argues, Bellini's and other portraits of Doge Loredan not only register the sitter's standing; they are situated strategies intended to maintain or improve it:

> Bellini has captured the texture and intricate patterning of the damask of Loredan's official doge's robe and cap with *trompe l'oeil* effectiveness. We hardly need to be told that the use of damask for these ceremonial articles of clothing was an innovation introduced by Loredan when he became the elected ruler of Venice in 1501. The imported fabric . . . symbolized Venetian access to wealth and goods in the East through its historic position as dominating maritime power in the Mediterranean.

> Ceremonial sumptuousness could be used to show pride in the very sources of a ruling elite's affluence. . . . [Loredan's innovation] was consciously part of the programme advertising Venice's silk industry. . . . The portraits . . . both amaze the onlooker with their visual magnificence and serve as reminders of Venice's wealth and prestige.[52]

EARLY MODERN TECHNOLOGIES AND POLITICS OF REPRESENTATION AND THEIR CONSEQUENCES

TECHNOLOGIES: THE SYSTEM OF EARLY MODERN PAINTING

An often-told story hops from one table of academic discourse to another: among journals, conferences, catalogues, salons, textbooks, and other venues for the dissemination of whatever genealogies and ideologies of the history of the present the disseminators wish to promote. It is a story about the role eyes, images, observers, paintings, cameras, and film play in sustaining the technology and ideology of "representationalism." Its theme in one version of the story is that the "film camera is an ideological instrument" expressing "bourgeois ideology" and producing "a directly inherited code of perspective, built on the model of the scientific perspective of the Quattrocento."[1] From the perceived analogy among the ways images are constructed in perspective, the camera obscura, photography, and film, a thesis is generated about "the history of cinema: it is the perspective construction of the Renaissance which originally served as model."[2] The monolithic view embedded in this story has often been criticized. Martin Jay, for example, questions the assumption that "what is normally claimed to be the dominant, even totally hegemonic, visual model of the modern era" is the one derived from and identical with "Renaissance notions of perspective in the visual arts and Cartesian ideas of subjective rationality in philosophy."[3] Jay explores internal tensions in what he calls the scopic regime of "Cartesian perspectivalism" as well as possible alternative regimes (10–18) and concludes with the advice that a pluralistic approach to scopic regimes may be the most useful.

A more thoroughgoing critique of the monolithic view appears in Jonathan Crary's *Techniques of the Observer*. Crary disarticulates the mono-

lith at both ends, arguing that the camera obscura implicates a discursive and technical model different from those of perspective and photography. The resistance he offers to the reductive simplicity of the monolith view is salutary. But in its emphasis on disjuncture and discontinuity Crary's argument may cut right through the long striations of a tissue of logical connections that could lend it force and integrity. He is

> wary of conflating the meanings and effects of the camera obscura with techniques of linear perspective. Obviously the two are related, but it must be stressed that the camera obscura defines the position of an interiorized observer to an exterior world, not just to a two-dimensional representation, as is the case with perspective. Thus the camera obscura is synonymous with a much broader kind of subject-effect. . . . Above all it indicates the appearance of a new model of subjectivity. . . . First of all the camera obscura . . . defines an observer as isolated, enclosed, and autonomous within its dark confines. It impels a kind of askesis, or withdrawal from the world, in order to regulate and purify one's relation to the manifold contents of the now "exterior" world. . . . At the same time, another related and equally decisive function of the camera was to sunder the act of seeing from the physical body of the observer, to decorporealize vision. The monadic viewpoint of the individual is authenticated and legitimized by the camera obscura, but the observer's physical and sensory experience is supplanted by the relations between a mechanical apparatus and a pre-given world of objective truth.[4]

In spite of Crary's account of the novelty of the camera obscura, the structure of relations he describes is continuous with perspective in an important respect: both involve the abstraction and alienation of a monocular system of vision from the binocular organic system. In both, the increase and refinement of visual power is consequent on its being free, alienated, from the limits of the body. In *On Painting* Alberti shows himself fully aware that he is proposing a hypothetical method in which seeing is described on the model of picture making and geometry, an abstractive model that "requires the mathematics, but not the physics or physiology, of vision."[5] Nevertheless, Alberti arbitrarily assigns the vertex of the geometrical system—the distance point—the value of an eye: the eye of a virtual observer, a cyclopean robot, constructed and controlled by the system. Having been abstracted from the body, Alberti's virtual system of vision is then reincorporated in an imaginary body, an idealized geometrical phantasm that any empirical viewer may incarnate by standing in the right place.

"Pre-cybernetic machines could be haunted; there was always the specter of the ghost in the machine."[6] As Beth Pittenger has suggested, Donna Haraway's statement can be turned around: precybernetic humans could be haunted by the specter of the machine in the body, an idea-producing machine, a mathetic or mathematical *dianoia*, trapped in the *morbidezza* of the body and its senses.[7] One can readily imagine that the epistemological anxiety about the limits of the senses expressed from the time of Copernicus on would already haunt Alberti's project. Comolli notes that "when the invention of photography . . . perfected the *camera obscura* and thereby achieved what generations of painters had for centuries demanded from the technique of artificial perspective—the possibility of copying nature faithfully . . . —the human eye was abruptly seen as neither altogether unique, nor quite irreplaceable, nor very perfect."[8] Again, a specter of this anxiety may shadow Quattrocento experiments in perspective and magic. Comolli's terms can be applied to perspective as well as to photography: "a strengthening of confidence in a perspective and analogous representation of the world" is offset by "a crisis of confidence in the organ of vision," in which the human eye was "devalorized and deposed from its central place by the eye" of perspective's cyclopean observer (52).

The technical dialectic of abstraction from and reincorporation in the body—the abstraction and reincorporation of instrumental systems that extend and expand human power—constructs (and operates along) a continuum of prosthetic metamorphosis that should be contrasted to Crary's breaks and discontinuities. Consider, for example, his account of how Locke, Hume, and Descartes internalize or reincorporate the alienated structure of the optical instrument containing the virtual "eye of the observer," reinscribing it as a figure of cognitive and perceptual process: being an "apparatus that allows the entrance and formation of 'pictures' or 'resemblances,'" the camera obscura provides Locke with a model of sensory activity, while the enclosed observer, "completely separate from the apparatus," is equated with the faculty by which the subject inspects, interprets, and judges perceptual sensations. Most important for my purposes, Crary emphasizes the "juridical" and, indeed, political character of Locke's conception of the observer within. Noting that Locke elsewhere comments on the meaning of *in camera* as "within the chambers of a judge or person of title," he quotes Locke's application of a cognate figure to the appearance of sensations in "the mind's presence room" and asserts that

> Locke . . . gives a new juridical role to the observer within the camera obscura. Thus he modifies the receptive and neutral function of the apparatus by specifying a more self-legislative and authoritative function: the camera obscura allows the subject to guarantee and police the correspondence between exterior world and interior representation and to exclude anything disorderly or unruly. Reflective introspection overlaps with a regime of self-discipline.[9]

This discussion continues Crary's project of differentiating the camera obscura from perspective. Yet in an earlier version of his camera obscura chapter, we find rhetoric that ascribes a similar policing function to perspective: "Monocularity, like perspective and geometrical optics, was one of the Renaissance codes through which a visual world is constructed according to systematized constants, and from which any inconsistencies and irregularities are banished to insure the formation of a homogeneous, unified, and fully legible space."[10] If there is an implicit politics, a scopic regime, in the Lockean model of cognition—or in the models of Descartes, Hume, and Berkeley—aren't the "Renaissance codes" that underwrite graphic representation equally charged with implications of a hegemonic desire that would elevate *disegno* from its lowly quarters in manual craft to its belvedere atop the palazzo of the mind's judicial and executive oversight?

Sensitivity to the political dimension of the story it tells is one of the virtues of *Techniques of the Observer*. Crary notes that the models of continuity he interrogates

> have been used by historians of divergent and even antithetical political positions. Conservatives tend to pose an account of ever-increasing progress toward verisimilitude in representation, in which Renaissance perspective and photography are part of the same quest for a fully objective equivalent of a "natural vision." . . . Radical historians . . . usually see the camera obscura and cinema as bound up in a single enduring apparatus of political and social power, elaborated over several centuries, that continues to discipline and regulate the status of an observer. The camera is thus seen by some as an exemplary indication of the ideological nature of representation, embodying the epistemological presumptions of "bourgeois humanism."[11]

Whatever one's political preferences, the radical view as articulated by Crary is more sophisticated than the conservative view, more attuned to

the possibility that any claim to knowledge of the "fully objective" may itself be "ideological," whether in the pejorative, prescriptive, or descriptive senses of that term. The "apparatus of political and social power" may not be "a single enduring" one, but it is always there in some form, and *there* in *some material form.* Unless we take it into account by at least pretending to be skeptical of the claim to objectivity, we can't place the question of "verisimilitude in representation" in an interpretive framework that makes traces of motive, desire, and interest not only discernible but also legible in particular material forms. The objective of the present chapter is to begin to develop a framework of this kind for use in a very restricted field, the field of early modern painting, and to show that many of the structural conflicts and changes Crary assigns to later moments of his *longue durée* from the Quattrocento to the present may be found in telescoped form in that early micro-sequence. "Representationalism" as an ideology is already a contested issue during the period in which "the Renaissance codes through which a visual world is constructed" were being formulated.

In order to narrow my focus from visual culture and technology to painting, I turn now to consider another version of the oft-told tale I began with. It is, again, the story of

> the long development within Western art, dating back at least as far as the late Renaissance and tremendously accelerated since the mid-19th century, toward the progressive thinning-out of that texture of cues within the overall compositional structure whose interaction has seduced the viewer into the imaginative experience of objects, spaces, and qualities—in short, of a world which is only virtually, rather than actually, present before him. As the specificity of these cues, and the density of their interlacing, have waned, an ever-larger and more overt role has been asserted "from beneath" by the material realities of pictorial construction.[12]

I cite the story from Sheldon Nodelman's analysis of the phenomenology of painting-observer relations because he not only subjects the constitutive and regulative protocols of "the long development" to a rigorous analysis but also tells the story from the standpoint of someone who can view it whole because it has concluded. According to Nodelman, the "millennial history of internally focused composition in painting" was terminated by Frank Stella and his peers, who proclaimed "in a hitherto

unexampled way the activity of painting in real space" and, by emphasizing the status of "the picture as an object within that space," exposed it as "a relatively timid and constrained object. This constraint resulted precisely from its commitment to a pictorial mode of functioning," and Stella's aim was to imperil "the delicate web of convention, the tacit suspension of belief, upon which pictorial virtuality depended" (8, 13).

I will argue that very early in the long development Nodelman charts, and within the scopic regime of representationalism he characterizes, there are modes of painting that speak to us of "the activity of painting in real space." They may not loudly proclaim it, but they quite audibly mutter it. There are painters in the sixteenth and seventeenth centuries whose work displays a motivated correlation between the "thinning-out" of the "texture of cues" to representation and the variable thickening of the texture of paint. Nodelman's story tends to thin out similar patterns of variation discernible in early modern micro-sequences—patterns that reproduce in attenuated and accelerated form versions of the development he traces from the dominant accent on virtuality toward, if not to, the accent on "the material realities" and activity of painting. Yet the terms, the rhetoric, of Nodelman's analysis are immensely suggestive because they center attention on the political implications of the aesthetic, formal, and technical parameters he discusses. So, for example, though "Stella and his peers" may have exposed the representational picture as "a relatively timid and constrained object," in Nodelman's prose it regains its despotic power. He stresses its ability in its own right to impose "constraints . . . upon the spectator's choice of position by the characteristic pictorial form and mode of address" (23), its "capacity to polarize the viewer into confrontation, to focus his attention upon itself . . . and to subject him to a variety of manipulations in space" in order "to enforce the conducts necessary for effective reception of . . . [the] fictive world at the expense of his awareness of the actuality in which he was concretely immersed" (25).

This politicization of formal relations aligns Nodelman with those "radical historians," described by Crary, for whom the camera obscura and cinema are "bound up in a single enduring apparatus . . . that continues to discipline and regulate the status of an observer."[13] His resistance to the idea of "a single enduring apparatus" notwithstanding, Crary shares with Nodelman a sensitivity to the aesthetic, formal, material, and technical factors that contribute to the construction and subjection of the

observer. Their politico-formal approach provides me with an interpretive model applicable to the particular strategies or modes of painting I shall discuss. But it is applicable only if a major component of the model is altered. Whether monolithic or segmental, the story Nodelman, Crary, and others tell is based on the premise that virtuality, representationalism, and the domination of the observer originate in Quattrocento perspective. The genealogical account that traces the double movement of alienation and reincorporation—"the abstraction and formalization of vision" and its prosthetic relocation "in the subjectivity of the observer"[14]—back through cinema, photography, and the camera obscura to perspective tends to treat the latter as if it were coextensive with the early modern invention or rediscovery of virtual space per se.

This is an extraordinarily reductive simplification of a more complicated state of affairs, one that I shall henceforth refer to as *the system of early modern painting*. The representational fabric of this system is a dense weave of several modes of depiction, only one of which is partially identifiable with Quattrocento perspective—partially because, as we'll see, this mode includes many more features than perspective and can do without perspective in its construction of virtual reality. Nevertheless, as we'll also see, this mode dominates and is strategically central to the scopic regime of early modern painting. Once it is singled out and contextualized, once its contribution to the design and effect of the total representational fabric of the system is described, Nodelman's politico-formalist reading can throw a valuable light not only on its practical uses and ideological implications but also on the way the other modes appear to reinforce, enrich, modify, or critique the political content of its aesthetic form.

Finally, before I move into my account of the system of early modern painting, I think it is worth noting something so obvious that it tends to be taken for granted and ignored in genealogical constructions of the origins and careers of modern (and postmodern) scopic regimes. The fabled origin in Quattrocento perspective is a convenient fiction; introduced for heuristic purposes, it masks earlier stages in a story that can be taken back, if one wants, to the Paleolithic. Our modern story begins *in medias res*, and, in my view, it is a strategic error to adhere so rigidly to that origin as to black out its precursors, especially the mode(s) of "medieval" painting that Quattrocento perspective both interacts with and reacts to in a continuous process of meaningful negotiation. Thus I set my starting point back a step by including a precursor mode in the system of early

modern painting—partly for the reason I just gave, and partly because this mode, which I call *decorative*, does not vanish with the onset of the new regime but is continuously, variously, rewoven and reinterpreted in the system's representational fabric.

I distinguish four modes of painting as the constituents of the early modern system and give them the names decorative, graphic, optical, and textural. In *the decorative mode*, painters use pigment, color, light, and technique primarily to emphasize two things: (a) the *symbolic* link of the sacred image to the otherworldly (supernatural, transcendent) figure or event it represents—for example, God, the Virgin Mary, Christ, the saints, the Annunciation, the Nativity, the Crucifixion; and (b) the importance, value, and preciousness of the painting's context and support—(the altar, the church or chapel interior, the ritual activity taking place in the vicinity of the artwork, the wealth, piety, and importance of the patrons who commissioned it). Because of its context and symbolic function, the decorative mode is used to dramatize the distance and difference between the image and the figure or event it represents. It's expressly an artificial, flat, conventional representation rather than a lifelike one because the transcendent figure or event it symbolizes exists beyond it (in real sacred history, or in real "heaven"). The image doesn't magically contain and activate the powers of those figures and events by itself.

The image is *liturgical* rather than magical, which is to say that its power is not its own but is conferred on it from outside by ritual practices believed to solicit and activate divine power and grace.[15] For example, the painted altarpiece is connected to the Mass celebrated beneath it at the altar. The painting *decorates* and celebrates this liturgical context. It decorates not only in the sense of beautifying but also in the sense of honoring (as when we speak of a decorated war hero or athlete). But the painting is also *decorous* in that it possesses *decorum*. Decorum is fitting or appropriate behavior, behavior that observes propriety and shows that one knows one's place.[16] In this case, to be decorous is to be deferential: the decorative image represents itself as deferring to the superior value and importance of the transcendent figure or event of which it's (merely) an image. It is part of the *decor*, which, like a stage setting, is supposed to help put priest and/or worshippers in the proper frame of mind so that they can get the most out of the liturgical drama in which they participate:

Viewing an altarpiece is hardly an act of detached aesthetic experience. The act of viewing is—or ought to be—an act of worship. In no other pictorial category is seeing so charged with responsibility—and, potentially, with such consequence. What distinguishes the altarpiece functionally from other kinds of devotional imagery is its liturgical situation. Set above the altar table, the painting is transformed by the ceremony over which it visually presides: the celebration of the mass. . . . Its own authority as an image is enhanced and validated by its presence at the elevation of the host.[17]

At the same time, decorative painters may use this liturgical motive to direct attention to the splendor and virtuosity of their art—to the lustrous beauty of crafted surfaces, brilliant color, the lavish display of gold and other precious materials, and above all, the display of fine workmanship.

For both religious and aesthetic reasons, then, in the decorative mode primary emphasis falls on the embellishment of the opaque surfaces—the wooden panels of altarpieces, the glittering mosaics of walls and ceilings—that provide the setting for liturgical action. Interest in breaking through the surface, in creating spatial illusion, in treating the surface of the panel as a window through which you look toward an imaginary three-dimensional scene—is inhibited by the requirements of liturgical art. An art that brings out "the material preciousness of objects of veneration"[18] is valued more than an art that reduces the ritual object to a window on the virtual reality of spatial illusion.

The constraints of decorum that motivate the decorative mode apply to the virtual observer as well as to the image. Here, Crary's reason for preferring the term "observer" to the term "spectator" illuminates both the general concept of observer and the specific position constructed by decorative painting. He notes that while "*spectare*, the Latin root for 'spectator,'" literally means "to look at,"

observare means "to conform one's action, to comply with," as in observing rules, codes, regulations, and practices. Though obviously one who sees, an observer is more importantly one who sees within a prescribed set of possibilities, one who is embedded in a system of conventions and limitations. And by "conventions" I mean to suggest far more than representational practices. If it can be said there is an observer specific to . . . any period, it is only as an *effect* of an irreducibly heterogeneous system of discursive, social, technological, and institutional relations. There is no observing subject prior to this continually shifting field.[19]

The deference of image to referent ideologically expressed by the liturgical context and style of decorative painting is a deference to be imitated and assimilated by anyone who occupies the site of ritual observance which that context and style cooperate in constructing.

In *the graphic mode*, things are painted *as they are known or thought to be*, that is, as people imagine they really are and appear. This includes not only the lifelike or naturalistic imitation of three-dimensional forms in space and of spatial relations, but also an imitation that shows itself to be based on the study and knowledge of the way things are made and the ways they are seen: for example, knowledge of anatomy, of such craft objects as clothes, jewels, and architecture, of perspective, and of the effect of light on three-dimensional forms. In the graphic mode, the surface of the painting is effaced or "windowed out"; color is less brilliant, more muted and varied, so as to represent the way things appear at different distances and under different conditions of light—though the color of any object appears constant because "the painter paints the color he knows the object to have, unaffected by interference from the environment."[20] The graphic mode often features even lighting that helps model the forms in smooth transitions from lighter to darker areas; it also features the use of contour lines, outlines, that "fix" the individual form in relative isolation in order to clarify its appearance. In some cases, when the effect of stable and monumental form is desired, human figures will be made to resemble statues, producing a strange effect of stillness even in representations of physical activity or exertion. In Florentine versions of the graphic mode "the desire to create the plasticity of sculpted relief" led painters to strive for the impression that "what we see in the picture was and will be that way forever because it has been freed of all accidental and transient qualities."[21] It has, in effect, been locked into place. The same tendency is apparent in the graphic construction of a position for the observer produced by the system of rational perspective. This observer position, or virtual observer, is fixed, locked into place, at a particular distance and height determined from within the picture by its geometrical organization.[22]

In the Flanders of van Eyck and his contemporaries we find a different inflection of the graphic mode, one in which decorative effects are (a) "retracted" from the opaque surface of the support to the imaginary sur-

faces of the forms depicted behind the picture plane, and (b) conflated with incipient *optical* effects (see below). Thus Marcia Hall writes of van Eyck's *Virgin of the Canon van der Paele*:

> We have the sense that a fleeting moment has been captured and made eternal, its reality recorded in a thousand minutely observed details of shimmer and glint, of texture and surface. The light recorded here is not the predictable stage illumination of the Italians that clarifies the space and figures' placement in it.[23]

And Panofsky says of van der Weyden: "As in all Early Flemish Painting, his lines are not abstract contours separating two areas of flat color, but represent a condensation or concentration of light or shade caused by the shape and texture of the objects."[24] Of pre-Quattrocento painting Gombrich observes that when

> we come across the representation of an object that should really shine and sparkle, a piece of jewelry or a golden chalice, we are as likely as not confronted with real gold paint or even the imitation of the jewels in solid colored paste. . . . [T]he real discovery of Flemish illusionism . . . lies in the introduction of . . . a new gamut of textures from sparkling jewels to mat velvet, that can be expressed by the distribution of lights. . . . The way Jan van Eyck picks out the lights on brocade . . . can perhaps be seen as an infinite refinement of those networks of gold that were conventional in Byzantine art. . . . The Northern tradition had always set its pride in the accumulation of fine detail, picking out the flowers of a meadow or the leaves of a tree. But only the mastery of texture that springs from the new attention to reflections and highlights could lead the van Eycks to their transformation of landscape detail into a microcosm of the visible world.[25]

It was precisely this meticulousness for which Karel van Mander in 1604 praised northern artists under the term *nettischeydt*: in Walter Melion's paraphrase, the painter's "image is *net* when . . . it divulges no trace of rendering, exhibiting a mirror-like finish that accentuates the description of surface textures. . . . *Nettischeydt* invites scrutiny from a close vantage point, since it allows the painter to miniaturize detail without compromising focus."[26]

This tradition continues into the seventeenth century. Svetlana Alpers writes that the "attentive eye" of the Dutch artist, as of the microscopist, "treats everything as a visible surface either by slicing across or through

to make a section (as Leeuwenhoek was one of the first to do) or by opening something up to expose the innards to reveal how it is made":

> Whether it is edibles such as cheese, a pie, herring, fruit, and nuts, or collectibles such as shells, vessels, and watches, we are offered the inside, or underside, as well as the outer view. Cheeses are cut into, pies spill out their fillings below the shelter of crust, herring are cut to reveal flesh as well as gleaming skin. Shells and vessels of precious metal or glasses topple on their sides . . . and watches are inevitably opened to reveal their works. Objects are exposed to the probing eye not only by the technique of flaying them, but also by reflection: the play of light on the surface distinguishes glass from metal, from cloth, from pastry. . . . Each thing exposes multiple surfaces in order to be more fully present to the eye.[27]

The graphic motive in Dutch art is encouraged by the competition between painters and other craft workers: in "the crafted surface of their representations," the painters seduce the eye with phantasms of the edible and the collectible that vie with their originals as objects of price and pleasure (114–16).

In general, then, the images produced in the graphic mode are governed by prevailing conventions of objective appearance. "Objective" implies both a reflexive and a transartistic motive. It is reflexive in that the graphic image is conspicuously ("graphically") displayed as a product of analytical observation and knowledge. Perspective paintings, for example, often flaunt their perspectivity even as they teasingly flaunt their planned violations of the system's rule-bound proprieties. It is transartistic in that mastery of the principles and techniques of production asserts itself beyond the art of painting *tout court*. From the time of Alberti, the discourse of art articulates a claim implicit in practice: that the scope of the image maker's mastery extends not only to the structures and actualities the art imitates but also to the very structures and techniques of observation.[28] This transgressive reach correlates with the social and economic incentives that influence the conventions governing objective appearance: the incentives to such new developments in science and technology as those documented in Martin Kemp's *Science of Art* and Alpers's *The Art of Describing*;[29] the incentives to such developments in the representational tastes and ideology of patrons as the appeal to idealizing classical canons of the "hard" or "closed" body;[30] the incentive given by courtly and bourgeois strategies of conspicuous consumption to new developments in the production and

distribution of craft objects, and to the opening of new markets (even new class venues) for them; the incentive given in the Netherlands by the complex cultural negotiations between the conflicting value systems Simon Schama explores under his wittily ambiguous rubric *The Embarrassment of Riches*, which provides me with my leitmotif for the study of Dutch portraiture in Part 3 of this book.[31]

Michael Baxandall's classic study of interactions between social and artistic practices in Quattrocento Italy elucidates the graphic as a "cognitive style" that both expresses and responds to transartistic incentives. Citing "instructions for gauging a barrel . . . from a mathematical handbook for merchants by Piero della Francesca," Baxandall notes that

> the conjunction of painter and mercantile geometry is very much to the point. The skills that Piero or any painter used to analyze the forms he painted were the same as Piero or any commercial person used for surveying quantities. . . . An obvious way for the painter to invoke the gauger's response was to make pointed use of the repertory of stock objects used in the gauging exercises, the familiar things the beholder would have been made to learn his geometry on—cisterns, columns, brick towers, paved floors and the rest. . . . In his public appearances, the painter more normally depended on his public's general disposition to gauge. To the commercial man almost anything was reducible to geometrical figures underlying any surface irregularities—the pile of grain reduced to a cone, the barrel to a cylinder or a compound of truncated cones. . . . This habit of analysis is very close to the painter's analysis of appearances. As a man gauged a bale, the painter surveyed a figure. . . . A painter who left traces of such analysis in his painting was leaving cues his public was well equipped to pick up.
>
> Quattrocento education laid exceptional value on certain mathematical skills, on gauging and the Rule of Three [a technique for dealing with problems of proportion]. . . . [T]his specialization constituted a disposition to address visual experience, in or out of pictures, in special ways: to attend to the structure of complex forms as combinations of regular geometrical bodies and as intervals comprehensible in series. . . . [T]here is a continuity between the mathematical skills used by commercial people and those used by the painter to produce the pictorial proportionality and lucidity that strike us as so remarkable now. . . . The status of these skills in his society was an encouragement to the painter to assert them playfully in his pictures. . . . It was for *conspicuous* skill his patron paid him.[32]

Inasmuch as the Quattrocento graphic is informed by and valorizes the knowledge, skills, discourse, and practices of the mercantile oligarchy, it may be said to be informed by and to valorize a particular set of economic and political as well as social interests. But it is not a mere instrument and product of this patronal ideology: as an element of "cognitive style" and a manifestation of the "period eye," the Quattrocento graphic *represents* the patronal ideology. The graphic mode is evoked and developed in a context that inscribes it with the values of the patron class.

In using the word *graphic* to identify this mode, I intend to activate several of its senses: the etymologically derived scriptive or textual sense of silent, fixed, readable inscription; the technical or formal sense of skillful drawing and composition, as in the noun *graphics*; the referential sense of mimetic secondariness, that is, of appearing to be a copy, an image that serves and serves up a preexisting original; the dramatic or exclamatory sense conveyed by such idiomatic phrases as "that's a graphic instance of what I mean," "scenes of graphic violence," or "a graphic illustration," phrases often used to denote something excessive in the attempt to be truthful or clear.[33]

In *the optical mode*, things are painted *as they are seen*, or, more pointedly, painted in such a manner that the way they are shown and seen modifies, obscures, or conflicts with their objective structure and appearance. The conditions of vision and visibility that affect, alter, or interfere with graphic delineation are represented and emphasized. The drama and effort of looking may be registered in such a way as to displace attention from what the object looks like to what or how the observer sees. The optical mode is sometimes described as delivering a "retinal impression," and although this is a pure effect of representation it is easy to inscribe it in a genetic narrative that further displaces attention from observer to painter: "Hals seems to have literally squinted while looking at his subject and stored the retinal impression in his mind."[34] Optical representation is marked by an interest in depicting variations in the luminosity (patterns of light and shade) of the visual field. To use James Gibson's distinction, the visual *field* is overlaid like a screen or grid on the visual *world*. Whether the motives informing optical effects are best served by the tonal softening of sfumato ("which seeks to direct the eye to the significant elements and hence focus the narrative") or by chiaroscuro (which seeks to exploit

"the contrast between the highlights and shadows for theatrical effect"), the result is to interpose visual uncertainty—or uncertain visibility—between the observer and the objective appearance.[35]

David Summers has argued that chiaroscuro is a form of contrapposto, and it is obvious that one motive for emphasizing chiaroscuro was to heighten the dramatic effect of the figural antitheses featured in contrapposto design.[36] Summers notes that in the Renaissance the term "*contrapposto* had a wider meaning than it has now, and could refer to any opposition," chiaroscuro among them,[37] but my interest lies in the fact that the stricter sense of the term picks out a dominant feature of graphic design, one that allowed artists to display not only their compositional virtuosity but also their knowledge of the body *and* of the sculptural legacy of the ancients. In the interest of intensifying the visual rhetoric of a specifically graphic effect, the painter activates a specifically optical technique, for when contrapposto is intensified by chiaroscuro, the focus of contrast is shifted from the parts of the body to the environing pattern of lights and darks in which the body is embedded. In this example, the optical emphasis emerges as a by-product of the graphic motive. Chiaroscuro, one of the systems brought into play to enhance graphic representation, is also one of those used to subvert it by dissolving into shadow the signifiers of volumetric form.

The conceptual and practical experiments of Leonardo da Vinci and the Venetian painters had much to do with the development of this mode, and although Marcia Hall's account of their contribution is restricted to their use of color, its terms suggestively sketch out the more general characteristics of the mode:

> Leonardo filled his numerous notebooks with observations of how color is affected by light, by its surroundings, by reflections. . . . When [he] established that the color of something will never appear the same way twice because light, humidity, and surrounding colors are never exactly the same, . . . he did nothing less than add time as a new dimension to the world of the painting. His own work demonstrated a means to capture the transitory by reproducing momentary effects of light and atmosphere, and therefore to distinguish one instant from what had come before and what was to follow.

> In the course of the sixteenth century the analysis of the effects of environment on color became the special province of the Venetian painters.

Atmosphere, haze, clouds, sunlight, and reflections became actors in
cinquecento Venetian painting. In the heavy, humid air found in a city
built in a lagoon, one perceives shapes as slightly imprecise and with
softened contours; reflections from the canals create accidental lights
that enliven a surface quite arbitrarily. The Venetian painters were more
alert to the subtle variety of what the eye perceives—and more willing
to incorporate these variations into their pictorial system—than the
Central Italians, who preferred to paint things more as they knew
them to be.

The Venetians learned to eliminate line and to blend the figures and
the setting. . . . Textures seen at close range . . . are differentiated by
brushstrokes and bold impasto [thickly applied paint], but not with
painted outlines. . . . Shimmering surfaces, colors that seem to shift in
inconstant light, forms that dissolve in light—these are some of the
effects the Venetian painters were able to achieve with their technique.[38]

To Hall's comment on Leonardo's introduction of temporality we may
compare Crary:

[A]s observation is increasingly tied to the body . . . , temporality and
vision become inseparable. The shifting processes of one's own sub-
jectivity experienced in time become synonymous with the act of
seeing, dissolving the . . . ideal of an observer completely focused on
an object.[39]

Crary might well be describing the same phenomenon as Hall, but the
deletions signified by the two sets of ellipsis points are, first, "in the early
nineteenth century" and, second, "Cartesian." Crary notes that "the break-
down of the perceptual model of the camera obscura" is "decisively evi-
dent . . . in the late work of Turner. . . . Instead of the immediate and
unitary apprehension of an image, our experience of a Turner painting is
lodged amidst an inescapable temporality." He adds that Leonardo's sfu-
mato, "which had generated during the previous three centuries a counter-
practice to the dominance of geometrical optics, is suddenly and over-
whelmingly triumphant in Turner" (138). Yet Leonardo's sfumato is also
intimately implicated in his own incipient and indecisive experiments
with natural, artificial, and synthetic perspective, experiments that at least
gesture toward a counter-practice. It is no secret that the influences of An-
tonello da Messina, Leonardo, and Giorgione produced in Venice what can
easily be described as an optical counter-practice to the dominance of

graphic *disegno* in Florence and Rome—this was recognized and dispar-
aged by Vasari.[40] Thus the structure of changes spread out over the rela-
tively long term of Crary's story may also (*mutatis mutandis*) be observed in
the micro-sequences of early modern painting.

The optical mode offers the observer a more active interpretive role
than the graphic mode because it appeals to and exacerbates a desire for
clarification. It enjoins the observer to peer into shadow, identify dim or
ambiguous shapes, distinguish figures from space where chiaroscuro over-
rides individual forms, sort out the motions of figures from those of light,
shade, and paint, make decisions about the actual colors of material sur-
faces dominated by the tonal play of light and shade, and differentiate sta-
ble form from transitory flickers. The Giorgione/Titian *Fête Champêtre*,
for example, constructs an observer who "must bring things into focus,
penetrate the shadows, complete the image with his imagination."[41] In his
later work

> Titian juxtaposed and overlapped unblended daubs, leaving it to the
> spectator to fuse them and make them intelligible. Forms are suggested
> rather than defined, and the viewer completes the painting by the act of
> viewing. The painter, no longer the self-effacing craftsman who merely
> records objectively, assertively presents himself as interpreter. The viewer,
> no longer passive, is asked to participate by projecting himself into the
> image and completing it. (213)

This participatory projection is positional, corporeal, as well as psycholog-
ical: instead of being fixed in place, as in perspective construction, the op-
tical observer position is mobile, affixed to a point that shuttles back and
forth along a vector perpendicular to the picture plane, moving close to
"penetrate the shadows" and then back to recompose the scene.

I want to emphasize that this shuttle, although it may arbitrarily be ac-
tivated by any empirical spectator, is an element of the virtual construc-
tion. The status of the observer shuttle is easy to misconstrue. If one
adopts the reductive stereotype of the aloof, disembodied, "infinitely ex-
tended Gaze" abstracted by traditional "Western painting" from "the du-
rational temporality of the viewing subject,"[42] then it stands to reason that
when variations among the parts of a painting compel the viewer "to os-
cillate back and forth to seek an adequate reading through successive
complementary views . . . such displacements . . . are understood as merely
'time out'"[43]—adjustments made by the empirical spectator in order to

secure the legibility of the whole promised (or expected by) any specta-
tor who prepares to occupy the fixed viewing position of the virtual or
ideal observer.[44]

This distinction between the fixed observer and the moving spectator
may hold for many predominantly graphic paintings (depending, of course,
on the size and placement of the image), but it clearly doesn't hold for
paintings that feature a variety of optical and textural effects. The latter
don't merely *tolerate*—as Nodelman puts it—"greater freedom of move-
ment . . . along this depth axis";[45] they *demand* it. This isn't the spectator's
"time out" from occupying the fixed observer position, but "time in" for a
mobile virtual observer. The relation between mobile and fixed positions is
not, however, simply comparative, as implied by Nodelman's "relatively
greater freedom of movement" or by Hall's parallel statement that Titian's
forms "are suggested rather than defined."[46] The relation may also be con-
testatory and emulative: sfumato, chiaroscuro, and open brushwork may, in
the contest with Venetian and Florentine precursors or contemporaries, be
mobilized as challenges to clear definition, "the visual fix," and the values
it expresses. The flicker, the motion, the figural hide-and-seek that not only
evoke but also express the dispersal of vision into glances and saccades, the
temporality of seeing, may be mobilized to offer resistance to the eye-
freezing and objectifying effects of the graphic.

Before moving on to an account of the final mode, I think I should
comment briefly on the relation of my formulations of graphic and opti-
cal modes to the two sources from which they obviously derive. The first
is Wölfflin's distinction between linear and painterly tendencies, which he
saw as the most significant and inclusive of his five polarities: "The devel-
opment from the linear to the painterly, comprehending all the rest, means
the progress from a tactile apprehension of things in space to a type of con-
templation which has learned to surrender itself to the mere visual impres-
sion, in other words, the relinquishment of the physically tangible for the
sake of the mere visual appearance."[47] Despite the frequent criticism of this
scheme, I have found it useful and usable so long as: (1) we ignore the epis-
temological pretensions evident in the attempt to link modes of painting to
modes of vision, (2) we avoid its binaristic reductiveness, and (3) we place
much more emphasis than Wölfflin did on the differences made by the vis-
ible material elements of painting—the representation of pigment, the
traces of the brush or palette knife, the topography of paint on the surface.

The second source is the contrast, similar to Wölfflin's, that Ortega y

Gasset draws between the constructions of "proximate" and "distant" points of view.[48] Though this scheme is open to the same criticisms, I have found the idea of a shift from a more "objective" to a more "subjective" set of cues suggestive because of the way it resonates with the recent interest, mentioned above, in reading Venetian opticalism as an attempt to represent the effects of a mode of viewing more closely tied to the conditions of bodily perception than is the graphic. Ortega's idea that the shift he analyzes represents a *retraction* of vision also resonates with the effort to construe some examples of optical painting as evidence of a counter-practice to the aggressiveness of the visual fix produced by submitting all forms to—in his words—"an external force: the geometrical idea of unity" that constructs and dominates the abstracted or objectified subjectivity of the graphic observer.[49]

In *the textural mode* the qualities of paint and the traces of the painter's hand are interposed between the eye and the image. Textural painting represents the activity of painting and the sensuous, material qualities of paint as intrinsic parts of the image one sees. Thus, to shift briefly to Peirce's terms, if the graphic mode accentuates the values of the image as an iconic sign that denotes by resemblance, the textural mode accentuates its value as an indexical sign that represents the cause—painting—of which it is the effect. Textural effects add ambiguity to the details that display them: does the observer encounter a ray of light or a streak of yellow pigment dragged across a dry paint surface? Texture sometimes challenges the transparency of the picture plane by overlaying the "window" with a topography of pigment. And sometimes it makes the painting look unfinished, still in process.

Art historians refer to the actual execution, the handling of the medium, as *facture*, both a French and an English word denoting a process or manner of making something—as in *manufacture*. Generally, for art historians the study of facture is the study of the actual method of production, though their accounts of what took place "back then" whenever the actual painter was actually at work often don't clearly distinguish what the painter did then from what the picture does now. Thus—as I explain more fully in Chapter 18—I find it helpful to mark this distinction by letting *facture* denote the traces of what the painter did then, and *texture* the representation of those traces now visible as part of the painting.[50]

I suggested earlier that the intensification of contrapposto by (or into) chiaroscuro illustrates one of the processes by which a graphic motive may activate an optical effect more or less as a by-product. This is a specifically Italian development. In Flanders, the seed of the optical mode is planted in graphic painting when the van Eycks and their contemporaries begin to differentiate the textures of imaginary surfaces according to the relative reflectance and absorption of light. This intensification of a particular emphasis in graphic representation brings into more strenuous play the use of whites, the *bianchetti* discussed by Gombrich as the means by which the Flemings produced their effects of *lustro*.[51] Similarly, it may be hypothesized that the seed of the textural mode planted in optical painting is the *bianchetto* used as a highlight. "The term highlight . . . may still carry with it the implication not only of the highest, that is the brightest light, but also of the effect of . . . relief" (23). Gombrich is concerned here only with the "impression of relief" (ibid.), imaginary protrusion behind the picture plane, but highlights are in fact often produced by superimposing a spot, a small blob, of white paint. This micro-eminence represents in miniature the topographic field of pigment perpendicular to the plane, a field which, in the work of many painters displaying optical and textural effects, is composed of more thinly painted concavities of shadow and more thickly painted convexities of light.

The emergence of textural effects has often been explained as a by-product of the conjunction of optical representation with the use of canvas and the exploitation of its weave:

> Unlike the smooth, hard surface of the gesso-prepared panel, canvas offered to the painter's brush a coarse-textured woven surface. While this roughness could be minimized by using a finer weave or, as was frequently the case in Florence, by application of a thin gesso ground, the Venetians accepted the rougher surface and exploited its expressive potential. Moving across such a ground—which militated against sharp, continuous contours—the brush left a broken trail of pigment, open and suggestive. . . . In this new technique of oil painting the actual stroke of the brush naturally came to assume a more significant and signifying role, since the trail of paint it left behind determined the very character of the forms rendered. . . . The brush itself served as a drawing implement, recording the pressure and direction of the guiding hand; the surface of the painting became, in effect, the record of successive and accumulated touches.

Multiple layers of pigment behave differently on canvas than they do on a smooth-textured surface because the color in the interstices shows through and modifies the effect of whatever has been brushed across the top. . . . The pigments take on a texture, sometimes still very thin and transparent, but play off against other passages where they are thick and impasto. Brushstrokes are allowed to remain unblended, in analogy to some of Michelangelo's sculptures where the . . . marks of the artist's touch would have been regarded as evidence of an unfinished state by cinquecento critics, but, also as with Michelangelo, they have an expressive function.[52]

Earlier I cited Hall's observation that Leonardo's discursive and pictorial researches into optical effects "did nothing less than add time as a new dimension to the world of the painting" (68). The temporality Hall refers to is that of the depicted scene—the "momentary effects of light and atmosphere." The visibility of texture represents and indexes a different temporality: the time of painting. Texture is the indexical, sign-bearing matter that represents "the work of the brush in 'real time' and as an extension of the painter's own body"; the "constantly displayed . . . traces" of brushstrokes represent the time and "work of production." These comments by Norman Bryson express what he finds praiseworthy in non-European, above all, Chinese painting but lacking in "Western painting," which—as a whole, presumably—"manipulates the sign in such a way as to conceal its status *as* sign."[53]

Despite the remarkable and perverse inaccuracy of Bryson's generalization, his description of the temporality represented by texture is precise and helpful. It suggests that texture is less the "evidence of an unfinished state" than a representation of the act of finishing. In that respect, texture could be said to "unfinish" or "definish" the painting. It may be used to signify the time and work of production, and in that capacity it may be given the semiotic function of an index, the grammatical function of a deictic marker, the rhetorical function of metonymy. Like the *pentimenti* that signify changes of mind, conspicuous texture not only inscribes the painter's activity in the image and diverts the observer from the putative content or subject matter, it throws into question the representational primacy of the immaterial semblance.[54] It dominates and diminishes the immediacy of representation. The represented image itself becomes the signifying medium of, the excuse for, not an art of describing but an art of making. The topographic display of pigment foregrounds the painter's in-

terpretive act and calls for an interpretive response. Where texture is, there graphic objectivity and optical subjectivity are challenged, threatened, perhaps undone. That even the semblance of things can be imaginatively penetrated and known is contested, for behind the veil of texture appearances lose their volume and recede into a ghostlier demarcation.

Texture unsettles the calm and full measure of representationality, and subjects the pretensions of the graphic mode to ironic interpretation. The image is not something for observers to see, know, and genuflect before but something for them to make and unmake, something perpetually incomplete that extends its desire for completion into theirs. The effect of unmaking produced by texture in painting by Rembrandt has been beautifully characterized by Michael Kitson: it is as if, he writes, "the top layers of paint have been left off and . . . the surface now visible is what would previously have been the underpainting or sketch." In graphic representation, "the brushwork follows the contours and internal modelling of the form," but in passages of texture "not only are the surfaces of the forms left out but the transitions between tones are omitted as well. A stroke of paint is used simultaneously to indicate . . . form, color, texture [of the object imitated], and tone." As the "representational function" of brushwork diminishes, so that, for example, we often can't identify "the material of which . . . costumes are made," the paint, "applied in square overlapping patches," takes on "its own vitality."[55] The body of pigment, its richness, its fiery or golden glow, its fatness, seductively distracts the observer and threatens to subvert the graphic hierarchy.

Texture thus has the potentiality to bypass or interfere with the contract-driven emphasis on the content and commission of the painting, on its religious, civic, courtly, or commemorative function, on its value as a marker of the patron's status, taste, interests, culture, or power. The demands these graphic and optical emphases make on their observers may be challenged by the more indirect and perhaps more seductive solicitation of the textural observer by the painter's hand. But so long as conspicuous texture doesn't entirely subvert the effects of traditional mimesis, the conflicting energies of actual and virtual tactile values, together with the energies of paint and chroma, generate conflicting modes of observership. It is as if the letters in the words on a page were inscribed in different sizes, shapes, and colors. On the one hand, the narrative and descriptive features of the signified image continue to preempt, manipulate, and constrain the observer's response. On the other hand, the touches or traces of

the hand may appear independent of the graphic motive, perhaps in competition with it: when the signifying elements pit themselves against the signified image (and its referent), when texture refuses to let their materiality disappear into the semblance, the observer is offered a more active share in the interpretive activity by which the meaning of the image is constituted.

Like optical painting, textural painting activates the observer shuttle. It constructs a viewer who is invited to move up close, touch the surface, run fingers over it, make manual contact with the work of the painter's hand (a museum guard's nightmare); but who is then invited to move back and recompose the texture within the image. The observer is set in motion on a perpendicular shuttle, moving forward and backward before the painting. The task the textural mode assigns its observer is to interpret the contribution of the texture to the meaning of the detail it affects, and of the image and story represented through the screen or veil of texture.

The textural and decorative modes are both characterized by a display of conspicuously worked *pigment* (the term for paint considered as material stuff) and of variable topography in which some areas are thin and others thick, some flat and others in relief. But there is a difference. On the one hand, decorative topography tends to modify and enrich the opaque surface and support of the painting and the (usually religious) object of which it is part. In doing this it often outshines the passages of painting devoted to representing imaginary three-dimensional figures "behind" the surface; it diminishes the effect of illusion or diverts attention away from it to the material richness of the actual surface. On the other hand, while textural topography also affects one's reaction to the surface, the surface in question is the fictively transparent "window pane" of the graphic mode, and what the texture modifies, enriches, interprets, is the view of the imaginary three-dimensional image "behind the window." The veil of texture modifies graphic and optical effects, and throws the painting more decisively into the space of the observer. When paint texture is a conspicuous aspect of representation, the objects it signifies— no matter what their distance from the plane in imaginary space—are pushed closer to the plane. Texture represents "the play of the signifier" over against the imaginary signified, and this play is an index whose referent is the act of production. More specifically, open brushwork may signify the activity of a hand quicker than the eye.

Although this signification is indexical and therefore designates a tem-

poral and causal reference to a past act of painting, the reference is itself ambiguous. It may be considered as a historical index pointing back in time toward what the painter did *then*. Or it may be considered as a virtual index, a pure effect of representation generated in the course of the observer's interaction with the painting *now*. This distinction should be kept in mind to defend against the tendency of commentators to restrict themselves to the past tense of genetic narratives, as in the comment by Grimm I cited above: "Hals seems to have literally squinted while looking at his subject and stored the retinal impression in his mind. His loose brushwork captured this impression in its entirety."[56] What Hals and his brushwork did then are inferences drawn from the observer's interpretation of what the optical and textural phenomena are doing now. Not loose brushwork *tout court* but the representation of loose brushwork conveys the impression of a momentary optical impression and cues the observer to squint in order to recuperate clear graphic detail from shimmers of light and slashes of paint.[57]

The representation and effects of the surface are marked in the decorative mode, diminish in the graphic mode, begin to resurface as by-products of the interest in optical effects, and return to prominence in the textural mode. As we note the return of effects of texture, we can look back and revise the meaning of its absence. We can see that texture was what was suppressed to promote the interest of graphic representation, and we can think about the meaning of that suppression. What values does its absence promote? What does the conspicuous self-effacement of the veil of paint imply about the skill, the mastery, the attitude toward the painting as image, the relation to the observer, and the interests or tastes of patrons, valorized by graphic representation?

Some paintings may appear to be exclusively graphic or optical. But the great majority of paintings, although they may feature one of the modes, will share in one or more of the others. In that respect, the system constituted by these four modes and their interplay may be viewed as synchronic over a long period of time. Nevertheless, a diachronic pattern is discernible in the shift from decorative to graphic dominance that occurs during the fourteenth and fifteenth centuries, and in the emergence of new modes, the optical and textural, that compete with the graphic from the late fifteenth century on. In synchronic perspective, the graphic re-

mains the fundamental mode of early modern painting. Until around the time of Impressionism, the optical and textural modes remain subordinate to the graphic motive, contained within it as qualifications. Even as they modify and challenge the basic representational orientation of graphic painting, they support and strengthen its objectives. Yet the system undergoes changes that are themselves systemic in that they are driven by the interaction of three basic variables: shifting from decorative to graphic depiction tends to displace effects of texture from the actual surface of the painting to its imaginary depth; shifting from the graphic to the optical mode tends to (re)activate the textural mode, but with effects that differ from those of the decorative mode; shifting from wall and wood panel to canvas, and from fresco and tempera to oil, tends to encourage the play of optical and textural effects.

In aspiring to convert this strictly formal analysis of modes into a scheme for politico-formal interpretation, I try to avoid the lure of determinism, to cultivate negative capability and keep open the possibility of strictly ad hoc determinations. So, for example, the interplay and contrast of different modal passages in a single work may or may not have more than formal significance. They may or may not speak of (or to) its relation to other paintings, painters, and styles—the domain of interpictorial politics—and they may or may not comment on some aspect of its context and apparatus of production: institutional location, terms of commission, genre, iconography, narrative program. Within these limits, some obvious relational hypotheses suggest themselves. If the politics of the decorative mode—the politics of religious decorum—is literally inscribed on the surface of the work's formal/material organization, can we say that the politics of the graphic mode is to be sought in its resistance to the decorative emphasis on textured opacity, in its windowing-out of the surface and its assertive representation of a second world in illusory space? In purely aesthetic terms, we might well judge certain graphic performances to make a counter-decorative statement. Or, to mention a specific example, we might conclude that the kind of modal interplay Fra Angelico excelled in served to dramatize the competing claims and attractions of decorative and graphic painting, perhaps to interrogate the conventional division between the decorative rendering of the hieratic figures that dominate the altarpiece and the more graphic scenes that window out the predella situated in the lower margin of the sacred object. Yet this formal play, this exploitation of modal difference, may not be interpretable as a comment on

the context and apparatus of production unless it can be shown that decorative and graphic accents are already invested, however loosely, with divergent ideological implications.

Such investments may be contingent on other factors. For example, Sylvia Ferino Pagden argues that "from the Duecento onwards, and particularly in the Renaissance," not only did "religious images in general . . . [have] a marked aesthetic character" but—especially in works "by painters of the caliber of Raphael and Duccio"—they also became sites of "potential conflict between religious and aesthetic function because . . . these artists created aesthetic prototypes which . . . soon became objects of veneration in themselves," as when, according to Vasari, the divine Raphael's unfinished *Madonna del Baldacchino* was given the status of a medieval cult image by having a chapel built around it.[58] What Vasari calls "the perfection of Raphael's art" consisted in his accomplishments in graphic idealization and optical drama, and thus if, in the rhetorical displacement Vasari is so fond of, "the power of creation" passes "from a literally divine being . . . to a metaphorically divine one, the artist,"[59] this hyperbolic valorization rubs off on the modes themselves, gives them a cachet previously identified with the decorative mode, and thereby makes them formal expressions or instruments of a process of displacement central to the politics of secularization. The hand that holds the sacred canopy over these human creations is also the hand that serves the *disegno* underlying all the graphic accomplishments of early modern technology, scientific as well as artistic. The graphic in that respect sublates the religious image—upholds its authority while submitting it to changing economic and political demands and to the emergent hegemony of what conspicuously displays itself as a science and theology of art.

My choice of *graphic* as the key term for the early modern scopic regime was initially prompted by David Summers's account of its currency in the Medicean circle to which Michelangelo belonged. Summers discusses the term in a commentary on Angelo Poliziano's *Panepistemon*, a treatise first delivered in 1490, then published in 1491, as the inaugural lecture of a series on Aristotle's *Nichomachean Ethics*. I should note that, although Summers's densely woven account substantiates my decision to deploy *graphic* as a term for a generalized discursive framework, such a deployment goes against the grain of his argument, which is focused on reconstructing the theory of art implicit in Michelangelo's work and au-

thenticating it as Michelangelo's. This leads him to skip over precisely the problematic elements in the discourse of art that interest me.

Summers points out that the Greek term *graphikē* is Poliziano's "humanist translation of *disegno*, essential both to the theory and practice of Italian and especially Florentine painting," and it has the range gradually acquired by *disegno*, from mastery of the technical means of representation in painting and sculpture to "the metaphysical *disegno* of Federico Zuccaro" and other Neoplatonizing writers. Thus, for Poliziano, "*graphikē* stands to the arts it embraces as mathematics stands to philosophy." The source of *symmetria*, it is "compounded of proportion, judgment (which is finally virtually indistinguishable from *disegno*) and imagination, all in the service of the representation of life, movement and feeling." This, according to Summers, places *graphikē* at the basis of Michelangelo's extension of *disegno* to the source of "the realization of the illusion of the living body as the agent of the soul."[60]

One of the most important themes in Summers's exhaustive survey of the clusters of key terms through which he tries to read Michelangelo's mind is the union of theory and practice. His argument is "not that theory 'causes' practice, but rather that Renaissance artists . . . thought and talked among themselves about what they were doing and that such thinking and talking was an indispensable element in the definition, development, diffusion—even the cogency—of the art style they all practiced" (7). As one of his reviewers, who endorses this argument, notes, art in the Cinquecento "was considered to be a form of knowledge, and the theory of art was derived from the habit of thinking about what one was doing." Thus the emergence of a differentiated discourse of art in early modern Europe interacted continuously with the practice of art, and what distinguished this situation from medieval and even classical contexts was that "making and discourse came to be seen as inseparable."[61] This doesn't mean, however, that the result of such differentiation was either an autonomous or a disinterested discourse. If in medieval culture the discourse of art was explicitly embedded in the language of religion and morality, the early modern discourse of art differentiated itself in terms that veiled its dependence on and orientation toward social and political interests. The veil was sometimes diaphanous, as in the familiar attempt of artists to transform their self-representation from artisans to intellectuals. But for my account of the graphic regime, two other aspects of the discourse are more important. Both are discussed or mentioned by

Summers, though he barely touches on the interrelation between them that I find significant.

The first aspect is political and is illustrated by the specific context of the encounter between Poliziano and Michelangelo that Summers makes so much of: "the so-called academy in the Medici gardens" presided over by Lorenzo,[62] whom Poliziano served as a permanent dependent member of the household. The second aspect is ideological and is illustrated by the structure of Poliziano's *Panepistemon*, which Summers describes as "a whole intellectual system in outline, based on the Aristotelian premise of the unity of knowledge. . . . All knowledge is divided into three parts: inspired (theology), invented (philosophy) and mixed (divination)," and the arts, listed under philosophy, are divided into speculative and practical. Poliziano classifies "the arts of design (as they would come to be called) under the second category of practical arts," which in turn "fall into two divisions, architecture and *graphikē*," the latter being subdivided into "painting and sculpture in all their various forms."[63] Summers further shows how Poliziano follows Alberti in emphasizing the theoretical and mathematical dimensions of the practice of *graphikē*, and in deriving his definition of painting and *graphikē* from sculpture, thereby "more than fulfilling Lorenzo de' Medici's desire to encourage the art" of sculpture.[64]

Here the mutuality of interest that brings the various projects of patron, writer, and sculptor into harmony is noteworthy. It need not be viewed with suspicion; nevertheless, the importance of the patron's role in guiding these projects should not be ignored.[65] The significant connection between that factor and the *Panepistemon* may be gathered from a glance at the title itself. It is unfortunate that the Greek word *epistēmē* is the root of *epistemology*—though ultimately that in itself may prove interesting—because this further obfuscates the sense Plato's dialogues consistently give the word, an obfuscation already performed by the misreading of Plato we associate with Platonist and Neoplatonist traditions. In the dialogues, *epistēmē*, when used thematically and not just casually, denotes something more restricted than the knowledge we associate with epistemology: it denotes technical know-how, the mastery of the principles of practice that enable *technē* to be an art rather than a knack.[66] *Epistēmē* primarily denotes conditions not of cognition but of production. That it has become embedded in the very different project of epistemology, focused on cognition, dooms this project to the radical instability which has been its fate,

for the cognitive claims to the possibility of knowledge and truth that secure both the modesty and the power of epistemology as the mirror of nature rest and press down on the clay foot of a productive *logos* that constitutes the nature it mirrors.

The restricted sense of *epistēmē* is sometimes conveyed by translating it as "science," in the sense of applied or instrumental knowledge. But this may obscure Plato's emphasis on its intimate association with rhetoric, the art of persuasion, and thus with the uneasy politics of an apprehensive society. *Epistēmē* makes its possessor capable, confident, and—to use another of Summers's (and Plato's) key terms—*deinos*, that is, clever and skillful, therefore strong and powerful, therefore dangerous and to be feared.[67] A doctor and orator are *deinoi* not merely because they possess *epistēmē* but because *epistēmē* is understood as know-how divorced from ethical considerations, know-how that may be used to deceive and get the better of others. The technical mastery it confers is always potentially political mastery, and Plato often suggests this by taking advantage of etymological networks that link *epistēmē* with *epistatēs*, the possessor of *epistateia*, social, political, or military authority.[68]

None of these questionable meanings needs to be imputed to Poliziano's treatise or to his use of the titular term, *panepistemon*, "all-knowing." Nevertheless, considerations of power and interest pervade not only the genetic circumstances of the treatise—the primacy given to the art of sculpture favored by Lorenzo—but also its structure. Such considerations would seem at first glance to be canceled out by Poliziano's displacement of the Aristotelian system of knowledge from reality to art—from the knowledge that discloses the truth of the actual universe to the knowledge that enables the artist to produce a virtual universe that is either mimetically or ideally "true." But a displacement of this sort is easily reversible. First, Poliziano's system aims simultaneously to give the artist greater power over his art and to give the patron who deploys the artist and his art greater power over the *intendenti* he wishes to impress. Transgression of knowledge/power from the virtual to the actual world is thus inherent in the genetic circumstances. Second, Summers shows—without seeming to notice it, or at least to comment on it—how the subsequent development of the paired notions of *graphikē* and *disegno* can lead to an inversion of the analytical scheme of the *Panepistemon*. He traces the journey of the arts included under *graphikē* from the *infima species* of the scheme to its genus in the following steps:

1. In earlier writers, *disegno* as *graphikē* denotes the specific technique of drawing and the "labors of the hand."[69]

2. Since "many artisans work from patterns, which are best provided by the skilled draftsman," *disegno* and *pittura* "can be used more or less interchangeably" (253). Summers is here paraphrasing a notion already expressed by Cennini and developed by Alberti.

3. "As the idea that design (or painting) is necessary to a greater number of arts is repeated, *disegno* is gradually separated ever more distinctly from the individual arts that share it in common" (253). At first identifiable with technique, it comes to be opposed to it and to distinguish true art from "lowly craft. Technique separates the arts, but *disegno* unites them" (257).

4. *Disegno* is the basis not only of all the arts but "of all human sciences" (258). The particular source Summers cites for this claim is Francisco de Hollanda's *Four Dialogues on Painting*. De Hollanda argues that "*disegno* or *pittura*" is "the art or science . . . from which all others proceed," for painting includes the production not only of resemblances in the fictive space of the iconic sign but also of their referents in the world beyond the icon. One paints this world "in inventing and producing new forms and figures and in using new styles of clothing and various materials, in occupying space, raising buildings and houses adorned with paintings, in cultivating fields, ploughing the fields in stripes and patterns, navigating the seas by means of sails, in combat, in ordering the lines of battle, and finally in all our operations, movements and actions" (258).

In this argument, de Hollanda could well be expanding a passage in the first book of Castiglione's *Cortegiano*. After mobilizing ancient witnesses to the importance of cultivating "il saper disegnare ed aver cognizion dell' arte propria del depingere," Count Ludovico da Canossa adds that this art, "besides being most noble and worthy in itself, proves useful in many ways, and especially in warfare, in drawing towns, sites, rivers, bridges, citadels, fortresses, and the like."[70] Summers notes that de Hollanda's claim appears together with such related and equally commonplace notions as "the theme of *Deus pictor*" and "the ideal of the courtier as his own work of art."[71] Castiglione's Count introduces the *Deus pictor* topos just after the passage cited above, but when he goes on to say that whoever can imitate God's art deserves great praise, "chi po imitare" reminds the reader that *Deus pictor* is itself an imitation of its chiasmic partner, the *Pictor deus* whose praise is enhanced and potential power implicitly exaggerated by the analogy. In the seventh paragraph of Book 2, these, along with related clichés

of *discordia concors*, are redirected to the art of self-representation. However commonplace these notions may be, their strategic deployment in such contexts gives them a novel and potentially subversive spin. And however fanciful they are, they hint at the more interesting implication in the scheme elaborated by Poliziano in the preceding century.

Poliziano distinguishes philosophy as invented knowledge from theology as inspired knowledge. To situate *graphikē* and *disegno* in the former category is in effect to replace the idea of knowledge as mimetic cognition of prior reality by the idea of *epistēmē* as the source of the production of new actualities. Already in the context of Poliziano's bookish lecture we glimpse *in nuce* the new epistemological criterion that will develop during the next two centuries, which Paolo Rossi describes as the criterion "of knowledge as *making*, or of the identity between cognition and construction." This criterion, according to which only "that which is made, that which is *artificial*, constructed, or reconstructable can be truly known," negates "the Aristotelian doctrine respecting the relations between nature and art."[72] To transform knowing into making is not necessarily to fictionalize reality, though when de Hollanda emphasizes the contribution of *disegno* to a variety of technical and social constructions, he takes a step in that direction. We can take it a step further by training Poliziano's interested treatment of *graphikē* and *disegno* on the overall scheme of the *Panepistemon* and treating the traditional epistemology it outlines as itself the product of human *disegno* and interest, the interest, that is, in elevating and promoting the science of art.[73]

The political implications of this interest blare forth from the continuation of the de Hollanda passage quoted by Summers, who directs attention to its odd imagery: architecture and sculpture "are as rivers that are born" from painting as from a fountainhead,

> the mechanical trades are rivulets, and certain useless things, such as cutting with scissors, are stagnant puddles, formed by water that backed up when it had submerged everything under its dominion and empire, as one may verify by observing the works of the Romans, all derived from the art of painting. In their painted houses, their works in gold, silver, and metal, in vases, in ornaments, in clothing and in arms, in triumphs, in all the variety of their works, one may readily assert that from the time they became masters of the world, the noble lady Painting was universal sovereign and mistress of all their productions, arts and sciences, extending her domain even into written composition and history.[74]

This is admittedly a caricature, and a crude one, of an aspect of a transgressive desire that might well be called graphic imperialism, but it will serve to suggest the extent to which, in the intellectual climate prevailing in the Medici circle, the discourse of art consistently overflowed the banks that confined *graphikē* and *disegno* within the channel of mere iconicity. The claim that painting was more than a mimetic fiction, that control of representation could give knowledge (of the world or of the self), spills over into the claim that painting—construed metonymically as the embodiment of *graphikē* and *disegno*—could give power, the power to affect and thereby change the world and the self.

The discursive context I have just sketched with Summers's help should give historically specific resonance to the word *graphic* and justify my selection of it as the name of the scopic regime of early modern culture. To summarize, *graphikē* is *disegno esterno*, the visualization by art and geometry of the *disegno interno* that is "the art or science . . . from which all others proceed" because it is basic not only to the representations of human productive activities but also to the activities themselves, and it therefore constitutes a point of convergence for discourses of science, art, and power.

In Florence and other mercantile communities, the graphic was the dominant mode of what Baxandall calls "the period eye" because it expressed the skills visual art shared with the commercial practices of patrons whose pious donation enabled them not only to construct new liturgical spaces but also to infiltrate and occupy them and to become in effect joint owners of church property:

> In Florence it was merchant families rather than princes or nobles that played the key role in artistic patronage. Mendicant orders, though continuing to play a part, did so more and more in conjunction with families. . . . Painters found employment more frequently by far with merchant families than elsewhere. It was a type of patronage that centered to a large extent on the family's chapel in a church, usually belonging to a mendicant order.
>
> Through church and convent [San Marco] the Medici coat of arms was resplendent, so that the building gained the aspect of a monument built in their honor.[75]

In the different circumstances of papal patronage during the first two decades of the Cinquecento, the essentially secular needs of the papacy as a state in constant conflict and negotiation with other states generated a

demand for exemplary images in the monumental and classicizing accents
of the graphic mode. These accents contributed to the lucid and power-
ful delivery of a complex program in which layered historical allegories
were intended to sacralize the exemplarity, enhance the authority, of an
increasingly secular discourse of papal self-representation. The competi-
tion between Raphael and Michelangelo, although an important part of
and influence on that discourse, was in competition with it inasmuch as
their emulative achievements made it possible to sacralize the exemplar-
ity and enhance the authority of the artists on whom patrons relied so
heavily for political propaganda. "According to Vasari, the *School of Athens*
shows how astronomy, geometry, philosophy and poetry can be reconciled
with each other by theology."[76] But of course the context of Vasari's opin-
ion is ekphrastic: he is describing the way Raphael visually embodies
these diverse repositories of cultural capital and reconciles them in paint-
ing. The project of the *Lives*, which Vasari explicitly characterizes as one
of resurrection (with death and hell replaced by oblivion), is nothing less
than the displacement or at least extension of theology from religion to
art, of divine power from God to artists, and of a limited but real soterial
power from the authorities of the Church to the author of the *Lives*.

For Vasari this project is intimately associated with, and indeed rides
upon, a hierarchy of formal preferences dominated by the basic features of
the graphic mode:

> Vasari firmly established the practical and theoretical importance of
> drawing, defined as the progenitor and foundation of the three arts of
> painting, sculpture, and architecture. . . . More specifically, drawing is
> viewed as the key to the entire imaginative process, the medium of
> the painter's very thought as well as of its concrete expression. . . .
> According to this aesthetic, at least in its more dogmatic formulations,
> the quality of its drawing provides the critical measure of a painting,
> and the significant criteria of formal judgment for a critic like Vasari
> are basically graphic and plastic values: line and shading, form and
> proportion. The painter's primary problem is the representation of the
> human figure in contour and modeling.[77]

The attachment to graphic values profiled by David Rosand derives not
only from Vasari's admiration for Raphael and Michelangelo but also
from his admiration for dukes and other members of the patron class.
That he is both a promoter of graphic values and a prudent servitor of

those in power—this linkage may be purely associative, may owe little or nothing to the political potentiality of graphic form per se. But even the associative linkage is grounded in the classicizing and idealizing features of the mode, and in the appeal its displays of anatomical, geometrical, and architectonic virtuosity make to *loro che sanno*.

Rosand's comment on Vasari appears in an account of the conditions of painting in Venice that suggestively explores the way different modal and stylistic tendencies may correlate with differences in political culture and guild structure. What made it easy for Vasari to integrate the arts under *disegno* was that "Florentine artists from Giotto to Michelangelo had moved with relative ease among the visual arts, working at times in painting, in sculpture, and in architecture" (15). In Florence, although painters belonged to one guild (the Arte degli Medici e Speziali, which also included the spice dealers from whom painters got their pigments) and sculptors to another, whereas there was no guild for architects, the system was permissive: one artist could belong to different guilds and many types of work could go on in a single workshop. In Venice, however, the painters, called *figurer*, were confined to the Arte dei Depentori, a craft guild that included leather-workers and sign painters, among others.[78] Because it was in effect illegal in Venice to violate the precincts of the different guilds, painters did not as a rule practice sculpture or architecture, and there was thus less incentive to develop a more general practice based on the arts of design, drawing, and measurement. Not that Venetian painters didn't draw or use perspective, but their interest in and use of drawing were different. They relied more than the Florentines on free sketching and open calligraphy, on a practice of drawing intimately associated with tonal variations, chiaroscuro, and brushwork—a "painterly" drawing oriented toward optical effects as opposed to the draughtsmanlike painting that was a central feature of graphic style in Florence and Rome.

The relatively permissive conventions of Florentine practice went hand in hand with a relatively open, competitive atmosphere for artists, the atmosphere of criticism and ambition to which Vasari attributed Florentine excellence "in all the arts." This reflected more openly competitive and variable patterns of patronage than in Venice, where the access to patronage was more subject to control or interference by agencies that represented the often-conflated interests of the state and the patriciate. In a pair of essays, Gombrich has associated the Florentine "leaven of criticism" with the notion of artistic progress first discernible in the Florence

of Ghiberti's time:[79] the notion that one advanced the progress of art by demonstrating "problem-solutions" that would "contribute to the body of [artistic] knowledge."[80] Gombrich argues that this notion removed art from "the social nexus of buying and selling" (4) to "an autonomous realm of values" (10) in which the artist's quasi-scientific "mission" was dissociated from his "commission" (3) because artists aimed their graphic demonstrations not at customers but at the experts, their fellow artists "and the connoisseurs who can appreciate the ingenuity of the solution put forward" (7).

However, Gombrich's emphasis on removal from "the social nexus" is placed in question by his own account, since he concludes that the new art was endorsed not only by artists but also by "the courts and patrons who . . . [could not] afford to be thought 'Gothic' and 'backward'" (10). Emulation among artists in the name of artistic progress exerted pressure on the competition among patrons who invested in programs that, whatever their immediate objectives, were always in the last instance strategies of self-representation. It was in the patron's interest not only to encourage emulation for its results but also to respond to it. And the trends patrons encouraged and tried to keep up with were predominantly graphic trends, as Gombrich's argument suggests. "Increased control of technique and a greater fund of knowledge"—cited by Bram Kempers as "the most visible fruits" of Florentine culture—were outcomes that both artists and merchants sought after, albeit in different ways and for different purposes. The merchants, for example, aspired to increase control not only of economic techniques but also of the techniques wielded by artists.[81] The graphic mode was both an instrument and a product of this dual service, and it was also itself a signifier of power and knowledge. "Problems . . . should not only be solved; they should be seen to be solved,"[82] and this reflexive display has ideological value in that it solicits an authority similar to the authority people nowadays accord to science. Alberti's system is sometimes called the *costruzione leggitima*. The phrase betrays an ideological motive: it is a construction whose chief value is its legitimacy. Even paintings that knowingly violate the construction cultivate and display conspicuous perspectivity, or graphicity—the *look* of perspective and graphic construction.

It seems possible, then, to discern cultural, social, and political agendas that either *ad*here to the graphic by association or *in*here in its formal capabilities. Is it also possible to locate such agendas in optical and textural

performances? Are there instances in which the differences between graphic and optical effects are transformed into contestation? Instances in which optical/textural passages seem to be deployed in a manner that stages resistance to graphic agendas—deployed, for example, to obscure where the graphic clarifies, loosen where it fixes, animate where it freezes, soften where it hardens? An antisculptural, antimonumental, antilinear counter-practice? Though Vasari treated this invidiously, less as a counter-practice than as a defect, apologists for Venetian painting from Pino through Dolce to Boschini elaborate on their basic motif, the demotion of *disegno*, in a manner that increasingly promotes optical and textural values as if they were Venice's emulative response to the Florentine graphic and the hegemonic context for it provided by Vasari. The earlier Florentine emphasis on *disegno* and the later Venetian emphasis on *colorito* reflect an implicit conflict over the relative merits of the graphic and optical modes that would become explicit in the discourse of French academicians in the seventeenth century. Similarly, the partially overlapping debate about the relative merits of "smooth" and "rough" manners of painting arises in response to the drift of the optical toward the textural mode. Van Mander carries Vasari's position to the Netherlands when he claims that the smooth style (*nettischeydt*) he associates with van Eyck, Dürer, Bruegel, and other Northern painters is preferable to "the newer modes of rendering based on the flagrant brushwork of Titian's epigones."[83]

The formal interplay of bound variables that characterizes the system of early modern painting thus provides a necessary but not sufficient basis for politico-formal interpretation. Yet within the *disegno/colorito* distinction lurk the makings of a more sufficient basis, which would surface in the rhetoric of the French polemicists. This rhetoric has been analyzed by Jacqueline Lichtenstein as activating an ancient distinction

> between ornament and makeup, between a regulated and unregulated use, between lawful employment and abuse. . . . In the case of language, it was addressed to the din of hyperbole, the indulgence of metaphor, the glut of tropes that were charged with overwhelming content and obscuring the purity of the idea. In the case of the image, the distinction concerned coloration, whose brilliance was accused of shrouding the line and corrupting its efficacy. The analogy is often explicit in medieval rhetoricians: "Employed sparingly, rhetorical figures enhance style just as colors bring out a drawing; when used too lavishly, they obscure it and cause the clear line to disappear."[84]

Lichtenstein aims to show how even the defenders of *colorito*, preeminently Roger de Piles, exploit the biased gender implications that inhere in the traditional distinction, comparing "the surprises of coloring" that seize the spectator to "the surprises of love" by which "the lover is victimized" (84). But her account of the apologetic task confronting the colorists clearly brings out the long tradition of masculinist/idealist/elitist investments that undergo a *rinascita* in the scopic regime founded on *disegno* and dominated by its achievements in graphic representation:

> In taking up the defense of color, they attacked the domination of discourse as well as the superiority of drawing, the hegemony of a mimetic and therefore metaphysical conception of the image along with the privilege of the idea for representation, the principles of morality at the same time as the pedagogic virtues of rules. They insolently defended the purely sensible qualities of painting, indecently vindicating makeup, pleasure, and seduction. . . . This rebellion was already evident in the writings of the Italian colorists, although their defiance was timid and often cautious.[85]

In painting by Venetian colorists there may have been an incipient rebellion against the strict construction of graphic order identified with the Florence-Rome axis. But perhaps it was only a rebellion against precursors, a set of episodes in the politics of emulation.[86] Rosand has convincingly analyzed the devices by which Titian, Veronese, and Tintoretto use their quotations of perspective—their representations of perspectivity—to show how it can be subordinated to tonal and textural effects that deliberately counter its spatial momentum or else help theatricalize it (by depicting it as an artificial backdrop) in order to reassert the dominance of the picture plane.[87] As Titian's early compromise between Bellini and Giorgione gradually shifts its accent from the former to the latter, the vitality of surface play intensifies: light, "realized in the substance of paint, triumphs over rendered architecture" as this "substance—the articulated strokes of Titian's brush, undermining the precision of architectural line—comes increasingly to determine pictorial structure and space in Titian's later work."[88] But even in the altarpieces of his predecessor, Bellini, Florentine perspectivity is quoted only to be challenged as

> the clarity and commensurability of perspective construction become subject to the penumbra of a different architecture, an architecture founded on the Byzantine experience of the church of San Marco.

Although the basic shades may remain the same, the rationality of
Brunelleschian geometry, its clear linear articulation, is muted by the
irrational glow of golden mosaics and by a tonal envelop that obscures
the precision of contours. (94)

Glow may be defined as the fusion of color with light, the moment
when the graphic effect slides into the optical, when the exact color of an
object incandesces so that instead of being a light reflector it becomes a
light source.[89] Furthermore, glow is the fusion not only of color with light
but also of light with paint and brush-strokes, with the skin of the paint
surface on the panel or canvas. Bellini's representation of the decorative
effect produced by mosaics displaces it into an optical mirage that trans-
gresses and partly veils the perspective clarity of design—only partly, be-
cause, as in the San Giobbe altarpiece, the scene the decorative aura sanc-
tifies features heroic nude figures and classical motifs enhanced as much by
the foreshortening that elevates them as by the golden veil descending
from above. One can't do justice to such performances by speaking
merely of the decorative and graphic tendencies by which they *are influ-
enced*. Rather they seem to *represent* those influences as such, to stage the
encounter between them in a manner that charges the aesthetic qualities
of each mode with contextual associations. Thus if, as Peter Humfrey
speculates, "the apsidal mosaic of the S. Giobbe altarpiece would have con-
veyed ecclesio-political allusions to Venice's Byzantine past, and to her im-
perial pretensions to have inherited the authority of imperial Byzantium,"
and if at the same time the Byzantine motif was "calculated to modify the
powerful illusionism of the work,"[90] an illusionism that gestures toward
the design of Florentine host tabernacles, one may suspect that the conflict
between traditional and modern, East and West, the conservative values of
Venice and the assertive progressivism of Florence's visual culture, is con-
densed and dramatically conveyed in the conflict of decorative and graphic
effects. But this conflict is in turn upstaged by the dominance of the "tonal
envelop" that distances the decorative surfaces and attenuates anatomical
articulation of the bodies so that they fall from the ideality of graphic pet-
rifaction into the sensuous *morbidezza* of optical passages that anticipate
Giorgione.

The cultural politics of modal critique are more obvious in the milieu
of Rembrandt's Amsterdam, which is an active *entrepôt* for artistic no less
than other commodities, in which the emulative hate/love relation with
Italy is very intense, and which is at a distance, temporally and spatially,

sufficient to allow painters a synoptic grasp of the system of early modern painting and of its range of possible uses and meanings. Thus an antigraphic polemic has been attributed to Rembrandt both in his time and in ours by those who disapprove of his violation of the values of smooth finish and clear definition promoted in the classicistic theory of art. In *The Art of Describing* Svetlana Alpers argues that Rembrandt represented his estrangement not only from "the Italian notion of narrative painting" but also from "the Dutch art of describing" in his resolute refusal "to produce the transparent mirror of the world of the Dutch *fijn-schilderkunst*. . . . His engagement with the working of paint is an alternative to the crafting of descriptive surfaces" and is the means by which he challenges "the authority of his fellow artists and their culture"[91]—and also the patrons, dealers, and academic critics who shared the classicizing values of the smooth style and graphic mode.

Such values were soon inscribed in a graphic code that gave preferential status to "clear outlines, good drawing, historical accuracy and intellectual consistency" and that aimed at "standards of excellence . . . that would greatly simplify the evaluation of art, and raise painting and its criticism to the level of a science."[92] These are among the desiderata inventoried by Gary Schwartz during the course of his diatribe against Rembrandt's fuzzy half-lengths of the 1650s, with their "strong emotional appeal to collectors of a sentimental type" (306). Rembrandt, he remarks with annoyance, "walked straight into the line of fire" by executing "works that were practically tailored to the classicists' idea of misguided art," and this was silly of him because the new classicistic "consensus had been finding support among larger and larger circles of patrons and artists" and "was taking form in new institutions—confreries, brotherhoods, academies—that were acquiring the support of government and kings" (308).

Once again, the resistance to graphic criteria has political and perhaps ideological as well as aesthetic significance. Rembrandt and Hals were very different kinds of painters. But at least during the 1630s their commissioned portraits reflected and respected their patrons' preferences for graphic values. In these, Claus Grimm remarks, because Hals's interest in *peinture* "collided with the expectations of clients who wanted an 'objective' mirror image," he "displayed his virtuosity almost reticently," and though he had early "developed an unparalleled improvisatorial freedom" with anonymous models, it wasn't until many years later that he would display this freedom and allow his vaunted play with optical and textural

values to surface "in the more conventional portraits."[93] Commenting on the contribution of loose brushwork to the "disorderly reality" of Steen's comic images of topsy-turvy households, Mariët Westermann notes that "[w]ell before Steen, Brouwer, Van de Venne, and Adriaen van Ostade reserved their loosest strokes and muddiest smudges for peasants and wastrels."[94] Alpers points out that by 1650 in the north it was "the smooth style associated with Van Dyck, rather than the rough one, that was perceived as appropriate to the court, and historically it was seen as the new fashion replacing the old style of Rembrandt" because it appealed "to a knowing and imaginative courtier."[95] *Rembrandt's Enterprise* develops the argument of *The Art of Describing* into a revised and more fully elaborated demonstration of the way the conspicuous handling of paint may be interpreted in politico-formal terms as a counterpractice that targets the graphic investments and representational desires of those who wield the power of commission. Finally, alternatives to the views of both Schwartz and Alpers have been developed by H. Perry Chapman, and by Ernst van de Wetering, whose technical studies of Rembrandt's facture are unparalleled.[96] I shall consider their positions in Part 4, and particularly in Chapter 24.[97]

With the single exception of Michelangelo, those artists who enjoyed the most conspicuous worldly success in the Renaissance and Baroque periods, whatever else they might be, were always great portraitists.[1]

Since tragedy is a representation of people who are better than we are, [the poet] should emulate good portrait-painters. In rendering people's particular shape, while making them [life]-like, they paint them as finer [than they are].[2]

Commemorative portraiture must often reject the present in favor of a fictive image, selected for its appropriateness to the portrait commission.[3]

2

POLITICS: THE APPARATUS OF COMMISSIONED PORTRAITURE

I borrow the term *apparatus* from film theory and criticism, where it is a contested site. On the one hand, some would restrict the concept to cinematic machinery—camera, film, sound, editing, etc.—and describe the development of the cinema primarily as an effect of technological determinism or autonomy combined with a "drive to replicate reality" that works through technical advances toward "an ideal cinema which ever more fully represents the world of sensory experience."[4] On the other hand, some insist that the first group mystify or neutralize the pressure of hegemonic interests on technical development and scopic desire and thus extend the notion of apparatus in a more or less Althusserian manner to the ideological, semiotic, politico-economic, and metapsychological construction of the subject of cinema.[5]

My interpretation of the term conforms roughly to that of the second group, whose critical position closely resembles what I take to be Rembrandt's quarrel with the scopic regime of mimetic idealism. As we shall see, if the inventor of the Rembrandt look could participate in this polemic, he would not only support the extension of the representational apparatus to signifying practices that mediate ideology, he would also advocate the representation *of* the apparatus in painting. This has already been suggested by Alpers in her emphasis on Rembrandt's theatricality. I shall push that emphasis further, arguing that the theatrical mode functions as a critique and that the values and interests implicit in the regime Rembrandt criticizes are very similar to those discussed by Jean-Louis Baudry in his analyses of the genealogical relations of cinema to the scopic regime and idealist commitments of early modern visual representation.[6]

Film theorists situate the apparatus at the intersection of several functions—"recording, processing, and projecting or exhibiting," in one scheme[7]—and consider the literal "cinema machine" as a "nodal point" at which lines of force converge from "a larger social and/or cultural and/or institutional 'machine.'"[8] One might think of the apparatus of portraiture in similar terms as a nodal activity at which converge the diverse motives and interests, the strategies of self-representation, of those who participate in it. The apparatus would thus include several "dispositive" stages: the *motivation* for portraiture by the social, political, and cultural factors that make it useful, desirable, valuable, etc.; the *organization* of different (if often overlapping) sources of patronage on the one hand, and of the studio or workshop, the unit of production, on the other; the routines of *negotiation* that govern interactions between patron and studio, routines through which painters are selected and contractual arrangements concluded; the practice of *emulation*, which encompasses all the forms of interaction— the study of other painters, influence, borrowing, imitation, allusion—between painter and painter, painting and painting; the *preparation* of the materials and scene of painting; the act of *production*; the *exhibition* of the finished product. I note in passing that emulation occupies a special place in the apparatus inasmuch as it is the channel through which the aesthetic dynamics of artistic change flow into its sociopolitical basin.

Of these dispositive stages, it is clear that emulation, preparation, and production are most fully or directly representable, and that the others can be brought into the content of portraiture only by interpretive work that constitutes signifying links between the more and the less representable stages. So, for example, conspicuous emulation—as when a Rembrandt painting represents its relation to a painting by Titian or van Dyck or Rubens—provides a site onto which may be displaced pictorial comments on the more remote sociopolitical stages of the apparatus. The first and last stages, motivation and exhibition, are less representable but very important because they involve the pragmatics of commission. They are intimately connected and, in effect, they close the circle of dispositive stages, as may be seen by putting the obvious questions to the strategies of exhibition: Where? For whom? For what purposes? The linkage between the more and less representable stages can be established by exploring certain prior conditions of preparation and production. There are, for example, the familiar technical and aesthetic parameters that are specific to medium and genre, the so-called stylistic conventions that include such

state-of-the-art factors as pigment, ground, support, facture, palette, light, and design. These both delimit and enable the material and formal practices of painting. As the *means* of representation they are themselves representable, and the interpreter's task is to associate them with the forces of representation—the social preferences that motivate production—and with the social practices the product participates in. This involves taking into account the characteristics, interactions, and effects of the four modes that comprise the system of early modern painting discussed in the preceding chapter—especially interactions that challenge the mimetic clarity of the graphic mode, which is most suitable for portraiture. On the side of the *object* of representation, there are recognizable conventions of dress and attitude. The latter include rhetorical or gestural conventions for the positioning of the body and the head, and the direction of the eyes, conventions aimed at controlling the meaning and activity of the gaze that connects sitter with observer. Here, the task for the interpreter is to correlate the object with the means of representation, and convert the resulting complex to a signifying index of the other dispositive stages.

It follows from this account that when in subsequent chapters I speak of the fictions of the pose and the plots of portraiture, I refer primarily to *the representation of the apparatus of portraiture*. It is by attending to this representation that the *mise-en-scène* of portraiture is translated into its *mise-en-abîme*. When we turn to Rembrandt in Part 4 we shall see that the apparatus in question, the apparatus in place, is the articulation of the scopic regime and of the discourse of patronage and art that emerged interdependently in Italy, bearing the powerful impress of its Quattrocento origins and Cinquecento developments. In the sketch of that discourse which follows, I don't propose to explore the detail of territory that has already been crossed and recrossed by so many generations of Renaissance scholars. My aim is restricted to telling a story that has specific reference to what I think the Rembrandt look "sees." The Renaissance for Rembrandt is the state of the apparatus as his portraiture represents it.

"Every painter paints himself" (*ogni dipintore dipinge se*): this aphorism, attributed to Cosimo de' Medici by Poliziano, crops up several times in fifteenth-century Florence, and it is discussed by several twentieth-century scholars in contexts that make it a many-faceted reflector of the cultural and political apparatus behind early modern painting. It reap-

pears, with minor but significant variations, in utterances expressed by or attributed to Savonarola, Leonardo, Michelangelo, Samuel van Hoogstraten, and others, including Lorenzo de' Medici's poet, Matteo Franco. André Chastel, who documents the occurrences of the aphorism, links it to the influence of Ficino's Neoplatonism on that ideology.[9] I choose it as the touchstone of my sketch of the scopic regime challenged by Rembrandt, a regime I call "mimetic idealism" because it privileges both the increased naturalism or realism made possible by improved representational techniques and the idealization demanded by the portrait's social and political functions.[10] David Summers cites the aphorism at the end of a statement that can stand as a definition of this regime. He is describing what Renaissance viewers were conditioned to look for in portraits:

> Renaissance images were presumed to make us see more than we are shown and, more specifically, to make us see something higher than we are shown. We see a higher, spiritual inwardness in external forms. . . . The apparent sitter in a Renaissance portrait was thus an external appearance showing an inward truth, and so, it might be said, were Renaissance works of art in general. The spirit they expressed, however, was not simply that of their subject, it was also that of the artist, who gave the painting its "life." The *Mona Lisa* is a painting of—taken from the appearance of—a Florentine merchant's wife and at the same time a painting of—from the hand and sensibility of—Leonardo da Vinci. This second, genetic relation between artist and image was fully recognized in the Renaissance; it is the meaning of the Renaissance commonplace "every painter paints himself."[11]

On a more pragmatic level, the mimetic idealism described by Summers translates into a set of overlapping expectations, many of which are conveniently summarized in John Pope-Hennessey's study of Renaissance portraits: "a lively concern with physiognomy," "a punctilious study of particularity," an injunction to "portray 'the motions of the mind'" along with "mutability of mood," the assumption that "appearance is inseparable from personality," an insistence on "external fidelity" that rests on the belief in the consonance "between the visible and hidden aspects of the personality, between what can be perceived and what lies concealed within."[12]

Among the currents of thought that flowed into this concept of mimetic idealism, Neoplatonic metaphysics is preeminent, and Thomas

Greene explains our aphorism as a formula that condenses within itself the dynamic in which

> the mind absorbs the otherness of the external creation by yielding itself up. . . . Ficino writes: "Our soul tends to become all things, as God is all things." This giving up of the self to the nonself no more constitutes an annihilation of the subject than does the diffusion of the One in the many; it is simply one more of man's divine prerogatives, and perhaps the central prerogative. . . . It is only in this larger conception of dynamic interchange that one grasps the deepest interpretation accorded the familiar formula attributed to Cosimo de' Medici: "Every painter paints himself" (*Ogni pintore dipinge se*). Later formulations can be found in Pico and Patrizzi; perhaps one hears an echo of the idea in Leonardo's remark: "Whoever paints a figure and cannot be that figure, cannot reproduce it."[13]

Martin Kemp has decisively challenged earlier attempts (by Chastel) to find echoes of such ideas in Leonardo's references to "auto-mimesis": since, as he shows, Leonardo "considered that auto-mimesis was a cardinal sin for the painter," his accounts of it "are highly at variance with Ficino's philosophy in particular and with Neoplatonic thought in general."[14] This doesn't mean, Kemp goes on to argue, that Leonardo did not espouse mimetic idealism: he believed "that the artist should strive towards a higher goal than imitation of (and love for) his own features," a goal that "lies outside the mind of man—in Nature," that is, in the study of "those supremely certain truths which can be mathematically demonstrated," a study whose products are perspective and proportion (316–17, 319). It is this that enables the painter to depict "the variability of souls as manifested through the variety of bodies which the souls . . . form."[15] Kemp's analysis leaves standing a basic tenet of mimetic idealism, which is that since "the soul forms the body" the body reveals the soul.

Summers supplies a context for the aphorism similar to Greene's in discussing its relation to the Neoplatonic concept of Idea: writers on art appropriated the concept to characterize "the subjective and at the same time the spiritual nature of art." Savonarola, for example, explained "that every painter paints himself . . . not insofar as he is a man, because he can make images of lions, horses, men and women that are not himself; rather he paints himself insofar as he is a painter; that is, according to his *concetto*, and although there are diverse *fantasie* and figures that painters

paint, all are according to his *concetto*." Behind such explanations Summers finds Neoplatonic psychology, in which perceptions are reformed or revised by "the imagination or fantasy" into "concepts" that "excite the eye of the mind . . . to the universal ideas of things it contains within itself." The representation of truth in art thus involves the invention of forms that are fictive in being different from—better than—the referents they purport to resemble. The artist is analogous to the Ficinian lover, who "perfects the image of the beloved according to his own constituting idea, hence the lover, seeing his own realization in the other, sees beauty in his beloved which others do not. . . . Truth must be set out in a garment of fiction just as every painter paints himself."[16] This Neoplatonic scheme situates the formula in an *emboîtement* that opens up the act of portrayal to the metabolic flow of spirit animating and uniting the World Mind, Soul, and Body. The formula becomes an epistemological metaphor, an epitome of the "assimilationist" dynamic described by Greene. The *se*, or "self," in "every painter paints himself" receives from the context its heavy ontological meaning as a reference to a real entity—not its casual or unstressed meaning as a deictic marker: in effect, "every painter paints *his self*" as it exercises its "divine . . . prerogative" by absorbing or "yielding itself up to . . . the nonself" and producing *fantasie* of the ideas of others.

The representation of mimetic idealism unfolds at the juncture and under the pressure of two similar but differently inflected programs: the idealized representation of "lifelike" scenes and figures, and the visible embodiment of an invisible idea.[17] The latter develops in the shadow of a fantasy of unity or wholeness of the One dimly prefigured by the reciprocal specularity of bodies, souls, and minds, gazing at each other across the gap of a twoness they aspire to transcend. Despite the apparent mutuality of this scheme, Neoplatonic transcendence is oriented toward the first person: every painter paints himself. The psychology of love is basically autoplastic. It would therefore be better to separate the formula more cleanly than Summers does from the Neoplatonic program. Whether in the homoerotic form it takes in Ficino's *De Amore* or in the latently misogynist skew given it by Bembo in Castiglione, the narcissistic implications of the psychology obscure an important point focused by Greene in his emphasis on dynamic interchange and assimilation: the artist's sympathetic penetration of the other he imitates and idealizes is supposed to uncover the other's truth as well as his own.

Summers recognizes this point in his later book when he argues that
the reference of the formula to the

> genetic relation between artist and image . . . adds another dimension
> to the central paradox that the objective world is only evident from a
> point of view. Individual style, or manner, developed together with
> portraiture . . . so that the work itself became "physiognomic" at
> the same time that physiognomy became a part of the science of
> painting.
>
> The viewer of a Renaissance portrait, then, was assumed to see, by
> means of the painting, the spirit of the sitter, and, inevitably, the spirit
> of the painter who had given it its apparent life. This assumption could
> be expanded to explain . . . the consonance between the character of
> the work, and the reaction in the spirit of the beholder.[18]

Modern viewers, whose gaze is the medium of a different ethnopsychol-
ogy, have a hard time seeing all these Renaissance spirits, and one of
Summers's objectives is to explain the genealogy, motives, and logic of
the discourses that made such seeing possible. In that respect his book is
a kind of intellectual-historical sequel to Baxandall's ingenious and de-
tailed decoding of "the period eye" in *Painting and Experience in Fifteenth
Century Italy*.[19] Baxandall tries to recover the gestural iconography that
governed the translation of discursive meanings and categories into pic-
torial form. Near the end of his analysis, he turns to Quattrocento art
criticism for a vivid example of the way the assumption of mimetic har-
mony affected rhetorical practice. He notes a peculiar but systematic
looseness in the writers' use of descriptive terms: they conflate the quali-
ties a painter depicts with the quality of his mode of depiction, "move-
ment of the painter's figures" with the "inferred movement of the paint-
er's hand. . . . It is once more the Quattrocento sense of mind and body
in the most intimate relationship: as a figure's movement directly ex-
presses thought and feeling, the movement of a painter's hand directly re-
flects his mind."[20]

These comments elucidate the general orientation of a discourse that
provides a framework for—and inspires confidence in—the readability of
images, converting them into transparent conveyors of the determinate
meanings "behind" them. Note that the transparency or erasure of the
material picture plane that characterizes the graphic mode harmonizes
with the ideological transparency privileged by a discourse that encourages
the viewer to look through the visible figure to the mind or soul of which

it is formally an icon and dynamically an index. The self-effacement of
the painter's hand and its traces is a mark of tactful obeisance: the painter
doesn't want to get too much paint or too much fancy brushwork be-
tween the observer and the patron's image. The representation of the
painter's truth is subordinate to that of the sitter. If in its Neoplatonic con-
text the aphorism adumbrates the harmonious relation between painter
and patron, it does so primarily in terms of what it reveals about the lat-
ter. The one-sidedness becomes evident when we consider that the puta-
tive source of the formula was not a painter but a patron, who sometimes
occupied the role of subject/other in the relation, and on whose generos-
ity so many artists, architects, and Neoplatonists depended. This consider-
ation brings the apparatus of patronage more clearly into view. The patron
would presumably be more interested in the revelation of his own inner
truth and beauty than in that of the painters he hires. If Cosimo was in-
deed the source, he was probably saying something pithy rather than pro-
found, speaking not as a Neoplatonist but as a patron experienced in deal-
ing with painters, perhaps giving shrewd advice to a potential patron. And
even so carefully unpretentious a patron as Cosimo would have agreed
with Kris and Gombrich that since the artist's aim "was said to be to pen-
etrate into the innermost essence of reality, to the 'Platonic idea' . . . be-
hind the surface of appearance . . . the portrait painter's task was to reveal
the character, the essence of the man in an heroic sense."[21] The hero in
question is the patron, not the painter.

The advantage of the Neoplatonic interpretation of the formula sug-
gested by Greene and Summers is that the notion of "dynamic inter-
change" between self and other privileges the benign understanding of
the apparatus of patron/painter relations as a symbiosis, while helping to
muffle the actualities of conflict and negotiation that have an equal share
there. It is useful for both patron and painter to let themselves be in-
scribed in a discourse that enables them to see "a higher, spiritual inward-
ness in external forms," a discourse in which culture-specific interpreta-
tions could be legitimized as giving knowledge of inner reality. Yet if
Summers and Greene are right to situate the formula in this network of
ideas, this festival of mimetic harmony and specularity, their reading at
once points toward and fails to acknowledge the ironic basis that gives the
network a function in the cultural politics of early Renaissance patronage.
Both glide too quickly past the initial site of enunciation, the putative fa-
ther of the formula.

"Every painter paints himself"—the priority accorded to the painter is nicely undone in the following passage:

> It is hardly fanciful to feel something of Cosimo's spirit in the buildings he founded, something of his reticence and lucidity, his seriousness and his restraint. To the fifteenth century this would have been obvious. The work of art is the donor's. On Filippo Lippi's *Coronation of the Virgin* in the Uffizi, we see an angel pointing to a kneeling monk with the words *iste perfecit opus*. It used to be thought that we must here have the self-portrait of the painter, but it is now accepted that the donor must be meant.[22]

The reinterpretation dramatizes the conflict for control of the rights of self-representation that underlies the Neoplatonic symbiosis, and it makes the outcome of the conflict clear: every patron paints himself. Thus as the formula descends from the One through the Neoplatonic *processus*, the union of its two partners gives way to the specular duality, the dynamic interchange, of interpenetrating spirits, who then fall into bodies that bounce off the ground and break—like the two halves of Aristophanes's *symbolon* in the *Symposium* (191d)—into the fragmented complementarity of the cash nexus:

> A fifteenth-century painting is the deposit of a social relationship. On one side there was a painter who made the picture. . . . On the other side there was somebody else who asked him to make it, provided funds for him to make it and, after he had made it, reckoned on using it in some way or other. . . . The man who asked for, paid for, and found a use for the painting might be called the *patron*, except that this is a term that carries many overtones from other and rather different situations. This second party is an active, determining and not necessarily benevolent agent in the transaction of which the painting is a result: we can fairly call him a *client*. . . . Money is very important in the history of art.[23]

Here, "every painter paints himself" is subjected to the tug of oppositional perspectives. To the painter, it expresses the power of his recognizable style to inscribe his signature, his hand, in everything he paints. To the patron, it may express the painter's vanity, his repetitiveness and self-indulgence, the imperialism of his desire.[24]

What was significant for the development of artistic production in early modern Europe was that in Quattrocento Italy the tension of con-

flicting interests built into the apparatus worked as much to the advantage of artists as to patrons, and it did so at two levels, the first more indirect and oriented toward the economic and moral conditions of patronage, the second oriented more directly toward the incentives of art. I want to consider both levels, the first a little more closely than the second, because it is still too easy for art historians to use Cosimo's aphorism as a stick to beat patrons with:

> The unique power of the creative self is seldom lost upon men and women eager to "improve" their social station. The Medici, past masters at covering the traces of their own ambition and wealth under varying cloaks of republican communal service or friars' piety, made sure their carefully masked power flourished by associating themselves with the most powerful contemporary artists. . . . Later Medici continued to co-opt the founding masters of the early Renaissance, funding funerary and other monuments to their memory and thus indirectly raising their own association from the morally dubious pursuit of moneylending to connoisseurship. Clearest of connections between collectors' and creators' self-interests is found in the massive gathering of artists' self-portraits accumulated by the Medici.[25]

Here the worldly-wise Inside Dopester lays bare the crass motives behind the power of the image makers and the production of their own images in biography and autobiography. So simplistic and reductive an account conforms to the picture of the apparatus of patronage that is, as we'll see in Part 4, the target of Rembrandt's critique. Critiques of this sort are strategies of revisionary allusion that rely for their force, their claim to originality, on the representation of a simplified and generalized version of the target.[26] Their implied reconstructions creatively distort the past in order to make it reflect the present and more immediate focus of critique. One can't motivate or explain the form and import such distortions as Rembrandt's and Eisler's take unless one gives a competing, perhaps equally distorted, account of the past they distort. Rembrandt's interpretation of patronage is also an interpretation of painting, and this two-sided critique of the apparatus responds not directly to Italy but to the Italianism residing in the Dutch scene of patron/painter relations. Inasmuch as this scene both differs and derives from the conditions of patronage in Renaissance Italy, an understanding of Rembrandt's critique presupposes some account of the latter.

Eisler touches on an important theme in the study of patronage in

Italy, the causal link between pious donation and the "morally dubious" practice of usury; a theme, incidentally, that is not prominent in literature about seventeenth-century Holland because, owing to the low rate of interest for which the Dutch were nefarious or famous, questions of avarice were dissociated from questions of usury.[27] But Eisler's rhetoric, with its insinuations of conspiratorial practice, is at best a distraction. There is no way of distinguishing what the Medici thought they were up to from what they and others said they were up to—said, or wrote, in texts intended, like portraits, to impress some present or future constituency. When Peter Burke asserts that piety was one of the "three main motives for art patronage in the period" between 1420 and 1540 (the other two were prestige and pleasure, and no doubt the allure of alliteration played some part in this triadic formulation), he is careful to describe the motive as something displayed rather than something felt: "'The love of God' . . . is frequently mentioned in contracts with artists; and if piety had not been an important as well as a socially acceptable motive for patrons, it would be difficult to explain the predominance of religious paintings and sculptures in the period."[28] Speculations about the hypocrisy of individuals, or their capacity for self-deception, or the purity of their motives, are less interesting in this context than an inquiry into the discursive conditions whose pressure makes a particular cluster of motives not only good to think but also good to display.

What decisively motivated patronage in the culture of the Italian city-state was a particular conflation of interests—political, economic, religious, and ecclesiastical—that produced a mechanism of equilibration, a kind of thermocouple sustaining reciprocity or "feedback" between piety and usury. Everywhere in Europe, the foundations on which the revolution in banking and commerce rested met with the expected medieval condemnation of excessive interest and the sin of avarice, and the Church position was upheld by humanists in the south as well as in the north. It is true, as Myron Gilmore notes, that by the middle of the fifteenth century "the canonical enforcement of restitution for ill gotten fortunes had long ceased to apply to the merchant prince" (it still applied, for example, to small moneylenders in Florence), but there was nevertheless "enough force in the old beliefs to create in the minds of men a sense if not of guilt, at least of a conscious desire to spend a fortune in ways that would benefit the community."[29] The evidence for guilt exists in the wills of merchants, which contain admissions of usury and reparations for it. Charles Avery

writes that, to the extent that the prejudice against usury survived in Florence, it was

> a serious disability to the banking business. Yet, inconvenient as it may have been to the banker, it was of fundamental importance to art patronage, for the accepted way of expiating the sin of usury was to finance the repair, construction or decoration of some religious foundation. Nearly every public building in Florence had some religious connection and would qualify as the object of a settlement of this kind of moral debt to the community. The greater the profits that accrued, the greater was the stigma attached to the lender and the greater was the sum needed to clear his conscience and his good name. Thus the Medici, the most successful bankers, felt obliged to devote a considerable proportion of their profits to such ends.[30]

I am not completely persuaded by the definiteness of Avery's profits/ stigma/payoff ratio, since strictly speaking a sin or vice cannot be "discharged" by being repaid like a debt, so if it is treated as one, the stigma it incurs can't be very serious. Furthermore, the strategy of patronage probably has a less purely defensive aspect, for when a religious institution is the recipient of such patronage and thus effectively encourages the sin of usury to its own profit, then "the accepted way of expiating the sin" makes a usurer of the religious donee.

Avery goes on to supply, perhaps unwittingly, an example of the kind of complicity this strategy would involve:

> Of course, this system provided undoubted opportunities for self-advertisement in the lavishness with which men supported public projects, but appearances were carefully maintained by a patron as astute as Cosimo de' Medici. When donating funds to the monasteries of San Marco and San Lorenzo, he insisted on meeting practical needs such as the monks' accommodation, very much in the spirit of pious atonement, before turning to the embellishment of the churches proper, which would contribute more obviously to the prestige of his family. In any case, the interpretation of what constitutes a fitting expiation for successful usury tended to be surprisingly generous: for instance, the expense of erecting the huge Medici palace could be counted, inasmuch as it added luster to the city. (3)

There is some irony in the fact that Fra Angelico's painting for Cosimo's special cell in San Marco—appropriately enough, an *Adoration*—is so

different from the more austere frescoes in the cells of Angelico's fellow monks. Its busy, pageantlike style resembles that of Gozzoli, Angelico's pupil and one of Cosimo's favorites, who decorated the palace. This adds a certain pungency to Avery's phrase "the monks' accommodation": Angelico's style accommodates itself to, and thus betrays, the more sumptuous and worldly taste of the restrained patron. The difference reflects the compromise to which all parties agree in sustaining the equilibrium by which the banker's profits may be transformed to monastic instruments of "pious atonement." Nothing more tellingly conveys the spirit of this practice than the wry briskness with which Vespasiano, from whom Avery gets his anecdote, trots through the spiritual bargaining that led to the rebuilding of San Marco: Cosimo went to Pope Eugene IV to see about doing something to remove "the load which lay on his conscience," and the Pope suggested that "if he was bent on unburdening his soul, he might build a monastery."[31] It is as if the Pope kept a wish list of projects handy in expectation of usurious opportunities. In this system of exchange, the sermons by which friars and theologians kept stoking the fire under patrician guilt must have made an important contribution to improvements in church property.

The system exhibits the peculiar moral tonality that suffused the cultural and institutional setting of Italian public life: a tonality identified by northern European observers with the worldliness and hypocrisy of a Mediterranean civilization that had always regarded its rude Gothic neighbors with contempt; a tonality that some reduced to the level of caricature in the figure of the diabolical Machiavel, while others were at once fascinated and repelled by the spectacle of a world that was all theatrical facade, all artful dissimulation. On a more sympathetic reading, the tonality appears to be the function not so much of individual agents' moral hypocrisy as of a quasi-corporate balance of competing interests that may be described as "moral homeostasis." By this I mean that there existed a set of tacit understandings and a repetitive, self-regenerating structure of conventional or routine practices that served to trouble and pacify consciences; these practices provided motives as well as opportunities for expressing pious feeling and bound together financial, social, political, and religious interests into an interdependent network. So long as the structure guaranteed the simultaneous production of piety and profit, the network remained viable. A certain level of ethical pressure was more or less systematically assured by this thermocouple: enough to keep rich people patronizing and, in general,

contributing to public welfare so that they could continue to get rich enough to continue patronizing and contributing.

In such a climate, motives of piety, philanthropy, and art may be separable from worldly self-interest in the individuals who profit from the network, and may in fact be stimulated by the expressive channels the system makes available to them. But the structure of practices itself has a corporate moral character that can become routinized through its success in stabilizing the balance of individual interests and of the institutional functions the individuals carry out. If patrons, pope, superiors, and local clergy help each other maintain appearances, enlisting in their service such assistants as Fra Angelico, it is partly because they respect the force of conscience in a world where everyone takes factional motives for granted. They followed Hamlet's tenet, "assume the virtue if you have it not," and improvised idealized facades, ceremonial roles, not merely for protection and deception but with genuine concern for the well-being of the public institutions that both depended on and enabled their *virtù*.

No one understood this better than Machiavelli, who carefully separated political ethics from personal morality, and who abstracted a specifically political system of forces from the immediacy of social experience in which they were embedded. His approach to politics was founded on the adoption of a hypothetical premise, which may be characterized as follows: "whoever wishes to perform well in the theater of politics must postulate, *whether or not it is actually the case*, that human beings are individually untrustworthy, nasty, and brutish." Without membership in and loyalty to the collective order—and in particular the republican constitution—the political or polis-dwelling animal could not long survive his subjection to unruly *animo* and self-interest. It has been said that for Machiavelli the aim of the "dynamic equilibrium" secured by the mixed constitution was "to restrain those special interests in the state which, if allowed to go unchecked, would destroy it."[32] But the argument of the *Discorsi*, especially I.3–8, is a little different: ambition, avarice, factionalism, aggressivity, and the other manifestations of *animo* were not simply to be restrained or repressed; they were to be given legitimate outlet in formalized political discourse, displaced into the organs of institutionalized conflict.

Machiavelli's view distills and idealizes but does not distort the tacit ethic and understanding that informed Italian public life during his era. The premise that human individuals tend singly toward corruption and anarchy serves to stimulate the ethical pressure needed to keep the system

going. Given the particularism of Italian politics, and the inclusion of the papacy among the competing particular states, there was no ulterior institution to which one could look for transcendent sanction and governance. The true Machiavellian looks outward for salvation toward the vitality of political art and the political system.

Certain famous facades, like Alberti's at Santa Maria Novella and the Palazzo Rucellai, or Brunelleschi's at the Foundlings' Hospital, have no structural or aesthetic relation to the edifices they front and conceal. They represent a rejection of the principles governing Gothic and classical exteriors that introduce and harmonize with their interiors—that are "organically" integrated. The Italian Renaissance facade represents itself as hiding, not revealing, what is behind it, while contributing to the order and appearance of the public space to which it primarily belongs. Yet this concealment has a carefully limited scope. The structure behind and within may well be flawed, but the facade makes no attempt to conceal this from knowledge; it serves only to conceal it from the eye. One could go on living with dubious motives so long as one was not very often forced to confront or express them openly, so long as they could be channeled into the appearances that graced the piazza. Making no claim to be reality, claiming only the status of a fiction that showed how reality could or should be, the facade of public actions was nevertheless operative as an ordering force in political reality. These are at least the manifest consequences of the system; some less desirable latent consequences will be discussed in the next chapter.

The dissimulation advocated by Machiavelli and Castiglione was expected to strengthen the fabric of a civic order founded on the compromises, complicities, and duplicities necessitated by the factional character of Italian politics. Since ethical fictions were also political realities, one could feel grateful to the facade for maintaining a barrier between the face value of positive public actions and the privacy, the possible questionability, of the motives that generated them. The *virtù* that produced the facade was a source of pride and satisfaction, not of shame:

> The pleasure of possession, an active piety, civic consciousness of one or another kind, self-commemoration and perhaps self-advertisement, the rich man's necessary virtue and pleasure of reparation, a taste for pictures: in fact, the client need not analyze his own motives much because he generally worked through institutional forms—the altarpiece, the frescoed family chapel, the Madonna in the bedroom, the

cultured wall-furniture in the study—which implicitly rationalized his motives for him, usually in quite flattering ways, and also went far towards briefing the painter on what was needed.[33]

So much then for the contribution of the moral conditions of patronage to the *discordia concors* of patron/painter relations. In turning to consider their effect on the incentives they offered artists, we can move from the first to the second of Peter Burke's list of three motives for art patronage—from piety to prestige and its political value: "Machiavelli . . . saw the political use of art patronage and suggested that 'a prince ought to show himself a lover of ability, giving employment to able men and honoring those who excel in a particular field.'"[34] As Martin Wackernagel and others after him have argued, this motive directly stimulated technical innovation and led both to new levels of representational skill and to the more rapid and diversified emergence of regional styles.[35] Chastel discerned a negative index of this change in Savonarola's use of the aphorism to remind artists "of their Christian responsibility" and persuade them to reform "their heart" and the art that reveals it by restoring "traditional norms."[36] Baxandall shows how the desire for prestige placed a higher premium on artistic skill, which became a more valuable commodity than precious materials, and he describes various procedures available to "the discerning client" who wanted "to switch his funds from gold to 'brush,'"[37] (17), a change advocated by Alberti and one that structurally correlates with changes from decorative to graphic emphasis.

In the dispositive stage of negotiation, the contribution of artists to iconographic programs was not negligible, according to Charles Hope, who deduces from the documentary evidence that "it would be wrong to imagine clever laymen imposing incomprehensible instructions on docile and ignorant artists." Hope attributes the prominence given "to complex programs and learned advisers" to "the development of iconography as a subject of academic study" by learned scholars who may invent many of the complex programs they discover.[38] He infers from his reading of the record that patrons gave more scope to the artist's power of *disegno*. The prescriptions of detail, form, and theme are of course significantly affected by the constraints and opportunities of technical innovation, and here events occurring within the dispositive stage of emulation play an important role.

What facilitates harmony instead of tension between patron and painter is their common interest in the idea that the painting should dominate the

observer in the same way that a good orator—and his speechwriter, if he has one—should dominate his audience. The rhetoric of graphic representation aims to delight, convince, and instruct, and it does this in good Aristotelian fashion by displaying the equivalent of the speaker's ethos, that is, the painter's virtuosity combined with the patron's generosity (not to mention his wealth, taste, piety, and textual knowledge). However divergent they were, the aims and claims of both parties symbiotically reinforced each other, and it may be that occasional draughts from the well of mimetic idealism watered by Neoplatonic orders helped keep them congenial. Even Lauro Martines, who does his best to demystify Neoplatonism as the ideology of rich oligarchs, "a program for the ruling classes," and who insists that "elite identity was fundamental to the fortunes of Renaissance art," acknowledges "the unity of interests binding patron and painter."[39] But only one of the parties pays. Every painter paints his own inner truth if and only if he depicts the inner truth of the patron whose arm and brush he is, and the patron is the final judge of that. If Mona Lisa and her husband didn't approve of or agree with the inner truth they saw in the *Mona Lisa*, they might, in wondering about Leonardo's inner truth, have given the formula another mean twist: this painter *only* paints himself.

Such a turn was in fact given it by Michelangelo in an anecdote cited by Summers: "Shown a painting of indifferent success in which an ox stood out as most skillfully painted, Michelangelo is supposed to have said 'Ogni pittore ritrae se medesimo bene' (Every painter portrays himself well). This play on words was not only a harsh criticism, but as Michelangelo well knew, it changed the whole meaning of the saying."[40] In Michelangelo's travesty, the formula denotes literal if unwitting self-portrayal, or rather the self-betrayal lurking in the formula: the self-portrait of the painter as a dumb ox. The derisive comment raises precisely the questions—about relations between self-portraits and portraits of others—that project the formula into the orbit of Rembrandt's practice. Its relevance to Rembrandt has been indicated by Gary Schwartz: "Samuel van Hoogstraten quotes a pertinent saying of Michelangelo's that he may have heard from his master Rembrandt: 'All painters are best at painting their own likeness' . . . Michelangelo said it in jest, but for Rembrandt it was to become a fact of life."[41] Schwartz cites this during the course of his acerbic comments on Rembrandt's penchant for self-representation, which, he suggests, may be read psychologically as "representations of vanity."

Rembrandt's outpouring of self-portraits abducts the formula from its

comfortable nesting place in Italian Neoplatonism and converts it to a comic hyperbole. The change produced in the formula by its journey north suggests that Schwartz would have done better to call it a fact of culture rather than a fact of life, and, more specifically, a response to the politics of the patron/painter apparatus as Rembrandt found it—the collaborationist politics in which the aesthetic freedom of the painter was encouraged so long as his virtuosity served the patron's interest and suited his or her taste. During the sixteenth and seventeenth centuries this politics continued to prevail, though in the case of certain eminent artists— Michelangelo, Titian, Rubens, and van Dyck—the axis of power tilted a little from patron to painter.[42] Rembrandt's accomplishment, if it can be called that, was to invent a mode of painting that challenged the comfortable arrangements of this regime. The challenge was mounted primarily through his literalization of the self-portraiture metaphorized in the formula. The sheer number of the self-portraits contributes to the force of the challenge, which is further intensified by the fact that most of them represent the painter not at work in his studio but playing the role of the sitter or model, the *other* in the portrait relation.

In order to understand what motivates the challenge, to see what the Rembrandt look responds to in the aesthetics of the portrait relation and also in the apparatus of patronage that portraits directly or indirectly represent, we have to examine the structure of this relation in the context of the scopic regime of mimetic idealism. I referred above to the arrangements of that regime as "comfortable." They may have looked that way to a critical observer in seventeenth-century Amsterdam, but to at least one discerning participant much closer to the scene, the arrangements were more problematic. His solution to the pressure they imposed on the general practice of self-representation was to imagine that the practice could be regulated by a blueprint and a technology of self-fashioning. But in depicting the solution, he also showed that it only reproduced and intensified the problem it confronted. The discerning participant was Castiglione, and the solution was the behavioral practice of *sprezzatura* elaborated in *Il libro del cortegiano* (*The Book of the Courtier*). The account of sprezzatura epitomizes the particular aporia produced by the interaction of sociopolitical instability with new technologies of representation in the culture Castiglione depicts. It is, as we'll see, precisely the aporia that haunts the structure of portraiture developed under the influence of mimetic idealism.

CONSEQUENCES: SPREZZATURA AND THE ANXIETY OF SELF-REPRESENTATION

Lurking under the discussion of sprezzatura Castiglione assigns to his interlocutors and emerging fitfully but definitively throughout the *Cortegiano*, are hints of a general cultural failure: the failure of ascriptive norms of blood and lineage to sustain their moral authority and sometimes their political efficacy; a crisis of the aristocracy not unlike the one made famous by Lawrence Stone.[1] Two centuries of wars, social conflicts, economic crises, and epidemics, had produced, as Randolph Starn puts it in his wonderful study of the Camera Picta in Mantua, "a world of desperate remedies."[2] In the face of redistributions of power exploited or endured by self-made princely regimes and mercantile oligarchies, the ascriptive norms developed under feudal conditions remain necessary but are no longer sufficient. They have to be supplemented by skills of self-representation that respond to new legal, political, and ideological pressures on aristocratic status. For example, as Stanley Chojnacki has shown, starting in the early fifteenth century Venetian patricians had to meet state-instituted requirements for proving their noble credentials; the confirmation of noble identity came to depend less on family history than on legal procedures and official documentation that redefined the patriciate as an "essentially political" entity. In Tuscany, "governmentally conferred *dignitas*" came to supersede "ancient . . . lineage" as the primary determinant of noble status.[3] Thomas Kuehn's study of arbitration in Florence—like Stephanie Jed's account of merchant writing—brings out the increasing importance of performative techniques in the reproduction of family status and solidarity.[4] In the lordships of Northern Italy, to return to Starn's account, factitious "court genealogies," with their "masquerade of distin-

guished origins," were more openly presented and perceived as the rituals of performance that signified the rippling muscles of new power, "sheer political domination," just under the silky and transparent skin of traditional aristocratic authority.[5] Finally, looking north to the Netherlands and Amsterdam, from the late sixteenth century on we find a more concentrated and intense version of this process of redefinition in the emergence of the regent class, which has been called an "elite . . . of commoners" and in which—as opposed to "an estate society" like Venice—"status tended to follow wealth and power."[6]

What these examples have in common is an increasing emphasis on the need to *perform* status, the need to develop strategies of self-representation and class self-definition.[7] This is the need the *Cortegiano* thematizes and dramatizes. In Book 1, under the nominal topic of what the ideal courtier needs to know and to be able to perform, the interlocutors go through the standard arguments about the value of mastering the skills of literary, musical, and visual production. But objective emphasis on the acquisition of learning and art is to some extent a misdirection. From the closing paragraphs of Book 1 through the first twelve paragraphs of Book 2, it gradually becomes clear that the artistic production of objects models the artistic production of subjects. The ultimate aim of the acquisition is to convert painting and writing to living self-portraiture and self-textualization: *ut pictura habitus.* The clichés about learning the arts are displaced from the production and evaluation of artifacts to the production and evaluation of courtly behavior as a performance of "nature."

If this were all there were to it, the *Cortegiano* would be as bland a book as it is often made out to be, for the argument I have just outlined ignores all the more complex implications embedded in the concept of sprezzatura. The term is introduced in 1.26 as *una nova parola* by the speaker assigned to supervise the "game" of constructing the ideal courtier, Count Ludovico da Canossa. He defines it as an art that hides art, the cultivated ability to display artful artlessness, to perform any act or gesture with an insouciant or careless mastery that delivers either or both of two messages: "look how artfully I appear to be natural," and/or "look how naturally I appear to be artful." Killjoys might be inclined to dismiss this art as a culturally legitimated practice of hypocrisy or bad faith, but others would appreciate the suppleness of the definitional high-wire act performed by the count and his interlocutors. For the sake of simplicity, I shall call this the "sprezzatura of nonchalance," even though that name

is misleading, since what is involved is not merely nonchalance, *disinvoltura*, insouciance, the ability to conceal effort. Rather, sprezzatura is first of all the ability to show that one is not showing all the effort one obviously put into learning how to show that one is not showing effort.

This, however, touches only on the instrumental or purely aesthetic aspect of sprezzatura. What is it for? A second definitional aspect is beamed up by the count in 1.28, and I give it in Wayne Rebhorn's paraphrase: sprezzatura is "an art of suggestion, in which the courtier's audience will be induced by the images it confronts to imagine a greater reality existing behind them," and this enables the courtier "to make himself into a much more enticing and compelling figure than he might otherwise be."[8] Since, as Frank Whigham concisely renders it, "modesty arouses inference in excess of the facts," we may think of it as a sprezzatura of conspicuously false modesty.[9] Furthermore, the term's relation to the verb *sprezzare* (to scorn, despise, disdain) and the adjective *sprezzata*, which appears several times in Books 1 and 2, suggests a third aspect: in Rebhorn's words, sprezzatura designates "an attitude of slightly superior disdain" by which the performer indicates his easy mastery of whatever he is doing, his "scorn for the potential difficulty or restriction involved" and "for normal, human limitations."[10] Eduardo Saccone and Daniel Javitch associate the "disdain, misprision, or deprecation" implied by the etymology with a strategy for maintaining class boundaries; they argue for a sprezzatura of elite enclosure founded on the complicity of a coded performance in which the actor and his peers reaffirm their superiority to those incapable of deciphering the code.[11]

Javitch gives sprezzatura a different look by moving it into the political arena and treating it as a strategic response to "the constraints of despotism" in the courtly context of "fierce competition for favors":

> [T]he ruler's desire to keep his subordinates in check, as well as the court's standards of polite refinement, compel its members to subdue or at least mask their aggressive and competitive drives. That is why such qualities as reticence, detachment, and understatement are so valued at court. . . . The courtier . . . inhabits a world where graceful deceit is valued not only for its intrinsic delight but because the despot who governs that world makes it imperative.[12]

This suggests a fourth definitional aspect of sprezzatura as a form of defensive irony: the ability to disguise what one really desires, feels, thinks,

and means or intends behind a mask of "apparent reticence and nonchalance" (24). I hesitate to call this the "sprezzatura of deceit" because, as I'm about to suggest, it involves not deceit *tout court* but rather the menace of deceit, the display of the ability to deceive. I shall therefore, in the interests of vapid generalization and alliteration, refer to it as the "sprezzatura of suspicion."[13]

These formulations don't quite catch a reflexive nuance that hovers cloudily about them. Most of them focus on a skill of performative negation, the ability continuously to display that something is being conspicuously withheld: the ability, for example, to present oneself as someone who may have and can keep secrets, who has power in reserve, who does indeed possess the "aggressive and competitive drives" he is masking, who knows how to conceal unpleasant truths under "salutary deception" (*inganno salutifero*, 4.10). Deceit is among the "tropes of personal promotion" Whigham discusses in his fine chapter on that topic. He cites Puttenham's assertion that the "profession of a very Courtier . . . is . . . cunningly to be able to dissemble," and he offers the following comment on the statement by Federico in 2.40 that this "is rather an ornament . . . than deceit": "[d]eceit is both denied and admitted, redefined and excused; . . . it becomes . . . a sauce or manner."[14]

All these observations point toward more than the ability to deceive; they aim at the ability to represent the ability to deceive, at the courtier's ability *to show that* he has the art and, if called upon, is capable of deceiving. The sprezzatura of suspicion may thus be defined as the ability to show that one is not showing what one really desires, feels, thinks, and means or intends. Earlier I defined the sprezzatura of nonchalance (*disinvoltura*) as the ability to show that one is not showing all the effort one obviously put into learning how to show that one is not showing effort. *Disinvoltura* is presupposed by the sprezzatura of suspicion as both its behavioral sign and the medium through which it will if necessary be actualized. It is also both a competitive act in itself and a sign that its possessor is willing to compete for favors in court; a guarantee that the ambition and aggressiveness the courtier pretends to mask are really there, and available for his prince's use (see 2.18–25, 32).[15] To modify Puttenham's "profession of a very Courtier" in a manner that brings out the pun in "profession" and "very," the true courtier professes himself capable of falsehood; among the accomplishments by which he prefers himself to princes is his ability to show that he is cunningly able to dissemble. Strictly speaking, then, the

"trope of personal promotion" is not "deceit"—the ability to dissemble—per se. The courtier promotes himself and tries to win the prince's confidence by displaying his mastery of the behavioral rhetoric, the choreography, that signifies the ability and willingness to deceive.

The performance of sprezzatura is thus a figuration of power. But it is also a figuration of anxiety. The *Cortegiano*'s interlocutors show themselves to be sensitive to their precarious status in the Italian court culture of their time, a culture dominated by princes who were likely to be despotic and who more often than not were themselves perilously besieged as clients of militarily superior nation-states. The threat or actuality of disempowerment is a concern not only noted by the book's critics but also expressed by its speakers, and it is against the background of this anxiety that the effortless if not lazy elegance of sprezzatura is depicted as a source and sign of manly inner strength rather than of effeminacy. In other words, sprezzatura is to be worn as a velvet glove that exhibits the contours of the handiness it conceals. But of course the glove could be filled with wet clay. Perhaps this signifier of virile manhood only "camouflages vulnerability," as Whigham phrases it in describing the trope he calls "cosmesis," "the use of cosmetic aids to conceal or repair defects."[16]

The idea of cosmetic sprezzatura puts a mordant and defensive spin on the second of the definitional aspects mentioned above, the "art of suggestion" or conspicuously false modesty picked out by Rebhorn as enabling the courtier "to make himself into a much more enticing and compelling figure than he might otherwise be."[17] Presumably this is an art the courtier would cherish and practice with pride, and presumably, since the discussions about the perfect courtier and his female counterpart are prescriptive, those figures are ideals or models to be distinguished from both their inventors and their imitators. It may therefore go against the grain of the interlocutors' putative project to rewrite Rebhorn's phrase in a manner that highlights cognitive states—"more . . . than he might think himself to be, or fear himself to be"—and to ask what it might mean for a performer to think or fear that he is worse than he appears: worse not merely as a matter of security or vulnerability (Whigham's chief concern) but as a matter of conscience, an anxiety that is not merely practical but ethical. The *Cortegiano* is a book about self-representation. But self-representation has two dimensions, objective (representing oneself to others) and reflexive (representing oneself to oneself). The explicit theme of the book is learning how to represent oneself to others. Is it then gratuitous to ask how this

project may affect and be affected by the questions of trust and self-esteem that come into play when one takes reflexive as well as objective self-representation into account? Do all those who are urged to represent themselves as better than they think they are form a community in which it becomes as difficult to authenticate one's own performances as it is to accredit those of others? Doesn't such a community cast about itself a permanent shadow of representation anxiety? Can it avoid being haunted by its construction and representation of the unrepresented—by the specter of an unrepresented community of hidden and less worthy selves that its commitment to the culture of sprezzatura conjures up?

The danger of inauthenticity is embedded in the very structure of the social problem, and although sprezzatura is offered as a solution, the discussion soon makes clear that it is part of the problem. Early in the first book, Count Ludovico (who in real life belonged to old Veronese nobility) introduces a traditional dogma the other interlocutors will contest and reform: only from noble birth does the courtier derive "that certain grace which we call an 'air' [*sangue*], which shall make him at first sight pleasing and lovable to all who see him" (1.14). Another speaker, Cesare Gonzaga (in real life, a member of a newer branch of the Mantuan lineage), reminds the count that since he has often described *grazia* as "a gift of nature and the heavens," it can't be "in our power to acquire it of ourselves" (1.24), though what we are given can, if it isn't perfect, be improved by study and effort.

Here again, grazia is assimilated to noble birth as a gift of earthly and heavenly fathers; it isn't something that can be acquired. Gonzaga then puts the money question, to which the count answers with a recipe for sprezzatura: "for those who are less endowed by nature and are capable of acquiring grace only if they put forth labor, industry, and care, I would wish to know by what art, by what discipline, by what method, they can gain this grace" (1.24). This crucial move relegates the ideal of natural perfection to the background as a reality possessed by a lucky few and leaves it standing *as* a real ideal, an ideal to be imitated by a less fortunate majority that includes not only klutzy patricians but also clever arrivistes. To reiterate that grazia is a grace beyond the reach of art just before the account of sprezzatura unfolds is to make deficiency in grazia the enabling condition of ideal courtiership. The ideal courtier the interlocutors are in the process of constructing is not the absolute or inborn courtier, whose grazia is fully embodied, "organic," and inalienable. On the con-

trary, he is imagined as a simulacrum necessitated by failure to embody the fullness of being ascribed to aristocratic nature. In short, sprezzatura is treated as a behavioral prosthesis. Its function is to "supply a deficiency" in the natural grazia that comes from noble birth.[18] The "perfect" courtier constructed as the ideal to be imitated is not a true but a false courtier, a figure of dissimulation, untrue to the natural nobility he performs—untrue, that is, by virtue of performing it. Nevertheless, the interlocutors place the new ideal in a revisionary rather than nostalgic relation to the genealogical norm introduced by the count at 1.14 as traditional wisdom.

The count's gambit opens a series of dialogical moves that conspicuously exclude the norm from consideration in order to open up space for a performance that dissimulates it. The conspicuousness of the exclusion is important—it keeps the unattainable norm in play as a prediscursive reality, a real presence, that validates the discourse of courtiership dedicated to representing it. Equally conspicuous is an emphasis on the difference between the absolute and ideal courtiers, the original and the image. This is registered in 1.24 by Cesare's redundant triplets: "as for those who are less endowed by nature and are capable of being *aggraziati* only if they put forth labor, industry, and care [*fatica, industria e studio*], I would wish to know by what art, by what discipline, by what method [*con quale arte, con qual disciplina e con qual modo*], they can gain this grace." The first triplet marks the fall from grace by its focus on uncourtly labor and sweat, but the shift to terms of art in the second triplet marks the beginning of the fantasy of *renovatio* that will be completed by the disclosure that Cesare's art/discipline/method not only conceals labor/industry/care but also theatrically conceals—displays itself as concealing—itself. Part of the signifying activity of sprezzatura is thus to index a mode of behavioral production that selectively abstracts from, doesn't fully correspond to, what may actually have taken place. Its objective is to edge its performances with some form of indexical reference to the art and difficulty whose conspicuous mastery and transcendence gives the ideal its value.

In this expressly duplicitous conception, the naturalness art pretends to imitate is an artifact. If, in the process of imitation, the courtier combines the selectivity of Zeuxis with the sweet predations of Plato's apian poets, he does so in the manner of a thief: "even as in green meadows the bee flits among grasses robbing the flowers, so our Courtier must steal this grace from those who seem to him to have it, taking from each the part that seems most worthy of praise" (1.26). This skill in robbery serves an art

of dissemblance and defensive self-surveillance that guards against another
kind of theft· "we may call that true art which does not seem to be art; nor
must one be more careful of anything than of concealing it, because if it is
discovered, this robs a man of all credit and causes him to be held in slight
esteem" (ibid.). The courtier must be careful to avoid "exciting envy" and
must be "cautious in his every action" because "we are all naturally more
ready to censure errors than to praise things well done" (2.7). The culture
of sprezzatura teeters precipitously over an abyss of paranoia.

The failed ascriptive ideal of inborn virtue is also a physiognomic
ideal.[19] That is, it relies on the viability of the old belief that the face is the
index of the mind. The new behavioral economy of sprezzatura chal-
lenges this ideal. Its prime commodity is a particular genre of perfor-
mance, posing, and, within that, a particular subgenre of posing, pretend-
ing not to pose. The desired effect includes the element of pretense: the
observer's eye is directed away from the simple spontaneity of "not pos-
ing" and toward the performer's ability to pose *as if* not posing. Sustain-
ing the fiction of the pose, the fictiveness of spontaneity, is paramount to
the success of the project.

This success, however, is bound to induce failure because it is itself in-
duced by failure. Castiglione's interlocutors construct a model that calls for
rule-governed performances by actors who transform their faces and bod-
ies into signs of the perfect mental and psychic grace denied them by na-
ture. The unattainability of the real presence of grazia provides the ideal
courtier with a performance opportunity. It also guarantees performance
anxiety, not only because the courtier is always performing before an audi-
ence composed of performers like himself, and not only because he knows
they're performing and knows they know he's performing, etc. There is
also anxiety about the performer's own practice of dissimulation—about
his need to keep the performance of naturalness from being spoiled by
unwanted leakages of the less ideal nature he is expected to suppress/tran-
scend. One by-product of the culture of sprezzatura is the construction of
hiddenness, of concealed and flawed inwardness. The basic presupposition
of the courtier's performance is that the achievement of sprezzatura may
require him to deny or disparage his nature. In order to internalize the
model and enhance himself by art he may have to evacuate—repress or
disown—whatever he finds in himself that doesn't fit the model.

The discussion of sprezzatura in the *Cortegiano* thus opens onto a pros-
pect of apprehensiveness, distrust of hidden motives, fear of exposure, and

a general sense of the weakness of the courtier's position. Both as observer and as observed, the courtier's anxiety is focused on the hidden "reality" of the unrepresented self produced by—and haunting—the culture of sprezzatura. The problems that beset this culture are concentrated in the interpretive combat between performer and spectators/auditors, a field of play charged with tension between aesthetic *jouissance* and suspicion. Since, in order to represent themselves to others, performers represent themselves to themselves, since they watch themselves being watched, the force of persuasion and the production of meaning are reversible, alienable, circular: they can originate either in the observer or in the performer:

> As the theoretical force of the audience response becomes increasingly valorized, so grows the temptation to reactive and self-protective (and paranoid) interpretation. The legitimacy of self-judgment is undercut, but so too is the trustworthiness of audience response when the audience as well as the performer is ruled by the self-serving prescriptions of courteous projection. When all audience members are also (thereby) performers, their judgments become performances and so are subjected to . . . reinterpretive pressures. . . . The result is an inversely proportionate relation between the intensity of self-projection and the reliability of audience reaction.[20]

> For both Castiglione and Erasmus, the subject is truly and . . . ironically a subject-in-process / on trial, who molds himself for a sternly, rigorously evaluative gaze. Yet in this scheme of civil scopophilia, the question Who is watching can only be answered, You are. If it is to work, the subject of civility must both generate and incorporate the gaze of the other. You never relax your vigilance because you don't want to make that fatal, mortifying mistake; in order to avoid it, you have to see yourself . . . doing it.[21]

Courtly negotiation is thus a struggle for control over the power to determine the self-representation the performer conveys not only to others but also to himself or herself—a disjunction that reminds us the determination may include gender.[22] Though Barbara Correll mentions only scopophilia, her account of representation anxiety suggests that in the behavioral dynamics of the discourse of conduct scopophilia is inextricably chained to scopophobia.

This is the aporia that early modern portraiture can be shown both to confront and to reproduce when it is approached as a practice of present-

ing and representing acts of self-representation, a member of the performative genre I call "fictions of the pose." The problems of negotiation discussed above—the instability of performer/observer relations, the dangers of charismatic bondage—are vividly illustrated by developments in that practice. Because the observer's power is mediated by the painter's, the process of negotiation is complicated, and the painted presentation of an act of self-representation—posing—thus raises from another standpoint the question of the relation between the aesthetic and political limits of representability and their production of the unrepresented self.

FACING THE GAZE

[W]hile the artist represents the persons "out there," those persons also represent themselves to themselves, to their contemporaries, and to those who take their portraits. One can never tell who is looking!

—RICHARD BRILLIANT, *Portraiture*

In Henry James's *The Real Thing*, an artist finds that poor Miss Churm and an Italian named Oronte can pose as real aristocrats as the real aristocrats Major and Mrs. Monarch cannot. . . . The painting, it turns out, is the real thing.

—SVETLANA ALPERS, *Rembrandt's Enterprise*

Portrait painters sometimes tell me that when confronted with a sitter they do not think of his character at all, but look at his face like a still-life which never keeps quite still enough, and concentrate on the difficulty of realizing its structure. One eminent portrait-painter said he wished his sitters could be hung upside-down by the leg, like a dead hare.

—KENNETH CLARK, *An Introduction to Rembrandt*

The face is the index of the mind.

—OLD VERITY

There's no art
To find the mind's construction in the face.

—SHAKESPEARE'S DUNCAN

If . . . portraiture . . . turns the interior of the figure toward the outside and renders it visible . . . [it] would then admittedly have to be limited to such subjects in which symbolic significance is seen to inhere. . . . The true art of portraiture would consist in embracing the idea of a person that has dispersed into the individual gestures and moments of life, to collect the composite of this idea into *one* moment and in this way make the portrait itself, which on the one hand is ennobled by art, on the other more like the person himself, that is, the idea of the person, than he himself is in any one of the individual moments.[1]

$$4$$

THE FACE AS INDEX OF THE MIND: ART HISTORIANS AND THE PHYSIOGNOMIC FALLACY

A painting ought to change as you look at it, and as you think, talk, and write about it. The story it tells will never be more than part of the stories you and others tell about it. The stories—or interpretations, as they are sometimes called—come in different genres, such as the formalist, the iconographic, the connoisseurial, the genetic, the conservatorial, the contextual, and various mixtures of these and other genres.[2] These interpretive genres are in turn conditioned by the different genres they tell stories about, and in the present discussion the generic parameters of the story I tell will be adjusted to—or by—those that move the portrait genre through fifteenth- and sixteenth-century Italy. My story will also be conditioned by its opposition to a psychological subgenre of genetic interpretation, which I shall baptize "the physiognomic" because it organizes a variable mix of the data constituted in other genres (the formalist, iconographic, and contextual) in the service of a venerable and familiar project: reading the face as the index of the mind.

Portraits tell stories: they are interpretations of their sitters, visual narratives for which we assume sitters and painters to be, in varying degrees, responsible. In that sense they are representations of both the sitter's and the painter's self-representation. In addition, since art history has been going on for a long time, they come to us framed within the interpretations, representations, and self-representations of art historians. The stories that constitute the physiognomic species are woven of four different strands of commentary:

1. The sitter's social, political, and/or professional status, and his or her character, personality, "inner being," moral quality, and state of mind (mood and emotion, *gli affetti*);
2. The painter's characterization and the means by which he produces it;
3. The sitter's pose and appearance as the medium of characterization;
4. The archival data that provide the information used to confirm or fill out interpretations of 1, 2, and 3—historical information (or speculation) about the lives, behavior, and practices of sitters and painters.

Abbreviating these to (1) character, (2) painter, (3) image, and (4) archive, we can identify the physiognomic narrative as an ekphrastic practice based on the claim that character can be inferred from image. This claim, which presupposes the possibility that formal and physiognomic indicators may be correlated to produce a determinate interpretation of character, thinly disguises the extent to which the art historian's ekphrasis is influenced and indeed overdetermined by the archive.

Consider, for example, the following comments on Rembrandt's painting of Jan Six:

> The shrewd, worldly-wise look in his eye—he was thirty-six at the time—makes him seem much older than his years. His attitude is unaffected, as free and natural as possible. He has just come in from the street and, entering his friend's studio, is taking off his gloves and cape. Thus Rembrandt observed him, and thus revealed his innermost being.[3]

> [The portrait is an epitome of] Rembrandt's ideals—dignified masculinity, a certain quality of cool correctness mingled with an irrepressible warmth. Rembrandt endowed the living subject of his art with traits of an active and contemplative life, for in reality Jan Six was both a successful poet and a politician. . . . The automatic gesture of putting on a glove prefaces his going out into the streets. . . . The actual public face has not as yet been "put on" or arranged, but the subject's features are relaxed in a momentary unawareness of others as his mind is absorbed in gentle reverie.[4]

These and many other accounts of the portrait are organized around the information that Six was a businessman and politician on the one hand and a poet on the other, and epithets describing him are drawn from the conventional stock of qualities attributed to these types of the "active and contemplative life."[5] Six's character is thus produced by treating the image as an index of the archive. This procedure is identical with that based on the physiognomic formula, the face or body is the index of the

mind or soul, but here the face or body is replaced by the image, the mind or soul by the archive, and the divine or natural or social source by the painter.

The example of Rembrandt throws a special light on the physiognomic story because, even more than Titian, he is praised and damned for portraits that are hard to read. As Gary Schwartz uncharitably puts it in a comment on Rembrandt's anonymous half-lengths of the 1650s and 1660s, they "combine the attractions of inscrutability and unassailable artistic reputation," providing "the viewer with a flatteringly fuzzy mirror for his own most profound reflections on the meaning of life."[6] But such criticism is motivated by a commitment to norms of scrutability, a belief that the painter can and should make the sitter's face an index of his or her mind. "Thus Rembrandt observed him, and thus revealed his innermost being." Benesch's statement seems based on a chain of presuppositions:—first, that such an entity exists; second, that it can be known; third, that it can be revealed; and fourth, that Benesch knows it and can recognize it when Rembrandt reveals it. I say it seems to be based on these presuppositions because I have isolated the grammatical sense of the statement from its rhetorical force. The writer is obviously less interested in Six's character than in Rembrandt's accomplishment. Explicitly, the aim of art-historical physiognomy is to draw the character out of the image. Implicitly, however, physiognomic art history seems often to come into conflict with, if not to serve, the aim of converting the image into an allegory of the archive or of the painter.

Emphasis on the painter combined with the notion that the artist's achievement consists in revealing character strongly suggests that the sitter is construed as the passive site of revelation, perhaps unaware that the painter is extracting his true nature from his appearance. The portrait is an effect of the painter's interpretation of the soul, which is, in turn, an effect of the commentator's interpretation of formal and archival evidence. This makes the portrait an epitome of the sitter's character as it was generally manifested in his life reflected in the archive—an epitome of the being, the substance, inferred from what has been recorded about his or her activity, status, behavior, and so on. The physiognomic construal thus allows the sitter limited agency in constructing the particular self-representation that provides the basis of inference. The effect of reading the image as an allegory of the archive or the painter is a commentary that focuses on the kinds of people sitters are—that is, the kinds

they *were*—in the lives they lived apart from those rare, special, and re-
stricted moments during which they sat for their portraits. In the discus-
sion that follows I shall reverse the emphasis of the physiognomic story
and concentrate on the portrait as an index—an effect and representa-
tion—solely of the sitter's and painter's performance in the act of por-
trayal. In this shift of attention, the act becomes both the referent of the
image and its cause.

It will soon become clear, however, that my critique of the rhetoric of
physiognomic interpretation is a boomerang that circles back and slices
through my own ekphrases, for they rely on the same rhetoric and resort
to the same conjectural strategy of representation. I may not read the
painted face as an index of the sitter's mind, but since I do read it as an in-
dex of what sitter and painter "have in mind," an expression of their de-
signs on the observer, I can hardly avoid appealing to the very conventions
of inference to which I object. Nevertheless, the difference is important
in two respects. First, my stories focus on the representation of the act of
portrayal and thus depend less on the archive and more on the image.
Second, the stories are based on a theoretical stipulation that severely de-
limits the mode of representation: the act of portrayal represented by the
image is a fiction; it needn't have occurred in that manner; the portrait
only *pretends* to represent the manner in which it was produced. This is
implied in the statement that I read the image as an index of what sitter
and painter "*have* in mind" rather than what they "*had* in mind." The rea-
sons for this stipulation are complicated and will be discussed below.

Most of the standard stories art historians tell about early modern por-
traiture trace its emergence from the family archive, which includes such
commemorative icons as the death mask.[7] The death mask as image of
origin: both the profound insight of the standard story and its blindness
may be grasped by framing this image in a passage from Roland Barthes's
Camera Lucida:

> The portrait-photograph is a closed field of forces. Four image reper-
> toires intersect here, oppose and distort each other. In front of the lens,
> I am at the same time: the one I think I am, the one I want others to
> think I am, the one the photographer thinks I am, and the one he makes
> use of to exhibit his art. In other words, a strange action: I do not stop
> imitating myself, and because of this, each time I am (or let myself be)
> photographed, I invariably suffer from a sensation of inauthenticity,

sometimes of imposture. . . . In terms of image-repertoire, the Photograph . . . represents that very subtle moment when, to tell the truth, I am neither subject nor object but a subject who feels he is becoming an object: I then experience a micro-version of death . . . : I am truly becoming a specter.[8]

I imagine such a spectral, deathlike process of objectification as both the starting point and the continuing baseline of early modern portraiture, the baseline of a history that plays out a reversal of Barthes's schema. In this reversal, painters and sitters produce effects of subjectivity by diverging from and alluding to an initial set of conventions for objectifying subjects, conventions that are "mortiferous," as Barthes puts it, death-bearing, because they turn sitters into ikons. (Since I have decided to follow Peirce and use "icon" to denote a particular type of sign, I shall use "ikon" to denote objects endowed with religious or sacralizing meaning.) With the painter's help, sitters become living subjects by seeming either to resist objectivity or to fail to achieve it.

I begin this journey toward Barthes's insight *in medias res* with a scatter of quotations that suggest the pervasive and uncritical commitment to physiognomic interpretation among mainstream art historians. Figure 1 is an early work by Mantegna, dated around 1459 or 1460, and the sitter is Cardinal Ludovico Trevisan, also known as Mezzarota Scarampo.[9] Figure 2 is a bust of Nero. Pope-Hennessey follows Vasari in being a little critical of Mantegna's enthusiasm for a painting style "based on the Roman bust" and for his ability to turn men to stone. The cardinal, he tells us, was "a warrior prelate who . . . owned a famous collection of antiques," and he finds that this portrait, with its petrific and Roman air, "is commemorative" rather than analytical "and is designed to isolate Mezzarota's historic personality."[10] More recently, Ronald Lightbown has written that with its evocation "of a Roman bust" and "its ironical compression of the mouth," the painting "does full justice to the Cardinal's stern and resolute character." He adds that "although the portrait is objective, in that there is no attempt to render mood or expression . . . Mantegna's image does more than record the Cardinal's features, for it suggests the strength of will, the severe habit of command, the disillusioned experience of affairs that had stamped the countenance of this exceptional sitter."[11]

Now just how does he know all that? Obviously, he could have extracted some of his information from the archive. He also could have

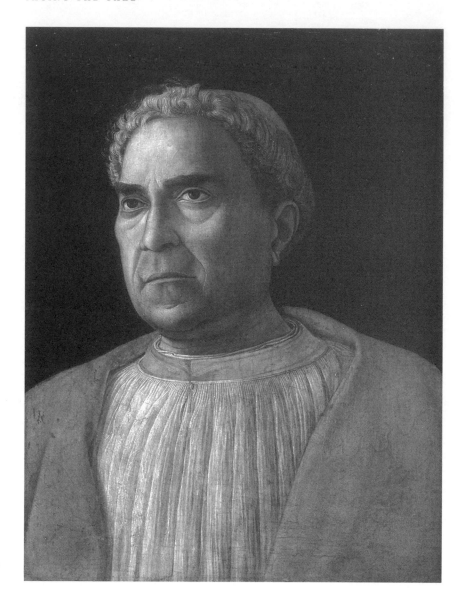

FIGURE 1

Andrea Mantegna,
*Cardinal Ludovico
Trevisan*, ca. 1469.
Tempera on wood.
Staatliche Museen,
Preussischer Kulturbesitz,
Gemäldegalerie, Berlin.

found, as another scholar did, that Cardinal Trevisan "began as a simple
physician and rose to be" the pope's chamberlain thanks in part to his
"unscrupulous managerial skills."[12] Is the face painted by Mantegna the
index of this quality of mind as well as the others? If we had the same
face and different archival data could we adjust our reading of the face to
accommodate a different physiognomic story? To shift from Mantegna to
Bellini, on what grounds does one writer claim that the portrait of Doge
Loredan is "a convincing presentation of his character" and another that

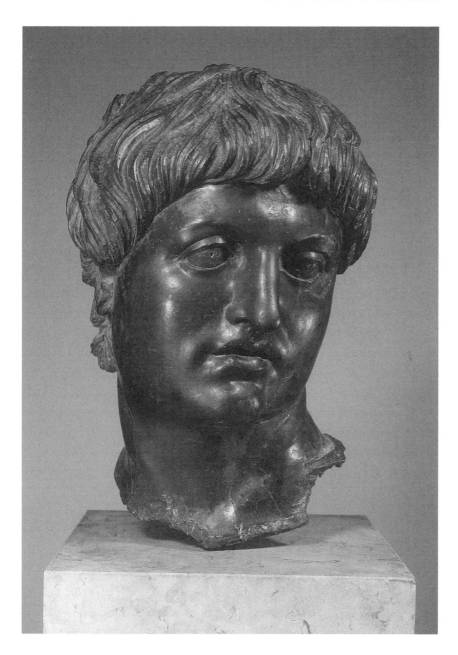

FIGURE 2

Artist unknown, *Bust of Nero*, Roman, first century. Musée du Louvre, Paris.

the portrait of Jorg Fugger is a "penetrating depiction of the sitter's physiognomy"?[13] Art historians openhandedly dispense judgments of this sort, but they also exercise commendable prudence in their refusal to elaborate, or share with us, the inside knowledge that enables them to read the face as an index of the mind. There must be a reason why good art historians,

who clearly know what they are doing, continue to permit themselves to read faces as indices of mind, and I want to suggest what it may be by glancing at the practice of another historian of Venetian painting.

One of the many valuable features of Norbert Huse's excellent contribution to his and Wolfgang Wolters's *The Art of Renaissance Venice* is the attention he pays to generational shifts of style and taste in portraiture. Huse comments, for example, on the "closed, uniform way in which up to about 1500 the ruling class had presented a calm, serious front, thanks to an obligatory portrait type and an obligatory bearing" (see fig. 16 below). He goes on to argue that the portraits of the early sixteenth century reveal "the younger men's dissatisfaction with the way their fathers had themselves painted." "Possibly," he speculates, "as a consequence of the grave political and moral crisis that Venice and its ruling class passed through at the beginning of the century, the portraits from these years reveal a far more restless group of people than those of the preceding generation. We meet with nervousness, melancholy, and resignation [see pl. 5]. . . . Entirely new provinces of the psyche came into view for painting. People like these had certainly existed before, but now, for the first time, they found artists who had an eye for them." Huse connects this change with an increase in formal reflexiveness: the new portraits "give away more about how they were produced. The attentive observer . . . is kept aware of the situation that one person is sitting for another, presenting himself or herself to be painted." New effects of lighting, composition, and posing "remind observers that the portrait in front of them is the result of the artistic interpretation of one person by another, and so does not show the sitter 'objectively,' not 'as he or she really is,' but as Palma, Giorgione, or Lotto saw the sitter."[14]

These statements are inconsistent. Why should credit for the new effects be assigned exclusively to the painter if it is true that the painter shows sitters not only as *he* saw them but also as *they* wanted to be seen? And, as he suggests, they wanted to be seen *being seen*, that is, aware of posing for painters and observers. So we should add, as Palma, Giorgione, Lotto, *and the sitter* saw the sitter. How does the critic know the new portraits didn't show the sitter "objectively"—or, to back up a step, how is he using that word? There is a clue in his comment on portraits of the preceding generation by Bellini: the painter "normally showed his people slightly from below, from a perspective of respect. His investigation was not of the surface of the faces, but of the person's essential nature"—this

presumably amounts to saying that Bellini represented each sitter "'objec-
tively' . . . 'as he or she really is.'" But how does Huse know what the sit-
ter's—any sitter's—essential nature or objective reality is? As I read his
analysis, the new fashion in representing "states of mind" tells us less
about the effects on individual psyches of "grave political and moral cri-
sis" than about the effects of a new fashion in representing the act of por-
trayal—the act of posing and painting. Signs of "nervousness, melan-
choly, and resignation" may be intended to represent reactions to more
direct scopic encounter; they may flag the decision to dramatize "new
provinces of the psyche," innovations in posing jointly arrived at by sitter
and painter; they needn't be more than that. The aim of such representa-
tion may be insight not into the psychology of the sitter but into the psy-
chology of self-representation and scopic encounter; in a word, posing.

 Distinguishing the study of portraiture as a genre from studies of por-
traits, Richard Brilliant criticizes the tendency of the latter to be

> preoccupied with the naming of subjects and the identification of
> portrait artists and the devices they use. . . . The agenda of such studies
> reflects . . . the traditional emphasis on the person portrayed as the
> center of empathetic and aesthetic response, although the latter is often
> compromised by the rapidity of the transfer of interest from the image
> to the person. Alternatively, attention may be directed to the role of the
> portrait artist in creating a work shaped by his talent and craft.[15]

I have been suggesting that "the rapidity of transfer" may be a function of
the alternative, that is, the art historians' focus on the artist. This may ex-
plain why they often don't hesitate to guide us through the likenesses of
long-dead sitters and into their minds and souls, and why, in doing so,
they use an undigested mix of archival evidence, the intuitions of lay psy-
chology, and the record of past beliefs, like physiognomy, that often strike
even them—the art historians themselves—as quaint, obsolete, bizarre, or
merely tedious, significant mainly as research opportunities. Obviously
they aren't ingenuously or uncritically indulging in metaphysical fantasies
but making some kind of descriptive sense, and their own physiognomic
interpretations, however laconic or impressionistic, belong to a code in
which the members of the profession exchange information about matters
other than the sitters' characters. Those other matters are obviously art-
historical matters. The art historians are more interested in the achieve-
ments of painters than in the characters of sitters, and if the conventions

that govern their psychological descriptions produce facile accounts of the face as an index of the mind, it is probably because the primary rhetorical purpose of the conventions is to praise the painter, not characterize the sitter. Sharing insights into *who the sitter was* is ancillary to demonstrating *what the painter was trying to do*.[16] Portrait painters themselves are likely to agree, at least according to the opinion reported by Kenneth Clark and cited in the epigraph to Part 2 above: "[they] sometimes tell me that when confronted with a sitter they do not think of his character at all, but look at his face like a still-life which never keeps quite still enough, and concentrate on the difficulty of realizing its structure."[17] Perhaps, then, they share Keats's conflicted longing for the stillness of "Cold Pastoral," the narcosis of "easeful Death," or of a death not so easeful, an effect of *nature morte* like that produced by Barthes's photograph: "One eminent portrait-painter said he wished his sitters could be hung upside-down by the leg, like a dead hare."[18]

Let's grant that, in the final analysis, we confront the painter's interpretation, along with subsequent interpretations of the painter's interpretation; a picture of Paul III is a Titian, a picture of Jan Six a Rembrandt. But since this tendency in art-historical practice correlates with a tendency to fire off casual, irresponsible, and undemonstrable assertions about the inner states of sitters, there must be something wrong with the framework of interpretive assumptions that supports the practice. One of the flaws of physiognomic ekphrasis in art history is that, in treating the image as an allegory of the archive, it bypasses the act of posing, which, in the prephotographic era, must always be an intentional act. The intention to be represented representing oneself breaks or at least loosens the linkage that makes the face the index of the mind in the kind of prediscursive or natural relation of effect to cause premised by such "sciences" as physiognomy, pathognomy, metoposcopy, astrology, and humoral psychology. My purpose in Part 2 is to unpack an alternative approach to portraiture and to show how it works. The approach consists in redirecting attention from the style and performance of the painter to the style and performance of the sitter as sitter—that is, not as a character in some historical fiction naturalized by the art historian, but only as the subject of and participant in a particular act of portrayal. This asks for a theory of posing that will recuperate the sitter's contribution—along with the activity that produced the portrait—as part of the content represented by the portrait; a theory of posing focused on acts and fictions of self-representation performed by

sitters and depicted by painters. Before getting to the theory itself, how-
ever, I want to explore conventions and structures of self-representation in
three contexts. In Chapter 5 I discuss them in relation to physiognomic as-
sumptions and the norms of mimetic idealism. Then in Chapters 6 and 7
I try to situate them in a more problematic framework formed by the in-
tersection of psychoanalysis with Norbert Elias's notable attempt to his-
toricize representations of interiority.

[I]f one wishes to deceive a man, what one presents to him is the painting of a veil, that is to say, something that incites him to ask what is behind it.[1]

PHYSIOGNOMY, MIMETIC IDEALISM, AND SOCIAL CHANGE

From the fourteenth century on, in early modern Europe there was an explosion of technical innovations in the arts and sciences. New representational techniques and forms proliferated in the visual arts, in writing and printing, in mercantile practices, in mathematics, cartography, and cosmology, in anatomy and medicine, in the regulation of conduct, in theater and public spectacle, in parliamentary institutions, and in the control of space and its occupants through the political transformation of architecture into civic planning. Much of this activity is based in graphic inventions and improvements that affect signifying practices in all media. The resulting innovations in notational and symbol systems literally underwrite other cultural, social, economic, and political changes. They produce growing awareness that by altering the materials, methods, and modes of representation, one can alter whatever it is one's representation stands for, signifies, refers to, or imitates. This includes one's representations of oneself as well as of others and of the world.

The effect of the graphic revolution on the arts of self-representation is especially noteworthy: a gradual shift of emphasis occurs from a naturalizing toward a constructivist view of the semiotic relation between body and soul, face and mind, outside and inside, visible and invisible; a shift, that is, from the view that the relation preexists discourse, science, and knowledge, toward a view that it is partly or wholly created by discourse, art, and interpretation. If the shift accompanied a new appreciation of the possibilities of the forms and media of (self)representation, that sense was countered by new sources of anxiety and by the growing skepticism in-

scribed, formalized, in the work and influence of Descartes. The Cartesian connection is made clear, even parodied, in the Heideggerian rewriting of the cogito ("I think therefore I am") as "I represent myself therefore I am."

The dramatic improvement in representational techniques that initially took place in Italy from the early fifteenth century on gave promise of what writers of the time called "an artificial imitation of nature" capable of somehow delivering the life of the soul in the likeness of the body. But if the mimetic skills that produced good likenesses were prized, so also was the ability to idealize the likenesses.[2] Visual artists may have had a field day showing what bones and muscles were doing under skin and clothes, and graphically depicting every wrinkle, whisker, and wen. Patrons obviously appreciated these skills, but apart from a natural inclination to demand wenless portraits, they were interested in displaying other things under the skin besides bones and muscles: greatness of soul, for example, distinction of mind, force of personality, and purity of blood; the warrior's or courtier's high spirit, the cleric's deep spirituality, the merchant's prudence, the aristocrat's inborn grace, the ruler's godgiven majesty. They wanted not only accurate resemblances to store in the family archive but also, and more importantly, exemplary images—images that commemorate the individual as the model, the embodiment, of the status, values, norms, and authority of a particular class, lineage, institution, or profession. The mimetic interest was necessary but not sufficient, since its chief effect was to individualize the sitter, whereas what the patronage system required in addition was idealization. A "good" likeness was good in both senses; it was both accurate and exemplary.

Vasari beautifully expresses the exemplary function in his account of the Bellini. He notes (in Plinian fashion) that the houses of Venetian gentlemen are full of portraits of

> fathers and grandfathers, up to the fourth generation, and in some of the more noble [families] they go still farther back—a fashion which has ever been truly worthy of the greatest praise, and existed even among the ancients. Who does not feel infinite pleasure and contentment, to say nothing of the honor and adornment they confer, at seeing the images of his ancestors, particularly if they have been famous and illustrious for their part in governing their republics, for noble deeds performed in peace or war, or for learning, or any other notable and distinguished talent? And to what other end . . . did the ancients set up images of

their great men in public places, with honorable inscriptions, than to kindle in the minds of their successors a love of excellence and of glory?[3]

Vasari also has a lot to say about mimetic skills and values (anatomy, modeling, perspective, the ability to emulate nature and make figures seem alive) but in the melioristic schema that imposes at least superficial order on the narrative of the *Lives*, the mimetic accomplishments that distinguish the second *età* of the modern *rinascita* are sublated by the idealizing grazia and *maniera* of the third. Schematic emphasis on the progress of art isn't allowed to conceal the conflict of norms that drives it. Viewed from the standpoint of the third period, the fate of the mimetic precursors is like that of John the Baptist: they grow smaller as their successors grow larger. Vasari thus mythologizes—but doesn't falsify—the structure of values that emerges in the practice and discourse of early modern visual art and is discernible in its portraiture. Summers's compact description of this structure, cited in Chapter 2 above, is worth repeating here:

> Renaissance images were presumed to make us see more than we are shown and, more specifically, to make us see something higher than we are shown. We see a higher, spiritual inwardness in external forms. . . . The apparent sitter in a Renaissance portrait was thus an external appearance showing an inward truth, and so, it might be said, were Renaissance works of art in general.[4]

Mimetic idealism has its roots in the theory and practice of Vasari and his predecessors, and versions of it are still going strong today. I suspect, in fact, that the comments of the art historians I cited in the preceding chapter are informed by the ideology and illustrate it. Even if they don't believe it, they act as if it were the case, and they continually deliver themselves of insights into the inward truth of external forms.

The story of mimetic idealism is shaped by the conflicts and compromises of the two stylistic impulses that are its protagonists: on the one hand, the new mimetic power generated by the relatively rapid development of graphic technology and the science of art from the early fifteenth century on; on the other hand, the pressure toward exemplary idealization imposed by the motives of those who commission paintings.[5] The question that needs to be asked about this ideology and about the portraits that reproduce it is: Just what sort of inward truth is revealed? Is it some generalized human truth, or the truth of an elite class, or a moral truth,

or a political truth, or the truth of an individual subject, or the truth of the artist's vision? Did Renaissance sitters really hold—and do their portraits represent—the assumptions attributed to them by Pope-Hennessey, that "appearance is inseparable from personality," that fidelity to nature is more than skin deep, and that there is a consonance between "what can be perceived and what lies concealed within"?[6]

At this point I think it is worth pausing to ask whether and why, confronted from the start by the highly evolved skills of *homo hypocriticus*—and by the widely disseminated (if variously interpreted) opinion that life is a play, the world a stage, and all the men and women merely maskers—people accepted the opinion of the experts that the face is a totally reliable and authoritative index of the mind, or that the body is necessarily an index of the soul. Xenophon's Socrates claimed that states of mind, though invisible, can be represented to the eye. The durability of this opinion was confirmed when, some time later, Alberti wrote that "the painting will move the soul of the beholder when each man painted there clearly shows the movement of his own soul."

The basic formula of physiognomy, "the face is the index of the mind," confers on the word "index" its active, Peircian sense of a dynamic—and, in this case, causal—relation. (The face is the index of the mind as smoke is an index of fire.) As a general theory and discourse, physiognomy supplies an intellectual rationale for social formations legitimized by and dependent on the ascriptive categories—blood, lineage, gender, seniority—that naturalize customary rules and roles and thus tend to perpetuate their inertial givenness. Its contribution to this process owes in part to its mystified status: it is a discourse that passes as prediscursive and thus conveys "effects of truth."[7]

Physiognomy and related ethnosciences were long imbricated in a network of discourses bound together by a common semantics and epistemology, a network compendiously profiled in Kemp's review of the tradition available to Leonardo da Vinci:

> The causes of facial effects were embraced by the medieval science of
> physiognomy, a science which had progressed from a minor branch of
> the Greek legacy—minor but with a crucially Aristotelian element in
> its pedigree—to become a subject worthy of serious philosophical
> attention. Medieval physiognomic theory was fully integrated with
> the study of the soul in procreation and the four temperaments, with
> important implications for medicine and morals, to say nothing of its

associations with astrological mysticism. Physiognomy was regarded as "a science of nature; by its application anyone sufficiently well versed can ascertain the characteristics of the nature of animals and men." So wrote Michael Scot in his *Liber phisionomiae*, a copy of which Leonardo owned. By reading the "external signs" of human and animal features, the initiates of this science possessed the power to see the "inner truths" of character, as demonstrated in Roger Bacon's *Secretum secretorum*, a treatise apocryphally based upon advice given by Aristotle to Alexander.[8]

Kemp's rhetoric registers the reliance of this network on the strategies of genealogical bricolage that lend effects of authority, science, and knowledge to a fabric of interpretive fantasies uncertainly stitched together. We recognize the logocentrism and specular or mimetic redundancy of the founding premise: given a dynasty of books inscribed with and preserving the Inside Dope uttered by a dynasty of august Inside Dopesters, the books are the faces, the external signs, that mediate our access to the souls and minds and inner truths of the great teachers they index.

The premise is of course familiar because it has been exhaustively dissected and deconstructed, first by Nietzsche, later by Heidegger, and more recently by critics whose projects may in other respects be incompatible, for example, Rorty's critique of philosophy as the mirror of nature and Derrida's grammatology. The physiognomic credo, "the face is the index of the mind," is close kin to the logocentric credo, "the voice is the index of the mind." They share the traditional semantic structure Derrida and others ascribe to logocentrism. Whether one figures voice/mind and face/ mind relations in terms of the transparency of speech and face or the expressibility and picturability of mind, what is involved is a sign/referent relation that yokes together indexical and iconic functions in a tensional equilibrium: the two members are dynamically connected by a difference that makes the referent superior to the sign—the referent is the cause and the sign the effect—but the difference is partially damped down by the assumption or ascription of a mimetic bond between the signifying effect and its referent. This bond enables the effect to present itself or be interpreted as an image of its cause enables the effect to *represent* and not merely signify its referent. The indexical icon is a fundamental instrument of Judaeo-Christian discourses that center on the creator/creation bond. The alterity of the indexical function is discursively stabilized by establishing the effect as the sign of the transcendence of the creative principle—the sign, that is, of its trans- or pre-discursive status—but the tran-

scendence is contained within discourse by the iconic postulates of resemblance. In the move from *signum dei* to *imago dei*, the divine referent of *signum* and *imago* becomes not only the cause of an effect but also the original of an image, and the relation shifts away from pure otherness toward a strategically indeterminate degree of sameness; to say that the referent *becomes* the cause and original is paralogistically to say that it is installed or inscribed as the effect of its effect.

The discourses that validate the truth claims of this logocentric semantics derive their authority (paradoxically if understandably) in part from being written, stored, and transmitted, and in part from being written in the learned language used by writers who spoke vernaculars but thought about and signified the truth in Latin, a Latin made more magisterial both by its official character and by its assimilation of weighty Greek terms. Our suffixes *-gnomy* and *-logy* reflect and convey this positional eminence. For centuries physiognomy was interconnected with other forms of *gnosis* and *logos* in a loose and shifting network—or patchwork, or bricolage—of mutually supporting discourses of truth, traditions of lore, and customary practices, which included physiology, medicine, biology, psychology, astrology, and cosmology. Pythagoras, Plato (via the *Timaeus* fragment), Hippocrates, Aristotle, and Galen are among the major patronyms ritually celebrated along with God in the genealogies by which the network authorized itself. But they were celebrated in often-tattered Latin robes.

The questionable origins of many discourses in fiction, myth, hypothesis, conjecture, faulty induction, and overemphasis on syllogistic reasoning were muffled by the naturalizing effects of mechanisms of transmission that were as prestigious as they were unreliable. Yet these questionable origins were not only muffled, ignored, and forgotten, they were also preserved, by the accidents and mistakes (scribal errors, fragmented texts, glossarial fantasies, etc.) attendant on the interpretive power vested in pretypographic practices of writing and reading. Those who were

> largely responsible for keeping alive a knowledge of the liberal arts and classical philosophy and science in the early Middle Ages . . . follow[ed] the traditional practice of a long line of compilers and commentators who had long since lost contact with the classical originals. In many cases the late encyclopedists were removed from classical Latin authors by five or six, and from Greek authors such as Plato and Aristotle, by

ten intermediate sources. . . . Yet they give the impression that they are handling the original works. . . . Notwithstanding their shortcomings, these rudimentary compendia were to hold a central position in the intellectual development of the West for nearly a millennium.[9]

The difference between the state of their source texts and the state of ours today makes it easy for us to see how "the revival of classical learning" inaugurated by the debarkation in Italy of Byzantine scholars and Greek texts could also revive the questionability of the origins of the medieval discourse network along with its legitimizing texture of -gnomic and -logical truth effects.

However, disenchantment in the upper levels of culture presupposes some prior state of enchantment. With respect to the discourse of physiognomy, this poses a double problem of credibility, ours as outside observers, and that of all the natives we observe. Given a historical record in which, as I noted above, the highly evolved skills of *homo hypocriticus* have been documented from the beginning, can we possibly believe that people at any level and at any time were such fools as to accept the opinion of the experts that the face is a totally reliable index of the mind? I have no idea whether ordinary folks spent several eons stupidly believing this sort of thing; no idea whether, if they could read or be read to, they paid any attention to highbrows like Plato, Aristotle, Galen, and other textual luminaries, or to the learned clerks and doctors who cited their authority. The cachet of textual authority has to be supplemented at the level of practice and performative repetition. The credo is brought into play, for example, whenever people get sick and doctors cast their horoscopes, but I can easily imagine that patients were as skeptical of the credo as they were of the rhetoric of the self-styled experts whose diagnoses and prognoses were based on it.

Nevertheless, even if nobody knew anything about the credo, everyone was affected by it. For example, physiognomic assumptions based on some version of the outside/inside or body/soul linkage have always had an important ideological function in helping to naturalize the inequities of gender, rank or class, and race or ethnicity. So it seems likely that regardless of what people thought or believed, the credo was operative, was influential, at the level of the discourse networks that continuously transform exploitation into hierarchy. The standing cultural order that the male is both different from and superior to the female gets support from the standing order that their bodily differences index inalterable mental

and psychic differences. This example suggests that regardless of what people thought or believed, the physiognomic credo maintains its ideological force not only because it has textual authority but also because it belongs to the uncontested background of daily life. To be taken for granted cloaks the credo in prediscursivity and, as I noted, helps mystify effects of fantasy as effects of truth.

Probably, then, the credo assumes another kind of importance when it is forced from the background to the foreground by developments that convert it from an ideological *de*posit to a cultural posit, an ideal—and a threatened ideal. By "developments," I mean the convergence of two sorts of changes: first, the changes in technologies of representation I referred to above as a graphic revolution; second, the political and economic changes that were destabilizing established social arrangements and threatening traditional discourses and iconographies of status, rank, gender, and group membership in general. These changes interfere with more traditional patterns of cultural transmission in which forms of interiority are inscribed on the body by customary practices while being ascribed to natural forces. They help disengage the construction/representation of mind or soul from the prediscursive dominance of social reproduction and begin to resuscitate it within discursive fields of pedagogy, art, and conduct literature, where both the human capacity and the motivation for inscribing the soul on the body are more precariously exposed.

The ancient association of physiognomy with medicine meant that analysis of the signifying activity of the body was traditionally a sort of symptomatology focused on the involuntary emission of soul signs—signs of the soul's medical or ethical or humoral condition. By contrast, as in the concept of sprezzatura, the emphasis in courtesy books is not only on controlled behavior but also on the voluntary performance of "involuntary" soul signs:

> Since Antiquity, it had been accepted that physical movement revealed the inner self. In medical and physiological writings from Aristotle onwards, movement is seen as an index of the emotions; it is also perceived as a guide to an individual's character and moral or ethical state, since these are defined in part in terms of control over the irrational passions. The notion that deportment was an index of character, and thus also of social status, was not new to the Renaissance. What was new was the view of deportment as something to be cultivated rather than simply observed, and the location of movement at the center of discussions of ideal social

behavior. In the sixteenth century, for both courtiers and members of the socially aspiring bourgeoisie, physical movement became a continuous index of the social and ethical self, and subject to intense scrutiny.[10]

Physical expression of the mental and spiritual is one of Alberti's main preoccupations in his treatise on painting. . . . It is equally a preoccupation of Guglielmo Ebreo's treatise on dancing. . . . It is much reflected in fifteenth-century judgements of people, their gravity or levity, aggressiveness or amiability.[11]

Fermor's account of the extension of controlled movement from figures of dance and "figural style" in painting to gendered deportment in general compactly illustrates the genesis in balletic, dramatic, and graphic fictions of what would be proposed as idealized performances of "natural" behavior—expressions, that is, of the "social and ethical [nature of the] self."[12]

When a rival credo challenges the old physiognomic formula, the face is the index of the mind, the latter is compelled to abandon its comfortable hiding place of power within the tacit background of customary practices, to come forward and assert itself, and to defend its virtue. The face *should* be the index of the mind, the natural expression of the subject's inner nature, but in early modern Europe the interpenetration of technical with social change imposes a new and unsettling semiotic task: the face is now required to be the index of the mind's ability to make the face the index of the mind. This may be called the credo of physiognomic skepticism, or the credo of sprezzatura. The representation of interiority can no longer be left or delegated to nature. It gets promoted as a skill to be cultivated, a technique of performance essential to successful participation in public life: something princes, courtiers, statesmen, lawyers, merchants, prelates, doctors, and even artists and poets have to learn—not to mention their daughters, wives, and mothers.

Whatever is "understood as 'within' the body," Judith Butler writes, "is signified through its inscription *on* the body." This is a social fabrication, and, Butler adds, since the body is a signifier of naturalness, the fabrication "perpetually renounces itself as such."[13] Psychogenesis and socio genesis, to use Norbert Elias's formula, are two sides of the same transhistorical process. Yet there are conditions under which the *appearance* of fabrication, of artifice, is harder to renounce, conditions under which self-representation becomes more explicitly presentational or performative, conditions congenial to the emergence of physiognomic skepticism. Such conditions materialized in early modern Europe when the task of in-

scribing the soul on the body began to shift more massively from tradi-
tional socializing processes toward new technologies of representation and
self-representation.

Norbert Elias tried to document this shift almost six decades ago when
he focalized Erasmus's treatise on pedagogy, *De civilitate morum puerilium*
(1530), as the turning point of his history of manners. He connects more
attentive observation of behavior and more deliberate modes of self-
fashioning with the humanist emphasis on writing, reading, and the revi-
sion of antique lore in terms of contemporary experience: "reading has
sharpened seeing, and seeing has enriched reading and writing."[14] The rad-
ical implications of this emphasis have more recently been unfolded in Lisa
Jardine's study of the means by which the historical Erasmus, a politically
marginalized "maverick innovator," invented and marketed "that much
idealized figure, Erasmus," through judicious "textual self-presentation" and
entrepeneurial deployment of the resources of the print medium.[15] Jar-
dine's portrait of his "self-portrait in pen and ink" allows us to glimpse, as
in a funhouse mirror, what lies behind such Erasmian pearls of wisdom as
"external decorum of the body proceeds from a well-ordered mind" and
"the well-ordered mind of a boy . . . is most strongly manifested in the
face."[16]

If these pearls paraphrase the physiognomic formula, they do so in a
pedagogical context that shifts the emphasis from ascription and custom-
ary socialization to prescription and formal instruction. Consider, for ex-
ample, the burden placed on the poor young performer's ocular manage-
ment skills by the prescriptive stage directions that immediately follow
the physiognomic injunction:

> [T]he eyes should be calm, respectful, and steady: not grim, which is a
> mark of truculence; not shameless, the hallmark of insolence; not darting
> and rolling, a feature of insanity; nor furtive, like those of suspects and
> plotters of treachery; nor gaping like those of idiots; nor should the eyes
> and eyelids be constantly blinking, a mark of the fickle; . . . not too
> narrowed, a sign of bad temper; nor bold and inquisitive, which indicates
> impertinence; but such as reflects a mind composed, respectful, and
> friendly. For it is no chance saying of the ancient sages that the seat of
> the soul is in the eyes. (274)

But clearly the form the performer gives the seat determines the form he
gives the soul. The negative injunctions that unfold a Theophrastian

nosology, a gallery of unsavory personifications, have a very modest purpose. They carefully beg the question of whether the tutee shares those characteristics and the feelings attached to them. Though they help him picture and remember all the dispositions he should studiously avoid, all the things he shouldn't be, they warn him only not to show them.[17] Strategic repression is the message conveyed by the subtext of the tutor's instructions. The student is enjoined to use his eyes not to see but to give himself to be seen—or to avoid being seen. As Barbara Correll notes in quoting this passage, the emphasis on "internalizing discipline to incorporate body consciousness" betrays "a reflexive element not seen in chivalric culture," an element she associates with the representations of "instability and uncertainty" and of "a problematic bourgeois self-image" that emerge during the "transition from medieval to civil manners."[18] In her stimulating study of the sixteenth-century *Grobianus*, Friedrich Dedekind's "nightmarish inversion" of the *Cortegiano* and other conduct books, Correll demonstrates that "something of the 'grobian' is never really absent from the ideal with which . . . [they] were so preoccupied. For what we could call the grobian within—the recognition that good behavior is predicated on militantly remembering a worst-case scenario—is also the lesson they teach."[19] This perception is directly applicable to the Erasmian passage cited above: "the successfully socialized subject of [Erasmian] civility is the man or boy who is disciplined to keep the worst-case scenario ever in mind" (87).

Erasmus's optical precepts are only stages on the way to a more performative destination. Later in the treatise, the physiognomic formula is again echoed and further modified: "clothing is in a way the body's body, and from this too one may infer the state of a man's character,"[20] a claim that puts a decidedly nonphysiognomical spin on both the mode of inference and its object, and that amounts to a more intensified demand for image management. Since, as Erasmus describes it, everybody seems to be venturing inferences all the time, one has to be careful not only to avoid sartorial solecisms but also to conceal the effort with displays of *disinvoltura*: "A degree of negligence in dress suits young men provided it does not lapse into slovenliness"; "Let others admire you while you yourself appear unaware that you are well turned out" (279).

De civilitate features a fiction of pedagogy in which the teacher modestly claims as his "special task" instruction in "external decorum." This, he admits, may be "a very crude part of philosophy," but it is nevertheless

"conducive to winning good will and to commending . . . illustrious gifts of the intellect to the eyes of men" (273). The radical importance of such instrumental pedagogy emerges a few sentences later. Here is the passage followed by Correll's enlightening comment on it:

> Now everyone who cultivates the mind in liberal studies must be taken to be noble. Let others paint lions, eagles, bulls, and leopards on their escutcheons; those who can display "devices" of the intellect commensurate with their grasp of the liberal arts have a truer nobility. (274)

> The devices (strategies) Erasmus focuses on are techniques of the body, techniques that constitute the devices (signs) of "nobility" as acquired goodness. . . . Here Erasmus begins to replace the idea of noble birth with a new idea of acculturation: the accumulation of formal knowledge and social techniques of the body and of the labor necessary to acquire them, as a substitute for, even something to be regarded above, social station.[21]

Thus it is that in spite of the self-effacing claim to impart only "a very crude part of philosophy," Erasmian pedagogy challenges ascriptive norms and their basis in physiognomic discourse. This entitles him to assert later that if "one's parents" deserve, "next to God, the highest respect . . . [n]o less respect is owing to teachers who, in forming men's minds, are in a sense their intellectual parents."[22]

Although the express occasion of Erasmus's lesson in manners is to instruct "the most noble Henry of Burgundy," he is careful to state that since the nominal recipient, already accomplished, may find some of his teaching unnecessary, his purpose "is rather to encourage all boys to learn these rules more willingly" (273), and he concludes with the reminder that "[w]hatever benefit can be derived from all this, my dearest Henry, I wish to be imparted through you to the entire fellowship of boys" (289). With this device he underscores the fictiveness of direct address as well as that of the speaker—Erasmus thereby becomes "Erasmus"—and glances at the mere instrumentality of his noble addressee, whose function is to help the pedagogue become the intellectual father of all boys by his exploitation of print technology.

Elias recognizes the new power released by the marriage of pedagogy with printing: Erasmus "manifests the characteristic self-confidence of the intellectual . . . who is legitimized by books."[23] But in his commentary the impact of pedagogy on physiognomy is assumed rather than expressly

considered. Jacques Revel is more precise than Elias in specifying Erasmus's relation to the physiognomic tradition:

> Erasmus' book was a composite of disparate materials reworked over a period of centuries, all making the same point: that physical signs—gestures, mimicry, postures—express a person's inner state in an intelligible fashion, revealing the disposition of the soul. . . . By such signs even the most intimate secrets are revealed.
>
> Conversely, if the body reveals a man's innermost secrets, it should be possible to influence and redress the dispositions of the soul by regulating the visible outward signs. Hence a literature came into being whose purpose was to define what was legitimate and to proscribe what was improper or wicked. The inner man was viewed solely as an object to be manipulated, to be brought into conformity with a model based on the notion of a happy medium, a rejection of all excess.[24]

This distinction more sharply pinpoints Erasmus's seriously playful revision of the physiognomic formula. "The face is the index of the mind" begins to mutate into the formula of physiognomic skepticism paradigmatically (or even parodically) dramatized by Jardine's Erasmus: the face is the index of the mind's ability to make the face (appear to be) the index of the mind.

There is a certain risk attached to the fact that although this is the formula for masking, manipulation, and hypocrisy, Erasmus deploys it in the service of moral reform:

> Erasmian rules of *civilité* are universal because they are based on an ethical principle. *In every man, appearance is a sign of his being and behavior is a dependable indication of qualities of soul and mind* [my italics]. Good instincts, virtues, and intelligence have but one translation, which can be seen in bearing as in clothing, in behavior as in speech. Body positions, facial expressions, comportment . . . , and even clothing . . . are thus not simply regulated by the demands of a life governed by relations with others . . . ; they have a moral value that leads Erasmus to consider them from an anthropological, not a social, point of view.[25]

The italicized phrase appears to reproduce the physiognomic formula, but the context indicates that the phrase "appearance *is* a sign" has the weight of "appearance *should be* a sign." What is important, as the continuation of Chartier's commentary shows, is the emphasis on the need for formal pedagogy:

Although Erasmus's work marks a decisive moment in raising the threshold of modesty, in calling for controls on emotion, and in requiring the repression of impulses, it does not do so by referring to the lifestyle (actual or wished for) of a particular social group. It does all these things in order to teach morality to children. This turned *civilité* into an initial learning experience and Erasmus's treatises into textbooks for primary instruction—often for use in schools. (79)

The mention of schooling in this context—Chartier's topic is the impact of print on culture—glances at a fundamental aspect of the structural changes his work has so brilliantly illuminated: the emergence in early modern Europe of relatively specialized and varied venues of secular schooling as supplements or competitors to religious pedagogy and the more informal customary practices of domestic training.[26] Under the conditions of social change Elias and many others describe, the interlocking development of new writing and pedagogical technologies—new technologies of self-representation and self-understanding—contributes to a structural shift in the layering of public discourse, a shift that includes but extends beyond the effects on physiognomy mentioned above. It is a shift whose general form has been typified in an explanatory model elaborated by social historians and theorists who put into play variants of the basic distinction between ascribed and performed or achieved status/role relations. I have discussed this distinction, its possibilities, and its limitations at some length elsewhere and will only note here that sociologists use the terms "ascription," "ascriptive," and "ascribed"—terms that ironically, tellingly, imply an act of writing—to denote strategies, habits, and terminologies or sign systems by which constructed relations of gender, generation, status, and rank are naturalized, that is, defictionalized—*faux*-etymologically "unwritten" (a-scribed)—and thus legitimized.[27] So, to repeat examples I have listed above, blood, lineage, gender, and seniority are ascribed categories that naturalize customary rules and roles and thus tend to perpetuate their inertial givenness. They serve to redistribute and stabilize power in a system of differential sites of authority that represents exploitation as hierarchy. They support and in turn are supported by the lore sedimented into physiognomic discourse.

Improvising on the concept of ascription, I have coined the term *reascription* to designate the extension of the forms and terminology of primary socialization (in the family) into the domains of what we today construct and recognize as secondary socialization:[28]

The facts that the processes of secondary socialization do not presuppose a high degree of identification and its contents do not possess the quality of inevitability can be pragmatically useful because they permit learning sequences that are rational and emotionally controlled. But because the contents of this type of internalization have a brittle and unreliable subjective reality compared to the internalizations of primary socialization, in some cases special techniques must be developed to produce whatever identification and inevitability are deemed necessary. . . . [For example, the techniques applied in the socialization of religious personnel] are designed to intensify the affective charge of the socialization process. Typically, they involve the institutionalization of an elaborate initiation process, a novitiate, in the course of which the individual comes to commit himself fully to the reality that is being internalized. When the process requires an actual transformation of the individual's "home" reality it comes to replicate as closely as possible the character of primary socialization.[29]

The monastic, conventual, and ecclesiastical communities of the Middle Ages were reascribed as families, and the initiate's affections and responsibilities were transferred from the primary to the secondary family. But the account given above by Peter Berger and Thomas Luckmann is based on contemporary social organization, and the distinctions it makes are too simple and rigid to be applied to premodern modes of socialization. A complication in this scheme is introduced, for example, when the secondary family is literally a family and household. Socialization in guilds and craft fellowships is based on the domiciling of apprentices, and it was an aristocratic practice at least from Roman times to board male children in other households for training. In these practices the function of paterfamilias is conflated with that of pedagogue. Here, we might say, secondary socialization is carried out within the primary sphere of the household, but in such a way as to reinforce the integration of the larger order or class to which the aristocratic or craft households belong.[30]

Thus, as ideological weapons, reascriptive mechanisms like those that blur the distinction between fathers and teachers or between friends and relatives can cut both ways. On the one hand, they can be used to extend both the aura and the reach of kinship: "In dealings between nobles—as equals, or as senior and junior partners—the language of family relations . . . extended beyond the ties of blood. . . . The family . . . provided both model and terminology for relationships in the community as a

whole."[31] On the other hand, they may be used to devalue literal blood or kin or household relations as part of the process by which their affective power is alienated to the extended kin groups (kindreds, lineages, phratries, tribes) and to the greater family or brotherhood of the church or guild. In the time of New Testament culture, before Christian reascription had become routinized, it was recognized that conversion demanded precisely such a rejection of one's own, for alienation was represented in dramatic and conflictive terms as a radical choice between domestic and extradomestic loyalties:

> I have come to set a man against his father, a daughter against her mother, a daughter-in-law against her mother-in-law. A man's enemies will be those of his own household.
> Anyone who prefers father or mother to me is not worthy of me.
>
> Jesus replied, "Who is my mother? Who are my brothers?" And stretching out his hand toward his disciples he said, "Here are my mother and my brothers. Anyone who does the will of my Father in heaven, he is my brother and sister and mother."[32]

Christian ideology contentiously, transgressively, appropriates the relations of primary socialization from the earthly family so that they may both validate and be subordinated to the heavenly family. The heavenly family in its turn mediates the ascent to the male parthenogenesis of the Trinity.

From our perspective, then, reascription extends the forms of primary socialization into institutional domains that in today's world are now routinely organized and recognized as secondary, or else, as in the cases of craft and aristocratic domiciling, it introjects a form of secondary socialization into the primary sphere of the household. When we survey older practices, we note that what we would consider secondary identifications developed through explicit pedagogy in role-specific training were diffusely imbued with the affective force of implicit pedagogy.[33] Thus, as I noted, the role-specific training of apprentices and novices for craft guilds and the religious orders tended in the Middle Ages to be recoded in the linguistic and kinship categories of primary socialization that dominated domestic life in nuclear households and extended families.[34] Commenting on the medieval phenomenon of "the presence of 'bachelors' in the leader's entourage," Jonathan Powis remarks that "the immense authority and prestige embodied in the household of a great man presumably encouraged ambitious young nobles to attach themselves for a time to his 'fam-

ily.'" But he adds that "this function of the household was gradually losing its significance by the end of the Middle Ages; formal educational institutions—schools, colleges—increasingly took their place in a noble's *curriculum vitae*."[35] In Italy from the thirteenth century on, different forms of (more explicitly) explicit pedagogy were instituted within the civic community: church schools declined; the master/apprentice system of workshop training persisted; merchant schooling (vernacular) and humanist pedagogy (Latin) emerged into prominence. Communal and independent schools provided alternatives to household tutors.[36]

If these developments worked to sustain existing class differences, the diverse forms and curricula of explicit pedagogy have in common a performative emphasis that would ultimately reinforce factors contributing to the erosion of inhibitions on mobility.[37] The sociopolitical subtext of whatever gets taught—whether Latin or vernacular, Cicero or Ariosto, Euclid or the abbaco, composition for *orationes* or for *ricordi*—is instruction in the performative skills of self-representation, instruction in mastering the know-how needed to fashion the equivalent of what Aristotle in Book 2 of the *Rhetoric* called the ethos of the speaker. The ethos in this context would be the persona of speaker or writer as notary, merchant, magnate, statesman, father, schoolmaster, clergyman, prince, or courtier.[38]

Such changes in the pedagogical frameworks of identity formation, which obviously affect the apparatus of patronage and therefore the practice of portraiture, are precisely those that were subjected to scrutiny in Elias's now classic account of the history of manners and the civilizing process. Painting and portraiture play virtually no part in his story, but his study engages their fundamental preconditions because his central theme is the effect of societal change and emergent autocracy on discourses and practices of self-representation. That engagement is, as we'll see, flawed but generative: it contains in confused form the seeds of an account that can be better articulated in the terms of Lacanian psychoanalysis. My route toward a theory of portraiture that has a vaguely psychoanalytic edge to it will thus wind through a critical synopsis of Elias's argument.

6

ELIAS ON PHYSIOGNOMIC SKEPTICISM: *HOMO CLAUSUS* AND THE ANXIETY OF REPRESENTATION

The importance of *The Civilizing Process*, and especially of its first volume, *The History of Manners*, has increased in recent decades.[1] Elias's methodological emphasis on the dialectical integration of "sociogenetic" and "psychogenetic" phenomena into a single field of study has made his work, published in 1939, belatedly fashionable.[2] Social and cultural historians invoke it as they would invoke the Bible, though often they do so as Christians invoke the Old Testament.[3] Elias is coupled with Bakhtin in one study, with Bourdieu in another, and with Foucault in several others as a kind of simplistic precursor of Foucauldian analysis.[4] Peter Burke, for example, couples Elias's history of the "demand for the reform of gesture, in other words for stricter bodily control," with Foucault's "alternative history of the body," equally practice-oriented but "emphasizing control over the bodies of others as well as over the self."[5] In concerning himself with proto-disciplinary institutions of normalization, Elias may be said to have written a history of "technologies of the self"—using Foucault's phrase loosely—*avant la lettre*, but a history that is psychologistic rather than discursive in orientation, focused more on repressive than on what Foucault ironically terms "creative" articulations of power, and directed toward postclassical and prediscilinary regimes rather than classical and disciplinary regimes. What I find most relevant to a study of portraiture as a practice of self-representation is related to the last point and to a problem at the heart of his historicizing analysis of the emergence of modern notions of interiority.

Elias's point of departure is a critique of the essentialist spin given by

the social-science methodology of his time to two interlocking exclusions, "that of the individual outside society and . . . that of a society outside individuals." This dissociation produces the image of "the individual as *homo clausus*, a little world in himself who ultimately exists quite independently of the great world outside . . . ; his core, his being," is hypostatized as the "true self" encapsulated in its capsule, the self-sufficient agency invisibly walled off "from everything outside, including every other human being," by its opaque container, which the rhetoric of behavioral science metaphorizes as "the black box." The "individual processes" going on inside the box are sometimes "termed the 'soul' or 'mind'"—or the "ghost in the machine"—and cannot be "an object of scientific investigation."[6]

Arguing that this conception is historically conditioned, that metaphors of shell and core, outside and inside, correspond to nothing in the reality they refer to, Elias traces modern versions of the image back to "roughly the Renaissance" and to "the extraordinary conviction carried in European societies" since then "by the self-perception of human beings in terms of their own isolation, the severance of their own 'inside' from everything 'outside'"epitomized by the Cartesian split between the "thinking ego" and the "external world" (259, 250–251). He claims that during the course of the sixteenth and seventeenth centuries, after a period of increased social mobility,

> a more rigid social hierarchy begins to establish itself once more, and from elements of diverse social origins a new upper class, a new aristocracy forms. For this very reason the question of uniform good behavior becomes increasingly acute, particularly as the changed structure of the new upper class exposes each individual member to an unprecedented extent to the pressure of others and of social control. It is in this context that the writings on manners of Erasmus, Castiglione, Della Casa, and others are produced.[7]

As "social control becomes more binding . . . the compulsion to check one's own behavior increases" (82). In the restraint of affect, Elias locates the germ of the modern version of *homo clausus* and of the soul or mind concealed within the black box. External compulsion, he argues, became internalized, and self-control operated "independently of external agents as a self-activating automatism. . . . The firmer, more comprehensive and uniform restraint of the affects characteristic of this civilizational shift, to-

gether with the increased" internalization of "control mechanisms . . . are what is experienced as the capsule, the invisible wall" dividing the inside from the outside. Denied direct expression in action, the encapsulated impulses "appear in self-perception as what is hidden from all others, and often as the true self, the core of individuality" (257–58).[8]

Readers familiar with Elias's work and its critics will know that I am selectively picking out a specific sector of his argument and discarding others. In particular, I would like to dissociate my appropriation of his *homo clausus* thesis from the tendency toward "evolutionary gradualism" that has disturbed some critics, from his reliance on a Freudian topography of the psyche (put into play even though he criticizes Freud's essentialism and tries to historicize the insights he borrows), and from the focus of his psychogenetic interpretations on what he calls "Affekt-Oekonomie."[9] It is clear from many of his utterances that he aspires to give a structural account of change focused on inferences about psychic structure derived from his reading of conduct books as normative representations of *and* influences on behavior and feeling. Such questions as those of "socially instilled displeasure and fear," "sociogenic fears," and the "psychogenesis of the adult makeup in civilized society cannot," he insists, "be understood if considered independently of the sociogenesis of our 'civilization.'"[10] Notice that the object of psychogenesis is not "the adult" *tout court*—the individual member of a class—but "the adult *makeup*," which suggests a generic and discursive representation.

This aspiration to an emphasis on structure and representations is, however, more often than not honored in the breach. In his reprise of the argument about lowering the threshold of shame, for example, Elias describes "the growing split in personality" that is its consequence in the following terms:

> The conflict expressed in shame-fear is not merely a conflict of the individual with prevalent social opinion; the individual's behavior has brought him into conflict with the part of himself that represents this social opinion. It is a conflict within his own personality; he himself recognizes himself as inferior. He fears the loss of the love or respect of others, . . Their attitude has precipitated an attitude within him that he automatically adopts toward himself.[11]

He goes on to discuss "the growing differentiation between drives and drive-controls, between the 'id' and 'ego' or 'super-ego' functions." The

latter, the control function, "forms the center from which a person, partly consciously and partly quite automatically and unconsciously, controls his 'inner life,' his own affects and impulses" (294). These may be speculations about the behavior of merely hypothetical or exemplary individuals, but the psychologistic rhetoric tends to locate conscious and unconscious agency in each individual, and thus to make the analysis veer toward the very individualism Elias's general theory is constructed to avoid. As a result, what he conveys is an unmediated representation of actual psychic conflict within individual subjects, not his representation of the cultural representations of the conflict on which his conclusions are based. This is surely not what he intends to convey; since it may be the consequence of his reading practice, a word about the latter is in order.

Elias's objective is to track the gradual stages of "increased social prescription of many impulses, . . . their 'repression' from the surface both of social life and of consciousness" (142–43). His method is to cite and then comment on a chronological set of examples repeatedly called upon to testify to different aspects of this change. For example, Della Casa's *Galateo* is a member of the set because it contains passages that proscribe nose blowing and other public exhibitions of bodily effluvia and that are harbingers of an emergent—that is, postmedieval—anxiety about social boundary maintenance. Elias reduces each text in his series to a collection of examples symptomatic of changes in attitude and identifiable as the opinions of the time mediated through the author. The *Galateo*'s opinions are thus attributed to Della Casa as a reflector of his era. The method of quotation and commentary renders conspicuous both an odd feature of the former and the commentator's failure to notice it: Elias passes over in silence the fact that in the *Galateo* the *pro*scriptions are also *de*scriptions that dwell on and rhetorically embroider what they proscribe. Disgusting things, the narrator insists at the beginning of chapter 3, should never even be mentioned, whereupon—in a kind of perverse praeteritio—he spends the rest of the chapter describing unmentionable acts. It can easily be shown that the narrator of the *Galateo*, like that of the *Cortegiano*, is a fictive site of enunciation and is marked by the text that represents "him" as unreliable.[12] Lisa Jardine's analysis of Erasmus's self-construction in print suggests that a modified version of the same hypothesis may be entertained about the fictive (if not necessarily unreliable) narrator of *De civilitate*. If, then, one conflates the *Galateo*'s narrator with the author, who in turn is reducible to the opinions of his era, it is hard to know what to

do with the strange message this procedure conveys—namely, that this narrator, or author, or era, has a dirty mind. Because Elias elides the discursive complexities of the textual representations that constitute his evidence, his focus is perforce diverted from the agency of discourses and representations to that of the exemplary or hypothetical subjects they depict, and their psychic conflicts are actualized by being made the objects of a kind of pop-level Freudian analysis.

My aim is to recuperate the emphasis that, for me, gives his argument its power—the emphasis on discourses and representations as causes of inner conflict and as the sites of our interpretive access to it. This emphasis is most obvious in a paraphrastic or profile view of his two major premises about the production of a "hidden self" or "unrepresented inner self" as *an effect of representation.* The first is that *homo clausus,* the inner self, the soul, the black box, the ghost in the machine, etc., is not a prediscursive entity but an effect of discourse and a product of new technologies of representation, technologies of behavior affected by developments in printing, theater, visual arts, mercantile practices, and schooling. The second premise is that the special attribute of *homo clausus* as a product of representation is to be hidden, suppressed or repressed, created *as* the unrepresented so as to conform with the norms of permissible representation.

The generative force of these premises lies in their focus on the social and technological production of interiority. But when the implications of the second premise are spelled out, they illuminate an effect of internalization that Elias leaves in shadow: if there is a "true self" that appears "in self-perception as what is hidden from all others," it must be because people are schooled to represent more appropriate versions of "true self" or character or personality. Or, to put it the other way around, the representation of the "inner self" one is enjoined to present to others produces as an interior or private representation an unrepresented remainder, the "inner self" one is enjoined to keep to oneself. Elias is not consistent in dealing with the effect of this production, as the following example will suggest.

In a passage of the preface to *The History of Manners,* part of which I quote above, Elias mentions "the decisive role played in this civilizing process by a very specific change in the feelings of shame and delicacy," and then goes on to state that as "[t]he standard of what society demands and prohibits changes . . . the threshold of socially instilled displeasure and fear moves; and the question of sociogenic fears thus emerges as one

of the central problems of the civilizing process."[13] Correll astutely re-
marks of this passage that the different degrees of specificity attaching to
"shame" and "sociogenic fears" are not inconsequential. Praising Elias for
giving more weight to "less determinate structuring spheres" like anxi-
ety than to "any peculiar forms—such as shame and embarrassment—it
may take," she illustrates the problem in a comment on Gail Kern Paster's
The Body Embarrassed. One of Paster's achievements, she claims, is to see
that by "introducing shame to subject formation" Elias's account of "civ-
ilizing enculturation" makes it possible to assimilate the study of affects
"to a study of Renaissance 'humoralism.'" But this achievement has its
downside: Paster's "argument buttresses and applies Elias's ideas to pre-
sent a clear and unquestioned development of sociopsychic restraint and
repressive effects. It thus tends to work in a way that seems more con-
cerned with effects (shame) than with causes (for instance, discourses on
indecency)."[14]

When social and cultural historians influenced by Elias's work concen-
trate on the way internalization lowers the threshold of shame or embar-
rassment, the specificity of that emphasis diverts attention from a more
problematical issue linked as much to the bifurcated structure of repre-
sentation itself as to the putatively bifurcated interiority of its referent.
Correll interrogates the possibility of direct access to "sociopsychic . . . ef-
fects" and gives priority to the agency of the discourses and representations
that mediate those effects, that provide the only records we have of them,
and that may even be imagined to produce them. In accordance with this
preference, she argues for the more indeterminate and diffuse category of
anxiety, to which she gives resonance by passing Elias's formulation of in-
ner conflict through Kristeva's account of abjection, in which the body as
"the place of cultural inscription" is "marked by the action of aversion, of
ab-jecting."[15]

In line with Correll's reasoning, it seems profitable to redirect attention
and speculation toward the potential range of effects produced by the on-
set of new and more diversified representational technologies; the effects
produced when the behavior of privileged groups, and especially their
habits of self-representation, is increasingly determined by the obligation
to internalize and perform the institutional models of deportment dissem-
inated through those technologies. Chief among the effects deduced from
a perusal of the early modern evidence is the anxiety of self-representation
I discussed in my account of the culture of sprezzatura in Chapter 3. This

is partly an anxiety that involves self-surveillance inasmuch as the artful performance of morality may trouble the performer's sense of the morality of performance. It is partly an anxiety based on the awareness that the power of representations is always contingent on the ability at once to disguise and to convey the representation of power. And it is partly an anxiety about the obligatory fictiveness or illusoriness of the "self" conveyed by the performance.

The new behavioral and pedagogical technologies that drive the civilizing process conceptualized by Elias involve a long-term transformation from more overt and direct to more covert and indirect expressions of violence. Because the first volume of *The Civilizing Process* is devoted chiefly to the evidence of psychogenesis deposited in the history of conduct literature, the account of the transformation is unfortunately dominated by the emphasis on specific changes in affect-economy: emotions in feudal societies "are expressed more violently and directly" with "fewer psychological nuances and complexities in the general stock of ideas. There are friend and foe, desire and aversion, good and bad people."[16] During the Renaissance these "simple oppositions" give way, and people begin to "see things with more differentiation, i.e., with a stronger restraint of their emotions" (71). The psychologistic vein diminishes in the second volume because Elias there concentrates on sociogenetic analysis and traces in considerable detail the structural ground of affective change in the "figurational dynamics" by which "an upper class of relatively independent warriors or knights [was] supplanted by a more or less pacified upper class of courtiers" in urban duchies and absolutist monarchies.[17] This level of analysis makes it easier to replace the emphasis on an economy of affect with an emphasis on the economy of representations. Following Elias, and partly under his influence, there have been many accounts of the changes in representational economy by which the dominantly militaristic representations of feudal societies are transformed into the more diversified portfolios of displaced violence that characterize the graphic modalities of early modern representations.

To cite one example, Jonathan Goldberg writes of the dialogues describing (and prescribing) schoolboy life in Vives's Latin primer of 1538 that "[t]he book participates in what Elias calls the civilizing process, for these scenes of everyday life construct the everyday through grammatical and pedagogic proprieties."[18] Discussing a sentence in Claudius Desainliens's 1583 variation of Vives, *Campo di Fior*, Goldberg comments:

> "Venistis huc armati": "Have you brought your weapons? Have you brought your tooles?". . . . The "civilized" young men have been properly schooled, open violence restrained and resituated (the great shift charted by Elias . . .), as when they recast colonizing as kingly "munificence," or when they recognize the proper tools necessary for the tasks of civilization—the writers' weapons of quill and quillcase (replacing arrows and sheaths). . . . The pen is mightier than the sword.[19]

Later Goldberg glances at the bifurcation of interiority in his parenthetical comment on the effect of the "'civilizing' processes with their displacements of violence (turning upon the subject to found the split subject)."[20]

Elias had argued, in Roger Chartier's words, "that between the Middle Ages and the nineteenth century, . . . the necessary control of impulses was transferred from an exterior prohibition, imposed if need be by force, to a stable mechanism of self-restraint."[21] Chartier complicates the thesis by crossing it with Louis Marin's studies of the politics of representation:

> Marin's work . . . permits us to understand how confrontations based on brute force or pure violence changed into symbolic struggles—that is, into struggles whose weapons and rewards were representations. The image has this power because it "effects a substitution of the external manifestation in which a force appears . . . with signs of force." . . . One might add, prolonging this encounter between Marin and Norbert Elias, that it was that same pacification (at least relative pacification) of the social sphere between the Middle Ages and the seventeenth century that transformed open and brutal social clashes into struggles between representations in which the stakes were the ordering of the social world, hence the recognition of the rank of each estate, each body, each individual. (95–96)

It goes without saying that feudal confrontations were no less representational than those in which violence was displaced to—for example—the rhetorical, theatrical, mercantile, and propagandistic registers of early modern discourses and practices.[22] The structural criterion of difference between earlier and later in this case is the relative distance of displacements from more transparent representations of force:

> [A] command on the one hand is always explicitly or implicitly complemented by an 'or else' clause, a pointer to the command-giver's ability to use coercion in order to overcome recalcitrance or resistance on the part

of the person receiving the command. On this account, there is a distinct (and sinister) factuality to commands, an implicit (and sometimes explicit) reminder that "we have ways to make you obey. . . . "

On the other hand, a command is a thoroughly intersubjective operation: by means of it, one subject seeks to initiate and control another subject's activity. It is also thoroughly symbolic in nature, and presupposes the other subject's ability to entertain and interpret the message.[23]

Because feudal institutions "were focused on the imperatives of military command" (35) and feudal negotiations were determined in the last instance (as Marxists would say) by military threat, the sinister factuality was always closer to the surface of representation. The "military aspects intrinsic to the political enterprise" were more conspicuous (39), and there was a closer "implication between war and political arrangements, and . . . between political experience and violence," in feudal than in postfeudal representations (35).

The "seigneurial" mode of production, as Georges Duby calls it, "was predicated on the firmly established power to exploit the land and the men who cultivated it"[24]—a power which, in Powis's words, "was made visible in stone" and which imposed its own localizing constraints: "Over the generations, castles and land bound families to their locality."[25] The castle was itself a representation of defensive/aggressive power that materialized and characterized—and aggrandized—the social unit of the *domus*, which in "the high society of the twelfth century" in northern France consisted of

the household or two-generation family. . . . The framework within which this group became aware of its cohesion was the house or *domus*. . . . [T]he specific function of those who spoke of their noble status traditionally was and remained military. . . . This basic structure shaped an entire set of attitudes, especially those of respect and deference. So compelling was this structure that every metaphor that sought to express power relationships . . . in some way made use of the image of the house.

More distinctly than either their forebears or their descendants, the knights of the twelfth century were basically inheritors. This process of taking root in an agrarian environment . . . served to ensconce the lay aristocracy more solidly than ever within the confines of the house (*domus*). It also explains why, ever since the second third of the eleventh

century, the name of the house tended to become the common surname of all the offspring of the "race." Under these circumstances it is appropriate to view chivalric society as an assembly of juxtaposed houses.[26]

This context is necessary to supply the motivating factors not mentioned by Elias in his emphasis on the restricted scope of medieval conduct literature: "precepts on conduct while eating had a special importance. Eating and drinking . . . occupied a far more central position in social life than today."[27] The factors are more explicitly indicated by Anna Bryson when she connects learning table manners to the general objectives of aristocratic pedagogy. She observes that late medieval courtesy books tend to express and ritualize "relations of lordship, service, and hospitality in the noble household," and to "emphasize symbolic acts of deference," chiefly by directing attention "to one sort of social occasion and to the relationships which are to be expressed in the rituals of that occasion: this is the main meal or banquet, the ever-renewed expression of the solidarity and hierarchy of the noble household and its relation to the outside world in the obligation of hospitality."[28]

The restricted scope of the medieval discourse on manners reflects the dominance of the scene of primary socialization—the noble household—as the site of pedagogy. Table manners are both the synecdochal representation of the existing order and a central means of reproducing it:

> Not only did great families inherit a power of command over others; the institution of the family itself provided a setting and an idiom in which command could be exercised. . . . [T]he head of an aristocratic household enjoyed exceptional resources with which to assert both the distinction of his house and his own role as its leader. . . . [N]othing better marked out the pre-eminence of a great lord than to dispense lavish entertainment for his kinsmen and followers.[29]

A more dialectical view of this privilege reveals it to be apotropaically inscribed with the shadow of the violence always lurking behind the representational surface:

> Manners demonstrated ruling-class leadership, domination based on land, title, and physical force. One who offered hospitality in peace could offer hostility in war as well.

> Loyalty was the chief value in peace and in war; hospitality, generosity, and politeness were gestures of peace in an environment otherwise structured by violence. . . . Such values came with historical contra-

dictions. Loyalty, feudal order, hereditary power—all stood as ways of preventing conflict which preserved conflict.[30]

In this context "aristocratic manners were not practiced with an eye toward social competition or advancement," as they would be later; "they served as the visible sign of a determined and legitimate place in a presumably unchallenged social order" (46), and as representations reinforcing the presumption, implicit in the term "unchallenged," of a monopoly of the means to violence, but violence held in reserve, a last resort, the iron fist of exploitation and brute force visible within the velvet glove of feudal hierarchy.

Reduced to its simplest and most general premise, the traditional account of the structural change involved in the passage from feudal to state society still provides a viable framework for the phenomena under discussion here. In this account, the political and economic orders are first embedded in and then differentiated from the social order:

> Previously, in the Christian West, the possession of political power had been embedded in other forms of social power; its practice had been the prerogative of privileged people *qua* privileged people, just another expression of their social superiority. By the same token, the loyalties which it sought to evoke were part and parcel of other people's general condition of social dependency. *Qua* organization, on the other hand, the state unifies and makes distinctive the political aspects of social life, sets them apart from other aspects, and entrusts them to a visible, specialized entity.[31]

Correlatively, we may say that political and economic representations were first more fully embedded in and then gradually, partially, differentiated from social representations that derive their authority from ascriptive and reascriptive indicators of status.[32] Among the factors serving to sustain embedded authority were the relatively underdeveloped infrastructures of transportation and communication that, by inhibiting long-distance negotiations, imposed a local or cellular character on feudal agrarianism and thus reinforced the personalistic, familistic, and domestic forms given to the representations of authority and deference. These forms—the forms in which what may be called the feudal body was invested—were thus jeopardized by "improvements in the road systems in various parts of Europe, . . . the growth of literacy, . . . developments in the material and social technology of warfare, . . . [and] the increasing significance of eco-

nomic processes mediated by money and centered on the towns"[33]—to which, once again, should be added the development of graphic media and methods of representation, a development including but much more comprehensive than the growth of literacy. The general consequence is that political, social, and economic powers are not only alienated from the feudal body but also magnified, redistributed in an emergent network of institutions that give more scope to nonmilitary and nonagrarian forms of appropriation and competition. The specter of violence, dissociated from physical force, gradually gets disseminated throughout the social order, where it lurks as a specific and ever-present danger, the danger of loss of control, within every nexus of symbolic exchange or negotiation. This is the danger Elias associates with the civilizing process.

In Correll's powerful revision of the trajectory elaborated by Elias, new technologies and media of representation not only registered but also facilitated the gradual displacements and dissemination of the forms of power, with the result that "sixteenth-century encounters" between court and city were "practiced with an eye toward social competition or advancement." Aristocrats and bourgeoisie both sought

> to encode competition through increased emphasis on consideration and sensitivity to what in personal behavior might offend. Significantly, in this point of transition, if the former court attempted to hold onto what it was, the urban bourgeoisie tried to codify and justify a less certain identity. In this respect, the modified precepts of the humanist and bourgeois etiquettes specifying what one does—and especially, what one does not do—expose what one is not yet and would like to become. . . . With a reflexive element not seen in chivalric culture, they negotiated uneasily between an ideal self-image and a phantasmal unknown with the capacity to loom horrifically.[34]

Foregrounding "anxieties and fears of . . . the unregulated" phantasm (46), bourgeois representations of conduct thus "produced an internalized punitive spectacle that was constitutive, rather than cathartic" (48).

The distinguishing feature of these idealizing representations, the source of much of the anxiety they depicted, was their express fictiveness, their undisguised reliance on rhetorical and theatrical protocols of performance. This is the burden of Anna Bryson's reinterpretation of the Elias thesis. She argues that, although conduct books in the sixteenth and seventeenth centuries don't ignore the medieval topics, they place much

more emphasis on the function "of presenting or 'representing' personality rather than simply acknowledging relationship." They "feature a vocabulary that continuously refers to manners as 'representations.'" Their express assumption that "the body was a text from which good and bad character could be read" led them to direct attention to rhetorical and theatrical techniques of body management.[35]

Elias observes that medieval writings on conduct were reflective rather than constitutive: "Those who wrote them down were not the legislators or creators of these precepts but collectors, arrangers of the commands and taboos customary in society."[36] He goes on to hint at, but never fully develops, the idea that Renaissance courtesy books, partly because of printing, were increasingly effective in producing the combined effects of pacification and more coercive social control. They were more aggressive in proposing general models of deportment and anecdotal illustrations of the proper way not simply to behave but to perform behavior. Bryson touches on this when she notes in passing that while "all codes of manners involve the representation of idealized character traits, . . . [s]ixteenth- and seventeenth-century codifications of manners . . . show a peculiarly intense interest in correct forms of behavior as modes of self-presentation. . . . They were depicting an idealized personality as a model to be imitated, but they were also recommending good manners as the means of constantly producing the image of an idealized personality."[37]

This argument improves on Elias's approach by redirecting it toward issues not merely of self-representation but of the quasi-theatrical production of self-representation, which Bryson formulates in a statement that evokes the paradox basic to the culture of sprezzatura: "Through his manners the gentleman was supposed to proclaim his 'natural' virtue and title to authority, but such manners were self-evidently the product of education, effort and artifice."[38] The adversative construction of this sentence quietly yet forcefully picks out the major pressure point: the perception of bifurcated interiority is at once registered and confused by the interdependence of the "nature" one has to learn and is supposed to proclaim and the other "nature" everyone by the same token assumes is already there and must not be proclaimed. Since these two natures and their difference are simultaneously produced and mutually implicative, the second is no less "the product of education, effort and artifice" than the first. The paradox hazily adumbrated by Elias but brought into

sharper focus by more recent studies like Correll's and Bryson's is that the sense of an unrepresented, perhaps unrepresentable, inner self is the specific product of relatively more powerful regimes and technologies of representation that both encourage the expression of inwardness and limit the forms it can take.

Among the many studies that explore epitomes of this shift in symbolic and gestural economies, one of the clearest is Georges Vigarello's account of representations of deportment focused on the training and carriage of the body. Vigarello notes that medieval comments on knightly deportment, which were generalized and cursory, initially tended to stress the knight's need for "overall strength: . . . a powerful chest and shoulders were even more highly valued than beauty."[39] But even during the Middle Ages the influence of the Church began to modify the representations of potential force and violence, producing in the rules and guidelines of deportment

> a cultural trend away from the more brutal and triumphant images at which the descriptions of knights seemed to hint. The cleric was here to take the lead over the soldier, restraint over adventure, caution over impulsiveness. In fairness, both dimensions are present, each in its own simplification. Courtesy was imposing discipline on a caste whose ideal of physical violence had some parallels in its posture. It did it soberly, by dictating behavior and the position of the body.
>
> In the sixteenth century this mechanism became more pronounced. . . . A new court nobility was being established as the world of chivalry faded, and the emergence of a formal etiquette and a courtier class seemed to generate rules of deportment for the body. . . .
>
> Beginning with the sixteenth century, a changed culture regulated the behavior of the nobility, which, in order to define itself, invented the idea of civility. (151)

During the seventeenth century, the aestheticization of violence increases:

> Fencing and riding are "fields" in which the body's uprightness is a sign of good manners. In these "technical" activities the straight body is filled with a self-controlled politeness. The measure is less and less one of strength, and increasingly one of elegance. In the end it is dance that sets up models aimed at excellence and distinction. It was to be the foundation for an art of controlled, developed and privileged performance. . . . On the stage of the body, signs of strength are fading further. (179)

The process of aestheticization is also a process of fictionalization. This is so because the performances it mandates presuppose the internalizing of constraints that divide the agent between the aestheticized "self" he or she performs and the hidden or unrepresented self that is the by-product of the performance. The former is thereby marked as fictive, perhaps illusory and deceptive:

> Through a bearing that must always be "honest" and unchanging, one is able to disguise the emotions. "Nothing must show on the outside." (177)

> Rules and order direct behavior until it is an art. Manners become a theatrical and showy element which is largely privileged. Prestige is never far from pose. . . . Court society demands of its actors a constant awareness of their posture, and in such decorum can be read, among other things, the "science of decent people." One must "show." All spontaneity is erased, and thus a secretive and calculated structure of bearing and behavior is encouraged. (178–79)

Here we encounter the problem of truth in advertising, the problem imposed on practices and discourses of self-representation by the growing importance of technique in what Elias calls psychogenesis: the problem of representation anxiety associated with the onset of physiognomic skepticism. When the inscription of mind and soul on face and body gets committed to technical means and motivated performances; when, as a result, the contribution of artifice to the expression of interiority is harder to conceal; and when, at the same time, the norms of correct psyche impose a barrier between permissible and impermissible forms of expression; then a new fissure opens up between the interiority one is socialized to represent and another interiority one is socialized to keep to oneself. Obviously, what *shouldn't be* represented is not the same as what *isn't being* represented. Awareness of prohibition is not the same as inattentiveness. My point is that the more you are socialized to be aware of the difference between *should* and *shouldn't*, the less likely you are to be merely inattentive to what you don't represent. Awareness of the difference between the inner self you are supposed to represent and the one you are supposed to hide becomes culturally significant.

It stands to reason that the diffusion of techniques for representing inner truth is—as Elias shows—simultaneously the diffusion of techniques for concealing it, and that the public level of suspiciousness or skepticism is bound to be raised, especially when icons of inwardness are stylized,

idealized, and taught by the book. Behind the represented inner self lurks
the unrepresented inner self. As this division begins to insist on public
awareness, so also does a new interest in the meaning, the uses, the dan-
gers, of privacy and secrecy. "The 'private life,'" Barthes writes in *Camera
Lucida*, "is nothing but that zone of space, of time, where I am not an im-
age, [not] an object."[40] The accent is placed on something left over, a surd,
an excess, and therefore on something—a reaction formation—that pre-
supposes a culture with the representational resources, the normative pres-
sures, and the discursive desire to produce a repertory of public objectifi-
cations and induce subjects to perform them. Barthes glances at the dark
side of this performance when he notes the subject's dissatisfaction with
the inauthenticity of its self-objectification. This may be called represen-
tation anxiety. Another name for it is narcissism.

Cartesianism, if it did not prove that the soul and body were distinct from one another, nevertheless destroyed the fabric of unity which the poetics of correspondence had woven. . . . Descartes, looking back on his philosophical work of the 1630s . . . , sensed that the kernel of his own philosophical reflections lay in their construction of the human subject as alien from itself.[1]

LACAN ON THE NARCISSISM OF
ORTHOPSYCHIC DESIRE

What I take from Elias, with a little revisionary embroidery, is the idea of the discursive production of a hidden self or unrepresented inner self as *an effect of representation*, and of a particular regime of representation associated with social and technological changes in early modernity. What I now plan to do with this idea may be suggested by the following statements, which will provide a link joining *homo clausus* to the Lacanian subject:

> *[T]he failure of its representation is its positive condition.* The subject tries to articulate itself in a signifying representation; the representation fails; instead of a richness we have a lack, and this void opened by the failure *is* the subject of the signifier. To put it paradoxically: the subject of the signifier is a retroactive effect of the failure of its own representation; that is why the failure of representation is the only way to represent it adequately.[2]

> Narcissism is the impossible effort of the subject to reunite with himself in his own objectified image . . . within the register of representation. . . . Narcissism leads to alternation between self-deprecation and pretension.[3]

Since both statements are from essays in critical theory of psychoanalysis—the first is part of a meditation on Lacan and the positive power of negativity—neither engages the failure of self-representation in terms that situate it in social and cultural history.

A start in that direction was made in 1991 in an issue of *October* "devoted to the attempt to demonstrate the pertinence of psychoanalytic analysis to the politics of representation" and, more centrally, to demonstrate its relevance to a historical conceptualization of forms of subjectiv-

ity.[4] In the issue's first essay, for example, Mladen Dolar argues, against Freud's tendency to treat the experience of the uncanny as strictly universal, that there are historically specific forms of the uncanny.[5] Through a Lacanian discussion of doubling, he tries to demonstrate that there is "*a specific dimension of the uncanny that emerges with modernity*. . . . Ghosts, vampires, monsters, the undead dead" give the uncanny its modern form, and they are not simply archaic residues but "something brought about by modernity itself" (7).

This demonstration, like the others in the issue, relies for its logic on Lacan's concept of the object small *a*, which is his term for the way the absence of the real is represented in the symbolic order. As Joan Copjec puts it, "it is necessary to *say* that the real is absented, to *declare* its impossibility. The symbolic, in other words, must include the negation of what it is not."[6] A negation, or an absence, that declares itself is an example of the trope I have elsewhere described as *conspicuous exclusion*. In Lacan's own words, the object small *a* "is that other element that takes the place of what the subject is—symbolically—deprived of. . . . [It is] not the object of desire but the object *in* desire. . . . Something becomes an object in desire when it takes the place of what by its very nature remains concealed from the subject."[7]

Lacan's formulation of the object small *a* as a marker of absence in the symbolic order—the cultural order of discourse networks—is intimately linked to his critique of biological or epigenetic theories of development as prediscursive, essentialist, and deterministic. For these he substitutes not only the discursive field established by the postulate that the unconscious is a language,[8] but also a set of tropes and descriptions drawn from optics, theater, perspective, and mirrorgazing. The significance of this set is that, although the tropes are often used to describe the scene of primary socialization and "instinctual" processes, they seem to implicate performative acts rather than passive experiences, acts that in turn produce reactions constitutive of the changes traditionally associated with "development" or "maturation." His basic move is to substitute for the biological lexicon that privileges development and maturation, and for the phenomenological lexicon that privileges consciousness and self-consciousness, a specular lexicon that describes subjectivity in terms of self-representation—or, to borrow a favorite concept from the virtual reality market of the 1990s, in terms of interactive self-representation. It is because of the paradoxes inherent in the structure of representation that

the subject's relation to itself takes the form of the conspicuous exclusion signified by the object small *a*.

This basic move has been well characterized by Barbara Freedman:

> For Lacan, self-identification is based on a representation that alienates as it procures: "Man becomes aware of this reflection from the point of view of the other; he is an other for himself." Following Freud's work on negation, Lacan argues that self-reference is procured only through an expulsion and repression of a part of our being.[9]

Becoming aware is fundamental to the alienating structure of self-representation: desire for the "part of our being" absented from representation is desire for the object small *a*, and it is this desire—displaced, troubled, confused by the conflicting desire to assimilate the ideal image that "can never be fully assimilated"—that Lacan identifies as the source of narcissism.[10]

My sense of narcissism in its Lacanian avatar has been influenced by an essay in which Copjec correctively appropriates from Bachelard the concept of the *orthopsychic* subject, a term he uses to designate the exemplary embodiment of scientific thought "constructed by the institution of science." This subject is so constituted as to be "obliged to survey itself, its own thinking, not subjectively, . . . but *objectively*, from the position of the scientific institution."[11] In reading this and the following statements, one should keep in mind their applicability to the effects of early modern institutions and discourses of science, printing and publication, conduct, religious reform, pedagogy, patronage, and merchant writing (with its secret books).

Copjec goes on to distinguish the orthopsychic relation conceptualized by Bachelard from the panoptic relation conceptualized by Foucault: in the former, it is "just this objective survey that allows thought to become (not wholly visible, but) *secret*."[12] In the course of broadening this concept to the status of a general cultural construction, she insists that Bachelard does not mean to posit

> an original, private self that happens to find in objectivity a means . . . of concealing itself. He is arguing, rather, that the very possibility of concealment is only raised by the subject's objective relation to itself. For it is the very act of surveillance—which makes clear the fact that the subject is external to itself . . . —that causes the subject to appear to itself as culpable, as guilty of hiding something. . . . The ineradicable

suspicion of dissimulation raised by the objective relation guarantees that thought will never become totally coincident with the forms of the institution. Thought will be split, rather, between belief in what the institution makes manifest, and suspicion about what it is keeping secret. All objective representations, its very own thought, will be taken by the subject not as true representations of itself or the world, but as fictions. . . . Once the permanent possibility of deception is admitted . . . the concept of the gaze undergoes a radical change. For, where in the panoptic apparatus the gaze marks the subject's *visibility*, in Lacan's theory it marks the subject's *culpability*. The gaze stands watch over the *inculpation*—the faulting and splitting—of the subject by the apparatus. (27–28, 30)

This passage not only articulates the split between represented and un-represented interiority implicit in Elias's account of increased institutional surveillance of behavior; it also depicts them—the orthopsychic subject and *homo clausus*—as complementary effects of a particular discursive and technical apparatus.

In the Lacanian idiom Copjec appropriates, "the gaze" (*le regard*) is a cardinal notion. It is not the look, nor is it "a seen gaze, but a gaze imagined by me in the field of the Other." This gaze, which "circumscribes us," constitutes us as "beings who are looked at, in the spectacle of the world," a spectacle that therefore "appears to us as all-seeing. This is the phantasy to be found in the Platonic and panoptic perspective of an absolute being to whom is transferred the quality of being all-seeing."[13] But the gaze is not only "around" us. It is internalized, turned "inside-out" (82), and elided into the illusion, the misrecognition, "of the consciousness of *seeing oneself see oneself*" (83). The gaze is the scopic function of the discourse networks that produce subjects: insofar as "our relation to things . . . is constituted by the way of vision, and ordered in the figures of representation, something slips, passes, is transmitted, from stage to stage, and is always to some degree eluded in it [vision]—that is what we call the gaze" (73), and its double force, circumscription and inscription, makes it "an *x*, the object when faced with which the subject becomes object."[14] This ordains "the pre-existence to the seen of a given-to-be-seen,"[15] and thus what is misrecognized as self-presence or self-presentation—"the illusion of the consciousness of *seeing oneself see oneself*"—is the structure of self-representation.

The subject is an agency that cannot simply *appear* but *gives itself to be*

seen, makes appearances, an agency grammatically and existentially located in the middle voice, for if, as Elizabeth Grosz puts it, "I look" and "I am looked at" are mediated by "I look at myself," then the real meaning of "I am looked at" is "I get [myself] looked at," that is, "I represent myself."[16] It follows that the seeing of the I that looks is that of a subject already objectified, self-alienated, by the gaze that makes looking itself a function of getting (oneself) looked at. The *subject* in Lacan gets its name from being *thrown under* its appearances and signifiers when it gives itself to be seen, from disappearing into the absence that defines self-representation, from subjecting itself to *the I that gets looked at* as to the orthopsychic object of desire.[17]

As a function of the scopic drive, the structure of representation is identical with the structure of castration: "The gaze is . . . , like the phallus itself, the drive under which the subject's identity and certainty fail. The subject is necessarily alienated, for it is defined on Lacan's model as *seeable, shown,* being seen, without being able to see either its observer or itself."[18] Thus the "inside-out structure of the gaze" as internalized Other cannot produce panoptic saturation, and the orthopsychic subject must be the alienated and objectified semblance, "the fiction of self-representation" in which the subject can see itself "as a whole only by being placed elsewhere"—the formula, as Jacqueline Rose (whose words these are) notes, of the mirror-stage dialectic.[19] The subject sup-poses itself.

In order to illustrate the structure of these relations, Lacan borrows from Renaissance discourses of optics and perspective the famous profile of the visual cone or pyramid used by Alberti, Leonardo, and others. In Alberti's *costruzione legittima* the vertex or distance point represents the hypothetical viewing point, the eye of a virtual (and monocular) viewer whose position and prospect are controlled by the system but who can in turn control the form of what is seen by vertical or horizontal adjustments of the vertex/eye. The lines radiating from the vertex to the base are bisected by a transversal that represents the picture plane or "window."[20] But "behind the window," or on the plane, the orthogonals and transversals that measure recession in imaginary space converge in the opposite direction and terminate in a vanishing point fixed in the vertical base of the first triangle, a point correlated with and "mirroring" the distance point or monocular vertex. If the orthogonals that radiate from the vanishing point are extended through the intersecting plane to a vertical drawn through the distance point, the latter becomes the base of a second

triangle (or cone, or pyramid) and this produces a bisected specular figure in which—as in Yeats's famous double cone—each triangle partly contains and is partly contained within the other. Alberti doesn't take this step, but Lacan does.[21]

In Lacan's variation, the two simple triangles are separately inscribed in a first diagram and superimposed in a second.[22] The different values assigned to the vertices, bases, and intersections of the simple triangles are combined in the composite. The vertex/eye at the distance point, which he initially calls the "geometral point," is, in the second triangle, located in a base called "picture," and in the composite the two elements together are renamed "the subject of representation." The vanishing point is called "point of light" in the second triangle, and in the composite it becomes "the gaze." The intersection is called "image" in the first triangle, "screen" in the second, and "image screen" in the composite. As commentators have noted, by identifying the gaze with the "point of light" Lacan makes it represent not only "the intrusion of the symbolic into the field of vision" but also the conditions for the possibility of vision, yet the identification suggests that these conditions cannot be comprehended within the sciences and geometries devoted to optics.[23] The scientistic figure transferred from physics and "nature" to the symbolic order of culture both demystifies the former and foundationalizes the latter, so that, as Copjec observes, semiotics "is the science that enlightens for us the structure of the visual domain. Because it alone is capable of lending things sense, the signifier alone makes vision possible."[24] By representing the intersection as opaque—rather than (as in Alberti) transparent—Lacan associates the occlusion of the gaze from the field of vision with a site for the projection of "the given to be seen" either as an image *of* or as an image *for* the subject of representation.

Alberti's vanishing point rewritten as the gaze, and blocked by the screen, marks the annihilation of vision and the subject. When, in the composite, the vanishing point becomes the mirror image of the distance point that marks the visual activity of the subject of representation, it signifies the annihilation at the heart of that subject. The point of light and the gaze thus retain the value of the original vanishing point

> at which something appears to be missing from representation, some meaning left unrevealed, [and this] is the point of the Lacanian gaze. It marks the *absence* of a signified; . . . it indicates an impossible real. The subject . . . cannot be located or locate itself at the point of the gaze,

since this point marks, on the contrary, its very annihilation. At the moment the gaze is discerned, the image, the entire visual field, takes on a terrifying alterity. It loses its "belong-to-me aspect" and suddenly assumes the function of a screen. . . . The veil of representation actually conceals nothing; there is nothing behind representation. Yet the fact that representation *seems* to hide, to put an arbored screen of signifiers in front of something hidden beneath, is not treated by Lacan as a simple error that the subject can undo. . . . Rather, language's opacity is taken as the very *cause* of the subject's being, that is, its desire, or want-to-be. The fact that it is materially impossible to say the whole truth—that truth always backs away from language, that words always fall short of their goal—*founds* the subject. . . . The subject is the effect of the impossibility of seeing what is lacking in the representation, what the subject, therefore, wants to see.[25]

This desire becomes narcissism when the subject believes, in Copjec's words, that its "own being exceeds the imperfections of its image. Narcissism . . . seeks the self beyond the self-image" and is thus "the source of the malevolence with which the subject regards its image" (Copjec 37).

So far, this account of Lacan has focused on what appears to be a transhistorical analysis of the cultural constitution of subjectivity, and therefore an analysis that has predictably been accused of being "essentialist." I will suggest shortly that its transhistorical claims are reflexively qualified, but apart from that the accusation seems to me to be trivial because any approach to cultural variability and historical specificity presupposes a transhistorical, or universal—or synchronic—framework of hypotheses on which to plot a narrative of diachronic changes.[26] Given Lacan's polemical, theoretical, and methodological project focused on the revision of the Freudian framework, he is hardly obliged to make this diachronic move. Nevertheless, the Lacanian framework by no means opposes or prevents it; on the contrary, the idea that the unconscious is a language, and, more specifically, a discourse network, encourages receptiveness to cultural variability and enables diachronic interpretation. It displaces the subject of psychoanalysis from predominantly psychobiological to predominantly psychosocial and psychocultural patterns of change, from an "essentializing" interplay of ontogenetic with phylogenetic structures to a relativizing interplay of psychogenetic with sociogenetic discourses.

Perhaps I should interject at this point that I have little interest in trying to justify or be faithful to Lacanian psychoanalysis, or to explicate it

for its own sake. Were I to do so I would have to take into account the impact on his theorizing of the wry, allusive, conspicuously cryptic, and comically competitive discourse that, by representing itself as the performance of "the one supposed to know," mocks both the performer and the establishment in a sustained act of orthopsychic mimicry. (I would have to consider, for example, the deconstructive effect of such hilarious meta-communications as the following, in which a comment appropriate only for those present at a lecture is transcribed for, and thus transposed to, the reader: "I don't know whether you can see the blackboard, but as usual I have marked out a few reference-points.")[27] Such a task is neither relevant to my topic nor within my competence. My interest is less in "the subject" per se than in the effect of particular media and apparatuses on the dynamics of self-representation. Hence my designs on Lacan are confined to selective appropriation of "moves"—relatively (if not fully) isolatable sets of formulations—that help me get a purchase on some of the conceptual knots by which any approach to questions of self-representation is complicated. And it goes without saying that I have a particular stake in Lacanian moves that seem to intersect and illuminate a diachronic analysis focused on changes produced by new technologies in the structures of self-representation. These are the moves to be considered in the pages that follow.

Lacan states that the composite diagram "enables us to glimpse how the subject . . . is caught, manipulated, captured, in the field of vision" (92):

> [I]n the scopic field, the gaze is outside, I am looked at, that is to say, I am a picture.
>
> This is the function that is found at the heart of the institution of the subject in the visible. What determines me, at the most profound level, in the visible, is the gaze that is outside. It is through the gaze that I enter light and it is from the gaze that I receive its effects. Hence it comes about that the gaze is the instrument throught which light is embodied and through which—if you will allow me to use a word, as I often do, in its fragmented form—I am *photo-graphed*. (106)

Kaja Silverman has seized on the divided last word as a point of entry into a historicizing revision of what she reads as Lacan's essentialism: "Even in his deployment of the photographic metaphor, Lacan resists historical periodization," for the division of the term suggests "that, if the camera is an appropriate metaphor for the gaze, that is because it models or schematizes

its objects within light. This is a definition of photography which strips it of most of its apparent specificity."[28] This reading is in itself arbitrary and dubious, since Lacan's arch reference to "a word . . . in its fragmented form" directs attention to the power of the linguistic signifier and thus to the double meaning of "graph" as both visibility and legibility; such moves encourage one, as Copjec argues, to ponder the difference between the optical and semiotic approaches to visibility and visuality.

Nevertheless, the project that motivates Silverman's interpretation is suggestive. She distinguishes the gaze as transhistorical structure from the image/screen as a historical variable, a category that "makes possible a historical and social specification of gaze, subject, and object, and opens the way for an account of the subject's limited agency with respect to the representations through which he or she is apprehended" (175). And she designates the modern version of the image/screen as "camera/gaze" because, "due to its association with a 'true' and 'objective' vision, the camera has been installed ever since the early nineteenth century as the primary trope through which the Western subject apprehends the gaze" (135). Whatever the merits of her long account of the hegemony of the camera/gaze, the notion itself suggests to me that since the early modern scopic regime I have been describing is dominated by new graphic technologies of representation, it may appropriately be called the graphic gaze, giving "graphic" all the specifying attributes explored in my discussion of the graphic mode in Chapter 1. Indeed, my contention is that Lacan's analysis already posits something like the graphic gaze as the form of the early modern scopic regime and takes into account its influence both on the construction of subjectivity and on the psychoanalytic discourse of the subject. I shall now try to support this contention by considering Seminar XI together with the early mirror-stage essay.

The gaze that presides over "the dialectic of objectification with the other" produces the orthopsychic (and singularly masculine) ego ideals through the kind of Lochinvar assembly line, or bildungsroman, described by Lacan as "the succession of phantasies extending from a fragmented body-image to a form of its totality" that he calls "orthopaedic—and, lastly, to the assumption of the armor of an alienating identity."[29] It is "in the Other that the subject is constituted as ideal, that he has to regulate the completion of what comes as . . . ideal ego" and thus to "constitute himself in his imaginary reality."[30] Since it is therefore impossible for the subject ever to coincide "with the real being from which representation cuts

it off," orthopsychic desire generates a counter-desire for what is missing, for the unrepresented, for what is sup-posed or trans-posed, for the subject thrown under its appearances and annihilated by representation.[31]

The term *orthopsychic* may in some respects overlap the term *exemplary*. Both can designate images of correct psyche, soul, or personality, representations of ego ideals, and both may be used indifferently to denote images that provide icons of identification.[32] But "orthopsychic" adds to "exemplary" the connotations of the narcissistic complementarity between the ego ideal and "the self beyond the self-image." "Orthopsychic" denotes what is given to be seen when that giving loses or absents or conspicuously excludes the giver and seer. To replace "exemplary" with "orthopsychic" is to bring to bear on the analysis of self-representation the structural dynamics of a Lacanian story that has something in common with the story told by Elias: because the gaze is internalized in the construction of the orthopsychic ego, what lies within this alienating identity becomes the hidden, or the hiding; *homo clausus* announces itself in the "suspicion of dissimulation."[33] "The effect of representation"—or is it the effect of the effect-of-representation?—is "the suspicion that some reality is being camouflaged, that we are being deceived as to the exact nature of some thing-in-itself that lies behind representation. In response to such a representation, against such a background of deception, the subject's own being breaks up between its unconscious being and its conscious semblance" (37).

It shouldn't be surprising to find formal similarities between the genesis and structure of *homo clausus* as theorized by Elias and the Lacanian notion of "the real being" hidden behind its orthopsychic semblance. Both, after all, respond to a common Freudian precursor and advance the hypothesis that psychogenesis entails schismogenesis. But there are more substantive reasons for the similarity, and they call for a more roundabout explanation.

When Lacan modifies the Freudian biography and topography of the psyche, he does so in terms not only of specular figures but also of figures drawn from sculpture, theatrical spectacle, chivalric warfare, "geometral" perspective, and painting. In the mirror-stage essay, the figure of "le stade" is shifted from one kind of stage to another—from Freudian narratives of epigenetic and instinctual development to scenes of mimetic and competitive performance. In Seminar XI, tropes that signify self-representation and self-alienation are based on paradoxical features of the perspective system developed by Alberti, Brunelleschi, and their contemporaries, while

the scopic triangulation of subject, observer, and gaze is parabolically explored in an account of representations mediated through painting (and "stained" by the paint). Commenting on the anamorphic skull in Holbein's *The Ambassadors*, Lacan expressly situates the source of his own figurations in early modern visual practice and technology: "at the heart of the period in which the subject emerged and geometral optics was an object of research, Holbein makes visible for us here something that is simply the subject as annihilated—annihilated in the form . . . of castration."[34]

The particularizing effect of this parade of signifiers has been minimized:

> Lacan's mirror stage has been misconstrued by literalist attempts to render it inseparable from the experience thereby implied: an infant's recognition of its own shape in the apparatus of a mirror. Lacan never intended to link the appearance of a human ego to a looking glass, nor even to the fact that—like Narcissus—an infant could see its reflection on the surface of a body of water. The scenario of the infant at the mirror is the index of something that has always occurred, with or without that apparatus: the mirror serves as a metaphor and a structural concept at the same time that it points to a crucial experience in psychic development. . . . Anika Lemaire says that by viewing the process of humanization in mirror-metaphor terms Lacan eschews the problem of ethnological and historical relativity.[35]

But how could this carefully selected apparatus and signifying medium fail to make a difference—precisely the difference of historical relativity? It fails only when the mirror is treated as a metaphor rather than as a metonymic or indexical sign of the set of changes of which it is part, and which it mediates. Lacan's child looks at its image not in a lake but in a product of specular technology, and what it sees is described as a kind of "statue": the mirror image "appears to him above all in a contrasting size (*un relief de stature*) that fixes . . . [the form of his body] and in a symmetry that inverts it."[36]

Just as Lacan's "stade" is not an epigenetic phase but a site of performance and self-representation, so, I repeat, the mirror is not a lake. Not merely because it is vertical rather than horizontal and its surface is rigid rather than ripply (a ripply surface would distort or fragment the body and frustrate Lacan's visualization), but because it is specifically constructed to provide virtual space for the activity and product of self-representation. As such, it is a relay point for multiple mediations. In the

register of iconic signs, it provides the medium within which originals may encounter their virtual doubles. In the register of symbolic and indexical signs, it is an always latent and sometimes manifest mediator of a history that has made mirrors possible and desirable commodities. Such a history would cite the improvement of glass- and mirror-making during the early modern centuries—the centuries Lewis Mumford calls "eotechnic" ("the dawn age of our modern technics")—as one of the reasons why large mirrors "became relatively cheap and the hand-mirror became a common possession," and why,

> for perhaps the first time, except for reflections in the water and in the dull surfaces of metal mirrors, it was possible to find an image that corresponded accurately to what others saw. Not merely in the privacy of the boudoir: in another's home, in a public gathering, the image of the ego in new and unexpected attitudes accompanied one. The most powerful prince of the seventeenth century created a vast hall of mirrors, and the mirror spread from one room to another in the bourgeois household. Self-consciousness, introspection, mirror-conversation developed with the new object itself.[37]

But perhaps the mirror didn't produce this epidemic of vanities all by itself. If it stands for, it surely doesn't exhaust, the expanded range of technical mediations that include the other techniques of representation, communication, and exchange alluded to in the rhetoric of Lacan's analyses. For example, he depicts the child as negotiating between the "virtual complex" that consists of "the image and the reflected environment . . . and the reality it reduplicates—the child's own body, and the persons and things around him."[38] What it "sees" is not solely a self-image but a more comprehensive and organized scene, pehaps something like a family portrait. A couple of sentences later, the scene is further particularized when he describes the child leaning forward to inspect its mirror image and being "held tightly . . . by some support, human or artificial (what, in France, we call a 'trotte-bébe')": a securely constrained little person in a localized and well-appointed world.[39] Does this constraint contribute to "the turbulent movements that the subject feels are animating him" (2) as he observes and inclines toward the "total form of the body" in the mirror? The shadowy presence of nurse, mother, or father (probably the mother?) hovers about the actual and reflected scenes either attached to, replaced by, or replacing the manufactured apparatus of support.

Freud's account of autoeroticism and primary narcissism is thus resituated in a comfortable bourgeois setting that visualizes "*an identification*, in the full sense that analysis gives to the term: namely, the transformation that takes place in the subject when he assumes an image." This assumption, Lacan continues, "would seem to exhibit in an exemplary situation the symbolic matrix in which the *I* is precipitated in a primordial form, before it is objectified in the dialectic of identification with the other"— the very form "that . . . will also be the source of secondary identifications" (2). The scene, that is, displaces, condenses, visualizes, and dramatizes in the episodic medium of the Imaginary a process that is Symbolic, temporal, discursive, and dialectical. The scenic signifier misrepresents ("represses") what it signifies, and Lacan's account flags the misrepresentation by blurring the express relations of temporality, priority, and succession.

The rationale of this confusion has been trenchantly captured by Jane Gallop:

> The infant is thrown forward from "insufficiency" to "anticipation." However, that "insufficiency" can be understood only from the perspective of the "anticipation." The image of the body in bits and pieces is fabricated retroactively from the mirror stage. It is only the anticipated "orthopedic" form of its totality that can define—retroactively—the body as insufficient. Thus the impetus of the drama turns out to be so radically accelerated that the second term precedes the first,

and this precession simultaneously produces the subject's fantasy of orthopsychic paradise (identification with the ideal ego) and its expulsion into the permanent anxiety of narcissism (desire for the ego ideal).[40] Although it appears that "the internal linear progression of the drama leads to rigidity"—the rigidity figured in "the armor of an alienating identity"—Gallop argues that from the retroactive standpoint "it is rigidity that produces irreversible chronology" (86). The arbitrariness of the submission to this fate is hinted at when Lacan writes of the *Gestalt* of the mirror image—in a passage that flaunts the confusion of temporal relations—that it "symbolizes the mental permanence of the *I* at the same time as it prefigures its alienating destination; it is still pregnant with the correspondences that unite the *I* with the statue in which man projects himself, with the phantoms that dominate him, or with the automaton in which, in an ambiguous relation, the world of his own making tends to find completion."[41]

This arbitrariness, however, is not predicated of the individual agent or subject, as if s/he had a choice in the matter and could avoid alienation by remaking the world. Rather, "the world of his own making" signifies at once the arbitrariness and the rigidity of the sphere of cultural production and representations. That is the source of the particular structural and technological preconditions that make it possible not only for Lacan to formulate but also for the subject to "have" or go through a mirror stage. Lacan's critique of biologism or epigenesis is sharpest when signifiers of art, skill, and performance saturate passages that purport to be dealing with issues of representation and identification at the level of primary process—as when, in the mirror-stage essay, he begins by referring to the infant's assumption of the "specular image" (2). This dramatizes the extent to which nature is saturated by cultural signifiers, and primary process, by sedimentations of art and technology deposited in and as the cultural "real": the extent to which—even in the specular "*infans* stage"— the mirror image is "the source of secondary identifications" and "situates the agency of the ego, before its social determination, in a fictional direction" (2); the extent to which the Imaginary and its phenomena are preposterously displaced and condensed visualizations—genealogical backformations—of the Symbolic order and its discourse networks.

So, for example, literacy makes it "natural" to learn behavior by the book among those who have the means and motivation to do it, and thus it works to destabilize and redefine the traditional understanding of naturalness as the expression of processes that transcend human power or intention. Elizabeth Eisenstein argues that printed books setting forth more precise behavioral codes and roles "duplicated in a standardized format, conveyed by an impersonal medium" and "internalized by silent and solitary readers," helped create "a collective morality. . . . Type-casting in printers' workshops thus contributed to new kinds of role-playing at home." But, she continues, it wasn't only the "'middle-class' morality" of Protestant households that was affected:

> "Upper-class" etiquette . . . was [also] fixed in a new way in the sixteenth century. The behavior of boys and girls became subject to rules and regulations which were not really new . . . but which became more difficult for parents and teachers to ignore. . . . Children were instructed not only how to be "correct" in their general conduct, table manners and apparel . . . but also, in really remarkable detail, just how they must convey by their comportment and facial expression that they were well

bred. After reading about all the ways one's eye movements and eye-
brows must be controlled . . . and going on to learn what one should
do with one's cheeks, lips, limbs, one would expect to find that an
increased self-consciousness would set off the early-modern from the
medieval sensibility.[42]

Learning to behave becomes learning to perform behavior. The more in-
formal acculturation entrusted to agencies of primary socialization and
implicit pedagogy is both supplemented and challenged by the mimesis
of visual and verbal representations of behavior that develops in contexts
of secondary socialization and explicit pedagogy.

If the new models render more apparent the conventional basis of "na-
ture" and "breeding," and the premeditated basis of spontaneity, in tech-
nologically mediated fictions and texts, they must also render apparent the
spectral back-formation of *homo clausus*. "The assumption of the armor
of an alienating identity" becomes, in the dialectic of this scopic regime,
the aim of the narcissistic pursuit of orthopsychic mimesis, a pursuit
shaped by the conventions of mimetic idealism. Or, putting it the other
way round, physiognomic skepticism, which presupposes and interrogates
a tradition of physiognomic realism, is the historical form narcissism takes
in this regime. "It is not for nothing," Lacan remarks, "that it was at the
very period when the Cartesian meditation inaugurated in all its purity
the function of the subject that the dimension of optics that I . . . distin-
guish here . . . was developed."[43]

"[S]eeing myself vividly portrayed by your art will provide me with a continual stimulus to purge my soul of its many defects, and seeing therein the illuminating rays of your genius (*virtù*) will kindle in my soul a noble longing for glory and honor." Claudio Tolomei understood very well what Sebastiano del Piombo could do for him. . . . [T]he portrait was not only to be drawn from him; it was also to be imposed on him to fix him as a moral being amid all the conflicting contingencies of existence. . . . This hoped-for portrait would establish him firmly and significantly as a worthy man. . . .

Such a portrait is reductive.[1]

8

FICTIONS OF THE POSE (1): THE FICTION OF OBJECTIVITY

Giving oneself to be seen; assuming the armor of an alienating identity; admiring and desiring the enhanced integrity and stature of the specular image: these phrases are as applicable to the motives for portraiture as they are to their original psychoanalytic contexts. This, as I have been arguing, is not because portraiture dramatizes or allegorizes transhistorical psychoanalytic process but because the terms Lacan uses to depict primary processes of narcissism, identification, and desire are terms that historicize psychoanalysis, terms borrowed from a graphically based regime of technologies of representation and from the secondary processes in which it intervenes.[2] Commissioning and posing for one's portrait are acts of self-presentation (which of course may include a gesture of conspicuous consumption), an intentional act in which one gives oneself to be seen in a semblance offered to others as an image possessing at least a core of specular truth. But as I argued in the Introduction, one never simply, unconditionally, presents oneself. Rather, one presents oneself *as*—as a sitter of a certain sort, and the "sort" is determined by a differential system of social conventions or discourses correlated to a differential system of poses. "A sitter of a certain sort" denotes a ready-made cultural interpretation, a prefabricated representation of, say, a noble, a merchant, a matron, a general, a patriarch, a marriageable daughter. To present oneself as any of these is not merely to perform it but to interpret oneself through it, and the painter in turn presents the portrait as an interpretation of this act.

In the foregoing discussions of mimetic idealism, *homo clausus*, and the orthopsychic relation, I tried to give a rough sketch of the general condi-

tions and the problematic of self-representation during a period in which technologies of representation underwent significant change. My objective was to establish a framework congenial to a particular method of reading portraits, a method trained on the complex negotiations visible in an image that pretends to record the results of a sitter's decision to seek, with the painter's help, the armor of an alienating exemplarity. Both the framework and the method are intended to generate accounts that can motivate, not merely describe, effects of exemplarity and physiognomy. The leading question, then, is this: what interpretive premises would we have to presuppose in order to read portraits as orthopsychic fictions that exceed mere exemplarity because they implicate—and may be visually disturbed by—representations of the unrepresented, and because they dramatize physiognomic skepticism? The string of premises that follows composes into a kind of prolegomenon because it enables us to be clear about just what it is a portrait does and doesn't represent—clear, in other words, about the connections and disconnections between the actual and the represented contexts of portrayal.

In normal practice, a portrait presupposes a desire and decision to be portrayed. If we read the sitter's image in the light of that assumption, we make the further assumption that the portrait signifies the act of portrayal that produced it. This in turn generates a third assumption, which is that the portrait not only signifies but also represents its cause. It is an image of the act of portrayal that produced it. Perhaps I should say that it represents *an* act of portrayal, since the image of the sitter posing for the painter couldn't be assumed by the sitter's contemporaries—and shouldn't be assumed by us—to be a faithful copy of the actual event. We know, for example, that painters worked from casual observation, from other paintings, from portrait miniatures and medals, and from verbal descriptions. And even if we assume that painter and sitter were present to each other our fantasies of what was likely to have taken place during the production of the image lead us to premise that the image may screen out or disguise or distort many details of the actual productive process. Consider, for example, interruptions, substitutions (of another's body), and changes of design: if we take these to be generic concomitants of normal practice, our awareness that they are unrepresented doesn't dispel them. Rather it places them in reserve, marks them as conspicuously excluded, and the effect of this move is to throw into sharp relief the fictiveness of the represented situation.

What actual posing is like can be grasped from the following anecdotes reported by Lorne Campbell:

> A bored sitter obviously presents problems and not all portraitists were able to paint and at the same time to keep the sitters entertained. In 1494, Cardinal Ippolito d'Este informed his sister Isabella that it was only for the love of her that he would submit to the tedium of sitting. . . . Isabella herself found the patience involved in staying still so much of an annoyance that she resolved in 1511 never again to make the sacrifice of sitting for her portrait. In 1516, she wrote that "we no longer wish to endure that boredom of staying patient and sitting for our portrait." Vasari was conscious of the "melancholy" frequently found in portraits of abstracted sitters and claimed that "while Leonardo was painting Mona Lisa's portrait, he engaged people to play and sing, and jesters to keep her cheerful and remove that melancholy which painting usually gives to portraits."[3]

It is both revealing and amusing to read Vasari's anecdote in the light of Pope-Hennessey's remark that the *Mona Lisa* results "from protracted ocular analysis."[4] Of many of Rembrandt's introspective portraits it could be said that the sitters may well be thinking sad or deep thoughts but that they may just as well be displaying the patience and resignation demanded of sitters by a painter who works slowly and laboriously, who is indeed famous for taking a long time to finish his portraits. To imagine this leads one to suspect that a note of reflexive parody may interrogate the gravity of the pose without in any way reflecting adversely on the sitters. And this fantasy may also prompt one to take seriously the merely practical turn Vasari gives to the term "melancholy," which he uses to denote not a humoral disposition or dominant character trait but a reaction to the boredom of sitting.

In order to include such imaginings in an interpretation, it would be necessary to begin with the theoretical premise that what a portrait represents, what it is about, is as much the act of sitting and painting, the act of portrayal, as it is the sitter's outward likeness and inner being. This is admittedly a deflationary hypothesis, one that involves giving up claims to deeper psychological insight or more densely historical knowledge. In this simple form, however, it is not a plausible hypothesis, since the evidence cited above suggests that the image we see should not be assumed to be an icon, a visual likeness, of the actual activity of posing and painting that produced it. Rather, it can only be an icon *if* we stipulate that it visualizes

an act of posing different from the one that (we imagine) actually took place. This stipulation converts the image to an icon that only *pretends* to deliver the act of posing it resembles, an icon that represents a fictive rather than an actual act of posing. Within that pretense and fiction, the image presents itself as an indexical icon, one that purports to denote by resemblance the act of portrayal and posing that produced it. We grant that its indexical iconicity is probably misleading: the image indexes a *normative* act of portrayal rather than the normal or actual process we imagine. In terms of what we assume about the actual painting and posing process, the portrait gives us a selectively abstracted and idealized image of posing. It creates a referential illusion. What it pretends only to reflect and refer to is in fact something it constitutes.

This is true of all traditional or pre-photographic portraits. Photography, Silverman reminds us, "conventionally requires the physical presence of an object in order to produce an image of it."[5] In painting, that convention is much weaker; the "object" need not—and may or may not—have been physically present. Instead, painted portraiture conventionally presents itself as *pretending* that the "object," the sitter, was physically present at and a contributor to the productive act—pretending that the object was drawn, as seventeenth-century Dutch writers expressed it, *nae t'leven*, "from life." Walter Melion's indispensable commentary on the 1604 *Schilder-Boeck* makes it clear that Karel van Mander and his contemporaries appreciated both the fictiveness and the ideological force of the *nae t'leven* claim:

> Picturing *nae t'leven* involves recording something seen at the moment of viewing it. The term specifies neither the medium nor the object of imitation, defining an image rather by reference to the cognitive process coeval with the act of representation. Works of art, like the things of nature, may be imitated *nae t'leven*. . . . [D]rawings *nae t'leven* can serve as models for subsequent campaigns of drawing *nae t'leven*. This is so because the process is mediated not by what is recorded but by the simultaneity of seeing and recording. . . . [W]orking *nae t'leven* conferred immediacy guaranteeing the documentary value of an image.
>
> As *nae t'leven* joins picturing to the process of seeing, *uyt den gheest* is a cognitive term, attaching picturing to the process of visual memory. . . . Besides stocking memory with visual impressions, drawing after life is essential to portraiture.[6]

On the one hand, to make an image appear to have been recorded "at the moment of viewing it" is to confer documentary value on it. On the other hand, to designate an image as a portrait is to affirm that it was drawn from life and thus has documentary value.[7]

To the extent that these effects are acknowledged as pretense or fiction, the image, the putative product or effect of normal practice, becomes the producer or cause of the normative practice it represents, so long as we view it under the convention of mimesis, in which to represent is to produce the resemblance of an original. In this mimetic formula the phrase "resemblance of" has referential force: it denotes the absence and prior existence of whatever object it represents, whether the object be an act, a figure, a scene, or anything else. In the case of portraiture the mimetic object and referent is not merely the person whose figure is represented but the act of portrayal, the three-way diachronic transaction between painter, sitter, and observer, the scene of posing and painting that comprises, as I noted in Chapter 2, the most representable of the dispositive stages of the apparatus—emulation, preparation, and production. Hence the basic fiction of portraiture is that the image we see reflects and records the way it was produced. We mark it as fictive because we recognize that since it may not have been produced that way, the image *constitutes* what it pretends only to reflect; its representation of the anterior act of portrayal, and of the motivational and ideological *dispositifs* of the apparatus that the act implies, is fictional. This is the basic plot, scenario, or fiction of early modern portraiture, and I call it *the fiction of the pose.* Its claim is that the sitter and painter were present to each other during the act of painting; that the painter is not only the delineator of the pose but also the sitter's first observer; that the sitter did in the studio (or wherever) what she or he appears to be doing in the portrait; and that in posing before the painter he or she was projecting the self-representation aimed at future observers.[8]

I am only giving a name to this scenario. Leonardo and his contemporaries invented it. The best way to grasp the significance of the invention—the way suggested by Martin Kemp in his book on Leonardo—is to contrast Leonardo's parade of caricatures to his painted portraits (figs. 3 and 4).[9] Kemp remarks on the artist's predilection for "satirically grotesque drawings of bizarre characters . . . particularly those of a narrative nature," and on his interest in searching "for extremes of physiognomy and expression"—the heroic as well as the satiric. "By these means he commanded an inexhaustible parade of characters, each evoking through

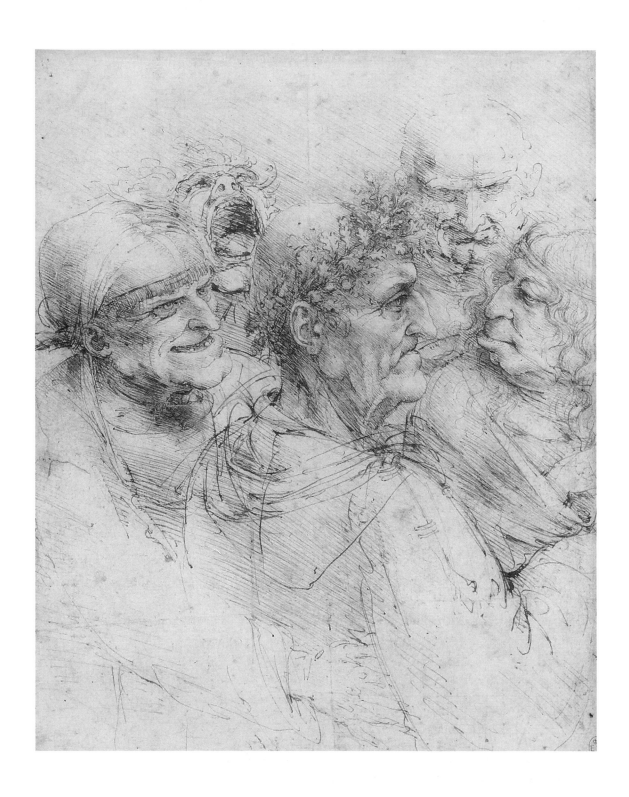

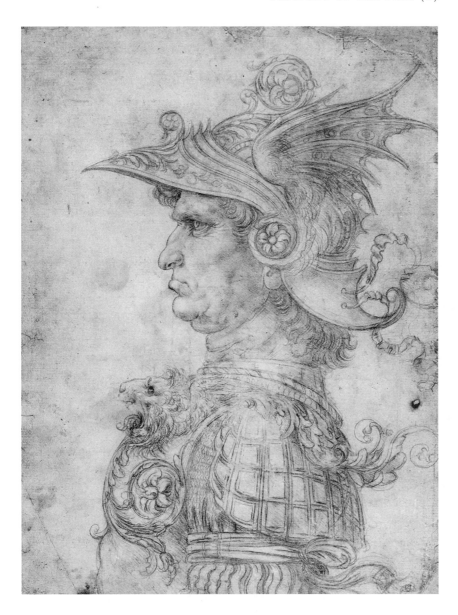

FIGURE 3

(Opposite) Leonardo da
Vinci, *Five Grotesque
Heads*. Pen and ink.
Royal Library, Windsor.

FIGURE 4

(Left) Leonardo da Vinci,
*Profile of a Warrior with
Helmet and Cuirass*.
Silverpoint on prepared
paper. The British
Museum, London.

its facial 'signs' an 'air' expressive of its inner temperament" (156, 159).
Whether these studies were gratuitous and self-delighting or sketches for
such projects as the *Last Supper*, *Adoration*, and *Battle of Anghiari*, they
depict precisely the convergence of physiognomic with melodramatic
simplification that the surviving portraits so melodramatically renounce—
though they don't renounce it without offering such hints as the picto-
nymic juniper and the ermine in the portraits of Ginevra Benci and Ce-

cilia Gallerani, without teasing observers to reach for one or another clue to a recognizable "inner temperament" and lineal identity.[10]

As generic statements, the portraits dramatize physiognomic skepticism. They take exception to the rule that the way to represent the face as an index of the mind is for painters to help sitters reduce themselves to symbols or impersonate exemplary historical figures or use emblems and visual puns like juniper and ermine that reductively equate a female sitter's "identity" with—or subordinate her "inner temperament" to—her lineage. Under this rule, the semblance produced by the more or less accomplished mimesis of a corporeal presence indexically transforms that presence, the referent of the semblance, from sitter to model. That is, the person who posed for the picture becomes, through its representation, little more than the quasi-anonymous bearer of allegorical, dynastic, and narrative (or textual) meanings; a dead image:

> The pose assumed by the figure should . . . be a very important concern, and only those attitudes that are calculated to enhance its dignity and gravity will be suitable. At the same time the symbolic character of the work should exact a note of abstraction and impassivity in the rendering of the face of the sitter. Unless he be endowed with unusual beauty, a detailed study of his features might necessitate the recording of physical defects that detract from the purity desirable in a symbol, and the evocation of individual moods would tend to reveal just those marks of personal feeling that stress the humanity of a man rather than the remoteness of a superior being.[11]

The "real" face/mind relation of a model, as opposed to that of a sitter, is irrelevant noise. Its absence, entailed by the model's theatrical function, may of course be inscribed in any sitter as the defining condition of the subject in representation, but I don't think this helps us much with Leonardo. Something is conspicuously withheld; an absence presents itself. But if the charged and explicit manner with which he enhances the anonymity of his sitters represents that absence as a problem for the observer, it shifts attention from the absence embedded in being-in-the-world to the absence embedded in being-in-the-pose. Leonardo thus offers us a critical standpoint from which to view the ideological pressure imposed on portraiture by contexts of patronage that encourage the equation of physiognomic identity with exemplarity.

Kemp argues that in the Mona Lisa Leonardo was "playing upon . . .

our irresistible tendency to read facial signs of character in everyone we meet" (fig. 5). The sfumato that prevents "the physiognomic signs" from constituting "a single, fixed, definite image" arouses and frustrates the desire to read the face as the index of the mind. What is new and important in the portrait, Kemp insists, is the "communicative liaison" it establishes, the representation of ongoing scopic encounter in which "she reacts to us, and we cannot but react to her."[12] To this I add that if the Mona Lisa has always made observers conscious of her consciousness of posing—conscious, in the Lacanian formula, of giving herself to be seen—the fiction of the pose reminds us that the sitter's first (external) observer is the painter.

Imagine, then, that she is watching the painter paint her. The turn of the body and barrier of the arms seem a little guarded at the same time that the understated modeling of the hands makes them appear relaxed, as if they had been in the same position long enough for her to have forgotten about them. The expression on her face bears traces of a similar tendency toward relaxation, but one that is being patiently, obligingly, and benevolently resisted. To view the sitter as if she is being portrayed in the act of being portrayed is to sense a protracted and very slightly strained or wearied but courageous attempt to continue looking at the birdie and continue saying "cheese."

When, however, we shift roles and imagine that the observer rather than the painter is the sitter's partner in scopic interaction, everything changes. Now the product of the protracted effort of posing and painting conforms more closely to Cecil Gould's sense of "regal relaxation," "superb confidence and tranquillity," but veiled by the attitude of "prolonged equivocation" or, in Kemp's phrase, the "knowing reticence" of expression Leonardo achieves by ambiguating "the crucial clues" to physiognomic apprehension.[13] The difference between these two scenarios is evidence of a scopic encounter at once so ambiguous in its cues and so sharply particularized in its functions (being painted versus being observed) that its range of possible meanings changes. In this interpretive moment a subject supposes itself and makes observers aware that it lurks behind representation.

A portrait that problematizes the mimetic and referential functions patrons value is a portrait that comments on its own genre:

As he worked year after year upon . . . [the Mona Lisa], the portrait of an individual was transformed into an essay about portraiture. The poet

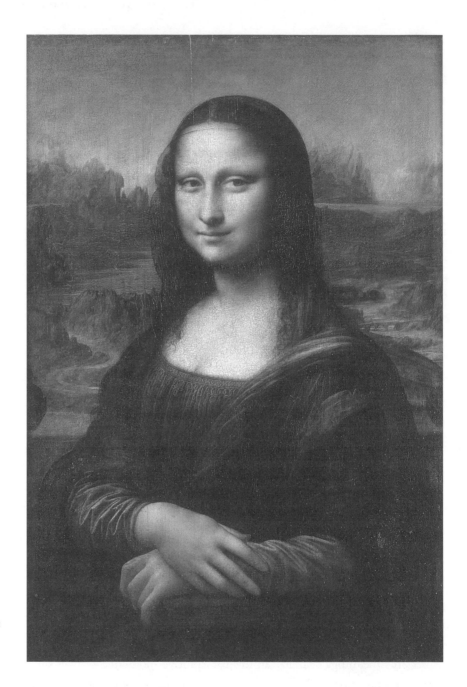

Leonardo da Vinci, *Mona Lisa*, 1503. Oil on wood. Musée du Louvre, Paris.

Bellincioni describes Cecilia Gallerani as "seeming to listen but not
to speak," and of the Mona Lisa that is also true. In neither case was
Leonardo concerned directly with psychology, but in both the working
of the brain was reflected in the immanence of movement in the face.[14]

Whether or not Mona Lisa seems to be listening, she seems to be waiting
patiently for something to finish. The poet's perception blends nicely with
Vasari's anecdote. But where Vasari thought music and jest were respon-
sible for the smile, Gould, with the partiality of his sex, blames it on Leo-
nardo's good looks and the lady's inclination to flirt:

> The famous smile anticipates prolonged equivocation and seems to
> welcome it. She is attracted by the painter, and knows enough of his
> reputation to be confident her own will not suffer. And if, in the event,
> rumor has belied him, or her charm were strong enough to prevail
> against even that defence . . . , well, so much the better.[15]

The romance of the *Mona Lisa*, which has been going on for nearly
half a millennium, testifies to the success of devices that hide the mind's
construction from the face. Leonardo accentuates the drama of scopic in-
teraction by making the fiction of the pose conspicuous enough to oc-
clude the kind of access to inner truth that physiognomy promises. The
indexical cues to the sitter's temperament, status, or emotional state are
obscured by another set of indexical cues, those that focus attention on
the sitter's reaction to painter and observers. It is part of the portrait's ef-
fect and message to dramatize the obscuring of the first set of cues. This
portrait, which is without identifying emblems or attributes, which ab-
jures the inert likeness of a family portrait, and which also abjures the
kind of background that would support a historical or religious event and
delimit the meaning of the expression—this portrait seems totally dedi-
cated to representing the hiddenness and complicating the drama of the
posing consciousness.[16]

A painting that makes palpable the presence of observers to the sitter
expresses a theatrical or rhetorical intention to pose. No equivalent of the
candid camera, no voyeuristic disclosure, is possible here *except* within the
context of deliberate self-representation. It will be obvious to anyone fa-
miliar with Michael Fried's *Absorption and Theatricality* that I am beginning
to trespass on his property, since I am concerned here with a version of the
contrast he draws between theatricality and absorption. By absorption

Fried means the representation of figures in "the state or condition of rapt attention, of being completely occupied or . . . absorbed in what [they are] . . . doing, hearing, thinking, feeling."[17] Absorption implies inattention to, or the absence of, the observer, and for Denis Diderot, on whose opinions Fried centers, this unself-conscious spontaneity guarantees the truthfulness of representation: "The state of our soul," he wrote, "is one thing, the account we give of it, to ourselves and others, is another" (91). Thus if the painter wants to persuade beholders that the body they see is a true index of its mind, he will also have to persuade them to accept the fiction of their absence or nonexistence as beholders. Diderot and his contemporaries were made uneasy by the "inherent theatricality" of portraiture, the constitutive conventions of which "call for exhibiting a subject, the sitter, to the public gaze; put another way, the basic action depicted in a portrait is the sitter's presentation of himself or herself to be beheld."

This formulation corresponds exactly to what I refer to as the fiction of the pose, and it raises the question whether it is possible, as Fried puts it, for the portrait painter "to *detheatricalize beholding* and so make it once again a mode of access to truth and conviction" by constructing "a new sort of beholder . . . whose innermost nature would consist precisely in the conviction of his absence from the scene of representation" (104). Fried's "once again" reflects Diderot's desire, shared with "anti-Rococo critics," to return to a mode of representation (Poussin and Raphael are Diderot's examples) in which individual figures and "the painting as a whole" declare their "unconsciousness or obliviousness of the beholder" (100–101). But the reference to "a new sort of beholder" suggests a slightly different implication, which is—as Margreta de Grazia has pointed out—that the desire for absorption arises as "a response to the belief that the viewer is somehow being cheated by all the theatricality or artifice (that something is being concealed or betrayed by it)."[18]

De Grazia rightly discerns the danger I tried to skirt in Chapter 5, namely, that my emphasis on the emergence of physiognomic skepticism seemed to indicate that there was "some earlier period (never precisely designated or illustrated) in which . . . viewers were duped into thinking that no artifice was involved: that outer would lead . . . naturally and prediscursively to inner." She observes rather that "such an expectation emerges *after* the [early modern] phenomena" I have been discussing, "that is, precisely in Fried's Age of Diderot." And while I think I have been careful not to claim that there was a mythical earlier age when all *viewers* were naive,

her cautionary remarks suggest that it is important to restate and empha-size, in the terms she provides, the argument developed in the preceding chapters: theatricality, posing, as a paradigm of normative behavior be-comes more central—becomes a thesis and a problem—when people are coopted to resort to new technologies to perform or represent themselves. This produces an anxiety about what "is being concealed or betrayed by" theatricality, and a desire to uncover "some bedrock essence beneath the pose that can only be made accessible if no one is watching." The dilem-mas de Grazia articulates are those of representation anxiety and ortho-psychic desire.

Fried is careful to note that the terms of his contrast are developed in response to a particular discursive context, and perhaps for that reason they don't quite work for me as they stand. If the fiction of the pose as I've defined it is basic to portraiture, then so is theatricality. From the premise that the portrait indexes an intentional act of portrayal, it follows that absorption can only be a variation on, or a conspicuously posed re-jection of, the fiction of the pose. Theatricality is not to be set over against absorption *tout court*, for there is—and given my premises, there can only be—*a theater of absorption*, which, by implication, is to be set over against a theater of theatricality. The absorption that neutralizes the presence of the observer must therefore be construed as *posing so as to appear not to be posing*. The pictorial evidence suggests at least two different versions of this scenario: the voyeuristic fiction of candor (as in "candid camera"), posing so as to appear otherwise engaged and oblivious of being painted or observed; and the fiction of distraction, posing so as to make it appear that after setting up to be portrayed and observed, one's body holds the pose but one's mind has wandered.[19]

These variations or counterplots of the normative fiction appear with great frequency in Dutch painting, especially where portraiture verges on genre, and genre on portraiture, and some of the most complex perfor-mances are those of Vermeer and Rembrandt.[20] I shall return to them in Part 3, but my interest in the present discussion is in still another variation that transgresses Fried's categories: it is possible for a sitter to appear "un-conscious or oblivious of everything but the object of his . . . absorption" and to make it appear that this object is precisely his "consciousness of be-ing beheld."[21] The presence of the observer, far from being neutralized, is fundamental to this fiction: the sitter preemptively offers herself or himself as an object of attention, indeed, an object rewarding attention, and in this

respect the pose is theatrical. But while conspicuously posing, the sitters enacting this fiction just as conspicuously avoid eye contact. The looks they solicit go unreturned; the spectators they acknowledge go unrecognized.

Paradoxically, this theatrical refusal to engage or interact with spectators may serve a detheatricalizing function if it stages a corresponding refusal to try to control response by "feignings or impostures addressed to the beholder."[22] The sitter might then appear to entrust to the painter the task of objectively portraying features in a manner that guarantees transparent "access to truth and conviction." For reasons that will soon emerge, I call this *the fiction of objectivity*. I distinguish it from the fiction of distraction by noting that in the latter the sitter's look tends to appear unfixed or unfocused, while in the fiction of objectivity it tends to appear fixed, as if responding to the instruction not to move. In the three-quarters view, the sitter's look is fixed away from the observer, to the left or to the right. But there is also a more engaged frontal variant of the fiction of objectivity in which the eyes are expressly averted; and another in which the sitter looks fixedly in the observer's direction but seems to stare—vacantly, or impassively, or complacently, or disdainfully (fig. 6).[23]

The aim of the signifiers of absorption in Fried's account is to neutralize the position of empirical beholder in order to constitute "a new sort of beholder," an observer position founded on the conviction of its "absence from the scene of representation."[24] The signifiers of objectivity in early modern portraiture produce a different effect: they serve to make the face the index of exemplary value, the transparent embodiment of "ideals of public virtue" presenting itself for the observer's admiration, veneration, and edification. Since it does the work of holy icons, classical statues, and ancestral masks, the exemplary portrait doesn't want to neutralize the observer. On the contrary, it represents a figure that presents itself to be looked at but refuses to return the favor. Remember the less famous of Walter Benjamin's two definitions of aura: "To perceive the aura of an object we look at means to invest it with the ability to look at us in return."[25] The aura is strangely enhanced when the object is invested with that ability precisely in order to dramatize its refusal to use it. Then the sitter's look dies into the gaze.

The two sources from which art historians derive the early modern portrait suggest why this is so: history paintings, on the one hand, and, on the other, such commemorative images as the death mask, the sculptured portrait bust, the relief profile, and the medallion. As to the former, I have

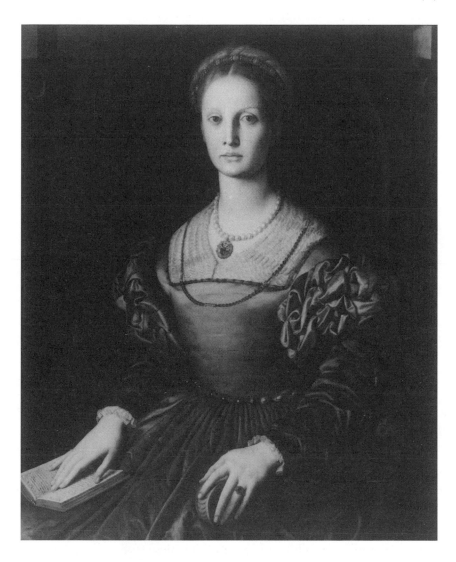

FIGURE 6

Agnolo Bronzino, *Portrait of Lucrezia Panciatichi*, ca. 1540. Oil on wood. Galleria degli Uffizi, Florence.

in mind not only donor portraits in religious and other narratives but also the later development described by Johannes Wilde when he remarks that because "the new portrait of the Cinquecento was a creation of monumental painters, not of specialists . . . you no longer have a record of each individual feature, no longer a map of every wrinkle in the face," but rather a totalizing impression that conveys social position, profession, character, and personality.[26] The effect of monumentality and restraint is to distance the image and discourage the observer from coming up close to get a better view of what Vasari calls "the coarseness of living bodies."[27] In terms of the conflict built into the general thesis of mimetic idealism,

this entailed—according to contemporary writers on art—a double conquest of nature. First you conquered nature in the sense that you mastered natural appearances through the science of art; then you conquered it (or her) in the sense that you produced more perfect images than nature did. This internal contradiction has been well articulated by Summers, who argues that the achievement of "naturalism," the ability systematically to reduce imitated forms "to their optical elements," opened up the possibility of the "aesthetic determination of relationships" that "would finally transform and overthrow naturalism itself."[28]

Turning from history painting to the other source of the portrait, the commemorative image, we can see the same logic at work. Correcting the defects of nature, transcending the coarseness of living bodies, doesn't mean merely touching them up to idealize them. On the contrary, the discourse of art from Alberti to Vasari betrays its commitment to violence against nature—to the necessity to flay, dissect, and dismember natural bodies in order to reconstruct them on a better model. Death in nature— the death *of* nature—is the prerequisite to the glorified state of the body resurrected by art. Again and again in Vasari's *Lives*, the rhetoric of resurrection, with its promise of a life *ultra naturam*, is displaced to an ideology of artistic creation based on fantasies of violence *contra naturam*. If such fantasies don't apply directly to the case of the exemplary portrait there are other senses in which the production of the orthopsychic subject may be said to be born out of death. We can see this in what may be (next to the death mask) the extreme version of the fiction of objectivity, the profile view (figs. 7–10).

In 1965, Rab Hatfield published an analysis of a famous set of Florentine male profile portraits that have in common the failure to "convince as representations of the actual physical structure of human faces"—they seem rather to represent relief sculpture—and he noted that "any real sense of intimacy is defeated by the profile view and by the remote flatness of the face." Claiming that the logic of their design conveys primarily a sense of aesthetic stasis, he suggested that the ledges in the portraits may be associated with funerary symbolism.[29] David Rosand subsequently developed this idea, connecting the ledge to antique funerary conventions, and arguing that it can signify either a posthumous portrait or else a *memento mori*.[30] Rosand unfortunately harps on the memento mori theme— unfortunately, because by concentrating on that universal elegiac message he deprives himself of a more context-specific interpretation, one in

FIGURES 7, 8, 9, 10

(Opposite, top left) Florentine, fifteenth century, *Matteo Olivieri.* Tempera on wood, transferred to canvas. National Gallery of Art, Washington.

(Opposite, top right) Veneziano (?), *Profile Portrait of Michele Olivieri (?).* Tempera on wood. Private Collection.

(Opposite, bottom left) Florence, fifteenth century, *Profile Portrait of a Young Man.* Tempera on wood. National Gallery of Art, Washington.

(Opposite, bottom right) Paolo Uccello (?), *Profile Portrait of a Young Man.* Tempera on wood. Musée des Beaux-Arts, Chambéry.

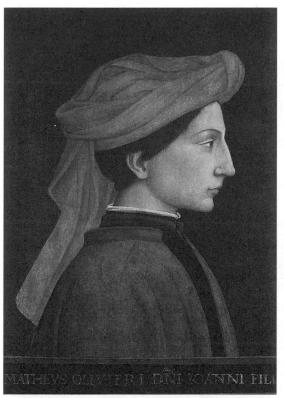

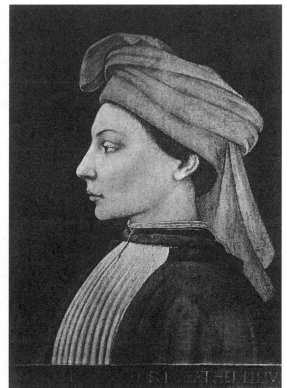

MATHEVS OLIVTER I DNI IOANNI FIL

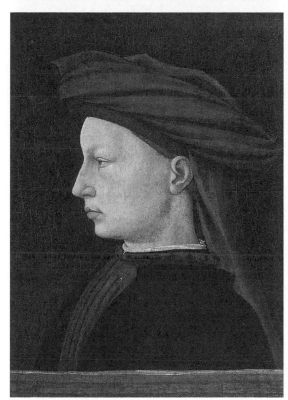

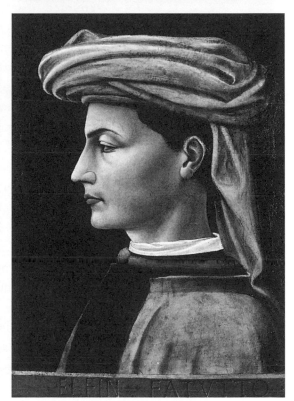

ET FIN FATV FIO

which the relation of the portrait to the sitter is neither *posthumous* nor—forgive the coinage—*prehumous* but *inhumous*, that is, a death buried, preserved, and represented in the portrait itself, a death signified by the fiction of objectivity.

Hatfield gets us closer to this meaning when he concludes from his survey of the subjects of several profiles that they "made notable contributions to society and . . . in several cases can be held to have died for its sake."[31] (This is a euphemism; according to the evidence he cites, some were murdered, and not in recognition of their altruistic public service; but the euphemism suggests the kind of work being done by the profiles.) He notes that it is not known whether the profiles were painted posthumously or from life, but he claims that it doesn't matter because everything in the portraits conspires to abstract the semblance from the particularities of physical appearance and encounter: the remoteness of the profile view, its defeat of intimacy, the "ordered beauty" that "seems the fixed condition" of the sitters' "being," and the sacrifice of likeness on the altar of exemplarity (318)—together, these features signify that when the look dies into the gaze, when "the stuff of life" is evacuated, and the bodily site prepared to receive the objectivity of an ikon, it matters little whether or not the sitters were alive since they *are* inhumed in the portrait like the skeleton beneath Christ in Masaccio's *Trinity*.

These examples of the fiction of objectivity suggest to me that there may be other options besides reducing its meaning either to mere exemplarity or—with Rosand—to the pathos of the *memento mori* theme and its corollary, the immortality conferred by art.[32] For we can imagine that Hatfield's examples are representations of the fictions of the pose, and that the different sitters are depicted following a common set of instructions guaranteed to stencil their profiles into a fashionable portrait stereotype evocative of values associated with classicizing relief in marble or metal.[33] The images tell us that each sitter agreed to place himself sideways before a dark back-cloth, fix his gaze firmly and unblinkingly ahead, look as grave and dignified as possible and hold as still as possible for as long as possible, so that the painter could convert his likeness into a stylized icon. In the four reproductions assembled on a single page by Hatfield the effort of posing is registered in different ways and with varying degrees of intensity. In every case, holding as still as possible is visualized as demanding a little attention—or even tension. The jut of the chin, the arc of the jaw line, the taut stenographic curve of the eyebrow, and the touch of shading

between jaw and cheekbone, act together with the tiny angular slash (the hint of compression) at the corner of the mouth to indicate proprioceptive awareness of holding the pose. This effect is reinforced by two other indications: the sitters' determined resistance to the backward slip or pull of their capes and collars, and their evident need to negotiate with the complex volume, position, and relative weight of the variously angled turbans they balance on their heads, which is another reason for sitting very still.[34]

Such signifiers of attentiveness are translatable into expressions of the orthopsychic desire to transcend what is, from the standpoint of exemplarity, the natural or defective or fragmented self-image which that standpoint relegates to the category of the nonexemplary. Several meanings of the term *objective* characterize the effect of this fiction: thinglike, inanimate; impartial, detached; impassive, not swayed by nor displaying emotion; seen from the outside, the object of others' attention. Embodying the gaze, disdaining the look, the orthopsychic subject aspires to exchange his merely natural and sullied flesh for a glorified body of paint, to pass through the looking glass into the pure ideality of an ikon. It is as an ikon, an other (not a self), that he gives himself to be observed, admired, commemorated, and venerated. This is the fiction of objectivity, and it is possible to see it only as an exemplary reduction, an idealized mimesis. But if signifiers of attentiveness are interpreted as signifiers of *the attempt to achieve objectivity*, the exemplary becomes the orthopsychic.

So much, then, for the orthopsychic *he*. But how about the orthopsychic *she*? What Hatfield did for the male profile in 1965 Patricia Simons did for the female profile in 1988, in an important essay from which I quote the following excerpts (figs. 11–14):

> Like nuns and donors, the women portrayed in profile are displayed and visible objects . . . inactive objects gazing elsewhere, decorously averting their eyes.

> A woman, who was supposedly vain and narcissistic, was nevertheless made an object in a framed "mirror" when a man's worldly wealth and her ideal dowry, rather than her "true" or "real" nature, was on display.

> The paradoxical rendering visible of invisible virtues, available to the visual medium as it was not possible in social reality, meant that artistic representation was a contribution to rather than a reflection of social language or control. A woman's painted presence shares with cultural values of the time an ideal signification.

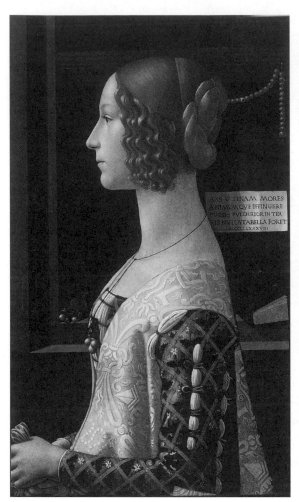

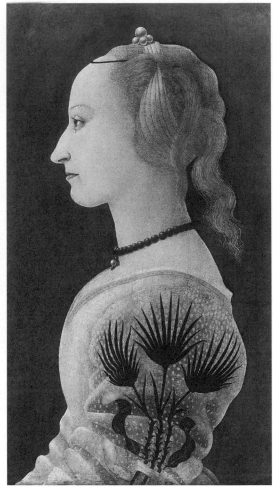

FIGURE 11

(Left) Domenico
Ghirlandaio, *Portrait of
Giovanna Tornabuoni,*
1488. Mixed media on
wood. Museo Thyssen-
Bornemisza, Madrid.

FIGURE 12

(Right) Alesso Baldovinetti,
Portrait of a Woman (profile),
ca. 1460. Tempera on
wood. National Gallery,
London.

When . . . Verrocchio or Leonardo . . . carved or drew Alexandrine
heroes in profile, they elaborated masculinity by way of solid helmets
and breastplates even more three-dimensional than the faces which are
also modelled in some relief. But Florentine female profiles tend to
appear on unstable, spindly bases. . . . The vulnerable and elegantly
artificial neck . . . separates the face from its already insubstantial
body. . . . In these mostly anonymous profile portraits, face and body
are as emblematic as coats of arms.[35]

Though the portraits of both men and women seem to be committed to
reproducing recognizable likenesses, those of women tend to be less
mimetic and more idealizing than those of men, and thus their mode of
objectivity differs: as heraldic reifications, "carriers of a 'dowry of virtue,'"

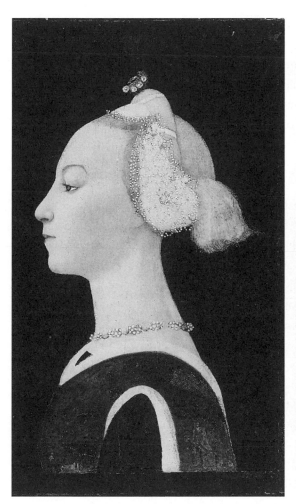 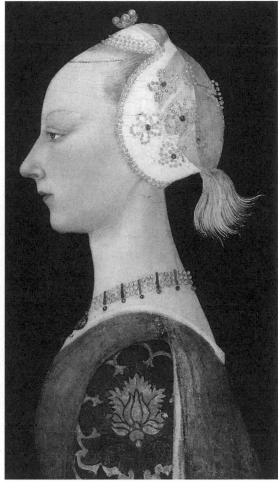

the women were, like their portraits, "primarily objects of a male discourse which appropriated a kind of female labor or property."[36]

Simons's account would seem to grant her sitters only an invidious form of exemplarity and thus to refuse them orthopsychic depth. Nevertheless, apart from the fact that her description of the sitters "decorously averting their eyes" is redundant for the profile (in which the visible eye is always already "averted"),[37] it contradicts her characterization of them as "inactive objects," and moves one to wonder whether there is *homo clausus* in woman, or at least in women painted by male painters for female as well as male upholders of patrilineal order and patriarchal power. Of the seven profiles Simons reproduces, no fewer than three of them contain details that suggest the sitter's preparation for or awareness of pos-

FIGURE 13

(Left) Master of the Costello Nativity, *Profile of a Woman.* Tempera on canvas, transferred to wood. The Metropolitan Museum of Art, New York.

FIGURE 14

(Right) Paolo Uccello, *Young Lady of Fashion.* Tempera on wood. Isabella Stewart Gardner Museum, Boston.

ing.[38] Even if we grant that profiles of women are in general more heraldic, more fully objectified, more reductively exemplary, and that their armor of alienating identity is not theirs but the agnatic lineage's, we still need a different explanation from the one Simons gives, for hers is restrictively focused on the power of the male-dominated lineage to violate the orthopsychic rights of women.

I would like to shift the emphasis to the context of male desire and anxiety that attends this violation. To banish the traces of the female sitter's *homo clausus* from representation is to elide the female subject who participates with male patrons and painters in the collaborative production of her image. In this, as Simons suggests, the female profiles only hyperbolize the situation of their sitters in life. But note that the elision of the female subject does not amount to elimination. Rather it is part of a self-scotomizing discourse in which males exile the subject, get her out of sight, and, with her cooperation, displace her to an excluded, unrepresented, sphere, the autonomous—and therefore independent and unpoliced—sphere of the silenced partner. There is a wonderful example, an enactment, of the collaborative production of this sphere, to which I shall now briefly digress. It occurs in a passage in Castiglione's *Cortegiano* that throws light on some of the issues implied but not spelled out by Simons.

In Chapter 3 I briefly mentioned the strategy of displacement by which Castiglione's speakers converted their commonplace injunctions about the importance of learning the arts—painting, writing, music, dancing—into advice about producing oneself as a work of art. But I passed over the production of gender difference, a topic that has received much attention from literary critics, cultural historians, and art historians during the last three decades. Elizabeth Cropper and Sharon Fermor, for example, have shown how ideals of feminine deportment depicted or described by (male) painters and writers, and inscribed in dance movements, reflected more general assumptions about proper behavior. In her comments on the ideological import of such "aesthetic categories . . . as *leggiadria*," Fermor notes that women were expected to show their worth "through naturalness and simplicity, in which the artifice was nonetheless assumed. The woman who danced with *leggiadria* was thus staging, or representing, her naturalness and reserve."[39] When the discourse of the *Cortegiano* suggests that such "staging, or representing," moves from art to life it activates the

logic of the Pygmalion myth in its Ovidian version, the logic expressly put into play in Book 3 by Giuliano de' Medici as he prepares to described the ideal *donna di palazzo*, which he calls "mea creatura." But the unsettling consequences of transferring the Pygmalion function to the agency of actual women have already been intimated in the first book, in the passage I referred to above. "All women have a great desire to be— and when they cannot be, at least to seem—beautiful," Count Ludovico di Canossa proclaims out of his wisdom, and he goes on to discuss the proper method of painting the face.[40] He praises the grazia of a woman "who paints (if at all) so sparingly and so little that whoever sees her is uncertain whether she is painted or not." But he is most impressed by one who, "not ugly, is clearly seen to have nothing on her face, it being neither too white nor too red, but has her own natural color, a bit pale, and tinged at times with an open blush from shame [*vergogna*] or some other mishap [?—*accidente*], with her hair artlessly [*a caso*] unadorned and in disarray, with gestures simple and natural, without showing effort or care to be beautiful. This is that careless [*sprezzata*] purity most pleasing to the eyes and minds of men, who are ever fearful of being deceived by art."[41] One wonders why the example of "vergogna" is given, and what some other "accidente" might be, and by the time one reaches the adjectival form of *sprezzatura*, one wonders whether this isn't as artful a performance of nature as the ideal courtier himself is capable of. "Sprezzata" reminds us that men respect and admire such skillful dissimulation as much as they fear it, and that women who have learned their lesson well are to be desired and admired and doubly feared (and therefore doubly desired, and triply feared) for their ability to conceal the truth behind a veil of physiognomic self-dramatization.

The veil gives back to men the fantasy they have inscribed on woman's body and mind through the discourse in which they persuade women to alienate and embody the fantasy so that the ideal courtier, like Pygmalion, may see himself limpidly reflected in the female counterpart he creates. But of course the men know that the women know how to wear the veil, embody the fantasy, and withdraw behind the mirrors they make of themselves. As the count adds new examples, his rhetoric conveys the connoisseur's smug and sagacious mystery of women's ways, but at the same time it betrays a frisson of pleasure at the possibility of being duped by an artlessness he knows is artful. His account of the proper way for a woman to let her hands and legs be seen registers this confusion. In the

following passage, which does he admire more, the spontaneity of disclo-
sure or the calculated theatricality of the performances that display it?

> The same is true of the hands which, if they are delicate and beautiful,
> and are uncovered [*mostrate ignude*] at the proper time, when there is
> occasion to use them and not merely to make a show of their beauty,
> leave one with a great desire to see them more and especially when they
> are covered with gloves again; for whoever covers them seems to have
> little care or concern whether they are seen or not, and to have beautiful
> hands more by nature than by any effort or design.
>
> Have you ever noticed when, in passing along the street to church or
> elsewhere, in play or through whatever cause, it happens that a woman
> raises just enough of her dress that she unwittingly shows her foot and
> often a little of her leg? Does it not seem to you to possess the greatest
> grace, if she is seen at that moment in a certain elegant feminine
> attitude, dressed in velvet shoes and dainty stockings. Certainly to me
> it is a pleasing sight, as I believe it is to all of you, because everyone
> thinks that such elegance of dress, when it is where it would be hidden
> and rarely seen, must be natural and instinctive with the lady rather
> than calculated, and that she has no thought of gaining any praise
> thereby.[42]

Since "mostrate ignude" strongly implies an act of exhibition ("displayed
in the nude"), it frustrates the attempt to insist on the polar opposition be-
tween unintended display and "per far vedere la lor bellezza," reducing it
to the difference between the sprezzatura of successfully masked exhibi-
tionism and *affettazione*, or failed sprezzatura.

In the second paragraph, the studied casualness produced by the re-
peated disjunctions—"o per le strade andando alle chiese o ad altro loco,
o giocando o per altra causa"—is transferred through "accade che" to the
act of display, which is carefully enough measured ("tanto della robba,"
"just so much of the dress") to suggest that "unwittingly shows" ("senza
pensarvi mostra") may be part of the act. Thus the message the lady
beams through the count's description is, "I have no thought of gaining
praise by this conspicuously unintentional exhibition of desirable body
parts." In his fantasy of her self-representation, the dissolution of the po-
larity art vs. nature, or calculation vs. spontaneity, constructs an aporetic
barrier behind which unpenetrated or undecidable motives materialize in
the form of the hiddenness and mystery of woman's mind. The con-
struction, however, is troubled by two of the definitional aspects of sprez-

zatura I discussed in Chapter 3 above, the *sprezzature* of nonchalance and of suspicion: (1) the ability to show that one is not showing all the effort one obviously put into learning how to show that one is not showing effort; (2) the ability to show that one is not showing what one really desires, feels, thinks, and means or intends. The first forces its way through the count's description and raises the question of what it is—art or nature—that he admires. But the second, which he ignores, raises more serious questions. The mysterious *she* who makes her face the index of *his* mind by withdrawing behind the mirror that reflects his fantasy becomes the tain of the mirror, the ghost in the machine, the secret agent in the black box—a Pygmalion, perhaps, in her own right.

The *she* produced in this gendering of *homo clausus* is not a prediscursive she but the creature of the male's discourse, the unrepresented self or subject position produced as the logical effect of his representation of her self-representation. The more effortlessly and dutifully and skillfully she performs his conception of female sprezzatura, the more the unrepresented *she* materializes as the hidden agent to stir up renewed desire and anxiety, renewed efforts to penetrate the veil: "a movement back and forth between the representation of gender (in its male-centered frame of reference) and what the representation leaves out or, more pointedly, makes unrepresentable. It is a movement between the (represented) discursive space of the positions made available by hegemonic discourses and the space-off, the elsewhere, of those discourses."[43]

In Renaissance Italy, the social and economic importance of women in the alliance strategies of oligarchic or aristocratic lineages is clearly indicated by the attention their members paid to dotal rituals and negotiations, and more particularly by the way the female members of the lineage were mobilized to police the social perimeter and position of women newly inducted through marriage.[44] I use the verb "police" advisedly because these practices are essentially constraints deployed to protect lineal investments in the marriage market, and the wifely embodiments of the investments unfortunately—from the standpoint of dotal strategies if not of personal sentiment—have wills and desires (and kinfolk) of their own, properties often caricatured or scapegoated in literature and defended against in the admonitory genres of *cassone* and boudoir decoration. The female sprezzatura described by Count Ludovico is all the more seductive to its narrator because it is a safely domesticated genre of self-representation. It is the portrait of a Lady, that is, the portrait of a woman who has learned how to

please and tease and perhaps dominate men while playing by the rules of a man's game in a man's world.

Such representations bring to the surface the concern that underlies the ritual precautions mentioned above and remind us that they reflect a pervasive discourse of male anxiety, anxiety directed toward what may be going on in the hidden reserve de Lauretis calls "the space-off." This may help account for the peculiar qualities of the female profiles so astutely analyzed by Simons. The profiles are caricatures of the portrait of a Lady. The most rigorously reified examples celebrate a cosmetic fantasy that denies the sitter her share in its production; a fantasy so intent on excluding her signs of life and will, the traces of *homo clausus*, as both to express and to parody male anxiety about the space-off. When we frame the profiles within the fictions of the pose, those signs and traces occasionally glimmer through details that convey the sitter's attempt to cooperate with patron and painter by freezing her features in place and performing the fiction of objectivity. It's in such performances that orthopsychic desire breaks through the screen of exemplarity and adumbrates the space-off hidden somewhere in *le dessous* behind the image of someone who gives herself to be seen.

FICTIONS OF THE POSE (2): REPRESENTING
ORTHOPSYCHIC DESIRE

Up to this point, I have been trying to show that if one approaches early modern portraiture through the fictions of the pose, one is in a better position to attend to "the content of the form," as Hayden White calls it—a better position, that is, to integrate sociopolitical and even, to a limited extent, psychoanalytic interpretation into the practice of formal analysis literary critics call "close reading." Since my examples of close reading have so far been limited in both quantity and scope, I shall devote the remainder of Part 2 to more detailed interpretations of a few portraits that play games with the fiction of objectivity.

Let's begin by returning to our friend Cardinal Mezzarota, or Trevisan (fig. 1), and recalling what the art historian says about him: with its evocation "of a Roman bust" and its "ironical compression of the mouth," the painting "does full justice to the Cardinal's stern and resolute character"; "although the portrait is objective"—his word, not mine—it "does more than record the Cardinal's features, for it suggests the strength of will, the severe habit of command, the disillusioned experience of affairs that had stamped the countenance of this exceptional sitter."[1] Examining some of the features that contribute to the overall effect will help us see if they support this account of the sitter's character, at least within the confines of the fiction of the pose. The first thing to notice is that the eyes are steadfastly fixed on a spot above and to the left of the observer. Second, the discreet foreshortening reinforces this look by positioning the observer below the head. Third, the tight circumflex of the mouth, corresponding to what Lightbown calls "compression," is accentuated by the incised ar-

rislike furrows curving down to the chin- and necklines. These lines, be-
cause they seem to be folds rather than wrinkles, indicate an effort to tuck
in the chin. Fourth, there is a subdued clash between the graphic mime-
sis of sculptural treatment (in texture, contours, and linear incision) and
the painterly infusion of pink tones about the cheeks and eyes; there's an-
other between the stiff vermilion mantle and the optical or tonal vibra-
tions that animate the finely pleated white shirt. Lorne Campbell argues
that the three-quarters view together with the treatment of detail and
light suggest that Mantegna may have been influenced by Flemish por-
traits to "look anew at Roman portrait sculpture and to produce classiciz-
ing adaptations of a Netherlandish portrait type."[2]

When we frame the image within the fiction of the pose, these four
features—the first three more obviously than the clash between graphic
and painterly handling—work together to put a peculiar spin on Light-
bown's physiognomic analysis: the character he flatly ascribes to the his-
torical sitter is transformed into an impression the sitter in the portrait
tries to perform. The scenario indexed by the pose may be phrased as the
sitter's instruction to the painter: "Let's do our best to dramatize gravitas,
to turn me into a Roman hero, to make me look monumental, grand,
warlike, exemplary, to make my face the index of a mind intent on con-
trolling what the face reveals about the mind." The fourth feature can
now be seen to reinforce this effect: the mingling of stylistic tendencies
associated with Northern and Southern practices provides an interpretive
code, in which the optical, transitory, nonsculptural passages associated
with Netherlandish painting set off the Romanizing of the head, and the
contrast marks it as an intentional performance, an effort to freeze the
pose in a classical attitude that accords with the preestablished scenario.

Pope-Hennessey uses the portrait to prove his point that Mantegna's
commitment to the antique was too academic and inflexible: for Man-
tegna, the sanction of ancient art "was absolute; it must be transcribed and
not transposed."[3] But the standpoint of the fiction of the pose produces a
different reading: the effect of the antique is transposed to a sitter who
stages it, gives it to be seen, strives to camouflage himself in it, and reveals
the effort by an attitude that isn't entirely comfortable. This portrait can-
not be classified simply as an official portrait because its focus is on the ef-
fort to perform official portraiture, the ongoing and not yet secure project
of seeking refuge in the marble sanctity of the surface of art. When
Lightbown claims that the portrait "is objective in that there is no attempt

to render mood or expression," he means no attempt by the painter. But what about the sitter? A little torquing will turn the statement toward the cardinal: he doesn't appear to be engaging potential observers with a display of mood or expression aimed in their direction. Rather, he appears to trust his face to an interpretation that confers on it the objectifying metaphor of the Roman bust, with its connotations of an achieved and fixed identity appropriately commemorated in durable stone or marble. It is the effect of objectivity that the sitter, cooperating with the painter, and discernibly conscious of being beheld, strives to perform, and it is, in turn, this performative project that the portrait dramatizes.

Notice how our focus on the fiction of the pose affects the kind of question we put to the portrait. We no longer have the brass to pop the physiognomic question, What is the nature of the mind indexed by the face? or, What does the portrait tell us about the sitter's mind, personality, essential nature, and so on? The question now becomes, How can we isolate the means by which a portrait represents the effort of painter and sitter to make it appear that the face is the index of the mind, regardless of the content we assign to the mind? To pursue this line of questioning is to forgo the attempt to translate the essential nature into a particular description. It is, instead, to search for the pictorial conventions that signify, not the essential nature, but the intent to reveal it. And as I suggested, this intent is best signified by formal devices conventionally associated with the effect of objectivity. In my variation on Fried's absorption formula, these are devices that make sitters appear "unconscious or oblivious of everything but" their "consciousness of being beheld." Sitters who cultivate exemplary objectivity do so by refusing eye contact: disdaining the look enables them to embody the cultural gaze. As Mantegna's portrait reveals, this format allows surprisingly complicated images, and by the middle of the sixteenth century Mannerist variations on the fiction of objectivity produce remarkable effects. I turn now to the work of a painter whose subtly subversive experiments in the fiction of objectivity are among the most haunting and compelling I know.

Pope-Hennessey writes that in the sixteenth century "the Medici showed an almost morbid interest in self-perpetuation, which resulted from a sense of dynastic insecurity," and he goes on to document this with a reference to the way Baccio Bandinelli's historical statues of the Medici, commissioned by Cosimo I, reveal the patron's "bias in favor of a class of portrait that was durable, timeless, and detached." This bias was what

"commended Bronzino to Cosimo I": "He approached the human features as still life. If the ducal physiognomy had to be reproduced in painting and not just in the impassive art of sculpture, this style was the least undignified."[4] A similar effect, the substitution of ivory for flesh, accentuates the objectivity of Cosimo's wife and son in Bronzino's great double portrait (pl. 1), and commentators respond primarily to this effect: Eleanora's "face appears unnaturally pale, smooth, shiny and hard, and her eyes are less luminous than the pearls of her necklace." The eyes are not translucent but "merely lustrous," and she is made "to resemble a highly finished carving of ivory with eyes of semi-opaque gems." This is from Campbell, who also notes how the sky "pales to an area of almost pure blue pigment around her head, as though she were emitting light like a haloed saint in a religious image."[5] Another critic centers on the way the still-life rendering of the dress "accentuates the inanimate quality" of the pose; "the Duchess is as rigidly armed as her husband" in the other portrait.[6]

The emphasis on the formal indicators of objectivity picks out an important aspect of the painting, but it isn't so much Bronzino's subject as it is his target. That is, the painting stages objectivity not to sanctify it but to interrogate it. I think you begin to sense its strangeness when you imagine yourself doing something you can't easily do in the Tribuna, the little room of the Uffizi in which it is hung, namely, move back and forth on a perpendicular shuttle in order to respond to its pushes and pulls. If the rigid armor of Eleanora's gown, pose, and stare warn you to keep your distance, the warning is motivated, intensified, by the powerful attractive force of the still-life detail tempting you to violate the barrier and touch the idol. The smoothness produced by Bronzino's self-effacing brushwork is occasionally, and conspicuously, interrupted by passages of textured pigment that roughen those areas of the panel on which the gold brocade patterns of the gown are painted. Unlike the decorative accents in medieval devotional panels and altarpieces, these passages do not fix attention on the preciousness of the actual support that symbolizes the value of the religious context within which the icon functions. Rather, they pass through the graphic window of representation to enhance the sensuous and tangible quality of illusory fabric. In Sydney Freedberg's view, "the garment makes a meaning of pure frozen ornament that seems separable from and more significant than the person it contains"—and Freedberg finds it characteristic of Bronzino that he "is always more penetrating in his interpretation of male than female sitters."[7] But this is to overlook the

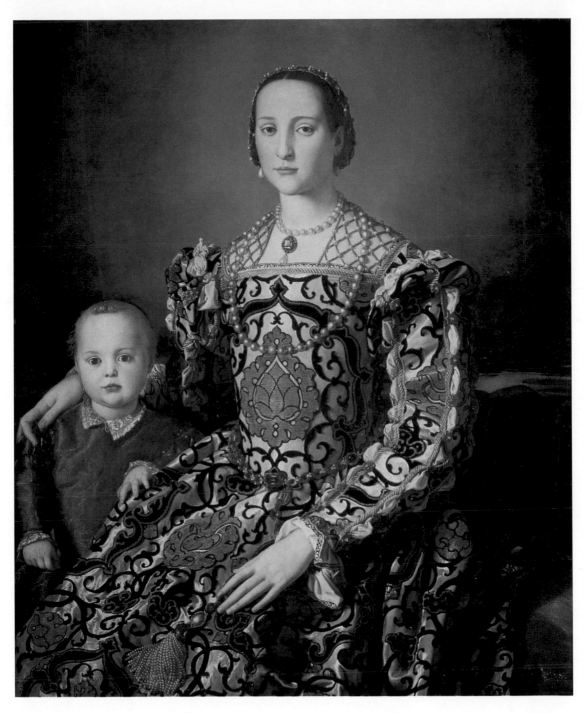

Agnolo Bronzino, *Eleonora of Toledo and Son*, 1546. Oil on wood. Galleria degli Uffizi, Florence.

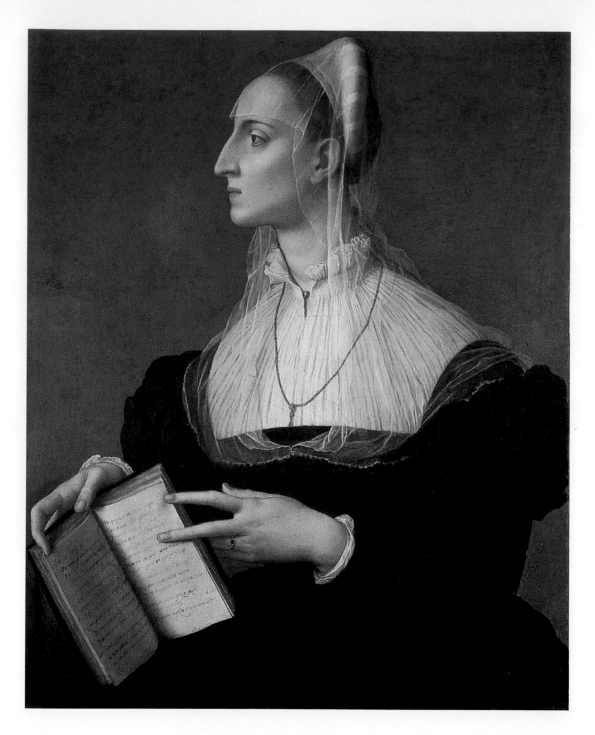

Agnolo Bronzino, *Portrait of Laura Battiferri*,
1560. Oil on wood. Museo di Palazzo
Vecchio, Florence.

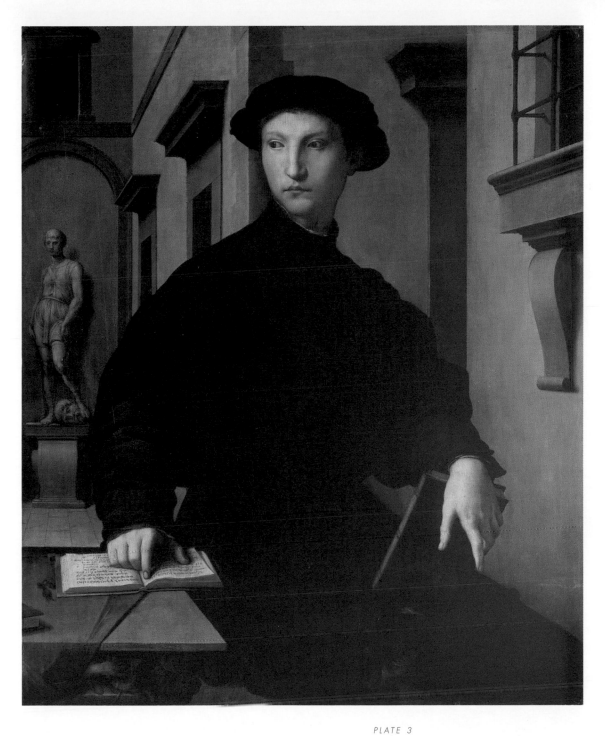

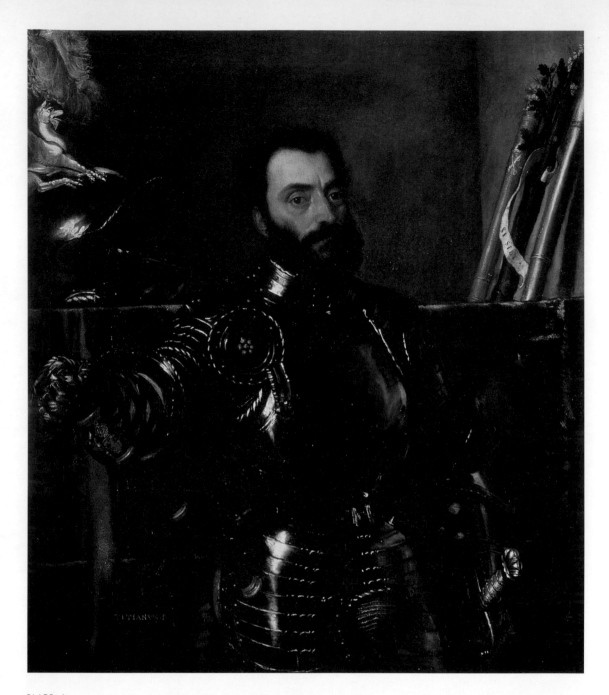

Titian, *Portrait of Francesco Maria della Rovere*, 1536–38. Oil on canvas. Galleria degli Uffizi, Florence.

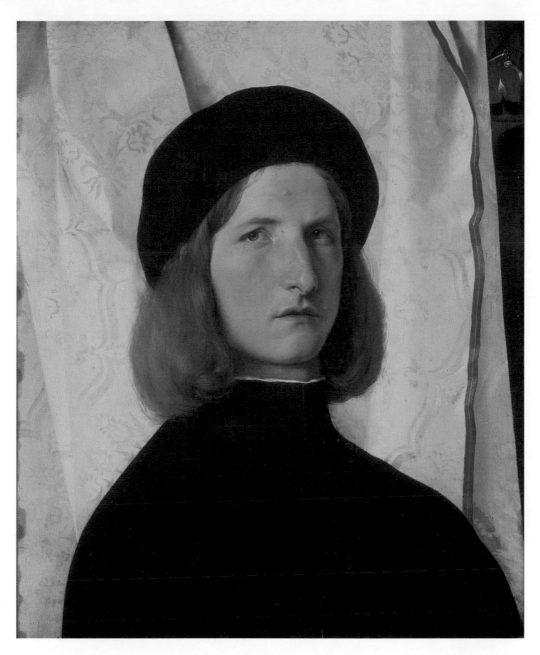

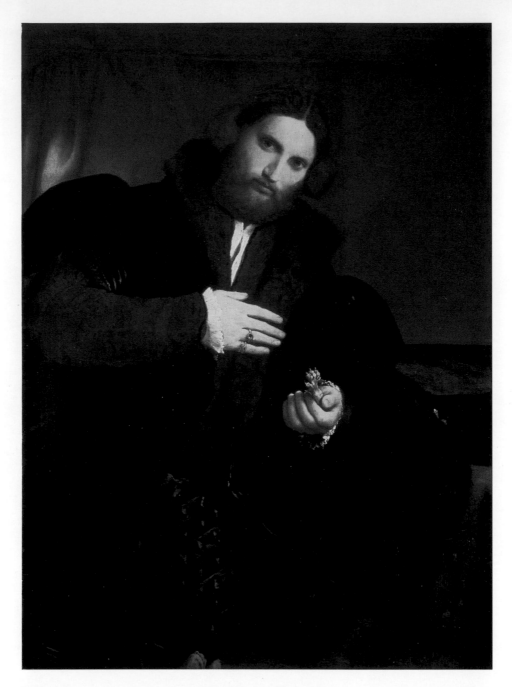

PLATE 6

Lorenzo Lotto, *Man with a Golden Paw*,
ca. 1526–27. Oil on canvas. Kunsthistorisches
Museum, Vienna.

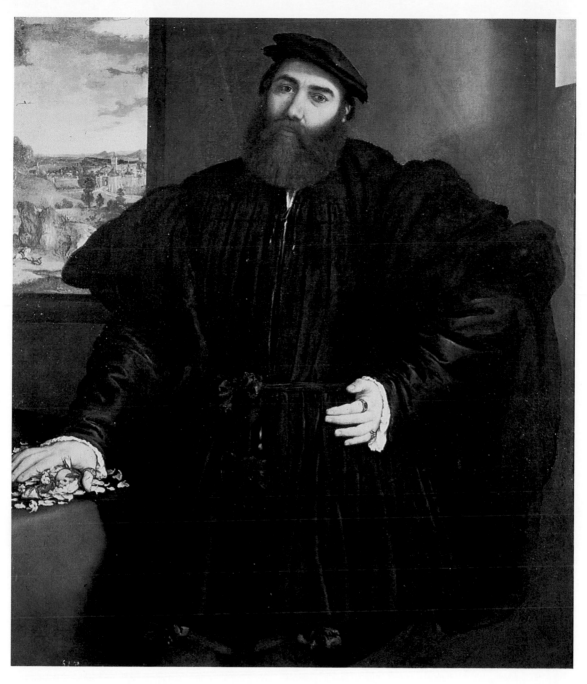

Lorenzo Lotto, *Portrait of a Man*, ca. 1535.
Oil on canvas. Galleria Borghese, Rome.

Lorenzo Lotto, *Portrait of Andrea Odoni*,
1527. Oil on canvas. Hampton Court,
London.

tension produced by the texture effect. The fusion of fabric texture with paint texture brings the fabric forward to the surface, closer to the observer, as if the painter's bid for admiration insidiously compromises—and thus dramatizes—the attempt to ensconce the idol in a *cordon sanitaire* of distanced objectivity. At the same time that scopic dynamism—the theatrical exchange and recognition of looks and glances—is suppressed, the distance protected by suppression is jeopardized and our sense of the sitter's attitude is thereby altered and complicated. The extended left hand appears more defensive, the eyes more hooded, especially when contrasted to those of her son, who fixedly stares us off.

The painting invites us to pry, dares us to violate the taboo of objectivity, and as it does, the hooded look knowingly inculpates the observer ("You want to see? Well, take a look at this!"),[8] and Bronzino's "haloed saint" becomes the gaze. Hers is the calm of a stately, ascetic, and profanely sumptuous madonna with features vaguely evocative of Piero della Francesca's Marian faces. The pose declares that what she gives to be seen is the essential she of courtly culture and its gestures of religious appropriation. Regal, maternal, conjugal, her fate—reversing that of Pygmalion's beloved—is to be transfigured into exemplary artifact.[9] The artifact is integral: within it there is only matter; its meaning, its soul, is all on the surface. If there is something more than meets the eye, it is of no consequence. Or at least it is none of our business, which begins and concludes in genuflection. She trusts the painter's art to hide the mind's construction from the face. Bronzino, however, betrays her recourse to that art, motivates it by the variations in facture that simultaneously establish and threaten the taboo against encroachment, and thus makes a small breach in the fiction of objectivity he and the duchess so flamboyantly perform.

His superb portrayal of the constraints and possibilities of this fiction heavily depends on the ability to represent the suppression of scopic dynamism as an effect at once conspicuous in its denial of eye contact and subtle in the various shades of dramatic meaning he teases out of it. Compare, for example, the spirited refusal of Laura Battiferri with the meditative reluctance of Ugolino Martelli (pls. 2 and 3). Both portraits seem meticulously designed and carefully staged to represent sitters too preoccupied in mind or spirit to be diverted by trivial interactions with the very observers for whom they so meticulously and carefully pose. The arch display of literary props simultaneously confirms and questions the

ascetic commitment to the life of the mind indexed by the pose. A modification of McCorquodale's comment on the *Laura Battiferri* brings out this ambiguity: "Negating any form of direct communication with the spectator, she chooses instead to convey her own nature through the display of the *Sonnets of Petrarch*, a gesture which further removes her from us."[10] On the contrary, as his reference to her intention—her desire to help the painter objectively convey her nature—makes clear, the gesture emphasizes the sitter's theatrical awareness of the spectators her look disdains, and thus draws her closer to us. At the same time that the sitters simulate absorption in Fried's sense, both give themselves to be seen—the fingers on the books are cues to this motive, more blatant in Laura's case, more ambiguous in Ugolino's. The rendering of flesh tones and facial contours—they seem to have been modeled with a carpenter's plane— further pushes absorption toward objectivity, and leaves the sitters uneasily poised between two fictions, two desires, of self-representation.

The dramatic power of Bronzino's portraiture comes from its coy feints toward and disturbance of the fiction of objectivity. In his hands, the objectivity is literalized as the goal of the posing subject who, striving toward orthopsychic integrity, aspires to the condition of an object fully made by art, an effigy with nothing hidden within, transparently expressing on the surface the *disegno interno* that forms it—turned inside out, so to speak, with its soul shining through the glazes, the observed of all observers. The desire for objectivity is partly conveyed by the visual hyperbole of the Pygmalion effect, that is, reversing Pygmalion's act but conforming to his misogynist wish in giving flesh the smoothness, and sometimes the hues and tints, of ivory, marble, porcelain, or wood, an effect augmented by strategically stressed contour lines that further freeze the effigies in place.[11] Yet this feint toward objectivity is only the setting or stage for the Bronzino drama, whose force is to challenge the impression of objectivity by intensifying the sense of a studied, theatrical pose. In the following comment on Ugolino, McCorquodale registers the resultant ambiguity but has trouble accounting for it: "it is at once 'natural' (he has interrupted his reading for an instant, marks his place with a finger, and remains wrapt in thought) and highly stylized, *manieroso*. . . . Martelli's oblique glance and the ambiguity of the pose enhance the sensation that we are permitted to penetrate his world only by chance" (50–52). Since McCorquodale's scare quotes around "natural" suggest that he judges it a *manieroso* effect, his concluding reference to chance is unexpected. Granted that in his

parenthetical scenario of absorption the finger marks the place for the thought-wrapt sitter to return to, the theatrical scenario of the pose that contains the parenthesis gives Martelli's finger a different function: it directs the observer's attention to the pages of Homeric Greek the resting hand holds open. Thus the illusion that "we are permitted to penetrate his world only by chance" is, like the illusion of absorption, conspicuous chiefly *as* an illusion, whose message is that we are permitted to penetrate his world only by design. Whatever else Martelli is absorbed in besides posing remains tantalizingly unclear. The portrait teases interpretation to circle round and round it, but refuses to let knowledge penetrate it. In this refusal, the fiction of objectivity betrays behind its surface revelation the pressure of orthopsychic desire.

Interpreters of Mannerism have been drawn to this pressure in its various manifestations. In his early study of Parmigianino, Freedberg emphasizes "the quality of decorum which attaches to the sixteenth-century personality in increasing measure from the late 1520s onward." He associates the sitters' "need to observe this controlled continence of spirit and behavior" with "their increasingly self-conscious pretension to, or actual possession of, the appearance of aristocracy and elegance," and he makes this the basis of the behavioral style to which painters like Parmigianino accommodated their artistic style:

> This generic personality depends most immediately on a degree of consciousness of self in the individual which seems both to exceed, and to be different in its nature from, the self-awareness of the person of the High Renaissance. The self-consciousness of Parmigianino's sitters is more intense, but less inwardly secure. This inward insecurity may not be betrayed, however; its presence is concealed beneath a mask of extreme self-discipline, appropriate to the contemporary insistence on decorum. This decorum is not the quiet, self-assured reserve of the High Renaissance but a tense and rigid self-restraint. The more complex and sensitive the man's self-knowledge, and the less his certainty of self, the greater the need for such a fixed outward appearance of control. An evident tension may arise from the imposition of this strict continence on inner feeling.[12]

The rhetoric that conveys this complex and subtly nuanced scenario flirts with the fallacies of psychological intuition and would be more persuasive if it were framed as the consequence of new conventions of self-representation rather than of psychohistorical changes taking place from

the late 1520s on. In his later contribution to the Pelican History of Art, Freedberg's comment on the Bronzino effect is more circumspect:

> Contact with the sitter is a confrontation only; communication is deliberately sealed off. . . . [The surface of the countenance has] the fixity and the impenetrability of a mask. The very attitudes of body that the sitters take intensify the sense of constraint: their behavior is according to a precisely controlled, willed, personal maniera, of which the high artifice serves as a mask for passion or as an armor against it.[13]

Opinions similar to Freedberg's about the insecurity of Mannerist sitters have long been attached to negative assessments of Mannerism, and against these John Shearman has objected that it is anachronistic to endow the style "with virtues peculiar to our time—especially the virtues of aggression, anxiety and instability"—since "the sixteenth century viewpoint of works of art was admirably relaxed."[14] Yet when he discusses the importance to Mannerism of "the concept of the work of art as an enduring virtuoso performance" by the artist, he connects this to a theatrical motive similar to the one implicit in Freedberg's account: "This is emphatically not Art for Art's sake, which implies independence of, and even contempt for, the approbation of the public. On the contrary, Mannerism is based upon an obsession with a favorable audience reaction" (44), and Shearman ultimately agrees with Freedberg in allowing the sitter to share this obsession with the painter, noting that in Florence after the Medici returned to power "the new court led to a new and therefore artificial aristocracy, and very artificial is the poise of the courtiers that Bronzino reveals to us" (175–76).

> [A]n understanding of portraits as direct substitutes for their sitters meant that the circulation of portraits could mirror and expand the system of personal patronage whereby power, privilege and wealth were distributed. Their uses included arranging dynastic marital alliances, disseminating the image of sovereign power, commemorating and characterizing different events and stages of a reign, eliciting the love and reverence due to one's lord, ancestor or relative. Because of these crucial functions, portraiture had to be theorized as unmediated realism. Yet although explicit invention or idealization was problematic, the *raison d'être* of these images was actually to represent sitters as worthy of love,

honor, respect and authority. It was not just that the real was confused
with the ideal, but that divine virtue was the ultimate, permanent
reality.[15]

The logic of Woodall's nicely balanced statement of the conflict at the
core of mimetic idealism secretes a more radical implication than the
statement itself acknowledges: the implication that the substitutability of
the picture sign (its formal identity with its referent) and its claim to mi-
metic realism are naturalizing fictions. That is, they present the idealized
image as a true icon of the referent. An artifact that represents its human
referent as if the referent were an artifact performs the classic semiotic re-
versal: the portrait becomes the original rather than the copy. This is no
esoteric proposition. It is a commonplace in discourses on photography,
epitomized in the syncopated colloquialism, "photogenic." In her account
of the scopic regime of the camera/gaze, Kaja Silverman cites examples
that "dramatize the anticipatory congealing of the body confronted with
a real or metaphoric camera into the form of what might be called a 'pre-
photographic photograph.' They resituate onto a nonhuman category
some of the gestures by which the subject offers him- or herself to the
gaze already in the guise of a particular 'picture.'" Thus to pose, to give
oneself "to be apprehended in a particular way by the real or metaphoric
camera," is to imitate not only "a preexisting image or visual trope" but
also "photography itself. 'What do I do when I pose for a photograph?'
[Craig] Owens asks. 'I freeze . . . as if anticipating the still I am about to
become; mimicking its opacity, its stillness; inscribing, across the surface of
my body, photography's "mortification" of the flesh.'"[16]

Semiotic reversal conforms to the logic of the orthopsychic ideal
whether in the more modern photographic regime Silverman labels the
"camera/gaze" or in the early modern graphic regime one might call the
"portrait/gaze" because portraiture, in metonymically condensing the
practices of self-representation encouraged by the apparatus of patronage,
gives shape to the desire to be (like) a work of art, and to own and dis-
play oneself as a work of art. Semiotic reversal describes the objective of
courtly self-fashioning. It is implicit in Vasari's evaluation of the achieve-
ment of the artists in his third period, especially Michelangelo. It is a pre-
dictable outcome of the clash between the new mimetic power of
graphic techniques and the pressure toward idealization that entails a kind
of sublation or partial transcendence of that power. It expresses the mag-

ical fantasy of escape from *homo clausus* that is most dramatically represented by the fiction of objectivity.

"Like all works of art," Sheldon Nodelman writes, "the portrait is a system of signs; it is often an ideogram of 'public' meanings condensed into the image of a human face."[17] In the semiotic reversal encouraged by mimetic idealism, the face and the portrait change places: "Like all works of 'nature,' the human face is a system of signs; it is often an ideogram of the 'public' meanings condensed into the portraits that represent it." This proposition finds pragmatic and faintly hilarious realization in the following anecdotal observation by Campbell:

> The interaction that took place between the conventions of portraiture and the conventions of behavior were no doubt many and complex, but it is often difficult to decide whether portraits showed people acting as they naturally did or whether people came to pretend to be portraits and act out roles created by artists. It is known, from documents and from representations in works of art, that princes made ceremonial appearances at windows, in galleries or on balconies, the sills and balustrades of which were often draped with rich textiles. In portraits, sitters were often depicted behind parapets, and the parallels are striking. . . . As versions of such portraits circulated throughout Europe, foreign visitors probably expected princes to appear as they did in their portraits, and, in such a situation, the princes would have been to some degree obliged to conduct themselves as they appeared to behave in their portraits.[18]

Campbell's princes would not be surprised to be told by Judith Butler that their "very interiority is an effect and function of a decidedly public and social discourse, the public regulation of fantasy through the surface politics of the body."[19] The obligation to be "pictogenic," to behave like one's portrait, implicates the form of giving-oneself-to-be-seen Lacan described, after Roger Caillois, as mimicry.[20]

This obligation is a caricature of what I have elsewhere called the abstraction rule: a portrait is not only an extension of the sitter's person but also an abstraction from it, therefore, if portraits help spread or increase the emanations of power nucleated in the princely presence, they also decrease the patron's control over the power. Several examples cited by Campbell show that if "it was in princes' interest to encourage the diffusion of their portraits at home and abroad, it was also essential for them to censor the portraits and to attempt to exert some kind of control over

their production."[21] The more they commit representations of their presence to the variety of media and mediators at their disposal, the less control they have over the way its pictorial emanations will be interpreted. The question implicit in Campbell's emphasis on the importance of portraiture is whether their skill as interpreters of emanations explains why such court portraitists as Holbein, Jakob Seisenegger, Titian, and Antonis Mor became influential or whether their eminence explains why others were, and we remain, impressed with certain interpretations of their princely subjects, interpretations that both celebrate and challenge the fiction of objectivity.

In early modern portraiture, objectivity may be considered the basic or *minimal schema* of the fiction of the pose. I borrow the italicized phrase from Norman Bryson, who in turn critically appropriated and revised it from the context of Gombrich's dialectical account of "making" and "matching." For Bryson, as for Gombrich, the schema is visual, a "state of the image" that relays the minimal information necessary for recognition: "the underlying portrait-scheme or stencil" of the profile, for example, or "the salient points of the face (the corners of the lips, of the eyes, and the end-points of the eyebrows) . . . regularly used as the key sites on which to place the cues of the sitter's physiognomic singularity."[22] For me, however, the visual data Bryson dwells on are cues to a dramatic or representational schema generated only within the field of differences produced by the interpretive decision to treat the portrait as an indexical icon of the act of portrayal. Such cues as the refusal of eye contact, the medallic appearance of the profile, the sculptural plasticity of the bust, and the transformation of flesh to ivory are among the variety of visual schemata that signify the single fictional scheme of objectivity. When this departure from Bryson's agenda is taken into account, his treatment of the ideological function of the basic schema contributes valuable insights into the meaning of objectivity as an orthopsychic ideal. In what follows, I draw chiefly on his discussion of history painting, since his remarks on the basic schema of portraiture are perfunctory.

Bryson introduces the notion of the basic schema in the course of an attempt to show how Barthes's analysis of the production of "the effect of the real" through the play of denotation and connotation may—if purged of its residual "perceptualism"—be applied to traditional narrative paint-

ing. Using Giotto's Arena fresco of the kiss of Judas as his example, he argues that religious painting of this kind relies on "iconographic codes" that "have achieved a regularized and official status," "codes of recognition that serve to standardize recognition of the image, and to subject it to conventions of legibility as binding as the conventions which govern the legibility of the written word" (62). Bryson goes on to show how Giotto introduces visual detail that complicates iconographic denotation with "comparatively uncertain connotations on the 'far side' of the threshold of the schema of recognition," and he argues that "the effect of the real is less a question of conflict than of symbiosis or covert alliance" between these two "levels of the sign" (65). For this symbiosis to occur, the schema must "appear as *citation* from an invariant repertoire of classic forms" (127) so that the connotative departures may register as transgressions of the iconographic code:

> Without the ceremonious and codified protocol of right recognition, there could be no scale of increasing distance from the semantic necessity of the gospel text (the minimal Byzantine schema) towards . . . the superfluity of the data concerning space, light, texture, color, reflection and atmosphere with which the Renaissance and post-Renaissance image will be saturated. . . . The excess produced by this difference can only last for as long as the official iconographic dispensation maintains its power. (65)

The advantage of following Bryson from portraiture to religious narrative is that it suggests a functional if not formal homology between their respective protocols of "right recognition," the iconography of orthodoxy in one case and of orthopsychic exemplarity in the other. What Sydney Freedberg calls the "quiet, self-assured reserve of the High Renaissance" and Norbert Huse the "calm, serious front" of the older Venetian generation are scopic conventions in which sitters give themselves to be seen, present themselves for inspection, by a generalized audience of peers—including other patrons—and clients or subjects.[23] These conventions satisfy the desiderata of mimetic idealism: resemblance on the one hand, exemplary enhancement on the other (figs. 15 and 16). They encourage the performance of a residually hieratic act of self-display, perhaps the "disclosure" of "a higher inwardness," that calls for prolonged and respectful scrutiny and meets it with a degree of inattention or nonchalance that reduces the intensity of scopic encounter. A sitter who is used to being

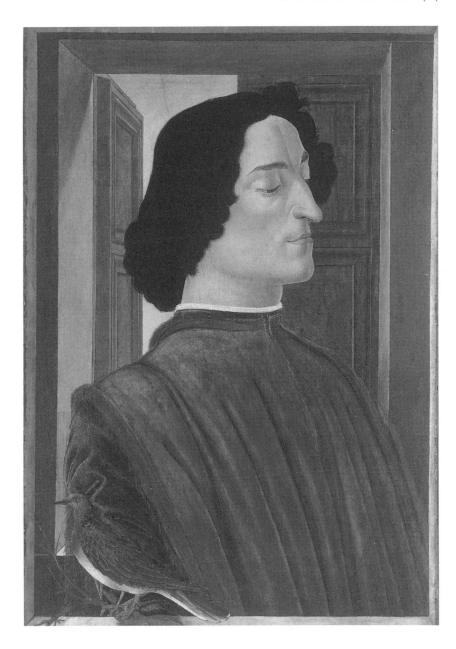

FIGURE 15

Sandro Botticelli,
Giuliano de' Medici, ca.
1478. Tempera on wood.
National Gallery of Art,
Washington.

looked at, who expects to be looked at, whose visage is represented as the embodiment of the gaze, need not deign to return the favor.

When Huse refers to the "closed, uniform way in which up to about 1500 the ruling class had presented a calm, serious front, thanks to an obligatory portrait type and an obligatory bearing,"[24] he describes the

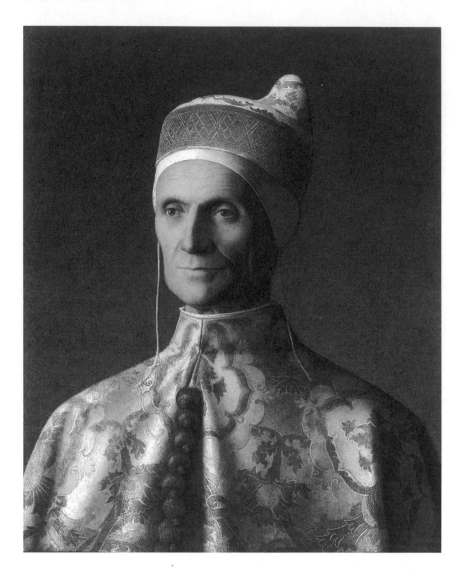

FIGURE 16

Giovanni Bellini, *Doge
Leonardo Loredan*,
ca. 1501–2. Oil on
wood. National
Gallery, London.

minimal schema developed to promote the iconography of civic and class
status prevalent in the generation dominated by the Bellini and Carpac-
cio. Writing of the group portraits that filled the "urban landscapes of the
istorie" commissioned by the Scuole Grandi in this period, Patricia Fortini
Brown notes that it was equally important to present a calm, *united* front,
and not only for the patricians but also for the nonpatrician members of
the confraternity, the *cittadini* whose

> dignified behavior would have been studiously similar. One suspects that
> these men would have smiled at the characterization of them by one

modern art historian as "identical wooden effigies." It was just as they wished to be seen. Looking identical was no disgrace, and "woodenness" to them was a virtue. They would have conformed rather well to the precepts of the merchant, Benedetto Cotrugli, who wrote *Il mercante perfetto*, a manual of etiquette, business practice and moral counsel for his contemporaries. He advised them to maintain their composure at all times, for " . . . all the speakers who wave the head, hands, or feet when they speak do it from weakness of the brain, and not for any other reason."[25]

He advised them, in short, to cultivate objectivity and eschew histrionics. For patricians and nonpatricians alike, objectivity was imbricated in the ritual repetition of ceremonial poses that enforced "right recognition." The virtue of woodenness, like that of stoniness or ivoriness, was the virtue of the gaze.

Surely in such portraits—the portraits of Huse's older generation and Freedberg's High Renaissance—no less than in those of their successors, the "attentive observer . . . is kept aware of the situation that one person is sitting for another, presenting himself or herself to be painted" and beheld.[26] The difference is that in the former set this person is not sitting for *an* other—not, that is, sitting for a specific other, an individual whom the sitter's eye contact singles out and to whose scrutiny the sitter reacts. Huse associates generational shifts of style and taste with a new intensity in scopic awareness and encounter, a new sensitivity to the "attentive observer." But this figure needs clearer definition than Huse gives it. In his account, it falls into the category of empirical observers that includes Huse—actual persons who encounter the painted scene of portrayal after the fact—and he doesn't distinguish that category from the category of virtual observer, the position constituted by the scopic dimension of the sitter's pose (the represented character and direction of looking, seeing, glancing, staring, etc.). The attentive and aware observer is best viewed as a figure constituted by the representation of a sitter who appears attentively aware of that observer. So, for example, of a portrait by Lorenzo Lotto, Huse remarks that the sitter "makes the alert observer aware not only of the painter's art but of the observer's position as a voyeur" (241).

By conspicuous citation of the objective schema, such painters as Mantegna, Leonardo, and Bronzino produce transgressive connotations, register the fall into theatricality, and adumbrate Narcissan depths behind the performative rhetoric that prevents the sitter's look from dying into the

gaze of the "official iconographic dispensation." When we turn to the Venetian generation following Mantegna and Bellini, we shall see that the preventive measures become more striking and varied. At one extreme we have Titian's subtle and sensitive management of the symbiosis Bryson describes; at the other, we have Lotto's unbalancing of it in portraits that lead Huse to doubt that this "master of moods" and restless explorer of the "psychological frontier" had any interest in the sitter's "'essence'"— that is, in showing "what lastingly characterized the sitter" (241–43). In the next two sections, I follow his lead in using the comparison between Titian and Lotto to suggest the increasing scope and complexity of the new portraiture.

Discussing the reaction of this generation to "the way their fathers had themselves painted," Huse centers on their impatience with the suppression of scopic dynamism, their interest in suggesting the sitter's interaction with the observer. No painter was in a better position than Titian, the prince of the painters of princes, to celebrate the values embedded in the fiction of objectivity, and none was more adept at making the optical subversion of those—basically graphic—values nudge exemplary poses into the shadows of orthopsychic desire. The kind of temptation Titian faced—and overcame—is epigrammatically summed up in Jean-Paul Sartre's wry comment on the function of official portraits: they "relieve the prince of the burden of imagining his divine right. . . . Even before meeting his model, the painter already knows the appearance he must fix upon the canvas: quiet strength, serenity, severity, justice." As part of the apparatus for achieving "solidarity between the prince and his subjects," the official portrait, "which protects a man against himself, partakes of the nature of a religious object."[27]

This comment feeds my Vasarian fantasy that some Cinquecento versions of the orthopsychic ideal may in part be reactions dialectically motivated by the potential imperfections the new mimetic skill achieved during the Quattrocento is able to reveal. The function of idealization in portraiture may to some extent resemble the one George Hersey attributes to the classical orders when, in *The Lost Meaning of Classical Architecture*, he likens "the classical formulas for symmetry, scale, and proportion to taboos."[28] Idealization works to sacralize the image, ward off the observer's evil eye, render the image inviolable. The possibility of violation is

proportional to the mastery of mimesis. Idealization offers the prince the armor of an alienating identity within which he can secrete what, according to Sartre, he sees reflected in non-Lacanian mirrors, "his only too human mediocrity" and a visage that betrays "only melancholy and confused moods."[29]

Titian's response to this challenge is to portray sitters whose poses reveal their awareness of and sometimes their difficulty with the demand that they embody the imperious gaze. This has often been noted in the most official of his official portraits, *Charles V at the Battle of Muhlenberg.* Huse remarks that the sitter is "not entirely at one" with the occasion; David Rosand describes him as "a reluctant warrior whose face appears somewhat oppressed by the surrounding glitter of his armor," and who seems "physically detached and emotionally distant."[30] Even more poignant, in my opinion, is the portrait of the duke of Urbino, who was both an ally of Charles V and a captain of the papal forces (pl. 4).

Commentators have always singled out Titian's ability to compress character and action in the sitter's eyes, the look, the scopic encounter with observers.[31] In this respect, there is something odd about the duke. We should note first that the placement of the catchlight in the eyes diffuses the ocular contact the sitter makes with the painter/observer for whom he holds the pose (fig. 17). From a distance the pupils add their luster to the other precious reflectors of light in the sitter's panoply, and thus participate in the iconography of ducal power. I am initially tempted to say that the eyes don't so much *look* as *display themselves*; but on drawing closer I am surprised, and even moved, to discover a facial *Gestalt* that signifies absorption—but absorption in the revised sense I've given to Fried's concept, absorption in the "consciousness of being beheld." The duke is gravely, thoughtfully, attentive to the task of sustaining a complicated pose that delivers the prearranged symbolic message. According to Harold Wethey, this message may in part be retrospective. Wethey notes that although Titian shows the duke "in the prime of life," he had "reached fifty-six in 1536, when the portrait was begun. His dark hair and beard belie his age, and one must conclude that Titian rolled back the years by a full decade to make this picture commemorative of the career of a man who died in 1538, the year in which the work was completed."[32] This view is supported by the various symbolic attributes in the background, which, as another commentator reminds us, were identified already by Aretino; they signify his papal and imperial commissions and so

FIGURE 17

Titian, *Portrait of Francesco Maria della Rovere*, 1536–38 (detail). Galleria degli Uffizi, Florence.

make the portrait a retrospective "compendium" of the duke's career as "a great *condottiere*."[33]

Such a program calls not for informal or lively representation but for the kind of statuesque and monumental treatment capable of compressing into the pose the integral totality of the career as the expression of the sitter's *virtù*. In accordance with this physiognomic norm of exemplarity, the duke adopts what the same commentator refers to as "a consciously heroic and celebratory pose" (228). But the duke's countenance, at once determined and reflective, reminds us that the occasion is commemorative as well as celebratory, and this suggests that in the statement I just quoted the adverb *consciously* should receive the primary emphasis. The portrait depicts a sitter who solicits—but does not fully sacrifice himself to—an impassive exemplarity; a sitter in the process of trying to memorialize what other commentators have called his "ideal persona" and the "impression of aristocratic poise and magnanimity."[34]

Robert Hughes has praised Titian's portrayal of "the inflexible determination of the military commander."[35] This comment should be redirected from the military commander to the sitter, whom Titian depicts as determined to produce the effect of inflexible determination; determined to make his face the index of the sort of mind the ideal military com-

mander is supposed to have—determined to lose himself, to vanish into that orthopsychic icon. But not quite making it; falling a little short. What is dramatized instead is the desire and the effort of self-representation. On the side of the sitter, this means that the failure to die into exemplarity, to embody the gaze, brings something else to life—the hint, the rustle, the expression, of something not fully legible in terms of the portrait's iconography. On the side of the painter, the portrait displays both his mastery and his love of the visual rhetoric of mimetic idealism, but it seems to do so primarily to display its resistance to the blandishments of that rhetoric. The resistance is conveyed by the way the painter makes the sitter his partner in exploiting the fiction of the pose to suggest, not the mind's construction in the face, but the mind's construction of the face; not the transparency of the body revealing the stereotypical soul of the commander, but the controlled activity of a body obeying the command to deliver that stereotype; not physiognomy, but fiction. With restrained eloquence, Titian's portrait of the duke registers the sitter's attempt and partial failure to transcend the fictiveness of his pose. And if I can be forgiven for indulging a final romantic fantasy about the portrait, Wethey's idea that "Titian rolled back the years" combines with the retrospective iconography to add another dimension to that fictiveness: they make the portrait a souvenir of what has been lost, a farewell to arms that touches the reflective mood of the face with nostalgia.

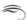

Lotto is famous for the intense, quirky, and enigmatic posturing by which his sitters solicit spectatorial response, and I shall illustrate this with some notes toward a mini-catalogue of Lottonian poses.

1. *Bishop Bernardo de' Rossi* (fig. 18). Because this early portrait is Lotto's most explicit evocation of carved or sculpted objectivity—monumental in form, smooth in texture, simplified in modelling, with angular, hard-edged transitions between planes—it is his most explicit challenge to that fiction. The sitter is not merely giving himself to be seen but staring down his viewers—including the painter—and the dominant effect produced by Lotto's treatment of the nostrils, mouth, and hand is of a tenseness, a slight rigidity, that I read as something like restrained impatience or impatient restraint, an attitude which, as Peter Humfrey observes, conspicuously resists the invitation to embrace the objectivity of an exemplar:

FIGURE 18

Lorenzo Lotto, *Bishop
Bernardo de' Rossi*, ca.
1504–5. Oil on wood.
Galleria Nazionali di
Capodimonte, Naples.

Although the *Bernardo de' Rossi*, like the *Doge Loredan*, presents a
dignified and credible image of a holder of high office, Rossi does
not appear as an ideal embodiment of that office. . . . [He] grips his
scroll in his clenched fist, and confronts the viewer with a stare that is
at once defensive and somewhat aggressive.[36]

Having agreed to pose, the bishop spurns the opportunity to indulge his
audience in orthopsychic hide-and-seek. He is good enough as he is:

he asks for a glaring light, then straightens up and lets us have it, wens and all.

2. *Young Man against a White Curtain* (pl. 5). This is Huse's title. Rodolfo Pallucchini and Giordana Mariani Canova look behind the curtain for the meaning of the portrait and call it *Young Man with a Lamp* (*Busto di giovane con lucerna*).[37] Huse mentions the lamp only in passing ("one of the commonest symbols of transience") and concentrates on the way adjectives applied to the curtain are transferable to the sitter: "the light brings out . . . unformed, uncertain qualities" in the young man; the curtain "looks agitated and petty" and "the hesitant outline of the edging on the right seems to paraphrase the character of the young man."[38] Others make more of the lamp. Thus David Rosand, after exclaiming at how many "Renaissance faces, whether proud in the vigor of youth or wiser with the experience of age, are poignantly set off by some reminder of their mortality," cites the example of "the flickering candle behind the brilliant white curtain" in this portrait.[39] Rosand presumably reads the sitter's expression as an index of shortsighted pride, and from this I infer that he views the "reminder" as a message the painter sends the observer from behind the unwitting sitter's back. Canova takes the same position but filters the message more carefully through the "irritable [*nervosa*] sensibility" she finds inscribed in the face: since the lamp can denote both transience and burning passion, what it connotes is "a secret inquietude" eating away at the sitter's youthful vigor from within.[40]

All three commentators read the painting ironically at the sitter's expense. This is especially odd in Huse's case, since he goes on to an astute characterization of the fiction of the pose, one that applies to Bishop Rossi as well as to the young man: "The viewer's gaze is met by that of the youth, who looks as if he wants not only to be seen but in his turn to examine the viewer. He makes the alert observer aware not only of the painter's art but of the observer's position as a voyeur."[41] This scenario is incompatible with one in which the sitter is unaware that insights into the state of his mind or character are being exchanged by painter and observer through the relay of visual metaphors and emblems. If, for example, the sitter's attitude indicates that he presented himself to be painted and is aware of being observed, isn't the relation of curtain to lamp part of the interpretive setting he agreed to? Huse claims that the curtain is "borrowed from [Lotto's] Madonna paintings" but is "neither calmly spread nor cast into noble folds" (241). It might then, to those familiar with the

relevant Madonna paintings, function as a rejective allusion, one that evokes and repudiates the monumental mode of devotional icons, repudiates also the knowledge guaranteed by the ritual repetition of iconographic formulas and embellishments.

The distressed curtain behind the young man seems contrived for this occasion only. On the one hand, it appears carelessly or hastily arranged in impromptu fashion as if to serve as a light reflector. On the other hand, its prominent repetition of folds slanting upward to the left is clearly influenced by—and thus signals—the intention to display the lamp. Noticing this, Huse's "alert observer" may become curious about what else is hidden in the dark space behind the curtain—possibly more emblems that will further elucidate the nervous sitter's state of mind—and may even feel an impulse to reach behind the face and draw the curtain aside. But any such move is discouraged, blocked by the set of the figure guarding the curtain. The turn of the body, the long line of its left shoulder pinning the curtain closed below the lamp, the beret curving back toward the right-leaning verticals which, emphasized by the curtain's green edge, oppose the pull to the left: these details conspire with the sitter's watchfulness to warn us off, so that the desire to strip the veil is now felt as a desire to violate privacy. The alert guardian makes the alert observer "aware not only of the painter's art but of the observer's position as a voyeur" straining vainly through the keyhole of the sign, behind the white curtain, into the black box of *homo clausus*, for some flickering glimpse of the sitter's (and painter's) mind.

3. *The Man with a Golden Paw* (pl. 6). Pope-Hennessey doesn't think Lotto's characteristic reliance on emblems to convey precise meaning succeeds in this portrait; he finds its message "inaudible."[42] For Huse, the meaning derives from the painter's complex interpretation of the fiction of the pose: the portrait "depicts a man who is posing, painted by an artist who, while acknowledging the pose, reveals it at the same time as 'put on', and so as a sign of split identity"; the easy slide into psychic revelation performed by this *ergo* leads to the generalization that "Lotto was concerned with the sitter's problematic relation to himself."[43] While Pope-Hennessey and Huse both restrict interpretive privilege to the painter, Huse, in eliding the sitter's share, claims nevertheless to have an insight— via Lotto's insight—into the sitter's problem. This goes well beyond the evidence deducible from the fiction of the pose, but a small adjustment in his formulation will allow us to recuperate Pope-Hennessey's verdict of

inaudibility, not, however, as a judgment on the painter's failure but as a description of the scenario conveyed by the pose: whether or not the sitter has a problematic relation to himself—and, admittedly, some of Lotto's sitters do look weird—he seems to enjoy having one with the observer.[44] The hand on the breast, a familiar gesture of faith or hope or sincere profession in religious paintings, is here theatrical and presentational: it floats forward from the cloak and invites the observer to share the meaningfulness of the emblem. But since the emblem resists decoding and frustrates the effort it invites, the response can only be perplexity about the motive behind the pose, and this perplexity translates into an effect of hiddenness, of privacy, similar to that which emerged from the scopic encounter with the sitter before the white curtain.[45] Norbert Schneider, after many sentences of inconclusive musing about the pose and the paw, speculates suggestively that the painter may have been influenced by the "precept of 'dissimulatio,' the demand—frequently voiced in the increasingly popular moralizing literature of the day—that the sitter's inward world remain concealed, or veiled."[46]

If we shift from the icon to the act of portrayal it indexes, we can hardly remain unimpressed by the way the sitter so strenuously labors to bring forth the complicated pose he and the painter have decided, or are deciding, to represent. In this shift, the sitter's appeal to the observer's weakness for decoding emblems is upstaged by his involvement with the painter. He appears either to be trying out the pose for the painter's approval or to be taking great pains to hold still in spite of the demands it makes on him. I am reminded of Samuel Pepys's often-quoted complaint about his session with the portraitist John Hayls: "I sit to have it full of shadows, and do almost break my neck looking over my shoulder to make the posture for him to work by."[47] Hayls's portrait doesn't fully hide the effort. Lotto's seems to thematize it and, in doing so, in registering the effort that conveys deliberateness, the portrait suggests that it is the sitter no less than the artist who, "while acknowledging the pose, reveals it at the same time as 'put on.'" When we shift back from the act of portrayal to its product, the result of this reading of the former is to make the latter proclaim that the sitter is no less, and perhaps more, than the painter's coadjutor in representing what is conceivably a travesty of sprezzatura, an object lesson in *affettazione*: on the one hand, an overly rhetorical promise of meaningful communication through the language of emblems; on the other hand, a deliciously blank-eyed enjoyment in the

expected failure of the emblem to deliver its message—enjoyment in producing the effect of inaudibility noted by Pope Hennessey. And the emblem, finally, is no less weird than the sitter.[48] If it is, as Pallucchini and Canova assume, a lion's paw,[49] it must have been efficiently shrunken; its rigid, spiky form gives it the look of a real body part rather than a miniature. Perhaps the emblem signifies itself, and the sitter is to be identified as a veterinarian or a taxidermist or, as Schneider suggests, a goldsmith named Lion—or perhaps not.

4. *Portrait of a Man*, whose short title from now on will be *The Dyspeptic* (pl. 7).[50] Pope-Hennessey speculates that since painters "can depict the act of thinking but cannot define thought," Lotto's aim in this and other portraits was to show the sitter "in some specific character or state of mind, and his use of emblems stems directly from the need to make the meaning of his portraits more definite and more precise." Thus the tiny skull and lily—and rose petals—under the Dyspeptic's right hand "seem to be used in their customary connotations of mortality and hope, and the sense of the imagery is faithfully reflected in the grief-stained face."[51] The statement is intended to illustrate the way Lotto—not the sitter—uses emblems to clarify meanings, but the clarity of its own meaning is compromised by the logic of its phrasing: for "faithfully reflected in" substitute "faithfully imitated by" and then extend this mimetic privilege from the painter to the sitter, the strain of whose attempt to deliver the message specified by the emblems is registered in the uncomfortable rhetoric of his cocked head and left arm. The result of this operation is to theatricalize the act of portrayal indexed by the pose: it is no longer possible to describe the Dyspeptic's "specific . . . state of mind" simply as grief—or, in Canova's words, as "il malinconico patetismo" (*Lotto*, 113)—for attention is redirected from whatever he may feel to his interest in his displaying it.

When the staginess and strain are imagined as reactions to the painter's presence, the effect is similar to that produced by *The Man with the Golden Paw*. The Dyspeptic appears either to be seeking the painter's approval for a novel way to convey elegiac sentiment, or to be heroically sustaining an awkward pose. One might suspect an aspiration, perhaps an allusion, to mannerist expressiveness, but if one does, the suspicion quickly yields to a sharper sense of the sitter's failure to achieve "una artificiosa imitazion di natura": there is *difficoltà* but no *facilità*. This is, however, a "failure" rather than a failure, a dramatic effect rather than an aesthetic defect. It is—as Humfrey remarks in contrasting Lotto to Titian—the source of

Lotto's peculiar power, namely, the sympathy with which he depicts sitters who are not at home with the histrionics of self-representation.[52] Unlike their more courtly and aristocratic counterparts in portraits by Titian and others, their emblematic exhibits and rhetorical flourishes betray the performance anxiety of sitters who, having agreed to pose, don't trust themselves, the painter, or the observer enough to be content simply to give themselves to be seen.

In this respect I find the Dyspeptic a moving figure, eloquent in the labored stiffness with which he tries to make a meaningful statement.[53] Yet the statement is confused by the emblematic and visual diversion of the landscape containing the tiny episode of St. George killing the dragon. Why has the sitter chosen—or been persuaded—to stand next to a window that resembles a picture frame, and a landscape that behaves like a religious narrative? How is the episode related to the emblems on the table and the sitter's expression? Why should hagiographic heroics be, on the one hand, included in this picture and, on the other, relegated to the position of staffage on the margins of the drama of portraiture? Far from defining the sitter's thought and making the meaning of this portrait "more definite and precise," a surplus of emblematicity scatters the observer's thought over a field of indefinite and imprecise possibilities. The Dyspeptic's "specific . . . state of mind" thus disappears behind a "grief-stained face" that offers itself less as an index than as an enigma.

5. *Andrea Odoni* (pl. 8). In this much discussed and much restored portrait of a Venetian antique collector, the sitter is operatically posed, like the man with the claw, holding one hand a little stiffly across his breast and with the other offering or merely displaying another of Lotto's portentous little symbols. He makes eye contact with the observer, but the eyes are shaded and the gaze softened so as to produce a slight sense of diffused attention, the kind of reflectiveness for which Rembrandt's fictions of distraction are famous. And in fact this painting was once attributed to Rembrandt and was housed in Amsterdam during his lifetime.[54] Of this particular fiction, I note only that it can make a sitter appear to have been holding the pose for a long time; when the pose is complex or contorted this intensifies our sense both of its difficulty and of the attempt of a sitter to go to any lengths to look meaningful. But what is he looking meaningful about? What is the relation of this fixed and protracted pose to the visual and symbolic action swirling around it? Why, for example, does he seem to hold his body in a manner that competes with

the choreography of the torso before him seen from the front and the torso behind him seen from the back?

The history and variety of critical responses to the Odoni are thoroughly canvassed by Shearman in his catalogue entry, and though he is generally skeptical of them, he endorses Burckhardt's idea that the statuette in Odoni's hand, a Diana of the Ephesians, "was a symbol of Nature or Earth in the Renaissance, and . . . that here Nature was contrasted with transitoriness exemplified by the antique fragments."[55] To a more elaborate variant of the nature/art interpretation, Shearman objects "that the 'antiques' have multiple and conflicting meanings attached to them . . . and that it remains unclear whether the statement about Art is Lotto's or Odoni's." In his view, "any statement in the picture is Odoni's," and he concludes by agreeing with Burckhardt "that the picture is conceptually and psychologically more complex than a simple portrait of a collector."[56] Huse discerns a "bluntness of face and body that makes Odoni appear a somewhat ponderous, narrow-minded person, a fetishist rather than a humanistic, cultured art lover,"[57] not the sort of person described by Pope-Hennessey, who thinks Odoni might be ruminating "upon the destructiveness of time and the indignities to which the culture of the past has been exposed."[58]

I know of no control enabling us to adjudicate between such incompatible attempts to make Odoni's face the index of either his or Lotto's mind, and so, for the time being, I digress evasively to the symbols with which Odoni has surrounded himself. The painting offers such an embarrassment of iconographic riches as to make commentators confess their bewilderment.[59] Most of the pieces have been identified, though even at that level there is room for disagreement: according to Huse, for example, the large fragment in the foreground is a head of Trajan but according to Humfrey it is a head of Hadrian.[60] Since, as Shearman notes, the pieces "have multiple and conflicting meanings attached to them,"[61] it is risky to assign each of them emblematic meaning, and commentators have for the most part treated them as a collective symbol (of Art, *Vanitas*, *Humanitas*, antiquarian culture, antiquity, the transitoriness of its fragments, etc.).

The most interesting of these possibilities is the emphasis on fragmentariness, and it is interesting because of a detail noted by Huse, the "almost alarming . . . way the marble statues change in Lotto's painting. The head of Trajan under the tablecloth looks hardly less alive than its owner, and is so placed that it seems to be just emerging from under the cloth."[62]

In Shearman's profile of the commentary, the focus on whether the figures are actual antiques or casts or reduced copies seems willfully to occlude their strangest quality: so far as one can tell (given an amount of restoration that makes any description a little shaky), most of the sculptures are softly enough modeled to suggest, if not flesh, the Pygmalion effect, that is, the phenomenon of marble becoming fleshlike, and therefore lifelike. As a result, the sense of dismemberment verges on the macabre. These figures lacking heads, torsos, arms, or legs are a cross between broken statues and mutilated bodies.

The Renaissance sense of ideal form comes from and is closely associated with a fragmentariness that both signifies the antiquity of the classical figure and makes it possible for the excavator to imagine and, even more, to revise and appropriate the glory of antiquity. Fragments become the material of metonymic and anecdotal fantasies. Their very fragmentariness gives them value as spurs to idealization. But if you show them undergoing the Pygmalion effect, that value mutates into terror before the vulnerable, dismembered natural body. Violence against the naked body is here enshrined as the model of idealization that produces the classical nude. And at this point one may be reminded of the Zeuxis fantasy, in which the artist selects the best parts of several maidens and combines them into a better body than poor old mother nature has to offer. "Selects" is of course a euphemistic or evasive way to describe an act of imaginary amputation. Lotto's classical figures demystify the euphemism; they transgressively conflate idealization with terror, the fragmentation suffered by ancient artworks with the remains in nature of artistic dismemberment.

All the participants in the iconographic guessing game this portrait inspires focus on the opposition between nature and art that Burckhardt picked out and that, as Shearman speculates, he probably developed in response to "the special emphasis given to the *Diana of the Ephesians* statuette by Odoni's gesture."[63] This archaic figure is crowned and apparently armless because imprisoned in a mummylike wrapping stippled so as to signify the breasts of the fertility goddess sometimes called *Polymastes* or *Multimammia*. Berenson notes without comment its resemblance to a figure in one of the Bergamo intarsia panels for which Lotto provided the designs.[64] The cover for the panel depicts the death of Absalom, and in the panel itself a king sitting on a throne, about to be flailed by a young man, looks upward in the other direction toward the Diana figure above the throne but oddly connected to it by a curved rod. To the left of the

figure is an emblem of lightning and thunder, and flanking both images is the inscription, "divina vindica impietatis." Here, the talismanic figure that protects the king against impiety associates the son's offense with the sin against nature. If I were to participate in the Odoni guessing game I think I would begin with the idea that the statuette bears a similar punitive or talismanic meaning, and this would move me to formulate the nature/art opposition more sharply than those who argue that Odoni's gesture signifies his preference for nature: what is the sin *contra naturam* that the portrait depicts? Is it connected with the sculptures? With the "transitoriness" suggested by their headless, armless, bodiless, and legless states? With their eerily lifelike appearance?

At first glance I am inclined to agree that since the portrait emphasizes time's sin *contra artem* it suggests an indictment of the vanity of investment in art and culture, and therefore a preference for nature, which inspires no false expectations of escape from mortality. Yet the expectation of escape can take other forms, two of which are inscribed in the Pygmalion and Zeuxis fantasies. Though both are primarily male fantasies involving symbolic violence to woman, they underwrite the more generalized symbolic economy of orthopsychic desire and mimetic idealism in the discourse of art. Dismemberment and dissection are to the resurrection of the glorious body in art what the Crucifixion is to the resurrection of the glorified body in religion. But they aren't performed on the son of God; they are fantasies that denigrate or violate the natural body and seek to replace it with external forms irradiated by "a higher, spiritual inwardness."[65] And they are permissible precisely because they are displaced to the merely mental and instrumental operations of art, where they may exert a more insidious and continuous influence on attitudes toward the body.

Perhaps, as Thomas Greene has suggested to me, it is to protect against the fractured vulnerability of the nude figures that Odoni is heavily swathed, even overdressed, and his aloof Diana is tightly wrapped up.[66] In this context his left hand seems not only poised in the operatic gesture of piety, devotion, truth, etc. It also seems protective, as if keeping his robe shut against the possible invasion of body parts, an invasion that has already begun, judging from the way the greyish ochre and cuprous brown tones of the antique fragments bleed into Odoni's fur collar. To take in these details is to begin to appreciate the complex pressures brought to bear on the sitter's effort to engage the observer's attention, an effort that makes many commentators uneasy. Shearman rejects Berenson's "strange idea that

Lotto was expressing his antipathy to his sitter,"[67] but Berenson, however confusedly, is responding to an air of diffidence or scopic resistance that Huse reassigns to the sitter: although Odoni seems to display the statuette to the viewer, "he does not hold her in such a way that he or the viewer can see her particularly well, but as if he wanted to argue about her and defend his collection."[68] For see how busily he solicits our attention, offers us symbols, arouses our insatiable lust to anatomize the man behind the pose, the man beneath the fur. And see how little he gives away.

The busy hands, figural contortions, and emblematic overload that characterize Lotto's portraits produce an effect that may best be called anecdotal. Anecdotes have considerable cachet these days because at the same time that they convey facticity, or fact-like-ness, the effect of the real (in Barthes's sense), they illustrate the teller's point; they are enlisted in the service of some scheme, some *telos* or purpose.[69] In form, the anecdote is episodic, or fragmentary; it is an *ex*tract in the process of becoming an *ab*stract, an example, a brief abstract or chronicle of the time. It is carefully snipped out of one context and pasted into another that supposedly illuminates its true meaning in—or *the* true meaning of—the first context. As a rhetorical act, it is part of an attempt to engage and persuade the receiver of the anecdote; as a rhetorical trope, anecdotality triggers the expectations I just mentioned.

Now suppose the anecdotalist makes a big play for your attention and starts to tell you about the funny thing that happened to him on the way to Wherever, but, just as he never reaches Wherever, the point you impatiently wait for never materializes. You begin to wonder either what you missed or what's missing from the anecdote. At this moment you may recall the original meaning of "anecdote" and understand why it got its name: "anecdote" is from Greek *an-ec-dota*, things "not given out." Originally anecdotes were secret or private narratives that—upon publication (made public if not printed)—became "hitherto unpublished," as in Procopius's "Unpublished Memoirs" of Justinian. The Lotto portraits I have been discussing are anecdotal in this sense. They are anecdotes about the anecdotes the sitters are thrusting in the observer's face.[70] And the burden of their anecdotality is the tenseness, the guardedness, the uneasiness, the discomfort, that betray the not-given-out brought into being by the effort of orthopsychic self-representation.

The portraits of Titian and Lotto help shape the course taken by the history of early modern portraiture I alluded to in Chapter 4, a history

that traces an awakening from the objectness of the death mask through
the fiction of objectivity, of exemplarity, to orthopsychic images animated
by the questionability of the face and the anxiety of representation. Be-
cause Lotto's anecdotal fragments insist on the *undisclosedness* of their sit-
ters' presentational intentions, this anxiety spreads from sitter to observer.
His emphasis on the dilemmas of scopic encounter gives the *now* of pos-
ing the force of a striking episode, an obviously planned and, in some
cases, vaguely confessional invitation to look for the deeper meaning, the
missing context, the secret history, of which the pose is an index and ex-
tract. But to respond to the invitation is to encounter a diffidence that
constitutes the observer as a voyeur peering into a new depth of privacy,
a depth that comes to light in the specific fragment of life that the sitter
devotes to being a sitter who publishes his secrets precisely *as* secrets.

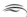

In the opening pages of Part 2 I noted that my story of early modern por-
traiture would enact a kind of reversal of the process of objectification
described by Barthes in *Camera Lucida* as the effect of photography. Per-
haps by now the implications of this reversal are clear. But perhaps also
my way of twisting the *Camera Lucida* passage makes those who know
that text uneasy. In the context of reversal, the fiction of objectivity be-
comes a productive sort of metaphoric death and resurrection, a dying
into the exemplarity and authenticity of the gaze. Barthes, however, ac-
centuates the negative: in the "subtle moment" when being photographed
troubles "a subject who feels he is becoming an object," he invariably suf-
fers "from a sensation of inauthenticity."[71] The preceding analyses suggest
that the positive and negative accounts are two sides of the same prob-
lematic: the problematic of narcissism as dissatisfaction with the inau-
thenticity of the subject's orthopsychic self-representations. If the death
mask of objectivity marks the starting point of my story, what happens af-
ter, as I have tried to show, is that sitters begin to rouse themselves, to
shake off this death, and to help painters represent them as living subjects
by seeming either to try for, or to resist, the effect of objectivity.

My argument in these chapters has been that the structure and prob-
lematic of the fictions of the pose may be accounted for in terms of the
structure and problematic of mimetic idealism, and that the notion of the
orthopsychic image as taboo may be elucidated by the way Lacan keys his
account of narcissistic self-alienation to the dialectic between the look

and the gaze. I don't want to go so far as to claim that the representa-
tional norms that serve the needs of the apparatus of patronage and paint-
ing induce culpability in the unrepresented—because not *orthos*—psyche.
Nothing I have shown or written here supports the validity of that in-
ference. But I *will* commit myself to a weaker inference or hypothesis:
whether or not the fictions of the pose mandated by these norms induce
the "ineradicable suspicion of dissimulation,"[72] they may be assumed to
induce cognitive dissonance between the awareness of unperformed self-
representations and truth to the norms governing the performances in-
scribed in the portraits.

I argued above that the psychogenetic work done by the apparatus
eventuates in the production of an orthopsychic rather than merely ex-
emplary subject because it also constitutes an "original" private self as a
kind of remainder, surd, or residue of the process. Embroidering on the
Elias thesis, I argued further that if we find evidence of the orthopsychic
dilemma we should attribute it to the specific agency and conditions of
the discourses and practices of early modern representation. The logic be-
hind this assertion is that the developments in graphic technology that in-
crease the possibilities for self-representation in art also increase the possi-
bilities for intrasubjective tension between performed and unperformed
versions of "inner self." In Lacanian terms, the sitter in portraiture defends
against the predatory gaze by assuming it in a mimicry which—conspic-
uous *as* mimicry—discloses a split between being and semblance. This is
the split Elias locates as the source of the black box within which *homo
clausus* represents what is absent from orthopsychic representation.

I want to end with an anecdote about the end. Cut into the ledge at
the base of a famous profile usually attributed to Uccello (fig. 10) is the
inscription "ELFIN FATUTTO," that is, "il fine fa tutto." The literal trans-
lation is "The End Does All," but Rab Hatfield argues that its exact mean-
ing in context is unclear and "perhaps deliberately enigmatic." His candi-
date for the "best interpretation" is an ethical dictum characteristic of
humanist thought, "'The Aim Counts' or 'The Purpose Decides.'"[73] But
in view of the notion of objectivity I developed on the basis of Hatfield's
research into profiles, I am drawn to another translation.

The Italian word *fine* has two forms, masculine and feminine. The
masculine *il fine* is predictably the more aggressive, meaning "purpose,"
"aim," "scope," while the predictably more passive feminine form, *la fine*,
means "conclusion," "close," "ending." Let's grant that Hatfield's translation

is grammatically and contextually correct: that noble profile is gravely set in an attitude of purposeful determination, and like the inscription its gravity seems engraved in relief. This is the representation not of a living form but of a sculptured form. It brings to a conclusion the project inscribed in but unfulfilled by Titian's duke of Urbino: the evacuation of life in the realization of exemplarity, the attainment of the armor of an alienating identity. When I shift my glance from the duke to the profile, I feel the gathering force of an ungrammatical but deeply appropriate mistranslation: "La fine fa tutto"; the end does, or makes, all; death makes the whole.

"Death is the mother of beauty," the editorializing speaker of Wallace Stevens's "Sunday Morning" admonishes the musing "she" who longs for paradise. "Death is the mother of beauty; hence from her, / Alone, shall come fulfillment to our dreams / And our desires." The speaker's resistance to that longing informs my history of the early modern career of portraiture, which falls from the orthopsychic paradise of the death mask and the commemorative profile into the conspicuously unrepresented desires of subjects who give themselves to be seen and watch themselves being watched (fig. 19):

FIGURE 19

Titian, *Portrait of a Woman*
("La Schiavona"), ca. 1511–12.
Oil on canvas. National
Gallery, London.

THE EMBARRASSMENT OF POSES: ON DUTCH PORTRAITURE

For both Castiglione and Erasmus, the subject is truly and . . . ironically a subject-in-process/on trial, who molds himself for a sternly, rigorously evaluative gaze. Yet in this scheme of civil scopophilia, the question Who is watching can only be answered, You are. If it is to work, the subject of civility must both generate and incorporate the gaze of the other. You never relax your vigilance because you don't want to make that fatal, mortifying mistake; in order to avoid it, you have to see yourself . . . doing it.

—BARBARA CORRELL, *The End of Conduct*

People know what they do; they frequently know why they do what they do; but what they don't know is what what they do does.[1]

Ap-prehension: the fear of being taken; the desire to take.[2]

[T]he urban bourgeosie tried to codify and justify a less certain identity. In this respect, the modified precepts of the humanist and bourgeois etiquettes specifying what one does—and especially, what one does not do—expose what one is not yet and would like to become. . . . With a reflexive element not seen in chivalric culture, they negotiated uneasily between an ideal self-image and a phantasmal unknown with the capacity to loom horrifically.[3]

LOCAL MATTERS

In Chapter 2 I argued that the apparatus of patronage in Renaissance Italy worked according to a principle of moral homeostasis: a structure of interchanges equilibrating the interests, scruples, and exigencies of religion and the Church with those of worldly self-interest and civic order enabled the apparatus to function. I noted that the basic mechanism (or "thermocouple") of the structure was "the particular conflation of interests—political, economic, religious, and ecclesiastical—that sustained reciprocity or 'feedback' between piety and usury." And I hypothesized the existence of a set of tacit understandings and a structure of conventional or routine practices that served to trouble and pacify consciences bound together in a homeostasis that assured enough ethical pressure to keep rich people patronizing and, in general, contributing to public welfare so that they could continue to get rich enough to continue patronizing and contributing.

Although the apparatus of patronage in seventeenth-century Holland operated in a very different social, political, and cultural climate, and although the uniquely low interest rates for which the Dutch were famous (or notorious) diminished the importance of usury, the apparatus was sustained by a system of moral homeostasis comparable to that of its Italian predecessor. The system has been trenchantly formulated and described by Simon Schama, and condensed in the titular pun of *The Embarrassment of Riches*. Schama observes that

> the unbroken tradition of moral comment on the madness of money . . .
> suggests an impressive degree of determination to contain economic

behavior within the bounds of "safety" and propriety. . . . The incorrigible habits of material self-indulgence, and the spur of risky venture that were ingrained into the Dutch commercial economy themselves prompted all those warning clucks and solemn judgments from the appointed guardians of the old orthodoxy. It was their job to protect the Dutch from the consequences of their own economic success, just as it was the job of the people to make sure there was enough of a success in the first place to be protected from. . . . The peculiar coexistence of apparently opposite value systems was what they [the artisan, merchant, or banker] expected of their culture. It gave them room to maneuver between the sacred and profane as wants or conscience commanded, without risking a brutal choice between poverty or perdition.[4]

Schama attributes this *mentalité* to the "precocity" that set the Dutch Republic "apart from other states and nations in baroque Europe. . . . It had become a world empire in two generations," and the response inscribed in their cultural representations showed the Dutch to be ambivalent: "The prodigious quality of their success went to their heads, but it also made them a bit queasy. . . . [T]he continuous pricking of conscience on complacency produced the self-consciousness that we think of as embarrassed" (8). Of an "energetic entrepreneur" who was also "an ardent Calvinist," Schama notes (with a casual sideswipe at the Weber thesis) "that so far from his religion accommodating his business, it generated a great deal of moral discomfort. That discomfort was only made more tolerable by acts of conspicuous expenditure on both pious and personal objects. So instead of religious anxiety inhibiting consumption (as it certainly meant to do) it might just as well have inhibited capital accumulation and indirectly encouraged expenditure" (334–35).

Beneath this level of moral discomfort, but closely related to the precocity of an upstart maritime economy and empire, Schama detects and unfolds a deeper layer of anxiety. He begins his first chapter with an analysis of (the fact or fiction of) the punitive "drowning cell" as a cultural symptom, a pedagogical exercise in "moral geography," a "frightening experience . . . designed to be an intensive rehearsal of the primal Dutch experience: the struggle to survive rising waters" (24). He goes on to show how, in "a culture saturated in symbolic and ritualized messages" (ibid.), this pedagogy and the anxiety behind it respond to the confluence of two dangers associated with two kinds of land reclamation projects:

> It is sometimes forgotten by political historians that the war for national independence took place at the same time as a particularly fierce phase in the struggle against the sea. The grimness of the latter made the self-inflicted "patriotic" inundations of 1574 especially poignant. But in many other respects the two battles were linked in the contemporary mind. Oddly enough, as the climate of politics deteriorated and collapsed in the Netherlands, so did the dikes. (37)

To those "who fought this battle on two fronts" the defenses against the two "tyrants," Spain and the sea, were "directly linked as formative experiences in the creation of Dutch nationhood" (42), and "[t]he notion of a communal identity retrieved from the primal flood and made watertight in conditions of peril" (34) was given biblical resonance in Calvinist discourse.[5] But in order to develop its moral geography of virtue, this discourse had to encompass more than the hydraulic and military/naval heroics of a "diluvian" society, and the something more returns us to Schama's titular theme: God had also given the Dutch "the wit and will to conquer the waters" in the service of the maritime trade that produced the embarrassment of riches, thus renewing "the drama of temptation" and with it the need "to moralize materialism" and reconcile capitalism with "godly patriotism" (44–50).

Presumably, returning to the theme should close the contextual circle within which to situate a discussion of Dutch portraiture as a practice of representation informed by embarrassment and its attendant anxieties. But taken by itself, the broad scope and rhetorically supple figuration of Schama's cultural analysis doesn't quite get us there. Some attention first has to be paid to a different stratum of the discursive and institutional context of moral geography, that is, to the political, fiscal, and military strategies by which (as Schama phrases it) the Dutch came to terms "with their vulnerable position in Europe and their conspicuously anomalous position as a mercantile republic squeezed between absolutist monarchies" (45). For this, I shall rely on Marjolein 't Hart's *The Making of a Bourgeois State*, a more abstract or bare-bones account of the pressures that shaped the republican "infrastructure" and indirectly contributed to anxiety and embarrassment. But even before turning to Hart's book, I think I should prepare readers for her discussion—readers who may be as unfamiliar with the making of that state as I was until recently—by supplying some historical background. "Historical background" is probably an inflated way to characterize what I actually plan to do in the next section, which

is to isolate one of the offices of the Dutch Republic and consider its name, its functions, its occupants, and its contributions to embarrassment.

When Charles V abdicated the throne of the Holy Roman Empire in 1555, he split the Hapsburg territories into two parts, giving one to his brother Ferdinand, the archduke of Austria, and the other to his son, Philip II of Spain. The seventeen provinces of the Netherlands thereby fell to Philip, whose aggressive policies soon led to a long series of revolts, the first of which was decisively suppressed by the duke of Alva in 1568. In 1648 the Treaty of Münster formally recognized the independence of the Dutch Republic, and the Eighty Years' War is bracketed between these two dates. In 1579, following the lead of the maritime provinces, Holland and Zeeland, the seven northern provinces joined together in the defensive alliance known as the Union of Utrecht. The Union of Provinces this alliance eventually gave way to was, as constitutions go, a Rube Goldberg contraption full of procedural roundabouts, a triumph of checks and unbalances, an aggregate always on the verge of disaggregation—or, to put it more soberly, a decentralized federation of provinces whose power originated in town councils. The provinces of Holland, Zeeland, and Utrecht were the main movers. Their eastern and northern neighbors were Gelderland, Overijssel, Groningen, and Friesland. Each town sent a delegation to its province's assembly of States and each province sent a delegation to the assembly of the States General in the Hague.

If the Union of Provinces was a Republic, it wasn't a democracy: it was a representational but not an elective system.[6] Positions on town councils, States, and the States General were filled by peer selection, the minority of the peers being nobles and the majority coming from an oligarchy of merchant families whose members (called regents) had established themselves through commercial success and political participation. Holland's wealth and maritime economy made it the dominant, and also the most mischievous, province, and Amsterdam the dominant city. Since at different times different cities and provinces had different interests driving them sometimes to cooperate and sometimes to compete, power and advocacy were not only decentralized but also unstable and factionalized.[7] At the center of this complex system of negotiations was a prudently imprudent (con)fusion of bureaucratic, charismatic, and traditional forms of authority invested in an office with a strange name and career, a word I

use here because of its lexical affinity to "careen." What follows is primarily a meditation on the office's name and career motivated by my sense that "prudently imprudent (con)fusion of . . . forms of authority" is a periphrastic way to characterize a structure of embarrassment.

To consider the name first, it must be very important because in his magisterial 1,231-page history, *The Dutch Republic: Its Rise, Greatness, and Fall,* 1477–1896, Jonathan Israel always capitalizes its first letter, even though in the other, admittedly shorter and less magisterial, indeed compendious, histories I have consulted the name gets less respect; its first letter is lowercase. I tripped over it again and again in the histories I read to prepare myself for this third part of *Fictions of the Pose*, which changes the scene of portraiture from Italy to Holland. The change of scene involves changes in the political conditions and social motivations of portraiture that have roots in the three special circumstances of Dutch history: the revolt from Spain, the formation of a republic, and the arrival of a new class of merchant patricians wafted in on the prolific spume of maritime economy. The important name figures prominently in discussions of all three circumstances, and it seemed to me that if I could understand its meaning I would have a better sense of the complexity of the relation between Dutch portraiture and its context. The results of my research are that, although I now think I know what it means, I'm not at all sure what it refers to. But at least this research persuades me that the very unclarity of its reference may be the key to the unclarity of the context. The term is "Stadholder."

What is "Stadholder"? In the Dutch-English section of *Renier's Dictionary*, the Dutch entry *stadhouder* is translated as "stadtholder," but the English-Dutch section fails to reciprocate: "stadtholder" is not listed. Arseen Rijckaert's *Hippocrene Standard Dutch Dictionary* offers reciprocity but no enlightenment: Dutch *stadhouder* is translated as "stadtholder" and English "stad(t)holder" as *stadhouder*. After such ambages, one moves quickly from lexicographical fast food to the more capacious larder of bona fide dictionaries and becomes grateful for the articulateness, the openness, the modest comprehensiveness served up by the *OED* and the third edition of *The American Heritage Dictionary* (*AHD*). First, the *AHD*: "stadholder . . . also stadtholder . . . *n.* 1. A governor or viceroy formerly stationed in a province of the Netherlands. 2. The chief magistrate of the former Netherlands republic." In a parenthetical notation the *AHD* adds, "Partial translation of Dutch *stadhouder*: *stad*, place; . . . + *houder*, holder."

Although "place" mistranslates *stad*, which means "town," we'll see shortly that the error is motivated by an accurate sense of the office's constitutional function.

The two *AHD* senses virtually repeat those in the *OED*: "2a. Originally, a viceroy or lieutenant governor of a province or provinces. b. The title borne by the chief magistrate of the Dutch republic."[8] Since the English have a history with the Dutch that predates the advent of New Amsterdam in America, the *OED* not only lists additional entries (Stadholderess, Stadholderate, Stadholderian, Stadholdership) but also conveys extra information in a special note: "the title was first conferred by the States General on William of Orange in 1580, and implied a nominal recognition of the sovereignty of the king of Spain. When the independence of the republic was acknowledged, the title of the office (hereditary in the house of Orange) remained unchanged."[9] Presumably the first sentence glosses sense 2a and the second 2b, since in 1580 one could not speak confidently of "the Dutch Republic," much less of its "chief magistrate." As always, the *OED* sounds definitive.[10] But is it right? Is the date correct? Was there ever a single Stadholder or chief magistrate for the Republic as a whole? If that office existed, and if it bore that name, was it hereditary in the House of Orange? Both sense 2b and the explanatory note turn out to be misleading or wrong. This can be attributed to the fact that both the office of the Stadholder and its history are too slippery to be accurately described within the compact scope of the dictionary entry. Just how misleading the entry is may be suggested by turning from the name of the office to some moments in its history. I begin with a glance at information supplied in Israel's *The Dutch Republic* about the so-called father of that Republic, William I, Prince of Orange, who was called William the Silent because he kept his own counsel. Assassinated by a Catholic fanatic in Delft in 1584, his career spanned the middle decades of the century and he began collecting stadholderates well before 1580.

William was appointed Stadholder of three provinces (Holland, Zeeland, and Utrecht) by Philip II in 1559 and served until 1567.[11] In 1572 the States of Holland formally acknowledged his claim to be Stadholder and military commander of all three provinces (173–75). "Between 1572 and 1576 there was just one Stadholder in the rebel Netherlands, William of Orange" (301). In 1576 the States General—still convening in Brabant—"agreed to recognize . . . [him] as Stadholder of those parts of Holland and Zeeland currently under his leadership," but it temporarily

suspended his authority in Utrecht and elsewhere (86). From this time until his assassination he was Stadholder in Holland and Zeeland, regaining the Utrecht stadholderate in 1577 (189), and being appointed Stadholder in the northernmost provinces of Friesland and Groningen three years later (303–4). Stadholders had been appointed by the Hapsburg emperor since the 1520s and by the provincial States after they were free of Spanish rule. In line with Charles V's practice, two or three provinces were often grouped under one Stadholder and, conversely, one person could collect several stadholderates.

After 1590, each of William the Silent's descendants was the Stadholder in up to five provinces, which he administered from the court of Orange at The Hague, while descendants of William's brother, the Count of Nassau, were Stadholders in one or both of the remaining provinces (Friesland and Groningen) for over two centuries. Willam's second son, Maurice, held five stadholderates from 1590 until his death in 1625. He was succeeded in these offices by his half-brother Frederick Henry, who in turn was succeeded by his son, William II. Following the latter's death in 1650, the stadholderate remained vacant until 1672. Because this period of twenty-two years was the first time the United Provinces were untroubled either by Hapsburg kings or by princes of Orange, it was called the period of the "True Freedom." But not until 1747 was a single member of the Houses of Orange and Nassau Stadholder of all seven provinces.

Nevertheless, the sources and breadth of the Stadholder's jurisdiction are hardly crystal clear. It may seem to casual readers, as it apparently did to the *OED* and *AHD* lexicographers, that the stadholderate eventually became an office of the United Provinces, the Dutch Republic, as a whole. The author of a recent and excellent history of early modern Dutch art distinguishes two levels of Stadholder: "Each province elected its own Stadhouder. . . . The States General appointed a general Stadhouder as well."[12] It is true that some Stadholders received their commissions from the provinces and some from the States General, true also that during the years of the English presence in the Netherlands (1585–88), the English, the States General, and the provinces disagreed as to where, institutionally, the appointments should originate. But there is no evidence that in the period I'm concerned with any Stadholder had ever been invested as "the chief magistrate of the Dutch republic." Obviously, however, when the central Republican offices were in The Hague, it was easier for the Holland Stadholder residing there to act as if he were the

chief magistrate—especially if, like Maurice, he was de facto commander of the whole Dutch army.

Schama concedes that although the office of Stadholder "was in no way comparable with that of the royal dynasties of baroque Europe, justified by divine unction and armed with absolute power," the House of Orange "did have its patriotic mystique." The "prowess and charisma" transmitted to the dynasty by William's patriotism, political skill, noble titles, and assassination gave his offspring a pronounced advantage, for they were sons of the Father of their Republic.[13] Their historians and contemporaries referred to them as princes, even when they weren't.[14] But this advantage also has its roots in the deeper inertial soil of deference to aristocracy:

> Under the Habsburgs, the Stadholders had been great nobles whose entourages reflected the splendor and hierarchical world of courtly culture. Despite the fact that, after 1572, the United Provinces were a republic, and had no royal master, the courtly culture and aristocratic outlook surrounding the Stadholders continued as before and, indeed, took hold even more strongly, being used by the new Stadholders to enhance their prestige, authority, and dynastic pretensions.[15]

During Maurice's tenure the court of Orange in The Hague may have lacked the grand baroque style, but Frederick Henry and his wife did their best to bring it up to speed.

The princely aura of this court could be simultaneously productive in external affairs (dealings with neighboring monarchies) and counterproductive—that is, embarrassing—in internal affairs (dealings with the urban elites). This was to be expected, given the strategically functional strain between the centralizing aura propagated by the position-holders and a position that was in principle a set of bureaucratic offices with de jure jurisdictions parceled out among the provinces of a decentralized burgher republic. As Gary Schwartz expresses it in his lively and astringent overview of this mess, when the States, after renouncing Philip's rule in 1581, failed to find candidates willing

> to assume all or some sovereignty over all or some of their lands . . .
> they began, by default, to call the United Provinces a "republic," a name
> borrowed from ancient Rome, with overtones of the Italian city-states.
> The institution of the Republic left the state exactly the same as it was
> before: a patchwork of overlapping powers, the most paradoxical of

which was that of the stadholder, a deputy "taking the place of nobody" (Huizinga).[16]

"[I]n the case of the Dutch," Schama observes, "national unification . . . is a contradiction in terms since they had come into being as a nation expressly to avoid becoming a state."[17] This is partly why a Stadholder should not be considered a "state-holder," as one of the authors cited in the OED entry mistakenly considered it in 1673. The literal translation of *Stadhouder* is "town [*stad*] holder," but since the term originally designated an appointed holder of another's power—a provincial governor who acted as the representative of the Hapsburg emperor—it was easy for one historian to assume that the word "'stadholder' is the literal equivalent of 'lieutenant,'" or "place-holder."[18] After the revolt, the limits imposed by the emperor on a Stadholder's jurisdiction and on an individual's tenure in office gave way to those imposed by the centrifugal design and the inefficiency of the Republican constitution.

I suspect it wasn't merely inertia that allowed the term "Stadholder" to settle in as an occupant of the Dutch constitution. It may also have been because the sense of merely delegated power was as important to the Dutch Republic as it had been to the Hapsburg emperor. The connotation of contingent or provisional power had an important resonance. In a society dominated by a nonhereditary class, the merchant oligarchy, the term rhetorically emphasized the primacy of constitutional over aristocratic criteria of authority. The emphasis lent support to the idea that the Stadholder was at least in theory beholden to other mechanisms of the Republic, mechanisms lubricated by the commercial and political success of the class of magnates whose control of civic government entitled them to be called regents. This doesn't mean that the stadholderate was ineffective, only that its occupants had to understand the interests of the regent class sufficiently well to outwit and divide its members in as many town councils as they could. Members of this class may have secretly envied or been intimidated by princely display and aristocratic manners. Many, as we'll see later, were tempted—more or less discreetly, more or less embarrassedly—to emulate them.

The strategic fuzziness imparted to the stadholderate by its aristocratic occupants may be underlined by comparing it to another office I haven't yet mentioned, the office of the Advocate General, later called the Grand Pensionary of Holland.

> Originally the Pensionary of the province (the cities each had their own) was only a legal adviser and spokesman, but the office was greatly developed by the personality of its holders. . . . Into the Pensionary's hands fell the task of preparing and carrying out decisions, formulating resolutions, providing information and carrying on correspondence. Almost inevitably he became in practice the nearest thing to a minister of state, not only in the province of Holland, but, since this was by far the most important of the provinces, in the Republic as a whole.[19]

Given the Advocate's range of legal, notarial, and diplomatic duties, his authority depended more purely than the stadholderate on the bureaucratic charisma of office. The custom of appointing members of noble families to the stadholderate ensured that the nonhereditary charisma of office in bureaucracies run by civilians and burghers would be enhanced by, embedded in, the ascribed "lineage-charisma" of traditional or patrimonial authority.[20]

A glance at the outcome of relations between the personally unprepossessing Stadholder Maurice and the powerful, personally "charismatic" Advocate who held office in the critical period from 1586 to 1618, Jan van Oldenbarnevelt, will suggest what the difference between these two forms of authority might mean. Maurice and van Oldenbarnevelt were allies for many years, and their cooperation kept the United Provinces together and running. But toward the end of the Twelve Years' Truce they fell out over a complexly interrelated set of issues involving religion, war and peace, and the conflict between the Stadholder's authority and provincial autonomy. During 1618, the year Maurice became Prince of Orange, he cautiously but persistently mounted a political campaign that culminated in van Oldenbarnevelt's being arrested, brought to trial, and—after Maurice refused to pardon him—executed.

I doubt very much that an Advocate General or Grand Pensionary could have had a Stadholder from the House of Orange brought to trial and executed. This was not because he lacked the Stadholder's institutionally conferred authority to back up political maneuvers with armed force but because the Orange standholderate, unlike the office of Advocate, was protected by a canopy of "lineage-charisma," or dynastic and patrimonial authority. The canopy traditionally sheltered and validated a residual *virtù* that lurked in the penumbra of the Stadholder's powers: the warrior's bearing and prowess, his skill as a military leader. But given the dynasty's "patriotic mystique" and the Dutch Republic's "emphatic resis-

tance to Caesarism," "in wartime the Stadholder existed in an uneasy capacity, part warlord, part commissioned officer."[21] The sheen and glitter of the Orange pedigree that encircles a Republican office can generate uneasiness all around, not least in the office holder, an uneasiness sometimes vividly betrayed in the formality of commissioned portraiture.

Many of the portraits of Maurice produced over the years in the studio of Michiel van Mierevelt represent a princely but over-panoplied and therefore uncomfortable warrior, a sitter without sprezzatura posing taut-legged and stiff as his beard. What saves the often tedious van Mierevelt gallery of important persons is that the occasional sitter appears to be not only committed to the exemplarity he performs but also hard at work performing it. This effort betrays a glimpse of the way the comedy of orthopsychic anxiety plays itself out in Dutch portraiture. In a portrait painted by van Mierevelt in 1625, shortly before Maurice died (pl. 9), the princely Captain-General is ensconced in feudal glory, conspicuously besashed, befringed, accoutered, and embowered in tell-tale orange. But although the gilded armor he wears is shot through with tints of reflected orange, it wasn't inherited from his father. It had been conferred on him twenty-five years earlier by the States General to honor his victory of June 30, 1600, over Spanish infantry on the beaches near Niewpoort.

The strange if consistent illogic of this collocation shines through Israel's comment on the outcome of the battle, which was part of a disastrous campaign in Flanders cooked up by Maurice and van Oldenbarnevelt. On the one hand, it was "a hollow victory" because it left the victorious underdogs "on the wrong side of the main Spanish army, dangerously exposed." On the other hand, since the underdogs owed their victory, such as it was, to the discipline inculcated by Maurice during "years of methodical drill," the battle showcased his particular forte, not as a warrior but as a military organizer and tactician: it was "the supreme vindication of method over force."[22] If this is what the Stadholder chose to commemorate in 1625, one can sympathize with the edginess of his pose. He stands like a CEO who is a little embarrassed by the remarkable armor he rented for his appearance at a charity ball.[23]

The scope and sources of the Stadholder's legitimate authority are as strategically fuzzy as everything else about the office. Symptomatic of this is the adversative and concessive zigzagging with which Israel's sentences try to traverse and contain what they describe:

The Stadholderate in each province was coupled with the captaincy-general, that is, command of the army. In practice, Maurits was also captain-general of the Union as a whole, with the Frisian Stadholder as his deputy, though, in contrast to later Stadholders, this was not formally proclaimed, albeit he was appointed admiral of the Union, overall commander of the navy. But while the stadholderate was coupled with the captaincy-general, it was not identical with it. For the stadholderate, as such, was essentially a non-military office, carrying powers and responsibilities relating to the political process and administration of justice. The Stadholder, no longer appointed by the king but by the provinces, was the highest-ranking office-holder and dignitary in each province. He was not a member of the provincial States . . . but could appear in their midst whenever he chose and address them, and, under various rubrics, was charged with resolving conflicts and deadlock within these bodies.[24]

Thus on the one hand, the stadholderate seems to have been a primarily administrative and judicial position with the bureaucratic and *burgerlijk* functions of a CEO. On the other hand, after 1572 the major stadholderates appointed by the States and States General were so deeply embedded in the interrelated Houses of Orange and Nassau that they seemed to be patrimonial legacies. Linking these bureaucratic and aristocratic aspects together was military command. Positions of command in the officer corps were usually filled by aristocrats, very often the same aristocrats who frequented the Stadholder's court in The Hague. The mingling of military and courtly functions at the political center of the burgher Republic contributed to one of the structural embarrassments analyzed by Schama, who notes "the marked unwillingness of the Dutch to allow the martial ethos status or dignity in its culture." They professed "an aversion for military force which their own conduct periodically belied."[25] Yet the most important improvements in military organization and efficiency in early modern Europe came from Maurice.

In their different ways, William I and his two sons were canny operators, but they were more than that: their military and political accomplishments were as vital to the stability of the Republic as to its successful resistance against Spain. Maurice's military campaigns and innovations in methods of warfare put sufficient pressure on Spain to force her to sign a Twelve Years' Truce with the Netherlands (1609–21).[26] For various reasons, some religious and some economic, many groups opposed the truce,

and Maurice himself changed his position with changes of political weather. Whereas Spain's military ventures had bankrupted the monarchy in 1596, the Dutch were economically and politically thriving under the combined leadership of Maurice and van Oldenbarnevelt, both of whom had to be persuaded to support the truce. In addition, their military position was enhanced by recent improvements, made from 1605 to 1608, in the defensive system of fixed garrisons built up since 1591 and strategically located in towns along the eastern frontier near strongholds captured and maintained by Spanish forces. These garrisons housed elements of a standing army that was three times larger than it had been only two decades earlier.

The years of truce could thus seem anticlimactic and even perverse to those who were motivated to take advantage of Spain's weakness. It could also seem vaguely appalling to burgher householders in garrison towns confronted by one of the consequences of military detente: the spectacle of local detachments of the once-standing army felled by Idleness, the daughter of Peace, whose wicked ways made them sink or topple over into the sedentary and supine diversions commemorated in countless genre paintings. But the army was forced back to its feet after the truce ended, and not until the early 1640s (following a series of military and naval successes) was the Republic's independence secured and the ground laid for its recognition in the Treaty of Münster in 1648. During this decade there was increasing hostility between the Stadholder, Frederick Henry, and the States of Holland, which lobbied for an early peace and cutbacks in military expenditures just when he wanted to continue campaigning in the south so that he could sit down at the peace table with more victories under his belt.

Holland's relations with the Stadholder were always strained after the Twelve Years' Truce had begun. The security Maurice gave the maritime cities with his military hand he jeopardized with his political hand after 1617, when a seemingly arcane religious controversy flared into the public domain and gave him an opportunity to increase his influence over city councils. In the first decade of the century, the controversy had begun in the sacred groves of academe, where Arminius and Gomarus, two Calvinist theologians teaching at Leiden, had a dispute. They argued over whether God had damned humans before the Fall and was therefore responsible for sin, or after the Fall, in which case God would be a little less omnipotent and His creature a little more capable of contributing to his

salvation. The former reflected the orthodox Calvinist position defended by Gomarus; the latter was Arminius's alternative.[27] Today, Gomarists would be pro-life and Arminians pro-choice, with the former term, then as now, being the more euphemistic of the two. Arminius and his followers proposed to implement their alternative in revisions of the Calvinist confession and catechism, and in 1610 they aired their proposals in a Remonstrance to the States of Holland. From the heat this document generated were kindled two of the catchiest terms ever burned into the historical record, "Remonstrantism" and "Counter-Remonstrantism." To oversimplify (since the details aren't pertinent to my story), Remonstrants were more liberal in religious beliefs, more Erasmian in outlook, and more tolerant of Catholics, therefore more conciliatory toward Spain. They were opposed by Counter-Remonstrants, who adhered more strictly to orthodox Calvinist doctrine, who were thus less tolerant of Catholicism and other heterodoxies, and who included refugees from the south desirous of fighting Spain and recovering their land.[28]

The controversy imperiled the unity of the Reformed Church in the Republic and smoldered on for years because, although most ministers were against the proposals, the idea of making religious practices more flexible so as to accommodate more worshipers had obvious appeal to statesmen like van Oldenbarnevelt and his allies. Sympathy for the Remonstrant cause was centered in the States of Holland and Utrecht, and in 1617 the former, led by van Oldenbarnevelt, passed a resolution aimed at increasing provincial control over doctrinal and ecclesiastical matters. Behind that move was a more general effort to obtain Holland's de facto autonomy from the Republic. At this point, with the Stadholder's authority and the always precarious integrity of the United Provinces further endangered by the assertiveness of the States of Holland, Maurice intervened. In 1618, he successfully carried out a campaign—using or threatening force where necessary—to purge Remonstrants from town councils, and by 1619, when van Oldenbarnevelt was tried and executed, the threat to the Republic's stability had been contained.

Was the Stadholder's motivation religious, theological, political, moral, ideological, or military? "His personal life," as Haley puts it, "was far from being a model of Calvinistic godliness, and his interest in the doctrinal issue was small. He is said to have remarked that he did not know whether predestination was blue or green, but he now proceeded . . . to make it Orange."[29] The controversy that had begun in 1604 with a single theo-

logical binary, Arminian vs. Gomarist, snowballed through the next de-
cade or so and picked up all other cultural binaries in its path. Packed into
the omnibus conflict between Counter-Remonstrant and Remonstrant
were Protestant vs. Catholic, strict vs. tolerant Calvinism, orthodox Cal-
vinism vs. other Protestant sects, war vs. peace with Spain, central vs.
provincial government, the interests of the Stadholder and the States Gen
eral vs. those of the Advocate and the States of Holland.

It was a relief for Remonstrants when Frederick Henry was appointed
Stadholder upon Maurice's death in 1625. He nevertheless adroitly tem-
pered his known Arminian sympathies, pursued a via media in order to
prevent Counter-Remonstrant backlash, and thus succeeded for a while
in creating a more tolerant religious atmosphere.[30] This agreed with his
desire in the early years of his tenure to seek either peace or another
truce with Spain, for Remonstrants were the mainstay of the party of
peace. But the situation altered in the 1630s when Frederick Henry
changed his mind and decided to increase preparations for war. The Ar-
minian faction had become dominant in the States of Holland and op-
posed his military initiatives. Once again, therefore, a Stadholder looked
for help from Counter-Remonstrant supporters of the war effort. Until
his death in 1647, Frederick Henry's military and aristocratic postures
made Holland's regent class nervous, and the conflation of these two pos-
tures could threaten burgher well-being. During his final years, his ef-
forts to increase the dynastic status of the House of Orange and the
glamor of its court aroused suspicion because many feared he would sac-
rifice the interests of the Union to further his alliance with a Stuart
regime on the verge of decapitation.

Frederick Henry's son and successor, William II, confronted a similar
range of problems, focused again on the intransigence of the Holland re-
gents and especially on their efforts to reduce the size of the army by re-
fusing to pay their share of the costs. William's ultimate response was
modeled on his uncle's. launching a coup d'état that would, by a show of
force, "break Holland and . . . save the Union and his authority,"[31] he or-
dered troops to march on Amsterdam. Although they didn't enter the
city, the threat of a blockade made the regents back down and abandon
their efforts to cut military spending. When William died of smallpox, his
sudden loss may have been "as devastating as it was inexplicable" to "the
Orangists and devout Calvinists" who supported him (609), but to his
opponents in Holland and its cities, there was a good reason why the

Stadholderless and Orangeless years that followed were called the "True Freedom."

During the period between the Twelve Years' Truce and the True Freedom, the struggle that divided the United Provinces, the individual provinces, the towns, and the town councils cut across social lines and produced strange bedfellows: "the faction patronized by the *nobleman* Maurits enjoyed broad support from the less wealthy but numerically strong segments of the urban middle class, while the more lenient Calvinists in favor of peace were led by *prosperous patricians* and *upper-middle-class individuals*."[32] Are the three italicized terms easy to differentiate? Do they tend to drift together? However bland they sound as historical labels, their proximity here indicates a new and troubling lability in the social order. In his account of the identity, the culture, and the past the Dutch invented in response to their "rebellion against royal authority," Schama observes that unlike "the Venetians, whose historical mythologies supplied a pedigree of immemorial antiquity and continuity, the Dutch had committed themselves irrevocably to a 'cut' with their actual past, and were now obliged to reinvent it so as to close the wound and make the body politic whole once again."[33] Schama's comment occurs in a chapter on the sources the Dutch used to construct the mythologies of their past. I am interested in their continuous effort to reinvent or mythologize their present, by which I simply mean their effort to claim, to *realize* and perpetuate, an exemplary class identity.[34] The distinctions and overlap among our three italicized categories are not just of concern to social historians. They also posed new problems of self-representation for the actors themselves: did they want to embody and perpetuate a class identity in which the boundaries—between upper-middle-class individuals and prosperous patricians, between prosperous patricians and nobles—were accentuated or one in which they were transgressed?

These problems of categorical distinction and overlap are discernible at the levels of both constitutional structure and social hierarchy. As to the former, we've seen that they could ambiguate the stadholderate and affect relations between its incumbents and others, and in addition our brief glance at van Mierevelt's portrait of Maurice suggested that they might also complicate the incumbent's task of self-representation. At the level of social hierarchy, the same problems and complications announce themselves as symptoms of a dramatic increase in the lability *of* a social formation and mobility *within* it. Lability and mobility are analytically separable

but mutually reinforcing motors of historical change, and I explored such an increase in general terms during my account of the Elias thesis in Chapter 6 above. The Dutch response to the particular forms of the increase they encountered has been concisely and sharply illuminated by Herman Roodenburg in an important essay critical of Elias. Roodenburg shows how they mythologized their present by informally adopting new rules of civility and modes of nonverbal communication (styles of dress and deportment)—in two words, new manners.[35] The kind of attention he directs to the evidence of visual self-display and body awareness in the fugitive medium of live behavior is easily extendable to one of the more enduring, and therefore effective, methods of mythologizing the present: the acts of self-portrayal portraiture pretends to record. Historians of Dutch art have always treated the portrait as an attempted solution to the problems posed by categorical distinction and overlap among the classes of a labile social order. In the chapters that follow, however, we'll see that Dutch portraits may have mythologized more than their patrons—but not necessarily more than their painters—intended, since they often present sitters who betray symptoms of the embarrassment produced by conflicting desires, the desire to distinguish and the desire to overlap; symptoms, in two words, of orthopsychic anxiety.

In *The Making of a Bourgeois State*, Marjolein 't Hart has criticized Schama and others for overstating the extent to which the Dutch Republic was a centralized state buttressed by "shared national feelings" and for overlooking "the contradictions among the multiple mercantile and entrepreneurial factions within the Netherlands. No powerful central institution existed which acted as an arbiter deciding what . . . [their] 'vital interests' should look like, and Dutch policies . . . were determined by continuously changing coalitions of provinces, cities, and factions," and especially by "the decentralized nature of economic growth."[36] Hart's thesis is that the various methods, policies, and institutions developed to defray the enormous costs of warfare incurred during the Eighty Years' War intensified "federalist tendencies within the Republic" (63). Their unintended consequence was the dispersal of the political forces that, had they consolidated, would have driven the Netherlands down the traditional routes to centralization taken by neighboring monarchies. But she reminds us that if the Republic was decentralized, it still *was* a state in that it con-

trolled a specific territory, used armed forces, and imposed taxes (26 and passim). In this respect, however powerful the major cities were and however autonomous they seemed, they differed from the Italian city states with which they have often been compared. The difference has a peculiar character: because the cities were less autonomous, their governing elites had more political power. It's to this peculiarity that I shall eventually trace the structural or political sources of the embarrassment I find in Dutch portraiture. But first, because more is involved than the stark distinction between a city that is a state and one that isn't, the difference between Italian and Dutch needs to be further specified.

Considered strictly from the standpoint of the mercantile structure based on writing, credit, capital, and long-distance trade, there is no difference. The ability to overcome absence and exert control over the temporal deferral connected with spatial distance is the enabling condition of early capitalism wherever one finds it. That is what the merchant's promissory and contractual instruments are for. But this expansion of economic power brings with it amplified risk, and, as Stephanie Jed and others have shown, the very merchant writing that makes the expansion possible is a discourse of self-representation—and self-justification—deeply inscribed with anxious awareness of the risk.[37] The precariousness of deferred returns and long-distance trade intensifies the importance of record keeping, not only as accountancy but also as a form of self-accountancy, part of a defensive practice of self-representation by which merchants monitor their performances and positions in their local communities. If long-distance and local interests entail different orders of motivation, they are intimately bound together in an unruly tangle of social, political, domestic, religious, and economic pressures. Thus although daily-life performances and strategies of self-representation may not be a crucial factor in long-distance trade taken by itself, their careful management on the home front is essential to survival and success abroad.

These truisms apply to medieval and early modern merchants anywhere. What distinguishes Dutch merchants from their Italian counterparts is the different political context within which economic activity was carried out: in spite of relative economic autonomy, not even Amsterdam was a political state. On the contrary, its membership within a broader constitutional entity was, according to Israel, the condition of its remarkable economic success: the "unique and characteristic Dutch blend of political intervention and business efficiency . . . amounted to . . . a har-

nessing of the Dutch entrepôt to the machinery of the Dutch state. The Dutch business world of the seventeenth century was fundamentally shaped by an assortment of companies, national and local, consortia with political links, cartels, and combinations."[38] Israel makes it clear that business in this politico-economic aggregate was run not from The Hague but from more informal sites closer to home:

> [D]espite the advent of a purpose-built exchange and of an army of licensed brokers, the old-style informal gatherings in smoke-filled taverns and, later, in the coffee-houses around the Exchange, continued to flourish. Power and influence at the Amsterdam Exchange was often exerted in back-rooms. The Amsterdam Exchange may have developed into the world's first true stock exchange but, throughout the era of Holland's primacy in world commerce, the dealing which counted often went on in informal surroundings. (74–75)

Nevertheless, he makes much of the "trade promoting and protective" interventionism of "an exceptionally strong and efficient state" with a "complex federal apparatus" (411), and although this emphasis is one of Hart's targets, the implications of the term "assortment" and the complexity of the federal apparatus provide the context for the peculiar fact that because Dutch cities were less autonomous, their governing elites had—or at least had access to—more power.[39]

Hart glances once at the Dutch-Italian difference when she notes that although Holland's fiscal system "resembled the public finances of the Italian city-states," its novelty "was that it encompassed a region larger than a city alone: the whole province experienced more or less the same tax burden."[40] But what about the peculiarity? How can a tax burden imposed by a state on its urban elites increase their power? Although Hart doesn't expressly deal with the question, it is wound like an armature around the core of her historical argument, which concerns the different strategies of crisis resolution employed by the Republic in its efforts to transfer the financial burdens of war onto society. The argument unfolds a sequence of three strategies distinguished by their different vectors of transfer, the first toward centrally imposed sources of revenue, the second toward provincial taxation, and the third toward public loans and the emergence of a system of public debt.

This sequence is itself significant. The centralist solution failed for several reasons, but the only one relevant for my purposes is "the fragmented

structure" of a central government dominated by a system of provincial representation in which the diverse interests of the provinces prevailed over those of the Republic (19, 113). Because the second strategy, the shift to taxation, generally requires not only the consent of the governed but also their participation and some satisfaction of their demands, the inadequacy of the first method made the Dutch state become "even more dependent upon the provinces." The second shift was particularly advantageous to Holland, which had "a highly developed taxation system" (114) that enabled "Holland cities . . . to put their stamp upon the Union's policies" (150). Finally, the shift of the war burden to the mechanism of public debt "provided ample opportunities for investment by the burghers" of those cities (173). It was attractive to potential investors because the loans were domestic, largely voluntary, and politically beneficial: they "secured the control of local elites over the issuing institution" (179). Since "almost all creditors lived in the core province of Holland, Stadhouders and the Councillors of State always had to consider that province's political preferences" (222). Thus the political economy of the Dutch Republic, "dominated by urbanization," was "ruled by different and competing socio-economic elites" (210).

If the moral of Hart's story is that these policies resulted in the weakening of the Republic's center, the moral of mine is that they made the major cities and their governing elites more powerful than they would have been as autonomous city states. From the standpoint of urban power, that is the upside of Hart's thesis. But it also has a downside. Her discussions show that the "Holland cities" she refers to—Amsterdam, Haarlem, Leiden, Rotterdam, Dordrecht, Gouda, Delft, Hoorn, Alkmaar, Enkhuizen— were constantly realigning against each other in pursuit of different interests and agendas. Their cooperative and competitive negotiations were complicated by their positions in the republican aggregate, a political *emboîtement* in which each city had to deal with the others, with its own provincial government, with the States General, with the Council of State, with the Grand Pensionary of the States of Holland, and with the Stadholder and his court.[41] Since in the ordinary course of political exchange and governmental routine the cities had more to gain precisely because they weren't autonomous, so also did their governing and merchant elites. But they also had more to lose. If power rippling out from separate urban centers was amplified by their connection and access to the republican center, by the same token its reflux could be more threatening and divisive.

The backwash of amplified power and danger intensified existing patterns of factionalization within each city. It raised the stakes of local matters.[42]

"Within Holland itself," Hart writes, "no single economic or urban elite emerged as rulers, owing to the wide differentiation in commercialization and the constant bickering of factions," and because of this and "the high degree of urbanization . . . several political elites watched each other jealously. These competing segments of the Dutch Republic blocked the formation of a centralized national state. No ideological or cultural center developed."[43] What Hart has to say about bureaucratic inefficiency and its consequences in The Hague and provincial offices is not unfamiliar to present-day Washington watchers: pork-barreling, special-interest pressure, influence-peddling—the whole package (187–205 and passim). Gary Schwartz's general comment on relations among the Republic's various "offices and organs" succinctly captures the problematic atmosphere of the situation Hart describes: "For all the care that was bestowed on protocol, the limits of these offices and of the States were bounded only by what their incumbents could get away with, and sometimes not even by that. Decisions came to pass, if at all, in a perennial round of swaps and deals, some implicit, some committed shamelessly to paper."[44] The context of this comment dramatically foregrounds the potentially divisive effect of access to republican power on urban politics: it is part of the introductory overview from which the author pans in on a close study of Rembrandt's Amsterdam patrons (and non-patrons), a study focused not only on the artist's poor skills in social navigation but also on the turbulent sea of factional bickering, suspicion, and surveillance Schwartz's anti-hero failed to weather. The thesis I read out of, or possibly into, Schwartz's account of artists and their patrons is that decentralization puts more power into local hands and therefore makes it more important to master, more foolhardy to ignore, the art or politics of self-representation. So, as I said, it raises the stakes of local matters.

That vague and vapid phrase "local matters" marks the tiny circle within which my topic vibrates. By local matters I mean what matters locally to the leading citizens, the ones who commission portraits—what important intra-, inter-, and extra-urban matters bring them together to socialize, argue, conspire, and negotiate in their homes, their streets, their neighborhoods, and their halls. More importantly, perhaps, "local matters" denotes what they do when they come together for these purposes: their relations in public, their behavior in public places, their interaction rituals,

their forms of talk, and their strategic interactions, in short, all the aspects of the presentation of self in everyday life Erving Goffman taught us to take seriously and to distrust.[45] To look back for a moment to Chapter 6, anyone familiar with the influence of Goffman and Elias on studies of early modern conduct will immediately recognize that within the circle of local matters the context of the suspicion and surveillance Hart mentions is guaranteed to increase sensitivity to the messages relayed through the various codes (gestural, sumptuary, behavioral) by which people communicate themselves to or conceal themselves from each other. Although Hart criticizes Schama for talking about "shared national feelings" in a decentralized polity, such uneasiness may be pan-Batavian not because it is disseminated at the level of cultural discourse but because it is continuously induced by the dynamic system of urban, provincial, and state interactions called the Dutch Republic, the very system Hart analyzes at the level of economic and political structure.

Hart's *The Making of a Bourgeois State* is a rigorous example of social science methodology: her compact and elegant hypothesis is supported by an impressive data base visualized in the charts and statistical tables that attend every step of the argument. The evidentiary base of *The Embarrassment of Riches* is visualized not by charts and tables but by illustrations of paintings, woodcuts, etchings, engravings, tapestries, tiles, emblems, and texts. Both studies explore and demonstrate the operation of ambivalent and contradictory structures productive of anxiety. Both in their different ways proceed by interpreting representations. But as the object of interpretation, the anxiety of local matters is complicated by an extra fold: it is directed toward—and it is partly a worry about the strategies and techniques of—self-representation. So it stands to reason that this anxiety is peripheral to Hart's project but that Schama gives it a long and hard look. And yet she provides an account that supports the object of his attention as a skeleton supports a body.

Schama, as we saw, locates one of the principal sources of anxiety in Dutch awareness of the parallelism—and the occasional intersection—of the war against Spain with the war against the sea. Having shown how such concerns are interwoven in the figurative and figural texture of public discourse and brought to bear on other aspects of Dutch life and culture, he goes on to characterize Dutch anxiety in its own terms. Thus he depicts a culture always trying to shore up the social dikes against the fear of being "vulnerably bereft of watertight compartments of experience,

moral and material, sacred and profane." The fear that "the norms and values of one realm" might not be prevented from "leaking into the domain of the other" was expressed in constant homiletic admonitions from the pulpit, registered in the wide dissemination of advice books on domestic virtue, and illustrated by the famously ambivalent genre scenes (household or brothel?). Schama's aqueous metaphor is intended to reflect the biblically enhanced association the Dutch made between the deferred but ever present diluvian peril and the "confusion, disguise, ambiguities and stratagems" that riddle this potentially "uncompartmentalized world . . . with anxiety."[46]

This precarious sense of moral geography seeps between the cracks of the state's federated partitions and into the cities, where it penetrates to the most basic and important unit of compartmentalization, the supposed refuge and microcosm of patriarchal order, the household, and within that even to the virtual space of the art that reflects once again and in smaller compass the same anxieties. When Schama praises the usefulness of Dutch art as "a document of belief," he cites Paul Claudel's insight into the preoccupation of the *nature morte* genre "with what he called *désagrégation*— a coming apart. Still lifes, he thought, were caught (in the Dutch) at their *toppunt*: the zenith before the fall; the moment of perfect ripeness before the decay. Militia pieces like *The Night Watch* represented the *désagrégation* of the group; both a setting-off and a coming-apart."[47] I find in the resonance of this term, *désagrégation*, the possibility of contrapuntal harmony between Schama's insight into pan-cultural anxiety and Hart's analysis of a centrifugal constitution, the republican aggregate, always on the verge of "a coming-apart." Schama's longest chapter centers on domesticity and the fear of *désagrégation* focused on and displaced to woman.[48]

Désagrégation is the real subject of Norman Bryson's brilliant essay on Dutch still life, which, entitled "Abundance," expressly takes Schama's dialectic of embarrassment as its point of departure.[49] Moving to the still center of the *emboîtement* of republic/province/city/neighborhood/*huts*/ furnishings, Bryson draws from its radiance the lovely metonyms of anxiety and traces their meanings outward: the contradiction at the heart of the *vanitas* tradition, the "governing principle" of which is "the conflict between world-rejection and worldly ensnarement" (117); "the still life of disorder, poised between harmony and catastrophe," depicted always after the gustatory *toppunt* and representing "a clash between the careful attention of those who make, the craftsmen and the painter, and the negligence

of those who enjoy" (121–22); Willem Kalf's images of precious objects, which, beautifully crafted and piled up as if on display, gesture beyond themselves and offer the observer a glimpse of the more abstract network of property, commerce, capital, and possessive individualism they are implicated in.

Kalf was famous for ostentatious still lifes (*pronk still-leven*) that reflected the more opulent tastes of wealthy merchants and regents in the decades after the Peace of Münster. In Bryson's comments on two examples of these—*Still Life with Nautilus Cup* and *Still Life with Metalware*—the resonant senses of *désagrégation* begin to bounce back and forth between Schama's cultural and Hart's political analyses:

> Still life of the table is deeply concerned with the issue of tactility
> because it is the hand and not only the eye which organizes its spaces,
> and the touch of hands in the everyday gestures of eating and drinking,
> which confers upon its objects their human warmth and resonance.
> Kalf's space is tactile, too, but this value is now in crisis. The combined
> influences of the art collection, oceanic trading and capital investment
> operate to undo the cohesion created in tactile space by gesture,
> familiarity and creaturely routine. This breaking or fracturing of
> domestic space raises an alarming possibility: that in the world implied
> by the painting, nothing can be truly at home. Because it has lost its
> bonds with the actions of the body, matter is permanently out of place.
> Its spatial co-ordinates are those of acquisition, navigation, finance. (128)

Thus wealth "is inseparable here from the ideas of competition and individuation. . . . The concepts of luxury and display" visually featured in the *Nautilus Cup* imperil "the intimate, cocoon-like space around the body" and expose it "to enormous distances: the distances of trade, but also the social distances between individuals and classes precipitated by the kind of massive and fluctuating economy which, rather than the table, is now the scene's real material support" (130).

To this eloquent and generally persuasive analysis I can add only two small modifications. The first is that wealth in Kalf's still lifes is depicted as inseparable not merely from ideas and concepts but from *motives* of competition and display. As for the second, Bryson stresses the disjunction between the intimate, the friendly, the homelike, and the vast abstract powers of a massive and fluctuating economy whose expansive spatial co-ordinates are those of acquisition, navigation, finance. His rhetoric ges-

tures toward the corruption of use value by exchange value and the eerie intrusion of Adam Smith's hidden hand behind—and threatening—the beautiful but fragile shapes of local matter. But this is to rush the Ghost of Capitalism Future onstage before its time.[50] What imperils and exposes the cocoon-like space of domesticity comes from within that space. The common drift of Hart's argument at the political level, Schama's at the cultural level, Schwartz's at the social level, and Israel's at the level of world trade is that, however massive and expansive those macro-structures may be, they are more bourgeois than capitalist in that they are managed through negotiations, deals, and conspiracies that get worked out, concluded, and plotted very close to home—in "smoke-filled taverns" and "back rooms," as Israel comfortably and comfortingly describes it.

Désagrégation, like *agrégation*, begins in the home, for a burgher's house is his castle, and although Lena Cowen Orlin's brilliant exposition of that proverbial phrase is directed to social and political developments under the gaze of monarchy in sixteenth-century Anglican England, some of her remarks apply equally well to the more diffuse and Calvinist sources of the moral gaze in the urban culture of householders in the Dutch Republic:

> The state designated the individual household, in the absence of the old authoritarian church and of a national police, as the primary unit of social control. It identified the householder as responsible for the maintenance of moral order in his immediate sphere but to macrocosmic benefit. And it reinforced the preexistent patriarchal hierarchy to further empower him politically and also to ensure his accountability. As a result the householder enjoyed a sense of individual agency that devolved from his hegemonic authorization.[51]

The same conclusion is reached from the two different historical starting points of nation-state and republic:

> During the sixteenth century . . . the phrase "A man's house is his castle" became proverbial. Even as the era of ambitious church and monastic construction ended, England also celebrated the decay of the old architectural form of the feudal lord's fortress. . . . Like the dissolution of the monasteries, the decline of the castle was the occasion for Tudor propaganda, while the central monarchy's deracination of the feudal system and of its rival nuclei of political, economic, and military authority was mythologized instead as the introduction to an era of internal peace and security. (2)

Customary male markers of patriarchal dynasticism, the residue of a feudal warrior ethos or the accumulation of a territorial estate all being less important in the Republic, the aura and status of a family household assumed correspondingly more significance. And within that household, it was the wife that was held responsible for the contentment or disarray of the domestic regime.[52]

Anxieties about domestic authority and personal property are inextricably linked with the construction of gender, since they inflect notions of both homosocial and marital relationships, coalesce in the symbolization of the woman as the most valuable and potentially most fugitive of possessions, and thus nurture the persistent hierarchy of the sexes.[53]

The "breaking or fracturing of domestic space," as Bryson calls it, is thus the generic form of the diluvian nightmare that afflicts the man of the house in Schama's portrait of Dutch culture. But it takes more specific forms as well. Commenting on ter Borch's famously mistitled genre painting, *Paternal Admonition*, Richard Helgerson locates the source of inquietude in a particular phase of the military/political story Hart tells:

> In that painting . . . the intruding soldier stands in for the missing brother, husband, or father. It is the soldier's presence coupled with the householder's absence that threatens to transform an otherwise respectable woman into a whore and to make a brothel of a bourgeois home.
>
> Both sides of this substitution deserve attention. The absent householder helps us identify the historically privileged consumer of these images, while the present soldier serves as an index to what may have been among the most acute personal and political anxieties of such householders: the fear that their own preeminence and authority in the affairs of the Dutch Republic—their political home—would be supplanted by a military-based monarchic regime.[54]

Although this comment is directed toward the state of affairs in the 1650s and 1660s, the well-documented hostility of burghers toward soldiers persisted through much of the Eighty Years' War, including the Twelve Years' Truce. It bore the impress of abiding if fluctuating tensions between the economic agendas of urban elites and the militaristic policies and objectives of the House of Orange. In that respect the hostility both reflects and contributes to decentralization. But it can't adequately be comprehended within the terms of Hart's political analysis because her

focus on The Hague as the site of the state bureaucracy is too narrow. The Hague was a social as well as political center, and as such, it was a court with international courtly connections and a gathering place for aristocrats, many of whom gravitated in the traditional manner toward military careers. Furthermore, as H. K. F. van Nierop observes, even though the nobility and the urban patriciate may have become integrated politically during the emergence of the Republic, they remained socially distinct; the nobles practiced "social apartheid."[55]

These, then, are the prosaic sources of a burgher's bad dream, in which a spectral vortex of soldiers, aristocrats, and princes flowing together with derelict wives and two-faced daughters and ill-wishing competitors and envious neighbors and even, occasionally, "the *grauw* or rabble, hated and feared by the respectable elements in society,"[56] engulf him in a Charybdis of *désagrégation*. But perhaps some of these specters ambivalently portray not only his fear but also his desire—portray, therefore, his embarrassment under the gaze. And perhaps this leads him either in prudence or in folly, in self-protection or self-abandon, to commission his portrait. And perhaps through this medium orthopsychic desire and anxiety will materialize in fictions that betray, therefore, his embarrassment under the gaze.

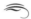

Lacan writes: "It is not true that, when I am under the gaze, when I solicit a gaze, when I obtain it, I do not see it as a gaze. Painters, above all, have grasped this gaze as such in the mask."[57] To say that embarrassment is the particular form Dutch culture gives the gaze, which the burgher tries to appropriate or defend against, is to reintroduce the Lacanian notion I discussed in Chapter 7. Lacan's strategically opaque prose represents the gaze in a manner that prevents the reader from "seeing" or picturing it. Hidden behind the textual screen of that prose, it nevertheless exerts the pressure of a mysterious drive even as it arouses lectorial desire: it is, we read, neither a seen nor a seeing force, but one that nevertheless "looks at me": the gaze "circumscribes us" as "beings who are looked at in the spectacle of the world."[58] Furthermore, Lacanian rhetoric presents it as a strictly specular force: something that operates whenever "our relation to things . . . is constituted by the way of vision," it is the scopic function of the discourse networks that produce subjects.[59] The gaze works not only "around" us but also "within" us; it is turned "inside out" to produce the illusion or misrecognition "of the consciousness of seeing oneself see oneself" (82–83).

Lacan insists on the structural priority and externality of this force, on "the pre-existence of a gaze—I see only from one point, but in my existence I am looked at from all sides" (72). "In the scopic field, the gaze is outside," that is, although "it" doesn't see me (95–96), I see myself being looked at: "I am looked at, that is to say, I am a picture. . . . It is through the gaze that I enter light and it is from the gaze that I receive its effects" (106). I enter the light of appearance already infiltrated and prepared to represent my-self—hence, in Lacan's formula, "the preexistence to the seen of the given to be seen" (74). Giving oneself to be seen implies looking at oneself be-ing looked at.

Lacan explores this dialectic in a double analogy. First, he compares self-representation to the function of mimicry in animals that protectively cam-ouflage themselves as parts of predators so as not to be perceived as prey.[60] Self-representation is a survival strategy in a war-torn world: the (human) subject, the mimic, takes on the coloration of the environment to protect it-self against the light of the gaze (98), and the effect is that splitting or "bi-partition" (106) occurs because mimicry "gives something to be seen in so far as it is distinct from what might be called an *itself* that is behind";[61] "the being breaks up . . . between its being and its semblance, between itself and the paper tiger that *it offers to be seen*."[62] In the second analogy, Lacan compares mimicry to painting, and, more specifically, to self-portraiture, in which the subject as painter "gives his painting to be seen" in a manner that invites the observer "to lay down" the gaze as one lays down one's weapons.[63] Again, the act of self-representation is depicted as artifice, and figures of military strategy and potential conflict or competition associate giving oneself to be seen with a structure of permanent anxiety, the anxi-ety of agents for whom being in the world implicates them in the lifelong struggle to control the gaze or protect themselves from it.

In the preceding sentence, perhaps I should have said "*a* gaze" rather than "*the* gaze." The gaze may be monolithic and occulted as a concept, but Lacan is mischievous enough to encourage a more prosaic construal of it as dominant ideology: "there are always lots of gazes behind" the pu-tative "gaze of the painter," even if the latter "claims to impose itself as being the only gaze. There was always a gaze behind"—the gaze of the religious institution, the aristocratic patron, the picture dealer.[64] The gaze itself is thus mediated, split, fragmented, multiplied, under contestation. Furthermore, as a transcendent signified, the gaze may (in Lacan's meta-phor) be anchored down by sets of signifiers in the scopic environment,

objects that look at the subject and, as representatives of the gaze, challenge it or offer it protective camouflage. Shining from the surfaces of these *points de capiton* (a term that means "upholstery button"), the gaze lends them a life, a performativity, *une insistence*, of their own.[65] It is distributed, disseminated, and anchored to all the conventions, means, methods, and materials of self-representation available in the subject's culture—in domestic and public spaces, in dwellings, furniture, dress, and gesture, and in portraits. As in the anecdote of the glittering sardine can that doesn't see Lacan but looks at him, they look at the subject.[66] The gaze is anchored in the ensemble of possessions and performances that provide the camouflage, the stuff of mimicry, by which the subject strives to fulfill orthopsychic desire, to embody or fend off the gaze. It is when there are more gazes than one, when the subject is confronted, looked at, by a pride of competing gazes, that embarrassment surfaces.

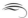

The famous reserve and sobriety of the *burgerlijk* pose repeated with variations in so many Amsterdam regent portraits of the 1620s and subsequent decades are generally understood to have functioned as symbols of prudent investment and moral restraint—defenses against the embarrassment of courtly ostentation imported from Antwerp and Paris, settling in The Hague, and decried by Calvinist clergy.[67] Yet at the same time, if Schama is correct, portraits and historiated portraits were instances of conspicuous expenditure: they were among the most costly of the pictorial genres decorating interiors, especially when commissioned from fashionable painters and enhanced by gorgeous frames.[68] They do more than testify to the competitive display of house-proud patrons. As they proliferate and materialize in home after home, they acquire a power of their own that transforms competition to collaboration. Displays not only of wealth and taste but also of appropriate bearing, they show potential sitters how to pose so as to represent themselves as members of a distinctive class. Such visual models of comportment and sumptuary style are social fictions of the pose and may be considered part of the history of manners, especially in a time when very few conduct books seem to have been translated into Dutch.

Confronting a society that "had become a world empire in two generations,"[69] one may legitimately speak not merely of self-made and newly rich individuals but of a self-made and newly rich class of individuals, the regent class, a class that had the opportunity to take an active role in its

own formation and to have some control over the conventions and media in which it represented itself:

> Broadly, the regents were those who participated in civic government as members of . . . the town councils. . . . The regents were never an oligarchy defined by birth or social status, even though, as far as they could, they became a closed patrician oligarchy, with a characteristic life-style of their own, especially after around 1650, and tended to marry exclusively amongst each other. What defined them as a group, and always formed the basis of their influence in civic society, was holding office in city government. Thus, young people, and women, could belong to regent families but no one could be a regent without holding civic office.[70]

Portraits also help define the regents as a group. Part of the furniture of the group's characteristic life-style, they become material agents in the collaborative construction of class identity and thus take on the restrictive and normative functions of an official code of self-representation. The emergence and expansion of a class of distinctive portraits produces the portrait of a distinctive class.

The relatively homogeneous character of both these classes is registered in the effect of redundancy induced by the sight of so many official portraits whose sitters wear roughly the same clothes and strike roughly similar poses. Of course the homogeneity is deceptive. Not every sitter wears only white-on-black. As one draws closer and looks harder one becomes aware not only of deferential imitations and aggressive emulations but also of variations and attempts at novelty—new inventions, new departures—by sitters and painters alike. Yet these only testify to the *need* for difference in the face of the sameness imposed by the restricted code of class self-definition. David Smith's observation about pair portraits applies equally well to individual portraits:

> In Dutch pair portraiture there are countless examples of . . . repetition of a limited repertory of poses and gestures. . . . Again and again one finds basic similarities between such works in their knee-length formats, their dark clothing and neutral backgrounds. . . . These portraits convey the overwhelming sense of a collective norm, in which formality and conventionality seem to carry the only meaning.[71]

Redundancy in this context has its usual effect of ideological and rhetorical reinforcement. It serves to disseminate a consistent message about *burgerlijk* style and virtues. Seeing similar types of portraits in each

others' homes helps the community of sitters persuade and reassure themselves that they are affiliated, given a corporate identity, set apart from others, by a distinctive and visible set of norms.[72] Such redundancy and restrictiveness are always to some extent present in commissioned and official portraits. But it is safe to say that they are more pronounced in Venetian portraits than in Florentine and Flemish portraits of courtly and aristocratic sitters, because of the sumptuary protocols and legally formalized status of the Venetian patriciate. That they are even more strikingly evident in Amsterdam portraits of the early seventeenth century may suggest the greater need for representational validation imposed on the regents by their unique predicament as a self-made and lately arrived class whose status was dependent on—rather than the precondition of—wealth and access to political office.[73]

In its original cybernetic context, "redundancy" denoted a strategy used to reinforce a message so as to guarantee its audibility or legibility against the unwanted but ineradicable "noise" of the delivery system. The noise built into the Dutch delivery system of patronage and portraiture was embarrassment. My aim in these chapters is to anticipate the study of Rembrandt that unfolds in Part 4 by exploring some of the traces of embarrassment in Dutch portraiture. The mediating purpose of this third part involves more than a reformulation of moral homeostasis as embarrassment. It also involves a return to concepts developed in Chapters 7 and 8, for its implicit thesis is that embarrassment as Schama conceptualizes it constitutes the specifically Dutch manifestation of orthopsychic desire and anxiety. I don't plan to belabor this thesis, because I hope it will be self-evident in the following account of some of the ways in which the Dutch confronted, revealed, betrayed, or tried to suppress embarrassment in their negotiations with fictions of the pose. The pressures that drive these negotiations originate in the shifting faultlines between hereditary nobility and the urban patriciate, between military and civilian cultures, between the politico-military objectives of the Orangist court and the politico-economic objectives of the regents and town councils. Thus the challenge I set myself in this part of the book is to determine the extent to which the traces of tensions specific to Dutch culture and society may be rendered visible in its portraiture when individual and group portraits—the former in Chapter 11, the latter in Chapters 12 and 13—are examined not with the resources of Radiography but with those of the new science of Posography.

The enrichment and enhanced confidence of elites outside the hereditary noble order was associated with the continued increase in portraiture of these clienteles. This was especially marked in the Dutch Republic. A wide range of portraits was produced, from individuals to married couples, family groups and civic bodies. Some of these images emulated previous or current court models, while others emphasized qualities and activities which justified the distinct position of non-hereditary elites. Some of Frans Hals's images of Haarlem citizens, for example, depicted responsive communicativeness, rather than the personal autonomy conventionally attributed to the hereditary, landed nobility.[1]

THE POSOGRAPHY OF EMBARRASSMENT: REPRESENTATIONAL STRATEGIES IN A DECENTRALIZED CLASS SOCIETY

Hals depicted personal autonomy on a monumental scale at least once, however, when, early in the seventeenth century, he painted his only life-size, full-length portrait (pl. 10). The subject is a wealthy Haarlem merchant, Willem van Heythuyzen, and Seymour Slive, who dates it in the 1620s, judges that the portrait "captures the confidence and vitality of the burghers who made Holland the most powerful and richest nation in Europe."[2] During this decade several Haarlem artists, following the lead of Willem Buytewech and Esaias van de Velde, were painting elegant groups of people lounging about in outdoor and indoor banquet scenes, often accoutered with those juicy *vanitas* symbols guaranteed to make the iconographer's mouth water. Van Heythuyzen, whose setting is similarly accoutered, could well be posing in what might be called "a high-life exterior."[3] Slive asks, rhetorically, who the "swaggering Van Heythuyzen" was

> and why the great sword? One likes to imagine that the man proudly displaying his weapon helped defeat the Spanish, sailed to the Indies to carve out a colonial empire for his country, and subdued the bloodthirsty pirates who harassed Dutch merchant vessels off the coast of Africa. But there are no grounds for believing that he was a military hero or an adventurer. His name does not even appear on the roster of the Haarlem civic guards.[4]

Claus Grimm, who is even more suspicious, insinuates that the portrait may stage too unembarrassed a version of the embarrassment of riches: "the great merchant plants himself with the commanding air of a general," assertively displaying rather than leaning on his downpointed sword,

assuming the pose of a military and feudal deportment that does not even deign to turn the face toward the beholder but holds him at a distance with the [other] elbow. . . . The concentration of all dynamic lines toward the highlighted face makes this life-size figure in black silk quite impressive. Yet the general impression is only rendered bearable by the suggestions of theatrical exaggeration. Hals emphasizes vain details such as the polished, high-heeled shoes in which the rich textile merchant struts like a peacock. The dark red drapery and the stone architecture also strike us as somewhat too obviously contrived.[5]

The sitter has a bad case of "Renaissance elbow," but the effect of over-statement is produced largely by modal interplay and perspectival mis-chief.[6] Several cues work to situate the observer's viewpoint roughly at the level of genuflection: the arm held akimbo is foreshortened, the tilted hat brim shows only its underside, and the sitter gazes downward. But con-tradictorily, the shoes are foreshortened for a much higher viewpoint, one more in accord with the focus of graphic delineation, the solidly modeled and, for Hals, smoothly planed face. Sharply contoured, lucidly drawn, and relatively free of brushwork, the face that sits in calm disdain amid the flashing, slashing, flickering play of light and paint is too substantial and weighty for the body that supports it, even though the misty puffery of collar, acting like a shock absorber or life preserver, holds the head aloft, lightens and levitates it, and helps the hat isolate it and affirm its preemi-nence. The problem is that the lower half of the body is hollowed out just where a genuflecting observer ought to see it most clearly. Below the boundary of the stiff bodice everything flattens and dissolves into incor-poreal pantaloons reduced to black shadow behind a few gossamer wisps of white paint. The conflicting high and low viewpoints translate into a vertical hyperextension of the figure, conferring on it a monumentality that may suit the sitter's attitude but seriously undermines the stability of his pose. The lozenge-shaped figure is top-heavy and threatens, as one takes its optical attenuation into account, to teeter. What saves it is the sword, which is at first glance displayed as a status marker but which now, tightly grasped (as the highlights on the knuckles indicate), begins to as-sume the prosthetic function of a necessary third foot.[7]

After observing that "[t]he Baroque trappings behind Van Heythuyzen are a rare note in Hals' work," Slive embarks on a scrupulous description of the background props that does nothing to diminish one's uncertainty about the tone of this performance: for example, Hals "has designed an

impossible structure out of bits and pieces of classical architecture, and there is no question that van Heythuyzen is weightier and stands more firmly than the curious construction behind him."[8] The construction of "the draped stage" is asymmetrical,[9] the pilaster shifted out of line to echo the turn of the body and elbow, and the left side of the structure is surprisingly thin and shedlike, given the pompous Roman entablature (complete with dentil frieze) it has to support—as if the whole thing had been hastily set up to provide a backdrop for the portrait occasion.[10] It may well be that "the swatch of violet drapery has been integrated into the great sweeping curve formed by his cloak and his colossal knee-breeches" (ibid.), but it, too, seems conspicuously ad hoc and adds to the effect of improvisation. Even as they supply a courtly baroque accent, the two lengths of hempen rope dangling down on the left—unvelvet prole-tarian stuff—expose the stage machinery and intensify the effect.[11] Fi-nally, to pursue this line of interpretation into the iconographic register where the strewn roses come to life, suppose we agree that "in the context of this formal portrait it is more probable that the roses refer to the van-ity of life than to the joys and torments Venus offers."[12] We might then also agree that the particular vanity of life indexed by this pose, this por-trait, *is* this pose, this portrait; the portrait of a merchant, a regent, who displays his desire to put on aristocratic airs but wants it to be known that this is what he is doing and that he isn't fully committed to the effect. He is, as the saying goes, "kidding on the square."

"We do not know whether Hals or van Heythuyzen himself decided that he should be portrayed standing big as life" and archly displaying the vanity of the setting and the pose,[13] therefore we are in no position to determine whether the painter was the ironist and the sitter his target, whether the two collaborated in sending up the vanity of courtly self-representation, or whether the effect simply got away from both of them. Does it help us choose among these alternatives to learn that the sitter was known as a philanthropist who "endowed a small home for old people on his estate" and that he was "best remembered for his efforts to promote the welfare of his fellow citizens"?[14] But regardless of how we respond, it is hard to construe the act of posing indexed by the portrait as entirely lacking in ironic distance from the represented performance. Maybe there is more significance, if less human interest, in moving away from the level of the specific motivations of individuals to the level of public discourses and practices, the level at which ironic distance takes on the value of a

cultural symptom. At that level it may testify to the performance anxiety of a new intruder in the landscape of European history: the nonhereditary merchant elite of the regent class; an arriviste class maneuvering to position itself in relation to the hereditary nobility, which had monopolized the practice of portraiture; a class whose experiments with conventions of self-presentation constituted an important part of its negotiations with the long-dominant aristocratic culture.

"Few Dutchmen," Slive notes, "even among those at the court in the Hague, felt pompous enough to commission" portraits on this grandiose scale.[15] The type "was not popular during the first half of the seventeenth century in Holland. It was one that was still primarily used for state portraits and the nobility; only the most powerful, the wealthiest or the most pretentious commissioned them. Moreover," Slive adds, "few Dutch homes were large enough for them."[16] This afterthought becomes more resonant when the sizes of homes are linked to the size, composition, and status of the household: "the family household was exceptionally well defined in the Netherlands. As far as figures permit reconstruction, it seems that Dutch homes were, on average, smaller, more tightly organized and more independent of extended family intervention than elsewhere in seventeenth-century Europe."[17]

This doesn't mean that particular city-dwelling patricians didn't build the equivalents of *palazzi*. But even when they built on the grand scale, "[c]onstraints of space in rapidly crowded cities like Leiden and Amsterdam were partly responsible for the convention that depth should be greater than breadth." Furthermore, "Dutch taste and the legacy of much less pretentious late-medieval establishments conditioned a preference for interior, rather than exterior display" (311). More interesting in terms of Schama's thesis is the wealthy burghers' patricianizing strategy of buying country estates, which often brought their owners a title. Schwartz's dry comments on the strategy pinpoint the ambivalent pressure of embarrassment:

> In the city itself, under the unsparing gaze of their fellow burghers, they settled for comfortable but not showy houses. The real struggle for status took place in the country, with the de Graeffs leading the pack. . . . The ownership of country estates brought with it the right to engage in the aristocratic pastime par excellence, the hunt. The de Graeffs in particular were well-known—and often ridiculed— for their love of the hunt.[18]

The smaller household of the nuclear family is itself an effect and symptom of historical differences that are preserved as sociocultural differences, differences compactly profiled in Peter Burke's comparative study of Venice and Amsterdam. On the one hand, the characteristic Venetian household was "not a nuclear family" but "a group of brothers living in a palace with their wives and children." The Venetian *casa* was "a 'collateral' type of family organization," in which the success of political and business careers depended on fraternal cooperation, and this was institutionally recognized in the "traditional form of trade organization in Venice, the *fraterna*." On the other hand, Dutch trading companies "were composed of individuals, not of families. Brothers traded for themselves. . . . Grown-up sons often lived in separate homes." This difference was reflected in tax assessments: whereas a Venetian nobleman "declares that he lives with his brothers in the family palace and then declares the family property, adding his 'speciality' or individual property if there is any," in Amsterdam "individual brothers and even sisters would be assessed separately." Thus "the nuclear or 'conjugal' family was dominant" in Amsterdam, while in Venice "the dominant form of social organization was the extended family, covering several generations and including the married male children."[19]

Patrician families in Venice and elsewhere in Renaissance Italy are the products of a history dating back to the eleventh century, a history of ascriptive technologies focused on the construction and maintenance— through variable alliance and inheritance strategies—of agnatic lineages.[20] In Venice through the sixteenth century, for example, nobles "were those . . . whose names were entered in the *libro d'oro*," and this meant that with very few exceptions "they were descended from people considered noble in 1297."[21] Compared with the long history of Mediterranean urbanism, the relatively late and rapid development of Dutch urbanism and its maritime hegemony produced a more unstable pattern of social change. Noting that in Amsterdam it was "difficult to take genealogies back earlier than the fifteenth century" (30), Burke outlines the effects of these different histories in terms of a simplified polarity: Venice was an "estate society" while Amsterdam was "a class society." The former "was divided into formally defined status groups, and power and wealth tended to follow status"; in the latter, "by contrast, status groups were defined informally, so that status tended to follow wealth and power."[22]

Of course, in the more rural, inland provinces of the Dutch Republic after the revolt, the nobility continued to thrive as a relatively closed es-

tate. But in the towns of the maritime provinces there emerged the more open society of an "entirely new . . . merchant elite."[23] The remote causes of this emergence have been located in large-scale reactions to Spanish/ Hapsburg aggression: the diaspora of skilled workers from Antwerp northward to Germany and eventually to Holland, and the shift of the world's emporium from Antwerp to Amsterdam. The proximate causes, according to Israel, are to be sought in the political and economic inventiveness, the organization and command of resources, that made it possible for the Dutch to extend their primacy from bulk trades to rich trades.[24] For, he argues,

> there was no true merchant elite in the northern Netherlands in the age of bulk freightage. Until the 1590s, the regents were the wealthiest group in towns of the north Netherlands. Although many of these were active businessmen, they were often brewers or retailers rather than merchants, and those who engaged in commerce were of modest means compared to any real merchant elite such as those of Antwerp, Venice, London, or Lübeck. The regent-merchants of the pre-1590 period dealt in grain, timber, salt, herring, and dairy products. Some . . . were also cloth dealers. . . . [But] this traditional wealth was rapidly driven out of the higher echelons of urban society by the grander "new wealth" generated by the "rich trades."[25]

Outsiders commenting on the pre-1590 state of affairs "described the Dutch regent class with evident contempt as 'the sovereign lords millers and cheesemen.'"[26]

The transformation of the regent class and its culture effected by the emergence of the new merchant elite made its relations with the nobility and the Stadholder's court complex and unstable. In the maritime provinces the cities and their regents "gained ground relative to the nobility," while the social, civic, and economic interests that united the regents often clashed with the Orangist court's cluster of military, political, and religious commitments.[27] Beginning in 1617 with Prince Maurice's aggressive espousal of the Counter-Remonstrant cause, and extending beyond the end of the Twelve Years' Truce well into the 1620s, these strains were intensified, and the integrity of regent interests was jeopardized, by the broad spectrum of conflicts compacted into the opposition between Remonstrants and Counter-Remonstrants.

The end of the truce in 1621 meant the resumption of Spanish ag-

gression in Europe and the colonies. Because the aggression was both military and economic, it had a pincer effect: Dutch trade suffered along with the industries connected to it; at the same time, the financial burden of military defense increased. A slumping economy coupled with the higher tax rates necessary to maintain the army incited popular unrest and occasional riots. External factors were compounded by internal failures, so that the crisis, which simmered on through the 1620s, involved more than economic and military pressures: "it was a crisis also of the body politic, society, and religion," for when Maurice's military and political effectiveness began to decline along with his health, so also did the viability of the political system he had cobbled together with the Counter-Remonstrants in 1618, "a body politic excessively reliant on the person of the Stadholder, in whom power and authority were concentrated."[28]

This crisis was exacerbated by the divisive aftereffects on city councils of Maurice's purge of Remonstrants. Because he pursued the general Orangist policy of an expedient taking of sides, as described in the following passage, he was forced to rely on but unable to count on the regents' cooperation:

> When conflict occurred, there was a tendency for the princes of Orange to line up with a majority of the provinces in the States-General against the single province of Holland (and, often, the city of Amsterdam especially), with a war-party against those who wanted peace, with the lower classes of the urban population against the regents, and with the Calvinist preachers against those who wished to keep the church tolerant and subordinate to political authority. When the situation is put in this way, it might appear that there were all the makings of civil war and social revolution. But the princes of Orange . . . took care never to allow matters to get out of hand. In the last resort they were themselves aristocrats and upholders of the existing social order. It is significant that . . . when they had the opportunity to make changes in the city magistrates, they still chose from the same regent class which had always been dominant.[29]

It might also appear that "the makings of civil war and social revolution" was the name of a button the princes of Orange could always push, a fear that always hovered behind the facade of republican discourse, the dark, diluvian possibility displaced but sustained as the unconscious of the discourse, the fear of *désagrégation*.

The 1620s in Holland were scarred by the frictional and volatile cross-cutting of economic, political, and religious alignments, by the fragmentation and multiplication of factional interests and positions. One imagines that for the members of the regent class—itself the product of social revolution—the threshold of sensitivity to problems of self-representation must have been lowered. One imagines, for example, that the strategies by which such merchant patricians as Heythuyzen sought to incorporate themselves in class signifiers and differentiate themselves from—even while emulating—the aristocracy may have become a particular source of concern and a potential source of embarrassment.

Among these strategies, portraiture has long been considered preeminent. In his magisterial portrayal of seventeenth-century Dutch culture, published in 1876, Eugène Fromentin argued that realism was the mode of representation most expressive of bourgeois values, and portraiture was the instrument par excellence of bourgeois realism.[30] Fromentin's thesis has been sharply interrogated by Joanna Woodall, who finds its influence lingering on in even the most sophisticated of contemporary studies, which continue to anchor their accounts of portraiture in presuppositions about the "reality of bourgeois values," the rise of individualism, and the emergence of a specifically bourgeois subjectivity in seventeenth-century Holland.[31] These presuppositions have been problematized, Woodall notes, by recent developments in historical research that reveal "continuities between the aristocratic values which preceded the Revolt and attitudes and behavior" among the merchant elite during the early decades of the seventeenth century (ibid.).

On the basis of this critique, Woodall formulates her counterargument: while "the Stadholder and remaining titled nobility continued to be depicted wholesale and visually identified with the courtly decorum, military command and landed estates of traditional hereditary aristocracies," the portraits of the Amsterdam burgher elite

> were initially conceived and comprehended with reference to traditional concepts of portraiture inherited and adapted from the aristocratic ideology which predominated before the Revolt. Portraiture remained a claim to an elevated, autonomous identity within interlinked social, political and spiritual hierarchies, although the *content* of that identity was responsive to the citizens' different circumstances. Espousal of "aristocratic" values was thus compatible with *burgerlijk* forms of self-presentation. . . . Portraiture positioned the sitter both within the

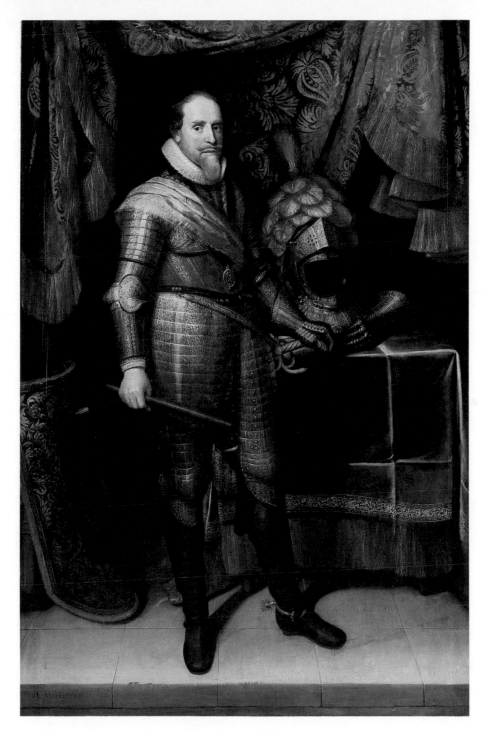

PLATE 9

Michiel Jansz van Mierevelt, *Prince Maurice of Orange, Stadholder,* ca. 1625. Oil on wood. Rijksmuseum, Amsterdam.

Frans Hals, *Portrait of Willem van
Heythuyzen*, c.1625. Oil on canvas. Alte
Pinakothek München, Munich.

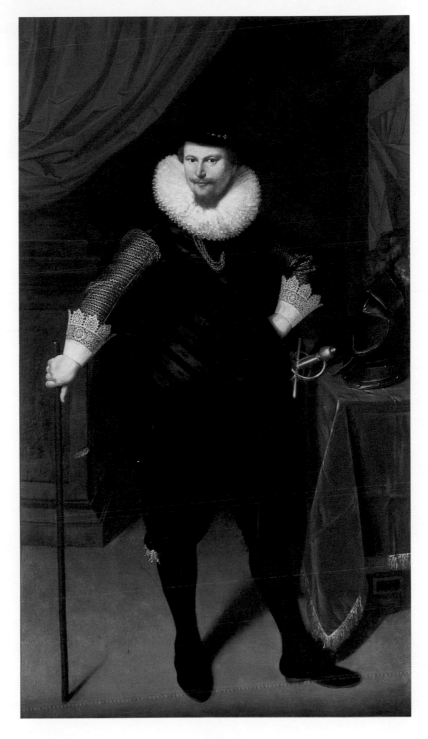

Cornelis van der Voort, *Portrait of Laurens
Reael*, ca. 1620. Oil on canvas. Rijksmuseum,
Amsterdam.

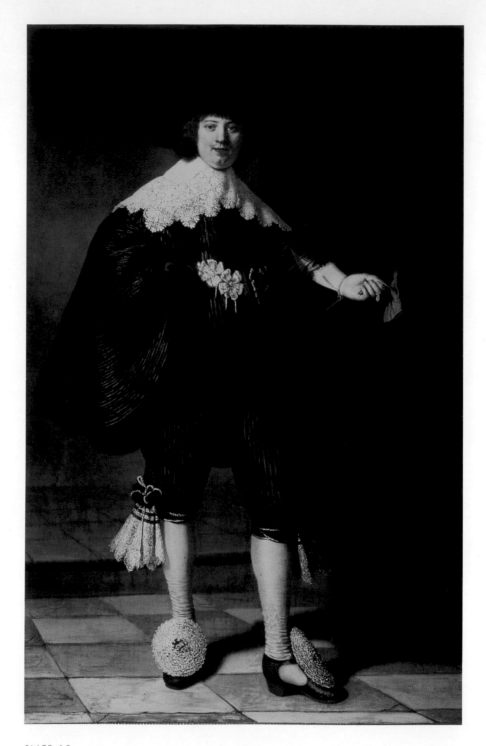

Rembrandt, *Portrait of Maerten Soolmans*,
1634. Oil on canvas. Private Collection.

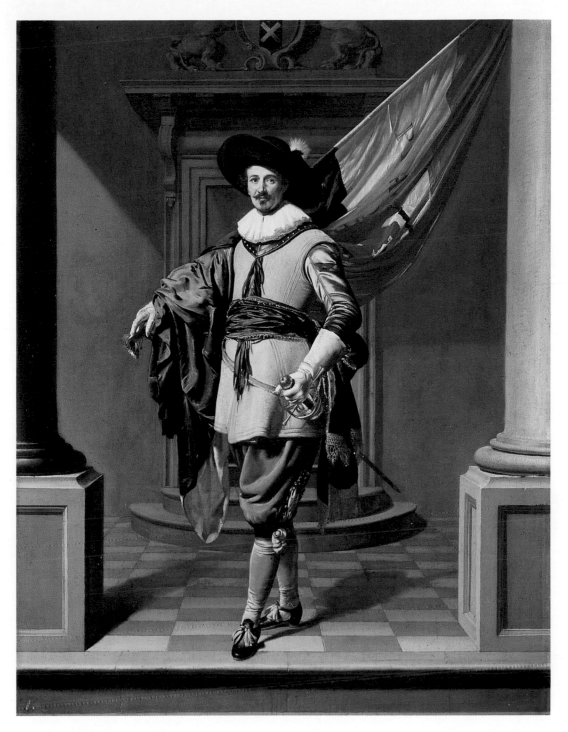

Thomas de Keyser, *Ensign Loef Vrederixc*,
1626. Oil on wood. Mauritshuis, The Hague.

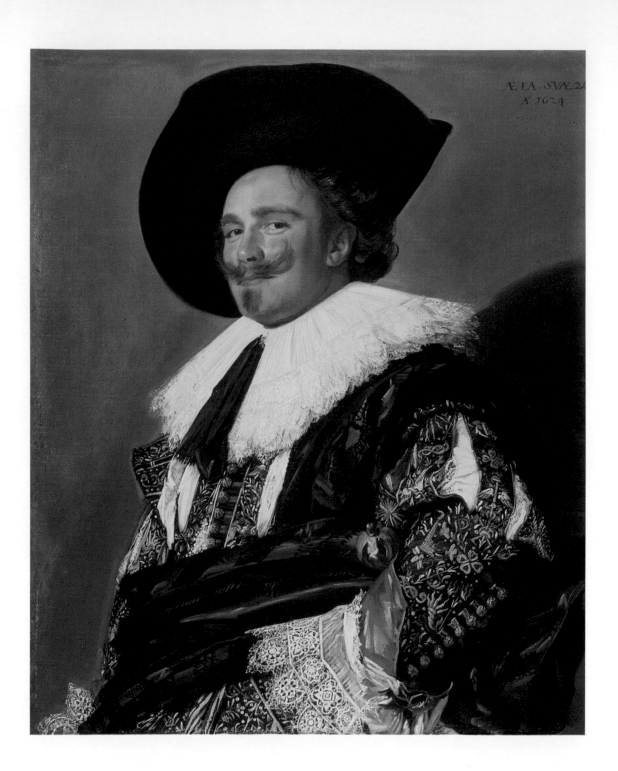

(*Opposite*) Frans Hals, *The Laughing Cavalier*, 1624. Oil on canvas. Wallace Collection, London.

(*Above*) Rembrandt, *Portrait of Jan Six*, 1654. Oil on canvas. Collection Six, Amsterdam.

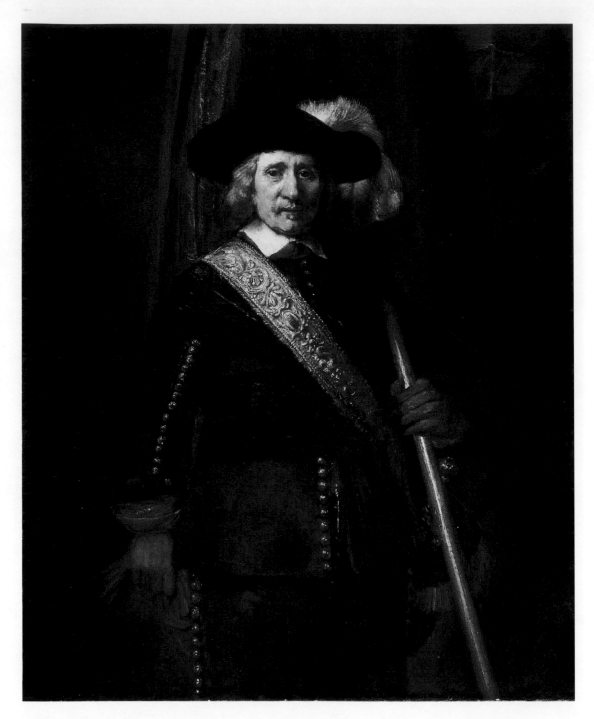

Rembrandt, *The Standard Bearer (Floris Soop)*, 1654. Oil on canvas. The Metropolitan Museum of Art, New York.

burgher elite and in relation to the hereditary aristocracy. However, there was no immediate sense of an irreconcilable division between established aristocratic identity and the complex of values which ultimately came to be defined as distinctively bourgeois. (78–79)

Having stated and illustrated this position, Woodall is careful to remind us that "black and white apparel, austere formats and rather rigid poses [are] characteristic of Dutch citizen portraiture [and] form a striking contrast with the colorful modes, elaborate settings and elegantly relaxed postures which have become identified with noble self-representation" (91). But she rejects the argument that this reflects a purely social "opposition between bourgeois and aristocratic values"—black and white apparel, she notes, had long "been a feature of self-representation at the Spanish court"—and maintains instead that members of the Amsterdam elite were motivated to eschew aristocratic "modes of portrayal . . . popular at the Hague court from around 1630" because of their political rivalry with "the Stadholder and his circle in The Hague."[32]

Woodall's argument is thus similar to that of Marjolein Hart, discussed in the preceding chapter, in emphasizing the political rather than sociocultural aspects of the opposition—in this case sumptuary and representational—between the regents and the republican center at The Hague. Yet since the republican center also happens to be a center and symbol of both courtly and military values, it's hard to see how political motives remain uncontaminated or unambiguated by sociocultural motives. The ambiguity smokes the edges of graphic decisiveness in setting up and depicting the act of portrayal, and the sfumato tends to blur the picture. It becomes difficult for seventeenth-century patrons (as well as twentieth-century critics) to establish clear-cut lines of interpretation and to avoid being embarrassed by transgressive possibilities that are part and parcel of the very conventions and discourse of self-representation. The readings of portraits I give in Parts 3 and 4 reflect my sense of this ambiguity as something revealed by small stresses, anomalies, and dislocations that disturb the complacencies of the pose. It is in those details that I look for the qualifications of exemplarity that signify the anxiety of orthopsychic desire in its particular Dutch avatar.

Woodall couples her historical claim to a skeptical or suspicious thesis about Dutch realism: realism is a style or technique used to naturalize ideological fictions. Refusing to accept an innocent account of realism as the characteristic expression of the pragmatic bourgeois spirit, she insists

on and demonstrates its function as a naturalizing strategy: "Portraiture as realism was an immensely useful way of representing a particular, desired position as if it were actually the case."[33] At first glance, this is hardly an original idea. It seems merely to ring up the familiar cultural constructivist position variously elaborated in post-Saussurian semiotic approaches to mimesis and representation (those, for example, of Barthes, Bryson, Bal, and Moxey), therefore the particular spin Woodall applies to it is easy to overlook. But it will become apparent if contrasted to the more conventional inflection Wayne Franits gives the constructivist thesis in his study of Dutch representations of domestic virtue.

Franits's point of entry is an intervention in the controversies about the relation between realistic images and moral meanings in Dutch art. He argues that, far from being hidden, as de Jongh and others claim, moral values and lessons are fully expressed through the images: "the much-vaunted 'reality' represented in these paintings can only be described as a selective, fictitious construct," one "fundamentally structured by a culture that privileged males." The effect of mimesis produces "plausible realities" that "resonate with an entire system of values, ideals, and even prejudices, all of which reflect common attitudes toward women at that time."[34] Because Franits's argument is directed against the hidden-meaning school of iconography, his emphasis is on the visibility of the system in the images: the images "are meticulous re-creations of reality" in that, through pictorial style and the selection of objects or motifs, they "mirror yet contribute to the value system of which they are part" (13–14).

Woodall's contention is different, but because she expresses it laconically, I want to spell it out. Her constructivist emphasis falls, not on the way moral content is fused with and directly transmitted through realistic style, but on the way the realistic form of the image fuses with the generic understanding of portraits as indexical icons. Portraits qua portraits present themselves as—to borrow the phrase Walter Melion cites from Karel van Mander's *Schilder-Boeck*—"*ghesichten nae t'leven*, 'views after life.'"[35] In actuality, the reality effect is transmitted from pictorial form through the posing figure to the referent, the sitter. But the generic understanding of a portrait as an image done from life reverses the direction: the reality effect is transmitted from the referent through the posing figure to the pictorial form.

During his interpretive paraphrase of the *Schilder-Boeck*, Melion attributes to van Mander and his contemporaries the following two linked

opinions: "[p]icturing *nae t'leven* involves recording something seen at the moment of viewing it" and "working *nae t'leven* conferred immediacy guaranteeing the documentary value of an image" (63). To give the first statement a metapictorial sense the author probably didn't intend, making a picture of *nae t'leven*—representing the act of drawing from life as part of the image—produces the effect of having recorded it at the moment of viewing it, and it is this effect that guarantees its documentary value. The effect may not only be a fiction; it may be recognized as a fiction, and Melion shows this recognition at play in his comments on van Mander's text and Goltzius's practice (63–64). The founding fiction of portraiture is that its representation is not a fiction.

Melion's comments elucidate what I take Woodall's thesis to be when it is unpacked, and its interest for me is obvious: it situates the thesis within the perimeter of the study of fictions of the pose. After she applies the thesis to readings of a series of portraits that illustrate different "strategies of portrayal" (relative to aristocratic conventions) through which the Amsterdam sitters chose to represent their status, virtues, and accomplishments, she concludes that "the 'reality' constituted by Dutch portraiture during the first half of the seventeenth century cannot be identified with either external appearances or positions within a fully fledged bourgeois ideology. Rather, by adapting received, 'noble' conceptions, categories and conventions, leading Amsterdam citizens used the realist mode of portraiture to claim positions equal to, but distinct from, both the hereditary nobility and each other."[36]

So, for example, of Cornelis van de Voort's full-length, life-size portrait of Laurens Reael of about 1620 (pl. 11), she points out that its format and iconography associated it with court portraiture and contemporary "images of sovereigns" (79). The sitter had a distinguished military and political career with the East India Company, and a noble title was eventually conferred on him, but not until six years after the portrait was painted. Therefore, she concludes, the image

> was not "realistic," in that it was not an unmediated, comprehensive reflection of his social position at the date when it was painted. The image not only represents Reael's achievement by 1620, but apparently realizes his ambition for a noble title long before he actually attained one. . . . Yet because portraiture was already widely theorized as the exact reproduction of actual appearance, this conventional, idealized and partial picture is rendered an accomplished fact for posterity. (82)

Woodall explains that although it "may seem surprising" to find "an Amsterdam citizen . . . [making] such claims," important office-holders in a city comparable to Venice as a world economic power "might well consider themselves worthy of the illustriousness and fame previously reserved for the hereditary aristocracy" (79)—especially if, like Reael, their name ("Royal") alludes to "the birth and wealth of a sovereign" (82).

But it is just here that questions about the tone of the portrait arise—questions similar to those raised by Hals's portrait of van Heythuyzen. A pendant to the portrait was painted several years later, after Reael got married, and Woodall ingeniously shows how the dangers of inflation and pretension are actualized when the portrait and its pendant are considered together as a marriage pair.[37] These dangers are already inherent in the pose of a figure armed, indeed loaded down, with cane, sword, gold chains, Renaissance elbow, and other symbols of noble manliness. Reael stands tall, aggressively locks his gaze on the observer, gives himself to be admired, and the effect he anticipates is already reflected in the complacent half-smile that lights up his features. But suppose the complacency is connected to Reael's pleasure in enacting a play on his name? Could that scenario preempt the charge of inflation and pretension? For then at one level the pose, together with the redundant iconographic panoply, would stage a visual joke, and the meaning of Reael's expression would change. The challenge leveled at the observer would be, "Do you get it?" And Reael stands tall as he embodies his name, regally and patiently lets us take him in, but gazes attentively to see whether he has taken us in. Now imagine another scenario implicit in the temporal thickness of the fictions of the pose: the observer Reael looks at and poses for is the painter who helps him perform the act of portrayal that will produce his painted image. His backstage life amid the working conditions of portrayal is not masked off from the painter, to whom, therefore, he exposes his pretensions as the price of idealization. Could the price also include the mild discomfiture of staging such an embarrassment of riches before an artisanal accomplice?—a discomfiture that may linger on when sitter and painter are replaced by the image and the observer?

A clue to this possibility lurks in the construction of the image. The tipped-up ground plane and foreshortened body make the virtual observer stand tall with Reael and meet him eye to eye. In that position we are closest to the strongly modeled face brought further forward by the collar that seems spatially to lie in front of as well as above the body. From

hat to hips the rhythmic shimmer of diagonal pushes and pulls turn the figure through space around the axis formed by the head and the right leg. But below that the body slants vertiginously downward and away from the picture plane, and declines into shadow. Losing volume as it descends, its stability is imperiled by a spatial warp that threatens to unhinge Reael's knees and by the attenuated vestiges of feet planted at weird angles far below the observer's eye.[38]

Given this gravitational predicament, the sitter seems not merely to grasp the cane but to push it into the ground, adding to its symbolic potency a new and more basic power, the rod of justice mutating into a crutch without which the whole body—a body obviously deprived of adequate vestibular information—seems in danger of collapsing leftward or slipping forward along an inclined plane. Reael tightens up, of course, and staves off disaster with the help of his down-stretched and opposed thumb. But the little gravitational drama has done its damage. Admittedly, Reael's royal masquerade may not be seriously compromised by this postural crisis. Nevertheless, even as the weightless elegance of the silhouette that signifies his legs contributes to the effect of idealization, it undermines the body's realistic basis. The result is a slight embarrassment, a slight increase in the air of deliberateness and effort with which the sitter labors to sustain his aristocratic stance. It is this air that blows the sprezzatura he strains for well beyond his reach.

"[B]ecause portraiture was already widely theorized as the exact reproduction of actual appearance, this conventional, idealized and partial picture is rendered an accomplished fact for posterity": revisiting Woodall's assessment, I am now tempted to subject it to a minor revision that takes the above commentary into account. What is rendered an accomplished fact is either the portrait of a sitter who may not fully have persuaded himself (or who is trying to persuade others) that the accident of his name entitles him to wrap himself in a heraldic banner of conventionality, idealization, and partiality, or else the portrait of a sitter who is not fully successful in concealing his struggle to ensconce himself in those noble attributes. As in the case of Hals and van Heythuyzen, it doesn't seem necessary or even possible to come to a decision about this at the level of the motivations of the individual agents who are party to the act of portrayal. Given Woodall's general thesis, it is more useful to assume that such uncertainties and ambiguities and potential embarrassments are to be expected whenever members of the burgher elite choose to repre-

sent themselves by deploying the strategy of portrayal Woodall calls "no-
ble emulation" (79). "Espousal of 'aristocratic' values" may well have been
"compatible with *burgerlijk* forms of self-presentation" (78), but when the
portrait of Reael is framed within the social and political tensions detailed
in the preceding pages, the message it illustrates is that the strategy of no-
ble emulation may be an enterprise risky enough to produce—or at least
betray the signs of—performance anxiety.[39]

Not to take the risk into account is to invite a risk of another kind: the
danger of being blindsided by the painter. This is what happens to poor
Maerten Soolmans, whose sin, in Rembrandt's 1634 portrait, is a pitiable
absence of performance anxiety (pl. 12). David Smith deftly highlights
the orthopsychic comedy of failed sprezzatura the portrait reveals: "Sool-
mans's courtly pose and gesture seem as 'staged' as his fancy dress is
'showy,' and the self-consciousness with which he gives his performance
suggests that his ties to the social convention he is striving to emulate are
themselves rather artificial. He could easily be accused of being a fraud."
But Smith goes on to justify the performance: "it would probably be
closer to the intentions of Rembrandt, whose self-portraits of this period
are often similarly theatrical, to understand Soolmans's manner and ap-
pearance as a form of self-dramatization. His aristocratic image, with its
shades of van Dyck, serves . . . to heighten his individuality."[40]

The size of the portrait (81.8" x 52.6") accentuates its pretensions. Its
place in Rembrandt's oeuvre resembles that of the Heythuyzen in Hals's:

> Together with its companion piece . . . [it] forms the only extant set of
> life-size portraits from Rembrandt's hand to show full-length, standing
> figures. This type of portrait—originally used in courtly circles—
> rapidly became popular in Holland around 1600 among citizens of some
> standing (e.g. Laurens Reael . . .) and sometimes also by rich but not
> socially prominent burghers [like van Heythuyzen].[41]

Smith compares it to "a group of less-than-life-size portraits" of dandies
"from this same period" and concludes that the taste "for such images of
fashionable elegance and refinement among Dutch patrons . . . reflected
larger aspirations toward aristocratic social standards formulated elsewhere
in Europe." He also notes the embarrassment effect: "many Dutchmen
during the early decades of the century seem to have felt ambivalent
about these courtly fashions and artful contrivances. The small scale of
such portraits not only makes them exquisite aesthetic objects, but sug-

gests a certain hesitation about letting them take on the stateliness and solemnity of a more monumental format. From this point of view," he continues, Rembrandt's Soolmans portrait shares with Hals's portraits of van Heythuyzen "a more serious investment in stylishness as an image of social form. In ensuing decades these courtly modes became ever more common as Dutch painters turned to the examples of van Dyck and the French painters working for the court of Louis XIV."[42]

I am inclined, however, to question the seriousness of Rembrandt's investment in Soolmans's stylishness. With his pinstripes on parade, Soolmans is everything a rich and successful sugar merchant could hope for in his son, or grandson: a Good Boy; a Nice Boy. My scruple is occasioned by Smith's linking the Soolmans to the self-portraits contemporary with it as theatrical forms of self-dramatization. For the self-portraits in fancy dress, as I shall argue, are not merely theatrical but metatheatrical, that is, they are representations of theatricality and critiques of self-dramatization, and as such they anticipate the objections of Diderot—analyzed by Michael Fried—to the tyranny of the beholder by which portraiture as a genre is threatened.[43]

A critique in the exacting sense is a self-critique that questions most intensively the values the critic most affects, and I am tempted to read a strong element of painterly self-critique in the portrait, some of which of course rubs off on the sitter.[44] I note, for example, the smooth and painstaking rendering of detail—the lace, the pinstripe brocade, the wrinkled stockings, the amazing buckles perched like doilies or bucklers or collapsed chrysanthemums on the shoes. Kenneth Clark nicely captures the ambivalence inscribed in this performance. Of the Soolmans and its pendant, he remarks that "Rembrandt has enjoyed his sitters' garters and preposterous shoes," and he reminds us a few pages later that during the 1630s "fashion in the Netherlands passed through a period of puritanism. The flowers on Mr. Soolmans's shoes were ridiculed in a poem. Black became the order of the day. This did not suit Rembrandt at all."[45] If he enjoyed the look and paintability of courtly dandyism, preferring it to burgher black, he also transferred to the image, as to a scapegoat, something of the embarrassment that preference may have caused—an embarrassment exquisitely conveyed by the arch iconic gesture in which an awkwardly poised hand and glove are memorialized by the graphic clarity of depiction.[46]

Finally, there is the not unrisible roundness of Soolmans's bottom-heavy face. Its lower contour could have been inscribed with the help of

a compass. What makes me particularly suspicious is its resemblance to the bland and chubby moonface of the 1632 self-portrait. There, Rembrandt archly poses as a Good Boy, a puritan fashion plate, who obeys the order of the day by ensconcing himself in the *burgerlijk* black of his or someone else's Sunday best (see Chapter 17 and fig. 41 below). If these two images are placed side by side and submitted to the following comment by Michael North, the mischievous spirit of Rembrandt's art peeks out and touches them both with traces of parody: "When painters were artistically and financially successful, they quickly became accustomed to the lifestyle of their middle-class or aristocratic clients. They bought houses in exclusive areas, filled their studios with works of art by foreign masters, precious objects and curiosities (which were meant to underline their social position) even when they, like Rembrandt, could not always afford them."[47]

The portrait of Soolmans remains, for me, a marvelous image, richly and subtly toned, compelling in the strangely vectored space that curves around (and in spite of) the strong diagonal recession of the tiled floor, and in the way its subdued palette sets off and ruddies the fleshiness of the face. This is the only tiled floor I can find in Rembrandt's Amsterdam portraits; it denotes wealth, and it connotes the ambience in which aristocratic and official portraiture is underscored by the conspicuous pains of perspectivity.[48] The joy of painting, the blandishments both social and aesthetic that seduce a Good Boy, are never more in evidence than in this portrait. But part of what I find marvelous is that the painting accuses itself of being what it appears to be, "an artificial construction in which persuasiveness was sacrificed and dramatic illusion vitiated in the attempt to impress the beholder and solicit his applause." This paraphrase by Fried of Diderot's criticism of theatricality applies equally well to both the Good Boys the portrait represents, the sitter and the painter, but the source of the criticism is not Diderot; it is the wicked spirit of a Bad Boy lurking in the treatment of Soolmans like a hairy hand in a velvet glove.[49] The portrait of Maerten Soolmans censures its sitter for his lack of performance anxiety.

The problem of performance anxiety has been concisely illustrated by Ann Jensen Adams in her discussion of two small-scale portraits by Thomas De Keyser, the 1624 *Portrait of a Young Man with a Greyhound* and the *Portrait of Loef Vrederixc as an Ensign* (1626). In the middle of a detailed iconographic account of the former's aristocratic symbols, Adams notes that "this stiff little sitter . . . and his equally stiff hound" lack only

the attribute of "courtly 'grace,'" and she goes on to speculate that since "de Keyser's next portrait in this format [the Vrederixc portrait] displays an excess of such grace, the lack . . . may be due to this Dutchman's suspicion of courtly pretensions, or courtly swagger. Even courtiers in the Hague felt twinges of self-consciousness about the excesses of international court customs and fashions. Many Dutchmen must have felt torn between a desire to appear sophisticated . . . and a suspicion [of] if not repulsion for the frivolities of international court life."[50]

The Vrederixc portrait raises a problem of another kind, a problem that will take us a little more deeply into the specific political tensions that contextualize individual and group portraiture (pl. 13). Vrederixc "stands resplendent, his body elegantly attenuated, proudly bearing the banner of an Amsterdam shooting company," which indicates that he holds "the highly prestigious position of ensign" in the company (1.109–10).[51] In civic militia-guard portraits, the ensign or standard-bearer, though third in rank after captain and lieutenant, "is always the most splendidly dressed, as if he, like the banner he carried, had to embody the splendor of the company."[52] When J. R. Hale remarks that the standard with its colors was both "an essential focus of contact to troops who had been scattered" and "the focus of regional or unit pride," the context of the remark is a discussion of sixteenth-century representations of actual soldiers—infantrymen and mercenaries.[53] In seventeenth-century Holland the colors are the focus of the civic and corporate pride of the militia guilds. The colors as markers of group solidarity and identity are clearly visible in most militia portraits, but they and the ensigns that bear them have little to do with troops on the battlefield and much less to do with mercenaries.

Returning to Loef Vredericx, then, just what kind of splendor does he embody? Is the ensign important because the symbol he carries rubs off metonymically on him and makes him too a symbol of group solidarity, or is the symbol important to the ensign as an indicator of individual achievement?

> Ensigns were traditionally well-heeled bachelors who could look
> forward to becoming, as did Loef, Lieutenants and, if lucky, Captains
> of a Company. . . . Loef was not a member of a regent family, but
> because shooting company officers were largely drawn from this class,
> his new office gave him an opportunity to mingle with Amsterdam's
> leading citizens. Shooting company officers often moved into real
> political office, such as city burgomaster.[54]

De Keyser, Adams continues, eschewed traditional depictions of ensigns as high-spirited soldiers on battlefields and chose instead to portray Vredericx as a "courtier-gentleman" in a classicizing "stage-like setting," a triumphal arch motif that evokes "an image of rulership" (1.112–14). Sensitive to the signs of iconographic overkill, she finds our hero displaying "an excess of courtly grace" (1.103).

The portrait visualizes the dream of upward mobility entertained by a dancing goldsmith who never made it as far as the rank or rung of Captain. See how the toe points, how it offers to cross the threshold and carry the fancy dancer down from his stage into the observer's space. But see at the same time how, when we sight up from the toe, the body and the banner seem to lean back and away from us as if ready to pivot rightward on the weight-bearing foot, the sword hand swinging toward us, the other one away. Yet this changes when we realize that the perspectival organization places the observer's gaze roughly at sash level, closer to the face in its large hat, farther from the tiny feet. If I choose to misread the signals relayed from the perspectival grid under his feet, I can imagine the dancer preparing to backpeddle in order to resist the downward tilt of the floor; then what saves him, what keeps him where he wants to be, is the upward tilt of the hat and the weight of the ceremonial sail on its mast.

The way the goldsmith weathers all the kinetic activity that threatens to destabilize him can't but increase one's respect for his performance. There he stands, transfixed in mid-step, frozen in the crosshairs of an X-shaped composition (the motif repeated in miniature above his head in the Amsterdam coat-of-arms). You have to admire the flair with which he calmly holds not only the pose but also the standard, the sword, and the hat. You have to admire it because something about his gaze insists on your doing so. For while his eyes engage yours, they don't exactly look at you. They're aimed in your direction so that he can observe the observer and admire the effect he makes. The difficulty of holding so complex and choreographic a pose is present in only one tiny detail: the crease beneath the chin. But it *is* present, and it reminds us of the effort that goes into his effortlessness. Imagine the athleticism it took for this dancing politician simply to stand there and give himself to be seen, bearing the encumbrances of his office graciously, gracefully, without embarrassment, but with more than a touch of tippy-toe effeteness.

It is hard to resist comparing this resplendent figure to the standard-bearer painted a decade later by Rembrandt in the more traditional pose,

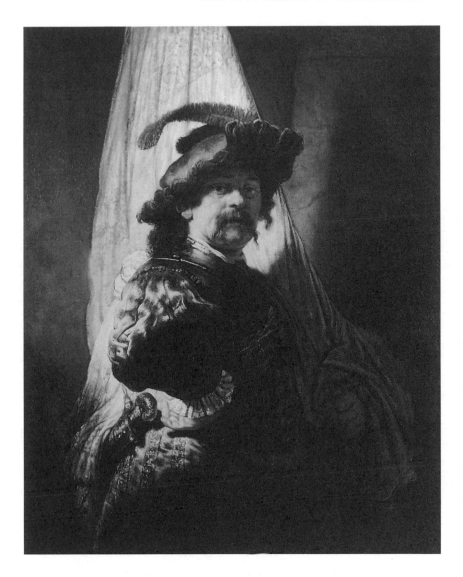

FIGURE 20

Rembrandt, *The
Standard Bearer*, 1636.
Oil on canvas. Private
Collection.

with its foreshortened Renaissance elbow exploding aggressively in the
observer's face (fig. 20). The RRP notes the sixteenth-century costume,
rejects the idea that this is either a self-portrait or the portrait of a particu-
lar individual, links the painting "with a 16th-century tradition . . . of
depicting ensigns as types of courage and contempt of death," and adds
that the extravagance of the costume "plays as important a role with . . .
[Rembrandt] as it did with his forerunners" (3.228–29). One reason this
isn't likely to be the portrait of a particular ensign is that the colors can-
not be identified. There is a discernible pattern in the folds of the ample

standard that falls around the sitter like a curtain, but the predominance of tonal over chromatic values obscures the normal signifiers, the emblems and color fields, of group affiliation. This is the depiction less of a battalion rallying point than of a *miles gloriosus*.

A more appropriately pumped-up set of descriptive phrases appears in Pieter van Thiel's entry in the catalogue of the 1991 exhibition of works by Rembrandt and his pupils: "the commanding presence of an actor whose mere appearance on the stage is sufficient to still an audience"; "the haughty bearing of the pugnacious model"; "a leg-of-mutton sleeve and a codpiece, a slashed beret and two large feathers. Only the feathers, sash and gorget would have passed muster" with bona fide ensigns.[55] After so bumptious and histrionic a characterization, one is almost disappointed to learn that this figure should be taken straight "as a symbolic representation of the ensign *sans peur et sans reproche*, the gallant hero who ran the greatest risk in battle" (202).

Whether or not this is—as H. Perry Chapman and others have claimed—a self-portrait, it has interesting relations to at least three etched self-portraits of the 1630s, all of them belonging to the category I designate "the macho thug" (fig. 21). The drooping moustache recalls that of the second state of B 17 (dated 1633); the plume resembles that of B 20 (1638); while the gorget, elbow, and turn of the body echo those of the first state of B 23 (1634).[56] Chapman thinks that the "coarse features and brutish appearance" of B 23 "call up . . . the fearsome leaders of Holland's past"—Rembrandt as ancient Batavian hero—and that both the etching and the painting convey "arresting dignity and self-confidence."[57] I suggest replacing "dignity" with "bluster." Batavian or no, B 23 is a delicious image of the busily cross-hatched bravo enjoying his boorish fatuousness. If we think of the painted standard-bearer with his extravagant, outdated costume as a translation of these attitudes and accouterments to a *type* ("of courage and contempt of death"), we may have second thoughts about Rembrandt's commitment to the standard-bearer or ensign as an exemplary military and social figure. In general, for reasons that emerge below, Dutch attitudes toward the military are ambiguous at best and will hardly support Chapman's unequivocal claim that after the revolt "armor acquired patriotic associations and served to declare the sitter's allegiance to the fatherland" (36).

When Adams notes that ensigns "were traditionally well-heeled bachelors,"[58] she supports her statement with two explanatory references but

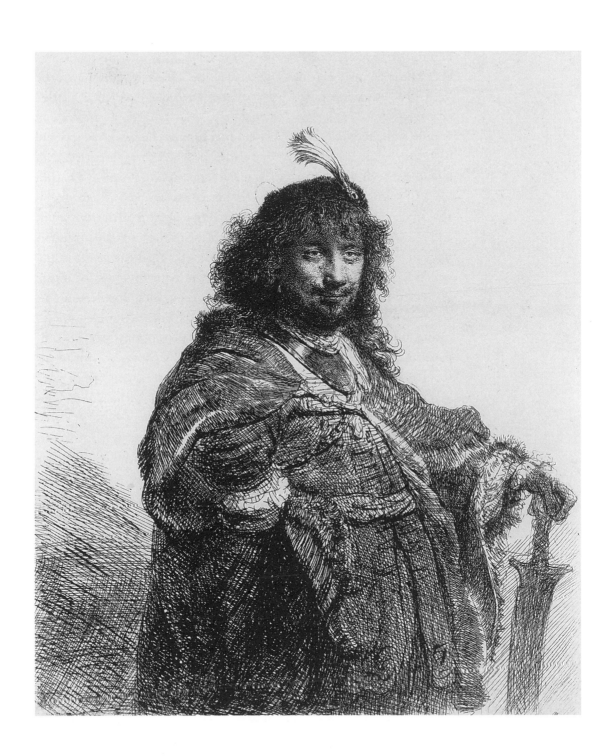

fails to note that they are excerpted from conflicting interpretations. Egbert Haverkamp-Begemann argues that the reason ensigns had to be bachelors "was undoubtedly because" they preceded "soldiers in battle" and were thus "exposed to great danger and should not risk leaving widow and children behind."[59] According to Slive, however, ensigns had to be bachelors because "the authorities believed that a married man would not be as free to swagger or spend money on uniforms as a bachelor."[60] It seems clear to me that the former rationale may be more applicable to the standard-bearers who are working soldiers in mercenary units, and the latter to the ceremonial, civic, and sociopolitical functions of ensigns in militia companies.[61] This is why Haverkamp-Begemann's claim, which appears in the context of a passage identifying the sitters who paid and posed for Rembrandt's 1642 *Nightwatch*, is puzzling. It reflects his effort to downplay, even while acknowledging, the historical evidence indicating that by the early 1640s the military functions of the shooting companies were minimal, if not a thing of the past.[62] Chapman reaffirms the opinion that by the time of Hals their functions were "largely ceremonial" and goes on describe de Keyser's ensign as dressed in "the height of fashion in the 1620s." For her the painting is an example of how "armored portrait formulae, developed by Titian and Antonis Mor to glorify rulers of the great absolute states, were adapted to promote the values of the urban oligarchs of the Netherlands."[63] Is the freedom "to swagger or spend money" among these values?

Slive's acerb assessment of the authorities' motive is based on his view that, although the militias may have played a heroic role in the defense of Haarlem during the opening years of the Revolt, even as early as 1596 they "had taken on something of the character of sport clubs, and evidently the Dutch military leaders who conducted the war against the Spanish were not very impressed with the fighting ability of the reorganized Haarlem militia companies." By 1616,

> when Hals painted his first group portrait of the Haarlem civic guards,
> the militia companies had virtually lost their military character. On
> the two occasions in the following decade when they were called
> upon to serve outside the city they saw only rearguard action. Their
> contemporaries had no illusion about their military importance. . . .
> Not armed service, but commissioning Frans Hals to paint their portraits,
> won the officers of Haarlem's civic guards their fame.[64]

In the light of this skepticism, how do we interpret the sartorial allu-
sions to military and aristocratic status that—beginning in the 1580s and
increasingly during the early decades of the next century—fill these im-
ages of militia companies? The Dutch, Richard Helgerson reminds us,
"had neither a strong military tradition nor a large aristocratic class de-
voted to arms," and the losses they suffered early in the Revolt showed
that they "needed something more than heroic burghers fighting for free-
dom and their faith. They needed a real army." Thereupon they set about
creating "the first modern professional army," hiring "troops and officers
from all over Europe," an army of mercenaries, outsiders, bound to the re-
public by contract rather than by loyalty and honor.[65] Although historians
don't agree about the effect of these developments on the role and func-
tion of the militia companies, many share Joneath Spicer's opinion that
"the rise in the effectiveness of the standing army" helps account for the
militia company's "decline in . . . military significance."[66]

The army was largely a creation of the Orangist court and the initia-
tive of Maurice, who disliked and resisted the Twelve Years' Truce and
whose aggressive policy toward Spain was not in the interest of the cities
or their regents. Helgerson comments on the irony of the fact that, al-
though the regents generally sought peace with Spain, so long as the army
fought "the towns prospered and ruled. But whenever peace threatened
to replace war"—as it did during the Twelve Years' Truce (1609–21) and
again with the Treaty of Münster in 1648—"tensions grew" between the
regents and the court.[67] Strictly speaking, as I noted above, this was not
so after the truce ended in 1621; during the crisis of the 1620s the towns
did not prosper and rule. But while the truce was in effect, tensions did
threaten to grow between soldiers and civilians, because the large number
of troops billeted in the system of fixed garrisons established in the
southern and eastern border towns of the Republic between 1591 and
1609 weren't compelled to profess arms often enough to let the civilians
enjoy their peace unburdened by soldierly visitation. "Soldiers in taverns
and guardrooms became as familiar, and fundamental, in the Dutch pe-
riphery as ships and seamen on the maritime seaboard," and by the 1620s
"Dutch painters were . . . painting soldiers in inns and brothels."[68] Also, in
the closing years of the truce, Remonstrant riots in several towns forced
Maurice "to keep a sizable force stationed in the interior of the Repub-
lic" in towns "far from the main Dutch defensive ring." Since "some forty

companies of troops were tied down in [the provinces of] Holland and Utrecht" alone (468–69), civilians in the affected towns may have felt burdened by the double trouble of surveillance and besottedness.

Because their "infrequent bouts of fighting" left military personnel plenty of spare time, the danger of polarization was high, and a major objective of Dutch military reforms was "to protect civil society from disruption by soldiers. Burgomasters and regents insisted that the soldiery be subordinated to civilian priorities" (267). Israel attributes the orderliness and discipline produced by the reforms as much to "the social and cultural circumstances of the fixed garrisons as [to] any specifically military innovations. Troops . . . needed to demonstrate their discipline . . . to the civilians to whom they were constantly on view" (269). Another by-product of the garrison system "was the creation of a new type of military aristocracy, consisting of men, usually of lesser noble origin, who through long service, ability, and loyalty to the Republic rose to the powerful position of governor, or deputy governor, of a garrison town," and whose residences became "the center[s] of social life and refined culture" in those towns.[69]

Although Helgerson's important essay focuses on a later period—it concerns the way genre paintings of the 1650s and 1660s represent threats to the domestic microcosm of republican order—his analyses of the opposition between "[m]erchants and soldiers, burgher fathers and knightly officers,"[70] sober householders and swashbuckling interlopers, illuminate the socially ambiguous conventions of individual and group portraiture prevailing in the earlier decades of the century. Discussing a momentous change in pictorial emphasis that registered the effects of the 1648 Treaty of Münster and the period of the "True Freedom," he observes that

> soldiers . . . became increasingly difficult to distinguish from nonmilitary gallants. While many men in armor, men wearing a cuirass or shirt of mail, still appear in these paintings, many other figures that contemporaries and subsequent commentators have agreed to call soldiers are distinguishable by little more than a sash, a sword, and a general extravagance of dress and manner. Were all these men meant to be seen as soldiers? Who can say? But that uncertainty . . . is precisely the issue.
>
> What opponents of a monarchic regime feared was just this blurring of categories. (59)

Whatever the truth of this emphasis on the novelty of the confusion between military and nonmilitary figures, it is the case, as we saw above and will see in Part 4, that from the late 1620s on Rembrandt portrayed himself and others—models, patrons, *tronies*[71]—in sometimes fanciful military attire. The examples range from self-portraits as a macho thug to frail elderly gentlemen wearing gorgets and plumed hats. In several pictures the occasional military accouterment is part of a connotational convergence of the exotic, the orientalizing, the historiated, and the theatrical, with the latter being the dominant effect. At least in these images "a general extravagance of dress and manner" is often depicted as histrionic fantasy, an aristocratic or seigneurial pipe dream, the object at once of loving pictorial elaboration and of wry amusement. On the one hand, the extravagance provides the occasion for a riot of painterly self-indulgence. On the other hand, the air of sartorial overkill is so conspicuous—an effect at times intensified by facial expressions that are out of keeping with the costume—as to encourage detachment, amusement, or quizzicality in the observer. Oscillating between these poles, the tone of depiction could be described as "embarrassed."

This tone accords not only with the uneasiness Helgerson describes but also with the uneasiness that, in Schama's interpretation, is reflected in the cultural role of the civic militia companies. He insists that, far from being considered military units, they served a countermilitary function in the symbolic economy of Dutch culture. Following a discussion of Dutch antipathy to soldiers with a general comment on *schutterstukken* scenes from the sixteenth century on, Schama calls the latter "pseudo-military ensembles" because they

> are emphatically group portraits of civilians in martial fancy dress. Their ranks are determined by their respective places in the patrician pecking order, and their regimental insignia and emblems and colors are closer to those of the civic corporations and guilds than to battle dress (which had no uniform at all). The gorgeousness of their array was an urban parade, and the *doelen*, even amidst the banner waving and the shouted Sunday drill, stood not as an extension of the military life into the civic, but as its opposite and alternative. The militiaman, the armed civilian, was as intrinsically benign as the professional soldier was malign. He was *of* the community and not a marauding intruder or an unwelcome billet. He could be relied on to bear arms in the Fatherland's hour of need.[72]

Helgerson's "[a] sash, a sword, and a general extravagance of dress and manner" describes many sitters who inhabit the individual and group portraits painted during the earlier decades and who may have wished to convey their military bearing but clearly did not mean to be seen as soldiers. Rather, they seem to be emulating aristocratic poses. Does this involve a blurring of categories between the merchant elite and hereditary nobility? In the light of the specific political tensions at work during the decades after the end of the Twelve Years' Truce, we may recall and expand Woodall's argument that strategies of noble emulation needed to be carefully deployed so that Amsterdam patricians could represent their independence from the Hague court, which was associated with the pro-war forces and the military presence and, after 1618, with Maurice's divisive and aggresssive Counter-Remonstrant interventions in the cities. Pieter de la Court, the voice of antidynastic regent ideology, warns against "not only officers, courtiers, idle gentry, and soldiery, but also all those that would be such."[73] This was written in the early 1660s, during the Stadholderless period and after the Anglo-Dutch war of 1651–54, but the social and political alignments—and prejudices—de la Court addresses had been in place for a long time: despotic centrism, courtliness, aristocracy, and "soldiery" easily blended together into a connotational field of representation within which any one element could be contaminated by the others. Thus even if the values identified with military and courtly bearing were socially attractive to regents aspiring to dramatize their patrician status, they might at the same time have been politically incorrect.

What, then, is a sitter to do? Let's return to 1624, the year of the Haarlem butter tax uprisings, and imagine that somewhere in Holland, a Holland through which the treacherously shifting crosswinds of post-truce controversy still swirl, there lives a sitter who is man enough to meet the perils of political incorrectness head on. Let's imagine further that he has found the painter whose dash and dazzle are attuned to his. Although it has been incessantly drummed into him that embarrassment is the better part of valor, he is too fond of his sash and extravagant wardrobe to let the voice of discretion cut him off from the glory he affects (pl. 14). He has, however, seen enough of the still unfinished portrait of van Heythuyzen to be willing to forgo the sword.[74] He also agrees, in the interest of prudence, to settle for something a little more modest in the way of format—something less than life-size and full-length. He understands the cost of glory; he will let himself be cut off at the waist.

When the result of these negotiations was liberated from its context of production and sent forth into the world to make a living, it failed at first to impress those who could advance its career and thereafter spent a long time languishing in a low-income bracket. Not until relatively late in the nineteenth century did an upward turn in its fortunes enable our arriviste to pass into the aristocracy of art and receive its noble title together with the long-deferred recognition it still receives a century later:

> *The Laughing Cavalier* . . . shows how successfully Hals conveyed a sense of immediacy in his commissioned portraits of the twenties. The handsome model's smile is a momentary one, the vivid characterization is indelible.[75]

> *The Laughing Cavalier* . . . is turned sideways and looks down at the beholder over his shoulder and elbow. This masterly pose is not mitigated by a polite turn of the head but almost reminds one of a fashion plate. But the friendly expression and the sidelong glance neutralize the aggressiveness of the pose. They seem to be an admission of the costume's stiffness and pomposity. . . . The painting . . . seems to capture a pause during a performance in front of people or in front of the mirror. The illusion of sweeping movement is achieved through parallel diagonals in the costume and face. The movement is interrupted by the casual eye contact with the beholder (no one could sustain such an exaggerated sidelong glance for long without finally turning his head toward the observed object). The demonstration is thus ironically broken: a distance is established between the person and his assumed role.[76]

The first description is from a survey, the second from a monograph. Epigrammatic compression is among the necessities and virtues of a good survey, and the antithesis in Slive's second sentence ("momentary" versus "indelible") compactly delivers a description of the pose and a judgment of the painter's achievement. But such compression comes at a cost. Grimm's more leisurely account unpacks a nuanced scenario at which Slive's summary "sense of immediacy" and "momentary" glance, but to which they don't do justice.

Slive has his monographic innings in his monumental study of Hals. But apart from some equally cursory descriptions, his comments are exclusively concerned with the iconographic problems generated by the embarrassment of emblematic riches "embroidered on his grey jacket," most of which "are too commonplace to be of much help" in providing clues

to the sitter's identity.[77] Then, after mentioning the influence of Alciati's emblem book and identifying the symbols on the sleeve (Mercury's cap and winged wand, bees, winged arrows, flames, and flaming cornucopias, 1.21–23), he concludes that "[w]hether or not all the embroidered symbols were meant to be read together as one gigantic emblem remains to be decided. Their presence, however, reminds us of how common such emblematic devices were in Hals' day, when they were found on clothing, household furnishings, walls, ceilings, and, of course, in books. The devices on the jacket of the *Laughing Cavalier* also show how easy it is for us to overlook them" (1.23). In short, though Slive's predecessors tended to overlook these clues to meaning, all that can be determined is that they *are* emblems and *have* meaning—they give themselves to be seen as meaningbearers—even if we don't have enough information to determine just what the meanings are or what they contribute to this portrait.

Given an area of an indeterminacy or undecidability that blocks interpretation, do we simply ignore it for the time being and shift to a different point of interpretive entry? Or, after we shift to the fiction of the pose, do we mark our present uncertainty as part of the effect: the sitter is holding forth the sleeve, flaunting it, for us to read, and looking at our act of inspection with benign self-satisfaction. It is too bad that the times have changed and the portrait has sailed into a culture of spectators who can't read what the sitter wants them to read.[78] But the failure of the symbols as an integrated collection to weather time and deliver the meaning that may identify or even interpret the sitter necessarily imposes a different mandate on the spectator who continues to look for the meaning of the pose.

The pose that declares the sitter's awareness of being painted and observed also registers the role distance Grimm describes: even as the officer gives himself to be seen in the attitude of the dashing cavalier, he all but winks at the observer whose critical assessment he conspiratorially shares, and indeed preempts. At the same time, another level of scopic exchange complicates this drama. Its focus is on the conflicting claims the officer's eyes and sleeve make on the observer's attention. For although he and his upturned mustachio command you to keep your eyes on his eyes, the perspective foreshortening accentuated by the hat situates your eyelevel well below *his* face and sinfully close to the pyrotechnics of the slashed sleeve thrust forward in *your* face.

This of course is where you as a sensible observer really want to be,

optically inching about with an imaginary magnifier and losing yourself in the luminous rich flickers of that gorgeous territory. You know perfectly well that the sleeve and the arm akimbo are to be deferentially received as markers of moneyed manliness. And you have been told by Slive and others that such markers have emblematic value; they add specificity to, perhaps confer identity on, certainly enhance, our general impression of a sitter described by the art historian—doubling as a connoisseur of vulnerable men and designing women—as "a man with whom men can identify when they are in a Walter Mitty mood and one whom many women would like to meet."[79] Nothing should interfere with that general impression. But unfortunately everything does. The proximity of the sleeve below the elbow is a trap entangling painter and observer in the lacy and fiery weblike patterns that seem to float forward to the panel surface, where their symbolicity becomes otiose and they register less as brocade than as flat untextured calligraphic activity—sheer, lovely, painterly noise. In the blithe voyeuristic abandon of this aesthetic conspiracy, the putative subject of the portrait is momentarily upstaged by indices of the painter's busy hand. But only momentarily. There the officer stands indelibly amused, forever catching the guilty observer in the act.

Hals sitters are famous, however, less for their indelibility than for their mobility of pose. Both Slive and Grimm appreciate the problem of interpretive framing posed by an effect like the momentariness of a smile, though they don't always translate their appreciation into practice. In his generalizing passages, Slive shows himself well aware that the "sense of immediacy" he finds in "the commissioned portraits of the twenties" does not reflect an actual scene of portrayal: to say that as a painter predominantly of portraits Hals was limited by "dependence on the model . . . is not to say that he never took a brush in hand unless he had a model in front of him: it is absurd to think that he made a burgomaster of Haarlem . . . hold an instantaneous expression or momentary gesture until he transcribed what he saw into paint."[80] Similarly, Grimm, after noting that the painting "seems to capture a pause during a performance in front of people or in front of the mirror" and that the "illusion of sweeping movement . . . is interrupted by the casual eye contact with the beholder," reminds us parenthetically that "no one could sustain such an exaggerated sidelong glance for long without finally turning his head toward the observed object."[81]

The term "vivacity," often applied to Hals, is used to denote not merely

lively brushwork but rather—as his contemporaries already recognized—the intimate fit between textural and figural animation. "Of course, Hals could not lend more actual motion to his portraits than a static picture allows. But he knew how to bring the impression of life and movement onto the canvas . . . [and] with his seemingly fluent way of painting, he thus achieved an outstanding terseness of expression" (104). Grimm describes with great sensitivity the optical or impressionistic effects produced by passages of texture that indicate cursive notations rapidly flicked out by the touches of the brush. But as I suggested in Chapter 1, his responsiveness to the perceptual orientation of the optical mode—its orientation, that is, toward representing the conditions of seeing—often tempts him to succumb to the genetic fallacy and spin past-tense fantasies about the perceptual or psychological reactions of the painter ("Hals seems to have literally squinted," 107).

Occasionally, however, he delivers a more structurally oriented comment that correlates figural, optical, and textural animation in a genuinely useful manner:

> The fluent brushwork . . . makes the individual color areas, particularly the faces, appear as if they were in motion. The repeated diagonal strokes at first seem to be the effect of a fleeting impression of the images; only a second observation, which concentrates on the execution of the painting, shows that they are elements of a sketchy brushwork. (70)

We need only reverse the order of this simple series of linked statements to understand and appreciate Hals's distinctive contribution to the typology of poses: sketchy brushwork indicates a fleeting impression, which in turn indicates a subject perceived as moving. The trademark Hals pose is posing as if in midmotion; pretending to be or to pause in the middle of a sequence of bodily movements or adjustments, pretending momentarily to interrupt or be distracted from some recognizable (because conventional) formal scenario. On the analogy of the slice of life, we may think of this fiction as the slice of pose. Its transitional or momentary quality is conveyed by brushwork that registers rapid response and thus connotes the obstruction to graphic clarity imposed by special conditions of vision or visibility ("a fleeting impression").[82] To speak of impressions and impressionism is of course to underscore the dominance of the optical mode, with its emphasis on the temporality of seeing. But Hals projects this emphasis from the eye to the corporeality of the posing figure, which

is thereby animated so as to appear caught in the midmotion of the slice of pose.

How are we to incorporate these formal observations on Hals's optical and textural impressionism into an account of the sociopolitical implications that attach to different fictions of the pose? What, for example, is the strategic value of the slice-of-pose fiction within the economy of the larger set of fictions? Let's begin by recalling Woodall's comment, cited at the beginning of this chapter as a prelude to my account of the anomalous grandiosity of the portrait of van Heythuyzen: "Some of Frans Hals's images of Haarlem citizens . . . depicted responsive communicativeness, rather than the personal autonomy conventionally attributed to the hereditary, landed nobility."[83] I take it that aristocratic "autonomy" is the impression traditionally, and most effectively, conveyed by the graphic fiction of objectivity, in which sitters give themselves to be seen but don't deign to return the looks they solicit. Is responsive communicativeness an alternative to, or even a defense against, this impression of monumentality?

Since textural and optical animation can threaten the package of graphic values objectivity delivers—clarity, calmness, and statuesque poise—the fusion of textural and figural animation that produces the slice-of-pose scenario better serves the spontaneous, informal, or momentary action of "genre paintings . . . than the more restrained portraits of dignitaries," and Hals was therefore slow to exercise his "improvisatorial freedom" in commissioned portraits.[84] Nevertheless, *The Laughing Cavalier* already shows him subtly interrogating a traditional pose. Perhaps, collaborating with Grimm, we could say that the portrait "seems to capture a pause during a performance" of the fiction of objectivity. His postural attitude is similar to that of Cardinal Mezzarota, whose portrait we encountered above in Chapters 4 and 9. The cavalier has assumed the conventional three-quarter position that would send his gaze imperiously leftward above and away from the observer. But now, as Grimm asserts, he interrupts the pose to make "casual eye contact."

"Casual" picks out the saving touch, the swerve from objectivity toward informality, yet it is too weak a modifier to convey Grimm's own rich characterization of the effect: "the friendly expression and sidelong glance . . . seem to be an admission of the costume's stiffness and pomposity," and thus "a distance is established between the person and the assumed role" (118), which is to say that the knowing and faintly amused look establishes the closeness of complicity between the sitter and the ob-

server. And this complicity confronts and disarms not only the embarrassment of/at the riches inscribed in the costume. It also confronts and disarms the embarrassment lurking in the decision to pursue a strategy of noble emulation in a quasi-military mode that would expose the cavalier to such dismissive epithets as Slive's "swaggering gallant" and to such invidious categorical associations as Christopher Wright's: the sitter "must be presumed to be some successful young soldier of the type which looks so different when seen merry-making in a barracks-room scene by Willem Duyster or Pieter Codde."[85]

In the *Cavalier*, as in the monumental image of van Heythuyzen, we can see Hals beginning to assay "the international tradition of formal portraiture."[86] The verb "to assay" registers the ambiguous range of the project—to evaluate, to experiment with, to interrogate, to challenge. During the same period he began to flirt with more unambiguously counter-traditional poses, and in the 1626 portrait of the Haarlem merchant and diplomat Isaac Massa (fig. 22), he produced "the earliest known single portrait of a casually seated model turned in a chair with his arm resting on its back," the first of several versions of this format that Hals painted throughout his career.[87] It is also a lucid example of the complex vitality Hals invests in the slice-of-pose fiction.[88]

Once again, I arrive at my sense of the fiction by torquing the observations of Slive and Grimm, who complement each other inasmuch as one leans a little more heavily on the expressiveness of Massa's mouth and the other on that of his eyes:

> The piercing glance he throws to the far left suggests he has abruptly turned his head to look at something close by. His parted lips make us feel they are about to move. Hals discovered early that a portrait was enlivened if the model looked *as if* on the verge of speaking.[89]

FIGURE 22

(Opposite) Frans Hals, *Portrait of Isaac Massa*, ca. 1626. Oil on canvas. Art Gallery of Ontario, Toronto.

> The action . . . is partly determined by the model's relaxed posture which, though it appears rather unofficial, might well have been the most comfortable pose to sustain the tiring sittings. . . . The glance of the eyes, however, indicates a momentary distraction. . . . [T]he eyebrows are raised—the right one more than the left; the mouth is slightly open; streaks of light and color around the eyes indicate a sudden impulse for the eyes to move. It is an "innerpictorial action" that interrupts the usual seated pose. Hals's observation concentrates on this particular moment of distraction when the model *seems* to have forgotten the prescribed pose.[90]

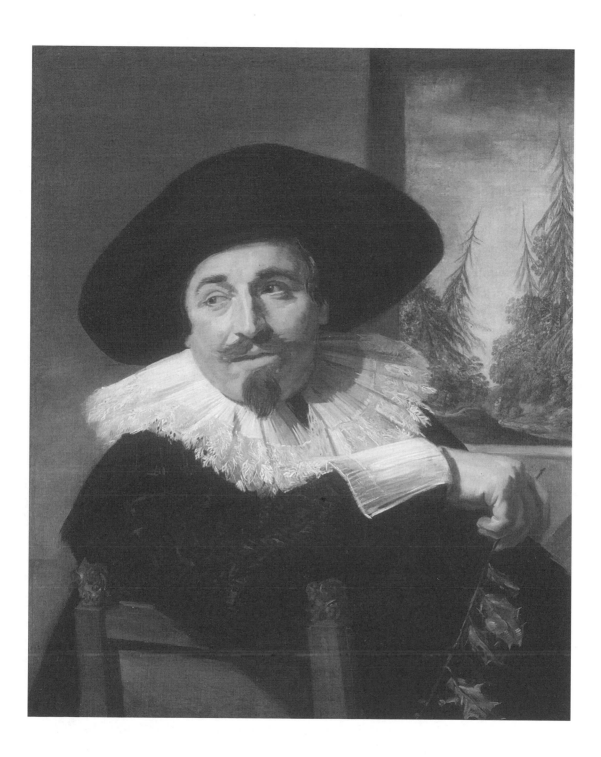

I have italicized the terms that gesture toward the fictiveness of the pose, but in both comments the gesture is perfunctory and contradicted by indicative statements about the postural predicament that would confront an actual sitter holding this pose.

In order to acknowledge the primacy and fictiveness of posing, Slive's first sentence would have to be changed to "He poses as if he has abruptly turned his head," and Grimm's second sentence to "He poses as if momentarily distracted." The sitter has chosen to pose for his portrait and to pose in this manner and to give himself to be seen by painter and observers, of whose scrutiny he must therefore be aware and for whose benefit he stages the effect of being distracted from and interrupting his pose. Just as, given the founding conditions of portraiture, there can never be absorption pure and simple but only a theater or fiction or performance of absorption, so there can be only a theater or fiction or performance of (momentary) distraction. Yet why go to the trouble of belaboring this distinction? What is its cash value here? Simply this: it compels us to think of the sitter as an agent motivated to present himself and be represented in a certain manner; he presents himself as—he pretends to be—a sitter who is in the act of interrupting "the usual seated pose," that is, the conventionally formal attitude of posing.[91] When the scenario is viewed in this manner, it enables us to embed it in the political context that gives specific meanings to the fictions of objectivity and of distraction. Because the first is formal, traditional, and weighted with aristocratic associations, the second is marked not merely as informal but as counter-formal and counter-aristocratic. Hals depicts Massa as someone who has chosen to present himself and be represented in the guise of a burgher rather than of a noble or a military figure; as someone who pretends to eschew the privilege of objectivity, and who has chosen instead to have himself painted posing as if not posing at the moment of depiction.

To interpret the effect as flatly counter-aristocratic, however, would be to overlook a disingenuous feature of the sitter's posing strategy. Grimm claims that his "relaxed posture . . . might well have been the most comfortable pose to sustain the tiring sittings," but I doubt that "relaxed" and "comfortable" do justice to what we see when we remember that Massa does not simply interrupt "the usual seated pose." Rather, he *holds* the pose of fleetingly interrupting the pose. Thus if we imagine him looking fixedly to his right in order to make it seem that the sideways glance is a momentary interruption—that, in Slive's words, "he has abruptly turned

his head to look at something close by"—we begin to appreciate the difficulty of Massa's postural tour de force. Our appreciation increases when we notice how the fleshy face pressing against the collar on the sitter's right seems fattened and flattened as if distended by that pressure. But this slight indication of discomfort is counterbalanced by the "playful gesture of the hand" loosely holding the sprig of holly.[92] The turn of the arm supported by the chair and culminating in that easy gesture secures the effect of relaxation against the hint of strain. This is not an unfamiliar scenario. We encountered it in Chapter 3, where I defined the sprezzatura of nonchalance as "the ability to show that one is not showing all the effort one obviously put into learning how to show that one is not showing effort." In his performance of the slice-of-pose fiction, Massa is trying not to show the effort he obviously put into holding the pose of the interrupted pose. At least in that respect the attempt at casualness suggests an aspiration to give the decidedly *burgerlijk* cast of the portrait a subtly aristocratic air.

Through the course of his career, Hals used this arm-over-the-chairback formula at least six more times.[93] Though they vary in degrees of elegance and informality, and in the relation of these qualities to the mix of graphic and textural effects, with one possible exception all of them eschew the slice-of-pose fiction and steadily present themselves to the painter/ observer. Those painted during the 1640s and 1650s replace the soft wide-brimmed burgher's hat worn by Massa with the stiff, high-crowned, narrow-brimmed hat fashionable in France earlier in the century, a change that reflects the turn toward more courtly fashions characteristic of burgher portraiture in these decades.[94] Our exception is the last portrait in the group, *Man in a Slouch Hat*, dated in the 1660s and famous both for the stenographic sketchiness that has led some to believe it is unfinished and for the enormous, bumptious hat with its wide brim perched at an impossible angle as it swirls in an orbit about the sitter's head (fig. 23).

Apart from the hat, this is simply the most relaxed and congenial figure in the set: a patient and steady gazer; a happy sitter. The meaning of the pose is affected by a nostalgic gesture toward reprise. Slive notes that "the vivid animation and the hint of a view of a landscape through the open window recall earlier works," and Christopher Wright finds its composition "curiously similar to the portrait of . . . [Massa], painted almost forty years before."[95] Both also comment on the sketchy handling

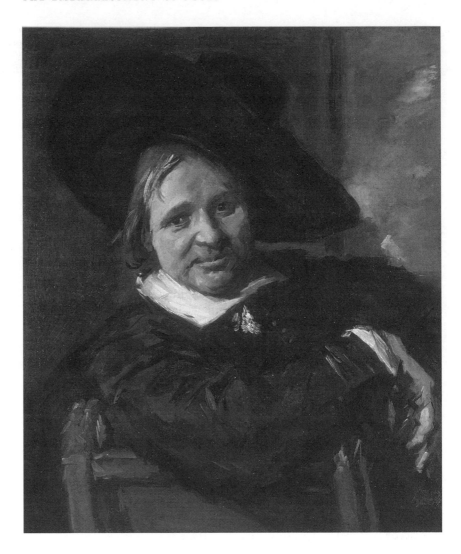

FIGURE 23

Frans Hals, *Portrait of a
Man in a Slouch Hat*,
ca. 1664–66. Oil on
canvas. Staatliche
Museen Kassel.

that distinguishes it from its predecessors. At first glance the sketchiness,
which denotes rapidity, does not accord with the express readiness of the
sitter to hold still. But the hat changes the picture. The pretense of infor-
mality yields to an acrobatic imperative: every aspect of the sitter's pos-
ture seems calculated to give the hat the ultimate tilt of rakishness and at
the same time to prevent its imminent slip toward or out the window.[96]
That precarious balance confirms the impression of momentariness, and
at the same time imparts a strange humor to the sitter's amused expres-
sion. He had set up to do a Massa or perhaps one of the more courtly ver-
sions of the 1640s (but with the wrong kind of hat), and now, because the

despotic hat cockily asserts its sway over him, he doesn't quite bring it off. As he adjusts like a dancer to its demands, the impish or embarrassed or resigned little smile acknowledges his predicament and preempts the observer's response. It tells us he knows we are enjoying the dance and tells us he enjoys our enjoyment if not our embarrassment.

Man in a Slouch Hat is a critical parody of the burgher's desire to strike courtly poses and a travesty on the desire for the smooth, graphic, courtly style that delivers them. It dramatizes an engaging haplessness in the sitter, speaks to the vexed relation between burghers and their sartorial/sumptuary ventures in self-representation, comments through the hat on the tyranny of fashion and through the conspicuous lack of finish on the arbitrary association of styles of posing with styles of painting. Like language, like other sociopolitical discourses, fashion has a life of its own, a performativity of its own that may destabilize any intentional performance. While wearers choose and use it to express one meaning, it chooses and uses them to express others. In their struggle to subdue it to their representational projects—status, identification, preferment—they risk being overmastered by a connotational density they can never fully control. This general problematic takes a particular form and runs a particular diachronic course in Dutch portraiture from the 1640s through the 1660s. It is most brilliantly evaluated and exposed in the later portraits of Hals and Rembrandt.[97] In the concluding section of this chapter I shall first briefly describe the problematic and then turn to Rembrandt's version of the exposé.

From the time Bartholomeus van der Helst was active in the 1640s, Dutch portraiture began to take a turn toward more elegant, van Dyckian formulas. Woodall's view of this development, as we saw, was that it intensified after "the defeat and death of the Stadholder Willem II in 1650, inaugurating a Stadholderless period during which the Amsterdam regents for the first time openly dominated the political arena" and during which "citizens adopted contemporary courtly modes of representation with impunity, because the court was no longer perceived as a potent rival for power and status."[98] But a comparison of her view with Richard Helgerson's leads me to question the degree of "impunity." Although he comes to a similar conclusion about transgressive protocols in this period, he is, as we also saw, more responsive to the anxiety expressed by Pieter

de la Court and others about "the contagion of foreign, aristocratic, and courtly manners [that] threatened burgher virtue and burgher rule."[99]

Granted that his topic is genre painting rather than portraiture, Helgerson's account of the complex interpretive relation of the former to history painting has relevance for the latter precisely because it takes the anxiety of regents into account. In the mid-seventeenth-century, he argues, history painting was recognized as the art of "the secular power of the monarchic state" (82). The descriptive "realism" of genre "not only differs from the text-based art of history painting but also is part of an ideologically motivated reaction against . . . the history that kings and soldiers make" (79). But with maps, soldiers, messengers, letters, and erotic subtexts, and facilitated by "the absence of the always absent male householder," that history infiltrates "the ill-protected fortress of burgher domesticity" (82). In this setting, in the face of the threats to the "True Freedom" figured, for example, by "the sexual encounter of a 'genre' woman and a 'history' man" (76), the Dutch householders who "entertained and were entertained by the representation of an invasion that few of them would have welcomed" (62) chose their painters and their strategies of self-representation. It was a period during which both painters and patrons, both genre and portraiture, manifested the new interest in the brilliant graphic delineations, the smooth style, and the classicizing tendencies associated with the fashionable portraitists who followed van der Helst. The swerve of art itself was courtly. But a scruple about this may be registered in a change noted by Slive: "after 1650 collective portraits of officers and their men were no longer painted," giving way to group portraits of officers or governors who preferred "to be seen as dignified regents rather than military men" and who adopted the somber dress favored by the officers of hospitals and orphanages and craft guilds.[100]

What I take to be Rembrandt's critique of the courtly swerve has been interpreted quite differently in Gary Schwartz's critique of Rembrandt's failure to swerve. Schwartz is most censorious in his comments on a set of anonymous half-length portraits painted relatively late in Rembrandt's career and characterized by a strong emphasis on the performance of absorption or distraction. I want to approach his account by way of Svetlana Alpers's hypothesis about the late portraits because her insistence on Rembrandt's entrepreneurial success in marketing the Rembrandt look counters Schwartz's argument. In addition, her characterization of his workshop practices illuminates the rationale behind those experiments in

the theater of absorption that Schwartz and many others, including Rembrandt's contemporaries, found perverse.

Alpers begins with the premise that Rembrandt was a sort of *regisseur*, who treated his studio as a theater "in which life had to be reenacted under his direction"; his paintings "represent life as if it were a studio event."[101] She goes on to argue that for him "life"—as in "drawing from life"—meant not nature but rather the posing performances he directed in his studio theater (78), and that his directorial control extended "even to those who sat to him for their portraits" (84). In many of the later portraits she finds "that Rembrandt blurs the distinction between those who pay to sit and those models who are paid." The "economic and social basis of the transaction between the painter and his sitters" is masked by "a calculated indeterminacy of clothing and setting . . . and often the absence of any distinctive designation of class." Consequently the sitters "do not look as if they came and paid Rembrandt to paint their portraits. They do not look as if they were his or any other painter's patrons" (85). From this Alpers infers that Rembrandt made his patrons accommodate themselves "to his studio practices," treating them "as he treats his models," in effect reducing them to members of his theater company (86). She connects such symptoms of the struggle against the values, constraints, and hegemony of patronage with formal features that characterize both portraits and studies in the 1650s and 1660s: the "focus . . . on the face and collar (and to a lesser extent the hands)," the indistinct treatment of the space around the figure producing the "telltale fade-out" that concentrates attention on the "act of a person representing himself and the artist's view of this self-representation" (82–83).

In deriving these formal characteristics from a studio practice motivated by the painter's desire to bring the scene of portraiture under his control, Alpers is defending a particular class of portraits—the anonymous half-lengths—against criticism made shortly after Rembrandt's death by the Flemish art dealer Abraham Bruegel, who dismisses them as "bagatelles": "draped half-lengths with only the tip of the nose illuminated, the rest being left so dark that one cannot identify the source of light." Bruegel sneers at the work of "inexpert painters" who "fudge their outlines" and "try to hide their models with obscure and cumbersome garments": "What a great painter will attack [?!] seriously is a beautiful nude in which he can display his knowledge of drawing."[102] Alpers calls Bruegel's description of the half-lengths "good if unsympathetic," and goes on

to insist that they are "Rembrandt's representations of his studio practice" *rather than* "willful rejections of accepted artistic norms."[103] This disjunction weakens her position, or at least the position I would like to extract from her argument as the basis of a dialectical reading of the Rembrandt look, and so I want to speculate briefly about the polemical pressure behind her statements.

Alpers's quarrel with Bruegel is connected to her quarrel with Schwartz. Schwartz uses Bruegel's phrase "the tip of the nose" as the title of his diatribe against the half-lengths, which are for him the "hard core" of "the common conception of Rembrandtesque," a conception he doesn't have much respect for:

> Against an undefined, gloomy background we see a venerable man or woman in the garb of a past generation, gazing sadly into space, part of the face and sometimes the hands illuminated dimly. . . . [T]he nameless half-lengths draw us into the more approachable world of ordinary people, thinking, apparently, about themselves. The age of the models, their aloneness with their thoughts, and the gloom around them lends the figures a maximum of what Hoogstraten called "soul." Like so many Dutch Mona Lisas, Rembrandt's half-lengths combine the attractions of inscrutability and unassailable artistic reputation. They provide the viewer with a flatteringly fuzzy mirror for his own most profound reflections on the meaning of life, a function they have admirably filled for three centuries.[104]

As the remainder of Schwartz's chapter shows, the terms "nameless" and "ordinary" encode his censure of Rembrandt for not appealing to the better sort whose good names and incomes gave them the power of commission, a failure he attributes to Rembrandt's violation of the classicizing norms (such as Bruegel's "knowledge of drawing") then in vogue. Given the premises of Schwartz's reception theory, one can appreciate his irritation with the fuzzy mirror provided by nobodies who lacked the power of commission. For if the "iconographic, stylistic and aesthetic meanings" of Rembrandt's portraits cannot be understood without archival research leading to knowledge of "the character and interests of those for whom they were painted" (358–59), portraits of sitters who never made it into the archive are doomed to be meaningless.

Alpers doesn't respond effectively to this critique. Her claim that the "evocativeness" and "calculated indeterminacy" of what appear to be commissioned portraits make their sitters indistinguishable from the

models Rembrandt paid to pose hardly meets Schwartz's complaint about the fuzzy treatment of apparently nameless sitters.[105] Nor is the assertion that Rembrandt was not willfully rejecting "accepted artistic norms" enough to disarm Schwartz's contention that, whether willfully or not, "Rembrandt walked straight into the line of fire" with half-lengths that are "veritable anti-classicist slogans, and were seen that way."[106] I think Schwartz is right about this—they *are* anti-classicist slogans, among other things—but I also think it would strengthen Alpers's argument against Schwartz to concede that point and consider how the terms of Rembrandt's challenge to "accepted artistic norms" can be shown to motivate the half-lengths.

The fuzzy mirror thesis was questioned by J. M. Nash in an ill-tempered review of *Rembrandt's Enterprise*, and though his attempt to develop an alternative explanation fails to persuade, the very failure opens the way to a more satisfactory approach to the half-lengths.[107] In one of his few positive comments he cites with approval Alpers's emphasis on the sitter's act of self-presentation and the artist's rendition of it. He uses this emphasis to reaffirm "the old and familiar view that was attacked so ferociously by Gary Schwartz" in the comments cited above, the view that Rembrandt's "slowly evolving painterly skills were directed to the presentation of humanity" and "to the workings of his subjects' minds." Nash counters the emphasis Alpers and Schwartz place on the evocative, indeterminate character of the later work by insisting that Rembrandt regularly "establishes not just that his subjects are thinking but *what they are thinking about*." In support of this claim he cites the Louvre *Bathsheba*, who "sits brooding over the letter she has just read," and the Rotterdam *Titus at His Desk*, whose pen, penholder, and paper indicate that "he is not daydreaming but thinking of what he will write next. . . . What we are drawn to do, as we contemplate these compelling presences, is not merely to project our thoughts onto their blank faces, but to rehearse in our minds the matters that are taxing their minds."[108]

This is, of course, special pleading. Since the half-lengths Schwartz and Alpers are concerned with lack precisely the props that give Nash his clues, they deny us access to the matters taxing their sitters' minds. But projecting our thoughts onto apparently preoccupied figures—Schwartz's fuzzy-mirror method—is not the only alternative open to us. We can refuse any and all speculations as to "what they are thinking about," and that includes even so modest and unwarranted a fuzzy speculation as

Schwartz's "[they are] thinking, apparently, about themselves."[109] If we stay within the interpretive perimeter established by the fictions of the pose, there are only two things we can be sure about. The first is that they *are* sitters, that is, persons who agreed to pose for the painter whether as patrons or as models. The second is that they don't seem to be attending to either the pose or the painter. They are performers in Rembrandt's theater of absorption, and the scenes that get produced in this theater—especially the half-lengths—have a specific narrative force: they are violations of the normative fiction of the pose, and our sense that the portrait situation structurally and socially privileges the norm makes the inattention of sitters conspicuous.

A peculiar light is thrown on this counterplot by publications that place a number of half-lengths side by side. Consider, for example, the two pages on which Schwartz assembles reproductions of half-lengths domiciled in Russia (306–7), and especially the Fuzzy Foursome on page 307 (figs. 24–27).[110] Tümpel thinks that in studies of this sort Rembrandt and his followers were "concerned with the seers of the Old and New Testament" and he describes them as "pensive figures, seeing with their inner eye what is invisible to others," figures portrayed "as waiting, hoping, meditating, and . . . taking on a profound human dignity through their faith and hope" (299). Yet viewing them all together makes one think each sitter was handed a script when she or he walked into the studio, and the script was the same for all of them: they were told to ignore the painter and think about something besides posing—as if a photographer should say, "Relax, be natural, don't look at the birdie, don't say cheese." But these, lest we forget, are instructions for performing a certain kind of pose, a pose markedly different from the normative fiction in which the sitter engages, addresses, or—as in the fiction of objectivity—indirectly acknowledges the presence of, painter and observer. These sitters perform the fiction of distraction. Having agreed to pose, having fixed their bodies in a holding pattern, they act as if they received or gave themselves permission to drift off.

The normative fiction isolates and sustains a special moment in which painter and sitter strive to produce an image "more like the person himself, that is, the idea of the person, than he himself is in any one of the individual moments."[111] But the emphasis of the fiction of distraction is on the tedium, the unimportance to the sitters, of a sustained period of posing during which the rest of their life is in abeyance. Their sense of that

FIGURE 24

Rembrandt, *Old Woman in Armchair*, 1654. Oil on canvas. The State Hermitage Museum, Saint Petersburg.

abeyance is often concentrated in the hands. The hands of each sitter in Schwartz's Fuzzy Foursome are not busy; they don't hold gloves or canes or handkerchiefs or flowers; they only hold each other. Folded as if in patience or resignation or composure or mere quiescence, the hands gathering light divert attention from the face and anchor a modest barrier between sitter and observer—a barrier more tense and guarded in the two male figures, whose elbows push off from their chair arms. These anonymous sitters keep the normative fiction before us in the mode of conspic-

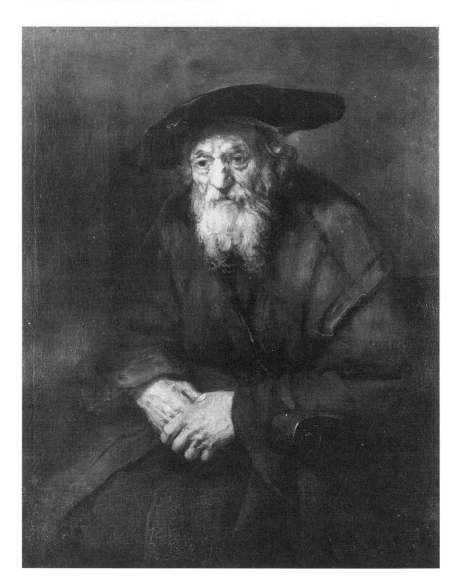

Rembrandt, *Old Man
in Armchair*, 1654. Oil
on canvas. The State
Hermitage Museum,
Saint Petersburg.

uous exclusion by so pointedly failing (refusing?) to acknowledge our
presence. They may indeed be "waiting, hoping, meditating"—patiently,
resignedly, entertaining sad and deep thoughts about the life interrupted
by sitting. But who can be sure that if what they express is indeed pa-
tience or resignation, it isn't an effect of the boredom and fatigue de-
manded of sitters by a painter who paints slowly and laboriously, who was
notorious for taking a long time to finish, and who may have wanted to
register in his paintings the effect of this demand ("waiting, hoping") on

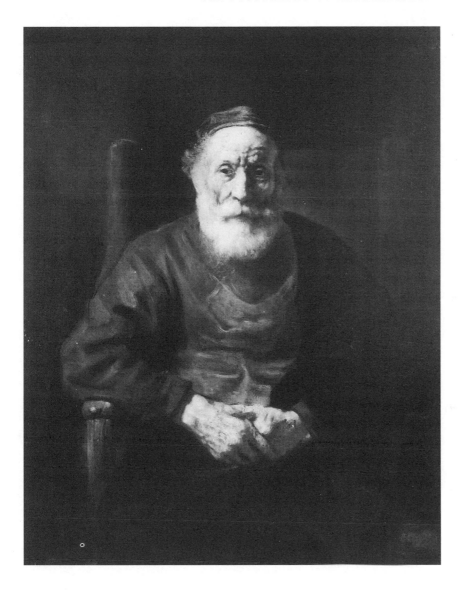

FIGURE 26

Rembrandt, *Old Man in Red*, ca. 1654. Oil on canvas. The State Hermitage Museum, Saint Petersburg.

his victims? That would be one way, admittedly devious, to make them sad and fuzzy mirrors for our most profound reflections.

Schwartz mentions one named half-length—the portrait of Nicholas Bruyningh (1652)—that falls into the fuzzy-mirror category and distinguishes it from the 1654 portrait of Jan Six (pl. 15), which reflects its sitter's "preference for clarity of structure and color."[112] He praises the latter for its "brilliant execution" and "daringly broad stroke" (260). Yet it has enough fuzzy-mirror features ("undefined gloomy background . . . , gaz-

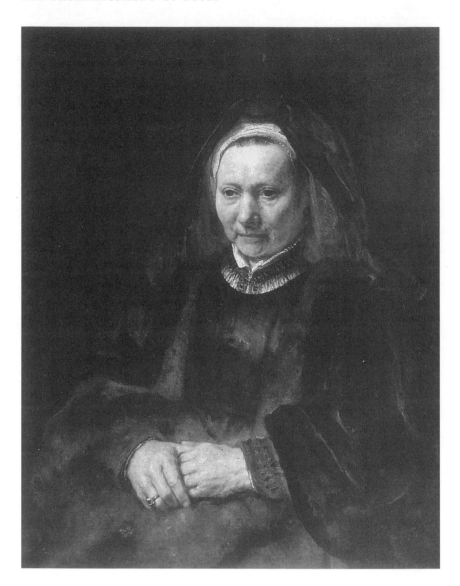

FIGURE 27

Rembrandt, *Old Woman Seated*, ca. 1655. Oil on canvas. Pushkin Museum of Fine Arts, Moscow.

ing . . . into space") to make me suspect that had its sitter been anonymous it might well have been demoted to the "hard core" of "Rembrandtesque." Its share of "the attractions of inscrutability" is attested to by a miscellany of "profound reflections" on the meaning of Six's pose, a portfolio thick and diverse enough to move Christopher White to exclaim in 1966 that "it is a party game for the imaginative to describe his thoughts."[113]

The party game includes speculations about what Six is doing with his

gloves: some say he is putting them on prior to going out and others say he is taking them off after having just come in, while at least one cautious soul, Seymour Slive, speculates that Six "is pulling on—or taking off—his chamois glove."[114] But as Sarah Whittier has pointed out to me, since tight-fitting chamois gloves like Six's have to be removed by first pulling at the fingertips, one of these options seems very unlikely.[115] And since the glove he holds in his bare hand merges indefinitely with the top of the other glove, it isn't clear just what he is doing. But the bare hand is not re- laxed. The black slashes outlining the fingers, the vigorous yellow and white glazing, and the angular buildup of the fist out of white daubs sharply juxtaposed to reddish and transparent olive-grey tones (reflections of the hand's sartorial environment) convey tension more than any graphic articulation of tendons and veins could have done. Modeling action rather than anatomy, they broadly and cursorily denote—but do not describe— that tension. Thus although the gesture is indeterminate, the indetermi- nacy takes the form of a slightly uncomfortable holding pattern.

Perhaps it is the gesture's indeterminacy that commentators try to nar- rativize away. The locomotive implications of their comments—he is just coming in, he is just going out—suggest a scenario more appropriate to the camera: "Let's settle on some revealing gesture to help us pretend that —busy and successful as you are—you didn't have the time to pose, so I had to (a) begin shooting as soon as you arrived, or (b) shoot you as you were on the point of leaving." By far the most interesting version of the scenario, the one on which I base my own reading of the portrait, has been elaborated by Alpers, who chooses alternative (b). "[W]ith a certain purposefulness," she claims, Six "is putting on his gloves to go," and she deduces from this gesture that he

> was unwilling to give the time necessary to sit for Rembrandt. His tilted head and shadowed eyes could suggest inwardness or withdrawal. But . . . I think they register rather that this is a sitter who is unwilling to play the part assigned, who is unwilling to do what is required to serve as Rembrandt's model. Six refused to be made over in Rembrandt's image. The speed of painterly execution and the imminent departure of the sitter dressed in his own street clothes represent Six as a sitter who got away. But in an important sense he did not. *Rembrandt recorded him in the very act*, remarkably adapting his manner to that of Six. *Though Six tried to make his escape*, it is Rembrandt's representation of him by which he is known.[116]

Alpers doesn't always differentiate between talking about what the painter did and talking about what the painting does, and by now I can be expected to protest against the genetic swerve of the scenario encoded in the past tense of the italicized phrases. It leaves the impression that we know what actually happened back then—what Six tried to do and how Rembrandt reacted—because the painting is Rembrandt's record of it.[117] Whether or not Six tried to escape, we may say that Rembrandt represents the attempt, and even that the representation pretends to be a record of the attempt. But I wouldn't want to foreclose the possibility that inwardness or withdrawal could be suggested, because it fits in with a reading closely related to Alpers's, the idea that Six *is represented as* "a sitter who is unwilling to play the part assigned," though my sense of that part differs somewhat from hers.

Alpers comments on the anomalous look of this portrait, "executed with a brilliance of brushwork achieved with an unaccustomed economy which must betoken an unaccustomed speed of completion" (93), and this is the textural cue to her story of the impatient and resistant sitter. It is, as her description of the paint surface and brushwork all but says, a Halsian cue: "the consistent thinness of the paint surface" and the sketchy treatment of the gloves, together with the vertical row of transparent yellow ochre slashes that signify the frogs adorning the cloak, project a Halslike impressionism, blending the effect of rapid painting with the slice-of-pose fiction.

These passages are as close to Hals as Rembrandt gets. Yet if there is a feint toward the Hals fiction of candor, the slice of pose, in the optical and textural rendering of hands, gloves, and cloak, it is not carried through in the depiction of the face. If I imagine Six poised before a mirror as in a dress rehearsal, the direction of his glance indicates that he is assessing the effect of the manual gesture. Before the imaginary mirror he evaluates the image of himself as a Hals sitter performing the slice of pose. But even that scenario counters the feint toward Hals or places it in quotation marks. And if the imaginary mirror is removed the glance loses its directedness, withdraws behind the transparent veil of shadow the hat brim throws over the eyes, and changes to a vacant stare. The veil, the stare, the set of the head, the relaxed form of the chin, the stiffened shapes of the two collars, and the way the face passively receives and absorbs the vivid play of tones reflected from cloak and linen: all this connotes the stability of a posing figure whose blank gaze may or may not indicate continued preoccupation with the manual holding pattern.

If, however, you step back and take in the whole figure, eccentrically shifted to the right and set at a slight angle so that the cloak with its warm tones and forward-jutting collar moves closer to the observer, you encounter another possible source of preoccupation.[118] For consider the cloak more closely: even though Rembrandt's impressionistic treatment partially dematerializes it and makes it appear less weighty, the question posed by its precarious perch remains: How long will it be before it slips off the shoulder? You may then be tempted to wonder for a brief moment to what extent the stiffness of the body and the angle of the cocked head serve as compensatory elements of a balancing act that defends against this embarrassment.

But your anxiety will be allayed as soon as you notice the false extension of Six's shoulder line curving down the cloak from under its collar. This stabilizes the cloak, reinstates the air of casual elegance it adds to the pose, and renews your admiration for Six's composure. You sigh in relief when you realize that a moment of difficulty, of danger to the sitter's self-possession, has been allowed to surface only to be—or only so that it may be—gracefully mastered. Another potential source of danger and embarrassment has also been handled with painterly finesse: the yellow slashes marching down the cloak not only help dematerialize it but also displace the sumptuous embroidery they represent. The impressionistic vagueness doesn't negate the garment's military or courtly connotations. But by replacing signs of dress with signs of paint it diminishes their impact and keeps them from being too ostentatious.

Slive suggests that Six is portrayed as if at "the instant when a man's gaze has turned from the outer world to his inner self."[119] A fiction of this sort is moving because the cues to the fiction of distraction and the Halsian slice of pose are framed within the stillness and fiction of the normative pose. I can't reconcile Six's expression with the fiction of candor proposed above, even Alpers's version of it, which is that the painting records an impatient and intransigent sitter "unwilling to give the time necessary to sit for Rembrandt," and which I would qualify as follows: the sitter poses as if unwilling to give the time necessary to hold the pose he holds. Thus it is easier for me to imagine that the painter arranged the pose only in terms of a certain level of body-consciousness in order to free the figure's thoughts to wander where they would, so that the body, left to its own devices, continues unthinkingly to maintain its holding pattern, just as the hand holds the glove. Patiently, but a little abstractedly, the sitter ac-

commodates the painter by presenting the figure of a man of action. But that is not a figure he fully fills, not a figure he commits himself to. Because the portrait conspicuously alludes to and just as conspicuously falls short of this ideal, it leaves us with a sitter who apparently wanted and agreed to be memorialized in paint, and yet who, when the time came, did not—or refused to, or was unable to—communicate himself to the observer. He doesn't quite return our gaze, though he seems aware of it. He has agreed to give himself to be seen; he is not interested in giving himself away.

In coming to this conclusion about the pose, I agree with the letter if not entirely with the spirit of Alpers's judgment that Six "is a sitter who is unwilling to play the part assigned." When she reads his unwillingness as a "powerfully visible" signifier, an allegory, of the archivally preserved instances of "Six's intransigence in the face of Rembrandt's demands,"[120] she follows the tendency of commentators who fall back on the Six archive to explain the portrait. But I remain intransigent in my desire to meet the demands of Six's face. I refuse the privilege of the archive. I have no idea what goes on behind the face. And if I ever want to find out more about Jan Six, I wouldn't begin by consulting the archive, where it is written that he was well educated, a poet, classicist, collector, merchant, and magistrate. I would reverse the procedure and begin with the one thing I can infer from framing that strange figure in the fiction of the pose: whatever preoccupies the sitter keeps him from fully participating in the planned scenario of self-representation. Perhaps the figure's resistance to interpretation only reflects my resistance to the archive. It is by overcoming the face and biography of a personage that Rembrandt adumbrates, or I imagine, something like a person beyond—hidden behind and by—representation.

Schwartz notes that Eddy de Jongh relates Rembrandt's "brilliant execution . . . to the sitter's ideal of courtly dash," and the observation seems archivally appropriate for two reasons. The first is that eight years after the date of the painting the first Dutch translation of the *Cortegiano* was dedicated to Six.[121] The second is that the burgher elite in Amsterdam inclined more to courtly poses during this Stadholderless period of the "True Freedom." Power shifted to the pro-Orangist and Counter-Remonstrant faction led by the de Graeff family, whose earlier portraits display relatively unembarrassed, and thus, from a certain burgher standpoint, embarrassing, affinities for courtly poses.[122] Compared to these, or to the portraits of van

Heyhuyzen, Reael, Soolmans, and Vredericx, in all of which the sitters perform, as it were, downstage, Six's sense of courtly dash is restrained and muted. The sitter shows himself aware of the pitfalls of embarrassment, or, to translate this awareness back into its Italian forebear, both the pose and the dashing brushwork that delivers it are performed with sprezzatura.

In the same year Rembrandt portrayed Six he produced his second painting of a standard-bearer, or ensign (pl. 16). This figure was identified in 1971 as Floris Soop, Six's neighbor and a well-connected citizen who had been active with Six in the affairs of the Amsterdam theater.[123] Prior to that time the painting was simply called *The Standard Bearer* and could easily have qualified as another of Rembrandt's elderly models dressed up in military apparel but looking more meditative than martial. Slive's comment on Six applies pretty well to this sitter's expression: the painter represents him at or after "the instant when a man's gaze has turned from the outer world to his inner self," and had he remained anonymous he too might well have moved any viewer who was not already lost in the mazy marvels of the impasto-encrusted sword belt to "profound reflections," this time on the dignity and sadness of military maturity. But now that we confront a real fifty-year-old ensign, the story changes.

Despite sixteenth-century English usage, an ancient ensign is something of an oxymoron in terms of either of the two rationales explaining why ensigns had to be bachelors, cited earlier: (1) they preceded "soldiers in battle" and were thus "exposed to great danger and should not risk leaving widow and children behind;"[124] (2) "the authorities believed that a married man would not be as free to swagger or spend money on uniforms as a bachelor."[125] Rembrandt's 1636 standard-bearer is at least a swaggerer. Whether or not Floris Soop was a bachelor, in other respects he doesn't look—or, to be cautious, no longer looks—qualified to fill either of these roles.[126] Scholars occasionally try to upgrade his qualifications. Haverkamp-Begemann, for example, deduces from the position of Soop's right shoulder and leg that "he is represented in the attitude of stepping."[127] Fortunately he doesn't go so far as to claim Soop is marching. But even "stepping" might be something of a chore, judging from the apparent size of the standard, the length and angle of the pole, the high position and relatively relaxed grasp of the hand on the pole.

I think the pole is a real problem. It is possible to imagine that he is hoisting the banner up, but visual cues also suggest that the pole rests on his shoulder and one may legitimately wonder whether its lower end

reaches to the ground. It is at any rate an anomaly in the convention of ensign pictures, considerably longer than all the other poles I have seen ensigns carry in both individual and group portraits, including Rembrandt's 1636 standard-bearer. Most of the latter are short-handled affairs that allow their bearers blithely to whip them about or twine their arms limply around them or rest them effortlessly on the shoulder or the hip while striking graceful and manly poses and even engaging in conversation. Although the banners themselves, whether draped or furled or billowing out, seem voluminous and vast, the ensigns display the colors as if their burden was light as a feather and compact as a portable umbrella. And the colors are usually identifiable. Compared to these facile performances, Floris Soop looks like a man holding a heavy broomstick, or a gondolier's oar, or a small flagpole. The banner falls limply behind him in a lurid half-light, drained of its colors, more like a stage prop than a standard, no help to anyone wishing to identify the company Soop belongs to and represents. Despite the splendor of his uniform, the unwieldy proletarian implement transforms him into the ugly duckling in the family of ensigns. It interferes visually with the idea that he is "stepping." Stepping out seems unlikely in spite of the stiffly angled right arm, which, as Haverkamp-Begemann suggests, doesn't merely hang but is held smartly in place. Be-plumed and be-sashed, got up in full regalia, the sitter stands at attention and presents himself for inspection.

Pieter van Thiel mentions this portrait after listing a number of individual portraits of civic militia ensigns who, like Soop, are "all dressed up in the clothes they would actually have worn on duty," and in the next sentence he states that they are "decked out in the very height of fashion, as befitted men who were the ornaments of their company."[128] De Keyser's portrait of the resplendent Loef Vredericx is one of these. Just what kind of "duty" calls for the level of sartorial overkill depicted in the portrait of Vredericx? Chiefly the "duty" to advance one's political career by mingling, as Adams suggests, "with Amsterdam's leading citizens." We should recall at this point Schama's hypothesis about the countermilitary function of the civic militias, the portraits of which represent "civilians in martial fancy dress" whose "regimental insignias and emblems and colors are closer to those of the civic corporations and guilds than to battle dress (which had no uniform at all)." These militias "stood not as an extension of the military life into the civic, but as its opposite and alternative" in the sense that the "militiaman, the armed civilian, was . . . of the commu-

nity" and therefore "intrinsically benign," whereas "the professional soldier was . . . a marauding intruder in an unwelcome billet."[129]

Floris Soop is just such a nonsoldier: no macho thug, no pugnacious bravo, no up-and-coming young burgher entrained on the Dutch *cursus honorum*. By the time he posed for his portrait, group portraits "of large bands of civic guards" had become "superfluous," and although "the companies were not disbanded," sitters in the subsequent smaller versions replaced colorful military dress with burgher white-on-black.[130] Soop's apparel seems to represent a compromise. But how old is it? According to I. H. van Eeghen, his service as an ensign began sometime before 1648 and lasted until his death.[131] Is this sober householder posing as a member of the Old Guard or a defender of the civic faith and the True Freedom against the fear of the dynastic takeover that will destroy the republican aggregate? A trifle wan or melancholy, but dignified, venerable, a citizen, he takes up his post against the old encroachments of the night and tries to look as military as he can while the shadows eat into his face and reach forward to pull him back into the darkness. Only the gleam of the pole and the buttons, and the magical texture of the swordbelt with its hiero-glyphic encrustations projecting from the surface of the canvas, resist the pull until they too dissolve in the shadowy depths. And all this time the standard-bearer holds himself erect, alone, in a dark corner of a wall or archway or city gate, performing his night watch by himself.[132] And the night is in his eyes.

12

METHODOLOGICAL INTERLUDE I: TOWARD
GROUP PORTRAITURE

As a method of reading portraits, the approach through fictions of the pose picks out a set of "pose genres" or subgenres within the genre of portraiture and encourages the interpreter to explore relations within the set. Despite the claims I have been making for the method, I'm painfully aware that mine is an admittedly idiosyncratic incursion from outside professional art history. At best, the project imparts a mildly historicizing spin to interactions among different fictions of the pose. At worst, some of the moves I've made along the way, especially my effort in Part 2 to cross Elias with Lacan, trespass on a field of inquiry I myself don't have much patience with: the so-called history of subjectivity. But since I am committed to the idea that changing technologies of representation cause changes in practices of self-representation, and since in my lexicon "practices of self-representation" is a plausible definition of "subjectivity," I think I owe it to myself if to no one else to show how the former may be insulated from the latter—how the historical parameters of such practices of self-representation as individual and group portraiture may be explored without reference to larger pronouncements about the history and vicissitudes of the poor subject. I choose to get into this now because I can do so without disrupting Part 3's line of argument. For it just so happens—one is grateful for small favors—that a famous Dutch group portrait has been subjected to the level of historicizing critique from which I am anxious to dissociate myself. There is a history that has to be refused in order to coax from the group portrait the history it discloses when considered primarily as a genre defined by its problematical relation to fictions of the pose.

The Anatomy Lesson of Doctor Nicolaas Tulp (pl. 17) was one of the major exhibits Francis Barker entered as evidence into his 1984 prosecution of "the bourgeois discursive regime" for its insidiously violent co-optation of early modern capitalism's "newly interiorated subject."[1] Relying on the evidence assembled in William Heckscher's erudite and far-ranging study, Barker uses the painting to excoriate both the dissection of a recently executed thief and the way Rembrandt represents it.[2] His calorific jeremiad against the politics of anatomy and its theater of cruelty leans heavily on Foucault garnished by a few passages in Heckscher, and might indeed be seen as an extended meditation on Heckscher's injunction "to keep in mind the close connection between the advance of science and the punishment of crime."[3] In Barker's view, the picture mystifies the truth of the public dissection of criminals by presenting as an exercise in "calm science" and rational inquiry what was actually part of an atavistic ritual of capital punishment retained to preserve order in the emergent regime of bourgeois capitalism.

Barker makes much of the fact that the sitters don't look at the corpse and that most gazes seem aimed toward the text propped up at the corpse's feet. This signifies, variously, the abstraction and textualization made possible by "the newer scriptural industry" in which "the flesh is indeed being made word," "the emergent themes of . . . [the] deadly science" of medicine, "the rational spirit of a capitalism which is able to represent itself" in the "gentle faces" of the sitters "as enlightened, liberal, and confident," even as the painting "predicates their tranquillity" and "philosophical serenity" on their ability "not to perceive the violent act of domination" being perpetrated just beneath their eyes in the name of justice as well as science.[4] The painting is itself complicit in bringing on the lethal new order, which it "strives to depict" and "seeks to portray" (75, 77): "the regime of subjection . . . is beginning to be practiced in this painting" (73).[5]

For Barker, then, the surgeons' primary function is to embody the bad faith of emergent bourgeoisification. Only ancillary to this does Barker let himself be distracted by the mundanity of arranging commissions and the vanity of striking poses. In these matters, the sitters predictably fail to meet his high moral standards. One charge in his gravamen against their "grave bourgeois faces" is directed toward their crass materialism: "the fact that each had paid to be present in the depiction may only serve to make us unduly cynical about the inner principle of such a collectivity" (76). This observation, which is dismissively relegated to parentheses, is

one of only four references to the conditions and motives informing the practice of collective representation.[6] He returns to "the inner principle" later in a mention of the "substantial amount of money" the sitters had paid to get commemorated (82–83), and a little before that, en route to another comment on their text gazing, he passes huffily by the sitters who look out of the picture: "those eyes which do not reach outward narcissistically for the returning gaze of the spectator are indeed focused on the text" (81). The anticipation of the returning gaze, the willingness to pay for it, and the desire for the redemptive mastery of the flesh that scientific and artistic representation promise are all aspects of the collective narcissism writ large in "the plethora of . . . group portraits in which this bourgeoisie, in its first ascendancy, celebrated and had represented its own solidity—as epistemological as it is political and social" (76–77).

The infrequency and astringency of comments about sitters indicate that Barker has little interest in, little sympathy with, group portraiture as a social practice. It may be criticized and marginalized but it needn't be analyzed. Initially, therefore, he dissolves it into the transparency of a window through which he looks to the painting's *mise en scène*: "a ghastly tableau, . . . which was in fact produced in a theater in Amsterdam before an audience who had paid for their tickets" and "who stand where we stand as we observe the painting," so that "we who now look unwittingly become" those spectators.[7] Eventually he gets around to the two flaws in the window: no dissection begins with the arm rather than the thorax, and the dissected arm is incorrectly rendered.[8] These conspicuous anomalies have encouraged interpreters to find allusions to Vesalius, his emphasis on the hand, and his portrait with the dissected arm in the *Fabrica*; allusions also to Aristotelian observations about the varied instrumentality of the hand.

In a strong and compact reading of the anomalies, Barker treats them as two aspects of a single visual comment on crime and punishment: "If the hand of a thief, as the offending member, would receive the special attention of the executioner, no less does it here receive the first ministrations of the anatomist against . . . the protocols, logic and custom of every other didactic anatomy of the period. The scene of dissection is thus the exercise of a jurisdiction over the body of Aris Kindt, an act of penal and sovereign domination" (74). This is a provocative elaboration of details and suggestions in Heckscher. But the question may still be asked: Who is Aris Kindt, and how did he end up on Dr. Tulp's table? The identification of

the corpse is linked to the date of the event the portrait is supposed to cel-
ebrate. The praelector of the surgeon's guild was an important figure in
Amsterdam; his inaugural and subsequent annual lectures on anatomy
were public events with the status of civic rituals. Commentators ask two
basic questions about the relation of the painting to the event. First, was
Rembrandt's portrait commissioned to celebrate Dr. Tulp's inaugural anat-
omy lecture delivered in January 1631 or his next annual lecture delivered
on January 31, 1632? Second, does the portrait only celebrate the event or
does it represent it as well?—"Was it this lesson Rembrandt has repre-
sented in his work?"[9]

Records show that Tulp's second lecture was held on the same day
Kindt was hanged for stealing a coat, hence those who opt for that date
presume it was his body.[10] It was hard for an iconographer like Heckscher
to avert his gaze from the riches lurking in a corpse identified as the body
of Aris Kindt: since the records also show that Kindt was a citizen of Lei-
den and that the University of Leiden had long resisted Amsterdam's suc-
cessful effort (in January 1632) to open a rival university, Heckscher not
implausibly read Tulp's dissection of Kindt as a symbolic act of revenge,
an allegory of interurban rivalry, "the punishment *in effigie* of a foe of
long standing."[11] Although he didn't take the next step and claim that this
message was inscribed in Rembrandt's painting, the step was taken by
Jonathan Sawday in a morally souped-up version of the hypothesis. Fol-
lowing Barker in his unequivocal assumption that Aris Kindt is the crim-
inal "Rembrandt *shows* being dissected," Sawday savors the fine irony of
an act of symbolic revenge "conducted at the expense of a citizen of Lei-
den" and "captured by an artist born in the rival city [i.e. Leiden]."[12]

The viability of this assumption was questioned some years ago by
A. B. de Vries. Even though he accepted the 1632 dissection of a corpse
that was probably Kindt's "as the basis for this painting," he deemed it
possible "that, having certainly been present at several other anatomy
lessons, Rembrandt may have portrayed some other dead body here," the
body of someone who was neither a thief nor from Leiden.[13] De Vries
and the RRP are both careful to distinguish what the painting represents
from the occasion that may have led to its commission.[14] Both reprove
Heckscher for having thought "that an actual situation was being de-
picted."[15] Both assume that Rembrandt's primary purpose, "in accordance
with his commission," was "to paint a group portrait."[16] Finally, both ac-
knowledge that in its novel interpretation of a group portrait "as an al-

most self-contained dramatic situation," the painting "includes several characteristics of historical painting."[17]

All this raises questions about the status and meaning of what Barker calls "the scene of dissection . . . portrayed in Rembrandt's painting."[18] His address to the painting is superficially no different from that of several other accounts that treat it as a symbolic or idealized reconstruction of an actual scene and classify it as a historical or dramatic fiction. But from the standpoint of commentators who insist it is primarily a group portrait, it is clear that he misconstrues its genre. The major symptom of misconstrual, as we saw, is his cavalier disparagement of the motives, conventions, practices, and purposes that inform the production of the group portrait qua group portrait. As a result, he has nothing to say about the specific aspects and problems of the genre, nor of the subgenres within it (anatomy lessons, for example), nor of Rembrandt's portrait as in part a reaction to or departure from generic precursors.

What must by now be obvious is that in the foregoing critique of Barker I have increasingly drawn on the views of de Vries and the RRP as if they provided an adequate corrective. The strength of their characterization of the painting is its discriminating and balanced claim that although Rembrandt's is primarily a group portrait rather than the visual record of an event, it feints transgressively toward the representation of an action, a quasi-historical scene.[19] Such a mixing of genres has troubled at least one critic, who attributes the painting's "lack of unity" to "the artistic conflict between the composition proper to a history painting and that of a group portrait."[20] But what counts as a "proper" composition in each case? The objection brings into focus the problem of defining, extrapolating, or establishing the generic criteria of group portraiture. How do the RRP and de Vries handle this problem?

Of the earliest Amsterdam group portrait of surgeons, the RRP notes that "the composition is obviously based on the arrangement . . . of the banquet of the civil militia"—with the meal being replaced by the corpse (!). The apparent scene of dissection in this and two later versions preceding Rembrandt's was used "solely as a thematic formula for a group portrait." In a prior Delft example, however, although "the arrangement of figures is that usually seen in a group portrait," the scene was set in an anatomy theater, therefore it "obviously refers to an actual event." Perhaps this is the exception that proves the rule, or at least the Amsterdam rule, because two sentences later, after objecting to Heckscher's assimilating the

realism of the *Tulp* to the Delft example, the RRP insists that "the group portrait does not, or does not primarily, relate to an actual event," and that Rembrandt's painting differs from its precursors "in the extent to which he interpreted this traditional subject as an almost self-contained dramatic situation."[21]

In other words, although the group portrait is not primarily the record or representation of an actual event, it may contain elements of historical fiction; it may represent things that didn't happen as if they happened. But what kind of event *does* the group portrait as a genre—and a genre distinct from history painting—purport to represent? Does the usual "arrangement of figures" in any of its subgenres constitute the representation or imitation of an event? Is the group portrait the record of an act of group portrayal? Is it therefore "real," or "realistic," in a way that differs from the fictive "realism" of historical or dramatic narratives?

De Vries is no clearer than the RRP about this: "We . . . see this work as a combination of realism and invention"; "In so far as one can speak of realism, it has mainly to do with the faces of the lecturer and the surgeons"; presumably, then, Rembrandt's "invention" is the source of the "several characteristics of historical painting" de Vries finds in the *Tulp*.[22] But what is the status of the "realism" that "has mainly to do with" the sitters' faces? Does de Vries mean that they were copied from life? Or that they look like they were copied from life?[23] More importantly, does "realism" imply that the faces were copied from life collectively? Is the group portrait the record of an act of group portrayal which the painter has augmented or varied by the inclusion of thematic formulas and symbolic elements? Or were the faces copied from life one by one at individual sittings? Relatively speaking, then, is the image of an act of group portrayal compositionally more "realistic" and less fictional than the invented narrative of a history painting, or are both equally fictional?

I'm pretty sure that de Vries and the RRP have an opinion about this, that it's one and the same opinion, and that it is an opinion I share. But they don't express it, either because they think it is obvious and can be taken for granted, or because they don't think it important enough to mention. Although they are much concerned with what the archive reveals about the identities and status of the actual sitters, their positions in the guild, and their share in the commission, they ignore what might be called the aesthetic problem raised by the representational relation of the group portrait to the prior conditions of portrayal. More significantly,

what they ignore is not only an aesthetic but also a political problem. Both aspects of the problem, and their inseparability, were perfectly expressed by Heckscher: "Tulp had to be made the center of attention while each individual of a group of persons nearly as important (at least from their point of view) had to be given sufficient prominence to satisfy their claim to permanent *gloria* and *memoria* without thereby detracting from either the corporate character of the gathering or the logical focus of the scene."[24] Unfortunately, this unobjectionable statement demands that some attention be directed toward the sitters' concern with and relation to the observer of the painting, and here, in the opinion of de Vries and the RRP, Heckscher went out on a limb:

> Obviously, . . . Dr. Tulp addresses, not the inner circle that we see in the painting, but "us," the beholders, just beyond it. (22)

> Aloïs Riegl—and later Heckscher—have suggested that "the public" ought to be seen as involved, when contemplating this painting. . . . We do not share this view.[25]

> Heckscher . . . wrongly thought . . . that an actual situation was being depicted, and that . . . the viewer . . . [would] need to feel himself as forming part of a larger audience (not shown) being addressed by Tulp.[26]

Heckscher's view is indeed a little weird. Since Dr. Tulp looks possibly at or over the heads of the two sitters at the left of the painting, the only way he could be construed as engaging an external "audience" is if one imagined that audience seated around the scene of dissection on the concentric benches of an anatomy theater—which is implied by the reference to "the inner circle," and which in fact Heckscher explicitly suggested earlier in his study.[27] This was certainly the way Barker must have taken the passage. Heckscher thus opens himself to the criticism that he imagines not a group portrait but an actual scene of dissection—precisely the fantasy that seduced Barker: "a tableau . . . which was in fact produced in a theater in Amsterdam before an audience who had paid for their tickets."[28]

In my view, however, de Vries and the RRP have seized on a straw man and used it to avoid dealing with the real issue, the one implied in Heckscher's comment about the dilemma that faces sitters who want to get their share of individual attention without "detracting from . . . the corporate character of the gathering." This becomes the central problem of group portraiture as soon as one acknowledges the ideality and fictive-

ness of the representational claim that distinguishes it as a genre: the claim that group portraits represent prior acts of group portrayal. Because the problem is simultaneously aesthetic and political, as Heckscher suggests, it implicates another claim: the claim the sitters make on the observer. Thus the study of the construction and manipulation of the observer position is essential to the interpretation of group portraiture as a genre. The tendency of de Vries and the RRP to dismiss the importance and minimize the complexity of sitter/observer relations makes their attitude toward the sitters—and toward the genre—no less cavalier than Barker's. Whether or not this disregard is motivated by anything more than a commitment to positivist scholarship, it seems in one respect willfully blinkered: except for a few generally snide or hostile references in de Vries, the signal contribution of Aloïs Riegl has been ignored.[29] My effort to shift interpretive attention to fictions of the pose in group portraiture will therefore take its point of departure from Riegl.

agrégat: Assemblage hétérogène de substances ou éléments
qui adhèrent solidement entre eux. = agglomérat.

—*Le Robert dictionnaire d'aujourd'hui*

Members of Holland's wealthy and intelligent middle class, forever ready
to band together corporatively, liked to see themselves represented as they
gathered under the pretense of some celebration; whether they were
banqueting, deliberating, or parading, they were always dressed in
their Sunday best and always at leisure.

—WILLIAM S. HECKSCHER[1]

Group portraits are not random collections of persons but deliberate
constructions of the significant relations among them. . . . In Dutch group
pictures, the integrated ensemble may *prevail* over the independent individual,
but in them the strong emphasis on the realistic depiction of specific individuals
permitted each person's portrait *to compete* for close, if momentary, visual and
psychological attention. The Dutch artists seemed *to compel* the viewer's
eye to move from face to face, never losing sight of the others in
the contemplation of the one.

—RICHARD BRILLIANT[2]

13

REMBRANDT'S EMBARRASSMENT: AN ANATOMY OF GROUP PORTRAITURE

A group portrait represents a prior event in which many individuals—sometimes very many—posed together at the same time in the same place while the artist reproduced the scene. But that, as Groucho Marx would say, is a likely story. It is clear that the end product must largely have been the result of sessions involving the painter and individual sitters or their likenesses. Sitters posed separately for a picture that would, they agreed, pretend they posed together.[3] In some of those isolated acts of portrayal, they may have pretended to pose as if interacting with others. To give a short definition, a group portrait is a picture in which sitters pretending to pose together actually posed separately.

How are the fictions of the pose set up in group portraits, and how does the method of reading portraits developed in Part 2 affect the kinds of interpretive protocols that have been in play since Aloïs Riegl's classic analysis of Dutch group portraits? The conditions specified by Brilliant in the epigraph to this chapter reflect that analysis, especially in the rhetorical hints of conflict encoded in the italicized terms. For Riegl, a group portrait was not "a mechanical collection of individual portraits" but "the representation of the *voluntary* gathering together [*Korporation*] of *autonomous independent* individuals."[4] The redundant emphasis of the italicized terms—*freiwilligen, selbständigen, unabhängigen*—indicates the problem: How can one allow for the effect of individual portraiture, which is what those who pay to get painted expect, yet keep the aggregate from falling apart into a mechanical collection of sitters who have nothing to do with each other—or worse, whose likenesses, each taken by the painter at a

separate sitting, are juxtaposed in such a fashion that they all jostle against each other as they compete for the observer's attention? They aren't bound together in the Italian manner by the closed internal unity of a historical action that subordinates the depicted actors and diverts the observer's attention away from the individual.[5] Neither action (*Handlung*) nor feeling (*Gefühl*) integrates them, but a form of attention or attentiveness (*Aufmerksamkeit*).[6] Individuals whose autonomy owes partly to the fact that each has paid to be an independent subject of portraiture may be expected to send forth different and competing vectors of attention, and their separateness may defy coordination from within the picture space. The problem as Riegl formulates it is precisely the problem—the problematizing—of the relation discussed in Chapter 8 above, that between the normal conditions of posing and the normative fictions of the pose. Michael Podro's paraphrase puts Riegl's formulation in terms closer to those I am using: "the tension between, on the one hand, combining the members of the group in some dramatic way, which appears to the spectator as a self-contained fictive world, and on the other, retaining a sense of the individual portraits which are not absorbed into a story."[7]

To what do the figures in a group portrait attend? What brought or brings them together? What motivating event or occasion provides a common focus for several separate centers of attentiveness? Lacking the internally unifying or subordinating effect of history painting, the group portrait must seek this effect elsewhere. Therefore it cultivates "outer unity with the beholding subject" ("äusseren Einheit mit dem beschauenden Subjekt").[8] Riegl's solution interestingly echoes but contrasts with Alberti's proposal that the meaning of a coordinated narrative (*historia*) be focalized by some figure in the painting who engages observers as a presenter, indicator, or interlocutor:[9] "I believe that all the bodies should move in relation to one another with a certain harmony in accordance with the action. Then, I like there to be someone in the 'historia' who tells the spectators what is going on, and either beckons them with his hand to look, or with ferocious and forbidding glance challenges them not to come near, as if he wished their business to be secret, or points to some danger or some remarkable thing in the picture, or by his gestures invites you to laugh or weep with them."[10]

Where the Albertian interlocutor extends internal coherence to the observer, Riegl, as Margaret Iversen puts it, "shows how it is possible to compensate for the diminished internal coherence needed to preserve the

quality of portraitlikeness by augmenting the external coherence, making a painting cohere by implicitly including the spectator."[11] But "including" understates a relation Riegl characterizes more aggressively as the "subordination" of the observer. Alberti's single figure is replaced in the group portrait by a pride of competing interlocutors whose aggressiveness Leo Steinberg captures in a passage that—if read with militia portraits in mind—glances uproariously at a spectacle of military and political incompetence: "The negation of psychic rapport between actors, their mutual autonomy and spirited dissociation even from their own doings—and their incapacity for joint participation in a unified space—all these 'negative' factors tightened the positive hold of each figure on the responsive viewer; the unity of the picture was, as Riegl put it, not objective-internal, but externalized in the beholder's subjective experience."[12]

If the observer supplies the coherence internally lacking in the group portrait, we may ask again what it is that brought or brings the aggregate together. Did a ceremonial dinner party bring Hals's guardsmen together? Did an anatomy demonstration bring together Dr. Tulp and the seven auditors/spectators whose attention he subordinates? Did meetings to go over accounts bring together Hals's regents and regentesses or Rembrandt's syndics? The obvious answer is no: what brought the sitters together was their desire to get painted in a group portrait that would capture and subordinate the attentive observer they rely on to vouch for a coherence everyone knows is purely fictive. In Richard Wollheim's view, Riegl is primarily concerned with the practical problems of construction that faced painters of group portraits and with their solutions to the difficulties presented by the genre's non-narrative and thus potentially uncoordinated subject matter. And it is true that Riegl's frequent use of the terms *subordinieren* and *Subordination* is directed chiefly toward the effects of these problems on formal and visual relationships. As Podro notes, "subordination . . . has not only the straightforward social implication, but an aesthetic one."[13] Yet this emphasis is reversible, since "subordination" in any language brings the social meanings more quickly to mind, and some of these are obviously present in Wollheim's account of Riegl's usage: "What is characteristic of subordination is that the various figures are united by looking up to one of their number, on whom they are in some way dependent, and this figure in turn looks outward to the spectator for recognition of his authority. The recognition, when he receives it, lends legitimacy to the respect that the other figures show him."[14]

Wollheim's language, like Riegl's, may confine its reference to the narrowly visual domain of scopic politics, but its rhetoric glances waywardly, with the force of displacement, toward the encompassing politics of the groups and artists that commission and produce the portraits. More than formal and visual considerations are involved in the statement that in group portraiture the fiction of the unified pose is paper-thin. All the "'negative' factors" mentioned by Steinberg point toward the dispersive and disunifying effects of the actual conditions of portrayal—toward the underlying threat of *désagrégation*. And since the whole point of group portraiture is to affirm "die innere Einheit" of institutional coherence and group membership, the aesthetic problem would seem to have the same form as the sociopolitical problem.[15] Even though the *occasion* of group portraiture as an *institutional* practice is intended to promote and commemorate the kind of solidarity that defends against the threat, the *form* of group portraiture as a *representational* practice is infiltrated by and reactivates the threat. Thus the institutional desire for exemplary collaborative performance is activated in a practice that stimulates the conflicting desire for exemplary individual self-representation, and it is easy to see how this contestatory structure encourages the anxiety of orthopsychic desire.

The form of attention specific to the genre is attentiveness to posing. Each sitter strives in his or her own way to cope with the genre's conflicting demands: on the one hand, to make the observer focus on that particular sitter as an "autonomous independent individual," and on the other hand, to subordinate all sitters to the pictorial unity of the *Korporation*. Once again, some of the word choices in Brilliant's formulation of the norms of group portraiture revealingly underline the pressure these demands impose, and stain even his description of the corporate ideal: "Such works are peculiarly cooperative and collusive in their nature, because each person in the group contributes to, and draws from, the presentational dynamic of the whole."[16] In what sense "collusive," a word that has long since lost its etymological innocence ("playing together") and become a synonym of "conspiratorial"? People collude when they act in secret with the intent to defraud others. In the production of group portraiture, who or what colludes with whom or what against whom or what?

"Some conformity to the norms of the group," Brilliant continues, "affects all members, forcing each person to evince some significant degree of participation as a way of manifesting the alleged coherence of the group, as represented in the work of art" (93). Perhaps, given the poten-

tial for actual disunity inherent in the practice of individual sittings, "the genre"—that is, the painter and the co-patrons negotiating in terms of existing precedents and conventions—has to act behind the back of the disruptive practice it presupposes as its sine qua non. Perhaps the collusion consists in constructing an observer who is allowed to notice and acknowledge the disunity of separate competing poses, the factuality of the portrait's actual piecemeal construction, and who is then urged or coopted or compelled to help "the integrated ensemble . . . prevail over the independent individual" (92–93) and to reaffirm the coherence alleged—if not proved—by the fictive fact and form of group representation.

The primary narrative of group portraiture, then, its dramatic agon, is the performance and representation of competitive posing. I think we should take Heckscher's observation seriously, perhaps more seriously than he takes it: "Members of Holland's wealthy and intelligent middle class, forever ready to band together corporatively, liked to see themselves represented as they gathered under the pretense of some celebration." This is to say—altering Heckscher's formulation—that they liked to see themselves represented (1) *as if* they had gathered under the pretense of some celebration, and therefore (2) as if they had gathered to pose as if banqueting, or deliberating, or parading. Let the awkwardness of the double counterfactual in the second clause register not only the complexity of the fiction of the group pose but also its precariousness: each "as if" is a potential pitfall of embarrassment.

Heckscher glances at the condition that has to be overcome in order to reinforce counterfactual unity when he likens the fictiveness of the group portrait to a *tableau vivant* in which "a number of reactions not necessarily occurring at one and the same moment are represented in simultaneity."[17] He is, however, describing Rembrandt's *Anatomy Lesson of Dr. Tulp*, perhaps the least precarious instance of the anatomy subgenre because, unlike the four extant seventeenth-century Dutch anatomies that precede it, the individual portraits were coordinated by a counterfactual narrative of dissection. A comparative survey of the members of this subgenre will illustrate the problems I have so far only described in general terms.

In the *Anatomy*'s predecessors the counterfactual effect of a coordinated group activity is much weaker. Of the twenty-nine sitters (including the praelector) who crowd together around the partly concealed corpse in the earliest of these, *The Anatomy of Dr. Sebastian Egbertsz.*, by Aert Pietersz. (1603), perhaps three do not appear to be trying directly to

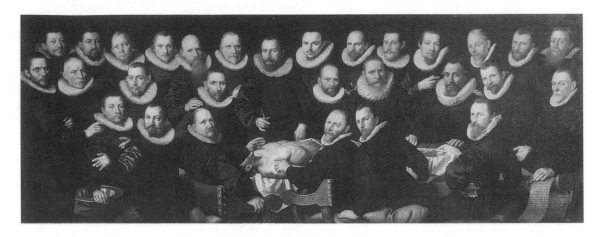

FIGURE 28

Aert Pietersz, *Anatomy Lesson of Dr. Sebastiaen Egbertsz. de Vrij*, 1603. Oil on canvas. Amsterdams Historisch Museum.

"subordinate" the virtual observer by means of eye contact (fig. 28). This appearance is deceptive in the case of the most important of these, the praelector, because by turning his gaze slightly toward the observer's left he gives himself to be seen in the pose that delivers the magisterial fiction of objectivity. In a second figure, seated at the lower right, the same effect is pretentiously exaggerated by a flaring Renaissance elbow.[18] The gesture may be read as an indirect attempt to acknowledge and subordinate the observer the sitter's eyes avoid, but its dandyism makes it more aggressive and serves as a reminder that what unites the sitters in this picture are the varied (but not very varied) means by which each sitter competes with the others in drawing attention to himself. Norbert Schneider responds to this when he observes that "[t]he arrangement reveals their desire to be portrayed as separately from one another as possible."[19] The obligatory manual gestures of presentation initially seem part of an effort to counteract the repetitiveness with which that desire is expressed. What could be more sociable and gracious than a hand resting on a neighbor's shoulder, another pointing toward a colleague (or a corpse), another inviting the observer to take in the scene? But in the context of the scopic competition that repetitively isolates each sitter, these presentational gestures assume a conflicting function: they archly signify the sociability and graciousness of the presenter's self-presentation.

To overcome the threat of *désagrégation*, it isn't enough to have sitters ignore the observer, especially if this takes the form of the fiction of objectivity. The shift of attention has to be motivated in a manner that begins to reintroduce elements of narrative coordination. Ann Adams sug-

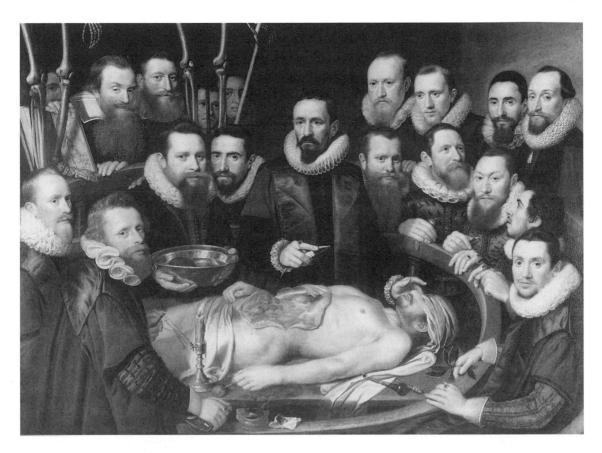

FIGURE 29

M. J. van Mierevelt,
*The Anatomy Lesson of
Dr. Willem van der Meer,*
1617. Oil on Canvas.
Collectie Gemeente
Musea Delft. Stedelijk
Museum Het
Prinsenhof, Delft.

gests that one obvious way to do this is to have sitters pretend to interact
not merely with their hands but with their eyes, as in the Delft *Anatomy
of Dr. W. van der Meer,* by Michiel and Pieter van Mierevelt (1617), in
which two figures look at others in the painting rather than at the viewer
(fig. 29).[20] But the general effect remains, as Heckscher insists, that "the
portraits are arranged for the benefit of the beholder, without regard to
the anatomy itself," and Adams goes on to show that "our attention is
drawn in all directions" because so many of the Mierevelt sitters make in-
terlocutory claims on it.[21]

Two things are worth noting, however. First, the painting gestures half-
heartedly toward a coordinating fiction: while one figure holds a bowl, the
praelector demonstratively holds his instrument over the corpse as if paus-
ing between cuts. Second, the Mierevelts try to diminish the dispersive ef-
fect by organizing most of the heads in companionable pairs and contra-
puntal groupings, such as the interlace of turns and gazes that livens the

forward and downward arc of figures on the right. And an interesting variant of the subordinating gaze is assigned to both members of the second pair of sitters from the right in the upper row: they look outward toward the left—not at the observer but in the general direction of observer space.[22] I use the expression "observer space" advisedly because when several figures look out of the picture, some often seem to make more direct eye contact than others. The observer position is not confined to a point, as in perspective construction; it fills an area. When a sitter's gaze hits the observer point, it signifies the interlocutory intention to subordinate the observer. To switch from Riegl's terms to mine, it signifies posing as if posing. But sitters who look into observer space while missing the observer point can't be said to subordinate the observer in the same way. They may well pose as if posing—as if, indeed, attentive more to the act of holding the pose than to the particular observer(s) for whom the pose is being sustained. But they may also seem to pose as if not posing, as if distracted, as if themselves subordinated by something in observer space that has caught their attention—an effect by which the interpretation of Rembrandt's *Syndics* has been notoriously bedeviled.[23]

To return to the Mierevelts' two out-lookers, they add their form of inattention to the others that undermine the semblance of a group activity focused on the doctor at work. That semblance is subverted by the insubordination of all those whose attention the demonstrator fails to hold. Accordingly, the scenario changes from a narrative to a symbolic fiction: from "the doctor poses as if in the middle of a demonstration" to "the doctor poses as if indicating his status of demonstrator." Although this status places him above the others, the act of indicating status brings him down to their level, since that is the act all the sitters equally engage in. All are pretending to pose together, primarily because each wants to benefit from the status conferred by membership (and, in some cases, position) in the group. The dominance of hierarchy, subordination, and community is restored only by appealing to the standard symbolic interpretation: "a group of men surround a corpse (or . . . a skeleton), which is the signifier of their profession and skill, and their identity as a group."[24] In this scenario, the doctor and the corpse are functionally interchangeable.

A step toward more effective internal subordination appears in a painting by either de Keyser or Nicolaes Eliasz. Pickenoy, *The Officers of the Surgeons' Guild* (1619), in which the demonstrator is surrounded by only five figures in addition to the skeleton he points to (fig. 30).[25] This time

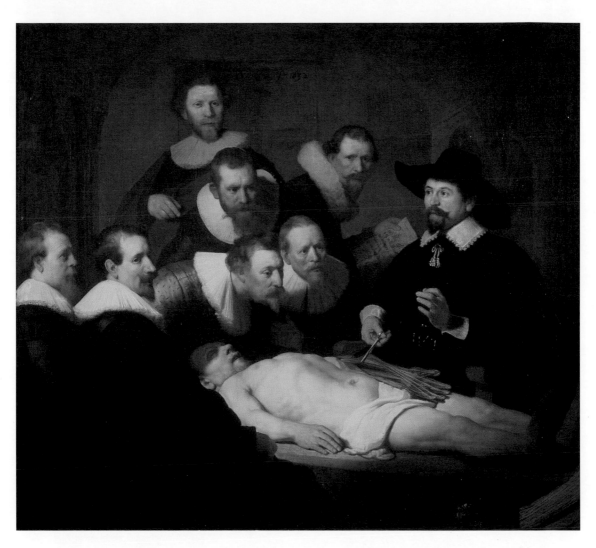

Rembrandt, *Anatomy Lesson of Dr. Tulp*, 1632.
Oil on canvas. Mauritshuis, The Hague.

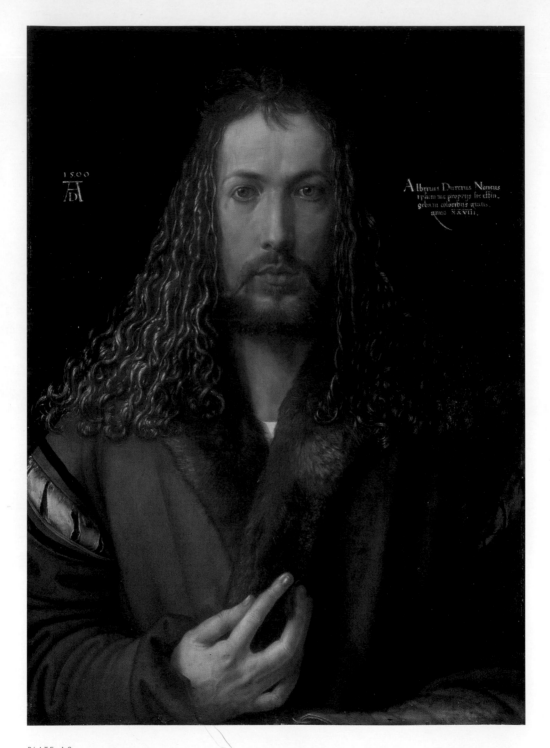

Albrecht Dürer, *Self-Portrait*, 1500. Oil on
wood. Alte Pinakothek München.

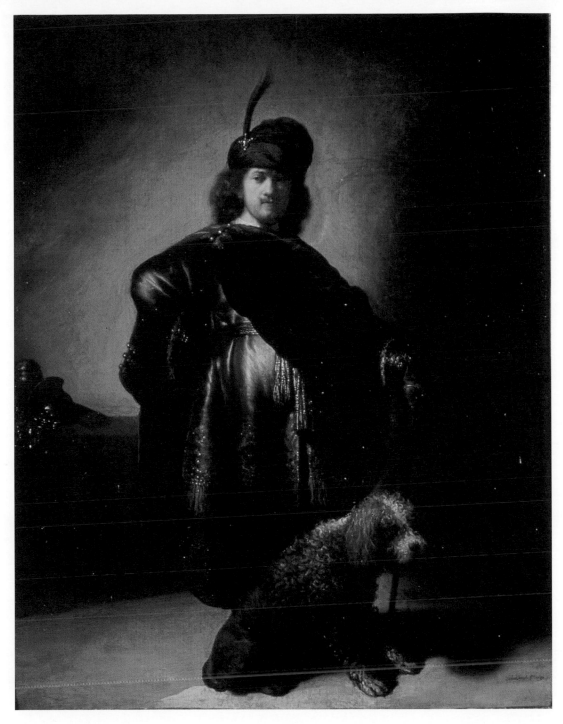

Rembrandt, *Self-Portrait in Oriental Costume*, 1631. Oil on wood. Musée du Petit Palais, Paris.

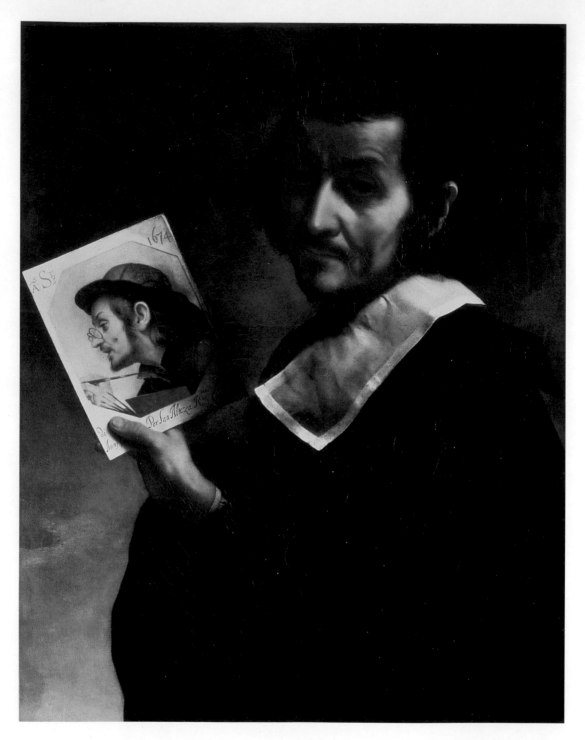

PLATE 20

Carlo Dolci, *Self-Portrait*, 1674. Oil on
canvas. Galleria degli Uffizi, Florence.

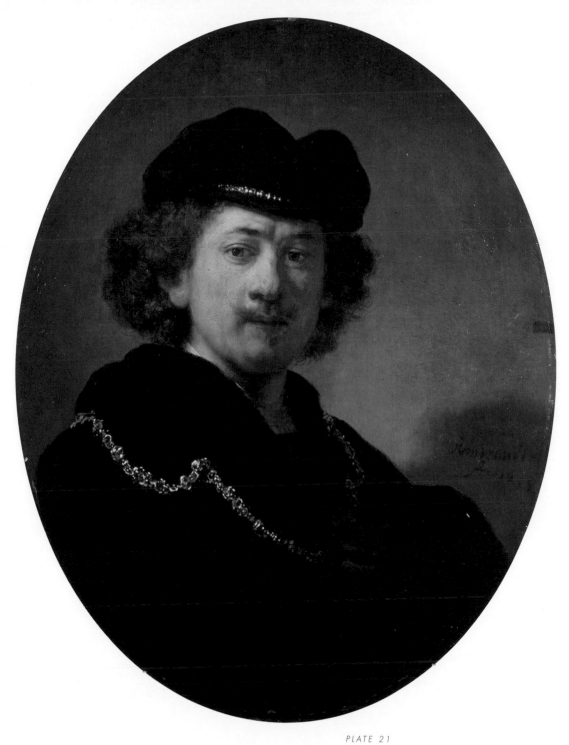

Rembrandt, *Self-Portrait with a Hat and a Gold Chain*, 1633. Oil on wood. Musée du Louvre, Paris.

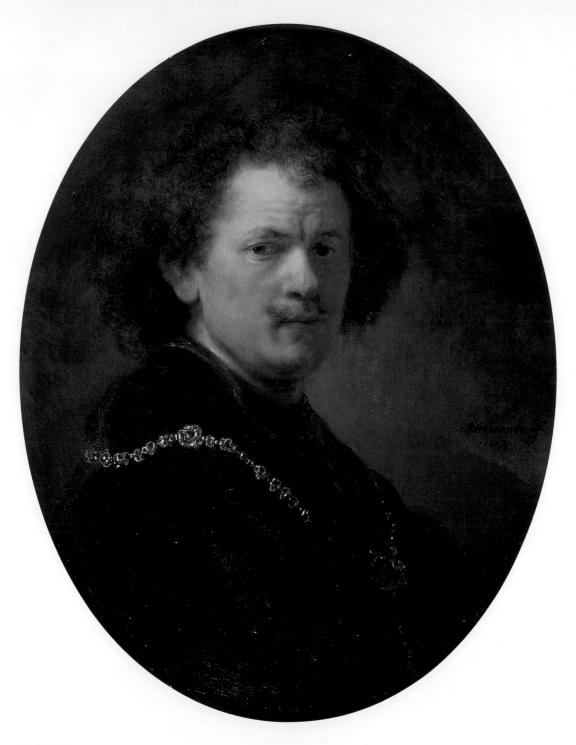

Rembrandt, *Self-Portrait, Bare-Headed*, 1633.
Oil on wood. Musée du Louvre, Paris.

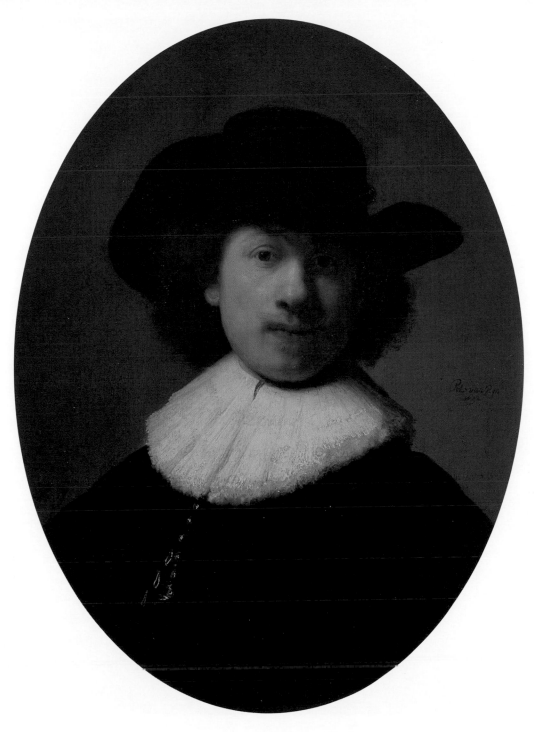

Rembrandt, *Self-Portrait*, 1632. Oil on wood. Glasgow Museums: The Burrell Collection.

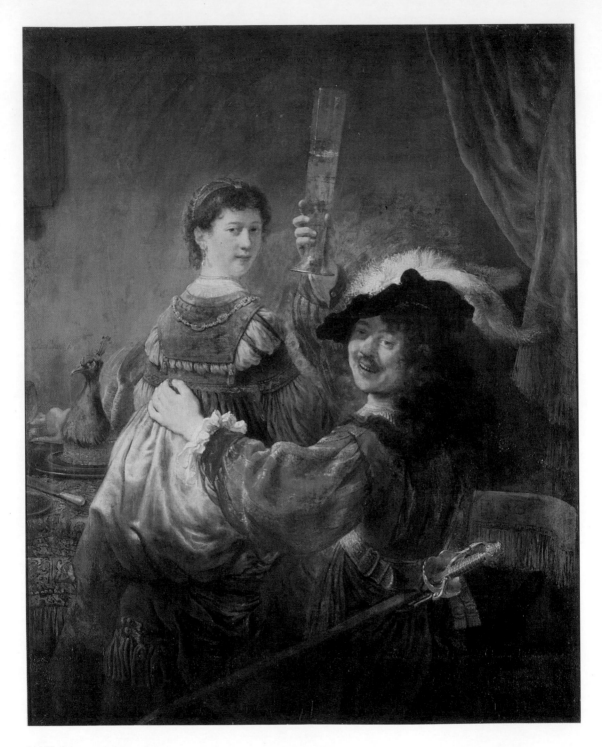

Rembrandt, *Self-Portrait with Saskia*,
1635–36. Oil on canvas. Gemäldegalerie
Alte Meister, Dresden.

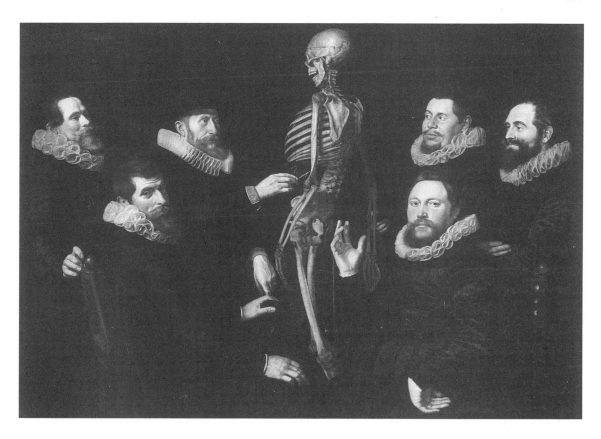

three pose as if attending to the demonstration, two look outward, and one of the latter, acting as indicator, gestures back toward the doctor at work.[26] In her careful effort to identify the generic limits of narrativity in this painting, Adams argues that, while it "appears to depict a moment in time," it doesn't literally do so: it "does not describe or even commemorate a particular event; it is not narrative. Rather it commemorates a fundamental guild activity," the lecture in osteology.[27] Yet she also claims that the two interlocutory figures in the foreground "gaze in our direction, as if having been momentarily distracted, but still aware of the lesson." They "gaze beyond the viewer" into the observer area "as if addressing a room full of people," who are thereby invited "to join the audience listening to the lecture. Thus . . . both the sitters and we are participants in a central activity," and Riegl's conditions for internal and external coherence have been met (1.55–56). Actually the figure on the left poses as if glancing directly at the observer point and subordinating its occupant. Only the figure on the right looks off into observer space. Even though he turns to-

FIGURE 30

Thomas de Keyser (?), *The Officers of the Surgeons' Guild*, 1619. Oil on Canvas. Amsterdams Historisch Museum.

ward the observer in the attitude of the Albertian indicator, he subordinates no one, for the touch of exotropy that diffuses his gaze and suggests vacancy gives him the look of a sitter preoccupied in sustaining his pose.[28]

Adams's conclusion that the painting is not narrative because it doesn't "literally" depict a particular moment in time is based on her distinction between commemorating a singular event (*a* lecture in osteology) and commemorating a particular kind of event that is periodically repeated (*the* lecture in osteology). The claim implied by her comment on the two interlocutory figures is that a particular kind of event is represented as if it were a particular event. In other words, though the portrait doesn't really narrate a particular lecture, it pretends to do so, and the medium of this fiction is the interlocutory invitation to the observers to join the on-stage audience "listening to the lecture."

But surely that can't be what the presentational gesture of the indicator means. In group portraits such gestures more often pick out visual than verbal or rhetorical enactments.[29] To vary Alberti's words, de Keyser's indicator "shows the spectators what is going on, and . . . beckons them with his hand to look"—to look at the historia the painting depicts, not to pretend to participate in it. And I submit that as a genre the group portrait does have its own form of historia, that it does "commemorate a particular event," that what de Keyser's interlocutor indicates in Albertian fashion is an event and qualifies as a narrative. Although I agree with Adams that it is not the narrative portrayal of a particular medical event, I don't think the indicator invites us to pretend to be auditors at a lecture. Rather, what he indicates is the portrayal of a particular artistic-histrionic-institutional event: he invites us to pretend to observe the act of group self-representation recorded in the indexical icon of de Keyser's painting. Here, then, is a description of the historia, the narrative, of this group portrait: several individuals and a skeleton who may well have sat to the painter on separate occasions, pretend to pose together as if participating in an osteology lecture.

Adams has reservations about the painting that spring from her construal of its subject: although the surgeons concentrate "with attentive gazes, brows slightly furrowed, . . . upon the lesson before them," she discerns "a light tension [that] flickers across their lips," and this, she claims, contradicts the desired effect of attentiveness, for the "sitters appear to be men who are listening to their colleague but thinking something entirely different."[30] Earlier she had characterized the two interlocutors as "mo-

mentarily distracted" but "still aware of the lesson" and inviting us to lis-
ten with them. Now, however, she is more critical and implies that Dr.
Egbertsz.'s onstage auditors are not very good role models for the rest of
us. I don't disagree with this impression but would prefer to account for it
in the terms established by my different construal of the painting's subject.
If their attention seems to wander, it may be because their thoughts turn
to what they are and pretend to be doing: posing, giving themselves to be
seen—even, in the case of the three sitters behind the interlocutors, trying
to deliver variations on the fiction of objectivity that make them appear
genially attentive to the demonstrator and his genial skeleton. No one de-
votes more attention to this business than the indicator, whose raised hand
points in a suitably—but carefully—relaxed manner toward the center of
demonstration. The nonchalance of that gesture complements the re-
strained protrusiveness of his elbow display.[31] Yet despite his nonchalance
and restraint, display—self-display—is the focus of his attention. Unlike
the interlocutor to his right, whose *coup d'oeil* targets an area of observer
space, the indicator doesn't so much accost us as give himself to be seen.
Discreetly, but imperiously, he basks in our regard and lets us enjoy his
stylish self-presentation before handing us on to the scene of bonecraft and
symbol of vanity he is sooner or later obliged to give way to.

 This discussion of three medical group portraits preceding *The Anat-
omy Lesson of Dr. Tulp* makes it easy to pinpoint Rembrandt's major inno-
vation: more absorption and less theatricality, which correlates with more
internal subordination and less external subordination. As Sawday ob-
serves, Rembrandt's portrait differs from the "static images" of his precur-
sors in that "something was happening, movement was taking place."[32] It
feints decisively enough toward the effect of history to persuade many
more commentators than Barker that in spite of its anomalies it presents
itself as the realistic imitation of an action. The melodramatic contrap-
posto of figures and glances gives the action its shape. Only Dr. Tulp's face
is shown from his left (our right), and in the magisterial three-quarters
position that conveys the values of the fiction of objectivity—a reminder
that while pretending to lecture he is holding a pose. In varying degrees,
all the other faces are shown from their right (our left) and torqued with
increasing force toward the profile view as we scan horizontally from Tulp
to the left edge of the canvas. Appropriately, the interlocutory figure at the
top most closely approaches the full frontal view.

 The double subordination Riegl finds in the painting is orchestrated

primarily by two manual commands. Dr. Tulp's vivid left hand coordinates the directional tempo of eyes and faces, while the indicator's more restrained gesture points the observer toward that performance. Unlike its predecessors, the majority of the portrait's participants—five of Dr. Tulp's seven associates—direct their attention to some aspect of the lesson. This is the generic novelty Barker's emphasis obscures: it isn't merely that the sitters avert their eyes from the corpse, but that most of them studiously avoid looking toward the observer. Not only are the figures who "narcissistically" engage the observer reduced to two, but even as Rembrandt's praelector is more clearly set off from the others than de Keyser's and more animatedly invested in the details of his demonstration, so the interlocutors are removed from the front to the rear of the group and from the bottom to the top of the composition. Indeed, by Barker's standards, they seem significantly less narcissistic than the out-lookers depicted by de Keyser, the Mierevelts, and Pietersz.

There is a difference of opinion among commentators as to whether one or two sitters make eye contact with the observer. The figure at the apex of the pyramid definitely does. The gaze of the figure to his left holding the page or book allows for more uncertainty. According to the RRP, only the former makes contact, but in Heckscher's and Michael Bockemühl's opinion both do.[33] Riegl argues that only the former "subordinates" the observer by pointing with his finger; although the latter's gaze is also directed outward, it is not aimed at the observer but is "a sightless gaze" that denotes "absolute attention" to Dr. Tulp.[34] As for myself, I find the calm, masklike demeanor of the topmost interlocutor haunting and the furrowed intensity of his fellow out-looker puzzling. Everything about the former is understated as, floating above the action and more sketchily modeled than his neighbor, he seems to withdraw behind a veil of shadow that falls between his form and those below him.[35] He gestures toward the corpse with a restraint that shames the comparatively flamboyant nonchalance of de Keyser's indicator.[36]

The two out-lookers may conceivably represent a division of interlocutory labor. The strange detachment of the ghostly indicator contrasts with the intense absorption of the three sitters below him, while his partner shares their furrowed intensity as if to mediate between the indicator and the others, or as if to project the scopic drama of dissection outward to the observer. But there is another possible reading, another aspect of the division of labor: while the indicator points, or half points, to the

scene of dissection, his partner holds up the page for the observer to read the names of the sitters. Given that scenario, it is plausible to read the latter's expression as mirroring the optical strain demanded of anyone who occupies the observer position and is being invited to peer beyond the act of dissection toward the contents of the page. What this intense figure thematizes is not the perplexity of anatomical instruction, but the difficulty and importance of establishing full contact with the observer. And even if the names of the sitters were inscribed on the page over the anatomical illustration by a later hand, the superscription only dramatizes the priority the generic fiction of the pose already asserts over the historical fiction of anatomical demonstration.

If there is, as the commentaries seem to suggest, an emphatic feint toward the historical fiction, one might entertain the possibility that this is the most dramatic way to induce the interpretive recoil to the generic fiction. We are not initially confronted with the nonevent of the generic fiction in which "a group of men surround a corpse . . . which is the signifier of their profession and skill."[37] Rather, we are encouraged to wonder whether the painting is the visual record of a public dissection before we are led to recognize that it isn't. This recoil is itself an event that emphatically reinstates the generic fiction. But which "we," which occupants of the observer position, am I referring to? Not the sitters and their contemporaries. From the standpoint of a belated observer, theirs is a different experience of the painting, which, I imagine, goes something like this:

What they initially see is a group portrait representing members of the surgeon's guild and celebrating Dr. Tulp.[38] They expect the painter to make them recognizable both as individuals and as members of their profession, and he has met those expectations by incorporating an integrated set of poses into a spatial and figural arrangement whose very form enhances their dignity: the High Renaissance pyramidal structure, given a nicely baroque diagonal skew, and the shell motif in the niche behind Dr. Tulp add an aura of sacred, classical, and aristocratic imagery. So far, all very nice, but nothing surprising. It is the next move that *loro che sanno* did not anticipate: having thus commissioned and planned a professional group portrait, the sitters decided they would stage a *historia*—would pretend to pose as if absorbed in an actual scene of dissection and pedagogy. This tableau is iconographically enriched by the aura of allusion that surrounds the hand and arm. The sitters' peers are treated to a moment of scopic wonder. But since the focalized area of enrichment is also the area

of procedural and anatomical anomaly, it becomes a trope. Entrapping and turning their attention, it provokes the recoil that reduces the "anatomy lesson" to a counterfactual fantasy, and thus brings them—and also us—back with a thud to the primary generic fiction of the pose.[39] So also, those who look outward give the game away: by revealing awareness of the observer, they mark the refusal of the others to do the same and heighten the grim intensity with which the latter pretend to pose as if not posing. Had they been directed by a photographer, we know what his initial instructions would have been: "Do not look at the birdie. Do not say cheese." But, as we'll see, those instructions are only part of a more complex performative game plan.

This dynamic reorganization of the observer position constitutes the real event, the eventfulness, that the portrait stages. But for someone whom it persuades to admire its "realism," the effect may be too stagy. Michael Bockemühl, for example, interprets the indicator's "exchange of glances with the observer" as a challenge to the latter to participate vicariously in the scene of dissection and do what the "protagonists in the picture" are doing—observing ("the lecturer, . . . the body, the book or the other figures"). Given this expectation he complains, predictably, that "the individual features are . . . more emphatically delineated than is really necessary for the situation. As a result it is true to say that the individual qualities of expression become all the clearer. However, this heightening betrays to today's eyes a tendency towards pose."[40] Yesterday's eyes, expecting a group portrait rather than a history, might have received the same message without any sense that the painting or the sitters betrayed themselves.

The observer, Bockemühl continues, is so disoriented by the uncertain viewing point, the claustrophobic composition, and the dense grouping of figures that

> the realism of the action is achieved at the expense of the remaining
> depicted reality. The plausibility of the action's coherence conceals the
> implausibility of the spatial situation. It is the action which unites the
> figures, and not the setting—for the setting is ultimately not the lecture
> theater portrayed in the picture, but the picture alone. In spite of
> everything, however, it is the uniting of the eight half-length portraits
> to form a group, representing a fitting manner of depiction in the view
> of the Guild members, that asserts itself as the principal reason for the
> portrayal. (41–45)

FIGURE 31

Figures in *Anatomy
Lesson of Dr. Tulp*. From
William S. Heckscher,
*Rembrandt's Anatomy
of Dr. Nicolaas Tulp:
An Iconological Study*
(New York: New
York University Press,
1958), 189.

I assume that this is also the principal reason he finds for the picture's be-
trayal. Yet every feature he itemizes asserts the merely quasi-mimetic or
-historical character given a fiction of group portrayal whose setting is in-
deed "the picture alone." Bockemühl's criticism, I shall try to show, is
identical with the self-critique visually built into the painting.

The fiction takes the form of an amateur theatrical, a little episode in
the theater of absorption. At its center is the histrionic competition
among three noninterlocutory figures, each of whom strives to outdo the
others in pretending to be as strenuously observant as he can (numbers 2,
5, and 6 in the standard chart used to map their location [fig. 31]); the fig-
ure to their right, number 4, joins in the competition, while number 7 to
his left—marginalized, a lately arrived supernumerary—plays his part
more tentatively. Yet this central drama of observation is strangely unfo-
cused. Where does each of the actors direct his gaze? Commentators have
raised this question only with reference to number 3, the interlocutor
holding the list of names. But I think a more careful consideration will
show this to be a general problem.

It's easy enough to say they avert their eyes from the corpse, though
this is far from clear in the case of number 5, who points his head for-
ward, and of number 2 directly above him. Number 5 seems initially to

be looking at the book, but comparison with the gaze and up-tilted head of number 6 to his left renders that less certain. If number 6 looks at the book, the lower trajectory of number 5's gaze could be interpreted as a sweep from the act of dissection to the corpse's feet; but if we imagine that 5 looks at the book, then 6's gaze would shift upward and shoot somewhere above or beyond the book. Number 2 could be looking at either of Dr. Tulp's hands as well as at the book. When number 4, in the left foreground, is compared to numbers 5 and 6, his bookward gaze shifts a little to his left so that it rests on the near edge of the volume or sweeps past it. Number 7's weakly furrowed look seems aimed in the direction of Dr. Tulp, but its path is cluttered with the obstacles of numbers 5 and 6. Finally, although according to Riegl Dr. Tulp subordinates the other sitters, his gaze may well miss all of them, for it moves indefinitely either toward or past number 2 and runs unimpeded across the picture through the alley between number 2 and those below him.

I don't think these scopic uncertainties are too fine to be impertinent. The difficulty in pinpointing the directions and targets of several intensely focused gazes produces a strong theatrical effect. It reminds us that the portrait represents a fiction of group portrayal: sitters who pretend to pose together, and to pose as if not posing, actually posed separately; each followed the group script by fixing his gaze attentively at something-or-other, and left it to the painter to identify its target and incorporate it with the others in the composite. And he didn't quite do it: the sitters in the composite are still gazing at something-or-other. Once we take the comparison of scopic trajectories into account, two or three sitters end up paying close attention to nothing in particular. To the extent that these trajectories confuse and ambiguate each other, the integrity (the "Einheit") of the action is jeopardized, and with it the sense of an integrated group. Furthermore, the sitters appear disconnected not only from each other but also from the corpse, and with good reason, for it wasn't in their space when they posed, and the portrait shows each of them hard at work fulfilling his individual version of the common assignment, holding the pose of posing-as-if-not-posing.

This reduplication of the key word is the only way I can articulate the particular performative demand the sitters' attitudes reflect. If I may anachronistically assimilate the painter to a photographer or film director, this is what I imagine him to say: "I want you to pretend not to be posing—to pose as if in the middle of an action. There! That's good. Hold it just like

that." To number 4 in the left foreground he might add, "but turn your head a little to the right so we can see more than your profile, and rest your hand on the chair (?) to anchor and accentuate that turn." To number 6 he might add, "hold your hand on your breast as you would if this were a standard portrait rather than a dramatic performance." In other words, they are not simply pretending not to pose, nor simply posing as if not posing, nor simulating absorption. Rather they are showcasing the histrionics of absorption. The pose the painter discreetly enjoins them to hold is the pose of *only pretending* to perform. For they are not actors or models. They are gentlemen and patrons. And that needs to come through.

To the extent that it does come through, along with the implication that the painter put this amateur theatrical together from a series of individual sittings, it compels us to revisit and revise one of Barker's main contentions. He insists, it will be recalled, that the sitters avert their eyes from the corpse. But if I assume that whenever and wherever the individuals sat to the painter the corpse wasn't present to them any more than they were present to each other, and if I discern traces of this disconnection in their attitudes, then Barker misdescribes what I see. That is, I don't see them not looking at the corpse. I see them not seeing it, just as it doesn't see them. What they are "looking at," to borrow a modern idiom, is the prospect of being identified as participants in a cleverly composed variation on the standard format for a professional group portrait. Pretending to pose as if not posing was part of their price of admission into it. But that's all it was. The sitters and the painting both insist they are not there to subordinate themselves to a drama of dissection. Rather, the drama of dissection is there to showcase them. Having gone so far beyond his precursors in the direction of dramatic coordination, Rembrandt pulled back. He respected —or at least he dramatizes—the wishes of his sitters by refusing to go all the way. As a result, some of them are left a little oddly, even comically, suspended between the group fiction and the competing projects of histrionic self-representation, between their obligation to subordinate themselves to the professional scenario and their desires for singular recognition. *The Anatomy of Dr. Tulp* foregrounds this conflict. In doing so it fixes the observer's attention on the embarrassment of scopic politics.

One source of embarrassment may be the corpse, which shares the sitters' predicament: it too is suspended between competing representational protocols. Dead as can be, awkwardly foreshortened and posturally distressed, this high-chested figure is tastefully draped in a loincloth and

gives off a marmoreal gleam, so that it almost qualifies as a Torso. It hovers, that is, between the two states Kenneth Clark has distinguished as nakedness and nudity—the nakedness of the vulnerable body, the pristine nudity of the classical statue and its avatars (some of which appear in Vesalius's *Fabrica* and other sixteenth-century manuals). If nakedness is the appropriate state for the object of an act of dissection, nudity befits the identifying logo of surgeons engaged in an act of portrayal and competitive histrionics. The dissected arm in its own perverse way tips the balance toward nudity and dissolves the anatomy lesson into a symbolic party game. It too is pristine, as if it had been washed and dried. Whether or not it actually was copied from an anatomical illustration is less important than that it strikes the eye with the force of decalcomania. It sits on the corpse like the cutout of a crazily twisted red guitar, like the tail blindly affixed to the proverbial donkey at Dr. Tulp's celebration.

But who finally pays for this party? The story is that *Tulp* was Rembrandt's first major commission in Amsterdam, and that it led to many more. My question addresses itself broadly to the embarrassment of commissions, and more specifically to the possible symptoms of preemptive embarrassment in this first commission. I note, for example, how the picture's light condenses in and glows from the corpse, how the luminous off-whites and reds of its death-tinted forms suffuse and animate the sitters' faces, especially those closest to it, how the high color of their passionate attentiveness is laid in with touches from the palette of the death they cannot see. For anyone inclined to read the corpse as yet another figure of *vanitas*, that meaning leaves its traces tonally and chromatically in their flesh. And perhaps if I also note how the luminosity of the corpse is dimly reflected in the crepuscular half light of the page of text in the foreground, and again in the page held by the second interlocutor, my reading begins to resurrect the shade of Barker's critique. But I resist that umbrageous turn in order to secure the possibility of Rembrandt's critique—the possibility that even as the painter of *The Anatomy of Dr. Tulp* gives the patrons what they want and fulfills the terms of his commission, he subtly demurs by introducing disturbances into the visual field of the programme.

There is no doubt that this "was a picture of the Establishment . . . and for the Establishment," and that Dr. Tulp would be happy to see his "smooth countenance . . . lit up by a faith in the new knowledge and the triumph of science."[41] The picture has always been able to drum up such praise as the following on behalf of its patrons and itself: "The illusionism

is enhanced by the vivid characterization of the individuals as well as by the artist's great power in dramatizing the moment within a coherent group. . . . Here, psychological and pictorial realism combine to create the feeling of an extraordinary event."[42] But just what *is* the "moment" and the "event"? If the painting solicits praise for the illusionism of the moment of dissection, it does so only to emphasize its illusoriness, to subordinate it by means of conspicuous anomalies and small scopic incoherencies that embarrass the extraordinary theatricalism of the event of group portrayal.

I conclude, then, that in *The Anatomy of Dr. Tulp* the generic discord between the fictions of group portrayal and anatomical demonstration is exacerbated by the way each of the sitters, who are pretending to pose as if not posing, seems primarily invested in his separate project of holding the pose for the painter. The painter thus stages his detachment from the commission by subversively exposing the embarrassment already built into the structure of a genre divided between the poles of cooperation and competition. Accordingly, the scopic politics of the painting is characterized by an observer position divided between dominant and recessive possibilities of interpretive response. On the one hand, the painting solicits praise as an extraordinary document of collective self-representation, a novel, vivid, and realistic portrayal of the Establishment. It celebrates the professional energy, the social complacency, the economic solvency, of a burgher class equipped with an apparatus of patronage that guarantees a steady flow of commissions and supply of painters. On the other hand, the painting makes room for resistance to such optimism by providing a covert from which, as from the wrong viewing point, the Establishment may appear anamorphically distorted, fragmented, or conflicted, and may betray, in the figures tensely posed above the corpse, the embarrassing excess and anxiety of individual self-representation.

If there is a "place" in the painting where this recessive viewpoint may lurk, or where the painter's detachment from his commission may be visible in occulted form, it can only be the place filled by the topmost figure, who plays the role of indicator. The strangeness of his withdrawn demeanor increases when we compare his limp gesture with the busy manual activity occurring at the site of dissection and with the absorption of the figures beneath him. The contrast between halfhearted deixis and theatrical intensity renders their performance more melodramatic and edges it with caricature. At the same time, it makes the indicator seem a little reluctant to indicate. His vague hand is closest in its formal disposi-

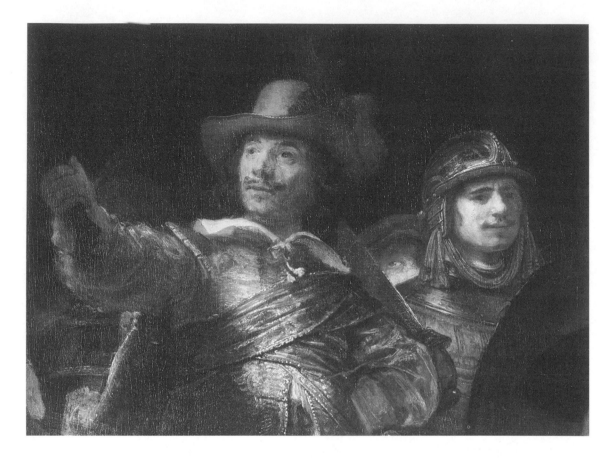

FIGURE 32

Rembrandt, *The Night-watch*, 1642. Oil on canvas. (Detail: ensign and militiaman with Rembrandt between them.) Rijksmuseum, Amsterdam.

tion to the sharply delineated hand of the corpse toward which it aims but—with its fingers curling inward—doesn't quite point. Indeed it might be said that the flaccid, soft, and slightly swollen appearance of this hand introduces into the painting another less melodramatic and more chilling signifier of death.

In the *désagrégation* of the *Nightwatch* the surrogate of the painter will slink further back and drop almost out of sight, leaving behind nothing but a monocular glare behind the ensign who gleams gloriously as he holds the standard high and gives either it, his holding it, or more probably both his appreciative attention (fig. 32). The eye in the lurking quarter-face, unseen by all in the painting and diverted from the observer, subordinates nothing. It follows the ensign's upward gaze and complacent connoisseurship with a look one would be foolhardy to try to characterize. Terms like "skeptical" or "incredulous" pass through the mind or even, one blushes to confess, "embarrassed."

REMBRANDT'S LOOKING-GLASS THEATER

Every painter paints himself.

I say among my friends that Narcissus, who was changed into a flower, . . .
was the inventor of painting. . . . What else can you call painting but a
similar embracing with art of what is presented on the surface of the
water in the fountain?[1]

An artist is always at a certain disadvantage when he paints his own
portrait. He must resort to the mirror, which inevitably introduces an
element of unreality, a kind of distortion that is bound to affect the
finished picture's emotional tone.[2]

The *mirror stage* is a drama whose internal thrust is precipitated from
insufficiency to anticipation . . . and . . . to the assumption of the
armor of an alienating identity.[3]

METHODOLOGICAL INTERLUDE II: ON SELF-PORTRAITS

In the Introduction I noted that I would approach Rembrandt's self-portraits as varied expressions of something I call *the Rembrandt look*, and I explained that I use this phrase to denote both the characteristic appearance of works attributed to (or deattributed from) Rembrandt—the way they look to observers, beginning with Rembrandt's contemporaries—and also the way they "look" *at* other paintings, by which I mean the way they represent their relations to other paintings by conspicuous allusion and revision. Most of my references in the chapters that follow activate the latter sense and treat the Rembrandt look as an instrument of revisionary allusion—as a look that takes in, sizes up (or down), and comments on, the modes and motives of other paintings in the genre, other styles of portrayal and self-portrayal. The former sense—that of a characteristic appearance—is the one activated by Svetlana Alpers in *Rembrandt's Enterprise* when, among such repetitions of the formula "the look of *x*" as "[t]he idiosyncratic look of Rembrandt's paint," "the look of his art," and "the look of his works," she writes that the "'look' of his works was all the rage."[4] Her deployment of this formula enables her to implement an ingenious and (in my opinion) fully persuasive strategy for dealing with the depredations of the RRP and others who have been engaged in reattributing Rembrandt paintings to pupils, imitators, and forgers.

Alpers hypothesizes that Rembrandt invented "the Rembrandt," alienated it from himself, and fetishized it as a precious market commodity, and that this commodity simultaneously proclaims his authority and promotes the replications, forgeries, and misattributions that secure its market value.

Just as money is a rematerialized abstraction and appropriation of value from commodities, and the bill of credit a rematerialized abstraction and appropriation of value from money, so the look of a Rembrandt painting, abstracted and abstractable from paintings by Rembrandt, assumes a similar value, a similar liquidity. Alpers concludes that since he "appears to have been willing, even anxious, to encourage others to pass themselves off as himself,"[5] since he "displays and extends his authority in a manner that calls authenticity into question," he was "in good measure responsible for the questions" that have been raised about the size of his *oeuvre*, and for the "mistakes and deceptions" that motivated the questions (121). Thus, she argues, the flourishing practice of deattribution and the decreasing number of "Rembrandts" only testifies to the success of Rembrandt's enterprise in using market techniques to disseminate the Rembrandt look, increase his authority, and raise the value of the commodity that bears his name.[6]

This argument is economically constructed to meet two different challenges. One is the problem of attribution posed by the RRP, the other is Gary Schwartz's massively documented study of the context of patronage within which Rembrandt worked.[7] Schwartz puts into play a simple and inflexible form of reception theory, whose thesis is that the "iconographic, stylistic and aesthetic meanings" of Rembrandt's work are heavily determined by "the character and interests of those for whom they were made" (358–59). From this thesis he draws a pair of parallel conclusions and cleverly manages to kill two birds with one stone. The first conclusion is that Rembrandt's modern interpreters have gone astray by not taking the milieu of patronage more seriously. The second, and this is the ingenious move, is that Rembrandt made the same mistake: had he taken that milieu more seriously, responded to it more respectfully, he wouldn't have squandered in later life the social assets he accrued as a successful portrait painter in the 1630s.

Alpers generally ignores the first conclusion—except to reject specific interpretations Schwartz based on his research—and concentrates on the second, arguing that he fails to discern the entrepreneurial "method in . . . Rembrandt's madness or bad behavior."[8] She insists that, given two alternatives, the developing open market for pictures on the one hand, and various forms of public and private patronage on the other, Rembrandt preferred the risks and freedom of the first because he "was not only unwilling to play the social game with patrons, he was also unwilling to pro-

duce works that could be paid for, and hence valued, in the accustomed ways"—he did not, that is, "wish to establish value by personal association with those who had status or power."[9]

Although I find this argument less compelling than the response to the problem of attribution, in part because Alpers conducts the argument on the genetic or archival grounds of battle chosen by Schwartz, her general view of Rembrandt's attitude toward patronage has deeply influenced the interpretations of particular self-portraits undertaken during the remainder of this study.

When we accept the designation of a painting as a self-portrait, we activate the empirical fiction of the mirror, which is that the first instance of such a picture could not have been produced unless the painter stood before a mirror and painted what he saw, or something like it. The phrase "first instance" underlines the double nature of this premise as simultaneously empirical and fictional. It is empirical because we assume that either a remembered or a copied self-portrait could only have originated in an experience of specular reflection. It is fictional because what we see could be an image made from memory, or the copy of a prior self-image, and one that someone else besides the sitter could have made. It is also fictional because, as I argued in Chapter 8, our fantasies of what is possible, or likely to have taken place, during the production of the image—fantasies including those mentioned in the preceding sentence—lead us to assume that the image may screen out or disguise or distort many details of the actual productive process.

In the images we designate as self-portraits, the fiction is complicated by several facts, factors, and assumptions that influence our response to the normative act and apparatus of production the self-portrait indexes. Everything changes when the fiction of the pose receives the specific form of the fiction of the mirror, when the cast of characters or subject positions in the former—painter, sitter, patron, observer—is replaced in the latter by the painter/sitter, the mirror, and the observer. Here, since we assume that the same agent both paints and poses, we can hardly ignore the fact that even if the painter paints himself painting, the unmirrored labor of productive activity tends to be screened out. Where the mirror was, there the picture plane shall be. And if the traces of activity are preserved in facture, that record only renders the exclusion conspicuous.

The exclusion becomes thematically important in self-portraits that do not represent the painter painting. The normative act of portrayal they index is not a selective refinement of the normal practice we imagine: it is a misrepresentation that expressly contradicts the normal practice by pretending to dissociate and isolate the act of posing from the act of painting. The basic fiction of such self-portraits is that the image we see *doesn't* reflect the way (we imagine) it was produced: the image still constitutes what it pretends only to reflect, but now it does so as an express pretense that denies the normative act we imagine. Thus divided against itself, the self-portrait of the painter as nonpainter is a *dissemblance*—not a deception but a disguise, an act of mimicry, a self-portrait masquerading as a portrait. In this dissemblance there lurks the orthopsychic possibility of a gesture of self-negation, a fantasy of self-idealization, a drama of heteromorphic identification that first splits the artistic subject into painter and sitter and then integrates the fragments into the alterity of the specular double.[10]

For the characterization and analysis of this particular "plot of self-portraiture," all students of the genre are indebted to Joseph Koerner's marvelous study of Dürer's 1500 self-portrait in Munich, *The Moment of Self-Portraiture in German Renaissance Art*, from which I borrow the phrase in quotation marks. Though Rembrandt's variations on this plot are quite different from Dürer's Christomorphic pose, they share with it the bifurcated structure of orthopsychic self-representation that Koerner has analyzed and articulated with unsurpassed clarity and power. I shall therefore pass through his reading of the Munich self-portrait (pl. 18) on my way to Rembrandt.

Koerner's prefatory comments on the painting depict a hyperbolic version of the fiction of objectivity:

> The artist has painted his likeness with the symmetry and formality of a funeral elegy. . . . Prepared for posterity, Dürer looks ready to serve as a frontispiece for some future biography or "collected works."

> Dürer fashions his 1500 *Self-Portrait* as an emblem of the powers of the individual creator. Through the panel's visual allusion to the *vera icon* of Christ, Dürer mythicizes the identity between image and maker, product and producer, art and artist, announcing that it is in art that human labor achieves its ideal. And through his en face pose, endowing his likeness with the "omnivoyance" of a holy icon, he celebrates himself as a universal human subject, whose all-seeing gaze is subject to none.[11]

The omnivoyance to which Koerner devotes a chapter resides in the steady, wide-eyed stare that had been used for centuries to denote spiritual absorption and thus to occlude the theatrical link to an observer suggested by sitters who appear to give themselves to be seen. Koerner's is a literally amazing performance; he weaves around the painting, and out of its substance, a labyrinthine network of cultural meanings through which and with which he always manages to trace his way back to enrich "the moment" at its center. A major emphasis of his interpretation, focalized in a chapter on the devotional concept of the *acheiropoetoi* (images "not made by [human] hands"), is that Dürer aspires in the 1500 self-portrait to represent it as an image of that kind and thus not only to sacralize it but also to mask or deny the actual process of its production. Koerner is entirely persuasive in showing that the form of the portrait conspires with the network of allusion (to the sudarium, for example) it generates to impress on the observer its resemblance to the *vera icon* and even, perhaps, its participation in its power: "Dürer places his own likeness at this heart of the sacred, fashioning himself after an image that not only looks like God but, in its sustaining myths of self-creation, perfect representation, and magical efficacy in atonement, has the powers and attributes of God" (99).

But Dürer's resonant representation of exemplarity is only one side of the conflicted plot of self-portraiture Koerner unpacks from the Munich portrait. The other side consists in the formal and iconographic signifiers through which "Dürer thematizes the unbridgeable rift between himself, in all his vanity, narcissism, and specificity, and the higher role to which he aspires. Dürer presents himself *as* Christ but reveals himself to be mere man" (67). Concentrating on the ostentatious display of skill in the depiction of the hair and fur, on the hint of dandyism conveyed by the elaborate coiffure and the elegantly fur-lined robe, and on the hand fingering a tuft of fur, Koerner shows how they emit "darker messages of vanity and bestiality" (172), by which the orthopsychic desire for the armor of Christomorphic identity is animated and in which it is entangled:

> Does this finger, like the rest of his hand, *display* its perfect form as an emblem of a body at once beautiful and beauty-creating? Does it, together with the middle finger, *grasp* the tuft of fur as emblem of the sitter's bodily and artistic being? Or does it rather *point* to the heart . . . ? It would not be hard to relate Dürer's specific hand gesture to . . . pictures [in which] the cultic power of the *vera icon* is made plain. As indulgenced image, it is an instrument of atonement, blessing the

beholder. . . . In Dürer's panel, the hand turns back on itself. Instead of
conducting redemptive love to the viewer, this likeness enacts self-love
or narcissism, one might argue, aiming to consecrate the artist's person
magically in his image. (174)

The fur Dürer fingers, as a displaced version of the hair with which he
identifies himself, is a way of associating himself not with the God
whose features he shares, but with the beasts of the earth. (170)

The irreducible indirection of Dürer's deictic hand thus does not
stem from our uncertainty about its iconography. . . . It is rather the
consequence of a historical moment in the history of reference, in
which the modern impulse toward self-display reoccupies the spectacle
of theophany. (176)

[I]nstabilities in Dürer's project . . . emerge . . . as gaps within his
pictures themselves, disparities between the "theory" that an image
proposes about itself—the theology, moral, or metaphysics it deploys as
its own commentary—and the image's physical appearance, which is
always more mingled, always elicits a more heterogeneous response than
any theory can support. (183)

In Koerner's brilliant analysis of this self-portrait, there is only one
point of interpretation I want to query, not so much to disagree with it as
to change the emphasis in a manner that I think lends his reading added
support. It concerns his account in the following passage of the relation
between the sitter's gaze and the hand fingering the tuft of fur, which,

> returning the touch of the artist's exploring fingers and silhouetted
> against their flesh, is the climax of Dürer's painting. There is nothing
> quite so alien to the kind of image mythicized by the *vera icon* as this
> sensual episode of exploration. . . . In our initial encounter with the
> Munich panel, we feel ourselves addressed directly by the artist's gaze.
> Once we notice the tuft of fur, however, and entertain the notion that
> Dürer is absorbed not in what he sees but in what he touches, that gaze
> will draw away from us, becoming a blanker stare. Touching the fur
> signals the sitter's interiority; it draws him inward toward his body as
> into his "self." His attention no longer seems focused on us as viewers
> or, within the plot of self-portraiture, on himself in the mirror. (160)

When I notice the sitter handling the tuft of fur, however, I find it only
too easy to imagine that the sitter's attention is focused directly on himself
in the mirror. For me, that gesture is the climax of the painting because it

transforms his omnivoyant stare to concentration on the pose. In an act of specular self-assessment, he appears to be fussing with the tuft of fur.

This appearance converts the spiritual absorption of the *vera icon* into the theatrical absorption of a sitter experimentally trying out the pose that will deliver the desired effect. It signifies his self-conscious attempt to adjust his attitude to the demands of the program Koerner describes. It introduces temporality into the plot of self-portraiture because it depicts a moment of preparation that precedes and will eventuate in the final pose, and a moment that foregrounds the confessional hints of pride and frailty Koerner adduces from other features of the image.[12] Thus it is precisely when, or because, I register the sitter's specular self-attention that the emphasis shifts from successful identification with the Christomorphic exemplum to the orthopsychic drama of his attempt at identification— the futile attempt to transcend the very theatricality that is the essence of all such attempts.

To move from the Munich self-portrait to those in which Rembrandt portrays himself in fancy dress is to move to a different sector of the spectrum of tonal variations without altering the basic structure of orthopsychic representation elaborated by Koerner. In many self-portraits Rembrandt actualizes, indeed hyperbolizes, this drama by posing not as Christ but as a patron. This practice renders the image opaque and confronts the observer with an aporia that has been lucidly described by Alpers:

> In every work in which he plays a role by serving as his own model, it is a matter of judgment whether a reference to himself in that role is intended and what the force of the reference is. The same could be said of those studies of heads and faces in which Rembrandt features himself, though I take it that in his deployment of these theatrical studio practices, Rembrandt allowed such uncertainty about the meaning to come into play in the making of the work. It makes for what I have referred to as the problem of the "subject" of his paintings.[13]

In the self-portraits I am about to explore, the painter paints pictures of himself rather than of others, but he paints himself *as* other(s), and very often in the guise of the sitters painters depend on for commissions. The interplay between these opposed tendencies rings all the changes on "every painter paints himself," and generates the critical and comic power of the Rembrandt look in self-portraiture. Rubbing against each other, these tendencies set up parodic vibrations that complicate our response to both

the painter and the sitters whose roles he enacts. They accentuate the mock solemnity of the broader performances and undercut even the less affected elegance of restrained and pokerfaced poses. Thus they target the interests and pretensions structured into both sides of the traditional apparatus of portraiture. And they suggest another reason why Rembrandt was, in the opinion of his contemporaries, a maker of poor likenesses. That opinion conformed to the criteria of "poor" and "likenesses" established in Italy on the basis of the assumptions of physiognomic realism. Finally, they give rise to the comedy of aporias I discussed in my introductory comments on the frontispiece to this book, the aporias of attribution and category identification suggested by Alpers when she remarks that Rembrandt "appears to have been willing, even anxious, to encourage others to pass themselves off as himself."[14] From this apparent willingness at least two rogue genres pop up beside "authentic" Rembrandt self-portraits: Rembrandt self-portraits by other painters and self-portraits by painters imitating a Rembrandt self-portrait.

The self-portraits in fancy dress have nothing to do with self-disclosure. What they portray is not the sitter's status, soul, personality, visual particularity, or state of mind, but the act of self-portrayal he performs for the benefit of the painter, the observer, and himself. More generally, their acts of portrayal instantiate and interrogate the traditional apparatus I tried to characterize in Part 1. That is, they dramatize and place in question the norms of good likeness privileged by the ideology of mimetic idealism and by the representational politics of commissioned portraiture that ideology reflects and reinforces. My account of the self-portraits thus focuses on the way Rembrandt avails himself of the opportunities posed by the dialectical interaction of portraiture with self-portraiture.

15

GOOD BOYS AND BAD: ORTHOPSYCHIC COMEDY IN THE EARLY SELF-PORTRAITS

Self-portraiture as a representation of, and commentary on, the apparatus that produces portraiture and that subjects its protocols to the patron's ratification: it is in this context that I propose to analyze the structure of the genre and Rembrandt's deployment of it. In his own time he was criticized not only as a painter of poor likenesses but also as the victim of a pathological obsession with fat paint; one contemporary noted of a particular portrait that he laid it on so thick that you could pick it up by the nose. These two characteristics are closely interrelated aspects of what I take to be the program informing the self-portraits in varying degrees of fancy dress.

About "poor likenesses," I would argue that the self-portraits interrogate the criteria of graphic clarity and mimetic idealism that inform definitions of good likeness and the apparatus and politics of patronage they support. About Rembrandt's obsession with fat paint, I would argue that the conspicuous display of facture or paint texture directly challenges the graphic principle and goes against the grain of a form of visual rhetoric that promises to bestow clear, persuasive, and knowable meanings on passive observers. Relations between smooth and rough painting thus enter not only into the politics of representation but also into the politics of interpretation, that is, the strategies by which patrons try to control, if not monopolize, the programs—the forms and meanings—of commissioned images.

Alpers devotes an illuminating chapter to the "idiosyncratic look of Rembrandt's paint," his insistence on its "thickness or materiality," his

preference for the rough over the smooth style, his delight "in displaying his delight in the laying on of paint."[1] Her emphasis is not merely on facture per se but on texture of a particular kind that differentiates Rembrandt's handling of paint from that, say, of Titian and Tintoretto, and not merely on facture as the producer of effects but on texture *as* an effect, a product, a represented feature that interacts with and qualifies the nominal subject of representation.[2] She argues that the representation of facture appeals "to the physical activity of touch" and that the emphasis on the presence—that is, the traces—of the painter's hand directs our attention to "the act of painting itself as the performance we view."[3]

Reactions to Rembrandt's facture date back to his own time, but for me the most telling moment in this history was A. J. P. Laurie's decision to look for the identifying traces of a painter's style not in those represented objects (ears, hands, etc.) on which Morelli focused,[4] but in the representing medium of Rembrandt's brushwork. Laurie's premise was that Rembrandt was not sufficiently graphic in his delineation of minor features for the Morelli method to work, and that it was therefore necessary to shift attention from the way objects were painted to the brushwork itself, considered in abstraction from those objects.[5] Notice the particular form his resituation of identifying traces takes: from features of the imaginary field "behind" the picture plane to the material features of—the pattern of brushwork and paint texture on—the picture plane; features that diminish the transparency of the surface and the immediacy of representation when emphasized by painter or interpreter. In its critique of Laurie's efforts, the RRP notes that they "were rooted in ideas conceived with the expressionist art" of his time (the 1920s), and I find this connection rather than its practical results significant as a symptomatic response to a "modernist" effect in Rembrandt, an effect contained—present but domesticated—within and by a body of painting that still, however reluctantly and rebelliously, follows the dictates of the graphic regime of early modern painting.[6]

Contained rebelliousness: no allusion to "contained subversion" is intended. My interest, following that of Alpers, is on the way Rembrandt's conspicuous handling of paint may be interpreted in politico-formal terms as a counterpractice that targets the graphic investments and representational desires of those who wield the power of commission.[7] "The master's touch," as Alpers describes it, can be ungentle. She notes how, in many works, "Rembrandt's rough painting mode . . . calls attention to the

kinship between pigment and human flesh," and how, in such works as the *Slaughtered Ox* and the two anatomies, he "identifies the painter with the role of one—butcher, hunter, surgeon—whose hand cuts and delves into the body."[8] These analogies recall the processes of etching and engraving, in which the hand holding the needle or burin presses it into the ground or the copper. Some of the effects Alpers describes in paintings are produced by the transgressive application of the operations performed in etching and engraving: the hand pressing the needle cuts into the cutaneous ground that protects the copper from the acid bath; the hand pressing the needle or burin cuts directly into the copper plate itself.

The pressure of the hand working obliquely or perpendicularly to the image-bearing ground from which the print will be taken produces in the latter a pattern of marks that translate into the tonal values of the represented object without losing their conspicuously nonmimetic appearance. When that appearance is interpreted as the effect of the constraints imposed by the medium and method of production, it showcases the labor of the hand and the dynamism of the ever-present, never-effaced, passage of the non-mimetic into the mimetic.

Etching thus differs from painting produced under the graphic regime that values erasive brushwork and the transparency of the picture plane. Insofar as nonmimetic hatchwork signifies an activity of image making that cuts obliquely or perpendicularly into the ground, it functions as an indexical sign. But it simultaneously conflicts and converges with another vector of perpendicularity that denotes the iconicity of the picture sign as a semblance: the mimetic or imaginary perpendicularity of the three-dimensional field "behind" the picture plane. The virtuosity for which etching is prized results from the interplay and tension between these two systems of perpendicularity. From the time of his earliest work, Rembrandt experimentally transferred this interplay to painting to produce a conflict between the indexical system of texture in rough painting and the iconic system of erasive brushwork in graphic mimesis. He uses conspicuous texture to assault the canonical skill or major weapon of graphic representation, its proud mastery and deployment of the system of iconic perpendicularity inscribed on the Albertian window that is produced by effacing the traces of the brush. But the inventor of the Rembrandt look knows that the assault is most effective and meaningful when he supplies the assailant with graphic targets of his own making—with canonical performances that mirror his desire and mastery of the graphic mode in

the smooth surface through which pass so many icons of specular resemblance. Turning now to a series of early self-portraits, I shall try to show how this modal interplay constitutes the dialectical structure of the Rembrandt look in painting, and how it alters the painter's interpretations of the sitter's poses.

Rembrandt's sensitivity to relations between smooth and rough painting is evident in his earliest self-portraits, as is clear from the contrast between the smooth and elegant sitters in figures 33 and 34, and the rough and hairy sitters in figures 35 and 36. It is not only the chain, scarf, gorget, and bejeweled feathered beret that make the first pair sleeker. It is the hair: brushed away from the face, continuously contoured, distanced by soft focus, smartly coifed in figure 33, upstaged by the tints and shades, the billow and raffish skew, of the beret that tops off figure 34. Figure 35 is famous for "the unruly curls of hair" scratched by Rembrandt "into the wet paint surface with the end of his paint brush or with his maulstick."[9] Like the windblown appearance of the hair in figure 36, this treatment produces a little wilderness about the face; the vivid, sparklike squiggles that intensify by contrast the facial shadow oddly anticipate arboreal passages in Rembrandt's storm-tossed landscapes. These two pairs may be related to each other as back-room to front-room or before and after modes of self-representation, and the contrast adds an edge of parody to each pair. So I think it would be wrong to say that we get the "real" Rembrandt in the hairy figures and the vain *poseur* in the others; and equally wrong to try to distinguish between figures that are experiments in expressing the passions and the more introspective images of what Chapman calls "the inner man."[10]

The first view is defended by Schwartz, who portrays Rembrandt as a Bad Boy, a nasty man,[11] a loser who had everything going for him in the 1630s and managed to dissipate his considerable social assets by his refusal to be a Good Boy and mind his manners and say "Thank you," and by his perverse way of dealing with patrons. Given this crabbed view, it is predictable that Schwartz treats the hairy images as products of "straightforward mirror gazing"—this is the real Rembrandt, and he's a mess—and plays up the vanity and bad faith of the smooth images with their "military and seigneurial posing" (59). One reason for his impatience is that Rembrandt, who affects gorgets and other military paraphernalia, behaved unpatriotically in dodging the equivalent of the draft at the end of the Twelve Years' Truce (21): "For a man who avoided service in the civic

guard, Rembrandt is remarkably quick to arm himself and his models, young and old" (61).

Chapman's view of this is more charitable. "Even though he was never in the military," she writes, "he shared values with those who were. His imaginary self-portraits in gorgets of the Leiden period . . . are analogies or counterparts to grander 'real' portraits in armor. As such they gave him a way to affirm his allegiance to the *vaderland*."[12] But which *vaderland*? The court at The Hague? The Estates General? Holland? Leiden? As we saw in Chapter 10, attitudes toward the military during the 1620s were various and problematical. Even after Frederick Henry's successes against the Spanish in 1629, the truce negotiations intensified conflicts between the anti-Catholic Counter-Remonstrants, who opposed peace, and the more liberal Arminians, who endorsed it. These differences, together with differences of economic interest, produced friction between the Stadholder and the States General led by Holland. But within Holland itself, diverse economic interests led some cities to resist the truce and others to support it. The textile towns of Leiden and Haarlem were Counter-Remonstrant and anti-truce in part because the war helped them against their Flemish and Brabantine competitors.[13] Amsterdam was Arminian and pro-truce; its overseas trade was adversely affected by war. In 1631, in the midst of this time of tension over truce negotiations, Rembrandt moved from Leiden to Amsterdam. So what is Rembrandt's *vaderland*? Or, as the Irish captain Macmorris hotheadedly exclaims to his Welsh counterpart Fluellen in Shakespeare's *Henry V*, "What ish my nation?"[14] Professional soldiers like Macmorris and Fluellen might well have conducted their flyting matches in the Dutch barracks and taverns so often portrayed in the first half of the seventeenth century. During the 1620s and 1630s, when Rembrandt worked on many military portraits and self-portraits, there were both political and social reasons why members of urban elites and those in their circles might be as careful about flaunting military airs as they would be about succumbing to the colorful opulence and courtly swash being celebrated by van Dyck. As I suggest in Chapter 11, the divided attitude inscribed in Rembrandt's military and seigneurial pictures may be characterized as embarrassment.

Where, then, in the early self-portraits, does Rembrandt's allegiance lie? Let's begin with an especially juicy example of the vainglory Schwartz contemns, signed and dated in 1631 (pl. 19). Chapman sees in this "curious full-length" an "imaginary variation" on an "elite convention of mil-

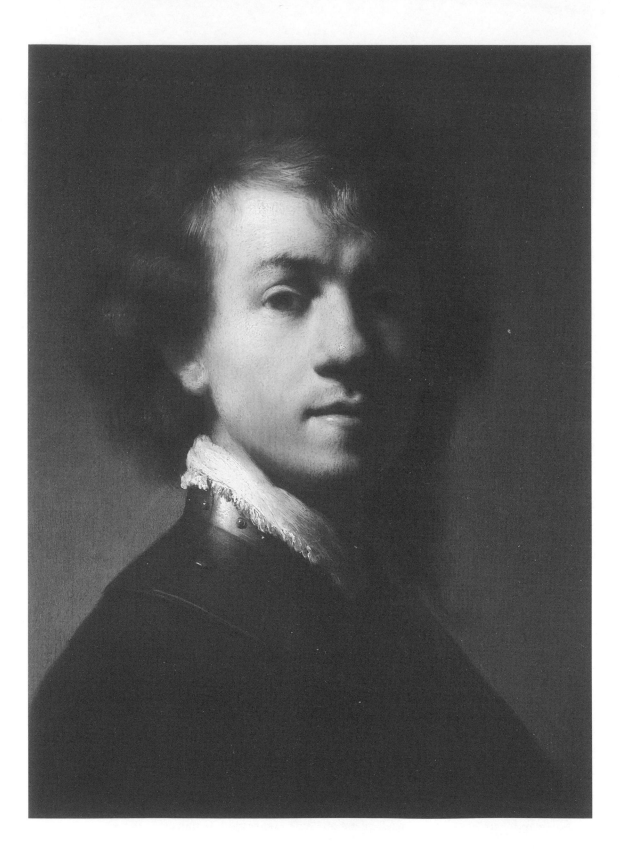

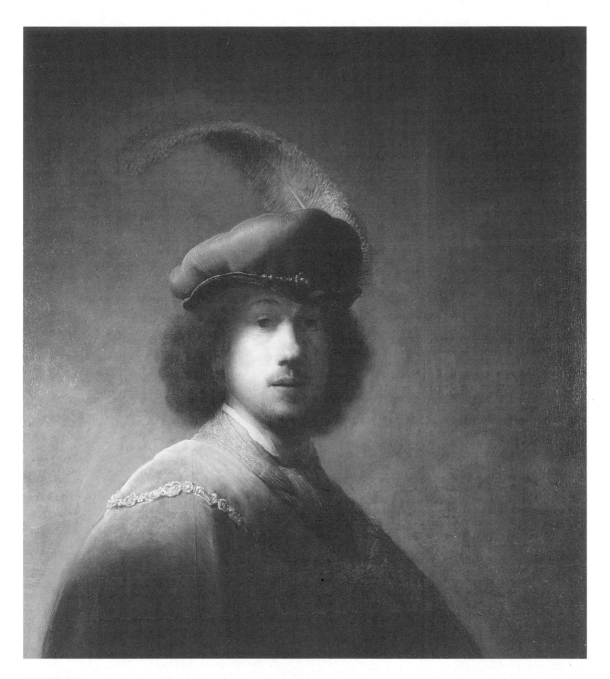

FIGURE 33

(Opposite) Rembrandt, *Self-Portrait*,
ca. 1629. Oil on wood. Mauritshuis,
The Hague.

FIGURE 34

(Above) Rembrandt, *Self-Portrait with
Beret and Gold Chain*, 1629. Oil on
wood. Isabella Stewart Gardner Mu-
seum, Boston.

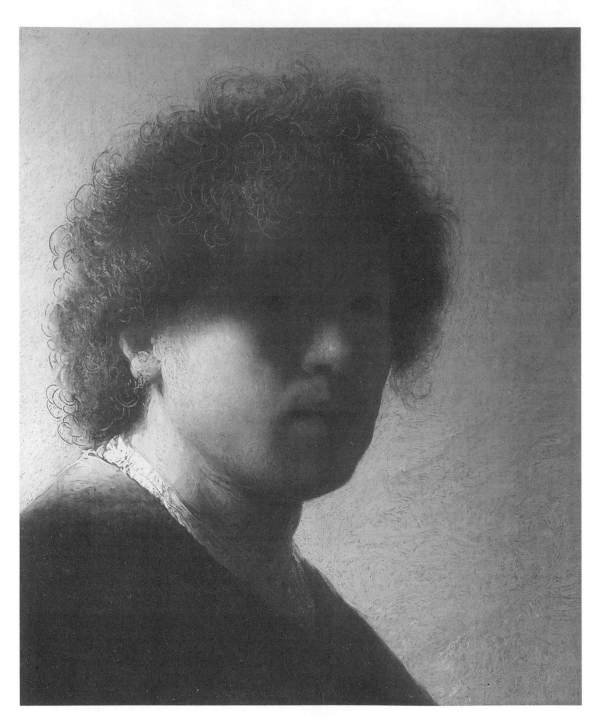

FIGURE 35

Rembrandt, *Self-Portrait*, ca. 1628.
Oil on wood. Rijksmuseum,
Amsterdam.

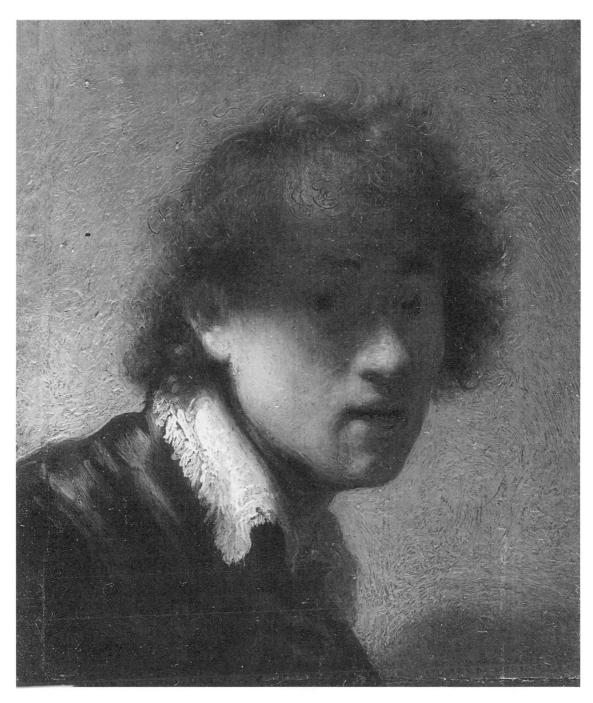

FIGURE 36

Rembrandt, *Self-Portrait*, 1629.
Oil on wood. Alte Pinakothek
München.

itary portraiture" employed in the court at The Hague.[15] Schwartz has a more styptic reaction: he catches Rembrandt out "masquerading as a Persian prince" in "a much grander type of self-portrait, full-length, in oriental garb, with armor and a noble dog as attributes."[16] Perhaps he has a point: following the convention of objectivity employed in so many portraits of rulers and generals, the sitter refuses eye contact and gazes imperiously leftward as he gives himself to be seen. Norbert Schneider, however, is unimpressed and even mildly amused; he suspects the sitter may be trying on costumes: "the histrionic artificiality of the scene is underlined by the presence of an alternative costume in the shape of Roman helmets lying on a table" behind the sitter.[17] This hurts. It drains the leftward gaze of its haughtiness and leaves the poor sitter eyeing himself a little dubiously in a mirror somewhere off to his right. The feather groping up toward the high shadows accentuates the figure's squatness, whose only excuse should be foreshortening, of which unfortunately there are no visible signs. This leaves the portrait dangling on the edge of a hilarious if beautifully toned piece of overkill. But what really pushes it over the top is the hangdog air of the noble canine attribute with its chic cut (half smooth, half hairy), its curls strangely similar to those in one of the hairy busts (fig. 36), and the not overly aristocratic droop of its flopeared head, which echoes the forward hunch of the windblown sitter in figure 36. The proper title of this picture is "Self-Portrait with Snoopy."

These early self-portraits already imply a correlation of painterly with social values: rough and textured painting goes with the image of Schwartz's Bad Boy, whose hand is sometimes the hand of a slasher; smooth transparent painting in the graphic mode goes with the image of Schwartz's Good Boy. They can be used to establish the poles of a continuum along which to chart Rembrandt's diverse experiments in self-portraiture, experiments that engage and modify each other, often with ironic or poignant effect. Sometimes graphic effects are challenged by minor outbreaks of textural guerilla warfare, and sometimes the battle between them is waged for control of the ambivalent and indefinite shadings of the optical mode. Several of the self-portraits painted up to 1640 display variously nuanced acts of negotiation between the two Boys. So, for example, in figure 37 the Good Boy sets up in proper regalia and begins to paint himself only to find that, like Dr. Jekyll, he is on the point of turning into bad Mr. Hyde. Other pictures are notable for the Bad Boy's renewed assault on the shapeliness and respectability conferred by the hat.

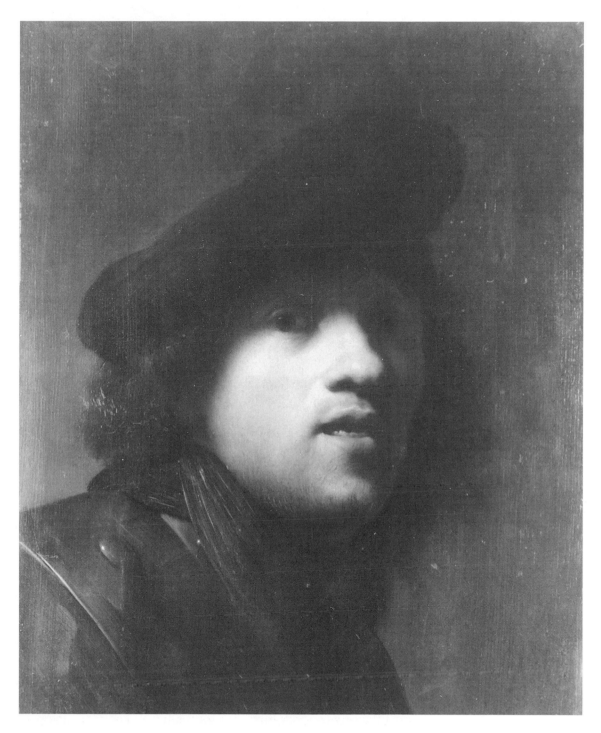

Rembrandt (?), *Self-Portrait*, ca. 1629.
Oil on wood. MOA Museum of Art,
Atami, Japan.

In figure 38, a painting that has been reassigned to a Rembrandt student, yellow streaks of paint double as (or possibly interfere with) the sheen of a head-flattening object halfway between a fedora and a pancake.[18] In figure 39, the scared soldier's helmet, with its Roman plume askew, is about a size too small, but at least its wearer manages to keep his honor, whereas in figure 40, a painting whose status as a Rembrandt self-portrait has been questioned, the purse-mouthed fantastico is undone—as he seems to realize[19]—by an extravagant variation on the fedora/pancake, one of the more bizarrely blocked creations in the history of Western haberdashery.[20] Schwartz blandly refers to this painting as "the last of the military self-portraits,"[21] but another commentator cites the opinion that Rembrandt is dressed up as the character called Capitano in the *commedia dell' arte*. Comparing the beret to an equally outlandish hat with twice as many feathers worn by Lucas van Leyden in a self-portrait of about 1519, he reminds us that such caps "could . . . allude to 'vanitas' thoughts" and wonders whether "Rembrandt is posing as a dandy or actually symbolizing Vanity."[22] Though the question is trivial—the two possibilities are scarcely disjunctive—it responds to an important effect: the mimicry of the Bad Boy sending up the aspirations of the Good Boy.

The Capitano's fantasy hat may be no more than an explosion, a brief moment of carnival release from the constraints of commissioned portraiture, and perhaps the pretensions of the modish cavalier merely provide an excuse for—or are sacrificed to—an experiment in a complex formal invention.[23] Yet both the context and the attire may supply cues to a more suspicious reading. The elaborateness of the headgear has some respectable antecedents among the chapeaux of aristocratic and military dandies painted by Raphael, Titian, Giovanni B. Moroni, Moretto da Brescia, and others.[24] The Italian connection becomes interesting when viewed in the light of David Smith's argument about the preference of Dutch patrons and painters for images that reflected "the ideals of the Renaissance court."[25] I don't mean to suggest that the Capitano is such an image. Though Smith makes much of the indirect influence of Castiglione, he is careful to note that the Dutch burghers took into account the gulf that separated their social ideals from those of the Italian court: "Dutch portrait painters, in giving their patrons the poses of princes and kings, sought at the same time to moderate the image in ways that made it credible to a middle-class audience. . . . But it is well to remember . . . that the Dutch burghers who posed in this manner may often have thought themselves to

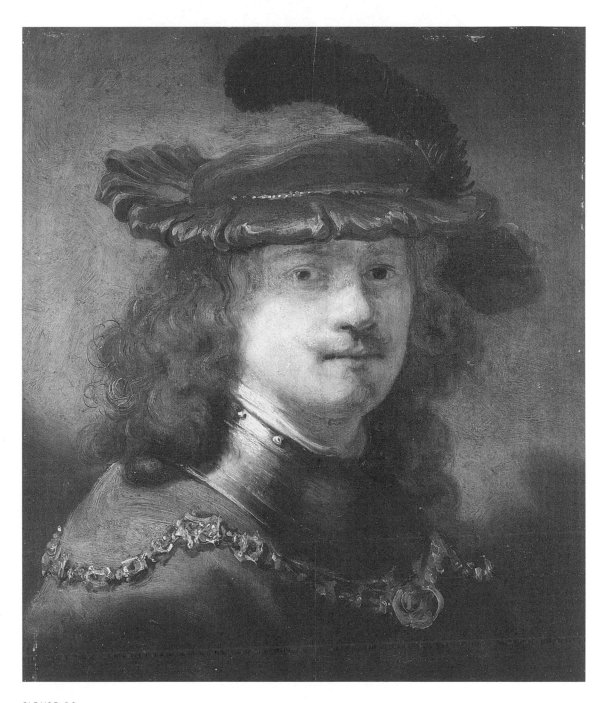

Flinck (?), *Bust of Rembrandt*,
ca. 1633. Oil on wood. Staatliche
Museen zu Berlin, Preussischer
Kulturbesitz, Gemäldegalerie, Berlin.

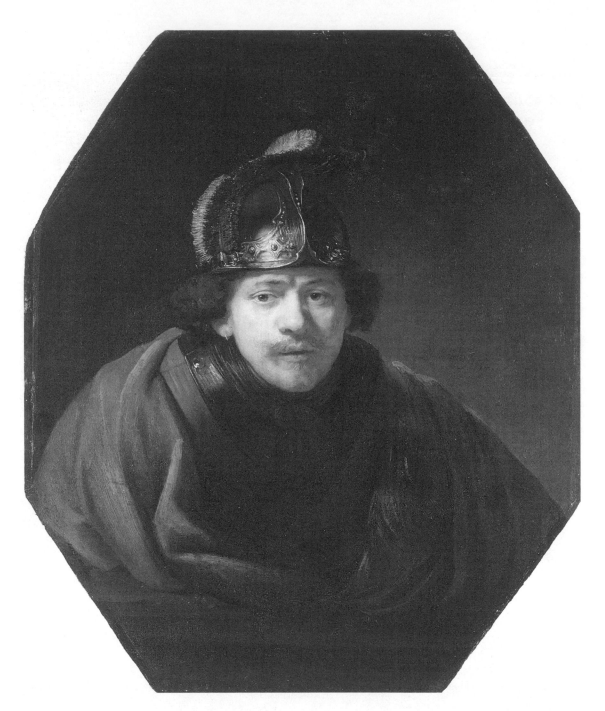

FIGURE 39

(Above) Rembrandt, *Self-Portrait with Helmet*, 1634. Oil on wood. Staatliche Museen Kassel.

FIGURE 40

(Opposite) Rembrandt (?), *Bust of a Man with a Plumed Cap*, ca. 1635–36. Oil on wood. Mauritshuis, The Hague.

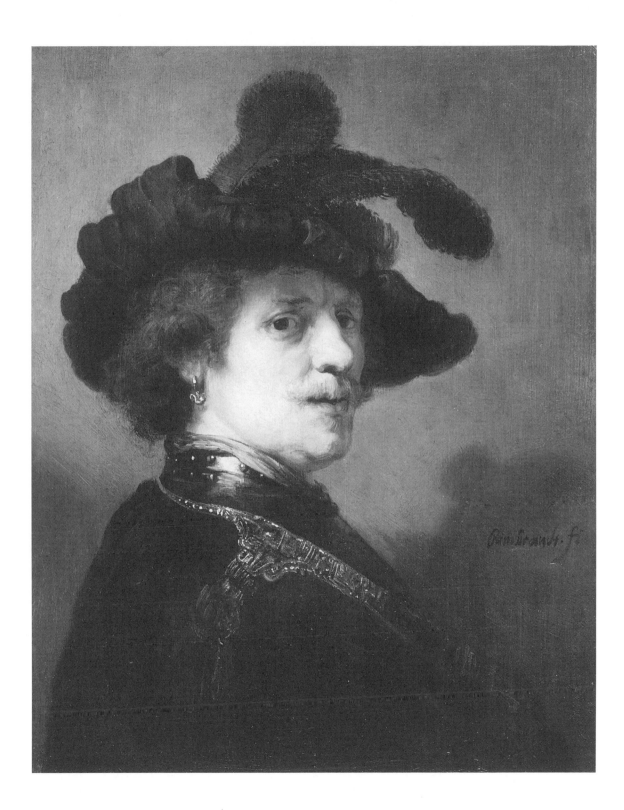

be imitating the citizens of Venice rather than Spanish Grandees," and that their portraits "tend to stress . . . qualities of sobriety and moderation," which, Smith insists, were not alien to Castiglione's "ideal of aristocratic decorum."[26] Rembrandt's Capitano is understandable as an image that violates these norms: a Grandee, a paragon of sartorial immoderation, another embodiment of *affettazione* or failed sprezzatura.

These examples are meant to suggest in a cursory way what it means to view the self-portraits as constituting a field in which different kinds of pose, dress, and painting (various mixtures of rough and smooth facture) speak to each other and engage each other in ways that open them up to what we nowadays call "suspicious reading." But suspicious reading to what end? How do we link these effects to the theme I defined as the critique of the politics of representation? The linkage is compactly described by Alpers in *Rembrandt's Enterprise*:

> The type of patronage in which the patron/buyer encouraged the professional to identify with him and hence serve him socially . . . flourished in Europe along with the new academies. Vasari, for example, a founder of the artists' academy in Florence, had favored an artist on the model of the educated courtier. . . . We can see marks of the social identification of the artist with the patron/buyer by comparing Bol's *Self-Portrait* with his portrayal of other sitters: he clearly fashioned his own image after theirs.

> Portraits of artists . . . proliferated in the Netherlands . . . and the Medicis' famous gallery of artist's self-portraits is representative of the interest in them that princes had. Their requests might specify, as the Medici agent did to [Frans van] Mieris, that the artist paint himself in the process of painting or holding some small work with figures by the painter's hand. In self-portraits of this type, the established order was defined and confirmed: the servant of the prince delivered an image of himself which served a certain social order and a certain notion of art.[27]

This service has never been more directly or engagingly depicted than in one of the works in the Medici collection, Carlo Dolci's half-length self-portrait of 1674 in the Uffizi (pl. 20). Dressed in formal attire, the artist holds up in one hand a small drawing—a portrait bust—of himself at work.[28] The drawing is inscribed to the royal patron (*Per Sua Alteza Regissima*). It shows the painter in profile with palette, brushes, work hat, spectacles halfway down his nose, a smudge on his cheek, painting with mouth open in rapt concentration. In a classic example of absorption, the

expression combines with the profile view to shut the observer out. By contrast, the figure holding this image is a classic example of theatricality. He looks over his shoulder at the observer, his head cocked and brow furrowed in an attitude of quizzical or apologetic deference that signifies the act of delivery mentioned by Alpers. The scenario implied by the double portrait is that the artist isn't sure the recipient will appreciate the gift of a portrait that displays her servant busy at his messy craft. The larger portrait offers this image of tactful concern as the real gift. The double portrait as a whole thus anticipates and disarms objections; by acquiescing to the patron's desire, it performs an act of courtiership.

If we imagine that the portrait bust represents a moment in the production of the picture that contains it, we confront a comic version of the dilemma described in some phrases from the epigraphs to Chapter 14: "An artist is always at a certain disadvantage when he paints his own portrait"; "a drama whose internal thrust is precipitated from insufficiency to anticipation . . . and . . . to the assumption of the armor of an alienating identity." Or, to put it in more prosaic terms, Dolci's self-portrait dramatizes a rupture in the series of dispositive stages that produces a socially acceptable dissemblance. It divides the production stage of the apparatus, the act of portrayal, into its front- and back-room components, posing and painting. The sharp contrast between the two images further dissociates them and insulates the artist as sitter and courtier from the painter at work. By conspicuously including what the official self-portrait conspicuously excludes, the double portrait comments on the strategy of self-negation and self-idealization that serves "a certain social order and a certain notion of art." Finally, the very ingenuity of the composition—itself a trivial accomplishment—contributes to this effect. As a dissemblance, Dolci's portrait indexes at least two discrete periods of production, one of them requiring a complex arrangement of mirrors, and thus it blandly, suavely, proclaims its own impossibility. This is sprezzatura with a vengeance.

In its melodramatic way, the Dolci self-portrait makes a point that applies to the interpretation of all portraits. to read a portrait indexically is to imagine its drama in a temporal framework. Because I premise that the completed portrait represents the act of portrayal that occurred in the past moment, which I'll call the *specular moment*, I am led to conclude that the painter/sitter designed his performance for the benefit of observers in the postspecular moment of the completed portrait. Then, he looked in the mirror and prepared the pose to be painted; now, the figure he painted

looks at or toward the observer. It is by distinguishing and correlating these two moments that we inscribe an intention in the very structure and appearance of the self-portrait: the intention to perform an act of self-interpretation that will be "bought" by whatever spectatorship the painting creates when it becomes available for display. In turning back to Rembrandt's self-portraits, I want to begin with an attempt to show the difference this temporal scenario makes to what we see and the way we interpret it.

16

MARKING TIME: REVISIONARY ALLUSION
IN SPECULAR FICTIONS

For this demonstration I choose two self-portraits in the Louvre, both dated 1633, and both assumed by many commentators to have been painted in emulation of Flemish baroque models, specifically Rubens and van Dyck. Let's call the softer more decorous Rembrandt who wears the beret the Count (pl. 21) and the hatless, more rugged and soldierly Rembrandt who wears the gorget the General (pl. 22). The differences in facture and background sharpen the contrast: the Count's beret domesticates his contours, enhances plasticity, and sets him off against a background that displays by its relatively smooth painting the hand of the Good Boy; the General is clearly more offended by the sketchy brushwork of the Bad Boy, who messes up his hair and generates a flickering aura that suggests an *esquisse* dashed off outdoors in cloudy umbrage. General Rembrandt glowers under a van Dyck sky.

The chief iconographic accents in the paintings are the Count's beret and the gold chain worn by both figures. The chain signifies royal favor, rank, achievement, and similar good things. In classical times it was a reward for military valor, and Renaissance princes bestowed chains on van Dyck, Rubens, Titian, and a few other famous painters, but not Rembrandt. He bestows it on himself.[1] As for the beret, Rembrandt frequently depicts himself in one or another version of it, accompanied by pretentious togs that are often about a century out of date. The association of the beret with the artist goes back to the sixteenth century. Chapman claims that at first artists wore the beret because it was fashionable and later, when it was no longer in fashion, "because of its traditional associa-

tion" with their art; also, the "intellectual connotations" that derive from its use by scholars made it a symbol of genius, learning, and the poetic spirit; therefore, she concludes, in the self-portraits in "historicizing costume" Rembrandt's beret "enhanced his virtuoso image as . . . the learned painter who lived and practiced his profession in the light of the great masters of the past."[2] But some of the assertions with which Chapman supports this iconography veer toward a different conclusion:

> By the time the artist had achieved sufficient status to consider himself a worthy subject for an independent portrait, he began to wear the fashionable garb of his courtier and humanist clients. . . . Cock's series [of portraits of Netherlandish artists presented them] . . . as learned gentlemen by modeling their portraits after a humanist format . . . and by clothing them in the fashionable attire of their educated, often noble patrons. . . . [Rembrandt's] concept of his profession predisposed him to the virtuoso gentleman-artist type of portrait favored by Rubens and van Dyck. (49)

These statements indicate that the beret's "traditional association" was not with art and artists per se but with artists posing as patrons, and more generally with the values and motives of the traditional apparatus of courtly patronage they embodied and affirmed by dressing up as aristocrats.[3] It was part of the ideogram of public meanings—culture, status, rank—condensed in performances produced by the symbiotic interaction between great masters and great patrons, between the conventions of portraiture and the conventions of behavior. What the beret as symbol enhanced was the image not merely of a positional role (the virtuoso artist) but of the instituted relation, the regime, the ideology, that produced the role and that each new performance reproduced.

Assuming, then, that Rembrandt uses the beret to make some statement about the apparatus and politics of patronage and his relation to it, it remains to be seen whether, in the case of the Count, the statement is nasty or nice. Let's begin with the gesture of the Count's gloved hand. Commentators have noted that in several van Dycks the hand on the breast is a sign of social class, and I can well imagine that Rembrandt's Count wishes he were van Dyck's Count, that he is trying hard to deploy his hand in an expressive gesture of social class, perhaps quietly directing attention to the chain.[4] But I don't think he succeeds. His hand has been characterized as "resting" on his chest and "holding" the chain.[5] Yet the

sketchy delineation of the glove, the restless changes of light, and the overall effect of animation challenge that reading because they make the gesture appear momentary—make the Count appear to be *fussing* with the chain. And this accords with some of the many adjectives commentators have sprayed at the painting, from "thoughtful" and "reserved" to "worried" and "uneasy." The gesture hints at uncertainty about the effect the sitter is trying to convey. Even more telling in this regard is the direction in which the sitter looks. Here, as we'll see, it's important to take into account the difference between the specular and postspecular moments— between the fiction of the sitter gazing at the mirror and that of his gazing at observers.

As my attention flickers back and forth between the sitter's hand and gaze, it becomes clear that the direction is not determinable. The slight tilt of the Count's head combines with a slight cast in the eye. In both figures the eye on our left is turned exotropically in relation to the other eye, rendering even more dramatic a change that occurs when we imagine someone gazing in a mirror: since the figure reflected on the surface of the mirror is much smaller and nearer than it appears owing to size constancy and the illusion of depth, the gaze appears to take in more and thus to be more diffuse (the angle of convergence being adapted for greater depth).[6] This intensifies a shuttle or flicker effect that prevents us from reading the sitter's gaze as unequivocally fixed on the eyes either of the observer or of the specular image. In fact "gaze" and "fixed" don't adequately describe what—given the overall suggestion of movement—may also be read as a glance. The sitters *could* be glancing at us. But they could just as easily and at the same time be glancing at the chain in the mirror. In oscillating back and forth between these possibilities, we narrativize the specific unease of sitters uncertainly poised at the juncture of the specular and postspecular moments. Of our two heroes, the Count's is the more critical condition. When the veil is drawn aside on the opening night of his postspecular run, he's still at the mirror, fidgeting with the chain, trying to make it cascade with appropriate chic, and not fully satisfied with the results. The painter's importunate brush, working (as expert investigators tell us) "with great energy and directness," won't give him the time he needs to settle his pose in a more confident gesture.[7] He has a right to look anxious.

The General is better off: with the golden rosette nicely perched on the near shoulder, his chain is roughly where he wants it, whether we like it

or not. The only thing that could conceivably trouble him is that the painter is expending more time and labor on the rosette than on all the other parts of the portrait combined. This no doubt accounts for the problem noted by expert investigators when they complain, as if reading the General's mind, that "the execution is of an uncommonly sketchlike nature" and "one wonders whether it may be incomplete."[8] The experts forgot to exempt the rosette and gold chain from their general verdict: the rest of the portrait is clearly the foil that sets this jewel off. It might be objected that the General has little reason to be disgruntled, since the item on which the painter lavishes his skill is no mere trinket but the symbol of honor and mark of distinction. To this the General could respond that the brilliantly illusionistic treatment of the symbol tends to desymbolize it, diverting attention from its significance to its visual splendor and materiality—and to its paintedness, which diverts admiration from sitter to painter. The gold semblance built up out of what one writer calls "thick stipples" of paint is conferred on the General by the artist, but as the token of his own achievement in painting it.[9] The painter uses official portraiture as an excuse to compete with his subject in the pursuit of honor. You might even go so far as to suspect that the sitter loosely bound up in a chain of paint is the site of the painter's self-representation. "We are not amused," mutters the General. Next time he goes back to van Dyck.

I noted earlier that the Count and General are assumed to have been painted in emulation of Rubens and van Dyck. I want to question the tense of the verb "have been painted," because it betrays a genetic interest in what the painter did back then—his actual practice—whereas my interest is confined to what the painting does in its *now*.[10] As I explain in Chapter 21, my concern is not with influence, imitation, emulation, borrowing, etc. as genetic attributions but with the interpictorial category of revisionary allusion that reverses the genetic lines of interpretive force: we speak of the influence *of*, but of an allusion *to*, van Dyck. Revisionary allusion is operative only if it is conspicuous as an effect of representation: a painting that alludes to van Dyck is one that identifies itself as looking like van Dyck and comments on that look.[11] Parallel to the indexical relation of the portrait to the act of portrayal is the indexical relation of the portrait to its targets of allusion. The convergence of these relations transforms artistic competition and comment into a more general comment on the conventions and politics of official portraiture, for the look of van Dyck, or Rubens, or Titian, or Raphael implicates the look, the style, and

the tastes of the patrons they depict. The symbiosis or complicity between the power of the painter and the performances that legitimate courtly power is nicely suggested in the following observation, which I cited and discussed in Chapter 9: "As versions of . . . [official] portraits circulated throughout Europe, foreign visitors probably expected princes to appear as they did in their portraits, and, in such a situation, the princes would have been to some degree obliged to conduct themselves as they appeared in their portraits."[12]

When revisionary allusion is embedded in self-portraits of the painter as patron, the stakes of parody or critique are raised. The allusion to painters who always in effect paint others in their own image or "style" combines with the reverse allusion to painters who paint themselves in the image of those whose wealth or authority entitles them to get painted. As we saw in Chapters 10 and 11, that image took various and sometimes conflicting forms influenced by the opposition of civic to courtly interests and by the shifting relations between regent and aristocratic modes of self-representation. Behind Chapman's discussion of "Rubens' tremendous but equivocal pull on Rembrandt," we may discern the pressure, the problematic, of embarrassment I discussed in those chapters:

> Rembrandt's Louvre self-portraits allude, primarily through their chains, to the ideal of the honored, gentlemanly virtuoso artist embodied by Rubens. But although Rembrandt assumed Rubens' role he could not have lived up to it. Rubens was a court painter, scholar, knight, and diplomat, and his identity as an artist, like his chain, was linked to these diverse positions. Rembrandt, in contrast, had received no chain and could not claim noble rank. Indeed he had settled in *burgerlijk* Amsterdam, and his relations with the court were perhaps already becoming rather strained. He could not appropriate Rubens' professional identity without transforming or transgressing it.[13]

Notice that Chapman uses the present tense ("allude") in the first sentence but the past tense in the others, which supply the historical information that supports her reading of the allusion. Because the reading emphasizes the constraints that prevented Rembrandt from identifying more closely with his model, it begs the question of whether or not he may have wanted to live up to and appropriate Rubens's role, and it fails to interrogate the paintings themselves for indications of an answer to the question.

To take the question into account is to shift attention from past constraints sanctified by their archival aura to the possibility that the response

recorded in the *now* of the paintings may be elective and optative, and that the act of self-portrayal may even display a critical attitude toward the constraints. This allows us to see in both the Count and the General a complex parody that operates on two levels. First, in staging the drama of artistic emulation, they simultaneously express the sitter's desire to play the gentleman painter and frame the expression in ironies that embarrass the desire. Second, the parody targets not only the separate self-representations of painter and patron but also their interdependence.

More than an index of the self or mind or artistic temperament "behind" the face, the official portrait is "an ideogram of 'public' meanings condensed into the image of a human face."[14] These meanings are shaped and confirmed by the way power shuttles back and forth through the dispositive stages of the apparatus, not the least important of which is emulation, in which the sitters' roles created by artists derive and depart from those previously created by other artists. Because "nature" imitates art, the painters' dependence on each other—their commitment to emulation—gives them an important voice in the articulation and maintenance of courtly norms. And yet, of course, in competing for the status and rewards patrons have the power to bestow, they confirm the patron's power over the production and producers of painting.

Rembrandt's parody of portraiture is thus also self-parody. Its object is less the representation of particular patrons by particular painters than the representation of their complicity in the apparatus that helps maintain the traditional institutions of patronage, a complicity that is both competitive—painter vies with painter, patron with patron, painter with patron, patron with painter—and collaborative, the results of competition testifying to the common structure of desire implicit in the social arrangements that motivate the discourse of commissioned portraiture and are sustained by it.[15] Shining through the individualized images of Rembrandt as Count and General are the generic images both of the patron constituted by the prevailing Flemish fashions of portraiture and of the painter who simultaneously celebrates and mocks the models he emulates, the patrons he simulates, and his own desire to overgo the former and become the latter. In Chapters 17, 22, and 24, I shall discuss self-portraits that comment in a similar manner on other fashions, one Dutch and the others Italian.

REMBRANDT AS BURGHER: WAITING
FOR MAERTEN SOOLMANS

Plate 23 is dated 1632, which means it was painted a year before the Count and General. Commentators single it out as the only self-portrait in which Rembrandt portrays himself in the relatively restrained, but still fashionable, uniform of the wealthy Amsterdam merchant. In one of his finer moments, Kenneth Clark notes that Rembrandt is doing "his best to conform" by taking on "the protective coloring of the class he adopted— or which adopted him," the class Clark describes as "the prudent cheese-faced merchants" who "bored" Rembrandt with their "black clothes" and "stiff white linen." Clark distinguishes this one-member class of self-portraits from two others that contain several members. On the one hand, he contrasts it to the self-portraits whose fancy getup protests against the merchants' "sobriety both of dress and behavior." On the other, he sets it against self-portraits that depict the sitter as a Bad Boy "scowling or snarling."[1]

Clark uses the snarling self-portraits to tell the story of the painter as the Bad Boy from Leiden who "decided to seek his fortune in Amsterdam." The narrative formulas that shape his story derive from the unpleasantnesses of the 1960s and 1970s: "This present age," Clark lectures us in his most civilized BBCese, "is not the first in history in which young men have been angry and contemptuous of polite society. . . . Since it is usually young men of talent who are angry, it is the angry young men who are successful, and this can be a source of embarrassment to them" (14). As Clark turns his lordly eye from John Osborne's unwashed generation to the boring prudence of the acquisitive class, you half expect him

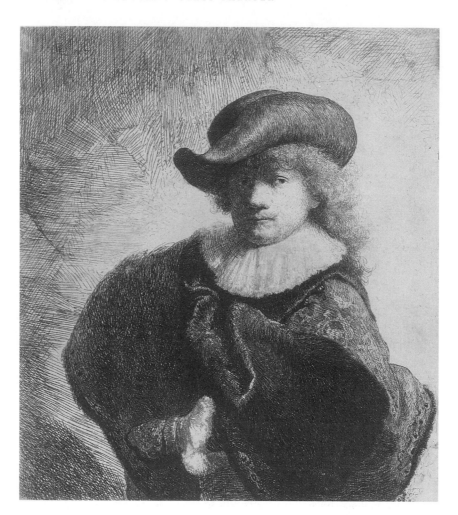

FIGURE 41

Rembrandt, *Self-Portrait*,
1631. Etching. Bartsch 7,
8th state. Rijksmuseum,
Amsterdam.

to aim his tart epigram at Rembrandt. But luckily he finds that success
didn't spoil or worry Rembrandt, "and in 1631, the year after the snarling
portrait, he did an etching of himself [fig. 41] smartly dressed with
cocked hat and cloak and clearly well-pleased with the results of his new-
found prosperity" (16). Clark refers to this etching—the title of which is
obviously The Mad Cavalier—as "the first of the 'show-off' portraits,"
and this is the context for his remark about the unusual restraint of the
Burgher.

The problem with this reading is that the Mad Cavalier bears an in-
teresting genealogical relation to the Burgher. An earlier state of the
etching depicts not a Mad Cavalier but a Dutch Gallant (fig. 42), which
expert investigators identify as the source of the Burgher. They note that

the Gallant's body "faces left, exactly as it does in the painting" but that the hat, "and to a slightly lesser extent, the head are . . . an exact mirror image of those in the painting." So they conclude that the Burgher combines "the body drawn on the print with the head and hat as the artist drew them (reversed relative to the print) on the etching plate."[2] If you compare the two states of the etching, you can see that, while the Mad Cavalier appears quietly to be struggling to control what resembles a straitjacket as much as an oversized cloak, the air of the Dutch Gallant is, as Clark might say, more "prudent." The development from the Gallant to the Cavalier reveals the ease with which Rembrandt's image of restrained Dutch elegance can be transformed through ceaseless doodling into its Italian congener, and it offers visual evidence that supports the attempt of some scholars to demonstrate the influence of Italian courtly fashions on the poses assumed by wealthy Dutch patrons.

Since the Burgher is dated a year later than the Gallant, and since it is one of the few painted self-portraits in which the body is turned toward the left, I find it hard to resist seeing it as an experimental modification of the Gallant, and to entertain the following fantasy of its genesis: the painting is a hybrid; the body was copied from the etching and the head from the mirror. But the more pronounced frontal orientation of both head and body produces a much less jaunty image. The lips are fuller, the eyes rounder, the nose thicker, the jaw lines softer, the visage as a whole fleshier. Furthermore, there's something a little odd, or uncomfortable, about the placement of the burgher head on the burgher body—as if the painter took a cardboard cutout or a mannequin's headless torso, dressed it up in a wealthy Amsterdam Patron suit, and stood behind it. The relatively sharp contour edge circumscribing the moonshaped face accentuates this effect. However it was actually produced, the normative scenario indexed by the image suggests—even in the strictly specular terms I just proposed (the face behind the cutout)—a complex and calculated act of hybrid composition that the sitter, theatrical in his restrained composure, seems blandly to ignore. The thought that the Cavalier, the Gallant, and the cheesefaced Burgher all represent the same sitter produces—at least in me—a very strong inclination to giggle. Let me try to explain why.

The Burgher may be unique in its Dutchness but it is a variation within—a member of—the class of self-portraits that represent the sitter as someone who would like to, can afford to, has the power to, is expected

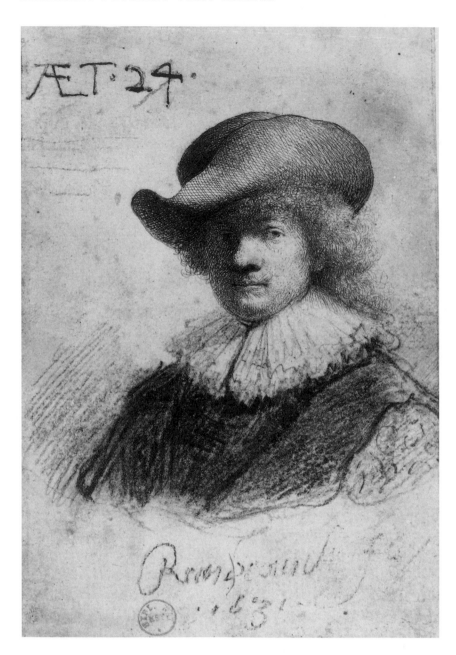

to, hire fashionable artists and get himself done in paint. Following the
principle that like attracts like, the sitter represents himself to postspecular
observers, potential patrons, as a Good Boy who knows and shares their
tastes, and whose studio is equipped with everything necessary to facilitate
the replacement of his features by theirs—including cardboard cutouts

that provide the "protective coloring" they can stand behind. He has moved to Amsterdam, set up his shop, hung out his signboard, and now patiently awaits the inevitable visit from the moonfaced Maerten Soolmans (pl. 12) and his fashionable friends. He offers his gaze to theirs as an exhibition of their gaze, a gaze that exhibits itself to be seen; the respectful mimicry of an earnest, well-fed, properly dressed, patient, and docile candidate for commission. What he does not offer, what he withholds, what constitutes his relation to would-be patrons as that of a voyeur, comes into focus when we situate this singular image in the gallery of Rembrandt's self-portraits, where it is surrounded by a collection of dandies and boors whose impish postures the Burgher's "smooth, naive countenance" conspicuously excludes. To register the force of that exclusion is both to acknowledge the innocence of his postspecular address to the world—an innocence that aims to disarm and pacify the spectator's gaze—and to find it a little bizarre. He shows that he knows that we know that he knows we are gazing at him. The head projecting from behind the body advances suavely on one side but withdraws coyly on the other.

It might be reassuring to shift from this direct engagement to the specular fiction. We may then explain to ourselves that the gazer in the mirror turns his face off center to catch the light for a better view of the pose he performs. Does he aim to disarm and pacify himself? The gaze of self-appraisal is round-eyed, blank. The shape and position of the cocked hat—his chief concession to dandyism—raise one eyebrow. And here, once again, reassurance is denied by a muted expression that invites decoding, offers possibilities: hints of surprise, of satisfaction, of faint amusement—responses to an apparition that isn't entirely familiar, questions addressed to the mirror: Can you believe this? Do you buy this? Will *they* buy this? But over such interpretive fantasies the poker face prevails; he gives nothing away, except that he is working on the pose and hiding behind the semblance of the patron for whom he serves as place-holder. The aggressive bravura of the Mad Cavalier, the more restrained but still stylish attitude of the Dutch Gallant, are carefully damped down. The sitter in this portrait is *such* a Good Boy; plump and portly; Maerten Soolmans *avant la lettre*. Hardly a trace of self-parody or patron-parody remains; only a trace. The trace becomes more pronounced as soon as we return to our senses and remember that the sitter didn't spend all his time staring in the mirror. The specular fiction allows for action as well as reflection and contemplation. Holding the pose is contained within it as one set of pulses in

an alternating current, the other of which is painting the pose. To imagine the activity screened out by the placid, pokerfaced Burgher is to envisage the specter of the Bad Boy behind the scene. I know the burgher ideal represents an act of portrayal different from the one that actually took place. He knows I know it, and blandly stares me down.

18

METHODOLOGICAL INTERLUDE III:
TEXTURE VERSUS FACTURE

When we shift attention from the self-portraitist's posing to his painting, we open up questions about how the act of painting is represented. Is the work of the hand "erasive," self-effacing, or is it preserved in visible facture as the record of precisely the activity screened out by the pose? How does the presence or absence of visible facture contribute to the fictions of the pose? Suppose we begin with a binary opposition between relatively invisible and visible facture, unfold it into a polar continuum, and apply the continuum to the analysis of individual paintings and groups of paintings. How will the interplay between the visible and the invisible affect the meanings we ascribe to fictions of the pose? Such questions are complicated by an ambiguity in the concept of invisible facture: analysis of the effects produced by smooth or erasive painting implicates one kind of invisibility; analysis of the underlying layers in the buildup of paint structure from support to surface implicates another. The first is an invisibility of the surface perceptible to the observer's eye—a relative and visible invisibility determinable by comparison with more visible passages of facture in acts of discrimination that presuppose the interpretive framework of the polar continuum. The second is an invisibility of the depth not perceptible to the naked eye and accessed only through radiography and the other techniques utilized in projects of attributional connoisseurship and conservatorial science. The distinction between these two kinds of invisibility is often overlooked, yet it is critical to any responsible practice of interpretation. What follows is an attempt to elaborate a theoretical basis for the distinction.

If paintings could speak, the statement the self-portraitist would make in his painting is not "I am painting this" but "I have painted this," with the latter being an indexical sign of the former. The relation of the pictorial statement to the moment and agent of production may be modeled on that of the *énoncé* to the *énonciation* or of the written statement to its writing. The "I," the agentive shifter in the pictorial statement, is similarly alienated from the agent who made the statement. This alienation makes it necessary for us to distinguish the kind of interpretive act we direct toward the statement and its shifter from the kind we direct toward the agency of the maker. The distinction, once again, is that between genetic and aesthetic interpretation. Analyzing material traces to learn something about the act encoded in "I am painting" is a different procedure—operates according to different criteria and with different objectives—from an analysis used to elucidate the meaning of the statement encoded in "I have painted."

In reports of genetic analysis undertaken for purposes of conservation, attribution, or dating, this distinction is seldom honored, and perhaps it doesn't have to be. Perhaps the aims of these projects make it unnecessary to distinguish traces as such from traces as represented effects visible to the eye without the help of microscopy or photography (X-ray, infrared, ultraviolet). It may not matter that analysis of the pictorial statement tends to be confused with or dissolved in speculations about its actual method of production. But in aesthetic analysis it does matter. Aesthetic analysis first limits the field of representation to what the unaided eye can see, and then marks the visible material traces as represented effects that are no less a part of the content or meaning of the statement than is the object of mimesis. Having said this, it's important to add that two other categories of visible traces may contribute to that meaning. One attests to intentional changes made during the act of painting, the other to structural changes that affect the material fabric of the painting after its completion. The first is the phenomenon of *pentimenti*, the signs that the painter has "repented" of an effect and reformed it: "When a painter changes his mind in the course of a picture and alters, say, the position of a leg, it sometimes happens that the old form will begin to show through in a ghostly way; this ghost is a *pentimento*."[1] Since *pentimenti* often surface gradually as the overpainting becomes more transparent, they may also belong to the second category, which consists of the alterations produced by time, chemistry, chance, and human design

(cleaning, repainting), which affect varnish, pigments, and the size or condition of the support.

"Visible material traces" is probably a misleading phrase because it seems to denote conspicuous texture, whereas I intend the phrase to denote traces represented erasively no less than those represented conspicuously. Our assumptions about painting assure us the traces are there even when, as in fresco and tempera, they are smoothed away.[2] But if we only had fresco and tempera to work with, my argument about the fictiveness of material traces would be gratuitous. The argument presupposes the field of differences retroactively constituted by the emergence of visible texture in oil painting, and especially in oil on canvas. Within the field of differences traditionally characterized in terms of the smooth and rough manners, comparative and contrastive relations are themselves potentially meaningful elements of painted fictions. As the intimate association of surface transparency with mimetic idealism suggests, they can have ideological as well as aesthetic significance, though this significance may be conferred only in the dialectic of revisionary allusion.

There is, finally, an important distinction between the fictiveness of mimesis and that of material traces. Mimesis represents itself as the illusory or imaginary depiction of an absent original, and it is illusory because of the material differences between image and original. Material traces are not imaginary or illusory—as they would be, for example, if the effect of paint texture were simulated by the crinkled surface of a reproduction. The traces explored in the aesthetic analysis of the statement "I have painted . . . " are materially identical with those explored in the genetic analysis of the act of painting. The distinction between them is purely analytic, a function of the different aims and criteria of the two procedures. Aesthetic analysis explores the way material traces affect the meaning of mimesis, and in that respect they function interpretively within the field of representation as elements of the fiction. Thus I use the term "fiction" to denote more than the imaginary, or illusory, or counterfactual character of mimesis, and I do so because the conventional identification of fiction with mimesis, based on material differences between image and original, has tended to obscure the specifically fictive dimension of material traces. Thus also I think it is useful to put into play a distinction between *facture* and *texture*. *Facture* denotes the work of the hand and its traces in the genetic frame of the *énonciation*, "I am painting," while *texture* denotes the represented traces in the fictive frame of the

énoncé, "I have painted." The distinction lexically sustains and reinforces the severance and alienation of the second from the first. My interest is in the texture that represents the facture rather than in the facture that produced the texture.

Once this distinction is made it becomes possible to take advantage of the insights into interpretation yielded by technical analysis of paint texture. One of the many valuable contributions of the RRP is its painstaking analysis and scrupulous report of the visible indices of the painter's work. Some of its comments on the Burgher (pl. 23) enrich the evidence on which the interpreter can draw:

> The top [layer of the] painting seems to have been rapidly executed; along the contours of the figure it has frequently been done wet-in-wet with the background.
>
> The background is done entirely opaquely in grey, somewhat lighter to the right than to the left. Especially in the lighter part it shows clearly visible brushwork, sometimes running parallel to the shoulder outline and further up set crosswise to it; elsewhere the background has brushstrokes running in various directions.
>
> The lit parts of the face are painted opaquely with a clearly visible brushstroke that follows the forms without directly producing modelling. . . . The mouth-line . . . [is] built up from a variety of brushstrokes. . . . The tuft of beard on the chin is done with strokes that can barely be distinguished one from the other. . . . The hair is . . . painted with somewhat woolly effect. The indication of form has been heightened with some fairly coarse scratchmarks (by the hat and on the right at the outline) and small, curling lines of paint. . . . The hat is painted in an opaque black, and is lent a strong impression of plasticity by a sheen of light done in grey and by the lively contours. . . . The ornament on the right is done cursorily.
>
> The collar, in white, greys and ochre, shows brushstrokes following the direction of the pleats. . . . The clothing is painted broadly. . . . The buttons and loops are formed quite roughly.[3]

Allowing for the RRP's occasional use of a magnifying glass and a microscope to abet the naked eye, we may isolate the observations that are accessible to normal viewing and pick out the significant variations along the scale from erasive to visible texture, and we may then ask how they affect the represented relation between the acts of posing and painting.

The brushwork that follows, accentuates, and builds up the plastic

form of the image reveals itself modestly getting out of the way of—dissolving into—"the shape being depicted," and, as the RRP notes of the portraits done in the 1630s, this effect is usually most salient in the "center of the face" and in the collar that "forms the basis for the head and determines its position in space" (2.10, 12). In the present case, however, the treatment of the "lit parts of the face" on the left is exceptional: the visible brushstroke feints toward transformation into plasticity—"follows the forms"—so that its failure to model not only converts a cue to depth into a cue to roundness that fattens the face, but also gives it a texture hovering between an effect of impasto ("painted opaquely") and an effect of paste that justifies Kenneth Clark's epithet "cheese-faced." In the peripheral areas of the painting, facture is evident as "noise" or "static" running crosswise to the form or cutting into the ground, but its effect is confined to minute passages. Comparison with other self-portraits in fancy dress, as well as with those of Clark's angry young man, marks the effect as a conspicuous gesture of understatement: the painter as well as the sitter is a Good Boy; he has subdued his more unruly tendencies and conformed to the canons of good taste that prescribe the smooth style for official portraits. And his commendable reserve is most apparent in the hat, where the "impression of plasticity" is considerably stronger than in the eight official-portrait hats of the patrons whose portraits during this period the RRP has assigned to Rembrandt. Yet this impression only serves to accentuate its departures from those hats: The off-center curl of its brim and the swirl of its ornament add a cavalier touch to the symbol of prudent investment, as if the painter couldn't resist the appeal of a more courtly, Rubensian bravery. But the touch is discreet, the ornament "done cursorily," and the whole effect is superbly spoiled by the chubbiness it crowns.

SPECULAR FICTIONS IN TWO ETCHINGS

The problems of specularity are compounded by the technology of etched self-portraits: the reversal of lateral coordinates we impute to the specular image is countered by the additional reversal that occurs when the print image reverses the plate image. J. M. Nash makes some suggestive observations about this problem in his comments on the 1648 self-portrait of Rembrandt drawing or etching by a window (fig. 43) and the 1636 self-portrait with Saskia (fig. 44).[1] He claims that in the former, Rembrandt appears to be drawing or etching with his right hand, and in the latter to be holding a pen or etching needle in his left hand. But this is already assuming a lot, and the lack of unanimity about what Rembrandt is doing in these two etchings testifies to their perplexing character. Of the 1648 etching we are told that: (1) he is "drawing at the window"; (2) he is "drawing (perhaps etching)"; (3) "he can only be etching"; (4) he is "sketching."[2] Of the self-portrait with Saskia we are told that: (1) he holds an etching needle in his hand; (2) he is drawing; (3) he is "drawing (or perhaps etching)"; (4) he has "something like a pen in his *left* hand."[3]

The reasoning behind the last opinion, which is Nash's, is strangely arbitrary. He argues that, whereas in the 1648 self-portrait Rembrandt etched what he saw and let the printing process transform the result from a specular to a counterspecular image, in the double portrait "he did alter the reflected image and so end with a print showing the artist," again, in counterspecular relation to the observer.[4] But why do we have to assume that the print represents only the artist gazing and not also what he gazes at, the specular image in which the mirrored *right* hand is visible? More

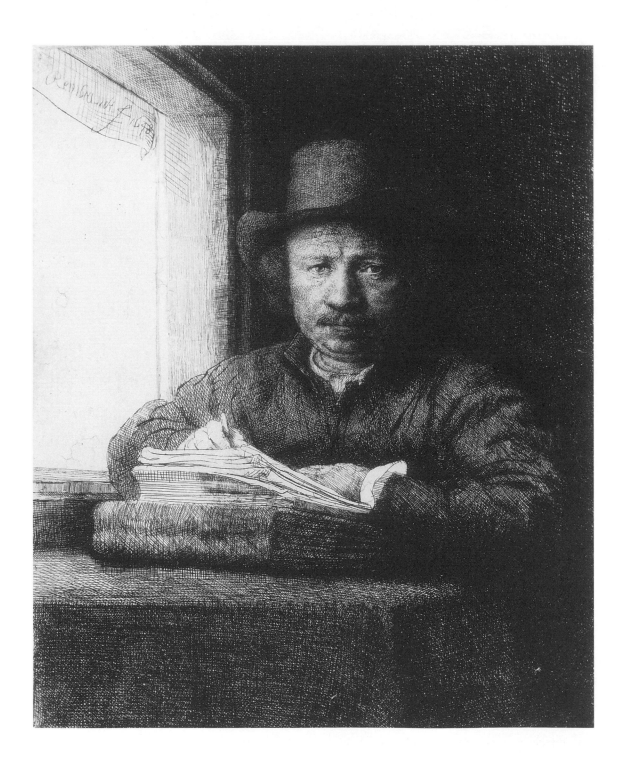

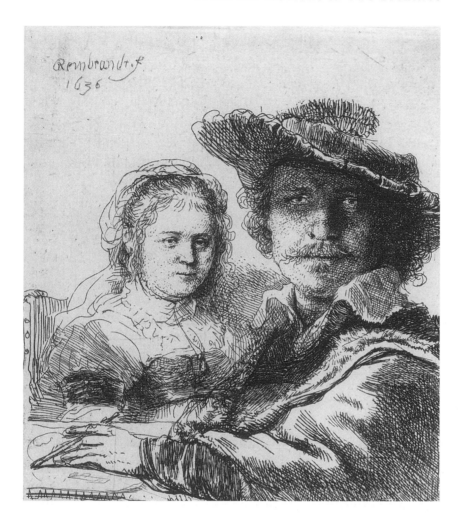

FIGURE 43

(Opposite) Rembrandt, *Self-Portrait Drawing at a Window*, 1648. Etching. Bartsch 22, 2d state. The British Museum, London.

FIGURE 44

(Left) Rembrandt, *Self-Portrait with Saskia*, 1636. Etching. Bartsch 19, 2d state. Teylers Museum, Haarlem.

important, does the difference between the two possibilities translate into a difference of interpretation or is it simply an instance of hair-splitting? Can it, for example, affect—alter, sharpen, or substantiate—an already-existing interpretation that has not taken it into account? I shall explore these questions by considering each of the two etchings in the context of a previous analysis.

In one of the most fully developed treatments of the 1636 double portrait, David Smith emphasizes the qualities of intimacy and privacy suggested in part by the table around which

> Rembrandt and Saskia carry on their daily activities, apparently only briefly looking up at the beholder. . . . There is more than just a sense of

momentary interruption in the gaze of Rembrandt and Saskia. There is also a sense of distance, of the exclusion of the beholder from their company, that belies the proximity inherent in the half-length format. Their faces are blank, unshaped by any trace of decorousness or polite interest. . . . Setting them around a table provides a readily grasped framework for their interaction. Yet at the same time, the fact that the near figure in a sense mediates between the beholder and his companion on the other side of the table leaves open the possibility of turning intimacy into exclusion.[5]

Smith responds primarily to the counterspecular fiction, pausing only at one point to mention the alternative in a comment whose potential interest is derailed by an irrelevant leap into the problem of the self:

The heightening of the tension between subject and beholder in this work surely arises in part from the fact that it is a self-portrait. Rembrandt may have meant the disengaged expression on his face to reflect the clinical scrutiny in the eyes of an artist examining his subject. As both the beheld and the beholder, he is here playing on the ambiguities of his relationship to himself as well. (139)

At one or two points, Smith, in my opinion, misreads what he sees. The sitters do not appear to be "briefly looking up at the beholder" but steadily fixing on the object of their gaze. Also, his characterization of their blank expression as "unshaped by any trace of decorousness" is a little off the mark, given the male sitter's feathered beret, fur shawl, and collar.[6] As in so many other self-portraits, Rembrandt depicts himself in fancy dress, but this is the only one in which the elegant sitter also represents himself as an artist, and I think this considerably modifies the meaning of his expression. If he is staring at himself, what Smith calls "clinical scrutiny" is better described as theatrical self-appraisal, an interrogatory rather than "disengaged" expression that conveys the sense of someone examining, or experimenting with, the pose to be represented. The suggestion of theatrical rehearsal is reinforced by an apparently minor touch, the position of the hand with the pen or needle casually and loosely but carefully placed between the middle finger and the raised forefinger.

If I shift to the counterspecular fiction, the blankness Smith mentions comes into focus, but it seems charged with the guarded and watchful look of a sitter appraising the observer for whom he holds his pose—or appraising the effect of the pose on the observer. And if I work my physio-

or pathognomic fantasy a little, and try to contrast the expressions on the faces of the two sitters, hers comes across as quizzical or curious, which, for me, intensifies his steady-eyed refusal to display any of the indices of the *affetti* that distinguish other self-portraits. Within the field of differences that characterize the Rembrandt look, his poker-faced refusal appears even more arch, and becomes aggressive: he challenges me to imagine what he thinks about the pose he concocts for my benefit; I respond defensively to the challenge and begin to wonder whether there isn't a shadow of amusement playing across the features he thrusts in my face. I suspect him of putting me on by overposing, and it worries me that he may think less of me because he finds my taste for such poses silly.

This comment on the politics and comic theater of representation gains force when we shift back to the preparatory moment implied in the specular fiction. The counterspecular parody supplies the aim of the performance the sitters design in the specular moment. I am then moved to imagine that the sitter appraising himself in the mirror may be putting himself on as well as me—performing a trifle obsequiously for the postspecular observers who expect and demand this sort of thing, accustomed as they are to the self-promoting rhetoric conventional in official portraits. Smith argues that in other portraits by Rembrandt and his contemporaries "the impression of intimacy depends in large part on the fact that the beholder's presence is not acknowledged"; the sitters have been "removed . . . from the rhetorical stage. . . . The etched *Self-Portrait with Saskia* marks a further break with that public, rhetorical ideal of social form," a move from intimacy to privacy effected by the way the sitters acknowledge the presence of beholders only to shut them out from the "intimate, ongoing rhythm of domestic life."[7] But I find it difficult to imagine that the artist participates either in that rhythm or in the practice of his art while festooned as a gallant in his Renaissance *chapeau*. If this is a depiction of privacy, it is the kind of depiction appropriate to "the rhetorical stage," and it conspicuously excludes the life that transpires off stage. What this account of the etching reveals, however, is not that Smith is wrong, but that many of his observations are suggestive and helpful, and can be supported or sharpened by modifications of the interpretive framework that activate the interplay between specular and counterspecular fictions. Smith's reading readily lends itself to the distinctions that a study of the interplay precipitates out.

Turning now to the 1648 etching, figure 43, I shall discuss it in terms

of the interpretation advanced by Nash.[8] He insists that Rembrandt "can only be etching, and etching the plate of which we now see the print," and he confesses himself puzzled by the print

> because it is so clear and direct. Manifestly, Rembrandt sat down before a mirror, placed a copper plate on a pad of papers, gazed at his reflection and depicted what he saw. That was all he had to do, and all he appears to have done, to produce an image not of what he saw before him, in the glass, but of what another present might have seen. The mechanics of etching have corrected the inversion imposed by the mirror. On the evidence of the Kenwood and Louvre self-portraits, this is exactly what Rembrandt would have wanted.[9]

A little further on Nash states that "a knowledge of the processes of etching . . . leads us to recognize the genesis of the right-handed pose, to recognize its authenticity and, in consequence, to accept the veracity of the portrayal. The eyes we see are the eyes of a man staring into his own eyes" (240).

Because this parade of assertions moves a little too crisply, definitively, smartly, peremptorily past the two scenarios it describes, it fails to register the full effect produced by their dissonant structures. Starting with the assumption that since Rembrandt was right-handed the lateral indices produced in the double inversion are those of face-to-face rather than specular encounter, Nash generates the counterspecular fiction but weakens its force by phrasing it as "an image . . . of what another present might have seen." The point of this supposal is that it alters the meaning of what we actually do see: if someone else is present in the specular moment, the sitter must be gazing back at that imaginary observer. Nash goes on to link the assumption of right-handedness with the specular fiction of "a man staring into his own eyes," but he ignores the alternatives between which the assumption adjudicates: the etching must represent the seer rather than the reflection he stares at.

I have no trouble entertaining both these divergent hypotheses, because they aren't contradictory. Rather, like the Necker Cube, they oscillate back and forth from one state to the other; they create an ambiguity but not a paradox. The problem arises when I try to extract a coherent reading from the following array of claims asserted or implied in Nash's interpretation. First, the imaginary observer does not occupy the postspecular position separated from the sitter by the temporal gap the etching

mediates; she or he is contemporary with the sitter. Second, the sitter is etching as well as gazing. Nash asserts this only in terms of the specular fiction: the sitter is portraying himself. But the same hypothesis must also apply *mutatis mutandis* to the counterspecular fiction: he is portraying the imaginary observer. And this doesn't square with the conclusion Nash so emphatically draws from his analysis: Rembrandt "can only be etching, and etching the plate of which we now see the print." He concedes that "we cannot see what the artist is working at: the copper plate is concealed beyond a pad of papers. But in identifying a self-portrait we discover the work-in-hand: it is the print in our hands."[10] The revelation evokes a metaphysical climax: "The invention invisibly under way within the work is the invention before our eyes. The visible invisibly contains itself."[11]

When this premature eureka is spoiled by the intrusion of the counterspecular alternative—the work-in-hand may be the portrait of the imaginary observer—the concealment that enables Nash's discovery turns around and disables it. Consider the following ensemble of details: the angle of the pad of papers; the position of the left hand holding them down at the bottom; the low viewing point suggested by the foreshortening of the book on which the papers rest; the uninformative shape of an implement that may but need not be an etching needle; the calligraphic treatment that dominates, flattens, de-energizes, and distances the sitter's right arm; the possibility that what the specular fiction may interpret as an expression of effort and concentrated focus is crossed, in the counterspecular fiction, by a look one may interpret as quizzical, perhaps patient, perhaps even a little suspicious or protective, as if the sitter has been interrupted, and shields his work from view; the closely related possibility that the sitter may not be working on a portrait—he could, for example, be writing or taking dictation.

From these observations and inferences I conclude that the invention "invisibly under way within the work" is precisely what the etching prevents becoming visible, and it does this in so conspicuous a manner as both to tempt us to wonder and discover what it is, and to keep us from succeeding. The gesture that teases by withholding is characteristic of the Rembrandt look, and I have been arguing that its motivation may be understood in historical terms as a reaction, a revisionary allusion, to the dominant claims and aims of mimetic idealism, the discourse of art developed in Italy. Nash's desire to unfold the invisible contained within the

visible is an accurate reflection of those aims, hence his reading is not so much irrelevant to the etching as proleptically criticized by it.

Another aspect of the etching emerges when we cross the implications of the two fictions. Let's assume that in the counterspecular fiction the sitter is portraying the imaginary observer, while in the specular fiction he portrays himself.[12] If I view this from the postspecular position, I imagine, first, that the sitter is composing his self-representation and, as in the Kenwood self-portrait (pl. 30), preparing what can only appear as a calculated effect; second, that in the transactions represented by the complete work I am invited to replace either the imaginary observer or the specular image of the artist. The sitter performs the role of the artist at work, and the etcher designs this performance so as to suggest that whoever the sitter gazes at, or whoever gazes at him, becomes his subject, model, or sitter. The etching thus takes on something of the function of a business card or self-advertisement. But the conspicuously withheld work-in-hand then serves as a come-on: if we want to see what he is doing, what he can do, we shall have to engage him to be our portraitist. He demands our trust. And perhaps we can have confidence in the simple, straightforward, unadorned figure inscribed in his business card, a figure so different from the elegant and pretentious sitter in other self-portraits. This man of the people won't let us down. But he won't let himself down either. For whether I imagine myself to replace either the first observer or the specular self-image, he will, in portraying me, portray himself. His gift to me will be a Rembrandt, not a Berger.

As the Prodigal Son in a number of Utrecht works clearly takes on the characteristics of a self-portrait by turning his eyes to the onlooker, it was natural to present oneself in this role. There are several portraits by Rembrandt in the form of anti-heroes.[1]

20

MARRIED, WITH PEACOCK: SASKIA IN REMBRANDT'S LOOKING-GLASS THEATER

The self-portraits range across a polarized spectrum between dressing up and dressing down. Many of those performances are given a sometimes eerie, sometimes hilarious edge of self-mockery by the way Rembrandt exploits the fiction of the mirror to produce a kind of double plot and this effect modifies our reaction to such fancy-dress motifs as the macho thug, the thoughtful courtier, the gruff general, the dashing picture of *disinvoltura,* and the roistering bravo in the double portrait of Rembrandt and his wife Saskia presumed to have been painted around 1635 or 1636 (pl. 24). All of them have this in common: once you designate them as self-portraits and bring the fiction of the mirror into play, you can imagine them not only looking at you but also checking themselves out in the mirror. And you can see that in some cases the double plot produces a high if not unlimited ceiling of risibility. For what is being presented to the viewer is not only the representation of the sitter holding the pose while the painter paints and the viewer looks, but also the representation of an act of self-inspection that evokes the context of a dressing room or a dress rehearsal. checking the mirror and getting the effect right before going public; part of the preliminary negotiations between painter and sitter.

In this chapter I shall turn once again to the hypotheses about Rembrandt's theatricality developed by Alpers in order to test them on a particular painting, the Dresden double portrait in plate 24. I say "test" because my reading of the picture differs somewhat from Alpers's, and though the difference is for the most part strictly interpretive, it implicates questions of a more general sort about the formulation of the theatrical

model, questions that focus attention on the problematic links between iconographic analysis and the effects of the thesis that portraits (including self-portraits) represent acts of self-representation.

The double portrait was probably painted a couple of years after Rembrandt married Saskia van Uylenburgh, the cousin of the then-thriving Amsterdam art dealer with whom he had moved in and set up shop after leaving Leiden in 1631. Since he was getting a lot of commissions during the mid-1630s, it was long assumed that this was a picture of the Rembrandts Living It Up—or, in David Smith's words, "an exuberant expression of Rembrandt's delight in his wife and his new-found prosperity." But alongside this interpretation there was another, which began to get more attention in the 1960s: "the painting represents the traditional image of the prodigal son wasting his inheritance among loose women."[2] Is this a moralizing picture? A historiated portrait? A confessional image? A celebration of the good life? A critical parody of it? Maybe it isn't a portrait at all—not an act of self-representation but simply "a narrative scene, for which Rembrandt and Saskia served as convenient models."[3] Both figures, Chapman notes, are wearing old-fashioned clothes (some of Renaissance vintage) that "would have been familiar from contemporary theatrical productions."[4]

After running through several conflicting accounts, Smith concludes that agreement on the picture is unlikely, and that it may be better to leave this image alone and move on to others. A random survey of reactions to the portrait tends to validate this opinion:

> He idolized his wife and represented her in a long series of portraits and allegories, not always in good taste.[5]

> The painter has portrayed himself as a swashbuckler with a sword and plumed hat and a beer-glass in his hand, and Saskia looks hardly a lady.[6]

> Saskia, wearing a heavy green dress, sits on the artist's knee and looks back at us over her shoulder. Her expression is decidedly dignified in marked contrast to that of her husband, whose coarse ebullient features are wreathed in a grin. He wears a fur hat with an enormous white feather, and holds up a glass of wine to drink the health of the spectator and boast of his possession. He might be some bravo boasting of a conquest from a painting by Caravaggio or one of his Northern followers. The differences of upbringing and temperament are clearly stated. It was a marriage of opposites.[7]

It is tempting to think of this work as a reflection of the painter's self-satisfaction at having passed from promising young artist to accomplished and acclaimed master. . . . Moreover, one cannot help but think of the change in his standard of living from the modest but comfortable life in Leiden to the splendor of housekeeping in Amsterdam.[8]

[T]here is no question that the scene takes place in a tavern, not in a home.[9]

It would be an unfair judgment . . . to place the obvious interpretation on all this: i.e., Leiden miller's son, having won fame and fortune in the big city, revels in riotous living.[10]

We are left wondering whether this picture is a Bible story in which Rembrandt and Saskia serve as models, or a double portrait as biblical masqueraders. In calling the picture *The Prodigal Son in the Tavern* we must bear in mind that there is no other representation of this theme with so sharply marked a portrait character. Other painters were given to telling the story in contemporary terms, as an everyday occurrence, an occasion for jollity. Their genre-like interpretation of the Bible message was at odds with Rembrandt's predilection for a sincere and direct reading of the Bible.[11]

The part of jolly toper was not in his nature, and I agree with the theory that this is not intended as a portrait group at all, but as a representation of the Prodigal Son wasting his inheritance. . . . Nowhere else has Rembrandt made himself look so deboshed, and Saskia is enduring her ordeal with complete detachment—even a certain hauteur. But beyond the ostensible subject, the picture may express some psychological need in Rembrandt to reveal his discovery that he and his wife were two very different characters, and if he was going to insist on her higher social status, he would discover within himself a certain convivial coarseness.

Rembrandt's choice of subjects is never accidental, and from an early date he had felt himself involved in the story of Samson and Delilah. He was disturbed at the thought of what an ambitious woman could do to destroy a man.[12]

Husband and wife are turned towards the spectator with an animated expression of gaiety, and the pattern made by the couple has the freshness and irregular lines of a wild flower. . . . However, there is something forced in the laughing face of the painter. Laughter was not as natural to Rembrandt as to Frans Hals.[13]

Both figures look back over their shoulders as if conscious of the audience, but each acknowledges the beholder in a different way. . . . In contrast to Rembrandt's abandon, Saskia's upright rigid posture and stern, expressionless face convey a warning. . . . Rembrandt's . . . identification with the Prodigal Son suggests a Calvinist acknowledgment of man's inherently sinful, wicked nature and an affirmation of faith in God's grace. . . . [Yet he] takes obvious delight as a profligate, at the same time as he confesses his sins. . . . [This painting] would hardly have ingratiated him with wealthy Amsterdam merchants. It flouts their *burgerlijk* austerity and strict morality.[14]

The Dutch theater was fond of the Prodigal Son theme, and numerous plays based on this parable were performed, including modernized versions known as the contemporary Prodigal Son. It is in this light that this unusual double portrait must be understood. . . . Nevertheless, there is no reason to suspect that either the artist or his young wife felt any strong personal association with the Prodigal Son theme.[15]

The interpretation of the painting as a double portrait of Rembrandt and Saskia . . . [has] now to be looked on as superseded. That Rembrandt used himself and his wife as models must certainly not be discounted, and is accepted by most authors; but opinion differs on whether in doing so he was seeking to have his own person and that of his wife play a role in his iconographic programme. . . . [Those who reject the Prodigal Son interpretation are] making insufficient allowance for the girl playing a lute, who is admittedly no longer to be seen but who makes any idea of this being a portrait quite unacceptable. . . . [The painting should] not be seen as an allusion to their own actual lifestyle, but rather as a moral example.[16]

One scholar finds wine in the glass, where another finds beer. One finds Saskia ladylike, where another finds her unladylike. One finds the newly rich sitters enjoying "the splendor of housekeeping in Amsterdam" (presumably in their own home), where another finds them behaving like a vulgar swashbuckler and his tootsie in a brothel scene. Noting that in 1905 Carl Neumann was so offended by the portrait that "he concluded . . . it was not intended to be seen in public," Madlyn Kahr argues that, on the contrary, it is "a moralizing picture in the conventional mode of tavern scenes, with the traditional message that the pleasures of the senses are sinful and should be avoided."[17]

"Is this woman a prostitute or an innocent . . . maiden or wife? And is

the space she inhabits a bawdy house or a middle-class home? Nothing in the setting or the woman's elegant dress would make the second possibility unlikely."[18] The painting is conspicuously short on information about its locale, and except for one detail, the ambiguity these sentences by Helgerson attribute to ter Borch's "Paternal Admonition," dated almost two decades later, applies equally well to the double portrait. A relatively large picture, about 4¼ feet by 5¼ feet, it was originally horizontal in format and then cut down on the left side, bisecting the dark shape that depends from the upper left-hand corner like an inverted hotwater bottle. This item is the exception, for it appears to be a scoreboard used for writing down expenses, and often depicted in tavern scenes. According to the analyses made and recorded by the members of the Rembrandt Research Project, the painting in its present state has suffered equally from partial deterioration and aggressive retouching.[19] X-rays show that there was originally a woman playing a lute between the two figures. This would bring the scene closer to the genre of tavern and brothel paintings popular at the time among the so-called Utrecht Caravaggisti.

The picture could thus be categorized as a portrait, as a history painting (the prodigal son), or as a genre painting, a class-centered category that includes domestic scenes, tavern scenes, brothel scenes, festival or "merry company" scenes (both indoors and out), peasant scenes, wedding scenes, *and* artist's studio scenes. They also include a few double portraits of artists and their wives, for example, those of Rubens, Ferdinand Bol, Gabriel Metsu, and Jan Steen, the first two unambiguously decorous, while the Metsu and Steen are conspicuously indecorous tavern scenes. Only the Rubens (1609) preceded the Rembrandt. In none of these examples, whatever the social scenario the sitters are performing, is one partner piled on top of the other, like Pelion on Ossa. There is plenty of proximity and fondling in tavern and domestic scenes, and there may well be images of lap-sitting, but so far I have not found any—especially not in fancy dress. Laps tend to be for children and pets. One resemblance, cited by David Smith, is worth mentioning: plate 65 in Alciati's *Emblematum Libellus* (Paris, 1534) shows a couple sitting under Venus's apple tree with their right hands joined together; the emblem is entitled *In fidem uxoriam* and, according to Smith,[20] it is the source of the Rubens marriage portrait. Unlike the Rubens, the woman appears to be perched decorously on the man's knee. Smith reads the emblem's iconography as signaling a transformation from courtly to con-

jugal love. But as Rembrandt's variation on this pose suggests, what comes around goes around.

The specular double plot contributes much to the strange effect produced by our happy cavalier, or prodigal son, or whatever it is he so studiously pretends to be. The fiction of spontaneous merrymaking is paper-thin, for the cavalier's spontaneity seems posed, his merrymaking signified rather than enacted. Indications of motion are strongest in his vigorously modeled head and upheld hand, in the cursive sweep of his left sleeve, in the angle of the sword and the curve of the white plumes. But this movement is diminished by three passages: the incredible black beret, a vibrant silhouette virtually emptied of the third dimension and active as a form rather than as an object; the contour edges that still the unshaded flabby hand; and the open mouth, which, in context, seems *too* carefully detailed and therefore frozen in a pose (a black new moon) rather than glimpsed in a temporary gesture. This is the Rembrandt sitter asking his mirror whether he can pass for a Very Wicked Boy. Taking the full range of possibilities into account, we might think of the portrait as a rowdy precursor to ter Borch's wonderfully mistitled *Paternal Admonition*, and subtitle it *Marital Admonition*, understanding, of course, that the effects of ambiguity seem to be more unambiguously delivered in the Rembrandt.

The double portrait seems transgressively both to call up and to mix up several contextualizing categories, not excluding the one picked out by Alpers, the category of studio performance. The scene as a whole is suspiciously busy—even the blank wall is made restless by variable tone and texture—and the activity is crowded uncomfortably in the diagonal plane from the sword handle to the peacock. The couple leave little room for the table, and the objects filling its narrow surface are all incomplete, either partially screened or pushed out of the picture. The apparently rich design of the tapestry covering the table is rendered in the sketchiest fashion and drained of color. This holds true for all the still-life props, including the curtain. It is as if the painter had passed up the opportunity to let his brush run riot among the inventorial pleasures licensed by the conventions of still life and genre. The conspicuous refusal to describe, the rejection of graphic mimesis for optical values where we might expect the former to prevail, arouses then foils the visual appetite for the prodigal scatter of lovingly observed things; the appetite for the vanities that lead the eye astray and seduce observers into justifying their sin by converting trinkets, textures, and toys into moral tropes. This refusal redirects the ob-

server's attention toward the actors in the more focused theater of portraiture, and thus it raises questions about the relation of the posers to the narrative they perform.

A single vanity, however, ignores the restraining order against still-life detail and thrusts its glare into the foreground: the peacock in its pie. This detail threatens to transform the double portrait into a triple portrait. I take very seriously the bust of the peacock pouting in its pie; the peacock seems serious about it, too. Such pies frequently appear in merry company and banquet scenes in early-seventeenth-century Dutch painting, in pictures identified—often explicitly—as representations of the prodigal son.[21] Many things have been said about the peacock down through the ages, and most of them have been bad. The shower of iconographic abuse poured over this beautiful if loudmouthed critter includes vanity, envy, arrogance, disobedience, lust, and pride. It was the bird of Juno, dispenser of riches, and so of the evils riches bring. There was a brief glimmer of hope for the peacock in early Christian iconography: because its flesh was tough and hard to cook and took a long time to putrefy, it was rewarded with the honor of symbolizing resurrection. But St. Augustine soon turned this around by using the resistance to cooking and to rot in his proof that bodies may remain unconsumed by fire, and therefore that the souls of the damned can suffer the bodily pains they deserve. (*Sic transit gloria pavonis.*) That the peacock doesn't taste as good as it looks is among the complaints lodged against it. "Do you," Horace dryly asks, "eat the feathers you so admire?" (satire 2.2.27–28). Then why not settle for the homely chicken (*gallina* [24], actually a *hen*, to intensify the contrast)? The Horatian opinion is repeated in a seventeenth-century Dutch manual of medicine quoted by Chapman, after she notes that the "elaborately constructed [peacock] pies were regarded as items of conspicuous consumption": they were "served more . . . for show than for taste."[22]

Rembrandt's pied peacock is unlike any other in the history of Dutch art: he is clearly not unaware that he has to drag around a chronicle of iconographic and culinary insults as long as his tail. And just where *is* his pride and joy of a tail? The two objects jammed in the pie behind the bird look less like wings than like fishtails, and the poor bird seems as decisively cut off from his cloudy plumage as he is from the fun. As he pushes aggressively forward on his well-baked plinth, his allegorical character shifts from vanity to angry contempt and envy. He frowns the frown of a surly Disney duck, and well he might, since his modest crest—a skimpy if bale-

ful bristle—makes a poor showing next to the elaborately adorned head of his human rival. His plumage, shorn of iridescence, has been preempted to serve as the nimbus setting off the cavalier's lavish crest: to the bravo belong the spoils—and the iconography—of Juno's bird. I find it hard to resist the temptation to see the peacock as the Bad Boy's comment on the Good Boy's reaction to this performance.

I don't seriously mean to imply that the double portrait expresses the iconography of castration; but it is not beyond belief that it contributes to the castration of iconography in the way the sitters send up the prodigality they pretend with such amusement to perform. Or at least *he* seems amused. I have not yet said a word about Saskia, and I have saved her for last because that is where the picture gets into trouble with the few critics who pay any attention to its representation of gender. They agree on the essential message it delivers, a message concisely expressed by the caption of a *New Yorker* cartoon: "There have been gains for a peahen here and a peahen there, but from a practical standpoint it's *still* a peacock's world." Or is it?

According to Madlyn Kahr, if the male sitter "exposed himself as the sinner," he also "depicted his wife in the role of the loose woman who tempts" him, and since Kahr notes that Saskia was also the model for Delilah in the Samson paintings he worked on during the same period, she includes the double portrait in a series of images that show the man "to be the victim of a woman." In her view, this is a moralizing picture of the Prodigal Wife by a man in whom women aroused "feelings of fear, hostility, and insecurity";[23] maybe it is about castration after all. But of course the idea that *he* is *her* victim itself makes *her his* victim, and this is the tack taken by Alpers. She approaches this problem from the more cautious and balanced standpoint provided by her emphasis on the way Rembrandt's "theatrical studio practices" can destabilize meaning, especially when the painter serves as his own model, and she suggests that in the double portrait he "hides behind, as much as he reveals himself through, the role of the prodigal son."[24] She nevertheless judges this to be a "forced, hardpressed, or overplayed" performance that dramatizes "a disruption of the married state" by an artist who had recently succeeded in "marrying up. Saskia, . . . who serves as a model for the tart on his knee, was a burgomaster's daughter. A certain tension between the two is involved in this picture, as Rembrandt without Saskia's clear consent, plays down the well-made marriage. . . . He exhibits extravagance in both a sexual and eco-

nomic sense rather than the economy expected of a good marriage" (40, 67, 40). Alpers uses the painting to substantiate her thesis that Rembrandt deemphasized family values in his art and that he turned away from the Dutch norm in creating "his studio at the expense of an established relationship between the household and art" (66). But she adds that in this painting, to his credit, "it is he, rather than the distinctly uncomplicitous Saskia, who delights in and takes responsibility for this upending of the marital economy" (111).

If I view the double portrait through the metatheatrical lenses borrowed from Alpers, the scene appears to me to be different from the one she describes. To begin with the figure of Saskia, the first thing I notice is that her billowing skirt accentuates her awkward position and oddly echoes the form of the peacock beside her. The different sizes of the three heads—hers directionally opposed to those of the two males—correspond to the range of displayed emotions. Between the grumpy peacock and the prodigal's frozen guffaw, her expression is harder to assess. It might be "decidely dignified," as one commentator writes.[25] But it might be arch. She might be looking fixedly, holding the pose, eyeing herself in the mirror; or she might be displaying genial patience. The turn of her head is uncomfortable. But this doesn't register as discomfort because the area between chin and ear is understated, especially when compared to the animated treatment of Rembrandt's turning head. Saskia's face seems merely to have been placed on her neck in the wrong direction. The angle of the face is pretty much the same as that in the 1636 etching, but the body has been torqued around, and the difference in effect is especially striking when you think of both Saskias gazing not at you, the viewer, but at themselves in the mirror, for then the painted Saskia takes on a quizzical and vaguely amused look of self-appraisal—as if she is having as hard a time as we are believing she could assume and hold that pose. Hers is the look of one who is doing her level best to act dignified but doesn't quite bring it off, in part because of the awkward pose and in part because her fellow sitter is either camping it up or else failing miserably to deliver the courtier's or cavalier's sprezzatura. I am inclined to laugh at him but sympathize with her effort to be accommodating while keeping her poise—and possibly also her balance. They could well provide a visual epigraph to Helgerson's "Soldiers and Enigmatic Girls" as they perform the dangers and play to the anxieties trenchantly analyzed in his essay.[26]

Thus I respond most forcefully to this painting's representation of the

act of collaboration or complicity in which the two sitters rehearse and monitor the performance they intend to deliver via the painter to the public. The story the portrait tells me is that the painter and his partner agreed that he would paint himself as a Bad Boy and Saskia as a Good Girl trying half-heartedly to look Bad. They may well be staging a tavern scene, a brothel scene, a domestic scene, or a biblical parable, or all of the above, but these possibilities share pride of place with an artist's studio scene. In this reading, painter and sitters produce an amiable parody of themselves, of their worldly life, of the drolleries of the genre convention, and of the theatricality of the poses models are expected to work up for moral parables and histories.

In addition, I see them blithely exaggerating what in fact they are reputed to have enjoyed doing during these Amsterdam years. Because of complicated legal arrangements affecting Rembrandt's access to Saskia's money and to debts owed her by her relatives, there was considerable interest in who did what with the family money. Gary Schwartz cites the gossip of Saskia's relatives that she had "squandered her parents' legacy through flaunting and ostentation," to which Rembrandt responded with a libel suit in which he boasts that "he the plaintiff and his wife were blessed richly and *ex superabundanti* with wealth (for which they can never be sufficiently grateful to the Almighty)." This piece of *chutzpah* is put in perspective by Schwartz with barbed conciseness: "He lost the case."[27] These and other data, he claims, "show us a Rembrandt and Saskia very much like the pair in the painting," and though he allows for "irony in the image," he insists that it "also reflected a reality" (193) of which he morally disapproves.

During the praise of Rembrandt and his fellow painter, Jan Lievens, Constantijn Huygens recorded in his memoir of 1629 or 1630, he interrupts himself to criticize their stubborn refusal to make the obligatory Italian journey: "they are know-it-alls," and their claim that they don't want to take the time away from their work is an excuse for "sheer laziness." This is written in the voice of an irritated but proud father, who then, having discharged his animus, concludes on the eulogistic note with which he began:

> [T]o make the miracle complete, they are less tempted by the innocent pleasures of youth—which they naturally consider a waste of time— than the couple of old men they resemble, full of years and far beyond such futilities. How often have I not wished that these marvellous boys

would ease up on the unrelenting energy they put into their all-consuming occupation—even if that is the way to make great leaps forward—for the sake of their weak bodies, which have already been robbed of youthful vigor by their sedentary way of life.[28]

In one of his infrequent defenses of his antihero, Schwartz takes issue with Huygens's criticism, which he attributes to self-interest, and points out that the two painters "as Huygens describes them are in fact living examples of the young artist in van Mander's *Foundations of the noble, liberal art of painting*: they do not waste their time on music, drinking, girls or trips abroad, they avoid bad company and seek out the right workmates, they resist the temptation to make easy money as portraitists and diligently attempt to master all the elements of history painting." They are, in two words, Good Boys who do everything they can to avoid getting caught in the wrong kind of genre interior. Their prudent and industrious behavior should earn them the respect of the other good burghers in Schwartz's book, and he appreciates this: Huygens, he complains, "berated them for some of their purest features" (77).

Rembrandt's purity, however, is short-lived, and for Schwartz the Dresden portrait documents a fall from van Mander's ideal of the artist as Good Boy. In finding Saskia complicit in the Good Boy's fall, Schwartz differs from Alpers, who disapproves because Saskia is the Bad Boy's victim.[29] Moral judgment also lurks behind the short shrift David Smith gives the double portrait during his positive assessment of the 1636 etching of the same subject. He speculates that Rembrandt eschewed available genre models for the "compositional formula" of the etching in order to avoid "the comic, often bawdy, mood" that would conflict with its "somber tone."[30] And he insists that although Rembrandt's personal attitude toward marriage is clear in the etching, when the two double portraits are set beside each other "their message . . . seems ambiguous" (137), for the painting imprudently threatens the image of marriage as friendship with the contaminations of genre painting, and this forces the painter to have recourse to a defensive indirection: it was because "the conventions of portraiture and genre painting could [not] be so easily mixed" that Rembrandt donned "the disguise of the prodigal son when he brought the two conventions together in the Dresden Self-Portrait with Saskia."[31] The obvious implication of this account is that the ambiguity and indirection of the painting make it morally as well as aesthetically inferior.

One could easily argue that the act of assuming such a disguise reveals the protectiveness, discretion, and thoughtfulness of a true friend: the painter risking loss of face to save the face of the relationship. But I have no interest in defending the morals of either the painting or its sitters. My concern is with the theoretical basis of the interpretive moves that prompt the various shades of moral disapproval expressed by Schwartz, Alpers, and Smith, disapproval generated by the decision to subordinate the interpretation of the painting to the documentary context, the archive, constituted by and for genetic inquiry. To reduce the painting to an illustration of the archive is to subject its inhabitants to the condescension with which outside observers view the natives who give themselves away because they don't know what they're doing and they certainly can't know what we know about them.

Such an archival or ethnographic reduction shorts out the metatheatrical resistor that Alpers's thesis builds into the design of the interpretive circuit. That resistor is the hypothesis of a *mise-en-abîme* relation between a portrait and the theatrical mode of its production that she posits as Rembrandt's studio practice—the hypothesis that what the image represents is not limited to the putative subject for which models posed but also includes a reference to the act of posing, and thus emphasizes the fictiveness of the subject. I call this hypothesis a resistor because it increases interpretive energy and desire by impeding the flow of documentary information, or "knowledge," from the study of life to the study of the artwork and back again.

When I take this resistor into account and try to peer beyond the aesthetic surface of the painting toward the shadows thrown by whatever information we have about Rembrandt and Saskia, I can easily imagine them thumbing their noses at the norms of self-representation promoted by patrons whose prudence is as visible as their wealth in both Gary Schwartz's book and Rembrandt's Amsterdam portraits. And they do not reserve the raspberry for Saskia's relatives alone. They send up a particular version of the system of asymmetrical polarities in which the virtues require the conspicuous display of their opposites to assure themselves of sharper definition, and so preserve their authority. In the bourgeois version of the system, business needs pleasure, restraint needs license, polite society needs low life, prudent investment needs prodigal spending, domestic virtue needs promiscuity; in short, the Good Boy (or Girl) needs the Bad Boy (or Girl). The efforts to maintain this polar opposition are

continuously subverted, and therefore continuously motivated, by the transgressive forces at work or play in the practices of daily life. As studies of early modern Dutch culture always show, and as Schama has definitively argued, conspicuous consumption and conspicuous constraint dialectically sustain the homeostasis of the embarrassment of riches, but the civic and commercial solidarity they promote depends on maintaining the distinction between these forms of self-representation, and thus between the artistic genres that served them.

Schama explores this dilemma in an essay critical of the practitioners of "the new orthodoxy of the iconography of genre paintings" because they premise that "the dividing lines between the worlds of vice and virtue, wives and wantons," make them actually—not merely ideologically—so distinct "that, once deciphered, such distinctions were indeed starkly self-evident."[32] As we saw in Chapter 10, his review of the evidence leads him to argue that "something very like the opposite seems to be the case, suggesting a culture vulnerably bereft of watertight compartments of experience, moral and material, sacred and profane. As much as its pastors prayed it might not be so, they were incapable of preventing the norms and values of one realm leaking into the domain of the other" (13).

The compartmentalization produced by artistic genres makes possible not only "the extreme delicacy and subtlety" of the transgressive imagery "with which artists like ter Borch and Metsu treat erotic subjects" (12) but also the coarser-grained parody of Rembrandt's *Marital Admonition*. When Schwartz notes, with reference to the double portrait, that during the 1630s the guise of courtesan "was being adopted playfully by the ladies of Amsterdam, along with the bucolic costume, and Saskia seems to have had a taste for both," he describes a representational strategy for plugging the social dikes.[33] Admittedly, the women Rembrandt subsequently lived with and victimized either lacked Saskia's skill or were overwhelmed by his scorn of compartmentalization. But I think the double portrait dramatizes this scorn, and does so by playing up just the "confusion, disguise, ambiguities and stratagems" that Schama discusses and that have so exercised Rembrandt's patrons in his time and critics in ours.[34]

My sense of the painting is influenced by its place in the set of pictures we designate as portraits of Saskia. Of these, Alpers writes, Rembrandt explores "the performative nature of modeling" but also reflects "on the enacted nature of a person so represented."[35] The double portrait gets some of its meaning from the other images in the Saskia gallery (figs.

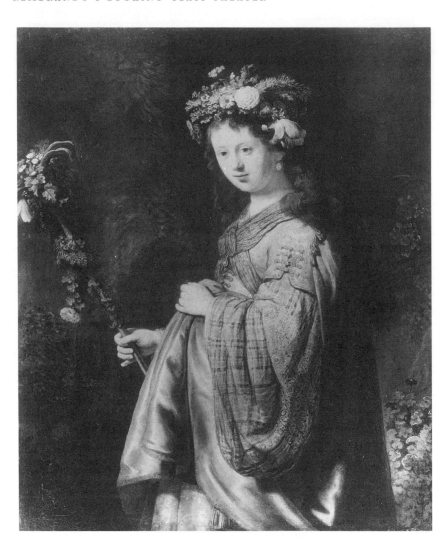

45–49). The figure whose virtual life is contained in the gallery's theatrical inventions surprises us with its subtle modulations from one situational self to another, and with its wide range of expression and sensibility, a range that perplexed Kenneth Clark:

> The slightly ludicrous, almost touching, discrepancy between the clothes and the persons they encase, evident in the national gallery Flora [fig. 48], and even more pronounced in a picture of Bellona [fig. 49], . . . was, after all, due to a failure of unifying imagination. The trappings belong to a world of fantasy. . . . The persons belong to the world of experience . . . and are represented without any mitigation which

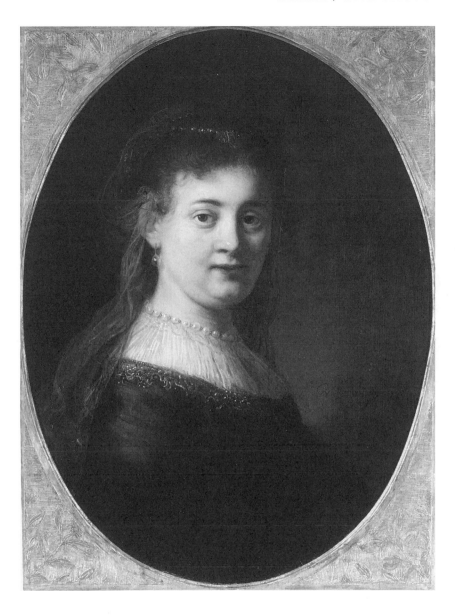

FIGURE 46

Rembrandt, *Portrait of Saskia with a Veil*, 1633. Oil on wood. Rijksmuseum, Amsterdam.

might bring their homely features into harmony with their splendid accoutrements.[36]

Notice the pliancy, the wit, the self-containment, and the joy in quiet theatrical mimicry with which Saskia seems to join him in deflations not only of Italian opulence and the Dutch weakness for it but also of the grandiose conventions of narrative history and myth. These allusions get their force

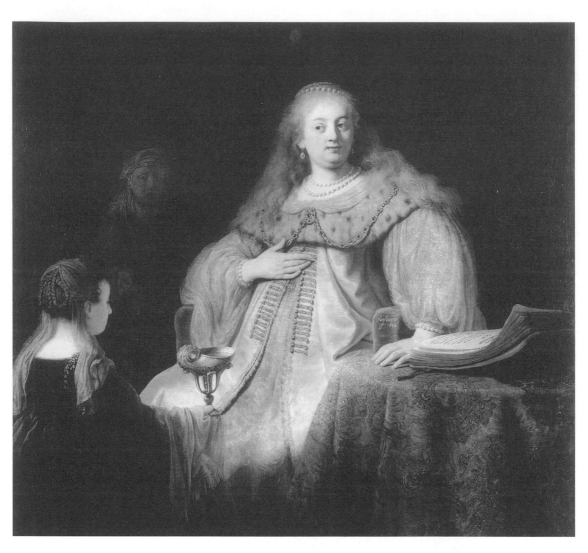

(Above) Rembrandt, [Saskia as] Sophonisba Receiving the Poisoned Cup, 1634. Oil on canvas. Museo del Prado, Madrid.

(Opposite) Rembrandt, Saskia von Uylenburgh in Arcadian Costume, ca. 1635. Oil on canvas. National Gallery, London.

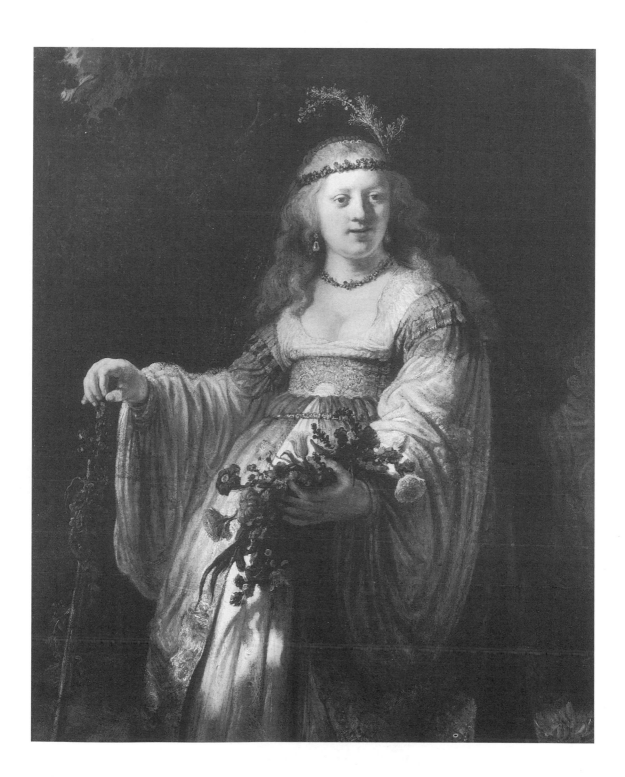

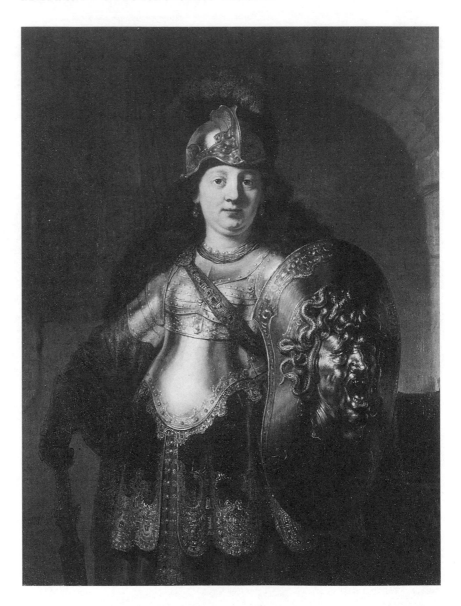

FIGURE 49

Rembrandt, *Bellona*,
1633. Oil on canvas.
The Metropolitan
Museum of Art,
New York.

and meaning, their occasional air of slight inappropriateness, from the var-
iously nuanced expressions of the sitter's role detachment—in one image
ironic, in another quizzical, in another parodic, and in several holding elab-
orate prop-encumbered poses with conspicuous patience. They testify to
an imagination that "unifies" sitter and painter in a single ever-changing
enterprise of representation. Rembrandt's depictions of Saskia thus make
her a partner in his project of revisionary allusion, and it is to the portrayal
of this partnership that I now return for my concluding remarks.

The portrait is double in more senses than one. It is a portrait about portraits—their social functions, their pretensions, their relations to the other genres against which they define themselves and their sitters. It is double in the genial air of hypocrisy produced by the strong effect of posing that mocks the hypocrisy of others, double also in the ambiguity, the transgression of generic boundaries, by which it targets anxieties and desires from which the sitters claim no exemption. Thus if both the painting and the sitters have been threatened with loss of face by critical disapproval or disagreement, we should consider the possibility that the critics have been scooped by the sitters. Theirs is too happy a loss of face. They enact their fantasy of lush living in conventional terms borrowed from an idiom they can't take too seriously. At once displaying and flouting the values of worldly life and art, they laugh at themselves and thus at the audience. Their collaboration testifies to the smiling assurance of two partners in art who share the pleasure of cooking up a travesty of two partners in sin. The metatheatrical theme of their travesty is less their *loss* of face than their witty *detachment* from it. They can play at being prodigals in good conscience because their pleasures include painting and posing. To those who accuse the Rembrandt depicted by this painting of having courted the peacock's goddess, the Juno who presides over the embarrassment of riches, he might well reply without a trace of embarrassment that—in the words of a twentieth-century entertainer—he cried all the way to the bank.

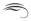

Juno herself appears, together with her peacock, in plate 25, a late half-length painting (ca. 1660–65) that reminds Julius Held of Titian's *La Schiavona* (fig. 19 above) and, more generally, of "a type of feminine portraiture frequently found in artists of the Venetian school."[37] Her rigid frontality is relieved by modulations that bring into play the different modes of the system of early modern painting. Texture mottling her left sleeve and mutilating the hand flattens them forward to the surface. On her right, graphic and optical touches enliven the form of hand, arm, scepter or staff, and cloak, and deepen the effect of recession initiated by the *repoussoir* shadow, the small black sinister silhouette, of the peacock. These shifting ambiguities of space contrast with the almost strained immobility of pose. The upper half of the figure is more firmly modeled than the lower half. Juno's pearls and other ornaments vary from deli-

quescent spheres to pointillistic splashes of paint. Somber browns over-come the richer Venetian red whose ghostly reflection glides through the shadows from its source in what looks like a table below her left hand in the lower right corner of the canvas.

Held describes the sitter as a "large though still youthful woman, turn-ing boldly outward, and displaying her ample form and regal attire with obvious, if good-natured, pride."[38] But as I stare at the painting, the sitter's "good-natured pride" mutates into a fixedly unfocused stare. She doesn't so much return my look as look through me with a gaze that reaffirms, against the play of tonal and modal variations, the initial hieratic impres-sion: her broad frontal presence is planted before me with near-oppressive symmetricality. It gives rise to a fantasy influenced by Held's suggestion that this may be a posthumous idealization of Rembrandt's common-law wife, Hendrickje Stoffels (95–96). I imagine a face resurrected from a death mask, as in early Renaissance portraits, but with gaze and color re-stored, and with the hint of a smile resembling those on ancient votive or commemorative images of the dead. The pallor of the sitter's forehead and the tonal contrasts modeling her face make it float forward trancelike out of the deep shadows. This effect becomes more intense when we no-tice that the lower half of the figure is dematerialized; its volume thins into a plane. The chiaroscuro foreshortening of her right arm creates an intervening space that pushes the figure backward while the left arm, as we saw, is flattened forward. At first unsettled by an atmosphere vibrating with spatial uncertainties, Juno's unnatural stillness is ultimately en-hanced, and if she seems initially to acknowledge her Venetian function of display, under the prolonged fixity of the gaze her gaze compels she changes from a posing person to a timeless presence.

Held concludes from his review of the iconographic evidence that Rembrandt's Juno stands before us primarily as the Goddess of Wealth, "the very image of proud opulence and conspicuous wealth," not the god-dess who assists "in marriage and childbirth, but a divinity who repre-sents, and is capable of distributing, the treasures of the world" (100). He reinforces this reading with some biographical speculations: the *Juno* "was painted at a time when the artist . . . was deeply in debt" and its "brazen display of opulence and wealth . . . is an exception" in a period during which he "probed the emotional depths of tragic heroines and troubled men," so many of whom are depicted as humble folk in homely garb.[39] Perhaps, then, the subject "failed to sustain the master's interest" as he

turned to embody truer values. Perhaps if, as the documentation suggests, the picture was commissioned and Rembrandt "procrastinated in finishing" it, this may have owed, among other things, "to a subconscious rejection of its very theme" (102–3). I don't know about that, but since I take seriously Held's assertion that the *Juno* "is a striking example of Rembrandt's interest during a late period of his life in the normative aspects of Venetian portraiture" (97), I would like to speculate about another form of rejection.

"It is peculiar enough that Juno holds her scepter upside down, in a pose that has been compared . . . with that of Flora leaning on her staff" (see fig. 48). Held makes this comment chiefly in order to support the hypothesis that Rembrandt had planned to have Juno behind a ledge or balustrade, without the support of which the motif of the inverted scepter "would be even more anomalous" (97). But let's enjoy and meditate on the anomaly we have. The inverted scepter Juno loosely grasps resembles the cane depicted in the regal self-portrait of 1658, a cane that—as we'll see in Chapter 24—commentators have associated with both a scepter and a mahlstick. To map this association onto the *Juno* would lend support to Held's hypothesis that the painting is somehow both about riches and about painting. My revision of the hypothesis is, first, that *Juno* alludes to the riches of Venetian painting, and, second, that the inversion of her scepter indicates a rejection of the very riches so lavishly evident in this image. The *Juno* presents both a protest against and a surrender to the Venetian precursor in an ambivalent performance that I shall discuss in the next chapter under the rubric of revisionary allusion.

The rejection of Venice is dramatically depicted in this painting as in so many others, and by the same constellation of devices. Amid the interchanges of painted jewels and jewel-like paint, of shadows that clasp and diminish the form, and tones that build it up, the haunting presence confronts us and yet, unseeing, ignores us. Her impenetrable and even death-like demeanor is rendered more poignant by ruddy cheeks and the hint of a smile. She may represent the wealth of the world but she is neither of nor in the world. The "brazen display of opulence" (103) is suggested in order to be overcome. Suspended and floating in shadow, Juno's fleshly substance condenses in the radiance of her face and bust, her oddly diverse hands, and the scintillae of her ornaments. Elsewhere, like her pearls, her being eternally deliquesces before the observer's eyes.

Among his countrymen at that time Rembrandt may have
been the most authentic Italianist.[1]

METHODOLOGICAL INTERLUDE IV:
ON REVISIONARY ALLUSION—REMBRANDT
AGAINST THE ITALIAN RENAISSANCE

Since the next three chapters will focus on Rembrandt's allusionary ne-
gotiations with Italian painting, models, and patrons, the aim of the present
interlude is to clarify the concept of revisionary allusion those negotiations
presuppose. I shall do this by engaging in a dialogue with—or to be less
euphemistic, a critique of—Kenneth Clark's *Rembrandt and the Italian Re-
naissance*. My chief purpose is to inquire into the cash value of "and," the
grammatical blank check in Clark's title. To change the metaphor, the
"and" is a bridge across which forces might travel in either or both direc-
tions: when it crosses from the Renaissance to Rembrandt we call it in-
fluence; when it crosses from Rembrandt to the Renaissance we call it al-
lusion. We may legitimately disagree about whether in any particular
work the conjunction between them is to be interpreted as a force pri-
marily of influence or of allusion. But in order to do that we would pre-
viously have had to agree, first, that there are two such opposed directional
forces, and, second, how to distinguish between them. Clark doesn't make
the distinction, and so, if I wish to interrogate his account of the conjunc-
tion, I shall have to do it for both of us.

Unlike influence, revisionary allusion is a practice, and, more specifi-
cally, a preposterous practice, a perversely palimpsestuous practice. The
following simple exercise will facilitate recognition of its difference from
influence.

First, take two artists and call them Prior and Poster. Then consider
the following two ways of describing who came first, or who did what to
whom:

1. Prior influenced Poster; Poster copied Prior's work, imitated his style, emulated his example. Poster anxiously rushed through Harold Bloom's cycle of revisionary ratios in a parricidal quest to become the author of himself.

2. Poster's work conspicuously quotes or alludes to Prior's work, style, or example.

Note that between the influence claim and the allusion claim there are three distinctions.

First, in the influence claim the lines of force run from Prior to Poster, while in the allusion claim they run from Poster to Prior. Second, the influence claim refers to Poster, but the allusion claim refers to Poster's work. Third, in the statement about influence the subject is Poster and the verb is in the past tense, but in the allusion sentence, the subject is Poster's work and the verb is in the present tense.

These distinctions are pretty simple-minded, but they make it clear that we are looking at two incompatible maps of misreading. They pick out a profound difference not merely between influence and allusion but also between the kinds of study constitutive of the difference. In literary studies, for example, influence study situates intertextual relations in a genetic and extratextual field of inquiry, whereas allusion study situates them in a rhetorical and intratextual field. In the first, the fiction of influence is treated as if actual and empirical; in the second, the fiction of allusion is treated as if virtual. *Mutatis mutandis*, the same difference obtains in painting. Consider, for example, the following phrases: "the influence of Titian on Rembrandt"; "Rembrandt's mastery and assimilation of Titianesque color"; "Rembrandt's reinterpretation of Titian"; "Rembrandt's allusion to Titian" or "quotation of Titian"; "Rembrandt's emulation of Titian." These articulate five different aspects of the artist/precursor relationship, and art historians tend to move casually among them because their discipline has oriented its practitioners to respond to influence as the primary category under which the others tend to be subsumed. Given the importance and difficulty of attribution, the skills of intuitive and/or scientific connoisseurship are essential to any subsequent study of painting. In literary study, on the other hand, where such skills are generally less indispensable, and where the problems of geneticism have been logically clarified (if not substantively resolved) by long debate, it is easier to maintain a consistent focus on revisionary allusion as a property of the work distinguishable from the range of genetic phenomena that may be classified as re-

sponses to influence. Such relationships as emulation, assimilation, and reinterpretation may be viewed under the aspect of either allusion or influence, but the meanings assigned them by one will be entirely different from those assigned by the other. My training in literary study leads me to eschew the genetic interest that has long dominated art history and to approach artist/precursor relationships primarily in terms of conspicuous revisionary allusion, "conspicuous" being the term I use to signify an effect registered by the interpreter as an emphatic feature of the work itself.

While the study of influences may tell us much about the precursor's effect on the artist and about the general choice of precursors the artist's work exhibits, it can tell us next to nothing about the particular meaning conveyed by the image of the precursor in any single work.[2] For the interpreter to specify the image as an allusion, and, more pointedly, as a revisionary allusion, is to assert that the work includes a reference to the precursor qua precursor as part of its meaning. Allusion to the work of the precursor may be merely an act of conspicuous *imitatio* that acknowledges and discharges a debt. But it may also be a less benign and more contentious act of *aemulatio*, a representation of the artist's struggle to clear a space for himself by overcoming the precursor. In this connection it's important to respect the difference between studying emulation and studying the representation of emulation. Only the latter is concerned with emulative allusion.

Emulative allusion is a moment in the larger dialectics of appropriation decisively characterized by Hegel and compressed into the term *aufheben*, initially—and inadequately—rendered in English as "to sublate" and more recently as "to supersede." Three different and conflicting senses of the term are activated in the Hegelian dialectic. *Auf + heben* primarily means to lift up, raise, elevate to a higher plane. It also means to suspend in another sense—to repeal, annul, destroy the force of. Thirdly, it means to keep, reserve, preserve, or store away. The *Aufhebung*, as Nietzsche more aggressively characterizes it in *The Genealogy of Morals*, is a continuous chain of reinterpretations by which the past is simultaneously overcome and reconstructed. So, for example, Poster's work alludes to Prior's work in ways that both (1) "cancel" it by showing it to be rendered obsolete, superseded by Poster's work, and (2) "uphold" it by representing it as a precursor, claiming for it more historical importance than it would otherwise have if it did not lead to, get superseded by, Poster's work. Thus Virgil sublates Homer and Dante sublates Virgil. At a different level, Christian

discourse sublates or supersedes those of classical antiquity and Old Testament culture by constructing them as misguided or blind precursors, full of lies and illusions, but in that very negation it enhances their historical generativity and resurrects them as the prefigurations it fulfills. Yet even as Christianity aims to negate the institutions, practices, and discourses of its precursors by radical appropriation and reformation, it can't help conserving—and being troubled by—the *aufgehoben* it has remodeled, transcended, and thus remaindered. This last term should forestall the tendency to emphasize only the "progressive" movement of the *Aufhebung*, which marks its course by conserving the shades of, reanimating the danger posed by, the precursors it continuously revives as its repressed others. The remainder is thus forced stubbornly, resentfully, *to remain*, living the half-life of a ghostly revenant buried under the cornerstone of a new narrative and haunting the renovated stories of the structure from which it was and is and will be dispossessed.[3]

In turning to consider allusion in the field of painting and in the specific case of Rembrandt self-portraits that emulate Italian precursors, I would like to retain the sense of the precursor as a revenant kept alive in order to trouble the new pictorial dispensation. With the purpose of restricting the concept of allusion so as to isolate and accentuate this dialectic within it, I confer on Clark's *Rembrandt and the Italian Renaissance* the privilege of being my own precursor. Clark's theme is "the manner in which Rembrandt transformed his style by the study of Italian renaissance art."[4] He traces the theme through several different modes and moments of Rembrandt's lifelong encounter with "the deep-rooted, recurring motives of mediterranean art" and its tradition rooted in classical antiquity.[5] Thus the first chapter on Rembrandt's anticlassicism is followed by chapters on his dealings with the art of the High Renaissance, the monumental tradition (large-scale composition), the Venetians, and the Quattrocento.[6]

The dialectic Clark explores in these chapters sets the classic/Renaissance and the romantic/Baroque sides of Rembrandt's character against each other. Rembrandt, he writes, rebelled against "the conventional academicism of his day, both in its baroque and its classical manifestation. The movement, turbulence and dramatic lighting of Baroque he enjoyed and mastered, but its rhetoric and reliance on emotional clichés he could never swallow. On the contrary, he found in the simplicity and concentration of pre-mannerist art a basis of design which would enable him to

present the truth with greater directness" (41), and his determination to achieve the "clarity and economy" at which classic art aims involved him in "a conscious effort to master the science of large scale composition" as practiced by Raphael and others (28, 85). But his "romantic" inclinations also made him susceptible to the influence of the great Venetians, and his work manifests his "sympathy with the imaginative world of Titian and Giorgione" (101).

The quoted phrases suggest that Clark is less concerned with allusion than with influence and assimilation, and it is largely by default that his study raises the problem of allusion. Clark's book first directed me toward this problem as a theme in Rembrandt's painting, and the fact that I center on Clark's limitations should not obscure the extent to which I have been stimulated and am still haunted by his monograph, especially by his precise, astute, and often brilliant attributions of particular influence. He is admirably cautious in discussing Rembrandt's responses to Italian art. He distributes them along a continuum that ranges from unconscious borrowing through conscious borrowing, assimilation, and reinterpretation to allusion; he is careful to distinguish responses in which Rembrandt struggles against his source; and he occasionally differentiates conscious from unconscious anti-Italian responses. This discrimination may be commendable from the standpoint of art history, but it is less satisfactory when viewed from the standpoint of an interpreter interested in a consistent, restricted, and focused study of allusion.

Clark writes of Rembrandt's mind and memory, of his conscious or unconscious responses, of the study that helped him transform his style, and although this is to be expected, his reader never feels securely situated in either a literally genetic account of the painter's creative process or a metaphorically phrased account of his work, whether an individual painting or some portion of the oeuvre. While I find all the materials for a study of allusion in Clark's book, I also find that the persistent geneticism of his approach skews his language in a manner that stands in the way of such a study. Therefore I am admittedly "remaindering" the book, putting it in play to provide a test case, a paradigm of traditional practice, against which my own quite different purpose and orientation may be contrasted. In what follows, I shall highlight the contrast by quoting and commenting on passages in which Clark distinguishes (or fails to distinguish) Rembrandt's various relations to his predecessors and models.

1. "All great artists have studied the work of their predecessors and

borrowed from it, if they have felt the need; but few have ranged so widely, or shown such powers of assimilation as Rembrandt. . . . In Rembrandt's re-interpretation of the art of the past we can see something that went far beyond even the most intelligent study, some intuitive sympathy with the form-creating energies of earlier epochs, that allowed him to dig out of his imagination ancient motives which he had never seen" (2). The first phrase refers to Rembrandt's conscious borrowing from the art of the High Renaissance in Florence and Venice, and Clark's first four chapters explore this theme. The second phrase is amplified chiefly in his final chapter on Rembrandt and the Quattrocento, and here he makes much of unconscious affinity, inspiration, and the mystery of the creative process, for example: "What are we to make of these analogies with great works of art which Rembrandt can never have seen and cannot even have known by one of those 'carriers,' copies or crude reminiscences, by which the germ of a formal idea is communicated down the centuries to those who are ready to receive it?" (188).

2. The first of two drawings "is an obvious reminiscence of Raphael's *Madonna della Sedia* [but without the child]. . . . The other drawing, although precisely in the same style, has all the appearance of a direct notation, and was probably drawn from life. . . . But Rembrandt's mind was still occupied by the *Madonna della Sedia*, and so the child, omitted in his direct reminiscence, reappeared unconsciously in a sketch of a thing seen" (47).

3. Rembrandt "had an incredibly retentive visual memory, and this applies to works of art as well as to transient impressions of movement or gesture. We can even say that his memories of works of art were always present in his mind like rough moulds into which he could pour his immediate sensations" (52).

4. "The design of Dr. Deyman's Anatomy Lesson, symmetrical and hieratic, its frontality modified by the curve of the apse, shows Rembrandt deeply involved in the Mediterranean tradition. Unconsciously it goes back to the early Christian mosaic at Santa Pudenziana."[7]

These examples represent straightforward attributions of, or statements about, influence. The first distinguishes conscious and unconscious responses to a particular work; the second is a speculation about the faculties that made the artist so receptive to influence, the third appears to suggest either the mysterious affinity Clark speaks of elsewhere or the generalized influence of a whole tradition. The kinds of problems inherent in influ-

ence study, and in genetic studies generally, are illustrated by Clark's descriptive idiom. For example, his use of "unconsciously" in the second and fourth statements is imprecise (not to say syntactically incorrect), verging on nonsense in the latter, where the phrase "deeply involved" is itself evasive. The second statement makes us wonder on what grounds Clark decided one response was conscious and the other unconscious, while the third exemplifies the standard weakness of genetic study, the arbitrary rhetorical displacement of attention from the work to the artist.

5. "Rembrandt has not merely borrowed an image from antique art, but has allowed it to control his whole system of composition" (81–82).

6. "Most of the landscape drawings are direct notations made on the spot. . . . But in the etchings, where he gathers these impressions together, Rembrandt makes use of those devices of lighting and grouping by which the sixteenth-century Venetians had first brought the irregularities of nature into a single focus" (110–11).

7. "Rembrandt developed a clearer and more concentrated style by study of the classical tradition. . . . But the art of the high Renaissance was also an artificial construction. Its types, gestures and draperies were contrived according to an ideal of beauty and decorum derived from classical antiquity. In using it, Rembrandt had to re-imagine it in his own terms" (146).

These statements are representative of the numerous passages in which Clark comments on the processes of borrowing and assimilation by which Rembrandt improved or altered his technique. Like the preceding three, they have nothing to do with reinterpretation or allusion.

8. "When borrowing a classic motive . . . he practically always changed the subject, and often modified the form in a way which revealed a long and enlightening process of thought. But he felt so much in sympathy with the imaginative world of Titian and Giorgione that when he took over one of their motives he usually retained the subject and even the vestiges of style" (101). Here, reversing the order of sentences, we pass from assimilation to reinterpretation, and Clark's subtle treatment of this theme is exemplified in the next two passages.

9. A particular figure borrowed from Raphael is not merely "a quotation but is completely absorbed into its new context, and is studied afresh from nature, with Rembrandt's mother as the model. He also changes the meaning of the original pose" (46).

10. "Since he cannot bring himself to attempt a Last Supper, he

adapts . . . [Leonardo's figure of Christ] to the subject of the Supper at Emmaus. . . . In this case, however, there was an intermediary, Dürer's woodcut in the Small Passion of 1511. The Christ breaking bread, and the attitudes of the two apostles, leave us in no doubt that it was Dürer who suggested to Rembrandt how Leonardo's motive could be transferred from the institution of the Eucharist to its earliest confirmation" (60–61).

Reinterpretation may, as in the above passages, be positive in the sense that it displays no revisionary impulse, is neutral with regard to its source, and does not struggle against it. But what about the following example?

11. The point of departure for Rembrandt's *Danae* "was a synthesis of two Titian figures. . . . But how far he has departed from his originals both in sentiment and form! The head of Titian's Venus is without expression; and her body is inert and self-contained, a kind of monstrous fruit, incapable of movement or sensation. The Danae is warm, responsive, open, outward turning" (108). Is Clark's judgment of Titian's Venus transferable to Rembrandt as the critical impulse that led to the latter's reinterpretation? Is this critical impulse, this anti-Titianism, inscribed in the painting itself? If so, what purpose does it serve, how does it contribute to the meaning of the image? Does the *Danae* get some of its force from quotation or allusion that reminds observers of Titian's nudes and its difference from them? Clark's comments raise these questions but leave them in abeyance. He notes only that both Titian paintings "were much copied in the sixteenth century, and Rembrandt could easily have known studio replicas" (ibid.). The questions are more directly confronted in his first chapter, as its title, "The Anti-Classical Rembrandt," might lead us to expect.

12. "Rembrandt's refusal to compromise with classic imagery lasted all his life, and this meant that certain subjects in which classic form had, so to say, staked out too strong a claim remained outside his range. He felt convinced, for example, that our first parents could not have been the graceful well-nourished Adam and Eve of Raphael; he conceives them as un-evolved types of singularly little charm" (36). I am not sure whether Clark's "too strong a claim" refers to the anxiety of influence or to the claims made for the idealization of the human form, but in any event Raphael is clearly present less as a great individual painter than as a paradigmatic example of classical style, and the implications of that style as a whole give Clark a point of entry into the human significance of Rembrandt's revision.

13. "When . . . we find Rembrandt illustrating a classical legend in an unorthodox manner, this is not through ignorance. More likely he has read the text with particular care and in doing so has seen through the conventional representations of academicism" (8). Yet Clark thinks Rembrandt had difficulty with his youthful efforts to control his anticlassical reimaginings. He does not find, among the early examples of "Rembrandt's anti-classical independence," many that are "pleasing." But in the passage I'm about to dwell on, we'll see that Clark has difficulties of his own because the criteria governing his sense of what displeases are not strictly aesthetic, so that uncertainty about the object of displeasure muddies the interpretive waters.

14. "In fact they are, to our eyes, some of the most unpleasing, not to say disgusting, pictures ever produced by a great artist. But they were admired in their own day, and even for us they achieve a kind of horrible fascination from the very violence of his reaction against the conventions of ideal art" (10). This judgment is immediately narrowed to Rembrandt's protest against the convention "which, by 1600, seemed to lie at the center of all civilized design," the nude, and Clark illustrates the protest with two 1631 etchings of "naked"—not nude—women, *Woman Seated on a Mound* (B.198) and *Diana Bathing* (B.201).[8] The term "naked" marks the distinction he had previously made in *The Nude* between the idealized form of the body and its unadorned naked truth.[9] "Rembrandt thought that the streamlined goddesses of Bloemaert or Goltzius . . . did not exist . . . and in his indignation at this piece of imposture he set out to show what the average woman with no clothes on was really like. I think he rather overstated his case; but apparently his contemporaries did not think so, for his etching of a naked woman seated on a mound had an immediate success."[10] At this point, the chilly effect of understated overstatement produced by Clark's "rather" prompts me to wonder whether Rembrandt thought Clark was overstating his case. He would no doubt have been familiar with the argument of *The Nude*, on which Clark bases his judgments of Rembrandt.

"To be naked is to be deprived of our clothes, and the word implies some of the embarrassment most of us feel in that condition." So Clark proclaims in the second sentence of *The Nude*, leaving us to wonder who the unembarrassed and uncivilized minority may be.[11] The point of view constructed by his rhetoric is signified by a "we" that fluctuates between the connoisseurial authority of a royal plural and a democratically inclu-

sive appeal to common human sentiment: "A mass of naked figures does not move us to empathy, but to disillusion and dismay. We do not wish to imitate; we wish to perfect" (26). During the decade following publication of *The Nude*, Clark went on to be High Civilization's *arbiter elegantiae*, a privilege that placed him directly—and in my opinion justifiably—in the post-1960s line of cultural fire. As Margaret Miles has shown, when he identifies nakedness with "a huddled and defenseless body" (23) or with "the shapeless, pitiful model that the students [in art school] are industriously drawing" (25), "the embarrassment most of us feel" is directed not merely toward nakedness per se but toward the naked truth of the female body.[12]

The tonal hint of condescension and the frequent identification of the "we" with the position of a privileged male gazer have made it hard for Clark's critics to appreciate the strength of the basic idea that informs *The Nude*, and so I would like to redirect attention to it. Critiques like that of Miles accentuate Clark's emphasis on the abstraction of nudity from nakedness in order to highlight what has been sacrificed in the process of reformation. And although that is surely one way to formulate and critique the Clark thesis, it doesn't quite do justice to a variant reading of the naked/nude relation occasionally discernible in *The Nude*. The variant is perhaps most concisely stated in one of Clark's comments on Rembrandt: "Rembrandt's male models are as miserably thin as his women are embarrassingly fat. By a paradox, the academic search for perfection of form through a study of the nude has become a means of showing the humiliating *im*perfection to which our species is usually condemned."[13] In other words, our unhappiness with the naked body is a backlash produced by our experience of its artistic metamorphosis into the ideal form of the nude body, the "balanced, prosperous, and confident . . . body re-formed" that is the most durable of "those inheritances of Greece which were revived at the Renaissance" (23–24).

All this Rembrandt surely understood. It is the basis of his critique and diagnosis of Clark's unhappiness. When he stumbled across Clark's casual opening reference to privation—"To be naked is to be deprived of our clothes"—he instantly knew that it glances beyond itself toward the more deeply embedded consequence of artistic achievement and inheritance: to be naked is to be deprived of our nudity. He knew that if we didn't have clothes and representations of nudity to begin with we wouldn't be embarrassed by our bodies in their "natural state." Like clothes, then, the nude

may be given the ambivalent value of a supplement that supplies the body's deficiency—"supplies" in two conflicting senses of the term, remedies and creates. A consequence of art or technology that manifestly improves on the naked body and therefore latently disparages it, the nude is initially an enhancement and ultimately a compensation. In short, it assumes a prosthetic function. But in the preposterous perspective of genealogical interpretation, nudity came first and provides the edenic vision of innocent perfection from which we fell and always fall into the sin of nakedness. Thus Clark notes that photographers of the nude, "in spite of all their taste and skill," cannot satisfy

> those whose eyes have grown accustomed to the harmonious simplifications of antiquity. We are immediately disturbed by wrinkles, pouches, and other small imperfections, which, in the classical scheme, are eliminated. . . . In almost every detail the body is not the shape that art had led us to believe it should be. (27)

The emergence or re-emergence of artistic and idealized canons of nudity, the depiction of better bodies than the bodies we have, accentuates the defect of mere nakedness, and makes the body a victim of prosthetic backlash. Clark attributes this to forms of cultural production that have broad but nevertheless specific historical provenance in the art of classical antiquity and its Renaissance revisions.

Do Rembrandt's images of the naked body support the idea that nudity slanders nakedness? Returning to the two etchings mentioned above, *Woman Seated on a Mound* and *Diana Bathing*, do both perform the act of anticlassical protest in equal measure? Although both are examples of the pictures Clark finds "unpleasing, not to say disgusting," he makes an important distinction between them: the former is a "protest against the nude in general," the latter "a more pointed blow at the nudity of classical goddesses."[14] *Woman Seated on a Mound* is certainly a departure from the classical ideal in that the sitter's body is flabby and ill-proportioned— too large from hips to knees—and her pose awkward.[15] But if a protest declares itself by evoking and then departing from the ideal, in what sense is the etching a protest? Perhaps in this sense: the figure is conspicuously arranged in a classicizing contrapposto that puts a strain on an unclassical body. But what's disgusting about it? To me the dominant effect of soft vulnerability is moving.[16] So also is the cooperative openness of a sitter doing her genial best to hold an uncomfortable pose (but with eye-

brows quizzically raised), and *that* is the story told chiefly through the contrapposto.[17]

Diana Bathing is arranged in a less open, more self-protective, contrapposto, and the edge of parody is sharpened by the touches of elegance in the coiffure and cloak. The sitter is identified as Diana chiefly by the quiver of arrows beneath her hands.[18] Clark has no doubt about its meaning: "The moral is clear. Goddesses are ordinary women, and ordinary women had better not take their clothes off" (11–12). This is oddly off message. One would have expected Clark to appreciate the anticlassical turn given by an amusingly skewed quotation. Instead, Rembrandt's moral seems to have shifted from a protest against classical idealization to a protest against female ugliness. In another passage, this misogynist edge flashes from Clark's modifiers: "His drawings of the nude became less provocatively monstrous; many of them, indeed, are quite seductive. . . . But the abstract system which antique art had imposed on the human body he would not admit. It violated two of his deepest beliefs: the uniqueness of the individual and the humility of our mortal state" (32–33).

Clark's sexist connoisseurship muddies the moral he attributes to Rembrandt. For why shouldn't Rembrandt's "deepest beliefs" include the positive acceptance of swollen bellies, flabby bodies, and "all the small furrows which an elaborate, habitual costume—garters, stays, sleeve-bands—leave on the soft surface of the flesh" (12)? It is precisely the male-dominated ideology responsible for the classical idealization of the nude that encourages the revulsion against nakedness to which Clark admits, as well as his approval of the more "seductive" drawings. Whether the "elaborate, habitual costume" is imposed on the body by current or antique fashions, it testifies to the artificial constraints by which androcentric discourse tries to reconstruct natural appearances to conform with the desires it legitimizes under the guise of ideals. Many of Rembrandt's early etchings and drawings portray the difficulty and pathos of living, of poverty, of working and aging, of conforming to alien ideals—a difficulty inscribed not only in the unadorned body, but also in facial expression—and although some depict violent emotion and hostility while others are humorous and randy, most of them (including the naked "nudes") dramatize the dignity with which the body's tribulations are endured.[19]

If the anticlassicism of an image is rendered conspicuous by visual cues that motivate the title *Diana Bathing*, it follows that the rejected norm, or better, the rejection of the norm, is an integral part of our experience of

the image. Rembrandt's moral would then be that goddesses are not at all ordinary women, are instead figments of the idealizing (male) imagination that prefers not to see women as they actually are and therefore slanders them by invidious comparison with the impossible ideal. Under this construal, the images perform or stage a protest. What they protest against is the work not of an individual precursor but of the style or tradition or norm any precursor embodies. To perform the protest is to allude to its target and to suggest a revision. Clark's remarks about the anticlassical "nudes" gesture in this direction but get diverted toward his or (as he implies) Rembrandt's distaste for the bodies of "ordinary women."

What holds true for the performance of protest also holds true for the performance of emulation: it may be directed toward an individual precursor and/or toward the tradition (style, norm) the precursor embodies. But in either case, characterizing the performance calls for a narrative that avoids the rhetoric of genetic surmise. Clark's study abounds in assertive but speculative cameos like the following.

15. "In addition to engravings of Raphael's madonnas and smaller figure pieces he had undoubtedly seen prints of the tapestry cartoons and of the frescoes in the *stanze*, then considered the summit of art. Rembrandt determined that he would achieve the same eminence" (85).

16. "Rembrandt was delighted by this version of pagan opulence [Titian's *Flora*] and determined to equal it" (132–33). Even if we allow for the obvious construal of these statements—these are the tricks of the art-historical narrator's trade, his readers will understand he doesn't quite mean what he says, he isn't trying to pass himself off as a psychic—they swerve from the artist's actual work to his rationale for producing it. Furthermore, they are concerned primarily with the anxiety of influence aroused in the sort of one-on-one agon illustrated at the beginning of this chapter by my example of Prior and Poster: The study of revisionary allusion has to move beyond this level of description, and it begins to do so in our next example, in which Clark explains why Rembrandt's attempt to rebel "against the smooth and restrained gestures of classicism" (22) led him to cultivate an antithetical style, the baroque, that turned out to be equally "distasteful" to him:

17. "He disliked the rhetorical imagery, the standardized types and the sinuous design. . . . Nevertheless Rembrandt recognized that Baroque was the triumphant international style of the time. It was the style of Rubens, whose unchallenged success, not only in Flanders but in Holland, was con-

stantly in Rembrandt's mind in the 1630's. To make his way as a painter of histories a northern artist had at least to speak the same language, and this, by some means which is not easily explained, Rembrandt succeeded in doing" (24). Here the target of emulation lies somewhere between the individual precursor and the international baroque. But the attitude of the emulator is reluctant, or grudging, and the results, according to Clark, are unsatisfying. Rembrandt was simply trying to make his way.

In Clark's first chapter, devoted to anticlassicism, he doesn't entertain the possibility of a critique or parody of the baroque similar to the one glanced at above in *Diana Bathing*. Nor does he yet broach a more complex form of emulative desire in which protest is balanced by admiration. This becomes a central concern of his fourth chapter, "Rembrandt and the Venetians," where he observes that "in several of Rembrandt's greatest portraits we feel the Venetian spirit permeating the whole design although we cannot point to the individual Titian or Tintoretto on which they are based." He goes on to add that although "the basis of Rembrandt's portraiture was very different from that of Titian"—and indeed, antithetical, rooted in the opposition of Protestant to Catholic—"the pictorial inventiveness of Venetian art was irresistible to him" (130). Here at last, with Clark's acute characterization of the painter's ambivalence toward the formal/normative features of the precursor, we arrive at what I think of as the full-strength concept of revisionary allusion.

In the foregoing dialogue with *Rembrandt and the Italian Renaissance*, I have been circling repeatedly around two basic questions of method: How can the emulative relation be approached as a property of the work rather than of the artist/precursor context? How can this personal relationship be re-cast in the larger terms of cultural contrast between different modes of formal/normative configuration? A third question is latent in the first two, given the central topic of Part 4: What impact will the consideration of these questions have on the study of Rembrandt's self-portraits? The first and third questions call for a sustained expository response that illustrates the approach through the interpretation of specific works, and this will take up the next three chapters. The second question can be dealt with more directly, and at a more general level, and I therefore devote the remainder of this chapter to it. Here again, my point of departure is a comment by Clark about one of Rembrandt's unorthodox illustrations of a classical legend.

18. "The most disturbing and the most unforgettable of Rembrandt's

anticlassical paintings is the Rape of Ganymede (1635). . . . It is a protest not only against antique art, but against antique morality, and against the combination of the two in sixteenth-century Rome. . . . Rembrandt's image gains immense power from his struggle against the potent charm of classic art. It is like one of those blasphemies which precede conversion" (12, 18). The account of the *Ganymede* from which this excerpt is drawn is as close as Clark gets to a full-strength revisionary reading, and although it remains trapped like a pupa in its cocoon of intentionality—the painting is an expression of the painter's feelings—We Have Ways of coaxing the revisionary imago out of its dark slumber.

In Rembrandt's *Ganymede* a shaggy, shadowy eagle lifts a brightly lit and graphically rounded baby by its arms, twisting them upward so that the bulk of its fat body drags below. The ponderous buttocks of our wauling and pissing hero—clearly a future gormandizer at banquets of the civic guard—strain to the utmost the levitational powers of a Jovian eagle that, with its wings outstretched and head pulled down by its burden, resembles a struggling duck. Clark believes the source to have been an engraving of a lost drawing by Michelangelo. The engraving depicts a well-muscled young man in the more efficient clutches of a very large ascendant eagle, whose claws sensibly grasp—and spread—the captive's legs. The youth is being *raptus*, in every sense of the word, and Clark speculates that "Rembrandt's feelings were divided between admiration for the design of the Ganymede with its acroterian eagle filling the sky, and a protestant-Christian revulsion against the sexual practices of paganism that Michelangelo's version so clearly implies: for Rembrandt never looked at a motive without pondering on the full implications of the subject" (13–15), and in this case the full implications, according to Clark, are disgusting: "I think that Rembrandt was shocked, and he was determined that his picture should shock" (15), and Clark was duly shocked.[20] It is nevertheless important to note that he treats Rembrandt's "reaction against the conventions of ideal art" (10) as the subject of the work and that he takes the subject well beyond the confines of the artist's response either to a particular precursor or to the classical style as a whole. He considers it in the broader context of cultural critique—the culture Clark depicts as the Dutch artist's "Mediterranean" other. In Rembrandt's response, the nude is parodied by the naked, the elegant by the crude, the high by the low. This move opens into one of the larger themes threading through Clark's book, a theme I now want to dwell on because it con-

tains the *aufgehoben* insight, the Clarkian remainder, that motivates my appropriation of *Rembrandt and the Italian Renaissance* and persists in my own approach to Rembrandt.

The theme is suggestively encapsulated by Clark's odd use of the lower case in "protestant-Christian." He is as concerned with Rembrandt's protestantism as with his Protestantism. The protest about which he is most persuasive is not the one Rembrandt directs against the sinfulness of antique art and morality per se. Rather it is the protest his art conspicuously directs against its own susceptibility to their allure, the sinful allure of sensuous *colore* and idealizing *disegno* that informs a Northern European fantasy of Mediterranean art, and of the life it conveys. This inner struggle is most compactly and sharply expressed in Clark's observation that although Rembrandt "was shocked" by Michelangelo's image, "he could not resist the motive; . . . he was fascinated by the bold curves of stomach and bottom," and yet "by showing the physical consequences of Ganymede's fear [the stream of urine] Rembrandt has gone out of his way to make it repulsive" (15–17), and from all this, he concludes, Rembrandt's image gains "its immense power" (18).

Clark's phrases tack adversatively back and forth as they describe Rembrandt's ambivalent response to Michelangelo's *Ganymede.* This grammatical zigzag conveys the conflicting pressures of the full-strength practice of emulation energized by the positive and negative charges of mimetic admiration and revisionary protest. The setting Clark provides for its activity is a field of forces that is very broad in scope: Rembrandt is "deeply involved in the mediterranean tradition," he interrogates "the ideals of mediterranean art," draws on "the deep-rooted, recurring motives of mediterranean art," and achieves the greatness "reserved for those brought up in a tradition of monumental religious art, with its roots in Mediterranean antiquity."[21] In fact, by placing Rembrandt's revisionary practice against a background at once so vast and so specific as Mediterranean culture, Clark inscribes it in a familiar paradigm of cultural dialectics.

The paradigm is a particular version of a more general binary structure that includes several possible variants, among them civilized vs. barbarian, Antiquity vs. the Middle Ages, Humanism vs. Romance, Greek vs. Goth, Court vs. Country—pairs I borrow from Richard Helgerson, who is careful to note that their meanings didn't stay fixed; rather, the terms "functioned . . . as floating signifiers . . . that remained opposed to one another though their specific references repeatedly changed."[22] Examining the in-

fluence of Elizabethan writing on the emergence of the nation state, Helgerson pins them down on English soil and affixes them to the dominant polarity of state vs. nation or sovereign vs. subjects, the centralized and unified state vs. "the multiplicity of interests and energies" that diversify the national community. He demonstrates that the politically superior term is aligned with the classic pole, the inferior with the anticlassic or nativist pole.[23] If the Renaissance state is a work of art, *natio* designates the (community of or by) nature that art must improve. This hierarchic or asymmetrical aspect is basic to the version of the paradigm I shall now put into play.

Pan-European in scope, the paradigm is structured by a discourse of cultural self-representation oriented on the north/south axis that was continuously shaken for over two millennia by the collision and interpenetration of Teutonic with Latin cultures. This discourse has historiographical and not merely historical continuity: it is a dialogical history of representation whose originary moment was Tacitus's ambivalent comparison of German and Roman societies in his *Germania*.[24] Writing from the perspective of a senatorial aristocrat sympathetic to republican ideals that had suffered under the imperial tyranny of Nero and his successors, Tacitus nostalgically displaces onto the Germans the lost virtues of republican Rome.[25] The author of *Germania* wants the best of both the primitive and the civilized, the tribal and the urban, abstracted from the drift of the disenchantment process that had led to empire and was exacerbated by the despotism, the orientalism, of emperors like Domitian.[26]

Even as Tacitus criticizes the Germans for their unruliness and instability and primitive economy (5, 15–17, 23, 26) he displaces onto them the old Roman virtues, founded on localism and tribal solidarity, whose loss he mourns: he admires the Germans for their democratic assemblies (11–12, 22) as well as for the strictness of their marriages, the trust between husbands and wives, and the loyalty inspired by kinship ties (18–21). He also comments on their ethnic purity (4), a theme that gets picked up repeatedly by German apologists during and after the Renaissance.[27] His respect for the classical virtues of *civilitas*—measure, clarity, discipline, organization, and *ars*—is everywhere evident, and, among other things, it leads him to discount as superstition the barbarians' religious practice and belief (39–40). But at the same time he recognizes the connection between their closeness to nature and the immediacy, the vibrancy, of their religious feeling. The mixed tones with which he describes the rites of the

Semnones and other tribes (39–40) suggest yearning for a time long gone when Roman divinities could still command reverence and devotion, when they were still the transcendent protectors rather than the servants of their human creators. He sees in pristine tribalism a standing reproach to the decline of ancestral Roman tradition and republican values. In this respect his views on Rome and its reformation oddly resemble those of Luther on Holy Rome and *its* reformation. At one point, in fact, he appreciates a custom that vaguely anticipates Protestant diffidence about icons: the Germans don't give their gods "any likeness of human appearance; they consecrate groves and glades and call by the names of gods that intangible quality they see with the eye of reverence alone" (9).[28]

Germany and German self-understanding were in effect settled, colonized, by *Germania*. *Germania* may have been Tacitus's protest against imperial Rome, but his Latin text was an extension of Roman power. However, the polarity of North against South is not a simple binary opposition. It is more like the fixed and moving points of a pair of compasses. The fixed foot is centered in the long history of Mediterranean urbanism and Greco-Roman culture. The moving foot traces an arc that traverses peoples whose journeys toward urbanization were by comparison more recent and rapid: the Germanic, the Gothic, the British, the Saxon, the Gallic, the Frankish, and the Batavian.[29] But the polarity and its continuity, as I noted, are discursive; that is, they are historiographical, genealogical, and mythological rather than historical. Northern self-representations are conditioned by the terms established in Tacitean discourse, terms renewed and modified during the Renaissance in textual interchanges between Southern and Northern humanists and in German apologetics that anticipated themes Luther would take up in his "Appeal to the Christian Nobility of the German Nation."[30] But since Tacitus and his classical predecessors came first, Northern responses were fundamentally reactive or counterdiscursive, or—to revisit Kenneth Clark's term—*protestant*.

My sense of this term derives from Dostoevsky, who wrote that what motivates and defines Germany

> is her Protestantism—not that single formula of Protestantism which was conceived in Luther's time, but her continual Protestantism, her continual protest against the Roman world, ever since Arminius—against everything that was Rome and Roman in aim, and subsequently—against everything that was bequeathed by ancient Rome to the new

Rome and to those peoples who inherited from Rome her idea, her formula and element; against the heir of Rome and everything that constitutes this legacy.[31]

Like the floating signifiers mentioned by Helgerson, the referents of "the heir of Rome" could change according to time, place, and circumstance. There was always, of course, the Holy Roman Church, but it was only during Luther's time—and largely because of Luther—that the pan-European Holy Roman Empire of the German Nation was led southward by Charles V away from its German and Netherlandish foundations toward Spain and Roman Catholicism. Foremost among the protestors against these heirs of Rome were the Northern provinces energized by Holland, and these too inscribed themselves into the Tacitean discourse. The Dutch derived themselves from an ancient Germanic tribe mentioned in *Germania*, the Batavians, and they reflected their eighty-year protest genealogically backward into the extensive passages in book 4 of Tacitus's *Histories* that narrate the successful revolt of the Batavian leader, Julius Claudius Civilis, against the Roman Legions.[32]

Dostoevsky's view of Northern anticlassicism is more Lutheran, more strident and one-sided, than others that share the ambivalence of Tacitean discourse. A suaver version of the protest appears among the adages written by Erasmus before he became Luther's adversary. Surprisingly for a humanist oeuvre, there are few traces of Tacitus in Erasmus's writings. But when he defends the rustic virtues of his fellow Batavians against Latin authors who contemn their boorishness, he shows familiarity with *Germania*. The defense concludes with two sentences that hilariously predict—in 1508, well *avant la lettre*—the embarrassment of riches:

The Batavi were a German tribe . . . who migrated owing to internal dissensions and occupied the extreme tip of the coast of Gaul, then unoccupied, and also at the same time an island situated between two stretches of water. . . . As a people they were strong fighters . . . but also powerful through their wealth. . . . Most scholars agree . . . that this island mentioned by Tacitus is what we now call Holland, a country I must always praise and venerate, since to her I owe my life's beginning. And I would that I could bring as much honor to her, as I have little regret in being her son! For as to that accusation of boorishness which Martial levels against her, and Lucan's charge of savagery, I think that either they have nothing to do with us at all, or both can be turned into praise. For which people has not been uncultured at one time? And

when was the Roman people more praiseworthy than when they knew no arts except farming and fighting. . . . If you call that rusticity, we freely admit the impeachment, in company with the virtuous Spartans, the primitive Sabines, the noble Catos. . . . *[Ours] is a straightforward nature, without treachery or deceit, and not prone to any serious vices, except that it is a little given to pleasure, especially to feasting. The reason for this is, I think, the wonderful supply of everything which can tempt one to enjoyment; due partly to the ease of importing goods.*[33]

The ambivalence of Tacitean discourse predictably increases when the focus of North/South comparison shifts from politics and socioeconomic organization to art. I want to consider one especially interesting example in the history of visual art because I think it illuminates the "Northern" context—in both its artistic and religious dimensions—of Rembrandt's ambivalent protestantism. The example is Heinrich Wölfflin's last book, *The Sense of Form in Art.*[34] Wölfflin there made Dürer's struggle with Italian art the focus of his story, which he organized by transferring to the North/South polarity the system of contrasts he had earlier developed in terms of linear vs. painterly and Renaissance vs. Baroque.[35] Thus he argues that the Southern sensibility is more graphic, rational, and rule-bound; the world the Italians create around themselves reflects their belief that freedom consists in measure, limits, proportion, symmetry, clarity, definiteness, individuation, and plastic form. But for the more mystical Germans, freedom is contingent on the relaxation of tectonic order and signified by the traces of broken rules. They believe in and prefer a flickering world of indefinite forms and motion, a world at whose heart a secret life surging through all things intertwines them in a pathless tangle and submerges individuals in the whole. "Both the architectonic column and the natural tree have their beauty; but in the one it is the beauty of a life restrained by tectonic laws, in the other the beauty of free organic life."[36]

As Wölfflin sees it—or at least as he expresses it—these ways of seeing are determined not merely by different cultures but by different ethnicities and "artistic physiognomies," national differences that stem "from the soil, from the race."[37] The old Tacitean theme of autochthony, deployed by German apologists in the sixteenth century, reappears here: a force Wölfflin calls "the German spirit" or "the German imagination" surges through and unites "the Germanic people" (16–17), submerging individual sensibilities in the collective racial sensibility. He is therefore bemused by the attraction that led Dürer and other German artists to

emulate so alien a *Formgefühl* as the Italian, and he wonders how it was possible that Italy could "become model and destiny for Germany? Does that not imply self-renunciation?" He nevertheless finds it true that "German artists of the sixteenth century were oriented toward Italian art" and that "their longing for the South, just as if they saw it as the land of promise, exactly coincided with the period of their own greatest creativity" (17). From this he draws a vaguely Hegelian lesson: "nowhere do the peoples of Europe stand in opposition to each other as absolutely self-contained characters; rather, the soil everywhere is receptive to 'the other' to a certain degree and, indeed, brings forth this other from within itself" (18)—just as, for example, Tacitus brings forth the German from within the Roman.

The lesson is self-referential: to see ways of seeing the way Wölfflin sees them is to see them in the manner he characterizes as German, or Northern. With its rhetorically reinforced emphasis on the autochthony of *Das Deutsche Formgefühl*, *The Sense of Form in Art* is itself an example of the arboreal and *unheimlich* sensibility it contrasts to the Italian penchant for a *heimlich* world of forms conspicuously domesticated by human art. Yet nothing could be more rule-bound and tectonic—in a word, Italian—than the dichotomies (linear vs. painterly, etc.) that structure Wölfflin's analyses of visual form.[38] Perhaps it isn't coincidental that the linear/painterly opposition he plants in Italian and German sensibilities is homologous with Tacitus's characterization of classical and barbarian cultures. Wölfflin has sown his contrast in the cultural field of Tacitean discourse and—like a good Tacitean German—naturalized Tacitus's categories: the Italian imagination is naturally artificial and rational while the German imagination is naturally natural and irrational. The Italians assert the dominion of mind over matter, but for Wölfflin's Germans, mind over matter means matter undermined.[39]

In his somewhat mystical and ill-defined ethnic typology, "the southern sense of form" overlaps what I refer to in Chapters 4 to 9 as the regime of mimetic idealism. It is a *Gefühl* oriented by the belief that ideal forms pre-exist in nature, that their perfection can be made fully visible, and that the task of the second nature of art is to find and imitate them "in materially solid and precisely outlined forms." The reality of ideal form can thus be objectified in the works of human art.[40] All this, compressed into the phrase, "objective form," provides the constraint, the defining obstacle, the object of temptation and protest and revision, in the

following statement: "The North . . . has the capacity to enter into the spirit of that which lies both behind and beyond objective form, and to be transported from the well-defined to the undefined" (23–24). This polarity is similar to the one developed by Aloïs Riegl in order to distinguish the subjective mode of attention in seventeenth-century Dutch group portraiture from the objective mode in Italian Renaissance art: in Michael Podro's paraphrase, "Dutch art aimed at creating the sense of an immaterial presence, of something essentially unavailable to perception and known by intimation or suggestion."[41]

The Sense of Form may seem idiosyncratic and even quaint in its ingenuous racism, a kind of throwback to a version of the concept of *Kunstwollen* already criticized in 1920 by Erwin Panofsky.[42] For me, however, this is part of the interest of the book. It is symptomatic of a Northern sense of "nature" constructed according to the rules of Tacitean discourse and its culture. It is also symptomatic, at the more general level, of revisionary encounters that take place between North and South in an area of discourse in which secular protestantism converges with religious Protestantism. Wölfflin's phrase "objective form" is a kind of cypher for the southern precursor and other that had always been there. The specific character Wölfflin attributes to it determines his construction of a Northern otherness liberated from that character: since the Italian other is immanent, that other's Germanic other is perforce transcendent. The visible world "cannot have the same metaphysical significance for the Germans that it has for Italy, since the Germans cannot conceive of the divine as contained in the finite world. Tacitus wrote that the Teutons worship the invisible."[43] This refers to the passage from *Germania* quoted above: the Germans think it incompatible with the majesty of the celestial gods to give them "any likeness of human appearance; they consecrate groves and glades and call by the names of gods that intangible quality they see with [the eye of] reverence alone."[44]

For Wölfflin, the pathos of the German struggle to master and overcome the Italian commitment to visibility was preeminently exemplifed by the career of Dürer (1471–1528), who twice visited Italy (1494–95 and 1505–7) and who spent his life swerving toward and away from the Southern sense of form. He sought a solution that would provide "an objective basis for beauty. . . . But he did not succeed . . . [and] finally withdrew in resignation," conceding that "God alone knows the highest, the true beauty."[45] This concession, along with its implied skeptical antecedent

("What beauty is, I do not know"), appears in Dürer's writings of 1512–
13 and also in the undated notes affixed by his editors to the third of the
posthumously published *Four Books of Human Proportions* (1528). In those
writings Dürer suggests that his pursuit of the Italian science of art, and
his own manuals in that line, were intended to compensate for the defi-
ciency. But perhaps the pursuit itself only exacerbates his sense of beauty's
transcendence. At one point he is moved to acknowledge that "the lie is
in our perception [*erkantnus*]." The context of the statement, which I give
in the nineteenth-century prose of the only English translation I'm aware
of, brings out the moment-by-moment struggle between the two posi-
tions. God alone knows the perfect beauty,

> and he to whom He revealeth it, he knoweth it likewise. . . . Being
> then, as we are, in such a state of error, I know not certainly what the
> ultimate measure of true beauty is, and I cannot describe it aright. But
> glad I should be to render such help as I can. . . . But it seemeth to me
> impossible for a man to say that he can point out the best proportions for
> the human figure; for the lie is in our perception, and darkness abideth
> so heavily about us that even our gropings fail. Howbeit if a man can
> prove his theory by Geometry and manifest forth its fundamental truth,
> him must all the world believe, for so is one compelled.
>
> [A]lthough we cannot speak of the greatest beauty of a living creature,
> yet we find in the visible creation a beauty so far surpassing our
> understanding that not one of us can fully bring it into his work.[46]

Joseph Koerner views the skepticism in such passages as "the outcome of
Dürer's struggle with the problem of beauty waged between the comple-
tion of his 1500 *Self-Portrait* and the beginning of his theoretical writings
(1511–1513)." But he notes that the skepticism is qualified by the artist's
determination "to understand beauty for myself."[47] The research pro-
grams motivated by this determination are those he inaugurated during
his Italian journeys. It isn't easy to assess Dürer's position: in the pursuit
of the transcendent beauty God alone knows, is our lying perception in-
formed or deformed by the desire for the alien riches of objective form?[48]

The same struggle is evident in the conflicted self-representation of
the 1500 self-portrait (pl. 18), which I discuss in Chapter 14 above in
conjunction with the analysis of Koerner. Koerner, it will be recalled,
demonstrates that even as the sitter assimilates his pose to that of Christ
in the *vera icon* tradition, this project is animated by and entangled in

"darker messages of vanity and bestiality."[49] In my comments on his reading I add that the effect of successful Christomorphic identification is also challenged by another detail: when the observer fixes on the specular self-appraisal of the sitter fussily fingering the tuft of fur, this index of theatrical rehearsal redirects attention to the orthopsychic drama. As the sitter betrays the narcissism of his desire to ensconce himself in the armor of an alien—sacrosanct—identity, the spiritual absorption of the *vera icon* turns into the theatrical absorption of a sitter futilely trying to transcend theatricality.

Koerner acknowledges the relation of his study of Dürer to the "self-consciously programmatic monographs" by Wölfflin and Panofsky, "the founders of my disclipline," and although he mentions *The Sense of Form* once, he totally ignores its North/South thesis.[50] He does, however, comment on "Italian aspects" of the 1498 Prado self-portrait that "bear witness to foreign sources of the artist's conception of himself," and he remarks ironically of the 1500 self-portrait that "it will always convince us . . . it was made to stand as frontispiece for surveys of northern Renaissance art" (37–39). In the former, Dürer "appears as worldly *gentiluomo*," but his "familiar face peers out at the modern viewer as if somehow mocked by his own costume." In the latter, he "thematizes the unbridgeable rift between himself, in all his vanity, narcissism, and specificity, and the higher role to which he aspires" (67). In both, self-representation is divided between the desire of self-transcendence and the critique of the desire, between the painter/sitter's allusion to himself affecting an alien identity and his wry protest against both his affection and his affectation. Although recognizable features of the North/South dialectic clearly appear in these contrasts, there is no need to confine them within the terms of Wölfflin's Tacitean discourse.[51] Nevertheless, there is one respect in which the 1500 self-portrait makes a kind of proleptic contact with a sector of the discourse that will increasingly concern Dürer in his later years. I can best approach this sector by rephrasing my description of the work done by the self-portrait: it performs the self-dividing conflict between an assertion of Southern visibility that assimilates *Pictor deus* to *Deus pictor* and the Northern protest against this act of hubris. What would it take for the protest to become Protestant? In the interaction of the problem of visibility in art with the problem of iconicity in religion, we can locate one of the affinities that would draw Dürer closer to Martin Luther.

Luther looked inward and upward to the Holy Ghost and God for sal-

vation rather than outward to the political and ecclesiastical orders. While he appreciated the importance of politics, he followed an Augustinian line in condemning human art as part of the larger classical/Roman dependence on human instruments to do the work that could only be properly done by the Holy Spirit. This, and not the political order, was the theater for the real drama of salvation, and he wanted to take it out of the institutional, architectural, and calendrical confines of ecclesiastical space-time so as to restore the primitive Gospel sense of community and transcendence. This project was undertaken on behalf of God as well as the soul. The triumph of the visible church was the triumph of the human over the divine. Luther called it a Babylonian captivity. Like the Mosaic conquest of the promised land and Solomon's building of the temple, it was a premature settlement. The Old Testament mediated through Moses, Luther wrote, "was not a promise of remission of sins, or of eternal life, but [only a promise] of temporal things, to wit, the land of Canaan. No one was renewed in spirit by this promise so as to lay hold on a heavenly heritage." So it was enough, he added, that "an unthinking beast" was sacrificed, "and the testament confirmed by its blood." The Mosaic promise could be fulfilled only by being transcended. The real point of possessing the promised land was to lose it. The enabling words with which Christ promised communion through the diaspora of his body and blood demanded the rejection and loss of what incarnation offered. "Christ said: 'The new testament in my blood'; not another's, but His own."[52] If one was to reclaim one's freedom of conscience, if one was to spring God from the traps of human imagery, one did not commit oneself to the unctuous hands of the priestly patron.

Luther's protest against this servitude or captivity consists in an account of the three ways in which the Roman church "shackles" the sacrament of the Lord's Supper. First, the Romanists deny the complete sacrament to the laity, reserving to the priesthood the right to partake of both kinds, body and blood, and thus using the divine sacrament to assert the superiority of priests over laity.[53] This confirms the "fiction of 'the indelible character'" derived not from the person of the priest but from his office.[54] The second shackle is the doctrine of transubstantiation, which affirms that at a certain moment, when the priest closes the ritual switch, the real substance of the bread and wine is replaced by the real body and blood of Christ, though the comestibles retain their appearance, or accidents.[55] Like electrotherapy, the divine current circulating through—and only

through—official channels of indelible character automatically disintegrates the sins of the week and sends a small charge of salvation up the spine. Luther recognized that this fiction continually retranscendentalized the man-made authority of the priesthood, that it made the individual dependent on the expensive architecture, machinery, props, and vestments of the visible church, and thus that it diminished the need for ethical struggle and self-confrontation. It both weakened the will and exacted tribute. The Roman mass made clear to sinners that nothing short of institutional power could purge them of evil. This message, already embedded in a language few worshipers understood, was driven home by the third shackle, the belief "that the mass is a good work and sacrifice," that the sinner has only to show up, go through the prescribed motions, and sacrifice a few pennies to the plate, and the ecclesiastical magic would take care of all the rest. For Luther, justification by works really meant justification without working for it.[56]

Luther's strategy in "Pagan Servitude" is to accentuate the testament over the sacrament, the word over the image, the verbal promise given once in history over the repeatable visible sign by which it was (merely) commemorated. In striving to free the Gospel word from the *visibilia* parasitic upon its power, he set himself against the whole course and tendency of the Roman Church. We're familiar with the allegorical programs by which, from the ninth century on, the church found itself continually elaborating its ritual, architectural, and ecclesiastical structures in its effort to keep pace with a changing world. Those structures, which mediated transcendence, became more densely, precisely, and rigidly hierarchic in form, and this form per se constituted its own ideological content. The Church tried to preserve the force and vividness of its ideology by expressing and materializing them in perceptible symbolic networks, the fictions of objective form it mystified as acts of God.

Excessive visibility was the hallmark of the visible church and its universe: the visibility of the Aristotelian/Ptolemaic cosmos to which medieval Christianity had committed its hierarchic vision; the visibility of the ecclesiastical machine; the visibility of cathedral architecture with its encyclopedic embodiment of Christian time and space and doctrine; the visibility of the Beyond, whose objective form was progressively elaborated through the centuries, especially in the region of Purgatory, where new construction was stimulated by the economics of indulgence. These commitments to the visible order subtly eroded the transcendence of the

reality they came to reflect, and they did so by the very assertiveness, the glorious efficiency, the indulgent costliness, with which the images confirmed their claim. Hans Jantzen writes that "the mystical enchantment of thirteenth-century interiors became an architectural expression of a sense of complete escape from the workaday environment, a feeling of having 'overcome the world' of material things."[57] Possibly so; but it was nevertheless the material forms that produced this effect. By their very power they tended to consecrate the visible image as a symbol, deny the allegorical mediation that produced it, and give it a share in the invisible substance it claimed merely to represent. The invisible conformed to the visible, depended on it, was effectively reduced to it, so that if the visible were destroyed or discredited, it would bring down with it the invisible world that was embedded, entrapped, within its objective form.

Luther's project thus has something in common with the Northern response to Italian art described by Wölfflin, who comments on the German artist's surprise at finding "that something alive can be embodied in stable proportions; that there is an art where content is completely contained within fixed form; that there are people who can fully express themselves in the visible."[58] Both Luther and Wölfflin's Northern artists recognize the need, appreciate the value, of objective structures, yet both react against their misuse. In their different ways, they protest against systems of representation that subordinate spirit to structure and ethics to technics.[59] Even as the artists open themselves to alien Italian splendor, they shy away from its power. Dürer glories in the visible, and in his mastery of it. He risks, indeed embraces, the Babylonian captivity of Italian form, the conquest of the promised land of perspective and proportion. Yet he knows, and shows, that the visible stands in the way, that to overcome the human is to overcome not only the measured solids and spaces of the domesticated world but also its opulence, its material contexture, the weightiness of the physical and institutional structures with which human art settles its visible Canaan.

Wölfflin's fabled commitment to his formalist method makes him insensitive to ideological and political motives crystallized in the visible motifs of Southern art. This is most obvious in *Classic Art*, which—following the scheme articulated by Vasari in his *Lives*—explores the emergence, during the first quarter of the sixteenth century, of a new artistic epoch and style that fulfills and supersedes the art of the Quattrocento.[60] "The Cinquecento set out with an entirely new conception of human greatness

and dignity." It produced "a new race of men" whose nature "was percep-
tibly . . . elevated" and informed by "a feeling for the significant, for the
solemn and noble" (208). Wölfflin by no means ignores the social dimen-
sion of this change: the new ideals reflect the transformation of "a bour-
geois art . . . into an aristocratic one," an art that combines grandeur, re-
straint, and "classic repose" in visualizations of the sprezzatura described in
Castiglione's *Cortegiano* (212–15). But his characterization is itself idealiz-
ing in a one-dimensional manner that betrays the enthusiasm of one of
Italy's Northern admirers.[61] An example will suggest what he leaves out.

 The Eucharist is the subject of two of the arch-shaped frescoes Ra-
phael painted between 1508 and 1512 for Pope Julius II in the Vatican
Stanze, the suite of papal apartments: the *Disputà* in the Stanza della Seg-
natura and *The Miracle of the Mass at Bolsena* in the Stanza d'Eliodoro. The
subject of the *Disputà* is Theology (identified by a personification on the
ceiling) and the fresco depicts a monstrance on a central altar surrounded
by seated and standing figures.[62] Some read, some communicate with
each other, some gesture toward the monstrance, and some gesture up-
ward, where the small circle of the monstrance is repeated in the larger
circle containing the Holy Spirit above it and in the even larger circular
throne on which Christ sits above the the Holy Spirit, surrounded by the
Holy Family and figures from the Old and New Testaments.

 According to Wölfflin, the fresco is an example of Raphael's early
move toward the new ideals and the "new visual standard" of the High
Renaissance. His analysis is strictly—restrictively—formal. He comments
on its "unity and calm," the "almost . . . reverent" feeling with which "con-
tours are drawn," the contrapuntal yet symmetrical organization of the
whole.[63] He justifies the restrictiveness of his analysis by insisting that for
Raphael and his contemporaries the fresco was not

> a synopsis of church history. . . . The all-important thing was the artistic
> motive which expressed a physical and spiritual state: . . . no one asked
> what the figures *meant*, but concentrated on what they *are*. To share this
> point of view needs a kind of visual sensuality, . . . and it is especially
> difficult for the Northern races to appreciate fully the value which the
> Latin races set upon physical presence and deportment. (88)

His effort to look with Latin eyes leads him to conclude that the tradi-
tional title of the fresco, *Disputà del Santissimo Sacramento* (*Dispute Con-
cerning the Holy Sacrament*), is inaccurate: "There is no dispute in this as-

semblage, hardly even any speech: what is intended is the representation of supreme wisdom, the assured presence of the profoundest mystery of the Church confirmed by the apparition of Divinity itself."[64] In other words, what is represented is the doctrine of transubstantiation. Indeed, the fresco gathers past and present defenders of transubstantiation into the mythic unity of an eternal moment, and the most dominant figure in the lower right sector is an articulate papal defender of the doctrine, Sixtus IV, the uncle of Raphael's patron, Julius II.[65]

Wölfflin nevertheless ignores just about everything that would have offended Luther. "On its simplest level," as Pope-Hennessey puts it, "the subject is the glorification of the Eucharist;" the program "comes from St. Bonaventure, and depicts in panoramic form the efforts of human theologians to penetrate the divine mystery."[66] "Penetrate" may be an aggressive term, but a good Lutheran would read it as a mystification and replace it with "construct." The iconography of transubstantiation is triumphantly—but also, the Lutheran would note, fantastically—visualized through the vertical motif of ascendant circular forms: the tiny host in the monstrance mediated through the Holy Spirit to the heroic body of Christ on his throne. On another level, both the theological program for the glorification of the Eucharist and its visual realization in the *Disputà* were cogs in the machinery of indulgence operated by Raphael's patron:

> The secularization of the Church in the fifteenth century led to the most dubious practices in financial matters, dubious because they exploited the religious devotion of the masses for the mere enrichment of the papacy. The sale of indulgences . . . had gone far beyond any theological consideration. It was lightly adopted by popes for materialistic ends. . . .
>
> In 1507 Julius II . . . announced an indulgence, the income from which was to be used for the building of the new St. Peter's Church in Rome. Pope Leo X . . . in 1513 continued the action of his predecessor.

The use of the Medici pope's indulgence during the next three years to close "a deal with . . . Albert of Brandenberg" led directly to the moment on October 31, 1517, when Luther "affixed 95 theses on indulgences" to the church door in Wittenberg.[67]

Given the limits of a formalist reading, is it possible to find an analysis in this mode that does more justice to the fresco's theme and context? My candidate is S. J. Freedberg's commentary, which is no less responsive than

Wölfflin's to the graphic qualities of the *Disputà* but which confronts
rather than elides the Eucharist. More importantly, it deploys a rhetorical
figure that places the formal organization of the fresco directly in the area
of Luther's concern. Freedberg emphasizes the link between the monu-
mental assertion of transcendence in visible form and the human source
of the assertion. He describes figures that transform themselves into the
living yet frozen architecture of the institutional facade—the facade
Luther would try to demolish, the facade behind whose authority Julius II
carried on his military, economic, and diplomatic wars. The Eucharist is
set out

> on an altar in the center of the vast arched picture field as its true
> protagonist, and as if the scene should half symbolize, half represent, an
> enactment of the Mass. The whole design focuses on the Eucharist, and
> depends in form and sense on relations to it. Echoing the shape of the
> wall, the disputants and their holy witnesses have been disposed in
> simple, grandly sweeping semicircles that enclose the altar. Their close-
> packed forms create the semblance of an architecture which . . . is the
> apse of a church. This shape has a clarity, harmony, and spaciousness . . .
> like that of an actual architecture, but it also has the flexibility of the
> living forms out of which it has been composed. . . . The figures that
> populate this structure have grown beyond Raphael's former scale,
> magnified along with the structure and the grandeur of the idea
> they and it express. Full forms, recollecting the antique, convey a
> decorum . . . that may reflect but more likely ennobles the ideal of
> behavior of the classicizing Roman court.[68]

This description converts the *Disputà* into a parable or allegory of what
Luther criticized: in the dramatic heightening and assimilation of the hu-
man pillars of the church to its architectonic idea, in the focus on the cru-
cial strategy by which, according to Luther, the Church takes the imagi-
nation prisoner, the political importance of the technology and ideology
of salvation could not be more tellingly portrayed—nor demythologized.

The *Disputà* transfigured by Freedberg's text presents the target of
Northern protest and the object of Northern desire. Within the context of
Tacitean discourse, the protest is of course more resonant, less perplexed
by desire, in Luther than in Wölfflin and Dürer. If "Northern" is viewed
in its Lutheran and Protestant aspect, it characterizes an imagination dri-
ven by the need to overcome human-made—indeed, man-made—civi-
lization, overcome classical and humanistic "reason" and its technologies,

overcome the specter of *orbs* domesticated and measured by *urbs*. "Northern" signifies an impulse to spiritual as well as social and institutional re-tribalization. It signifies another desire, not the desire to embrace the Southern sense of form but the desire behind the protest of iconoclasm: the desire to spring God from the traps of human imagery and renew divine otherness so that the wonder of transcendence transcended—of God's loving descent into the heart of each mortal soul—may be restored, and with it the Gospel sense of both the pathos and the dignity of unaccommodated humankind in all its nakedness. This is a sense for which Rembrandt's protestant art, both secular and religious, has often been praised, the sense foregrounded by Kenneth Clark's studies of his anticlassicism.[69] Indeed, the shapes and proportions of many of Rembrandt's naked figures conform loosely to what Clark calls "the alternative convention," the convention of the Gothic body that emerged during the fifteenth century and appealed "to Northern taste," and that features "bulblike women and rootlike men" who, "pale, defenseless, unself-supporting," betray their origins in the shame of nakedness. This is a description Tacitus and Wölfflin would have appreciated.[70]

When I speak in this general manner of protestantism in art and religion, my discussion is of course far removed from the many faces of Protestantism located in particular institutional settings and studied there by historians. And when I extend my Tacitean account of Northern protestantism to Rembrandt and his relation to the Gospel, it's obvious that, although I may be interested in Rembrandt's "religion," I'm not concerned with the particular history of the Reformed Church in the United Provinces, nor with Calvinist institutions and polemics, nor with Remonstrants and Counter-Remonstrants, nor with the uneasy relations obtaining between Dutch Calvinism and Lutheranism, nor with the way sectarian differences affect the strategies of artistic patronage.[71] Rather, my interest is in a protestantism Rembrandt shares with Wölfflin's Northern artists: a self-divided protest directed partly against the allure and dangers of the visible and partly against the artist's own delight in them. The protest is launched in the expanding field of Tacitean discourse, a field in which the Southern is no longer identical with Rome but spreads diffusely across the amplitude of the Mediterranean culture Clark subdivides into different temporal and regional styles (Antiquity, Quattrocento, High Renaissance; Roman, Florentine, Venetian).

Clark himself depicts the protest with a broad brush, contrasting Rem-

brandt's portraiture to Titian's in terms of the difference between Protestant and Catholic morality. The statement is exemplary and deserves quotation because it turns on itself at the end and acknowledges what Wölfflin calls "the danger of Italian art":[72]

> It may seem far-fetched to speak of Catholic and Protestant portraiture, but it is a fact that Titian's strongly Catholic approach to all experience, his hearty acceptance of doctrine and hierarchy, is perceptible in his attitude toward his sitters, and even in his sense of form. He saw each sitter as a type to be enhanced till it reached its perfect state. . . . Rembrandt, who was essentially a Protestant, saw each sitter as an individual human soul whose weaknesses and imperfections must not be disguised, because they are the raw material of grace. It was this pre-occupation with the individual which led him to study his own face so relentlessly. . . . How . . . arrogantly external by comparison are the self-portraits of Titian. *And yet, the pictorial inventiveness of Venetian art was irresistible to him.*[73]

Clark acutely characterizes the ambivalence of the painter's reaction to the formal/normative features of the precursor as a tradition that is at once cultural and esthetic. It's true that the casual grounding of the category "Catholic" in facile references to "acceptance of doctrine and hierarchy" and to the eschatological renovation of the body makes the contrast between Catholic and Protestant seem a little far-fetched. Yet there are social and political as well as religious reasons, institutional as well as cultural reasons, for Titian's "acceptance of doctrine and hierarchy," as well as for his typifying enhancement of his sitters; and there are more than merely Catholic norms and values embedded in his style. The equivalent in portraiture of the Southern belief in objective form discussed by Wölfflin is the fiction of objectivity, and I suspect that Titian's cultivation of this fiction in his self-portraits accounts for Clark's characterization.[74] But we saw in preceding chapters how Titian as well as Rembrandt subtly modified or parodied the fiction, Titian in his portrait of Julius II's kinsman, Francesco Maria della Rovere (see Chapter 9 above), and Rembrandt in several self-portraits. The aesthetic constraints and opportunities offered by Titian's commissions were congenial enough to enable him to focus on artistic problems and let the messages and programs take care of themselves.

The sustained antipapal protestantism peculiar to Venice among Italian city states in the Renaissance was much narrower in scope than the cul-

tural polemic of Northern Protestantism. Titian's lifelong struggle to reconcile *colore* with *disegno*, the optical values of *Giorgionismo* with the more graphic values of Florentine classicism, was carried out in and contributed to a conflict of values that went deeper than intercity rivalry. "The visual languages of Florence and Venice are no less different than their spoken tongues."[75] But it involved him in no fundamental cultural counterstatement, whereas for Rembrandt to imitate, emulate, appropriate, and sublate Titian was to grapple with an aspect of Mediterranean culture that is more specifically Venetian than Catholic. Venetian challenges to the hegemony of the graphic mode offered Northern artists a preemptive model of anticlassical protest that was dangerously alluring. It isn't enough to say that "[t]he pictorial inventiveness of Venetian art" reappears in Rembrandt's handling of light, paint, and brushwork, and in the play of the optical and textural qualities of the rough style that talks back to patronal demands for graphic clarity and transparency. Something else is at stake, something that works to moralize what might otherwise be mere aesthetic jeopardy. It would be easy to pin it down in the following inventory of phrases used to characterize Venetian (as opposed to Florentine) painting: "involvement with sensory data"; "powerfully sensuous presences, not semblances of statuary"; "sun-lit, atmospheric, and rough-textured"; "the weight and density of . . . fleshly substances"; "the warmth and lustre of the flesh"; "forms . . . born as color and . . . embodied in it."[76] But I prefer to get at the dangerous appeal of Titian's painting parabolically, and my parable draws on three texts.

The first is from Carlo Ginzburg's study of the cultural context for Titian's erotic images. Examining sixteenth-century "manuals for confessors and penitents," Ginzburg finds that their

> minute analyses of the sin of lust concentrate on the senses of touch and sound well into the . . . century. Sight is hardly mentioned. . . . Only later in the century did sight emerge slowly as a prominent erotic sense, immediately after touch. In the still unwritten history of the senses, due weight will have to be given to this eroticization of sight in respect to hearing, tied to such specific historical circumstances as the diffusion of the printing press and the increased circulation of images.[77]

Ginzburg associates this technology-driven shift of attention with the emergence, after 1540, of lust as "the sin discussed at greatest length" in the confessionals, and he suggests that this may help explain why the

"process of control and thoroughgoing repression of sexual life" became a primary concern in both Catholic and Protestant countries during the middle of the century.

My second text illustrates a Northerner's rabid response in 1570 to the Southern source of eroticization. During his Italophobic rant in *The Schoolmaster*, Roger Ascham enters into Tacitean discourse when he warns that the Siren songs and enchantments of Italy will do to young Englishmen what Circe tried to do to Ulysses, and that even reading Italian books translated into English will "open . . . such subtle, cunning, new, and diverse shifts to carry young wills to vanity and young wits to mischief, to teach old bawds new school points, as the simple head of an Englishman is not able to invent." Northerners view Venice not only as the Gateway to the East but also as the world's pleasure dome: in Venice, "it is counted good policy, when there be four or five brethren of one family, one only to marry and all the rest to welter with as little shame in open lechery as swine do here in the common mire."[78]

My third text, which transports us directly into that hotbed of southern lust, is an extract from Daniel Arasse's remarkable essay on the 1538 *Venus of Urbino*. Titian's Venus, Arasse writes, "is awake; she does not dream; she knows she is seen; she knows that she touches herself; she sees us, and she touches herself." The composition projects her body forward and extends the invitation to touch, but at the same time the large canvas with its life-size figure forces us to step back and view it from a distance so that "the beholder sees Venus but cannot touch her," and this dialectic between

> seeing and touching lies at the heart of Titian's pictorial art, and especially of his future development. As we know, . . . Titian will touch his canvases more and more in order to paint them—and . . . the Tuscan Vasari will admire how "one cannot see them close up but they become perfect when seen from afar." This is not [yet] the case with the *Venus of Urbino*. . . . But the future dialectic (which was to become so ponderous in the debates on colorism) of "touching in order to paint, withdrawing in order to see," is already posed here . . . in the rapport that the *Venus of Urbino* establishes with its viewer, under the form of . . . an *idea of painting*: painting Venetian style.[79]

Arasse's adept glide from the painting of scopic eroticization to the eroticization of painting suggests a displacement that implicates—or "invaginates"—the surrounding culture of desire within the erotics of painting.

This is the burden of my parable: what Rembrandt emulates and appropriates is not merely an "idea of painting" but the totality of the culture metonymically condensed in and represented by that idea. He may protest against the idea, as when his portrayals of nakedness register a protest against nudity and when his mythological paintings stage parodies of erotic images Titian and others "couched in a culturally and stylistically elevated code, the mythological."[80] But the (representation of the) protest only enables and justifies the (representation of the) Northerner's surrender to the seductions of the South.

My account of revisionary allusion in the context of Tacitean discourse has been prompted by Clark's balanced assessment of Rembrandt's encounter with Mediterranean and Venetian painting, and I conclude with a series of questions that anticipate the concerns of the next three chapters. Can we find in Rembrandt's self-portraits passages of painting that visualize a susceptibility to "the pictorial inventiveness of Venetian art" but at the same time suggest a normative critique of the very qualities represented as aesthetically irresistible? Do Rembrandt's Italianizing self-portraits enact the dialectic of sublation—that is, do they simultaneously transcend and reanimate the precursor's stylistic splendors? Do they represent not only the *heimlich* impulse to subdue and transcend southern splendors, to get out from under the shimmering shades and tints of Venice, but also the *unheimlich* return of those shades conjured up by the unruly "longing for the South" that troubles the Northern painter's project of transcendence?[81] And, to conclude with the motif I borrowed from Schama and developed in Part 3 of this study, isn't this the structure of embarrassment?

22

REMBRANDT AS COURTIER

"Like all successful painters," Clark writes, Rembrandt "was always on the look-out for fresh poses. In the 1630s he tried most of the current formulas: the hand on the breast of Van Dyck (although with a very different effect), the communicative gesture of Frans Hals, the diagonal pose of Rubens, as well as some admirable inventions of his own."[1] Clark is particularly impressed by the intelligence with which Rembrandt "studied the great Italians of the Renaissance, especially Raphael."[2] These deceptively casual comments on experiment, emulation, and study are the fruits of Clark's own deep study and cogent visual intelligence. But they contribute primarily to his analysis of influence and reaction (or challenge and response) and to his reconstruction of the painter's development. They don't bear on the issue of allusion in that they don't consider whether and with what effect Rembrandt paintings quote or cite their precursors. In this and the next two chapters, although I rely on the kind of information Clark and other scholars supply, I shall shift it from the category of influence to that of allusion. My purpose is to explore the range of allusion generated by self-portraits that present the painter in the guise of a patron and thus compress the complementary functions of painting and patronage.

It is an act of revisionary allusion when the self-portrait of the painter as patron quotes the identifiable features of precursor styles in such a way as to perform a critique of the protocols that constrain the apparatus of official portraiture. As I have been suggesting, one significant feature of the Rembrandt look is its evident commitment to revisionary allusion, to visible engagement in interpictorial commentary: it is a look that takes in,

463

sizes up (or down), and comments on the modes and motives of other paintings or styles of painting. For the painter to portray himself as a patron while portraying that figure in a manner that evokes the style of van Dyck or Rubens or Raphael is to interrogate the motives of all the parties to the transaction. Is the painter in representing himself as a patron also representing the patron as a painter? Do the lines of influence run from painter to patron, so that the latter is the site of infiltration, the embodiment of the painterly spirit that inhabits and interprets it? Do they run from patron to painter—does the identity of the two imply that the patron wants to *usurp* the painter's power and prerogative in order to produce what would ideally be a self-representation, that is, a self-portrait? Is the painter mocking his own desire to participate in the benefits of a practice that restricts his freedom, a practice dictated by the self-interested and self-preening motives of patrons whose agendas conflict with the painter's, motives for which he has little respect and which, with reflexive irony, he displays as his own?

Such questions are put in their most pointed form in the famous 1640 self-portrait in London, whose title—I think we can all agree—is the Courtier (pl. 26). Since it derives from Rembrandt's quick sketch of Raphael's *Castiglione* and the 1639 etched self-portrait based, like this painting, on Titian's *Portrait of a Man*, formerly thought to be a portrait of Ariosto (pl. 27), commentators concur as to its general dramatic meaning: it is a portrait about emulation; whether the emulatee is Titian, Raphael, Ariosto, or Castiglione, Rembrandt expresses his desire to compete with the Renaissance Greats, overgo them, and attain to their high social status. The elegant costume is a sign of this desire; once again, it is more than a century out of date. According to the consensus view, the Courtier is Rembrandt's dream of the golden age of mimetic idealism. Within this view, particular responses fan out in different directions. One line of thought is that this courtly dream was unattainable in seventeenth-century Protestant Holland; therefore, the portrait sits on the cusp of Rembrandt's downhill slide from the success of the 1630s in Amsterdam, and the Courtier's expression betrays "the first symptoms of inner crisis."[3] Another line of thought is that the Courtier isn't on the verge of a breakdown: far from it, he appears smug, self-satisfied, and well pleased with himself to some; aloof and dignified to others; haughty and even arrogant to still others.[4] And so it goes.

All these responses, however much they differ, derive from the common

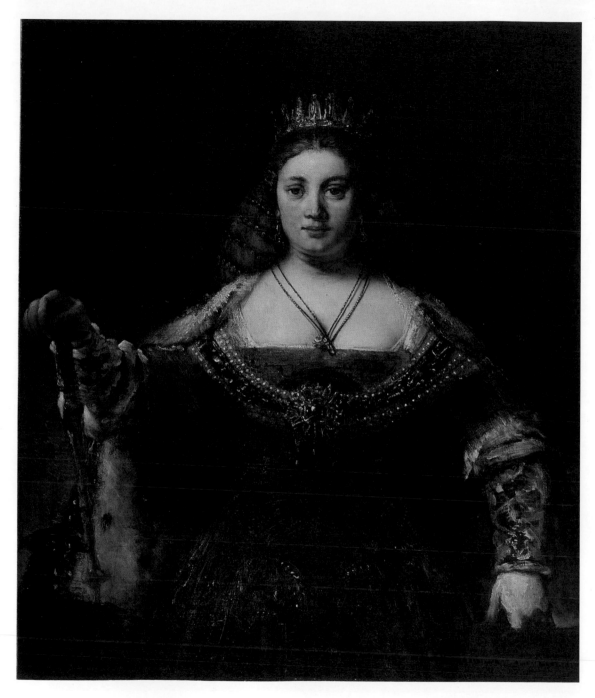

Rembrandt, *Juno*, 1662–65. Oil on canvas.
The Armand Hammer Collection, UCLA,
at the Armand Hammer Museum of Art
and Cultural Center, Los Angeles.

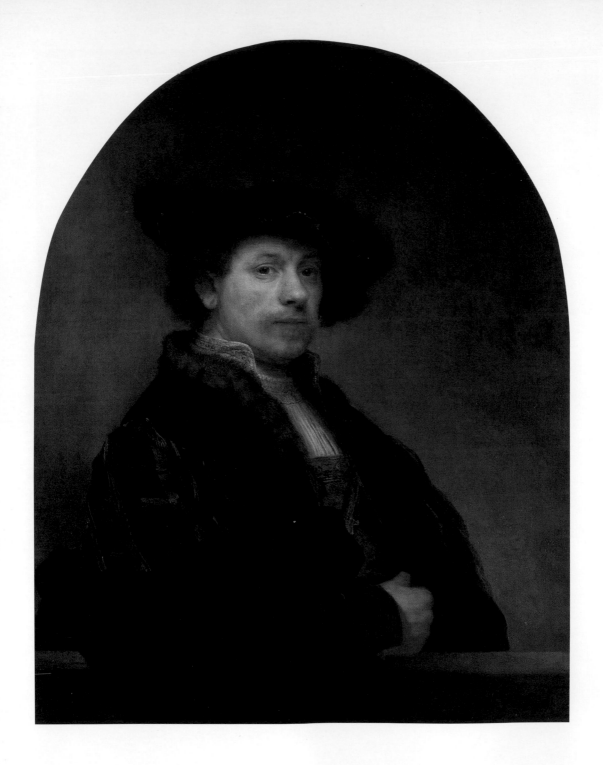

Rembrandt, *Self-Portrait at the Age of Thirty-Four*, 1640. Oil on canvas. National Gallery, London.

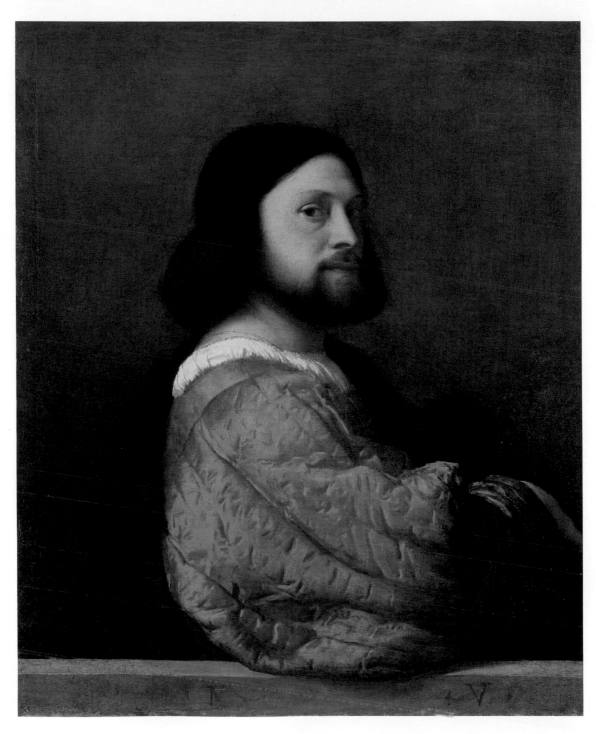

Titian, *Portrait of a Man ("Ariosto")*, ca. 1512.
Oil on canvas. National Gallery, London.

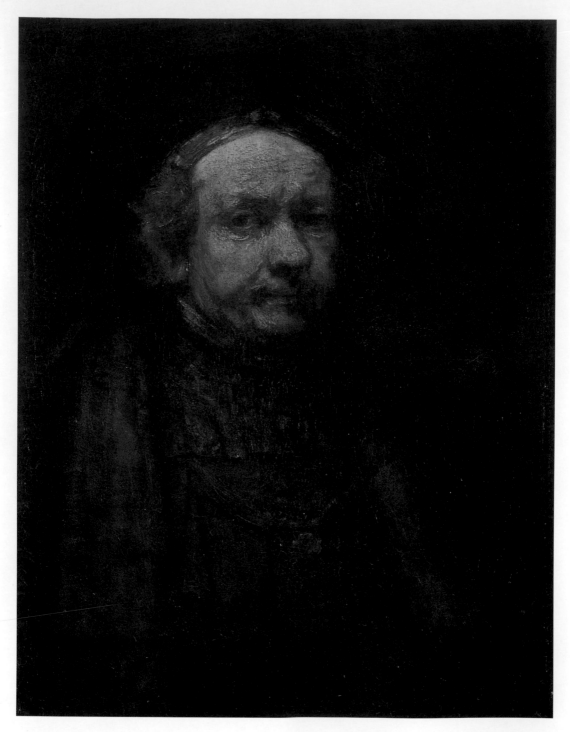

Rembrandt, *Self-Portrait as an Old Man*,
ca. 1665. Oil on canvas. Galleria degli
Uffizi, Florence.

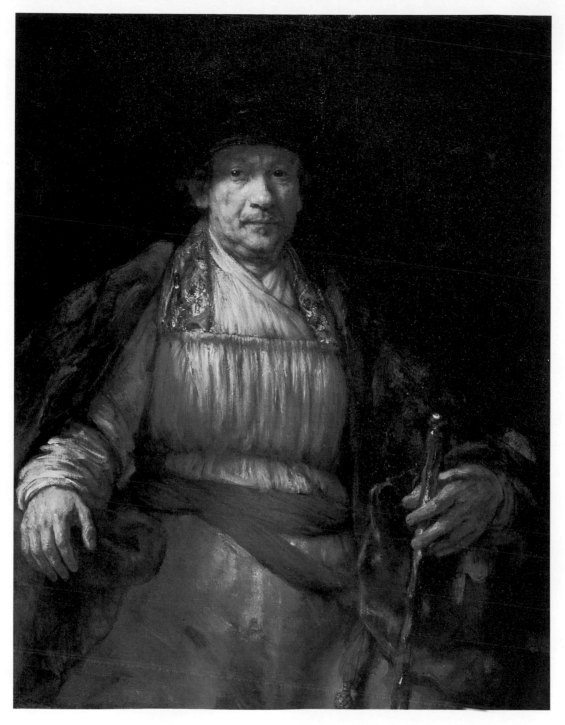

Rembrandt, *Self-Portrait*, 1658. Oil on canvas.
The Frick Collection, New York

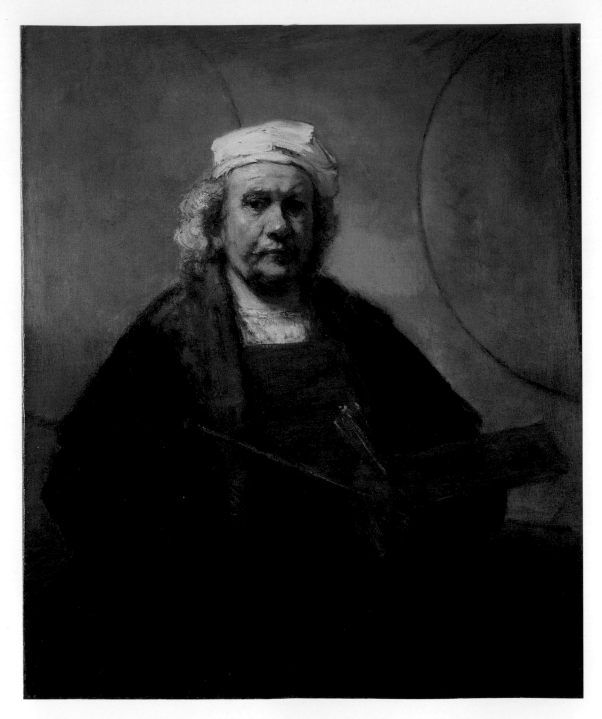

Rembrandt, *Self-Portrait as Painter*, 1660s.
Oil on canvas. The Iveagh Bequest,
Kenwood House, London.

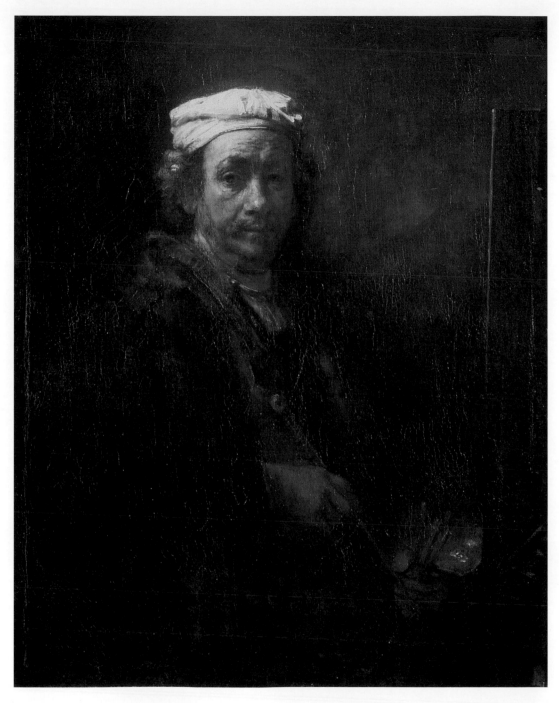

Rembrandt, *Rembrandt as an Old Man at His Easel*, 1660. Oil on canvas. Musée du Louvre, Paris.

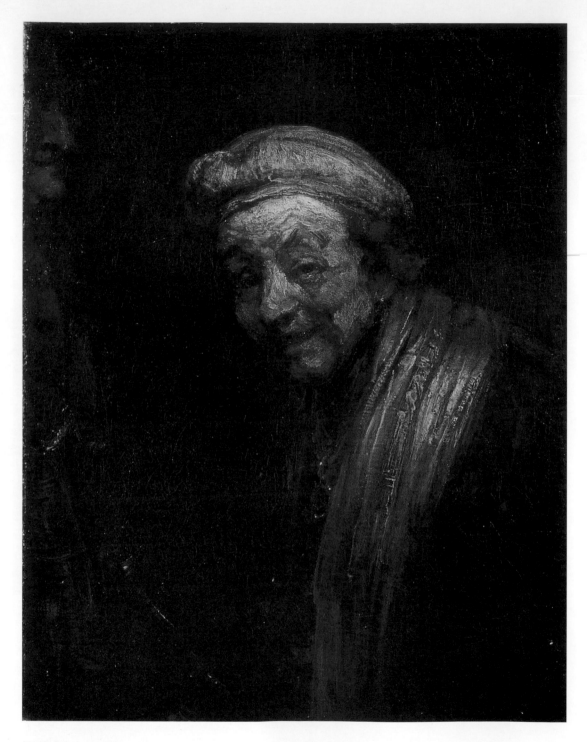

Rembrandt, *Self-Portrait as Democritus*,
ca. 1669. Oil on canvas. Wallraf-Richartz-
Museums, Cologne.

ground of the assumption that the Courtier dramatizes Rembrandt's nostalgia for the good old ways and means of patronage, his yearning for the days when those who had the power of commission also had the good taste to appreciate artistic achievement; and when they were generous enough to open not only their purses but their arms and ranks to the erstwhile practitioners of the manual art of painting who had served them so well. Not surprisingly (as people like to say nowadays), this is an assumption I'm going to challenge, because I think the Courtier challenges it. But its challenge to Italian models depends on affiliative allusions that encourage careful scrutiny of the interpictorial play of resemblance and difference. The meaning of the challenge depends, for example, on our recognizing that if the Titian sitter is closer to the observer than the Courtier, he is also more self-enclosed. His ledge or parapet seems higher relative to the body, in part because its foreshortening implies a lower viewpoint, in part because the billowing sleeve that rests lightly on it seems pushed up by it. The lighter color and more sharply drawn contour edges of the ledge top—compare the softer and darker modeling of its counterpart in the Courtier—make the barrier effect more pronounced in the former. Titian's sitter doesn't so much lean on the barrier as stand or sit behind it. His pose nicely balances nonchalance with the attentive regard of one who expects and welcomes attentive regard. As he turns his head toward the observer his body loosely and casually coils about itself in a position that shows us more of the sitter's back. The decisive energy that drives the diagonal vector down from the forehead arch through the straight nose and stiff beard to the sleeve dramatizes the ideal best rendered by the Italian term for the anonymous male portrait, *ritratto virile*.

Rembrandt's Courtier defines itself against this image, proclaiming both its resemblance to the Italian model and the difference that only the resemblance can make meaningful. The problem it poses for itself is, precisely, the problem of Rembrandt against the Italian Renaissance: how to represent an embarrassment of Renaissance riches without being embarrassed by the result. I can easily imagine Rembrandt admiring the painting in the Amsterdam home of its owner, his acquaintance Alfonso Lopez, and listening thoughtfully as David Rosand or some other Titian specialist extols the Italian sitter's sprezzatura: "the cool elegance," the "magnificently sleeved arm," the cloak "draped with such studied casualness," the "added strength" the face receives "from the dynamic profile of the surrounding hair and beard," "the direct encounter of those sharply alert and

intelligent eyes," "the calm confidence of the physiognomic expression."[5] Not surprisingly, Rembrandt rushed home filled with envy and schemed to make himself the object of similar devotions. He found a canvas a little larger than the one that supports the Titian sitter, and he selected from his store-room a wardrobe that was fancier, more complex, and warmer in tone. Not surprisingly, he lusted after the magnificently sleeved arm, but because he thought it would be in poor taste to emulate so salacious a display of material fatness and foreshortening, he flagged his refusal of the challenge with a *sprezzata* gesture of his own, twisting the cloak discreetly—but with the studied casualness of Raphael's Castiglione—over the tumid member. And as if to reward himself for such temperance he conferred a gold chain on the sitter (but again discreetly, modestly, nothing like the bravery that glitters on the Count and General), and topped off the whole confection with one of his frothy if lightly garnished berets.

It's not surprising that Rembrandt experienced anxiety in the face of Rosand's and Titian's preference for strong, dynamic, bearded manliness. Traces of it are already evident in the two images that preceded the Courtier. The auction sketch of Raphael's *Castiglione* (fig. 50) combines an exorbitant hat and rich beard in a pugnacious figure who resembles Castiglione less than he does the Bad Boy dressed up in the Count's togs.[6] Again, in the 1639 etching (fig. 51) the beret rakishly sets off a shoulder-length cascade of hair, and the tightlipped sitter sports a frown, mustache, and goatee that warns the observer his name is Trouble—though at the same time it may warn the mirror to be prepared for a possibly imminent change of pose to something less flashy and ludicrous.[7] The result of these experiments, however, is surprising (or at least not unsurprising): the Courtier suffers Samsonlike depredations that disclose a powerful ear and denude his face. The mustache is a parched shadow of its former self, the goatee is at best a disappearing trace, the jowls are naked to the glare of light, and the fuller lips borrow something from the Titian sitter's sensuality but are softer and rosier.[8] The beret adds elegance, offers protective cover, and casts lively shadows, but (unlike the Castiglione *chapeau*) leaves enough visible frizz to justify its function as a compensatory device.

To these differences, the compositional design of our two paintings adds others. To state it most generally, the Titian keeps or pushes us out, whereas the Rembrandt allows or draws us in. On the one hand, the former activates a projectile relation to the observer by placing the clearly demarcated outline of the figure against a background that shows the

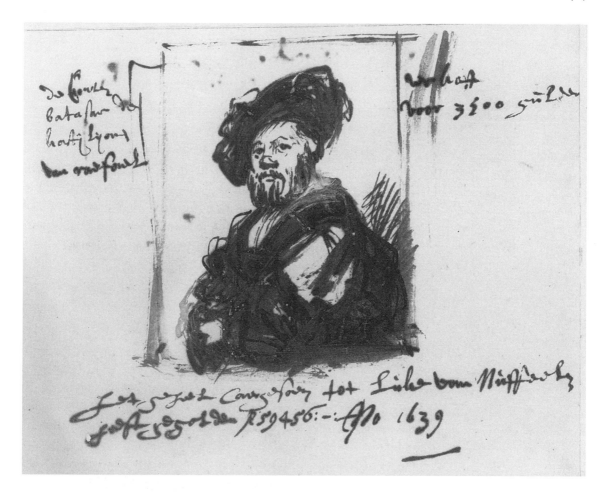

FIGURE 50

Rembrandt, *Portrait of Raphael's 'Baldassare Castiglione,'* auction sketch. Albertina, Vienna.

detail of canvas texture in a manner suggesting both flatness and proximity. In the Courtier, on the other hand, the busyness of broken surfaces and fine detail—which, in the Titian, is concentrated in the foreground sleeve—is distributed backward into depth, drawing the eye past the sleeve toward the middle distance of the collars, face, and shirt, and the subtle pencils of light and colored shadow that animate the cloak on the right. A sense of space is also created by concealing rather than accentuating the canvas texture, and this increases the force that draws the observer's gaze like raking light past the surface barrier. The Courtier invites the penetration of an ocular probe. The common motif of the ledge or barrier underlines the potential violation of the protective distance the Titian suavely and effortlessly maintains. Titian's sitter shows just enough limp wrist to suggest the courtier's obligatory insouciance, the studied

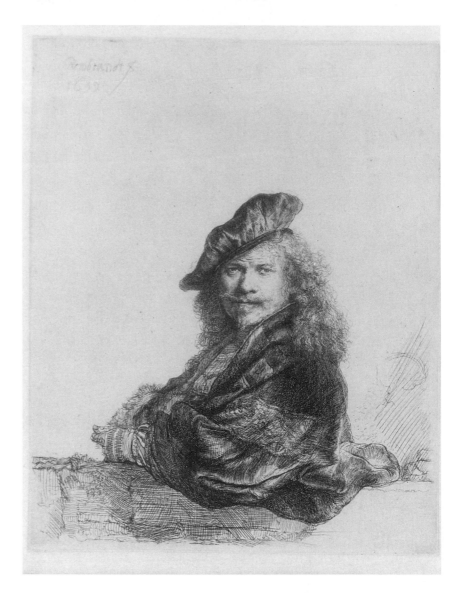

FIGURE 51

Rembrandt, *Self-Portrait
Leaning on a Stone Sill*,
1639. Etching. Bartsch
21, 2d state. Teylers
Museum, Haarlem.

negligence that harmonizes with the fall of the cloak. But the Courtier's
hand sits oddly blocklike, and fences off the area exposed by the opening
of the cloak.

So far, in this attempt to tease out the affiliative allusions that send
meanings back and forth between the Courtier and its major precursor, I
have ignored a possibility mentioned by several commentators: that Ti-
tian's painting is itself a self-portrait.[9] Three of these authors (Rosand,
Gould, and Brown) suggest that the direction of the Titian sitter's eyes

contributes to the effect of a self-portrait. How they determine this escapes me, since there is no evidence of specular distortion (exotropy, or variation in the planes of the eyes), and the suggestion itself seems methodologically perverse: knowing or believing a portrait is a self-portrait can tell us more about the direction and meaning of a sitter's gaze than the other way round. But my question is this: what would the painter of the Courtier see if he assumed that the Titian was a self-portrait?

Standing before the Titian with David Rosand in Alfonso Lopez's house, and assured by his courteous host that it was a self-portrait, Rembrandt would know from his own specular experience that when Rosand mentions "the direct encounter of those sharply alert and intelligent eyes," he can only be describing the sitter's address to the observer, and that if Rosand would shift his attention to the specular moment he would find it harder to determine what the sitter's eyes were directly encountering: is he gazing at the reflection of his eyes, or of his cloak, or of his sleeve? The shape of the eyes, the position of the iris in the eye on the left, and the slight uptilt suggested by the billow of the sleeve and the thrust of the beard, combine in an effect of calmly confident self-appraisal. Like directional arrows, the nose and beard point toward the gather of sleeve closest to the picture plane. Rembrandt sees a gaze that takes in, and thereby draws attention to, the impression the sitter's pose, sleeve, and cloak will make when they will have been painted and displayed. He can scarcely ignore the fact that the working conditions he knows so well have been conspicuously excluded: "dirty and untidy clothes" on which "it was his habit to wipe his brushes . . . while he worked. An artist who knew how to keep his station would never do such things."[10] Perhaps Titian was such an artist, or Rubens, or van Dyck. Anyway, this reminder of what the image screens out reinforces the shift of attention from the sitter's performance to the painter's.

Rembrandt is a little put off by the archness of a specular gaze arranged so as to cue observers to focus on the sleeve, to admire and desire what it represents: not only the painter's skill but also the rewards conferred on him for placing that skill in the service of the court. And yet, though he is put off, it's obvious that he partly succumbs to the allure. He admires the miraculous transformation of paint into satin and painter into courtly sitter. He sees there a fantasy of self-authorization that simultaneously mimics, advertises, and enhances the princely power of commission. Warned by David Rosand that the identification of the sitter as Titian is no more than

a "tantalizing suggestion,"[11] he realizes that it doesn't matter whether the
painting is a portrait or a self-portrait. The very uncertainty, he finds, is it-
self meaningful. He half envies the way in which the apparatus of court-
iership is firmly and harmoniously embedded in the apparatus of painting,
which, in turn, becomes an act of courtiership. And thereupon he goes to
work.

What he produces in the midst of all that splendor is the familiar and
indomitably Dutch bulb-nosed face of *Rembrandt f(ictor)*, a face courageous
in the express awareness of its unsuitability and vulnerability, a naked face
that exposes its failure to match Titian's magnificent display of "unem-
barrassed self-glorification"—a face, one might even say, in which the nu-
ance of quizzical embarrassment is itself unembarrassed. The relation be-
tween the Titian and Rembrandt faces is indeed like that between the
nude and the naked discussed in the preceding chapter. If I indulge my-
self in pathognomic fantasies, I can almost see a faint smile beginning,
which, together with the raised eyebrows and creased forehead, suggests
an interested, curious, and not wholly credulous response to the reflected
image. Perhaps he is dramatizing the effort to anticipate the comments of
those who will find him self-satisfied, or arrogant, or aloof and digni-
fied—but it is the effort, not the achievement, that the portrait dramatizes.

The relatively smooth painting, with virtually no texture tricks and
few signs of the slasher's hand, seems at first glance to belong with the
graphic transparencies that feature the Good Boy's technique:

> The whole picture is painted in a smooth meticulous technique, covering
> the ground completely. This is Rembrandt at his most precise and
> controlled; there is virtually no impasto, no contrast of thick or thin
> paint, no use of open brushwork to suggest form, texture, and the play
> of light. . . . Perhaps the only texture trick in the picture is the now
> familiar one of suggesting the hairs at the back of the neck by scratching
> with a stylus or brush-end in the wet paint; in the adjacent fur collar,
> Rembrandt resists the temptation to repeat the trick and paints the fur
> normally in light scumbles of brown and black over the dark cloak.[12]

As in other technical accounts—those of the RRP, for example—genetic
indices to normal practice are conflated with fictive indices to the prac-
tice represented not only *by* but also *as* texture tricks. This can be cor-
rected by rephrasing: instead of "use of open brushwork" and "scratching
with a stylus," "visible traces of open brushwork" and "visible traces of

scratching with a stylus." Interpretation is concerned not with the variations of paint texture abstracted for analysis by the conservator or connoisseur but with texture as a represented effect that has the same fictive status as imaginary light and form, inasmuch as it is part of the interpretable content of the painting.

It is well to remember that a phrase like "closeness to the surface" describes two different effects, one visual and the other material, the first being proximity in imaginary space and the second the represented texture of paint on the canvas. The relation of the second effect to the first may range from support to opposition, and any painting may activate a variety of relations within this range. So, for example, in oscillations produced by impasto between the effect of light and the effect of paint, the second may reinforce the first in one area and clash with it in another. Such variations not only make conspicuous the painter's interpretation of the sitter or specular image but also dramatize the acts of production and emulation that simultaneously uphold and transcend the aims of mimesis and exemplarity privileged by the apparatus of patronage. Within the field of the Rembrandt look, the Good Boy supports and the Bad Boy opposes those aims.

We may agree that the Good Boy's "smooth meticulous technique" dominates the Courtier. Nevertheless, comparison with the Titian portrait suggests the mischievous intervention, in the very heart of mimesis, of the Bad Boy's hand. It makes itself subtly felt in all the tiny touches that draw us in past the protective barrier to inspect or appreciate the painter's virtuosity, and thereby betray the sitter's vulnerability: the shading and creasing of the brow, the hair not massed (as in the Titian) but rendered in broken lights and halftones, the sketchy treatment of facial hair, and the detail of the collar and pleated shirt that brings us perilously close to the beardless jowl. The hat invites scrutiny for a different reason: its inexact shape is initially confusing because the cues to flatness are challenged by the foreshortening of the ornamental chain. The chain itself, though casually painted, marks a sartorial excess that signifies an insufficiently casual pursuit of elegance. These inducements to minute inspection make me aware, as I pry, that the Courtier is aware of my prying. He becomes watchful. I become uneasy, and step back to a more respectful distance. Then perhaps the equanimity of Kenneth Clark's Good Boy— "smug, self-satisfied," and "well pleased with himself"—partially returns. But the damage has been done. The incipient smile begins to fade from

the sitter's face as the double-dealing Bad Boy guides the painter's brush and observer's eye into micro-passages of paint. The painter thus betrays the sitter: his bid to overgo Titian—and Raphael—by transforming himself into one of their courtly patrons is spoiled. In this betrayal, the orthopsychic drama, the drama of failed exemplarity, announces itself.

The representation of a harmonious and mutually self-enhancing performance by the Titian painter and sitter gives us the ideal the Courtier tries to mirror, to achieve, to overgo. The effect of an attempt at resemblance is conspicuous; so also is the subversion of the attempt represented by the differences that dramatize the Courtier's failure to assume "the armor of an alienating identity."[13] As the facile appropriateness of this quotation suggests, it would take too little effort to situate the dialectics of self-portraiture in a badly overpopulated area of Lacanian discourse. What description could be more appropriate to the contrast between the statuesque quiescence of the sitter and the activity of the painter than the following? "[T]he total form of the body [in the specular image] . . . is given . . . only . . . in an exteriority in which this form . . . appears . . . in a contrasting size (un relief de stature) that fixes it and in a symmetry that inverts it, in contrast with the turbulent movements that the subject feels are animating him."[14] But the appropriateness, the resemblance, is purely phenomenal, and derives from Lacan's metaphoric use of the specular experience that underwrites the act of self-portrayal.

If some Lacanian descriptions seem to fit this experience, they do so contingently, and they can be applied only by displacing them from his discourse to the comic register of such secondary identifications and social mimicry as those performed by an intentional subject in the symbolic order. They may then, in that attenuated form, still cast illuminating shadows on the meaning of self-portrayal in the symbolic order, the scopic regime, the social apparatus, of early modern painting. Thus in the 1640 self-portrait the aspiration toward the ideal of the Good Boy is obvious. But no less obvious is the orthopsychic split between the imitated ideal and the imitation, a split in which the restless hand of the painter fragments the body image, destabilizing the performance in the looking-glass theater, and in which the sitter responds with a hint of diffidence that signals recognition of his distance from "the Ideal-I" of Titian. The seductiveness and splendor of the ideal is acknowledged in this display of emulation. But the difference is more than a "failure": it is a refusal to be fully seduced, to "go all the way" and submit to emulative desire. Simultaneously, then, the

Courtier performs a critique of the ideal and a self-critique of the desire. The sense of self-critique is sharpened when we line up the Courtier side by side with the sketch of Castiglione and the 1639 etching, none of them bearing close resemblance to the others, and all of them dramatizing the interpictorial dialectic of desire and critique that gives motive and meaning to Rembrandt's proliferation of poor likenesses.

The mischief wrought by the Bad Boy is aptly described in a comment by Joan Copjec cited in Chapter 7. Copjec interprets Lacan's understanding of narcissism as rooted in the subject's desire to transcend "the self-image, with which the subject constantly finds fault and in which it constantly fails to recognize itself. . . . Thus is narcissism the source of the malevolence with which the subject regards its image, the aggressivity it unleashes on all its own representations." This gives rise to the form of mimicry Lacan likens to "'the technique of camouflage practiced in human warfare.' The effect of representation ('mimicry,' in an older, idealist vocabulary) is not a subject who will harmonize with, or adapt to, its environment (the subject's narcissistic relation to the representation that constructs it does not place it in happy accord with the reality that the apparatus constructs for it)," but a subject at war "both with its world and with itself."[15] The apparatus of early modern patronage installs mimetic idealism as the specific form of *the gaze* that dominates the scopic regime—the screen of representation—within which *the look* of official portraiture arises, and with which the Rembrandt look is at war.

REMBRANDT IN CHAINS: THE MEDICI
SELF-PORTRAIT

Julius Held judges Rembrandt's gold chains to be "clearly studio proper-
ties" that function as signs of prosperity and self-esteem in the early self-
portraits. But Held also reminds us that they were considered symbols of
servitude as well as eminence and implies that this meaning may have in-
formed Rembrandt's use of the chain: "The proud painter honored him-
self with these sparkling pieces of jewelry—all the more so because he
could wear them without being beholden to anyone."[1] This notion is de-
veloped by Chapman and Alpers, who take the chain to signify Rem-
brandt's "professional ideal of . . . the honored but independent virtuoso
artist," his "serious ambitions as an artist," his desire to publicize his power
and authority in the studio rather than his worldly ambition for honors
from great patrons.[2]

Both critics, however, pass through alternative interpretations that seem
more in accord with the thesis of the present study. Alpers cites an opin-
ion that the chain states "a claim the imaginary nature of which testifies
to an awareness of the constraining and hence suspect nature of actual
royal favor."[3] Of an early self-portrait Chapman speculates that Rem-
brandt's "granting himself a fictitious chain" would be "deliciously ironic"
if he knew the painting

> was destined for Charles I. . . . It would have been both fitting and
> brazen to model his image after that of the courtier-artist best exempli-
> fied by Rubens' portrait in Charles's collection. For at the same time that
> Rembrandt seemed to embrace the courtly ideal he boldly defied it
> by claiming its honors, with scant attention to—or more likely, willful
> disregard for—the court artist's subservience to his patron.[4]

Chapman dismisses this ironic scenario, but I'm inclined to reinstate it because it is consistent with the Bad Boy's critique; it suggests that not the prince but the painter should have the right to confer the chain—on himself, of course, but also on the patron he, as sitter, impersonates. Indeed, since honor is in the gift, or mouth, or brush, of another, never of oneself, it is the painter who first honors the patron by his gift of art, and the patron's gift of a chain can only be a way to avoid being diminished by the gift that goes unreturned. In such discursive interchanges, favors are indistinguishable from fetters.

I prefer Chapman's brazen Rembrandt to the one who seeks honor in independence (which honor, by definition, diminishes), and I feel special affection for the Bad Boy who interferes with the Good Boy's quest of sprezzatura in the 1640 self-portrait. A poignant comment on this brashness occurs in a self-portrait painted many years later, now in the Uffizi (pl. 28). How it got there gives rise to different narratives, since documentary evidence is lacking. Chapman speculates that it may have been commissioned by Cardinal Leopold de' Medici for his collection of artists' self-portraits, while in a different story Ernst van de Wetering imagines it was "purchased" (not commissioned) by the future Grand Duke Cosimo III himself.[5] Chapman's rationale is more persuasive, or at least it is more relevant to the fiction of self-portrayal that interests me: she finds the idea of a Medici commission attractive because Rembrandt's "chain of honor (now with a medallion), his elegant historicized garb, and his black beret seem calculated to appeal to the illustrious Italian nobleman. They mark a person of elevated substance destined to join the company of distinguished artists whose self-portraits were already in the Cardinal's gallery." She notes also that Rembrandt "returned to the favored persona of his middle years, that of the romanticized virtuoso-artist."[6] But if there is such an allusion, the effect is chiefly revisionary; it emphasizes the difference of mood. This drama of commission is haunted by the ghostly revenant of "the favored persona" once again trapped in the patron's livery but marked by the hand of the Bad Boy. He eyes the observer a little defiantly and himself a little resentfully—defiantly performing his independence before the observer, resentfully acknowledging its dispossession to the mirror. The title of the portrait is Rembrandt Remaindered. Its sitter appears not so much "destined" as doomed to hang in the Cardinal's gallery.

"For the last time," Kenneth Clark writes, "Rembrandt has dressed himself up in his fur stole and chain, and his tired old face has the defen-

sive look that decent people adopt on official occasions."[7] It could be defensive; it could also be diffident—distrustful or skeptical of the specular image that exposes the face to its own gaze and displays the exposure to the gaze of the courtly connoisseur. But it is indeed a tired old face. The faces of old men and women Rembrandt portrayed throughout his career are animated or frayed by the warfare between seniority and senility— between the demeanors that bespeak authority, dignity, wisdom, or quiet self-containment and the signifiers of time's ravages on the flesh. Matriarchs and patriarchs, merchant princes, prophets, rabbis, scholars, and saints: the masks and virtues of seniority are scored by a hand that intensifies the brushwork of decay and renders senility more poignantly naked. In many of these faces, as in many of the later self-portraits, the nakedness is contained within the discipline of the mask.[8] But in the Medici self-portrait, that discipline falls away. The impasto that assimilates skin texture to paint texture intensifies the effect of nakedness by bringing the face forward to the pigmented surface of the canvas even as it flinches away as if to commit itself to the fingers of shadow that pull it backward.[9] The chain is sufficiently dematerialized to cause one commentator to include this work, wrongly, among those late portraits that "strip away all the attributes of the Renaissance man in which Rembrandt veiled himself for so much of his life."[10]

This painting is hardly in mint condition and heavy varnish no doubt contributes to the chain's dimness. Nevertheless, the dimness has thematic power: the spectral forms of chain and beret allude conspicuously to the evanescence of such long-gone fantasies of brashness as the Count, the General, the Courtier, and the earlier self-portraits in fancy dress. If this is indeed a commissioned portrait rather than an autonomous fiction or parody of the artist's ambition, the allusion is, as I said, less nostalgic than revisionary. The washed-out chain and the sitter's expression convey the diffidence of one who fears the seductive trap of patronage, "the constraining and hence suspect nature of actual royal favor"[11] to which the painter is beholden. The sparkle that has abandoned the jewelry is displaced and diffused into a blurred glow playing over the image and gathering itself about the face, where it sits flaccid and etiolated like the dried remains of a monstrously blotted and bleeding highlight.

<div align="right">*24*</div>

REMBRANDT IN VENICE: THE PATRIARCH

The embarrassment of riches; *l'embarras du choix*: having too much and being embarrassed by it—too much wealth or property, too much financial or commercial success, a dangerous surfeit and variety of worldly goods, a plethora of means. For a painter working in Amsterdam during the 1650s, the embarrassment of riches took the form not only of a thriving local art market but also of the patrimony it reflected *in parvo*: a painterly legacy that had been attracting interest for a century or two and that consisted of a dangerous surfeit and variety of styles, a plethora of technical means, disseminated from Florentine, Roman, Venetian, Parisian, and Flemish workshops. *L'embarras du choix* may have been even more embarrassing for a master painter with this legacy at his disposal and with more than sufficient means to make it new. How could he keep from being overpowered by its allure, or by his own facility, or by the blandishments of patrons who pressed him to squander the patrimonial largesse in ecstasies of mere imitation? This is clearly the question asked, if not answered, by the 1658 self-portrait in the Frick Collection (pl. 29).

Unlike the Courtier and the Medici sitter, no chain adorns this figure. It wants no chain: Rembrandt has promoted himself from the status of recipient to that of donor. He is now the beneficent Patriarch.[1] This promotion is immediately announced by the grand scale of the painting (52.14 inches x 40.38 inches). Schwartz confesses himself tempted by the thought that it may have been commissioned by a monarch, since he can't imagine "this, the largest and the most overwhelming of the self-portraits, hanging anywhere but in the collection of someone whose portraits were commensurately larger and whose dignity could bear comparison, at least

in his own eyes, with that of this awe-inspiring figure." Rembrandt, he tartly notes, made his own image larger and more regal than that "of the richest man he ever painted, Jacob Trip."[2]

The Patriarch is often compared to the Trip portrait, in part because both figures are seated, painted in three-quarter length, and hold walking sticks. But the Patriarch's cane is more than a fashionable accessory: it "brings to mind both a scepter and a mahlstick," and these associations are enhanced by the emphasis on his "massive strong hands."[3] The hand holding the walking stick is larger and more roughly painted than the vividly modeled hand on the left, and together with the forward jut of the cane, its proximity works to increase the depth of the picture space and the distance of the figure from the surface. To one capable patriarchal hand is committed a symbol of the law of the father that founds the order of patronage. And as Chapman's persuasive account of the painting's iconographic and formal implications suggests, the law is itself a two-handed engine. On the one hand, Rembrandt highlights the traditional associations of the frontal pose with spiritual or temporal authority and aristocratic status by wearing "a fanciful old-fashioned costume" that resembles "those in which he and his contemporaries attired mythological gods and biblical and historical heroes":[4] this connotes the law of the scepter. On the other hand, the Patriarch evokes "the luminosity of Venetian paintings," and its "distinctive textural, painterly technique," its "color and roughness of handling," recall "Titian's late works" (92): this connotes the law of the mahlstick.

Chapman frames the Patriarch in the terms of the Romantic thesis, arguing in effect that Rembrandt here turns his back on the law of the scepter and embraces the law of the mahlstick: just as he had elsewhere "used the frontal pose to enhance the authority of his clients," so he uses it here to assert "his importance, dignity, and domination"—not, however, as a figure of noble rank or kingly status but as the "Prince of Painters" whose eminence derives solely from "his artistic achievement" (94–95) and who proclaims his independence, his autonomy, by transcending and displacing the Venetian or Renaissance father.[5] She tries to distinguish this achievement from that of the Courtier on the grounds that in the earlier painting Rembrandt simultaneously conformed to an "established and . . . rather old-fashioned ideal" of the virtuoso artist and cast doubt on its validity as "a thing of the past and of the imagination" (81, 78). Unlike the Courtier, the Patriarch "relies on no clearly identifiable proto-

type" but demonstrates "a deeper understanding and more thorough as-similation of Venetian painting and, at the same time, a greater indepen-dence from that tradition" (89).

This distinction between the Courtier's role distance and the Patriarch's role embracement prompts many questions, but it is enough to point out that the Patriarch's apparel is no less old-fashioned than the Courtier's, the ideal he embodies equally conformist and traditional, and his pose more pretentious.[6] If autonomy is affirmed by Rembrandt's reinterpretation of older portrait traditions, it may also and at the same time be mocked by the assertiveness with which the elements of those traditions are featured in so theatrical and sartorially overstated a performance. That makes it hard to accredit the idea that the Patriarch finds Rembrandt "[s]eem-ingly"—and in all seriousness—"claiming the proverbial title 'Prince of Painters'" (88) but not of anything else. In the traditional apparatus de-picted by the self-portrait as patron, the law of the mahlstick is both har-monious with and subject to the law of the scepter variously policed by patrician, religious, ducal, royal, and imperial patrons.

What the self-portrait as patron depicts is always the relation between the two terms, painter and patron, never one of the terms alone. Hence the two senses embedded in the genitive construction of the proverbial ti-tle, "prince *among* painters" and "prince *over* painters," are inextricably and asymmetrically bound together, and the Patriarch more clearly represents the hegemony of the latter than the autonomy of the former. If the Dutch son raises a hand against the Renaissance or Venetian father, he does so by portraying himself as the father he challenges, indeed as both fathers, Renaissance or Venetian painting and the princely subject of that painting. And if the Patriarch is Rembrandt's portrait of Prince Rem-brandt by Titian, such a fantasy of power, so majestic a masquerade, may well, by its excess, make an ironic statement about the social and ideolog-ical context of Venetianism, though at the same time the rich Venetian facture and *colorito* register its continuing allure. Subdued traces of the Bad Boy's hand and the son's rebellion are already visible in the paternal inheritance, and the only thing that proclaims the Patriarch's autonomy, its transcendence of the fathers, is its reflexive staging of the conflict between role embracement and role distance. A Venetian critique of Venetianism, its effect is of a fantasy of power deliciously out of date, a fantasy of the desire for the authority and wisdom of "mythological gods and biblical and historical heroes," "figures of elevated spiritual or temporal rank,"[7] a

fantasy in which the sitter, by the seriousness of his demeanor and the outlandishness of his costume, both marks and mocks the intensity of his desire for deliverance into the golden body of paint.

All this is rich and strange, but we shouldn't let ourselves get too comfortable with or too ecstatic about Rembrandt's frequently remarked dialogue with Titian and Venetian painting until we consider a distinction introduced by Svetlana Alpers into the conventional view of the dialogue. Clark, Chapman, and Ernst van de Wetering, in their versions of the conventional view, note that although the Courtier alludes selectively to individual works by Raphael and Titian, the Venetianism of the Frick self-portrait is more generalized in its effect.[8] Clark observes that the Patriarch may be given "the grandiose, frontal pose derived from Titian, but the pleated shirt is a part of Venetian sixteenth-century dress" and "the Venetian spirit" so permeates "the whole design" that we can't identify a particular model.[9] For Chapman, "the style and composition of the Frick painting reflect Rembrandt's profound assimilation of . . . Venetian painting techniques" not only in its "roughness of handling" but also in its palette: "Rembrandt's colors closely approximate . . . the specific pigments Titian used to achieve his unified color scheme."[10]

Van de Wetering argues in similar fashion that the painter's increasingly salient and idiosyncratic adventures in the rough manner were influenced more by the politics of emulation than by the politics of commission. However, he locates the object of emulation less in Titian or Venetian painting per se than in the Vasarian model of the painter's career exemplified by Titian: Rembrandt not only emulated Titian in opposing the improvisational bravura of *colorito* to the graphic illusionism that testified to mastery of *disegno*; he may also have "modelled his artistic biography . . . on Titian's"—that is, on the myth of Titian promulgated by Vasari, who "warned young artists" that they should first cultivate "a painstaking and fine technique and only adopt the rough manner later in life."[11] Van de Wetering attributes this double emulation to several factors: the legendary status Titian had already achieved in Rembrandt's time, Titian's own emulative struggle against the graphic norms of Florentine and Roman painting, the ideas Vasari and van Mander associated with the "'splotchy' technique" of his later style, the transmission of these ideas "by word of mouth in the contacts within and between workshops," and the support lent by classical sources to the positive valuation of work that, like Titian's, looked unfinished and was best viewed from a distance.[12] Van de Weter-

ing concludes that although Rembrandt possessed a book of Italian prints and "had also seen paintings by Titian and . . . borrowed motifs from them, . . . it could well have been the Titian *legend* that had the strongest impact on him" (168–69). The view of Rembrandt's relation to Titian that I develop in the presence of the Patriarch differs ever so slightly in emphasis from van de Wetering's and is a little closer to Chapman's: I am less concerned with Rembrandt's emulation of Titian or Raphael or Rubens as a "Prince of Painters" than with his "pictorial criticism" of the function that proverbial title alludes to: the Painter of Princes.[13]

Alpers's account of Rembrandt's emulation is both more cautious and more skeptical. She remarks, first, that Rembrandt did not lay on glazes "in the Venetian manner" but "tended to build up a solid structure out of opaque pigments." Nevertheless, she adds in a footnote, "[t]o say that a painter did not paint in the Venetian manner is not necessarily to say that he did not want to convey the look of Venetian paintings." Even though Velazquez didn't paint like Titian, for example, he "seems to have wanted his remarkably insubstantially painted pictures to appear from a certain distance like ones structured in the complex Titian manner." But Rembrandt, although he "shared Titian's love of paint," did not, in her judgment, "want to convey a Venetian effect, whatever the viewer's distance."[14] Alpers, van de Wetering, and others agree in picking out Rembrandt's major and most obvious departure from Titian: "the remarkable differentiation in the handling of paint," which van de Wetering attributes to the early experiments of Rembrandt and Lievens in Leiden and to their attempts to differentiate themselves from Lastman.[15]

Regardless of what Rembrandt wanted to convey, do the paintings convey the look of Venetian paintings? If so, do they convey it conspicuously, in the mode of allusion? Alpers's claim is deductively motivated by her commitment to a more comprehensive genetic hypothesis: "despite our sense that Rembrandt . . . wanted to take his place in the European tradition, copying the art of the past was not central to the operation of his studio"; "he did not declare or reveal his models" or proclaim "his sources in the mode of emulation"; for him, "life in the studio replaced the art of the past."[16] These assertions don't square with another statement made in the context of a biographical profile, during which Alpers notes that Rembrandt never made the obligatory Italian journey: "Other artists, it was remarked at the time, were paid more for their works if they were known to have made the trip. Rembrandt, characteristically, made Italy a

matter of the look of his art instead of a matter of an actual journey" (61). Here, Alpers's language unambiguously designates an intended fiction and a calculated effect of allusion. Does interpretation of the paintings support the assertion? If "Italy" excludes the painting of Titian and other Venetians, on what grounds is the exclusion upheld? Alpers's logic can easily be extended to her acute observation about painting in the Venetian manner: just as Rembrandt made Italy a matter of the look of his art without having gone to Italy, so he made—or should I say *makes*?—Titian and Venetian painting a matter of the look of his art without actually applying his paint or building up his images as the Venetians did.[17]

If, then, the portrait of the Patriarch looks at Titian, and if it displays that look to the observer, how is the display to be characterized? In taking up this question, I want to return to Alpers in order to qualify my disagreement with her insistence on Rembrandt's refusal to reveal his models. The qualification is to be found in her own text. After noting that his reluctance to acknowledge "the authority of tradition" may be partly attributed to "an anxiety about its power in relation to his own," she asserts that

> Rembrandt did not simply hide his sources. He resisted the lure of authority offered by a canonical work in order to show that he was making it on his own. . . . The characteristic format of his late paintings—the single, half- or three-quarter length figure . . . —is also a sign of Rembrandt's resistance to canonical works of art. . . . Though Rembrandt knew and learned from previous artists, there is something Protestant in his unwillingness to acknowledge any authority outside himself.[18]

How does one reveal one's Protestantism, one's autonomy and individualism, without revealing what it is one protests against and refuses to conform to? Without, in other words, engaging in an act of revisionary allusion that discloses one's anxiety about—one's temptation to submit to—the power of the precursor?

This condition attaches to the law of the mahlstick no less than to the law of the scepter. Since many "canonical works of art" feature the "characteristic format" Alpers here attributes to Rembrandt, in what sense does he resist them? The Patriarch's full frontal view may be relatively rare, but in other respects the format is similar, for example, to the ones used in Titian's portraits of Francesco Maria della Rovere (discussed in

Chapter 9 above), Doge Andrea Gritti, Cardinal Pietro Bembo, Cardinal Alessandro Farnese, Daniele Barbaro, Benedetto Varchi, Pietro Aretino, Pope Paul III, and the two extant autograph self-portraits.[19] Of these, the look of the Patriarch most fully takes in the Washington portrait of Doge Gritti. It admires the swelling bulk of the ducal body, the dominance of reds, browns, ochre, and white, and the effect of *abbozzamento*, in which swift brushstrokes giving the structure of paint priority over that of the body make the portrait look unfinished. But it refuses to submit uncritically to the gorgeous allure of that effect. The portrait of the Patriarch ranges fluently from more textural and painterly roughness toward more graphic depiction in which the paint pays homage to the primary signifiers of identity, the face and hands. And as we'll see, by concentrating the most conspicuous barrage of painterly brushwork in an area below the sitter's belt, Rembrandt jeopardizes the Patriarch's stability.

My point is simply that signs of resistance to the canon are inextricable from signs of participation in it. The protestant can't supersede the precursor without reanimating the danger of recidivism—the danger of reviving rather than revising the precursor, the embarrassment of falling under its spell, succumbing to its power, declining into an epigone. The precursor desires vampirically to live forever by sucking the artistic lifeblood of succeeding generations. Clark pinpoints this danger at the end of his own comment on the Protestantism and individualism that made Rembrandt unique and distinguished his portraits from Titian's. I return once again to a passage from *Rembrandt and the Italian Renaissance* quoted and discussed in Chapter 21 above. The passage is informed by Clark's reference to the portrait of the Patriarch:

> It may seem far-fetched to speak of Catholic and Protestant portraiture, but it is a fact that Titian's strongly Catholic approach to all experience, his hearty acceptance of doctrine and hierarchy, is perceptible in his attitude toward his sitters, and even in his sense of form. He saw each sitter as a type to be enhanced till it reached its perfect state. . . . Rembrandt, who was essentially a Protestant, saw each sitter as an individual human soul whose weaknesses and imperfections must not be disguised, because they are the raw material of grace. It was this pre-occupation with the individual which led him to study his own face so relentlessly. . . . How . . . arrogantly external by comparison are the self-portraits of Titian. *And yet, the pictorial inventiveness of Venetian art was irresistible to him.*[20]

The italicized qualifier is the most important part of this statement because it picks out the aesthetic dimension of the anxiety Alpers mentions, the temptation to submit to the precursor's artistic power. But, as I noted above, the true protestant doesn't merely resist the irresistible; he stages his protest. In order to do that, he represents the irresistible so that he may confess his embarrassment and show himself overcoming temptation.

What, precisely, is at stake in this endeavor? In an essay on Vermeer I wrote many years ago, I discussed a temptation similar to the one mentioned above, the temptation of aesthetic idyllicism, which—varying a phrase used by Prospero in Shakespeare's *Tempest*—I designated "the vanity of art."[21] My argument was that in their different ways both Rembrandt and Vermeer depict the temptation and show themselves overcoming it. A Vermeer picture pretends so conspicuously to subordinate human complexities to "pure painting," to the vanity of art, that it focuses the observer's attention on them—by formal as well as iconographic means. Although that discussion dealt neither with portraiture nor with revisionary allusion, one passage speaks fairly directly to the latter topic and may be extended to the former. I was thinking of artists in Protestant Europe and of Clark's comment about Rembrandt's weakness for Venetian art, though I also had in mind standard fulminations against Italian morality, when I wrote that

> *Vanitas* is *Venitas* . . . and the Northern European painter must
> continually guard against the dangers of Venice. For the soul trapped
> in "Venice" inhales the splendor and abundance of surfaces, the richness
> of shape and color and texture, the vibrant radiance that ripples from
> sky and sea across flesh, jewels, robes, facades, and pillowed rooms.
> "Venetians" are slaves of that glittering world, and the voyeurism
> induced by its burnished light can penetrate into art. Paint . . . may
> increase the world's sensuous allure and reduce the observer's sensorium
> to famished eyes by abstracting the precious appearances of things
> from matter and dullness. Artistic *vanitas* surrenders to the natural
> gravitation of the medium toward delight in the aesthetically beautiful
> for its own sake.[22]

In England in 1570 Roger Ascham had complained of "the Siren songs of Italy," referring not only to the "faults . . . of religion" but also, and chiefly, to those of dalliance and lechery.[23] Granted that the siren visions the Dutch portraitist longs to reproduce are more sensuous than sensual, more Venetian than Venerean, their power to disarm his brush and se-

duce his palette confronts him with a moral and not merely an aesthetic problem.

The problem is how to dress and paint oneself up in an embarrassment of Venetian riches without being embarrassed by the result. Rembrandt risks just such an embarrassment by letting "the Venetian spirit" permeate "the whole design" of the portrait of the Patriarch. The law or regime of the mahlstick dictates that diachronic relations between artistic generations should be rigorously ordered according to the sequence of copying, imitation, emulation, and allusion. To violate the sequence by backsliding is to risk aesthetic embarrassment. But is it also an embarrassment under the law or regime of the scepter? Are both laws in danger of being violated when the colors and glow and surface richness make the portrait of the Patriarch so beautiful at the same time that the pose is so pretentious?—when, indeed, the beauty has come by association to symbolize and enhance and justify the pretentiousness?

Let's recall the list of Titian portraits, mentioned above, that feature a format similar to the Patriarch's. Three-quarter and full-length formats favored by Titian had become canonical for the portraits of dignitaries during the sixteenth century largely because of Antonis Mor, whose work was influenced by Titian and in turn influenced the subsequent development of court portraiture in Spain and the Netherlands. The formats themselves were thus infused with courtly and aristocratic associations that, as we saw in Chapters 10 and 11, could appear desirable or dangerous, or both at once, to regents and other mercantile magnates during the first four or five decades of the seventeenth century. And because the Patriarch has presumed to dress himself up in the borrowed robes of "mythological gods and biblical and historical heroes,"[24] his portrait puts those associations outrageously on parade.

How, then, can we exonerate the artist from the charge of violating the patrimonial law of the mahlstick when he invests so shamelessly in Titianesque splendor? Or exonerate the sitter from the charge of violating the patronal law of the scepter when he has thrown off every vestige of *burgerlijk* shame? Where can we look to find the traces of internal distance, the saving graces of critical allusion? We can begin by noticing that several paragraphs ago I slipped into the habit of calling the Frick painting *the portrait* of the Patriarch, as if someone else had struck the regal pose he wanted Rembrandt to fix for all posterity. That lazy locution makes a substantive difference to the way we think about the fiction of

the Patriarch's pose because it occludes its most striking feature, the specular drama of self-appraisal we activate as soon as we choose to view a portrait as a self-portrait. When we imagine ourselves watching the Patriarch eye himself as well as the observer, the uncertainty, the provisionality, and the cunning of preemptive self-assessment throw a veil over the majestic calm with which he gives himself to be seen and admired. There is suspicion in the veil, and a hint of mischief as well.

In the moment of specular self-appraisal, the Patriarch appears to draw back to study the effect, as if he has put on his princeliness with his costume and is trying it out on himself. If, in the postspecular moment, "his eyes engage the viewer in a direct, masterful way,"[25] that engagement is itself represented as part of the desired effect of specular preparation, and in this light the engagement becomes quizzical: he challenges the observer to accept his self-representation, but since he can't control the response, he continues watchfully to appraise the observer's appraisal. Watchfulness and quizzicality then travel back along the indexical channel to mark the sitter's performance in the act of portrayal: watchfully, quizzically, he challenges himself to accept his self-representation. My reaction to his performance is that he is still not sure he likes or is willing to accept what he sees. It is a reaction prompted not by the gaze alone but by the whole composition of the painting. The most remarkable thing about the Patriarch is that in spite of its vaunted immobility, the poised stillness of hieratic frontality, the figure's position seems unsettled, as if it has just been—or is about to be—readjusted. The Patriarch patiently, if guardedly, waits for me to take my eyes off him, so that he can shift slightly in his chair. Provisionally and experimentally he interrogates his body's present disposition.

This reading of the pose emerges from consideration of several contradictory or inconsistent cues that subtly dislocate the dominant frontality and ambiguate the spatial relations between the different parts of the figure. If we take our bearings from the arm and hand on the right, for example, they swing the spatial vectors around in a way that makes the flatly painted shoulder on the left recede and the furry cloak or tabard appear on the verge of slipping down. But if we begin with the luminous hand on the left and follow the foreshortened arm coiled like a spring, that side moves forward while the shadowy area of the tabard on the right recedes. Beginning at the center, the diagonal crossing of the shirt, the gathered-in waistband, and the sash reiterate a movement down toward the right and away from the spectator.

The hint of recession is accentuated by the curved verticals and differential lighting of the tunic above the waist (brighter on the left), by the turning of the brocade lapel on the right into the tabard, and by the overall relation of the tabard to the body: more deeply shadowed on the right, it falls over the upper arm in a plane behind that of the billow that loosely covers the wrist and lies, in turn, behind the walking stick and hand, whereas on the other side its diagonal forward fall exposes more arm and is draped tightly under the forearm and hand, which are brought forward to the picture plane by alternating cues of bright light and thick paint. Thus, in a restrained contrapposto, as the tabard is pulled forward on the left, the body withdraws toward the deep shadows on the right, where the overlapping planes and the large size of the hand increase the illusion of depth. But this impression is contradicted when we sight from the hand holding the walking stick to the smaller hand on the left, which then appears to shrink backward while its more aggressive partner curls around in a protective gesture that fences the figure off against intrusion.[26]

These visually illogical fluctuations also affect the perspectival relations between the upper and lower halves of the figure. A series of horizontal accents (the beret, the edge of the tunic, the gathered waist, the sash, and the hands) stabilize the triangle formed by the hands and face. Common intensities of tonal variation unify the triangle and join with the finer handling of paint in the service of graphic description to move the face (with its accent on the famous Rembrandt nose) closer to the surface than the billowing verticals of the tunic. The sense of relative proximity is enhanced by eye contact and by the way the verticals dissolve below the waist into sketchier and more diffuse runnels, whose subdued reflectance hollows out the bottom of the torso, moving it further back in space so that it appears to be behind the face as well as the hands.

Were the lower edge of the painting to be placed just below the hands, the effect of stability and balance would be much greater. But cutting down through the horizontal stays, a cascade of pendant or pendulous shapes—the nose, the chin, the throat, the shirt edges, the looping sash—exert a gravitational pull on the figure and drive the eye along vertical slashes of paint toward the cavity that opens up at the juncture of the dissolving thighs, and that deprives the figure of the monumental support a patriarchal patron deserves. The lower body spreads out with increasing indefiniteness; "details are blurred and melt into one another, so much so that the lower parts of the figure are inaccurate."[27] Far from suggesting

"the immobile assurance of a pyramid,"[28] the composition instills a sense of discomfort that isn't alleviated by the obtuse angle of the right chair arm and the barely determinable position of the left one. Because the obtuse angle implies a viewing point further to the left and closer to the smaller hand, it shifts some of the effect of the recession on the right to the eye of the beholder (thereby strengthening the cue to objective frontality) while making the body's relation to the chair and our relation to the sitter even more unclear than it already is. If we screen off the sitter's arms and make eye-contact level, he could well be standing or half standing.

Conversely—and this introduces a new complication—he could be slipping forward in his chair or sitting on the forward edge; the composition on the right (the implied length of the sitter's arm, the shadow between tabard and waist, the open face of the chair arm) suggests a throne-like depth of which the sitter isn't availing himself. The expansiveness of the lower body and its disproportionate size relative to that of the face tend to contradict the eye-level viewing point encouraged by the cues discussed in the preceding paragraph. For they situate the observer well beneath eye level, and the effect is reinforced by the relatively high waist-band, the angle of the cane, and the warm color of the sash.

It could be said that this genuflective observer position adds majesty to the Patriarch, but it could also be said that it makes him appear to lean backward, as if seeking to keep his distance from the object of his gaze. Yet notice how the dominant pyramidal structure of the painting is disturbed by still another pattern. Superimposed on the pyramid is an inversion that gives it the more unstable form of a lozenge. From the V that marks the juncture of legs and torso, it moves up to the hands and arms. Since the lozenge is not only parallel to the plane but also perpendicular, moving forward from the V to the hands and backward to the beret, it intensifies the impression that the sitter draws back into shadow behind the protective fence of his walking stick and hands. *V* is for *vulnerability*, a sense visually reinforced by the detail that signifies the backward flinch: lumpy jowls compressed between the chin and the shirt. The smaller V of the shirt's overlapping edges affords a glimpse of sagging flesh, and the fact that the edges are themselves securely held in place by the tunic makes this tiny triangle of senility's naked truth look exposed.[29] Tunic and tabard add further layers of protection. The rigid horizontal of the tunic is suspended by a collar that resembles a yoke. With its tightly gath-

ered waist and loosely girdled sash, the tunic looks weighty, ceremonial, weapon-proof, and not entirely comfortable.

Thus within the dominant image of hieratic and assured majesty, the clash of different possible ways to read the composition inscribes effects of momentariness and ambiguity, of vulnerability and diffidence. The assured Titianesque majesty that first impresses the observer gradually gives way to what I referred to as the guarded, quizzical air of a sitter who isn't fully committed to holding the pose he sees. By now this painter of many self-portraits knows what the fans expect of him: "an old pasha" who "sees himself as a sovereign in his realm of pictorial fancy" if nowhere else;[30] Rembrandt still "playacting," "dressing up to some role or image," perhaps "trying on old age the way he tries on the Titianlike garb."[31] Readers of lips and gazes among his fans reflect back to him the still-tentative relation of sitter to role that marks the drama of rehearsal, the performance not merely of Rembrandt playacting an old pasha but of a sitter attentive to his playacting: one sees a "stoically clamped mouth," another the "hint of a smile at the corners of the mouth."[32] One sees the philosopher-king's "regal detachment," another "piercing eyes" that directly "engage the viewer,"[33] though since the eyes pierce in different directions, only the eye on the right engages the viewer, while the other droops and looks downward absently toward the left.

For Bonafoux the hint of a smile suggests the *Vanitas* theme he identifies as "the intention behind this sumptuous entertainment, which is at once an ascetic exercise, a mockery and a defiance" by "a man bankrupt and ruined."[34] In keeping with my preference for containing such speculations within the framework of specular fictions, I associate them with the feature that makes this instance of the class of patronal self-portraits unique. With one or two exceptions, this is the only instance in Rembrandt's oeuvre of a self-portrait as patron in which both hands are fully visible, ungloved and distinct from each other, and in no other portrait are they so naturalistically and powerfully rendered.[35]

To conceal the hands is to attenuate the thematization of the difficulty or virtuosity involved in painting oneself not as the painter but as the sitter; to display them in some act or gesture unrelated to painting is to accentuate the difficulty—to remind us by conspicuous exclusion that the self-portrait we see mocks and defies our fantasy of the normative practice by which it was produced. It may be that showing the hand in the glove, or half thrust under an outer garment, or clasped in the other hand,

produces the same effect, but in the self-portraits that employ those motifs the hands are rendered in such cursory and conventional fashion as to divert attention from the impression of strain or virtuosity, or from the impression of an image that aggressively dissembles its origin.

In the Patriarch this impression, centered on the hands, is sharpened by the substitution of the cane for the mahlstick, which vaguely resembles it, especially at the top, where it is rounded off by a conspicuous splash of white paint doubling as a highlight. The resemblance gives the object the sign function of a symbol but not that of an index—or, as I shall suggest below, the function of a negative index. This distinction may be clarified by comparing it to Fried's similar focus on reflexive symbolism in Courbet. Of the *Man with the Leather Belt*, Fried proposes

> that the feeling of extreme tension associated with the sitter's right hand and wrist [that is, the hand on the left] may be seen as an expression of the physical effort involved in the act of painting, of wielding a brush or knife to apply paint to canvas, understood not as an image of a general function by which all paintings are made but rather as a vehicle of the painter-beholder's determination to be "true" to the lived actuality of his embodiedness for as long as was required to produce the painting before him.[36]

If this is so, and if "Courbet's paintings are powerfully expressive of having been made by an embodied being engaged in . . . the production of those very paintings" (49), then isn't the backward position of that hand counter-expressive, since it does not resemble the position of a painting hand? Granted it is a reflexive symbol, what it symbolizes is an activity of painting that must have looked, felt, and been different from the symbol, and so *if* the hand is symbolic, it must work by conspicuous exclusion of the normative act the painting as self-portrait indexes. It is a symbol but not an index—or, if it has an indexical function, the function is negative.

The Patriarch's mahlstick is a symbol "of a general function by which all paintings are made," but transformed into a cane it is part of a representation that denies or places in abeyance the lived actuality of the being engaged in the production of this painting. To thrust this anomaly in our face, and to portray the hands dissociated from the act of painting to the act of posing, is to proclaim the illusoriness of the pretense to mimesis and resemblance. Thus accentuating the effect of mimicry and dissemblance, the Patriarch's hands sharply focus the gesture of self-negation that the

painting as a whole dramatizes in such hyperbolic terms. *This Is Not a Self-Portrait*. But to return to the specular moment is to shift the focus from self-negation per se to the gesture that performs it, and this partly negates self-negation by recasting it as a motivated rehearsal of self-negation. *This Is Not a Portrait*. If there is a hint of a smile on the Patriarch's face, or any other hint, I think it is safer to key it to a fictive rather than genetic index of production.

In the fiction of *re*semblance, the hands of the Patriarch fence off the beholder in an effort to secure the distance at which visual mimesis is most effective, and thus to maintain the dominance of the majestic sitter over the painter. The same hands, undermining resemblance, render *dis*semblance more conspicuous by their connection with the cane that suggests the mahlstick. But of course this isn't the only source of dissemblance. The Patriarch as mimesis and resemblance is also undermined by the visible traces of the working hand that affirm the dominance of the painter over the sitter. Redirecting attention to the veil of texture that obscures mimesis brings into play another motive for the features of the composition that make the sitter seem to draw back for better self-appraisal:

> For van Mander and Hoogstraten, Titian epitomized the painter who had evolved stylistically from the easier "smooth" manner to the more difficult "rough" one, in which forms are loosely defined and paint is applied in broad strokes leaving heavy impasto. . . . From the very beginning of his career . . . [Rembrandt] had opted for this more difficult route and must have been conscious of its bold aesthetic effect, which was best seen from afar. When he had tried to give a painting . . . to Constantijn Huygens he had written that it should be hung "in a bright light and so that one can stand at a distance from it; then it will sparkle at its best." In the Frick painting Rembrandt made a virtuoso display of his own difficult and inimitable rough style.[37]

Visitors in Rembrandt's studio might well be advised to imitate the Patriarch and lean back from the painting so that, as Rembrandt considerately explained, they would not be overcome by the smell of paint[38]—or so that the clarity of mimesis would not be overcome by the veil of texture.

The Patriarch's face and hands—the oases in which the pattern of brushstrokes is most fully subordinated to the effects of graphic clarity and optical intensity—anticipate the postspecular function of museum guards in enforcing the prohibition against spectatorial invasion. This aes-

thetic motive adds strength to the theatrical motive inscribed in the Patriarch's specular self-appraisal. Together they persuade the observer to maximize the values of mimesis, and thus they support the work of self-alienation and/or self-idealization that makes the painter disappear into the Patriarch. But of course the prohibition contained in the advice reported by Houbraken is imposed so that it may be violated, and since St. Paul seems to have been Rembrandt's favorite saint, it's plausible to believe he would expect the law to make more alluring the sin it defines. The Patriarch is not the transparent record of a mirror image but a painterly interpretation that flaunts its forbidden textural delights and thus, once again, the disappearing painter reappears in his manual traces and evokes from the observer the hint of a smile in response to the mimicry and dissemblance "this sumptuous entertainment"[39] denies and proclaims in its ceaseless oscillations.

In the Patriarch, as in the other paintings I have discussed, the self-portraitist clearly seems less entranced than I am by the idea and representation of specularity. I noted in Chapter 14 that the premise of specularity is both empirical and fictional, and the subsequent discussion made it obvious that I need this premise in order to establish the indexical relation that will make the act of self-portrayal the referent of the picture sign, converting the preparatory *mise-en-scène* into an effect of representation and a part of the picture sign's meaning. The premise enables me to factor into that meaning the scenario of rehearsal, the specular self-appraisal that suggests the sitter's attempt to control and convey to—or impose on—postspecular observers a particular self-representation. It could be argued that the visual memory of an artist who portrayed himself so often may have been powerful enough to obviate the need of a mirror, but for my purposes the norm of specularity is flexible enough to include this alternative, since—if the memory is that powerful—the act of specular self-appraisal may be thought of as internalized. Our empirical assumption that a mirror had to be used at some point in an artist's career, and probably was used in the great majority of cases (especially by painters who did not depict themselves very often), preserves the normative status of self-appraisal before the mirror as an act the self-portrait visualizes.

Nevertheless, given this status, Rembrandt's self-portraits diminish the impact of specularity by compositional, perspectival, tonal, and textural devices that produce nonspecular effects. The result is not to obviate specularity but to affirm its strategic value in the dialectical field of the Rem-

brandt look.[40] It is the work of those devices to disrupt the stability of the image and the philosophical serenity of the sitter even as they load every inch of canvas with an embarrassment of the Venetian riches the portrait looks at with such longing. The same effects that set the darkly toned canvas aglow are responsible for the uncertainties of pose and attitude I have tried to describe in this chapter: the sense of vulnerability and protectiveness against exposure, the positional instability and hint of discomfort, the air of diffidence and quizzicality. These trouble the look the sitter directs at his image or at the observer who will replace him when the mirror gives way to the finished self-portrait. By disturbing a dress rehearsal for a Titianesque extravaganza that would never take place—since the sitter is the painter, not the patron—the same uncertainties preemptively stage the sitter's embarrassment at the Venetian grandeur he appropriates. They confirm that the tribute paid to Venice of splendor in the paint and grandiosity in the pose is no surrender but a revisionary allusion. To put it more forcefully, the staging of embarrassment marks the allusion as revisionary. In this imaginary Italian journey, Rembrandt, as they say, is going Dutch.

25 |

(EF)FACING THE HAND

If the graphic emphasis on specular effects upholds the sitter's share in the self-portraits, the textural emphasis on nonspecular effects upholds the painter's. We saw that when the latter encroaches on the former, as it does in the Patriarch, the varied and animated traces of the brush comment ironically on the quiet composure of hands not engaged in painting. Conspicuous texture increases the undertone of mimicry with which the dissembling painter invests (himself) in—besieges and occupies—the figure of the Patriarch, and thus it intensifies the effect of the painter's self-negation produced by the focus on the sitter's hands. The heightened clash between the laws of the scepter and mahlstick that results from this focus provides me with a handy transition to an account of the portraits that represent the sitter at the easel.

We might expect that relations between the texture produced by the hand and images of the hand that produced it would be more straightforward in self-portraits of the artist at work than they are in the Patriarch. When a painter portrays himself sitting before or standing near the easel, doesn't this assure us that dissemblance yields to resemblance, mimicry and ironic masquerade to the mimesis of truth? So, as we have seen, Alpers argues that when late in life "Rembrandt for the first time *paints* himself as the artist at work," in the Kenwood, Louvre, and Cologne self-portraits, "this is less a matter of . . . taking on yet another 'role'" or of "defining himself professionally as a painter" than it is a matter of "defining the self in paint."[1] In Chapman's story, since Rembrandt has been defining the self from the beginning, these two forms of self-definition

497

converge, and the first marks a change in the second: the Kenwood paint-
ing (pl. 30) "epitomizes the crucial shift in Rembrandt's self-conception
toward an identity based on acceptance of the dignity of his profession
and the supremacy of his style."[2]

Chapman supports this reading with some suggestive and valuable
comments on the relation of the painting's texture to its occupational
theme:

> The portrait is most sketchy and least finished in the area of
> Rembrandt's left hand, in which he holds his tools. In fact, his hand
> is so completely obliterated that his tools seem to take its place. Indeed,
> the intangibility of both his hands stands in marked contrast to his
> massive strong hands in the Frick portrait. His tools—his mahlstick,
> bundle of brushes, and unusual rectangular palette—are also only
> roughly and thinly blocked in, leaving the colors of his garments to
> show through. . . . Rembrandt's concern with artistic practice . . .
> extends beyond his garb and tools to his peremptory manner of
> execution in the Kenwood portrait. Thick impasto, visible brushwork,
> quickly incised lines, and seeming lack of finish, especially in the area
> of the hands, all call attention to the painting process. (98–99)

Translated into my terms, this passage describes the displacement of
power from the image to its production, from the portrayal of the act of
posing to the portrayal of the act of painting. The contrast with the hands
of the Patriarch brilliantly makes this point, and suggests further that the
dematerialization of the Kenwood sitter's hands correlates with the in-
creased materialization of the paint surface: as the hand disappears the
traces of its activity spread out and take over the whole image.

This has the makings of a good psychoanalytic story: the obliterated
hand marks a site of castration; the loss of the offending member is pun-
ishment for defying the law of the scepter-bearing father. Like the snaky
locks of Medusa in Freud's parable, the force and vitality of texture ob-
scuring the specular image suggest the magnification of manual power
that compensates for the loss.[3] Compensation also figures in Alpers's read-
ing of the obliterated hand: it "looks almost like a prosthetic device," as if
"Rembrandt had constructed his hand out of the instruments that it em-
ployed for painting."[4] She domesticates this somewhat uncanny image
with an Aristotelian insight that doesn't, however, do much to dull its
edginess: "The hand of the painter is represented in what, following Ar-
istotle's definition, we might call its instrumental use. . . . 'Take the hand,

this is as good as a talon, a claw, a horn, or again a spear or sword, or any other weapon and tool'"—where "weapon" and "tool" seem interchangeable, and their equivalence affects her extension of Aristotle's formula to Rembrandt, who has painted the hand as "a palette, maulstick, and brushes" (28). The aggressiveness of the hand that has deformed this hand with long straight angry slashes of paint belies any attempt to extract a simply positive or constructive message from the image ("acceptance of the dignity of his profession"). The traces of the slasher's destructive hand suggest that whatever "self" is being defined in paint, and as paint, is not free of the touch of defiance, shaded toward surliness, that darkens his address to the object of his gaze.

What this object is remains a question because the right and left hands have been transposed in repainting. J. M. Nash concludes from the transposition that since "Rembrandt does not represent what he must have seen when he faced his own gaze in the mirror," he is "presenting an image of the artist [not] as he scrutinizes himself in the mirror, but as he turns from undisclosed work-in-hand to confront us."[5] Nash, however, fails to distinguish between the two possible interpretations this arrangement allows: does the painting represent the painter gazing in the mirror or the specular image he sees? Since the former can't be ruled out, it must be considered an alternative that prevents Nash's reading from being unambiguous. We may further ask whether our response to the sitter's expression is in any way altered as we shift back and forth between the two alternatives. I shall pass over this for the time being in order to get to the point of Nash's conclusion: he uses it both to support Alpers's general insistence that "the image of the artist . . . at the center of his art . . . is certainly a fiction, a performance" (238), and to question her specific claim that this and other late self-portraits create "a new image of self" by exploring the paradoxes of self-knowledge, self-possession, and self-commodification.[6] To this Nash objects that they are no less theatrical than other paintings, and thus reveal very little about the painter's "self": the effect of negating the fiction of the mirror is that Rembrandt, in gazing at the observer rather than at his specular image, "presents us with The Painter, The Master, in the Studio," and this is "a self-dramatization in the manner of his other self-dramatizations, as a soldier, a courtier, or a saint, as Alpers has discussed in the chapter on 'The Theatrical Model.'"[7]

Wright's observation that the picture as a whole "is slightly blurred" tends to confirm Nash's reading.[8] The sketchiness and soft focus enhance

the sense of distance. The distance from the mirror implied by the amplitude of the figure translates into distance from the observer, and this in turn enhances the impersonal and mythic quality of an image that conveys, as Wright puts it, "a curious mixture of grandeur and melancholia."[9] What stand out most prominently are the broad impasto strokes on the turban: conspicuous as paint, they gleam on the surface behind which the figure stands, and seem to be not merely recipients of the light dappling the hair and face, but its source. The same effect is discernible in the Louvre self-portrait of the painter as painter (pl. 31), which Nash discusses in similar terms.[10] The turban as source of light assumes the signifying role and value assigned to the beret, gorget, and gold chain in the fancy-dress self-portraits: it displaces the source of honor, the power to bestow both honors and commissions, from the patron's insignia to that of the autonomous master of the studio.[11]

In her excellent commentary on the Louvre painting, Chapman stresses this contrast to the popular formula in which the artist poses (for himself or another) at the easel dressed "as an elegant gentleman-artist in contemporary fashionable attire." By representing himself in "informal working clothes and cap," Rembrandt "abandoned the humanist ideal of the gentleman-painter," opposed "the anti-ideal of the vulgar painter," *pictor vulgaris*, the painter as craftsman, to the tradition of *pictor doctus*, and "cultivated the image of an independent artist who valued his freedom and disdained his colleagues' quest for the kind of honor associated with worldly prestige."[12] But given a slightly different story—that the painter who depicts himself as the Burgher, Count, General, and Courtier doesn't fully espouse the ideal but both represents and parodies his attachment to it—can he be said fully to abandon it here?

The Louvre and Kenwood self-portraits establish their position in the field of the Rembrandt look by subtle but discernible reminders of previous poses, and here the attention Chapman pays to apparel is crucial. With the "workshop attire and unpretentious appearance" of the Louvre sitter she compares the Kenwood picture's "more embellished, perhaps slightly imaginary, studio garb," consisting of "a smock in deep Venetian red over . . . a fur-trimmed tabard" (98). The same tabard is draped over the "splendid golden tunic" worn by the Patriarch, and however different the tunic is from the smock, they share the same "square neckline" (91). Both figures also share the same shape, breadth, and complexly varied frontality. These resemblances, along with the cane/mahlstick displace-

ment, bind together the contrasting images of patron and painter, and add meaning to their differences.

Returning to the Louvre self-portrait, there may be a question as to how informal the apparel is, because one can glimpse a pleated white shirt that resembles the one worn by the Courtier, which has been recognized as a shirt that was fashionable in the sixteenth century (Chapman, 72). The position of the arm on the left, supported by what appears to be a chair (if he is sitting—he could be standing), also evokes the Courtier's pose, as does the turn of the body. The *pentimenti* of the beret, conspicuous enough to register a vestige of what has been abandoned, contribute to this effect—an effect that sharpens Chapman's interpretation by accentuating the traces of the target figure, the gentleman painter, or painter as patron, and giving them reflexive force. The painter has replaced the patron, has become his own patron, yet the traces of his mimetic desire and aspirations vibrating beneath the surface of the new format suggest that the desire has not been fully abandoned but persists in the mode of orthopsychic embarrassment.

There may thus be a touch of irony and poignancy in the assertively grand gesture condensed in the turban, and one that motivates the melancholia Wright finds in the Kenwood painting: the displacement of the beret by the turban may signify the lack of patronage as well as the proud appropriation of its power. And the irony is sharpened if we place the two possible interpretations—the sitter gazing at his specular image or at the observer—within the framework of temporal interplay between the specular and postspecular moments. The mixture of grandeur and melancholia then appears rather as a calculated effect than as a self-disclosure: the sitter pauses before the mirror in the act of composing his self-representation; he assesses the visual rhetoric that will most persuasively imprint its intended meaning on those who, in the postspecular future, will replace the mirror.

If, in replacing the mirror, we receive the message in the spirit of specularity, we shall have been reduced to passive reflectors on whom the meaning is inscribed. But merely to imagine this possibility is to prevent it from being actualized: to articulate the image into its specular and postspecular moments, superimpose the former on the latter, and infer from this that the painter has designed and performed a self-interpretation calculated to control our response, is to encourage us to oppose specular reduction by insisting on and exercising our rights as interpreters. Which,

in effect, "we" have just done. But perhaps the painter is complicit in this action. Perhaps, that is, in the hint of defiance, in the ensemble of technically problematic or ambiguous details, in the two blank eyed circles thrown out as bait to iconographers, and in the angry traces of the slasher, we may discern a self-subversive attempt to encourage our opposition by first soliciting, and then placing in question, an innocently ontological surmise about "the" self, one that aspires to apprehend the true story, the life story, of the Great Painter nobly, stoically, rising above it all.

[I]t is in the Other that the subject constitutes itself as ideal, that it has . . . to constitute itself in its imaginary reality . . . [but] it is not from there that it looks at itself.

I love you, but, because inexplicably I love in you something more than you . . . I mutilate you.[1]

Narcissism . . . seeks the self beyond the self-image, with which the subject constantly finds fault and in which it constantly fails to recognize itself. What one loves in one's image is something more than the image.[2]

26

THE LAST LAUGH; OR, SOMETHING MORE

Something more than meets the eye always meets the eye. Moving about in the valley of shadows variously called culture, nature, and history, we encounter the presences or traces of bodies and faces, but never them alone. Bodies and faces are signs. They give themselves to the eye as icons and indexes. But the constancy of their semiotic being for observers in the valley is not matched by any constancy of meaning, since they perform variations on cultural pre-scripts intended to domesticate the *something more* and prevent it from getting too unfathomable, undecidable, or scary. This book has been about a few of those performances in the genres of portraiture and self-portraiture. I have tried to indicate various ways in which the something more has been introduced, mediated, contained, and interpreted, and I have imagined various kinds of motives for the varieties of self-portrayal (by sitters and painters) discussed under the rubric "fictions of the pose."

Something more than meets the eye always meets the eye. Lacan called it the gaze, *le regard*, neither a seeing nor "a seen gaze, but a gaze imagined by me in the field of the Other."[3] The gaze is a theoretical entity, a metaphor, whose function is to emphasize both the agency of the subject and the transcendence of the cultural ground of subjectivity. Because of the gaze, Lacan argues, the subject is not an agency that simply *appears* but one that *makes appearances, gives itself to be seen*, looks at itself being looked at.[4] The real meaning of "I am looked at" is "I get [myself] looked at," "I give myself to be seen," that is, "I represent myself," and the seeing of the I that looks is that of a subject already objectified, self-

alienated, by the gaze that makes its looking a function of getting itself looked at.[5] This psychoanalytic perspective is vividly and reductively caricatured in the fictions of the pose.

During my discussion of the gaze in Chapter 7, I defined it as the scopic aspect of the discourse networks that produce subjects. But now, confronted by our last image and one of Rembrandt's last, the self-portrait as painter in Cologne sometimes called The Laughing Self-Portrait, that is, The Joker (pl. 32), I'm strongly moved to question the blandness of our little definition. The Joker insists on a testier notion of the gaze, and perhaps I can accommodate his demand by replacing the word *produce* with Althusser's term *interpellate*. To be interpellated is to be positioned, identified, and named as a subject, but in a peculiar manner: in Althusser's parable, it is to be stopped for questioning. More precisely, to be interpellated is not only to be hailed by the Law but also to stop and turn as if apprehensively anticipating apprehension and accusation.[6] *Interpellate* thus differs from *produce* in two ways. It suggests, first, that the subject participates in its own subjectification or identification and, second, that it participates as if responding guiltily to a summons.[7] Interpellation in Althusser's theory and the gaze in Lacan's have this in common: they mark "the subject's *culpability*. The gaze stands watch over the *inculpation*—the faulting and splitting—of the subject by the apparatus."[8]

The Joker is clearly an exception to the rule figured in Althusser's parable of apprehension. Like a scofflaw who has just been hailed, he turns and grins, or leers. It doesn't seem to bother him that "the gaze is located 'behind' the image, as that which fails to appear in it and thus as that which makes all its meanings suspect."[9] Nor does suspicion fill his eye with the *invidia* that "makes the subject pale before the image of a completeness closed in upon itself."[10] If, as he turns, he catches a glimpse of something more than meets the eye, a transcendence "closed in upon itself," why doesn't he respond as a good subject should, and strain in self-dissatisfaction toward the ineluctable presence of the Other? His is a display of terminal impudence.

Lacan may well be trying to justify the Joker's anomalous behavior when he argues that "a human subject" who makes "a picture of himself" and "literally, gives his picture to be seen" doesn't do so merely because "like the actor, . . . [he] wishes to be looked at."[11] Rather, he

> gives something to the person who must stand in front of his painting which . . . might be summed up thus—*You want to see? Well, take a look*

at this! [*Tu veux regarder? Eh bien, vois donc ça!*] He gives something for the eye to feed on, but he invites the person to whom this picture is presented to lay down his gaze as one lays down one's weapons. This is the pacifying, Apollonian effect of painting. Something is given not so much to the gaze as to the eye, something that involves the abandonment, the *laying down*, of the gaze.[12]

Why should the gaze be something the observer of a self-portrait is invited to lay down "as one lays down one's weapons"? Perhaps it is because making the gaze analogous to instruments of defense or aggression, and thus to symbols of hostility or fear or envy, links it to the anxiety of transcendence. In Copjec's paraphrase, the narcissistic desire of self-transcendence is "the source of the malevolence with which the subject regards its image, the aggressivity it unleashes on all its own representations."[13] Perhaps, then, what is pacifying and Apollonian in a portrait or self-portrait is the provision of a pseudo-gaze, the "image of a completeness" that is not "closed in upon itself" but offers itself to the eye as an accessible ideal, and thereby dispossesses "the evil eye of the gaze, in order to ward it off."[14]

Even as Lacan pretends not to believe that the painter aims his image as gaze at the observer, he presents the interchange as a battle of gazes. The painter's relation "au regard de l'amateur"[15]—the observer as dilettante and lover of what he or she looks at—is less coercive than cooptive. He invites this "amateur" to surrender his or her gaze/weapons and to embrace and "regarder"—to en-gaze—the picture, to love in the picture something more than the picture. "Les amateurs" is of course a category that includes patrons and princes as well as other painters and the ordinary art lover in the street. The painting is the field of a battle of gazes, but of false gazes: in the words of a Venetian Senator, "a pageant, / To keep us in false gaze."[16] If in portraiture, in gesture, in conduct, in pedagogy, in culture, in all self-representation there is a consensus about the falseness of the pageant—if, in other words, there is physiognomic skepticism—and if at the same time there is resignation before the authority (but not the authenticity) of these exemplary gazes, then orthopsychic desire will be lined with representation anxiety.

Something very like the "Apollonian effect of painting" has appeared in preceding chapters in my account of mimetic idealism, in Kenneth Clark's of mediterranean classicism, and in Heinrich Wölfflin's of the Southern sense of "objective form."[17] They are panoplies of false gaze, and in Chapter 21 I situated them in the cross-cultural context of Ta-

citean discourse as objects of protestant fervor and ambivalence. The Catholic Church was such a panoply for Luther, the nude for Rembrandt. But we've also seen how, at the level of individual response, the portraits by Rembrandt and the other artists whose work I have discussed (Mantegna, Leonardo, Bronzino, Titian, Lotto, Dürer, and Hals) problematize the invitation to lay down the gaze and to produce the Apollonian effect. For them it is a surrender, a temptation, a source of possible embarrassment, an easy way for the subject, whether as painter or as sitter, to reach for the alienating identity of an exemplar. They constantly allude to and protest against the Apollonian (al)lure: This Is Not the Gaze. In their revisionary parodies they overcome the blandishments of the pseudo-gaze, foregrounding the drama of orthopsychic desire and anxiety against the deeper shadows of the transcendence that "fails to appear in" the image and thus "makes all its meanings suspect."[18]

The Joker represents the latest and most aggressive stage of Rembrandt's looking-glass war against the pseudo-gaze. "You want to see?," he says, "well, take a look at this!" He gives himself the evil eye, but the malevolence is gleeful. The face is flayed, plastered, encrusted on the picture plane. As the paint crackles across it, the leer is trapped, immobilized, in pigment. Like other paintings assigned to this phase of Rembrandt's career, it is powerfully compelling, even spooky, because the mask appears to be inscribed on—the face and head to be wrapped around—nothing.

> The authenticity of what emerges in painting is diminished in us human beings by the fact that we have to get our colors where they're to be found, that is to say, in the shit.[19]

> Rembrandt . . . coated entire faces in a glossy, shining mudpack of viscid paint. . . . If I looked at my face in the mirror and saw this, I would be horrified. The texture is much rougher than skin, as if it is all scar tissue. . . . Paint is . . . already kin to sweat and fat, and here it represents itself: skin as paint or paint as skin, either way. It's a self-portrait of the painter, but it is also a self-portrait of paint. The oils are out in force, like the uliginous waters of a swamp bottom. . . . On the nose . . . the paint is semi-solid, as if the nose were smeared with phlegm or mucous.[20]

In the early modern history of the portrait the impulse to self-commemoration first materializes as the death mask from which portraits were taken:

[I]nitially the role of the Renaissance portrait was commemorative; it was consciously directed to a future when the living would no longer be alive. When Coluccio Salutati died in 1406, a mask or drawing was taken of his features. . . . Similarly, a mask was molded of Brunelleschi's features when he died in 1446. . . . In the Middle Ages masks of this kind were made in connection with sepulchral monuments, but in Florence in the fifteenth century they . . . represent a last despairing effort to salvage the data of physical appearance on the threshold of the tomb.[21]

The death mask represents a state of absorption that exceeds even the blindness or obliviousness praised by Diderot—represents not what Fried paraphrases as the "supreme fiction of the beholder's nonexistence," but rather the supreme truth of the sitter's nonexistence. What its makers desire is the death of mortality, the perpetuity of the indexical icon that gave birth to the imprint of a face freshly dead. This rigidly immortal sleep aspires to give itself to be seen to all the ages as the authoritative specter of the presence it truly was and wishes to remain: a spectral and ancestral authority. It constructs its own version of the fiction of objectivity, refusing to open its eyes to acknowledge the generations of gazes it solicits. It is not a speaking silence, just a silence. In the death mask nothing is withdrawn from representation. Therefore the orthopsychic desire of and anxiety about its subject's exemplarity have been stilled. Rather, they have been displaced, for they live on as the patrimony of the inheritors.

Like the picture that is worth a thousand words, the death mask shows us all we need to know, and thereby defends against interpretation, sublation, appropriation, revisionary allusion. It wants to be venerated for what it was, not interrogated or revised or renewed, not exposed to the vicissitudes of the future anterior. The early modern history of portraiture depicted in Parts 1 and 2 is the history of the portrait's escape from its mortiferous origin: its awakening to the question, the questionability, of the face; its emergence in the dawning shadow of physiognomic skepticism and representation anxiety, the shadow of the embarrassment of poses. This shadow falls with ironic force on the exemplary strut of a sitter who takes umbrage at the performance of exemplarity. It falls on, bites into, darkly hatches, the changing face that registers the prospect and retrospect of a career of such command performances. More often than not it hides or mutilates the too compliant hand as if ashamed of its squirelike service in helping patrons don the armor of an alienating identity. In the Bur-

gher, the Count, the General, the Courtier, the Patriarch, and the Louvre and Kenwood Painters, something is always *shown* on the verge of being withdrawn from representation. Some hint of mimicry or vanity or resignation or diffidence or defiance adumbrates the split between the imitated ideal and the imitation, alters the play in the looking-glass theater from exemplary heroics to the comedy and pathos of orthopsychic desire.

I. A. Richards once wrote, or almost wrote, that the word is the sum of its missing contexts.[22] So too the Rembrandt face presents itself as the sum of its missing contexts. The vaunted "inwardness" of the late portraits is often, as here in the Joker, a lightless void. If in early portraits shadows appear to be superimposed *on* the contours of the face they model, thus enhancing its solidity, here they seem to have penetrated within its volume and to have evacuated or uncreated its interior, producing the effect of a laughing death mask. The medallionlike object on the Joker's chain dangles on the verge of dissolution; it seeks protective impasto to avoid the fate of the figure, which, at that point, begins its descent into the spectral thinness of vanishing brushwork. The chain still has substance, even touches of sparkle, conferred by the metallic glow of the heavy and vigorously scored pigment that propels the figure from deep shadow toward the relief of the surface, where the intensity of the contrast desaturates chroma: the scarf, the white painter's hat, the craquelure of the face, are all suffused in the same golden tone.[23] From the tiny peaks of the *bianchetti* that glitter over the surface, the flowing light descends, solidifies, and transfixes the work of the slasher's hand.

The Joker is in some respects a nostalgic and acerb portfolio of past performances, the Mauritshuis *Homer*, for example, and the so-called *Jewish Bride*, the Venetianism of whose rich texture and color is lovingly intensified to the degree almost of parody. But to appreciate the social dimension of parody in the self-portrait, we have to take into account the looming figure on the left at which (or whom) the sitter points his mahlstick—"a mysterious figure, which . . . was . . . simplified (and thus rendered more obscure) in the final state—a relation not unlike that between Aristotle and the bust of Homer" in the New York painting.[24] The figure has been variously identified as a statue, a painting, and a person, and as Heraclitus, the god Terminus, and "a funny-looking old woman" in what was originally a larger painting.[25] But whatever it is, it too is decked out in gold chains, and the high placement of the head together with the aquiline nose in the version we have compels me to still another fantasy

of identification: the figure is the person, painting, or bust of the patron who commissioned the picture. He is therefore the ghostly embodiment of the gaze.

The gesture with the mahlstick permits different readings: the Joker is leaning against the figure, or advancing toward him, or proudly pointing in his direction, or prodding him. This is a compendium of possible relations between painter, patron, and patron's image, and if I were forced to choose among them, the determining factor would be my sense that the Joker hunches forward protrusively into the spotlight and toward the observer, and therefore that he is pushing the haughty figure aside. The light glancing off the figure's nose and chin keeps him from being upstaged, but in spite of this hint of resistance, the sitter has the last laugh. Here, finally, the Bad Boy comes out of the closet and celebrates himself.

The specular image is surprised by paint. It's as if the normative act of mirror gazing indexed by self-portraiture has been obscured, so that the sitter's reflection gives way to the interpretation of the painter, who already envisages the mirror embossed with carbuncles of pigment. These effects compose, for me, into a fantasy of alienation: the artist chose to visualize the passage of interpretive power from sitter to painter to the postspecular gaze; the passage of the image through paint to the peering observer, who would try to convert what *he* chose to visualize into an indexical sign of the normative act that produced it—and who would fail. For who can claim to *know* what went on between the sitter and the painter in the specular moment, much less what went on in the mind of the painter/sitter? Maybe he took revenge in paint on the beautifully textured ravages he saw. Maybe he used the specular image as a support for the paint effect into which it vanishes, the effect that replaces rather than reproduces the face. Maybe he meant to sum up in the Joker the effects of all the years of warfare in the looking-glass theater, the reversal or ironic fulfillment of the effort to assume the alienating armor, and maybe the Joker dramatizes the persistent complaint of the sitter to his mirroring gaze during those years: "You love me, but because inexplicably you love in me something more than me . . . you mutilate me." Maybe any number of things. It's a pretty dark stage. I make my interpretation of the Joker. He says "Boo!" and disappears.

REFERENCE MATTER

Notes

Introduction

1. Svetlana Alpers, *Rembrandt's Enterprise: The Studio and the Market* (Chicago: University of Chicago Press, 1988), 120.

2. J. Bruyn, B. Haak, S. H. Levie, P. J. J. van Thiel, and E. van de Wetering, *A Corpus of Rembrandt Paintings*, trans. D. Cook-Radmore, 5 vols. (The Hague: Martinus Nijhoff, 1982–), 3: 593. Hereafter referred to as RRP.

3. See Chapter 11 below, note 7 and passim.

4. The RRP's analysis of its technical and formal infelicities persuaded them to reassign it to one of his pupils. They judge the inscribed signature and date inauthentic, link it on stylistic grounds "with Rembrandt's work from the later 1630s," and assign it a rough date of 1638 (3: 595–96).

5. For complications, qualifications, and elaboration of this assumption, see Chapter 14, below.

6. Horst Gerson, *Rembrandt Paintings*, trans. Heinz Norden (Amsterdam: Meulendorf International, 1968), 290.

7. Kenneth Clark, *Rembrandt and the Italian Renaissance* (New York: New York University Press, 1966). I shall also make use of Clark's *An Introduction to Rembrandt* (New York: Harper & Row, 1978).

8. Admittedly these are three very large worms, but they are still on the ground from which the structural and institutional changes beneath the histories of forms and ideas are more visible.

9. Apart from a few etchings and some mentions of sculpture, all the images I consider are paintings and all the portraits were painted by artists in Renaissance Italy and seventeenth-century Holland.

10. Gary Schwartz, *Rembrandt, His Life, His Paintings* (New York: Viking Press, 1985). As will become evident especially in Parts 3 and 4, I rely heavily on this important book. Reliance sometimes takes the form of disagreement,

515

the kind of disagreement essential for the postcursor to find his way and go on. Schwartz's book is a landmark in Rembrandt scholarship, and I depend heavily on it for many of my interpretations. At the same time, because those interpretations are directed by a very different set of motives and concerns, they are often at odds with Schwartz's. But as I note in the Acknowledgments, *Fictions of the Pose* could not have been written without the help of his spirited and densely researched study. My comments on Rembrandt and Dutch portraiture in this study are most deeply indebted to the work of Schwartz, Svetlana Alpers, and H. Perry Chapman, and the debt is only deepened by the opportunity to find my own argument and design by disagreement and resistance.

11. Richard Brilliant, *Portraiture* (Cambridge: Harvard University Press, 1991), 7–8.

12. Some observations about the logic of this procedure, the logic of sublation and revision, appear in Chapter 21.

13. Svetlana Alpers, *Rembrandt's Enterprise: The Studio and the Market* (Chicago: University of Chicago Press, 1988); H. Perry Chapman, *Rembrandt's Self-Portraits: A Study in Seventeenth-Century Identity* (Princeton: Princeton University Press, 1990).

14. Much evidence of the range and flexibility of cooperative arrangements is adduced and discussed in a number of the essays in F. W. Kent and Patricia Simons, with J. C. Eade, eds., *Patronage, Art and Society in Renaissance Italy* (Oxford: Oxford University Press, 1987). See especially the contributions by Heather Gregory, Patricia Simons, and John Oppel. See also: Guy Fitch Lytle and Stephen Orgel, eds., *Patronage in the Renaissance* (Princeton: Princeton University Press, 1981), especially the essays by Werner L. Gundesheimer, Charles Hope, H. W. Janson, and Douglas Lewis; F. W. Kent, *Household and Lineage in Renaissance Florence: The Family Life of the Capponi, Ginori, and Rucellai* (Princeton: Princeton University Press, 1977), 227–92; and Rona Goffen, *Piety and Patronage in Renaissance Venice: Bellini, Titian, and the Franciscans* (New Haven: Yale University Press, 1986).

15. I attempt to define "discourse" and avoid mistiness in Berger, *Making Trifles of Terrors: Redistributing Complicities in Shakespeare* (Stanford: Stanford University Press, 1997), 222–28. The phrase "scopic regime" was coined by Christian Metz. In my frequent uses of the term "scopic" during this study I don't mean to activate its Freudian sense of visual pleasure as opposed to voyeurism. Rather, I use *scopic* to designate active looking as opposed to passive seeing.

16. Lisa Jardine, *Worldly Goods: A New History of the Renaissance* (New York: Doubleday, 1996), 18.

17. Alpers, *Rembrandt's Enterprise*, 37, 36–40.

18. David Freedberg has criticized Alpers for ignoring the theatrical practices of other European painters—Le Nain, La Tour, Poussin—but apart from being gratuitous (she doesn't claim Rembrandt was the first or only

theatricalist), this misses her main point, which is that Rembrandt's interest in posing as performance led to a disenchanted, quasi-Shakespearean emphasis on the theatricality of all actions, and to meta-social or meta-theatrical representations in which "the question and the ambiguity of social performance were very much in pictorial play" (Alpers, *Rembrandt's Enterprise*, 48, 57). David Freedberg, "How Rembrandt Made It," review of *Rembrandt's Enterprise* in *The New York Review of Books*, January 19, 1989, 30.

19. Brilliant, *Portraiture*, 40.

20. On the difference between "role" and "discourse," see my *Making Trifles of Terrors*, 323–26.

21. Judith Butler, *Bodies That Matter: On the Discursive Limits of "Sex"* (New York: Routledge, 1993), 2.

22. See *Making Trifles of Terrors*, especially chapters 11–14, for extended discussion and illustration of what I mean by "the play of discursive forces."

23. This is a safe, or minimal and thus "comprehensive" definition, a slightly embroidered version of Hannah Pitkin's even safer and more comprehensive "the making present *in some sense* of something which is nevertheless *not* present literally or in fact" (*The Concept of Representation* [Berkeley: University of California Press, 1972], 8). See also the compendious history of the term by Raymond Williams in *Keywords: A Vocabulary of Culture and Society*, rev. ed. (New York: Oxford University Press 1985), 266–69. Pitkin and Williams both make interesting correlations between the political and aesthetic uses of the term. W. J. T. Mitchell does this more briefly in his entry "representation" in Frank Lentricchia and Thomas McLaughlin, eds., *Critical Terms for Literary Study* (Chicago: University of Chicago Press, 1990), 9–22. For a skeptically toned intellectual history of the term, see the entry by David Summers in Robert S. Nelson and Richard Schiff, eds., *Critical Terms for Art History* (Chicago: University of Chicago Press, 1996), 3–16. For a critique of the attempt to hazard even so basic a definition as Pitkin's, see Jacques Derrida, "Sending: On Representation," trans. Peter and Mary Ann Caws, *Social Research* 49 (1982): 294–326, whose chief target is Heidegger's attempt to integrate and historicize the concept in "The Age of the World Picture."

24. Margaret Miles, *Carnal Knowing: Female Nakedness and Religious Meaning in the Christian West* (New York: Vintage Books, 1991; orig. pub. 1989), 10.

25. Joel Fineman, *Shakespeare's Perjured Eye: The Invention of Poetic Subjectivity in the Sonnets* (Berkeley: University of California Press, 1986), 297.

26. The thematic emphasis in accounts of representation may vary. One will focus on negation, absence, alterity, repetition, and desire, another on substitution, power, and reference, a third on fiction, imagination, and invention, a fourth on production and technology. Such accounts often question or problematize the status of the original, and with it the meaning of absence, in demystifying critiques of the referential illusion, "the precession of simulacra,"

and the myth of presence, and in the deployment of the preposterous meta-leptics of genealogy. But even the most radical accounts can't get rid of the ghostly transcendence of the absent original, which seems essential to the structure of representation. If whatever the representation claimed to stand for were not expressly marked as absent from its content, it would be not a representation but an original, or one of two duplicate identities, like Socrates' two Cratyluses. Thus the necessity of the ghost, which makes an absence present and which becomes even more essential when "representation" is reflexively modified and put to work in discussions of human subjectivity.

27. I enclose "image" in scare quotes to indicate that the term isn't restricted to visual phenomena.

28. Strictly speaking, as my colleague John Lynch has pointed out to me, one can't fashion oneself in the sense of creating oneself; therefore the verb can't take a reflexive object. But "to fashion" may be a syncopated way of saying "to fashion oneself as x or y," "to make oneself do or be something."

29. "It is probable that in every language there are resources for self-reference and descriptions of reflexive thought, action, attitude (these resources would go beyond referring expressions and would include forms like the archaic Indo-European middle voice). But this is not at all the same as making 'self' into a noun, preceded by a definite or indefinite article, speaking of 'the' self, or 'a' self." (Charles Taylor, *Sources of the Self: The Making of the Modern Identity* [Cambridge: Harvard University Press, 1989], 113.)

30. Stephen Greenblatt, *Renaissance Self-Fashioning: From More to Shakespeare* (Chicago: University of Chicago Press, 1980), 1–3.

31. Chapman, *Rembrandt's Self-Portraits*, 6, 7, 8, 11, 17, 24.

32. Judith Butler, *Gender Trouble: Feminism and the Subversion of Identity* (New York: Routledge, 1990), 135–36.

33. *Collected Papers of Charles Sanders Peirce*, ed. Charles Hartshorne and Paul Weiss, 6 vols. (Cambridge: Harvard University Press, 1960), 2.143–44, 157–73.

34. St. Augustine, *On Christian Doctrine*, trans. D. W. Robertson (New York: The Liberal Arts Press, 1958), 2.1, p. 34.

35. Photographs, Peirce notes, "are in certain respects exactly like the objects they represent. But this resemblance is due to the photographs having been produced under such circumstances that they were physically forced to correspond point by point to nature" (*Collected Papers*, 2.159).

36. Norman Bryson, *Vision and Painting: The Logic of the Gaze* (New Haven: Yale University Press, 1982), 52.

37. Roger Scruton, "Photography and Representation," *Critical Inquiry* 7 (1981): 579. That photographs can be "doctored" is also part of lay knowledge.

38. Peirce, *Collected Papers*, 2.157, 2.143.

39. See, for example, James F. Anderson, *The Bond of Being: An Essay on Analogy and Existence* (St. Louis: B. Herder, 1949).

40. *Values in a Universe of Chance: Selected Writings of Charles S. Peirce,* ed. Philip P. Wiener (Garden City, N.J.: Doubleday Anchor, 1958), 391.

41. Kaja Silverman, *The Subject of Semiotics* (New York: Oxford University Press, 1983), 18.

42. Umberto Eco, *A Theory of Semiotics* (Bloomington: Indiana University Press, 1976), 68–71.

43. Teresa de Lauretis, *Alice Doesn't: Feminism, Semiotics, Cinema* (Bloomington: Indiana University Press, 1984), 178.

44. I use "interpictorial" as an analogue of "intertextual" to denote the practices of individuals in the diachronic context of imitation and emulation.

45. Mieke Bal, *Reading "Rembrandt": Beyond the Word-Image Opposition* (Cambridge: Cambridge University Press, 1991), 32.

46. Ibid. See also pp. 75, 84–85, 114, 116, 128, 414n.28, and 427n.39. Bal's dissatisfaction with the diffuseness of Peirce's notion of iconicity as resemblance echoes that of Eco (*Theory of Semiotics*, 216) and Nelson Goodman, *Languages of Art* (Indianapolis: Hackett, 1976), 4 and passim. For these references, and for a clarifying discussion of related semiotic pitfalls, I am indebted to W. J. T. Mitchell's genealogy and critique of Peirce's trichotomy of signs in *Iconology: Image, Text, Ideology* (Chicago: University of Chicago Press, 1986), 54–66.

47. Eco, *A Theory of Semiotics*, 7, 54, 58, 62. For an illuminating discussion, see Thomas E. Lewis, "Notes Toward a Theory of the Referent," *PMLA* 94 (May 1979): 459–75.

48. The semiotic structure of the portrait as an iconic picture sign, like that of the verbal symbol, consists of two overlapping relations. Internally, what Meyer Schapiro calls "the non-mimetic elements of the picture"—"its sign-bearing matter, the image-substance of inked or painted lines and spots"—constitutes the signifier, while the image, "the appearance of the represented objects," is the signified. Externally, those objects in themselves (not their representations in the image) are the referents of the sign produced by the conjunction of signifier and signified. In fictive icons, it is the second relation that causes trouble, and so it is important for interpreters to specify how they construe the sign/referent relation, and how this construal responds to the demands of their practice and the questions they ask. My own construal of the portrait as icon runs as follows: if an icon is a sign that denotes by resemblance, and if resemblance is taken to occur between two semblances (visual appearances), one of which—the signified—is present in the icon and the other—the referent—absent from it, and if the latter, because it is represented by the former, is assumed to be its original, then the icon presents itself as referring to the absent semblance—as representing a referent. The referent may be fantastic or nonexistent, a portrait of nobody, but so long as the icon presents itself as an act of mimesis, it claims that the referent does or could exist elsewhere; pretending to be a copy, it presents a fiction of reference.

The quoted passages are from Meyer Schapiro, "On Some Problems in the Semiotics of Visual Art: Field and Vehicle in Image-Signs," in *Theory and Philosophy of Art: Style, Artist, and Society* (New York: George Braziller, 1994), 26–27. Originally published in *Semiotica* 1.3 (1969). It is on the basis of a distinction between the interaction of signifier with signified and the interaction of sign with referent that Mieke Bal develops her interesting and generative distinction—during a critique of Norman Bryson's terminology—between the orientation of "the glance" toward the phenomena of the work and that of "the gaze" toward the phenomena of the referent: see *Reading "Rembrandt,"* 138–76, especially 142–43.

49. John Pope-Hennessey, *The Portrait in the Renaissance* (New York: Pantheon Books, 1966), 18.

50. *Dolce's "Aretino" and Venetian Art Theory of the Cinquecento,* trans. Mark Roskill (New York: New York University Press, 1968), 125. See also pp. 281–83.

51. Rab Hatfield, "Five Early Renaissance Portraits," *Art Bulletin* 47 (1965): 320.

52. Jardine, *Worldly Goods,* 18–19, 119–20.

Chapter 1: Technologies: The System of Early Modern Painting

1. Marcelin Pleynet, quoted by Jean-Louis Comolli, "Technique and Ideology: Camera, Perspective, Depth of Field," in Bill Nichols, ed., *Movies and Methods,* Vol. 2 (Berkeley: University of California Press, 1985), 43. Pleynet's thesis is the object of Comolli's critical examination. Comolli, whose essay first appeared in 1977 (*Film Reader,* no. 2), reminds us that Pierre Francastel had emphasized—against the myth of the enduring dominance of Quattrocento perspective—"the coexistence of several figurative systems" (44). See Francastel, *Peinture et société* (Paris: Gallimard, 1965).

2. Jean-Louis Baudry, "Ideological Effects of the Basic Cinematographic Apparatus," in Nichols, ed., *Movies and Methods,* 2.534.

3. Martin Jay, "Scopic Regimes of Modernity," in Hal Foster, ed., *Vision and Visuality* (Seattle: Bay Press, 1988), 4.

4. Jonathan Crary, *Techniques of the Observer: On Vision and Modernity in the Nineteenth Century* (Cambridge: MIT Press, 1990), 34, 38–40. For an interesting brief discussion of the camera obscura as a trope in and of ideology—its uses by Locke and Marx, and recent commentaries on it—see W. J. T. Mitchell, *Iconology: Image, Text, Ideology* (Chicago: University of Chicago Press, 1986), 168–78.

5. David C. Lindberg, *Theories of Vision from Al-Kindi to Kepler* (Chicago: University of Chicago Press, 1976), 149. See also my "L. B. Alberti on Painting: Art and Actuality in Humanist Perspective" (1965) in Berger,

Second World and Green World: Studies in Renaissance Fiction-Making, ed. John Patrick Lynch (Berkeley: University of California Press, 1988), 374–75.

6. Donna J. Haraway, "A Cyborg Manifesto," in *Simians, Cyborgs, and Women: The Reincarnation of Nature* (New York: Routledge, 1991), 152.

7. Elizabeth Pittenger, "Aliens in the Corpus: Books in the Age of the Cyborg," in Gabriel Brahm and Mark Driscoll, eds., *Prosthetic Territories: Politics and Hypertechnology* (Boulder, Colo.: Westview Press, 1995), 204–18.

8. Comolli, "Technique and Ideology," 52.

9. Crary, *Techniques of the Observer*, 42–43. Though Crary doesn't mention Norbert Elias, this passage strongly evokes Elias's description of the "psychogenesis" of *homo clausus* as a function of "sociogenesis" in early modern Europe. See Chapter 6, below.

10. Crary, "Modernizing Vision," in Hal Foster, ed., *Vision and Visuality* (Seattle: Bay Press, 1988), 33.

11. Crary, *Techniques of the Observer*, 26.

12. Sheldon Nodelman, *Marden, Novros, Rothko: Painting in the Age of Actuality* (Seattle: University of Washington Press, 1978), 9.

13. Crary, *Techniques of the Observer*, 26.

14. Ibid., 150.

15. This is the official Church view. In practice, of course, things were different. The cults, shrines, and images of saints were guarantors, sites, and repositories of magical power. For a concise discussion, see Keith Thomas, *Religion and the Decline of Magic* (New York: Scribner's, 1971), 25–50.

16. Decorum is "that proportion, correspondence or conformity that style has with subject": Andrea Gilio (1564), quoted in John Shearman, *Mannerism* (Harmondsworth, Middlesex: Penguin Books, 1967), 166. Significantly, Gilio is expressing the norms and constraints of Tridentine reform.

17. David Rosand, "'Divinità di cosa dipinta': Pictorial Structure and the Legibility of the Altarpiece," in Peter Humfrey and Martin Kemp, eds., *The Altarpiece in the Renaissance* (Cambridge: Cambridge University Press, 1990), 146.

18. Paul Hills, *The Light of Early Italian Painting* (New Haven: Yale University Press, 1987), 16.

19. Crary, *Techniques of the Observer*, 5–6.

20. Marcia Hall, *Color and Meaning: Practice and Theory in Renaissance Painting* (Cambridge: Cambridge University Press, 1992), 48. See also John Shearman, *Andrea del Sarto*, 2 vols. (Oxford: Clarendon Press, 1965), 1.132–34.

21. Hall, *Color and Meaning*, 48, 68.

22. Throughout this study, I take for granted the distinction between the virtual observer—or observer position—constructed "from within" the painting, and the actual observer who stands and moves before it. The distinction has been made with great clarity by Richard Wollheim in *Painting as an Art* (Princeton: Princeton University Press, 1987), 102–3 and passim, where the

two are differentiated as the "internal" and "external" spectators or "the spectator in the picture" and the "spectator of the picture."

23. Hall, *Color and Meaning*, 69.

24. Erwin Panofsky, *Early Netherlandish Painting* (New York: Harper & Row, 1971; orig. pub. 1953), 1.251.

25. E. H. Gombrich, "Light, Form and Texture in Fifteenth-Century Painting North and South of the Alps" (1964), in *The Heritage of Apelles: Studies in the Art of the Renaissance* (Ithaca: Cornell University Press, 1976), 21, 31–32.

26. Walter S. Melion, *Shaping the Netherlandish Canon: Karel van Mander's Schilder-Boeck* (Chicago: University of Chicago Press, 1991), 60–61.

27. Svetlana Alpers, *The Art of Describing: Dutch Art in the Seventeenth Century* (Chicago: University of Chicago Press, 1983), 84, 90–91.

28. On the close relation and interaction between graphic modelling and the science of optics, see David Summers, *The Judgment of Sense: Renaissance Naturalism and the Rise of Aesthetics* (Cambridge: Cambridge University Press, 1987), 3–9.

29. Martin Kemp, *The Science of Art: Optical Themes in Western Art from Brunelleschi to Seurat* (New Haven: Yale University Press, 1990).

30. My colleague Professor Donna Hunter uses the phrase "visual fix" (borrowed from Stephen Heath's *The Sexual Fix*) to characterize the effect of a preference for "plastic or sculptural . . . forms that are bounded or separated from everything that is not form; it favors forms that are firmer than most flesh" and imbued "with a stillness that calls attention to the stasis inherent in all 'fixed' images." Hunter speculates that the visual fix may be a (humanist) response "to an abhorrence of variants on the hard, young, male body." I'm grateful to Professor Hunter for permission to quote these remarks from her stimulating paper "The Neo-classical Fix: The School of David and Reproductive Engraving, *or* Reproduction as Representation," delivered at the College Art Association in Chicago, February 1992.

31. Simon Schama, *The Embarrassment of Riches: An Interpretation of Dutch Culture in the Golden Age* (New York: Alfred A. Knopf, 1987).

32. Michael Baxandall, *Painting and Experience in Fifteenth Century Italy* (London: Oxford University Press, 1971), 87–89, 101–2.

33. Thanks to Beth Pittenger and Cathy Greenblatt for helping me sort and refine these senses of the term.

Graphic is also a key term in Ann Hollander's stimulating *Moving Pictures* (Cambridge: Harvard University Press, 1991). Precisely because she puts it to a different use in a different context, her emphasis on the connotations of truthfulness and authoritativeness indicates a basic lexical property of the term that reinforces the values I ascribe to it: "'Graphic' means 'like writing'; it also means 'like truth.' These two meanings combine and converge" because starting in the early sixteenth century "most pictorial reproductions of both sculpture

and painting were black-and-white prints" based on drawings and often at several removes from the hands responsible for the originals—"essentially 'written' versions, translations through several stages into a purely graphic language remote from paint or marble." Furthermore, "[p]rinted versions of paintings were . . . rendered authoritative by association with printed words" and thus "black-and-white pictures . . . became tools of instruction. . . . [T]he association between black-and-white printed representations and unadorned truthfulness . . . gives the term 'graphic' one of its meanings" (33).

34. Claus Grimm, *Frans Hals: The Complete Work*, trans. Jürgen Riehle (New York: Harry N. Abrams, 1990), 107.

35. The quoted statements are from Hall, *Color and Meaning*, 94.

36. David Summers, "Maniera and Movement: The Figura Serpentinata," *Art Quarterly* 35 (1972): 293. See also his "Contrapposto: Style and Meaning in Renaissance Art," *Art Bulletin* 59 (1977): 336–61.

37. David Summers, *Michelangelo and the Language of Art* (Princeton: Princeton University Press, 1981), 76.

38. Hall, *Color and Meaning*, 68, 199, 204, 205, 210.

39. Crary, *Techniques of the Observer*, 98.

40. "Quattrocento color-modelling," John Shearman notes, "has the stylistic effect of intensifying linearity," but "when color is liberated from its function of creating form" and is "deployed with greater flexibility," it can produce "chromatic emphases . . . independent of the formal construction," and the consequent "diminution of the linear content" may be intensified by "*sfumato* modelling, [which] replaces the precise and finite hardness of Quattrocento painting by softness of surface and elusive imprecision" (*Andrea del Sarto*, 1.132–33).

41. Hall, *Color and Meaning*, 202.

42. Norman Bryson, *Vision and Painting: The Logic of the Gaze* (New Haven: Yale University Press, 1983), 94.

43. Nodelman, *Marden, Novros, Rothko*, 24–25.

44. Bryson's concentration on the historicized virtual observer, whose "role, and the kind of work he is called on to perform, are constructed by the image itself" (*Vision and Painting*, xiii), leads him to ignore the role and work of the empirical viewer. As any on-site investigator of paintings knows, you can't learn very much about a picture by standing stock-still, fixed and immobile, before it, and letting your "prolonged, contemplative" gaze regard "the field of vision across a tranquil interval" (94). On the contrary, you move restlessly back and forth on the perpendicular shuttle. You may do this no matter what role the picture offers you as the observer in the painting. But there is a great deal of painting—early modern Western painting—that activates the shuttle by a variety of devices that pull you in for a better look at some detail you can't make out from a more comfortable viewing distance. Small size is the most obvious device, but there are many others—sketchy figures in the background,

for example, or dark half-tones filled with dim shapes, or books and letters with writing that seems to be legible, or transparent shadows thrown over strategic expressive junctures of the sitter's face. In many cases the message you receive from the closer view is, in Bryson's terms, erasive: "Isn't it wonderful," the painting says, "how the textures, forms, and tones of the virtual image refuse to yield to the appearance of paint—how velvet remains velvet, wrinkles wrinkles, and wood wood?" But in other cases the shuttle produces the opposite effect: "Isn't it wonderful how, as you draw close, the virtual textures, forms, and tones begin to change into facture, pigment, thick impasto, thin glazing, and the weave of the canvas."

45. Nodelman, *Marden, Novros, Rothko*, 24.

46. Hall, *Color and Meaning*, 213.

47. Heinrich Wölfflin, *Principles of Art History*, trans. M. D. Hottinger (New York: Dover Publications, 1932), 229.

48. José Ortega y Gasset, "On Point of View in the Arts," trans. Paul Snodgrass and Joseph Frank, in *The Dehumanization of Art and Other Writings on Art and Culture* (Garden City, N. J.: Doubleday Anchor, 1965), 99–120.

49. Ibid., 112, 107. Aloïs Riegl's opposition between haptic and optic modes, especially as applied to Dutch group portraiture, is also relevant, as the following brief paraphrase by Michael Podro makes clear: "the increasing capacity of the painting to surround the presented objects with a sense of atmosphere so that the spaces between objects are felt as part of a homogeneous optical effect," one that demands more active attention on the part of the observer without dissolving "objectivity . . . into passing subjective impression. Seventeenth-century Dutch art represents objects as having an existence independent of us, but does so in a way which leads us to be aware of an interplay between those objects and our own mental life" (*The Critical Historians of Art* [New Haven: Yale University Press, 1982], 94). For more on Riegl, see Chapter 13, below.

50. The name given to the visible brushwork of Titian, Tintoretto, and other Venetian painters was *pittura di tocco e di macchia*. For me the most important word in this phrase is *di* because it means both *of* and *by*: the touches and blobs are the effects as well as the causes of this method of painting. See Rudolf Wittkower's Introduction to the catalogue of a 1967 exhibition sponsored by the Columbia University Department of Art History and Archaeology, *Masters of the Loaded Brush: Oil Sketches from Rubens to Tiepolo* (New York: Wittenborn, 1967), xv–xxv, especially xvi–xvii. See also Ernst van de Wetering, "Rembrandt's Manner: Technique in the Service of Illusion," in Christopher Brown, Jan Kelch, and Pieter van Thiel, eds., *Rembrandt: The Master and His Workshop, Paintings*, trans. Elizabeth Clegg, Michael Hoyle, and Paul Vincent (New Haven: Yale University Press in association with National Gallery Publications, London, 1991), 12–39, especially 16–22. In the table of contents the essay is entitled "Rembrandt's Method." A lightly revised version

of the essay is now reprinted as chapter 7 of van de Wetering's *Rembrandt: The Painter at Work* (Amsterdam: Amsterdam University Press, 1997), 155–90.

51. Ernst H. Gombrich, "Light, Form and Texture in Fifteenth-Century Painting North and South of the Alps," in *The Heritage of Apelles: Studies in the Art of the Renaissance* (Ithaca: Cornell University Press, 1976), 19–35, especially 19–23 and 30–32.

52. David Rosand, *Titian* (New York: Harry N. Abrams, 1978), 11–12; Hall, *Color and Meaning*, 212–15.

53. Bryson, *Vision and Painting*, 89–90, xiii.

54. The *pentimento* acquired normative status as a signifier of the process of revision through the influence of Titian and other Venetian painters, who may have cultivated this sprezzatura of repentance polemically as a "counter-graphic" or *contra-disegno* effect. I call it "sprezzatura" because as a *signifier* of revision it is also an index to conspicuous carelessness. On sprezzatura, see Chapter 3 below. For the contribution of *pentimenti* to Velazquez's emulative dialogue with Titian, see Gridley McKim Smith, "Writing and Painting in the Age of Velazquez," in McKim-Smith et al., *Examining Velazquez* (New Haven: Yale University Press, 1988), 1–33, and for its influence on Rembrandt and his Northern European contemporaries, see van de Wetering, *Rembrandt*, 165–67.

55. Michael Kitson, *Rembrandt* (London: Phaidon Press, 1969), 21–23.

56. Grimm, *Frans Hals*, 107.

57. To take another example from Grimm, where he observes that Hals "commanded special sensory powers of discernment" (ibid.,102) I would prefer to focus on the present cause of the observation by saying that the paintings represent the painter's sensory powers of discernment and the rapidity of his sensory responses and manual decisions.

58. Sylvia Ferino Pagden, "From Cult Images to the Cult of Images: The Case of Raphael's Altarpieces," in Peter Humfrey and Martin Kemp, eds., *The Altarpiece in the Renaissance* (Cambridge: Cambridge University Press, 1990), 165, 168.

59. Ibid., 174.

60. David Summers, *Michelangelo and the Language of Art* (Princeton: Princeton University Press, 1981), 250–51, 254, 255. I am grateful to my colleague, Professor Catherine Soussloff, for directing me to this discussion.

61. Elizabeth Cropper, *Art Bulletin* 65 (1983): 157.

62. Summers, *Michelangelo*, 252.

63. Ibid., 250. The scheme of sciences in *Panepistemon* is conveniently laid out in Bernard Weinberg, *A History of Literary Criticism in the Italian Renaissance*, 2 vols. (Chicago: University of Chicago Press, 1961), 1.3.

64. Summers, *Michelangelo*, 253–54.

65. On this, see, in general, André Chastel, *Art et l'humanisme à Florence au temps de Laurent de Magnifique*, 2d ed. (Paris: Presses Universitaires de France, 1961).

66. Of the many loci in which to explore this usage, *Republic* I (the Thrasymacheia) and *Charmides* display it most prominently.

67. Summers, *Michelangelo*, 236–39.

68. Plato takes advantage of chiming signifiers in three different families of terms whose forms occasionally—in certain dialectal and modal variants—overlap: *epistamai*, the verb related to *epistēmē*; *ephistēmi*, to set up, establish, place over; and *epistateuō*, to be set over, in charge of. An *epistēmon* is someone with know-how, while an *epistatēs* is a supervisor, overseer, commander, etc. The convergence of these forms generates associations of knowledge, know-how, and skill with power and authority. The contexts have little to do with philosophy and epistemology but much to do with technique, technology, rhetoric, and politics.

69. Summers, *Michelangelo*, 251, 253.

70. Baldassare Castiglione, *Il libro del cortegiano*, ed. Giulio Carnazzi (Milan: Biblioteca Universale Rizzoli, 1987), 107–8 (1.49); *The Book of the Courtier*, trans. Charles Singleton (New York: Anchor Books, 1959), 77–78. Subsequent references will be to these editions.

71. Summers, *Michelangelo*, 257.

72. Paolo Rossi, *Philosophy, Technology, and the Arts in the Early Modern Era*, trans. Salvator Attanasio (New York: Harbor Torchbooks, 1970), 144–45.

73. By "interest" I mean more specifically what was involved in reorientating a traditional-appearing scheme to legitimate, first *graphikē* and *disegno*, then, through that, sculpture. The interest may be placed in a stronger light by redirecting attention from Poliziano's influence on Michelangelo (Summers's focus) to Lorenzo de' Medici's influence on Poliziano, hints of which appear in Summers's preceding chapter (*Michelangelo*, 242–43, 245, and 246–47.)

For a balanced treatment of Poliziano's complex relation to his humanist and Neoplatonist milieu, see the brilliant chapter in Thomas M. Greene's *The Light in Troy: Imitation and Discovery in Renaissance Poetry* (New Haven: Yale University Press, 1982), 147–70.

74. Summers, *Michelangelo*, 258.

75. Bram Kempers, *Painting, Power and Patronage: The Rise of the Professional Artist in Renaissance Italy*, trans. Beverley Jackson (London: Allen Lane, The Penguin Press, 1992), 183, 197. In *Piety and Patronage in Renaissance Venice* (New Haven: Yale University Press, 1986) Rona Goffen cites another form of occupation and another reason for the patronal conjunction of mendicant orders with noble families: "the right to burial in one's parish church was the irresistible quid pro quo exchanged with patrons by the friars for the building, decoration, and endowment of their churches" (23).

76. Kempers, *Painting, Power and Patronage*, 253.

77. David Rosand, *Painting in Cinquecento Venice: Titian, Veronese, Tintoretto* (New Haven: Yale University Press, 1982), 16.

78. For a more detailed account of the political and cultural context and its relation to the status of artists, see ibid., 7–16.

79. Ernst H. Gombrich, "The Leaven of Criticism in Renaissance Art: Texts and Episodes," in *The Heritage of Apelles*, 111–31, and "The Renaissance Conception of Artistic Progress and Its Consequences," in *Norm and Form: Studies in the Art of the Renaissance* (London: Phaidon Press, 1966), 1–10.

80. Gombrich, "Artistic Progress," 7, 8.

81. Kempers, *Painting, Power and Patronage*, 211.

82. Gombrich, "Leaven of Criticism," 121.

83. Melion, *Shaping the Canon*, 61.

84. Jacqueline Lichtenstein, "Making Up Representation: The Risks of Femininity," *Representations* 20 (Fall 1987): 78. See also Patricia L. Reilly, "Writing Out Color in Renaissance Theory," *Genders* 12 (Winter 1991): 77–99.

85. Lichtenstein, "Making Up Representation," 83. The graphic mode's aggressive policing of objects and the subjective lability of its optical other are expressed in the rhetoric with which Margaret Iversen paraphrases and cites de Piles's distinction between two uses of light and shade: one "models objects or figures and makes them tangible," while the other optically unifies "masses of light and shade." De Piles "understands modeling shadows as an objective registration of how light falls on objects, while chiaroscuro can be freely distributed: modeling shadows 'forces the painter to obey them, while chiaroscuro depends totally on the imagination of the painter.' . . . Both de Piles, with reference to the artist, and Riegl, with reference to the spectator, connect tactile, self-contained objects with the restriction of the imagination and chiaroscuro with subjectivity and the imagination's free employment" (Margaret Iversen, *Alois Riegl: Art History and Theory* [Cambridge: MIT Press, 1993], 114).

86. For a brief account of the graphic prehistory of this rebellion—"the challenge of realism" posed by Alberti and Florentine painting and met by Jacopo Bellini, Carpaccio, and Mantegna—see Patricia Fortini Brown, *Venetian Narrative Painting in the Age of Carpaccio* (New Haven: Yale University Press), 105–20.

87. See Rosand's text and catalogue copy in *Titian* (1978), the essays collected in *Painting in Cinquecento Venice*, and "Titian and Pictorial Space," in *Titian, Prince of Painters* (Munich: Prestel, 1990), 94–100.

88. Rosand, "Titian and Pictorial Space," 98. Even "the earliest Titian," S. J. Freedberg claims, sought in Giorgione's style "those elements which will liberate him from quattrocentesque literal, essentially objective, depiction: from forms copied in their immobility and contained in static order" (*Painting in Italy 1500 to 1600* [Harmondsworth, Middlesex: Penguin Books, 1975], 137).

89. On the attention paid this phenomenon by Venetian writers, see Mosche Barasch, *Light and Color in the Italian Renaissance Theory of Art* (New York: New York University Press, 1978), 101–2.

90. Peter Humfrey, *The Altarpiece in Renaissance Venice* (New Haven: Yale University Press, 1993), 204–7.

91. Alpers, *Art of Describing*, 225, 228.

92. Gary Schwartz, *Rembrandt, His Life, His Paintings* (New York: Viking Press, 1985), 306, 309. Schwartz is paraphrasing "the rules of art" reconstructed by J. A. Emmens in *Rembrandt en de regels de kunst* (Utrecht: Haentjens Dekker and Gumbert, 1968). See Alpers's appreciative comments on Emmens in *Rembrandt's Enterprise*, 9–10.

93. Grimm, *Frans Hals*, 101, 103. See also 85–86: "Hals's application of paint often reveals the direction of the touches" and this direction "is in a certain tension with the representation of the motifs. . . . In his portraits he had to comply with a patron's expectations, whereas in his depiction of rustic characters he could disregard academic rules." As we'll see in Chapter 11, not only in many later portraits but even in such relatively early works as the 1626 portrait of Isaac Massa in Ontario he exploited the fit between informal conventions of posing and the conspicuous impression of rapid and animated brushwork.

94. Mariët Westermann, "Steen's Comic Fictions," in H. Perry Chapman, Wouter Th. Kloek, and Arthur K. Wheelock, Jr., eds., *Jan Steen, Painter and Storyteller* (New Haven: Yale University Press, 1996), 61.

95. *Rembrandt's Enterprise*, 17–18.

96. See, e.g., his contributions to the volumes published by the RRP and his two essays in Brown et al., eds., *Rembrandt*, "Rembrandt's Manner," 12–39, and "The Invisible Rembrandt: The Results of Technical and Scientific Research," 90–105.

97. For Chapman's version, see H. Perry Chapman, *Rembrandt's Self-Portraits: A Study in Seventeenth-Century Identity* (Princeton: Princeton University Press, 1990), 74–77. For van de Wetering's, see *Rembrandt*, chapter 7, especially 160–69.

Chapter 2: Politics: The Apparatus of Commissioned Portraiture

1. Cecil Gould, *Titian* (London: Hamlyn, 1969), 11.

2. Aristotle, *Poetics* 1454b, 9–12, from *Aristotle: "Poetics I" with The "Tractatus Coislinianus," A Hypothetical Reconstruction of "Poetics" II, and the Fragments of the "On Poets,"* trans. Richard Janko (Indianapolis: Hackett, 1987), 20.

3. Richard Brilliant, *Portraiture* (Cambridge: Harvard University Press, 1991), 130.

4. Jeanne Thomas Allen, "The Industrial Context of Film Technology: Standardization and Patents," in Teresa de Lauretis and Stephen Heath, eds., *The Cinematic Apparatus* (New York: St. Martin's Press, 1980), 26.

5. The essays collected by Heath and de Lauretis in *The Cinematic Apparatus* aim to integrate these positions or, more properly, to subsume the first un-

der the second. See the valuable anthology edited by Philip Rosen, *Narrative, Apparatus, Ideology: A Film Theory Reader* (New York: Columbia University Press, 1986). As Rosen notes, the extended sense of *apparatus* conflates two French terms, *appareil* and *dispositif* (282); the latter, the broader of the two, bears a sense similar to that put into play by Foucault when he writes of the *machinery* for producing discourses.

6. Baudry argues for the influence of "Western easel painting" and "the perspective construction of the Renaissance" on the cinematic image and its ideology, the ideology of a single and centered subject, at once subjected to the laws of construction and offered what is represented as an accurate mimesis of truth, "a total vision which corresponds to the idealist conception of the fullness and homogeneity of 'being'" (Jean-Louis Baudry, "Ideological Effects of the Basic Cinematic Apparatus," in Bill Nichols, ed., *Movies and Methods*, vol. 2 (Berkeley: University of California Press, 1985), 534–35. Jonathan Crary's critique of this more or less monolithic view of "representationalism" is discussed above in Chapter 1.

7. Peter Wollen, "Cinema and Technology: A Historical Overview," in Heath and de Lauretis, eds., *The Cinematic Apparatus*, 14.

8. Rosen, *Narrative, Apparatus, Ideology*, 282.

9. André Chastel, *Marsile Ficin et l'art* (Geneva: Droz, 1954), 65–66, and *Art et l'humanisme à Florence au temps de Laurent le Magnifique*, 2d ed. (Paris: Presses Universitaires de France, 1961), 102–3.

10. "By silently assimilating the real to the ideal, naturalistic portraiture enabled a particular human being to personify the majesty of the kingdom or the courage of a military leader" (Joanna Woodall, introduction to Woodall, ed., *Portraiture: Facing the Subject*, (Manchester: Manchester University Press, 1997), 3.

11. David Summers, *The Judgment of Sense: Renaissance Naturalism and the Rise of Aesthetics* (Cambridge: Cambridge University Press, 1987), 111. The example of the *Mona Lisa*—as of many portraits of women—is loaded. See Elizabeth Cropper, "The Beauty of Women: Problems in the Rhetoric of Renaissance Portraiture," in Margaret W. Ferguson, Maureen Quilligan, and Nancy J. Vickers, eds., *Rewriting the Renaissance: The Discourses of Sexual Difference in Early Modern Europe* (Chicago: University of Chicago Press, 1986), 175–90, esp. 189–90.

12. John Pope-Hennessey, *The Portrait in the Renaissance* (New York: Pantheon Books, 1966), 73, 101, 82, 144, 300. See also Lorne Campbell, *Renaissance Portraits: European Portrait-Painting in the 14th, 15th, and 16th Centuries* (New Haven: Yale University Press, 1990), 27–39, and Johannes Wilde, *Venetian Art from Bellini to Titian* (London: Oxford University Press, 1974), 212–64, especially 252.

13. Thomas M. Greene, *The Light in Troy: Imitation and Discovery in Renaissance Poetry* (New Haven: Yale University Press, 1982), 152–53.

14. Martin Kemp, "'Ogni dipintore dipinge se': A Neoplatonic Echo in Leonardo's Art Theory?" in Cecil H. Clough, ed., *Cultural Aspects of the Italian Renaissance: Essays in Honor of Paul Oskar Kristeller* (Manchester: Manchester University Press, 1976), 312–13.

15. Ibid., 320. Kemp's analysis derives in part from Leonardo's statements about the constitutive role of judgment, which not only "moves the hand" of the painter at work but is also "one of the powers of the soul, by which it composes the form of the body in which it resides," and therefore tends to reproduce the latter in the products of the former—unless checked by the study of nature (ibid.,310–11; passages cited on 320–21 from Carlo Pedretti, *Leonardo da Vinci on Painting: A Lost Book [Libro A]* [London, 1965], 35).

16. David Summers, *Michelangelo and the Language of Art* (Princeton: Princeton University Press, 1981), 233. Presumably the painting is fictive in representing others as if they were visual and material objects—bodies, colors, etc.—rather than *fantasie* of his *concetto*: "Leonardo Bruni wrote that 'I admire the *ingenium* of the poet, but by no means do I admire the work, knowing that it is a fiction.' And Manuel Chrysolaras wrote that 'we admire not so much the beauties of the bodies in statues and paintings as the beauty of the mind of their maker . . . an image which is grasped through the eyes of the soul's imagination'" (232).

17. For an influential account of this unfolding, originally published in 1924 but still useful in spite of its involvement in now-dated controversies and discourses, see Erwin Panofsky, *Idea: A Concept in Art Theory*, trans. Joseph J. S. Peake (Columbia: University of South Carolina Press, 1968), esp. Chaps. 4 and 5, pp. 45–99. Of the many critiques of Panofsky's project, the one I find most trenchant is Christopher Wood's introduction to his translation of Panofsky's *Perspective as Symbolic Form* (New York: Zone Books, 1991), 7–24.

18. Summers, *The Judgment of Sense*, 111.

19. Michael Baxandall, *Painting and Experience in Fifteenth Century Italy* (London: Oxford University Press, 1974; orig. pub. 1972), 29–108 and passim: see especially 56–81.

20. Ibid., 145–47. The term *inferred* is important here. The writers Baxandall cites, chiefly Landino, are discussing artists (Masaccio, Angelico, Castagno, Lippi, and Botticelli) whose facture—the actual traces of the brush—is inconspicuous, so they can't be describing that, and must therefore be commenting on linear and compositional design—the *grazia* and *aria*, for example, of Botticelli's drawing, the inferred movement of the hand that produces the sinuous motion of contour lines.

21. Ernst Kris and E. H. Gombrich, "The Principles of Caricature," in Kris, *Psychoanalytic Explorations in Art* (New York: International Universities Press, 1952), 190.

22. E. H. Gombrich, "The Early Medici as Patrons of Art," in *Norm and Form: Studies in the Art of the Renaissance* (London: Phaidon, 1966), 40.

23. Baxandall, *Painting and Experience*, 1. I shall stick to the term *patron*. It is better for my concerns, which center on Rembrandt, and I prefer its etymological connotation. D. S. Chambers makes a distinction similar to Baxandall's, but his definition of *patron* will suffice for my purposes: "Patrons are those persons responsible, individually or collectively, for commissioning and paying for works produced by artists" (*Patrons and Artists in the Italian Renaissance* [Columbia: University of South Carolina Press, 1971], xxiv).

24. This, as Kemp shows, is Leonardo's opinion of auto-mimesis. See the passages cited on pp. 311–12 of Kemp, "Ogni dipintore," and those cited in nn.1–7 on 320–21.

25. Colin Eisler, "'Every Artist Paints Himself': Art History as Biography and Autobiography," *Social Research* 54 (1987): 76–77. Eisler begins by describing the aphorism as "Leonardo's profound truism, . . . one open to use and abuse" (73) and goes on to ignore the many Renaissance and modern accounts (including Leonardo's) of its use and abuse.

26. See Chapter 21, below.

27. For details, see Violet Barbour, *Capitalism in Amsterdam in the 17th Century* (Ann Arbor: University of Michigan Press, 1963; orig. pub. 1950), 80–88. See also Joyce Oldham Appleby, *Economic Thought and Ideology in Seventeenth Century England* (Princeton: Princeton University Press, 1980; orig. pub. 1978), 73–98, esp. 87–92, and Jonathan I. Israel, *Dutch Primacy in World Trade, 1585–1740* (Oxford: Clarendon Press, 1990), 77–79, 412–14.

28. Peter Burke, *The Italian Renaissance: Culture and Society in Italy*, rev. ed. (Princeton: Princeton University Press, 1987), 97.

29. Myron P. Gilmore, *The World of Humanism, 1453–1517* (New York: Harper & Row, 1962; orig. pub. 1952), 231. On the relation between usury and economic change, see Jacques Le Goff, *Your Money or Your Life: Economy and Religion in the Middle Ages*, trans. Patricia Ranum (New York: Zone Books, 1988).

30. Charles Avery, *Florentine Renaissance Sculpture* (New York: Harper & Row, 1970), 2–3.

31. Vespasiano da Bisticci, *Renaissance Princes, Popes, and Prelates*, trans. William George and Emily Waters, introd. Myron Gilmore (New York: Harper & Row, 1963; orig. pub. 1926), 218–19.

32. William Bouwsma, *Venice and the Defense of Republican Liberty* (Berkeley: University of California Press, 1968), 16–17.

33. Baxandall, *Painting and Experience*, 3.

34. Burke, *Italian Renaissance*, 98.

35. See Martin Wackernagel's excellent discussion in *The World of the Florentine Renaissance Artist: Projects and Patrons, Workshop and Art Market*, trans. Alison Luchs (Princeton: Princeton University Press, 1981; orig. pub. 1938), 286–95.

36. Chastel, *Art et l'humanisme*, 103. See, again, Wackernagel, *World of the*

Florentine Artist, 293–94. For hypotheses about Savonarola's influence on the idealist or spiritual side of mimetic idealism, see Marcia B. Hall, "Savonarola's Preaching and the Patronage of Art," in Timothy Verdon and John Henderson, eds., *Christianity and the Renaissance: Image and Religious Imagination in the Quattrocento* (Syracuse: Syracuse University Press, 1990), 493–522.

37. Baxandall, *Painting and Experience*, 17.

38. Charles Hope, "Artists, Patrons, and Advisers in the Italian Renaissance," in Guy Fitch Lytle and Stephen Orgel, eds., *Patronage in the Renaissance* (Princeton: Princeton University Press, 1981), 307, 339. For a recent extension of this thesis to altarpieces, see Hope, "Altarpieces and the Requirements of Patrons," in Verdon and Henderson, eds., *Christianity and the Renaissance*, 535–71.

39. Lauro Martines, *Power and Imagination: City-States in Renaissance Italy* (New York: Knopf, 1979), 216–17, 256, 243. Martines's concessive opinion seems based on the valuable commentary and collection of sources by D. S. Chambers in Fitch, Lytle, and Orgel, eds., *Patrons and Artists in the Renaissance*, and also on the classic account in Wackernagel, *World of the Florentine Artist*. For a useful classification of types of patronage and some examples of the kinds of "conflicts which made manifest the tensions inherent in the relationship," see Burke, *Italian Renaissance*, 88–123, esp. 88–98 and 107–10. During the later sixteenth century the "unity of interests" Martines acknowledges received institutional reinforcement in the development of academies under ducal patronage. See Charles Dempsey, "Some Observations on the Education of Artists at Florence and Bologna during the Later Sixteenth Century," *Art Bulletin* 62 (1980): 552–68.

40. Summers, *Michelangelo*, 233. Michelangelo's ironic treatment thus accords with Leonardo's view of the aphorism.

41. Gary Schwartz, *Rembrandt, His Life, His Paintings* (New York: Viking Press, 1985), 59.

42. See Stephen Orgel, "The Renaissance Artist as Plagiarist," *English Literary History* 48 (1981): 486–87.

Chapter 3: Consequences: Sprezzatura and the Anxiety of Self-Representation

1. The Italian text and English translation cited or referred to in this chapter will be Baldassare Castiglione, *Il libro del cortegiano*, ed. Giulio Carnazzi (Milan: Biblioteca Universale Rizzoli, 1987) and *The Book of the Courtier*, trans. Charles Singleton (New York: Anchor Books, 1959).

2. Randolph Starn and Loren Partridge, *Arts of Power: Three Halls of State in Italy, 1300–1600* (Berkeley: University of California Press, 1992), 86.

3. Stanley Chojnacki, "Social Identity in Renaissance Venice: The Second Serrata," *Renaissance Studies* 8 (1994): 348–49. In the reference to Tuscany, Chojnacki is quoting Claudio Donati, *L'idea di nobiltà in Italia: Secoli*

XIV–XVIII (Bari, 1988), 15, 22n24. Chojnacki's essay refines and accentuates a theme already present in his earlier "Kinship Ties and Young Patricians in Fifteenth-Century Venice," *Renaissance Quarterly* 38 (1985): 241–70.

4. Thomas Kuehn, *Law, Family, and Women: Toward a Legal Anthropology of Renaissance Italy* (Chicago: The University of Chicago Press, 1991); Stephanie H. Jed, *Chaste Thinking: The Rape of Lucretia and the Birth of Humanism* (Bloomington: Indiana University Press, 1989), 74–120.

5. Starn and Partridge, *Arts of Power*, 86–88.

6. Peter Burke, *Venice and Amsterdam: A Study of Seventeenth-Century Elites*, 2d ed. (Cambridge: Polity Press, 1994), 6, 11.

7. One way to look at this is to borrow C. B. Macpherson's concepts of customary and possessive market societies. (Even granted the criticism J. G. A. Pocock and others have made of the Macpherson model, especially as applied to seventeenth-century English political thought, I think it's useful as a way of describing the major sites of political, social, and economic conflict.) Elements of the possessive market society then appear to exert pressure on those who find it in their interest to preserve—and this comes to mean to *perform*—elements of the customary or status society.

8. Wayne Rebhorn, *Courtly Performances: Masking and Festivity in Castiglione's* Book of the Courtier (Detroit: Wayne State University Press, 1978), 38.

9. Frank Whigham, *Ambition and Privilege: The Social Tropes of Elizabethan Courtesy Theory* (Berkeley: University of California Press, 1984), 99.

10. Rebhorn, *Courtly Performances*, 34–35.

11. Eduardo Saccone, "*Grazia, Sprezzatura, Affettazione* in the *Courtier*," in Robert W. Hanning and David Rosand, eds., *Castiglione: The Ideal and the Real in Renaissance Culture* (New Haven: Yale University Press, 1983), 59–64; Daniel Javitch, "*Il Cortegiano* and the Constraints of Despotism," pp. 24–25 of the same volume.

12. Javitch, "*Il Cortegiano* and the Constraints of Despotism," 23, 26.

13. Different facets of sprezzatura are nicely turned and ambiguated by George Puttenham in discussions that fuse social with rhetorical tropes, courtliness with allegory: (1) "*allegoria*, which . . . not impertinently we call the Courtier or figure of faire semblant," and (2) "the courtly figure Allegoria, which is when we speake one thing and thinke another," and "which for his duplicitie we call the figure of [*false semblant* or dissimulation]" (George Puttenham, *The Arte of English Poesie*, ed. Gladys Doidge Willcock and Alice Walker [Cambridge: Cambridge University Press, 1970; orig. pub. 1936], 299, 186).

14. Whigham, *Ambition and Privilege*, 100–101.

15. See the wonderfully apt allusion in 2.19–20 to the passage of Scripture (Luke 14: 8–11) in which Christ explains to the wedding guest the advantages of strategic self-abasement: those who sneakily try to exalt themselves risk being humbled, but those who make a big show of humbling

themselves stand a good chance of getting their host to raise them to a higher place. The interchange at this point between Federico and Cesare dramatizes a wry version of the moral, one that brings out the competitive motive that drives even Christian sprezzatura. Federico lets Cesare identify the allusion and accuse him of theft, and then confesses in effect that he committed a terrible crime but didn't think Cesare was up to catching him out: "It would be too great a sacrilege to steal from the Gospel; but you are more learned in Holy Writ than I thought."

16. Whigham, *Ambition and Privilege*, 116.

17. Though I find Whigham's articulation and elaboration of social tropes enormously helpful, I depart from his scheme, in which sprezzatura is merely one in a set of eight "tropes of personal promotion," all on the same level. My narrower focus on Castiglione leads me to treat sprezzatura as a master trope of which deceit and cosmesis are variant inflections responding to different motives and pressures.

18. "Supply a deficiency" is an interesting idiom, as the following examples of usage may suggest. (1) From the 1634 English translation of one of Ambroise Paré's chapter titles: "Of the Meanes and Manner to repaire or supply the Naturall or accidentall defects or wants in mans body." (2) S. H. Butcher, pausing in his commentary on the *Poetics* to paraphrase Aristotle's view of the art/nature relation: "the function . . . of the useful arts is in all cases 'to supply the deficiencies of nature'" (quoting from *Politics* 1337a, 1–3—"prosleipon . . . anapleroun"—to fill up or supply what is lacking). (3) Peter Stallybrass, writing about transvestism in the English Renaissance theater: "all efforts to fix gender are necessarily prosthetic" in that "they suggest the attempt to supply an imagined deficiency" by the exchange of clothes or other means.

In these examples, "to supply a deficiency" is an idiomatic way of saying "to fill a gap." But the words also mean "to *create* a deficiency." Suppose someone who wants to tell you that art improves nature expresses it this way: "The forms of art supply deficiencies in the forms of life." That expression perversely delivers two contradictory messages, for it also says, "Art adds deficiencies to life and thus diminishes nature." This conflicted meaning precisely expresses the problematic of the relation between grazia and sprezzatura.

19. Indeed, the count refers to it in humoral terms as *un sangue* (1.14), which the Rizzoli editor glosses as *una fisonomia* (*Cortegiano*, ed., Carnazzi, 70 and 344).

20. Frank Whigham, "Interpretation at Court: Courtesy and the Performer-Audience Dialectic," *New Literary History* 14 (1983): 633–34.

21. Barbara Correll, *The End of Conduct: Grobianus and the Renaissance Text of the Subject* (Ithaca: Cornell University Press, 1996), 57.

22. See ibid., 16–17, for a brief critique of Whigham's failure (in *Ambition and Privilege*) to take issues of sexuality and gender into account.

Chapter 4: The Face as Index of the Mind: Art Historians and the Physiognomic Fallacy

1. F. W. J. Schelling, *Philosophy of Art*, ed. and trans. Douglas W. Stott (Minneapolis: University of Minnesota Press, 1989), 146. Quoted by Richard Brilliant, *Portraiture* (Cambridge: Harvard University Press, 1991), 129–30.

2. Under "genetic" I include all historical and archival reconstructions of the motives that condition the production, stylistic influences, theme, and function of a painting. Under "contextual" I include broader accounts of its social and political ambiance—for example, the apparatus of patronage, the place of painters in the occupational or guild structures of particular cities, and the influence of discourses of art on practice.

3. Otto Benesch, *Rembrandt*, trans. James Emmons (Cleveland: World Publishing Company, 1969; orig. pub. 1957), 86.

4. Albert E. Elsen, *Purposes of Art*, 2d ed. (New York: Holt, Rinehart, Winston, 1967), 219–20. On the vexing question of whether Six is putting on or taking off his glove, and on the portrait in general, see Chapter 11, below.

5. Such schemes are often introduced or justified on historical grounds as the beliefs and assumptions, and so on, of the past but not ours. The portrait is read as if from the standpoint of Rembrandt's contemporaries. This is a reading not of the portrait but of a seventeenth-century reading of the portrait—a reading sitter and painter "must have intended," since theirs was the *mentalité* of their time. The portrait itself remains to be interpreted in our terms, a procedure that needn't cause any problems once we reject the view that the past was peopled by "cultural dopes," as Anthony Giddens puts it in stigmatizing that view, and acknowledge that "their" terms are always constructed by us. So why not bypass intellectual-historical projections from the present to the past and shift instead to a more open, indeterminate reading that allows the painter and sitter to know as much as we do, to be as ironic or sophisticated about their *mentalité* as we think we are about theirs and ours?

6. Gary Schwartz, *Rembrandt, His Life, His Paintings* (New York: Viking Press, 1985), 305. According to Schwartz, the "iconographic, stylistic, and aesthetic meanings" of Rembrandt's portraits can't be understood without archival research (358–59). The archive is thus the determinant of the interpretation of character, the painter's story, and the image. See Chapter 11, below.

7. In a previously published version of this chapter I capitalized the phrase *early modern*. I suppose I was making a statement. There was a period during which it seemed important to me not to use the term "Renaissance," but although for most purposes I still prefer *early modern* to *Renaissance*—because it keeps out of the shadow of old academic turf wars and looks forward toward the modern rather than polemically backward toward the medieval—I no longer have a big enough investment in this issue to call for the upper-case emphasis. One reason for this change of mind—probably the main reason—is

Leah S. Marcus's wonderfully smart and sensible "Renaissance / Early Modern Studies" in Stephen Greenblatt and Giles Gunn, eds., *Redrawing the Boundaries: The Transformation of English and American Literary* Studies (New York: The Modern Language Association of America, 1992), 40–63.

8. Roland Barthes, *Camera Lucida: Reflections on Photography*, trans. Richard Howard (New York: Hill & Wang, 1981), 13–14. I am very grateful to Geoffrey Batchen of the Visual Arts Department at the University of California, San Diego, for bringing this passage to my attention and for his own stimulating discussion of the politics and ambiguities of the pose in "*Le Petit Mort*: Photography and Pose," *SF Camerawork Quarterly* 15, no. 1 (1988): 3–6.

9. For a compact bibliographical and biographical profile of Trevisan, see the catalogue entry by Keith Christiansen in Jane Martineau, ed., *Andrea Mantegna* (New York: Metropolitan Museum of Art, 1992), 333–35.

10. John Pope-Hennessey, *The Portrait in the Renaissance* (New York: Pantheon Books, 1966), 86.

11. Ronald Lightbown, *Mantegna* (Berkeley: University of California Press, 1986), 81–82.

12. Massimo Firpo, "The Cardinal," in Eugenio Garin, ed., *Renaissance Characters*, trans. Lydia G. Cochrane (Chicago: University of Chicago Press, 1991), 53.

13. Giles Robertson, *Giovanni Bellini* (London: Oxford University Press, 1968), 109; Terisio Pignatti, *The Golden Century of Venetian Painting* (Los Angeles: Los Angeles County Museum of Art, 1979), 34.

14. Norbert Huse and Wolfgang Wolters, *The Art of Renaissance Venice: Architecture, Sculpture, and Painting, 1460–1590*, trans. Edmund Jephcott (Chicago: University of Chicago Press, 1990), 241.

15. Richard Brilliant, *Portraiture* (Cambridge: Harvard University Press, 1991), 30–31.

16. Thus Oscar Wilde's expansion of the formula "every painter paints himself" may caricature, but doesn't falsify, the art historians' emphasis: "Every portrait that is painted with feeling is a portrait of the artist, not of the sitter. The sitter is merely an accident, the occasion. It is not he who is revealed by the painter; it is rather the painter who, on colored canvas, reveals himself" (from *The Picture of Dorian Gray*, quoted—with approval—by Brilliant, *Portraiture* 82).

17. Kenneth Clark, *An Introduction to Rembrandt* (New York: Harper & Row, 1978), 24.

18. Ibid.

Chapter 5: Physiognomy, Mimetic Idealism, and Social Change

1. Jacques Lacan, *The Four Fundamental Concepts of Psycho-Analysis*, trans. Alan Sheridan (New York: Norton, 1981), 112.

2. This double objective is already explicit in Alberti's treatise on painting: it is not enough for the student of painting to "take from nature" the regularities and peculiarities of human figures; "he should be attentive not only to the likeness of things, but also and especially to beauty" (Leon Battista Alberti, *On Painting and On Sculpture: The Latin Texts of* De Pictura *and* De Statua, trans. Cecil Grayson [London: Phaidon, 1972], 99). I quote from the Latin rather than the Italian text because the latter has "know [*conoscierà*] from nature" where the former has "take [*excipiet*]," which I prefer because it is more aggressive and thus more attuned to the idea developed in the statements that follow: the idea, illustrated by the story of Zeuxis and the Crotonian maidens, that although it is necessary for the painter to follow nature, that isn't sufficient because nature is defective with respect to criteria of beauty. Since no single actual figure meets the criteria, the artist must select and combine the best features from many models. Thus "to take from nature" involves not only careful study and observation, not only the mimetic skill of reproduction, but also a discriminative rapacity expressed as the desire to rob, pillage, or despoil nature of her best parts (and, by implication, to discard the remainder). The Zeuxian fantasy of idealization invoked by Alberti in these pages is a fantasy of amputation and proto-cyborgian reconstruction.

"By the turn of the sixteenth century" in Europe, Joanna Woodall writes, "the 'realistic' portrait was widespread. However, other artists, particularly in Italy, reconciled attention to the physiognomic peculiarities of the subject with more generalizing visual devices, such as the profile view (especially for women), or the analysis of face and body in smooth, consistently lit geometrical shapes. Such techniques were traditionally understood to attribute universal and ideal qualities to figures" (Introduction to Woodall, ed., *Portraiture: Facing the Subject* [Manchester: Manchester University Press, 1997], 2). This reconciliation was actually taking place well before the turn of the sixteenth century.

3. Giorgio Vasari, *Lives of the Most Eminent Painters, Sculptors, and Architects*, trans. Gaston du C. De Vere, 2 vols. (New York: Alfred A. Knopf, 1996; orig. pub. 1912), 1.494–95.

4. David Summers, *The Judgment of Sense: Renaissance Naturalism and the Rise of Aesthetics* (Cambridge: Cambridge University Press, 1987), 110–11.

5. "There are . . . in the history of figural art, two conflicting tendencies arising from . . . opposite poles, namely, the tendency to seek resemblance to the subject and the tendency to pursue its idealization or transfiguration. . . . The Italian Renaissance offers examples of the clear conceptualization of both tendencies" (Tullio de Mauro, Luigi Grassi, Eugenio Battista, "Portraiture," *Encyclopedia of World Art*, vol. 11, rev. ed. [New York: McGraw-Hill, 1972], 470). We shouldn't let the truistic character of this observation dissuade us from exploring the implications of the polarity.

6. John Pope-Hennessey, *The Portrait in the Renaissance* (New York: Pantheon Books, 1966), 144, 300.

7. On some of the ironies involved in conveying effects of truth, see the amusing observations by Richard Brilliant, *Portraiture* (Cambridge: Harvard University Press, 1991), 76–78.

8. Martin Kemp, *Leonardo da Vinci: The Marvellous Works of Nature and Man* (London: J. M. Dent, 1981), 158. For a brief survey of the later history of physiognomy, see Graeme Tytler, *Physiognomy in the European Novel* (Princeton: Princeton University Press, 1982), 35–48. Tytler's focus is on Lavater, but his acount is valuable for its reliance on German sources from the eighteenth century on—an archive barely evident in the slender bibliography to Patrizia Magli's otherwise useful survey, "The Face and the Soul," in Michael Feher with Ramona Naddoff and Nadia Tazi, eds., *Fragments for a History of the Human Body*, Part Two (New York: Zone Books, 1989), 87–127.

9. William Stahl, introduction to Macrobius, *Commentary on the Dream of Scipio*, trans. Stahl (New York: Columbia University Press, 1952), 9–10.

10. Sharon Fermor, "Movement and Gender in Sixteenth-Century Italian Painting," in Kathleen Adler and Marcia Pointon, eds., *The Body Imaged: The Human Form and Visual Culture since the Renaissance* (Cambridge: Cambridge University Press, 1993), 131.

11. Michael Baxandall, *Painting and Experience in Fifteenth Century Italy* (London: Oxford University Press, 1971), 60.

12. Fermor, "Movement and Gender," 134–38.

13. Judith Butler, *Gender Trouble: Feminism and the Subversion of Identity* (New York: Routledge, 1990), 135.

14. Norbert Elias, *The History of Manners*, Vol. 1 of *The Civilizing Process*, trans. Edmund Jephcott (New York: Pantheon Books, 1978), 78.

15. Lisa Jardine, *Erasmus, Man of Letters: The Construction of Charisma in Print* (Princeton: Princeton University Press, 1993), 4–5 and passim.

16. Erasmus, "On Good Manners for Boys / *De civilitate morum puerilium*," trans. Brian McGregor, in *Collected Works of Erasmus*, Vol. 25, ed. J. K. Sowards (Toronto: University of Toronto Press, 1985), 273–74.

17. The Erasmian instructor's advice to his student is not "don't *be* like those kinds of people" but "don't *look* like those kinds of people."

18. Barbara Correll, *The End of Conduct:* Grobianus *and the Renaissance Text of the Subject* (Ithaca: Cornell University Press, 1996), 46–47.

19. Ibid., 7. "The name [*Grobianus*] Latinizes the German noun (*Grobian*) for a coarse and common man, *grob* (coarse) Hans" (ibid., xiv).

20. Erasmus, "On Good Manners for Boys," 278.

21. Correll, *The End of Conduct*, 70–71.

22. Erasmus, "On Good Manners for Boys," 286.

23. Elias, *History of Manners*, 74.

24. Jacques Revel, "The Uses of Civility," in Roger Chartier, ed., *A History of Private Life: III. Passions of the Renaissance*, trans. Arthur Goldhammer (Cambridge: Harvard University Press, 1989), 169–70.

25. Roger Chartier, *The Cultural Uses of Print in Early Modern France*, trans. Lydia G. Cochrane (Princeton: Princeton University Press, 1987), 79.

26. See, for example, Paul F. Grendler, *Schooling in Renaissance Italy: Literacy and Learning, 1300–1600* (Baltimore: Johns Hopkins University Press, 1989).

27. Harry Berger, Jr., "From Body to Cosmos: The Dynamics of Representation in Precapitalist Society," *South Atlantic Quarterly* 91 (1992): 557–602. To call relations "ascribed" is to expose the disenchanted perspective of the observer who uses the term to expose what he or she may view as "native" mystifications. This action of the observer is expressed by the prepositional or directional force of the prefix in the real etymology of the term, *ad-scribe*. It has become standard theoretical practice since Marx to designate as "traditional" those systems of of social relations that institute the misrecognition of economic and technical practices as social practices, embedding them in the social and religious discourses (of kinship and lineage, gender, alliance, gift exchange, confession, sacramental authority, etc.) they represent as prediscursive realities. Maintaining this type of misrecognition is a project that dominates feudal and other pre-capitalist formations; their cultural and ethnographic records show them to have a strategic investment in restricting the work of psychogenesis as much as possible to processes of primary socialization that allow norms and skills to pass from seniors to juniors, from tuition to intuition, on a faster and shorter track than do the more technical and specialized processes of secondary socialization.

28. Ibid., 585–99.

29. Peter L. Berger and Thomas Luckmann, *The Social Construction of Reality* (Garden City, N.Y.: Anchor Books, 1967) 144–45. Because this book is a landmark of 1960s constructivism, it's a little ironic that the authors are so inattentive to their androcentric and pluralistic presuppositions. Berger deals at length with traditional forms of religious reascription in *The Sacred Canopy* (Garden City, N.Y.: Anchor Books, 1969).

30. I am indebted to Beth Pittenger for pointing out this complication and helping me reformulate the problem so as to take it into account.

31. Jonathan Powis, *Aristocracy* (Oxford: Basil Blackwell, 1984), 52–53.

32. Matthew 10: 34, 12: 48; *The Jerusalem Bible*.

33. I borrow the terms "implicit" and "explicit" pedagogy from Pierre Bourdieu, *Outline of a Theory of Practice*, trans. Richard Nice (Cambridge: Cambridge University Press, 1973), 94. They are roughly equivalent to Berger and Luckmann's notions of primary and secondary socialization, but Bourdieu's treatment of the distinction is more wittily attuned to the collective ideological and discursive forces that shape ascriptive practices.

34. This is of course more explicit in the nomenclature of religious training, with its Sisters, Brothers, Fathers, and Mothers Superior.

35. Powis, *Aristocracy*, 51. Powis here seems to confuse the pedagogical domiciling of noble sons in other households with the very different phenome-

non of the bachelors or "les jeunes'" described and interpreted by Georges Duby. See Duby, *Hommes et structures du Moyen Age* (Paris: Mouton, 1973), 213–25, and *Medieval Marriage: Two Models from Twelfth-Century France*, trans. Elborg Forster (Baltimore: The Johns Hopkins University Press, 1978), 11–15.

36. See Grendler, *Schooling*, 3–41 and passim.

37. See ibid., 409–10.

38. One consequence of the greater role of secular schooling in socialization was a new emphasis on the secondary inscription of gender and class difference. The contribution of the teaching of Latin to this has often been noted. See, for example, Walter J. Ong, *Fighting for Life: Contest, Sexuality, and Consciousness* (Amherst: University of Massachusetts Press, 1989; orig. pub. 1981). See also Grendler, *Schooling*, 87–102, and Correll, *End of Conduct*, 58–76. The now-standard view of this is concisely expressed by Richard Halpern in some observations on Tudor schooling, which "was designed to produce gendered as well as political subjects" and was also "intended to rescue elite male children from the contaminating effects of both a popular milieu and a feminine one. Training in Latin separated young males from the 'mother tongue' and introduced them to an exclusively male realm of culture" (*The Poetics of Primitive Accumulation: English Renaissance Culture and the Genealogy of Capitalism* [Ithaca: Cornell University Press, 1991], 27).

Chapter 6: Elias on Physiognomic Skepticism: 'Homo Clausus' and the Anxiety of Representation

1. Norbert Elias, *The History of Manners*, Vol. 1 of *The Civilizing Process*, trans. Edmund Jephcott (New York: Pantheon Books, 1978).

2. The quoted terms are from Elias's original subtitle: *Über den Prozess der Zivilisation: Soziogenetische und psychogenetische Untersuchungen.*

3. For example, Keith Thomas notes in his introduction to a collection of essays on gesture that, though the contributors confirm Elias's "view that this was a key period in the definition of civility as involving a strict curb upon physical impulses, they also demonstrate that he gave a misleadingly unilinear character to what was not a single, unfolding development" (Jan Bremmer and Herman Roodenburg, eds., *A Cultural History of Gesture* [Ithaca: Cornell University Press, 1992], 11).

4. Elias is linked with Bakhtin by Gail Kern Paster in *The Body Embarrassed: Drama and the Disciplines of Shame in Early Modern England* (Ithaca: Cornell University Press, 1993), 2, 14–19, with Bourdieu by Peter Stallybrass and Allon White, *The Politics and Poetics of Transgression* (Ithaca: Cornell University Press, 1986), 88–90.

5. Peter Burke, "The Language of Gesture in Early Modern Italy," in Bremmer and Roodenburg, eds., *A Cultural History of Gesture*, 79. Cornell University Press seems to have a monopoly on these couplings; see preceding notes.

6. Elias, *History of Manners*, 250, 249, 247. The essay from which these citations are taken was added as an introduction to the 1968 edition of the German text and is published as an appendix to the English translation.

7. Elias, *History of Manners*, 80.

8. Elias, *History of Manners*, 257–58. The totally different argument of Charles Taylor is oddly like the Elias thesis in its general outlines. In *Sources of the Self: The Making of the Modern Identity* (Cambridge: Harvard University Press, 1989), Taylor locates in the same period—but in the history of philosophy—a turn in "moral topography" toward a new sense of the inwardness of the self, a new focus on "the opposition 'inside-outside,'" and a new awareness that "[w]e are creatures with inner depths; and with partly unexplored and dark interiors" (111). For a sympathetic outline of the Elias thesis, see Rogier Chartier, *On the Edge of the Cliff: History, Language, and Practices*, trans. Lydia G. Cochrane (Baltimore: The Johns Hopkins University Press, 1997), 114–19.

9. See, for example, the review of the English edition by Susan Buck-Morss in *Telos* 37 (Fall 1978): 181–98, and Helmut Kuzmics, "Elias' Theory of Civilization," *Telos* 61 (Fall 1984): 83–99, which contains a response to Buck-Morss. Her balanced critique of Elias's reading of Freud (184–87) is especially valuable. I'm indebted to Tyrus Miller for bringing these to my attention and, more generally, for illuminating discussions of German responses to and critiques of Elias, including the massive attack on aspects of Elias (different from those I consider here) by Hans-Peter Duerr in *Nachtheit und Scham: Der Mythos vom Zivilisationsprocess*, 2 vols. (Frankfurt am Main: Suhrkamp, 1988 and 1990).

10. Elias, *History of Manners*, xiii.

11. Elias, *Power and Civility*, Vol. 2 of *The Civilizing Process*, trans. Edmund Jephcott (New York: Pantheon Books, 1982), 294, 292–93.

12. I defend this hypothesis at length and in detail in *The Absence of Grace: Gender and Narrative in Two Renaissance Courtesy Books* (Stanford: Stanford University Press, 2000).

13. Elias, *History of Manners*, xiii.

14. Barbara Correll, *The End of Conduct: Grobianus and the Renaissance Text of the Subject* (Ithaca: Cornell University Press, 1996), 21–22.

15. Ibid., 25. This action, Kristeva insists, is ambiguous because "it does not radically cut off the subject from what threatens it—on the contrary, abjection acknowledges it to be in perpetual danger," the danger (Correll adds) "of falling out of so-called symbolic security." See Julia Kristeva, *Powers of Horror: An Essay on Abjection*, trans. Leon S. Roudiez (New York: Columbia University Press, 1982), 9. Correll argues that the "managing of the abject is the goal of the aversive conditioning engendered in the lessons of conduct literature" (25).

16. Elias, *History of Manners*, 63.

17. Elias, *Power and Civility*, 8 and passim. But see the review by Buck-Morss (cited in note 9, above), p. 196, for a critique of the mystifying connota-

tions of the image of figuration as a kind of dance—an image "superimposed on a constant structure of class oppression" whose internal dynamics is better captured by "Hegel's allegory of the master and slave."

18. Jonathan Goldberg, *Writing Matter: From the Hands of the English Renaissance* (Stanford: Stanford University Press, 1990), 60.

19. Ibid., 63. The conflict in France between the nobilities of the sword and the robe was anticipated and comically encapsulated in England at the beginning of the sixteenth century by Richard Pace in the prefatory letter to his *De fructu* (Basel, 1517). Pace cites an anecdote in which "one of those so-called gentlemen . . . who always carry some horn hanging at their backs, as though they would hunt during dinner," angrily rebuffs his companions' praise of letters with "I'd rather that my son should hang than study letters. For it becomes the sons of gentlemen to blow the horn nicely . . . , to hunt skilfully, and elegantly carry and train a hawk. But the study of letters should be left to the sons of rustics." Here a member of the nobility of the horn defends against the rise of a nobility of the hornbook. Text and translation (slightly altered) in *The Babees Book*, ed. F. J. Furnivall (New York: Greenwood Press, 1969; orig. pub. 1868), xii–xiii.

20. Goldberg, *Writing Matter*, 97.

21. Chartier, *On the Edge of the Cliff*, 115.

22. For an account of the discursive representations of violence in medieval culture, see Robert Bartlett, *The Making of Europe: Conquest, Colonization and Cultural Change, 950–1350* (Princeton: Princeton University Press, 1993), 85–105.

23. Gianfranco Poggi, *The State: Its Nature, Development, and Prospects* (Stanford: Stanford University Press, 1990), 6.

24. *Medieval Marriage: Two Models from Twelfth-Century France*, trans. Elborg Forster (Baltimore: The Johns Hopkins University Press, 1978), 113.

25. Jonathan Powis, *Aristocracy* (Oxford: Basil Blackwell, 1984), 47. On encastellation and the militarization of Europe from the tenth through the thirteenth centuries, see Bartlett, *Making of Europe*, 65–70.

26. Duby, *Medieval Marriage*, 3–4, 9.

27. Elias, *History of Manners*, 60.

28. Anna Bryson, "The Rhetoric of Status: Gesture, Demeanor and the Image of the Gentleman in Sixteenth- and Seventeenth-Century England," in Lucy Gent and Nigel Llewellyn, eds., *Renaissance Bodies: The Human Figure in English Culture c. 1540–1660* (London: Reaktion Books, 1990), 143, 140.

29. Powis, *Aristocracy*, 49.

30. Correll, *End of Conduct*, 46, 40.

31. Poggi, *State*, 20. For the differentiation of economy from society, see, in general, the work of Karl Polanyi.

32. For a compact and suggestive profile of the contradictions producing "feudal entropy" and the development of the reascriptive structures of Chris-

tian polity to combat that entropy, see Poggi, *State*, 37–39. To the factors enumerated by Poggi should be added the development of the reascriptive structures of agnatic lineage along with the corresponding changes in alliance technology so brilliantly analyzed by David Herlihy, Christiane Klapisch-Zuber, and other historians of family, household, and marriage.

33. Poggi, *State*, 40.

34. Correll, *End of Conduct*, 45–46.

35. Bryson, "Rhetoric of Status," 143–44.

36. Elias, *History of Manners*, 61.

37. Bryson, "Rhetoric of Status," 144–45. For this reason, Bryson adds, such codes may be considered in Erving Goffman's terms to be "'conventionalized means of communication by which the individual expresses his character'" (144). I think the reference to Goffman's work common to Bryson and many other contemporary students of social and cultural history introduces an unnecessary confusion into their interpretive apparatus. Goffman's approach is valuable because he insists that the performance of any activity is always an activity of performance "oriented toward communication" and that the "interaction constraints" imposed by any situation "play upon the individual and transform his activities into performances," so that instead of "merely doing his task . . . he will express the doing of his task" (*The Presentation of Self in Everyday Life* [Garden City: Doubleday Anchor, 1959], 65). Also of value is his correlative insistence that, since the constraints demand performers to be selective in what they conceal and reveal, all representations—whether by a charlatan, an earnest worker, or a saint—are equally misrepresentations (58–66 passim). But this styptic contraction of representation to misrepresentation effectively precludes its deployment as a more general concept.

Goffman has a specific target here: the naive view he finds "in our Anglo-American society [that] . . . the character one performs and one's self are somewhat equated, and [that] this self-as-character is . . . something housed within the body of its possessor, especially the upper parts thereof." To this naive view he opposes that of the ironic and subversive Goffmanesque observer, which, with characteristic understatement, he calls a "report" (though inasmuch as it sometimes has the effect of a salvo of moral gunshots, it may not be entirely an understatement). In this report, he concludes, "the performed self was seen as some kind of image . . . which the individual . . . attempts to induce others to hold in regard to him. . . . While . . . a self is imputed to him, this self does not derive from its possessor, but from the whole scene of his action," and thus the performer "and his body merely provide the peg on which something of collaborative manufacture will be hung for a time. And the means for producing and maintaining selves do not reside inside the peg; in fact these means are often bolted down in social establishments" (252–53).

The problem with this analysis for my purposes is that in the basic distinction between public and private—or "front-region" and "back-region"—

performances, both are treated primarily as performances before others. Performance before oneself is a marginal topic in Goffman's project, and even as he exploits the notion that selves are performances, characters, and social productions, his terminology doesn't allow for the methodological distinction between presentation and representation that notion seems to require. As we move from "she presents herself" to "she presents her self" to "she presents her self as/in this or that character," the demand for the distinction increases: what she presents, performs, or displays is neither an unmediated self (a *presence*) nor merely another presentation, performance, or display; she presents a representation of the self the situation calls for and helps induce.

38. Bryson, "Rhetoric of Status," 153.

39. Georges Vigarello, "The Upward Training of the Body from the Age of Chivalry to Courtly Civility," trans. Ughetta Lubin, in Michael Feher with Ramona Naddoff and Nadia Tazi, eds., *Fragments for a History of the Human Body,* Part Two (New York: Zone Books 1989), 149. This selection is excerpted from *Le corps redressé: Histoire d'un pouvoir pédagogique* (Paris: Editions Delarge, 1978).

40. Roland Barthes, *Camera Lucida: Reflections on Photography*, trans. Richard Howard (New York: Hill & Wang, 1981), 15.

Chapter 7: Lacan on the Narcissism of Orthopsychic Desire

1. Jonathan Sawday, *The Body Emblazoned: Dissection and the Human Body in Renaissance Culture* (New York: Routledge, 1995), 145.

2. Slavoj Žižek, *The Sublime Object of Ideology* (London: Verso Books, 1989), 175.

3. François Roustang, "A Philosophy for Psychoanalysis?," trans. Terry Thomas, *Stanford Literature Review* 6 (1989): 175.

4. Parveen Adams, Introduction to "Rendering the Real: A Special Issue," *October* 58 (Fall 1991): 3.

5. Mladen Dolar, "'I Shall Be with You on Your Wedding-Night': Lacan and the Uncanny," "Rendering the Real: A Special Issue," *October* 58 (Fall 1991): 5–23.

6. Joan Copjec, "Vampires, Breast-Feeding, and Anxiety," "Rendering the Real: A Special Issue," *October* 58 (Fall 1991): 28. This provides a better explanation than Slavoj Žižek does for the question he puts to the last proposition of Wittgenstein's *Tractatus*, "Whereof one cannot speak, thereof one must be silent": "If it is already stated that it is *impossible* to say anything about the unspeakable, why add that we *must not* speak about it?" (*Sublime Object*, 164). Žižek's solution is "that the impossibility relates to the level of existence (it is impossible; that is, it doesn't exist), while the prohibition relates to the properties it predicates (jouissance is forbidden because of its proper-

ties)" (164). This solution destroys the very aporia which, according to Copjec and Lacan, sustains the subject in the symbolic order.

7. Jacques Lacan, "Desire and the Interpretation of Desire in *Hamlet*," trans. James Hulbert, in Shoshana Felman, ed., *Literature and Psychoanalysis, The Question of Reading: Otherwise* (Baltimore: The Johns Hopkins University Press, 1982), 15, 28.

8. A language Lacan explores with an occasionally hilarious and suspect assemblage of algorithms and diagrammatic loop-the-loops; these contribute to the parody of the rhetorical stance of the one-supposed-to-know that is his presentational hallmark.

9. Barbara Freedman, *Staging the Gaze: Postmodernism, Psychoanalysis, and Shakespearean Comedy* (Ithaca: Cornell Unversity Press, 1991), 53.

10. Ibid., 53. Freedman herself seems explicitly to identify narcissistic desire only with the desire to assimilate the ego-ideal (53–54), whereas the burden of her argument implies that narcissistic desire should be for what has been sacrificed to the representation of the ego-ideal, e.g., her statement that for Lacan the repressed is "the loss or negation that speaks our translation into symbolic form. The repressed is the price we pay for . . . our inscription in symbolic form" (54).

11. Joan Copjec, "The Orthopsychic Subject: Film Theory and the Reception of Lacan," in *Read My Desire: Lacan Against the Historicists* (Cambridge: MIT Press, 1994), 27. Originally published in *October* 49 (Summer 1989): 53–71.

12. Ibid., 27. See Gaston Bachelard, *Le Rationalisme appliqué* (Paris: Presses Universitaires de France, 1970; orig. pub. 1949), 66–81.

13. Jacques Lacan, *The Four Fundamental Concepts of Psycho-Analysis*, trans. Alan Sheridan (New York: Norton, 1981), 75.

14. Jacques Lacan, *The Seminar of Jacques Lacan, Book I: Freud's Papers on Technique, 1953–54*, ed. Jacques-Alain Miller, trans. John Forrester (New York: Norton, 1991), 220.

15. Lacan, *Four Fundamental Concepts*, 74. The kernel phrase in the original text is "la préexistence au vu d'un donné-à-voir."

16. Elizabeth Grosz, *Jacques Lacan: A Feminist Introduction* (London: Routledge, 1990), 77.

17. For a different account of the "given-to-be-seen," see Kaja Silverman, *The Threshold of the Visible World* (New York: Routledge, 1996) 174–85. I use the phrase to designate the reflexive practice of self-representation—giving *oneself* to be seen—whereas Silverman uses it objectively to designate "what we see when we apprehend the world not only through a particular image-repertoire, but from the position which is assigned to us in advance" (182). In Mieke Bal's words, Silverman uses "the gaze" to designate "the internalized social construction of vision, what others call visuality," whereas I use it to designate the internalized social construction of self-representation (Mieke Bal,

Reading "Rembrandt": Beyond the Word-Image Opposition [Cambridge: Cambridge University Press, 1991], 143).

I also want to dissociate the Lacanian concept of the gaze from the one proposed by Bryson in *Vision and Painting*. When, in the same discussion, Bal appropriates and clarifies Norman Bryson's distinction between "the gaze" and "the glance" she notes that they designate "two modes of looking" (142). This scopic sense of "the gaze" is related to the filmic concept of the gaze as the construction of a specifically male mode of looking. I follow Copjec in insisting that the Lacanian gaze not be reduced to or confused with the scopic gaze.

18. Grosz, *Jacques Lacan*, 79.

19. Jacqueline Rose, *Sexuality in the Field of Vision* (London: Verso Books, 1986), 183.

20. In Alberti's imaginary diagram—no images accompany his text— the triangle is visualized as horizontal, that is, with its vertex on one side of the page and its vertical base on the other.

21. For Lacan's deconstructive revision of the Albertian diagram as an exemplar of the science of optics and its limitations, see Copjec, *Read My Desire*, 33–34. Readers are alerted to the critique of diagrammatics by the obvious insufficiency and inefficiency of the figures Lacan—with mischievous pleasure—labors to convert to symbols of much more complex meanings than they can bear. As I observed in the preceding note, there are no diagrams in Alberti's *Della pittura*, only text, and Alberti's text introduces interesting complications through the rhetoric in which diagrams are described. On this, see my "L. B. Alberti on Painting: Art and Actuality in Humanist Perspective," in Berger, *Second World and Green World: Studies in Renaissance Fiction-Making*, ed. and intro. John Patrick Lynch (Berkeley: University of California Press, 1988), 373–408.

22. Lacan, *Four Fundamental Concepts*, 91, 106.

23. Silverman, *Threshold*, 133. "Diagram 2 . . . locates the subject within visibility" and "separates the gaze from the human eye" (ibid).

24. Copjec, *Read My Desire*, 34.

25. Ibid., 34–35.

26. This and the next paragraph are in part occasioned by Kaja Silverman's determined effort in *The Threshold of the Visible World* to distinguish the transhistorical character of the gaze (as a function constitutive of subjectivity) from historically specific variations of it in different cultural regimes. Silverman's discussion, which extends over three chapters (125–227), is a revised and amplified account of an interpretation that appeared in *Male Subjectivity at the Margins* (New York: Routledge, 1992), 125–56, which in turn is a revision of an essay of the same title, "Fassbinder and Lacan: A Reconsideration of Gaze, Look and Image," which first appeared in *Camera Obscura* 19 (1989): 54–85. These revisions are the work of someone obsessed by a desire not simply to use the Lacanian diagrammatic but to make sense of it on its own terms. Though, as I'm about to note, I am indebted to Silverman's effort to make sense of

the "image/screen," I don't think her detailed exposition of the diagrams is necessary to the relatively simple correction of theory she wishes to make.

27. Lacan, *Four Fundamental Concepts*, 105.

28. Silverman, *Threshold*, 132.

29. Jacques Lacan, *Écrits: A Selection*, trans. Alan Sheridan (New York: Norton, 1977), 2, 4.

30. Lacan, *Four Fundamental Concepts*, 144.

31. Ibid., 88–89. The phrase in quotation marks is from the *October* version of Copjec's essay (70).

32. For a concise analysis of Freud's formulation and Lacan's revision of the distinction between the ideal ego and the ego ideal, see Rose, *Sexuality in the Field of Vision*, 174–83.

33. Copjec, *Read My Desire*, 27.

34. Lacan, *Four Fundamental Concepts*, 88–89.

35. Ellie Ragland-Sullivan, *Jacques Lacan and the Philosophy of Psychoanalysis* (Urbana: University of Illinois Press, 1987), 29.

36. Lacan, *Écrits*, 2.

37. Lewis Mumford, *Technics and Civilization* (New York: Harcourt, Brace, and World, 1963; orig. pub. 1934), 111, 129.

38. Lacan, *Écrits*, 1.

39. Ibid., 1–2. "Tout embrassé qu'il est par quelque soutien humain ou artificiel (ce que nous appelons en France un trotte-bébé"—and the next phrase contributes to the tacit allegory of escape from constraints that involve more than his own turbulence: "surmonte en un affairement jubilatoire les entraves de cet appui, pour suspendre son attitude en une position plus ou moins penchée, et ramener, pour le fixer, un aspect instantané de l'image": *Écrits* 1 (Paris: Seuil, 1966), 90; "he [nevertheless] overcomes, in a flutter of jubilant activity, the obstructions of his support and, fixing his attitude in a slightly leaning-forward position, in order to hold it in his gaze, brings back an instantaneous aspect of the image" (*Écrits*, 1–2).

40. Jane Gallop, *Reading Lacan* (Ithaca: Cornell University Press, 1985), 86, 84. The parenthetical modifiers are intended to link this commentary to Rose's, mentioned above.

41. Lacan, *Écrits*, 2–3.

42. Elizabeth Eisenstein, *The Printing Press as an Agent of Change* (Cambridge: Cambridge University Press, 1979), 1: 429–30.

43. Lacan, *Four Fundamental Concepts*, 85.

Chapter 8: *Fictions of the Pose (1): The Fiction of Objectivity*

1. Richard Brilliant, *Portraiture* (Cambridge: Harvard University Press, 1991), 129–30.

2. Compare Joel Fineman's speculative thesis that Lacanian and other

modern and postmodern theories of the self derive from "powerful . . . models of subjectivity . . . invented in the Renaissance" (*Shakespeare's Perjured Eye: The Invention of Poetic Subjectivity in the Sonnets* [Berkeley: University of California Press, 1986], 46–47.

3. Lorne Campbell, *Renaissance Portraits: European Painting in the 14th, 15th, and 16th Centuries* (New Haven: Yale University Press, 1990), 178. For other examples and discussions of normal practice, some of them amusing, see 95, 139, 159–91.

4. John Pope-Hennessey, *The Portrait in the Renaissance* (New York: Pantheon Books, 1966), 109.

5. Kaja Silverman, *The Threshold of the Visible World* (New York: Routledge, 1996), 148.

6. Walter S. Melion, *Shaping the Netherlandish Canon: Karel van Mander's Schilder-Boeck* (Chicago: University of Chicago Press, 1991), 63, 65.

7. Depending on how one views it, this understanding can be problematized or reinforced by a category for which Dutch painters—especially those connected with Rembrandt's circle—had a predilection: the *tronie*, the study of an anonymous sitter, which functions either as a practice piece or as what Perry Chapman calls an "expressive character type" and classifies as a "category of non-portrait" (H. Perry Chapman, *Rembrandt's Self-Portraits: A Study in Seventeenth-Century Identity* [Princeton: Princeton University Press, 1990), 23, 38). *Tronies* may be exemplary studies—idealizations or caricatures—for the portrayal of different occupations, statuses, gender positions, or ages of life.

8. Cindy Sherman's several series of self-portraits play games with photographic fictions of the pose and have evoked from many commentators interpretations along the line I am pursuing here. For devotees of Sherman, my argument in this chapter may seem (*mutatis mutandis*) to traverse old ground.

9. Martin Kemp, *Leonardo da Vinci: The Marvelous Works of Nature and Man* (London: J. H. Dent, 1981).

10. Consider, as an amusingly strenuous example of reaching, the worldly-wise misogyny with which Cecil Gould disposes of Cecilia Gallerani: "She is of a kind which is familiar in the twentieth century—the highly intelligent, highly sophisticated, attractive, slightly neurotic young woman who holds a responsible job with men as her subordinates. Everyone knows she is the mistress of a prominent statesman or perhaps of an ambassador. She is often to be seen at high-level parties, a glass of champagne in one hand, a cigarette in the other and three or four men round her" (*Leonardo, the Artist and the Non-Artist* [Boston: New York Graphic Society, 1975], 72–73). The author of this statement obviously watched too many BBC specials.

11. Marianna Jenkins, *The State Portrait: Its Origin and Evolution* (New York: College Art Association, 1947), 7.

12. Kemp, *Leonardo*, 266. I speak of Leonardo's innovation in the context of early modern portraiture. Such effects had of course been produced before.

See, for example, Sheldon Nodelman's brilliant account of the Roman veristic portrait, "How to Read a Roman Portrait," *Art in America*, January/February 1975, 27–33, esp. 30–31.

13. Gould, *Leonardo*, 113; Kemp, *Leonardo*, 266–67.

14. Pope-Hennessey, *The Portrait in the Renaissance*, 108–9.

15. Gould, *Leonardo*, 113. Has there ever been—could there be—a male equivalent of the *Mona Lisa*? Wouldn't that be a project for Cindy Sherman? For a critique of homophobic and misogynist responses to Renaissance portraiture, see Patricia Simons, "Homosociality and Erotics in Italian Renaissance Portraiture," in Joanna Woodall, ed., *Portraiture: Facing the Subject* (Manchester: Manchester University Press, 1997), 29–51.

16. This effect would only be enhanced if, as has been proposed, the portrait had been cropped and the sitter was originally framed by the columns of a loggia, with the rest of the urban and domestic scene of posing conspicuously excluded. I am grateful to my colleague Donna Hunter for this suggestion.

17. Michael Fried, *Absorption and Theatricality: Painting and Beholder in the Age of Diderot* (Berkeley: University of California Press, 1980), 10.

18. Personal communication. In this and the next paragraph, the phrases in quotation marks are excerpted from De Grazia's brilliant critique of an earlier draft of this study.

19. Examples of the fiction of candor: Vermeer's letter writers, sleeper, and lace maker. Examples of the fiction of distraction: most of Rembrandt's studies of old men and women.

20. See my essays on Vermeer in Berger, *Second World and Green World: Studies in Renaissance Fiction-Making*, ed. and intro. John Patrick Lynch (Berkeley: University of California Press, 1988), 441–509.

21. Michael Fried, *Courbet's Realism* (Chicago: University of Chicago Press, 1990), 7.

22. Ibid., 7.

23. For a formally similar ocular fiction with a very different range of meanings, see H. P. L'Orange, *Apotheosis in Ancient Portraiture* (New Rochelle, N.Y.: Caratzas Brothers, 1982), especially 95–129, which deals with the savior-portrait in late antiquity.

24. Fried, *Absorption and Theatricality*, 104.

25. Walter Benjamin, "On Some Motifs in Baudelaire," in *Illuminations*, ed. Hannah Arendt, trans. Harry Zohn (New York: Schocken Books, 1969), 188.

26. Johannes Wilde, *Venetian Art from Bellini to Titian* (London: Oxford University Press, 1974), 212, 224–28.

27. The Italian phrase is "goffe come li natural": Giorgio Vasari, *Le vite de' più eccellenti pittori scultori ed architettori*, 9 vols., ed. Gaetano Milanesi (Florence: Sansoni, 1906, 1981; orig. pub. 1878–85), 4.9.

28. David Summers, *The Judgment of Sense: Renaissance Naturalism and the*

Rise of Aesthetics (Cambridge: Cambridge University Press, 1987), 3, 8. My exclusive emphasis on idealization as the source of effects of exemplarity may have left the misleading impression that no such effects are produced by unidealized verisimilitude. On the contrary, by their refusal to idealize, many fifteenth-century Florentine portraits make a sociopolitical counterstatement similar to that attributed by Sheldon Nodelman to the Roman veristic portrait in the first century A.D. The principal effect of mimetic "naturalism" may have been individualization, as has often been suggested. But in such portraits as those of Pietro Mellini, Neri Capponi, Cosimo de' Medici, and Filippo Strozzi, to mention only a few, veristic individualization may well signify the refusal of idealization. These merchants or oligarchs represent themselves as *cittadini* rather than *principi* or *nobili*, and they often minimize or eschew the markers of the patriciate.

29. Rab Hatfield, "Five Early Renaissance Portraits," *Art Bulletin* 47 (1965): 318, 324–27. See also Pope-Hennessey, *Portrait*, 35–48, for a similar but less probing account of male and female profiles.

30. David Rosand, "The Portrait, the Courtier, and Death," in David Rosand and Robert W. Hanning, eds., *Castiglione: The Ideal and the Real in Renaissance Culture* (New Haven: Yale University Press, 1983), 97–102.

31. Hatfield, "Five Renaissance Portraits," 328.

32. Rosand, "The Portrait, the Courtier, and Death," 101–4.

33. For details, see Hatfield, "Five Renaissance Portraits," 321–22.

34. These hints of individuated responses to a common stereotype are produced by comparative analysis that is admittedly an arbitrary and anachronistic move made possible by print and museum culture. It is no more anachronistic than archival reconstructions and physiognomic ekphrasis, only a different kind of anachronism. From a genealogical standpoint, interpretive conflicts over past data are unavoidably contributions to a discourse of competitive anachronism.

35. Patricia Simons, "Women in Frames: The Gaze, the Eye, the Profile in Renaissance Portraiture," *History Workshop* 25 (1988): 12, 15, 16. See also two essays by Elizabeth Cropper: "On Beautiful Women, Parmigianino, *Petrarchismo*, and the Vernacular Style," *Art Bulletin* 58 (1976): 374–94; and "The Beauty of Women: Problems in the Rhetoric of Renaissance Portraiture," in Margaret Ferguson, Maureen Quilligan, and Nancy J. Vickers, eds., *Rewriting the Renaissance: The Discourses of Sexual Difference in Early Modern Europe* (Chicago: University of Chicago Press, 1986), 175–90. I am grateful to Stephen Campbell for directing me to Simons's essay and to the first Cropper essay.

36. Simons, "Women in Frames," 17, 18.

37. I'm grateful to Sarah Whittier for pointing this out.

38. In the anonymous Melbourne profile the sitter's look is animated by tucking and backlighting the chin. In Lippi's double portrait, the situation of encounter changes the meaning of the woman's attitude from simple to

anecdotal posing, which inscribes in her features a faint smile of recognition or acknowledgment. In the Botticelli profile, a semi-detached hank of hair produces a slight disorder in the coif, which accentuates an awkwardness of demeanor that isn't neutralized by the conventional distortions of stylized representation. Simons's speculative identification of the portrait and the documentation on which she bases it ("Women in Frames," 18–20) indicate that the awkwardness represents a postural flaw noted by the sitter's contemporaries.

39. Sharon Fermor, "Movement and Gender in Sixteenth-Century Italian Painting," in Kathleen Adler and Marcia Pointon, eds., *The Body Imaged: The Human Form and Visual Culture since the Renaissance* (Cambridge: Cambridge University Press, 1993), 143, 145.

40. Baldassare Castiglione, *Il libro del cortegiano*, ed. Guilio Carnazzi (Milan: Biblioteca Universale Rizzoli, 1987), and *The Book of the Courtier*, trans. Charles Singleton (New York: Anchor Books, 1959): 1.40; Rizzoli, 98–99; Singleton, 65.

41. Ibid.: Rizzoli, 98; Singleton, 65–66, trans. slightly altered.

42. Ibid.: Rizzoli, 99; Singleton, 66, trans. slightly altered.

43. Teresa de Lauretis, *Technologies of Gender* (Bloomington: Indiana University Press, 1987), 26.

44. This topic has been exhaustively studied by Christiane Klapisch-Zuber (one of Simons's chief sources) and many others. See Klapisch-Zuber's *Women, Family, and Ritual in Renaissance Italy*, trans. Lydia G. Cochrane (Chicago: University of Chicago Press, 1985), especially 231–36 on the induction of new wives into the lineage. See also: Diane Owen Hughes, "From Brideprice to Dowry in Mediterranean Europe," *Journal of Family History* 3 (1978): 262–96; and Julius Kirshner and Anthony Molho, "The Dowry Fund and the Marriage Market in Early *Quattrocento* Florence," *Journal of Modern History* 50 (1978): 403–38. For a more recent revisionary study, see Anthony Molho, Roberto Barducci, Gabriella Battista, and Francesco Donnini, "Genealogy and Marriage Alliance: Memories of Power in Late Medieval Florence," in Samuel K. Cohn, Jr., and Steven A. Epstein, eds., *Portraits of Medieval and Renaissance Living: Essays in Honor of David Herlihy* (Ann Arbor: University of Michigan Press, 1996), 39–89.

Chapter 9: Fictions of the Pose (2): Representing Orthopsychic Desire

1. Ronald Lightbown, *Mantegna* (Berkeley: University of California Press, 1986), 82.

2. Lorne Campbell, *Renaissance Portraits: European Painting in the 14th, 15th, and 16th Centuries* (New Haven: Yale University Press, 1990), 232.

3. John Pope-Hennessey, *The Portrait in the Renaissance* (New York: Pantheon Books, 1966), 85–86.

4. Ibid., 181–83.

5. Campbell, *Renaissance Portraits*, 27, 25.

6. Charles McCorquodale, *Bronzino* (London, 1981), 93.

7. Sydney J. Freedberg, *Painting in Italy, 1500 to 1600*, rev. ed. (Harmondsworth, Middlesex: Penguin Books, 1975), 455–57.

8. Jacques Lacan, *The Four Fundamental Concepts of Psycho-Analysis*, trans. Alan Sheridan (New York: Norton, 1981), 101.

9. Bronzino's painting of the Pygmalion story is entitled *Pygmalion and Galatea*, but the early sources for the latter name are obscure. The name traditionally assigned to the nymph pursued by Polyphemus, "Galatea" was applied to Pygmalion's beloved by Rousseau and his contemporaries.

10. McCorquodale, *Bronzino*, 140.

11. Bronzino's "is a world of flawless beings whose perfect physical and apparent emotional balance places them beyond exigencies of time and place and blurs the division between nature and art; the sitters in his portraits themselves attain to the status of works of art, wholly interchangeable with the *dramatis personae* of his religious, mythological and allegorical pictures" (ibid., 9). In Bronzino's painting of Pygmalion and Galatea, the statue has clearly crossed the boundary in the other direction; yet, as Beth Pittenger has pointed out to me, this traditional move is complicated by the fact that her *contrapposto* and especially the positions of her hands compose into a strong allusion to Michelangelo's *David*, thereby producing an ironic commentary on the autoerotic, homoerotic, and misogynist character of Pygmalion's art.

12. Sydney J. Freedberg, *Parmigianino* (Cambridge: Harvard University Press, 1950), 28, 31–32.

13. Freedberg, *Painting in Italy*, 432.

14. John Shearman, *Mannerism* (Harmondsworth, Middlesex: Penguin Books), 15.

15. Joanna Woodall, "Introduction: Facing the Subject," in Woodall, ed., *Portraiture: Facing the Subject* (Manchester: Manchester University Press, 1997), 3. See also Woodall, "Sovereign Bodies: The Reality of Status in Seventeenth-Century Dutch Portraiture," ibid., 75–115, especially 79–82.

16. Kaja Silverman, *The Threshold of the Visible World* (New York: Routledge, 1996), 200, 202.

17. Sheldon Nodelman, "How to Read a Roman Portrait," *Art in America* 63 (1975): 27.

18. Campbell, *Renaissance Portraits*, 107. For a modern instance, see Richard Brilliant's amusing comments on Manny Warman's photograph of Dwight Eisenhower eyeing his portrait bust, Richard Brilliant, *Portraiture* (Cambridge: Harvard University Press, 1991), 161–63.

19. Judith Butler, *Gender Trouble: Feminism and the Subversion of Identity* (New York: Routledge, 1990), 136.

20. Lacan, *Four Fundamental Concepts*, 73–74, 98–100, 109–11. See Silverman's useful general discussion of this phenomenon in *The Threshold of the Visible World*, 196–207.

21. Campbell, *Renaissance Portraits*, 202.

22. Norman Bryson, *Vision and Painting: The Logic of the Gaze* (New Haven: Yale University Press, 1983), 56, 124–26.

23. Freedberg, *Parmigianino*, 32; Norbert Huse and Wolfgang Wolters, *The Art of Renaissance Venice: Architecture, Sculpture, and Painting, 1460–1590*, trans. Edmund Jephcott (Chicago: University of Chicago Press, 1990), 241.

24. Huse and Wolters, *Art of Renaissance Venice*, 241.

25. Patricia Fortini Brown, *Venetian Narrative Painting in the Age of Carpaccio* (New Haven: Yale University Press, 1988), 227–28.

26. Huse and Wolters, *Art of Renaissance Venice*, 241.

27. Jean-Paul Sartre, "Official Portraits," trans. Anne P. Jones, in Maurice Natanson, ed., *Essays in Phenomenology* (The Hague: Martinus Nijhoff, 1966), 157–58.

28. George Hersey, *The Lost Meaning of Classical Architecture: Speculations on Ornament from Vitruvius to Venturi* (Cambridge: MIT Press, 1988), 152.

29. Sartre, "Official Portraits," 157.

30. Huse and Wolters, *Art of Renaissance Venice*, 251; David Rosand, *Titian* (New York: Abrams, 1978), 126.

31. See, for example, Richard Wollheim, *Painting as an Art* (Princeton: Princeton University Press, 1987), 312; and Michael Brenson's review of the 1990–91 exhibit "Titian, Prince of Painters" at the National Gallery (Washington), *New York Times*, October 29, 1990, sec. B, p. 4.

32. Harold Wethey, *The Paintings of Titian*, Vol. 2, *The Portraits* (London: Phaidon, 1971), 23. In the full-length preparatory drawing made in 1536, the duke looks older.

33. Antonio Natale, catalogue entry in *Titian, Prince of Painters* (Munich: Prestel, 1990), 228.

34. Antonio Paolucci, "The Portraits of Titian," in *Titian, Prince of Painters*, 101; Charles Hope, *Titian* (New York: Harper & Row, 1980), 80.

35. Robert Hughes, review of the exhibit "Titian, Prince of Painters" in *Time*, September 17, 1990, 87.

36. Peter Humfrey, *Lorenzo Lotto* (New Haven: Yale University Press, 1997), 9–10.

37. Rodolfo Palucchini and Giordana Mariani Canova, *L'opera completa del Lotto* (Milan: Rizzoli, 1974), 90.

38. Huse and Wolters, *Art of Renaissance Venice*, 241. For a similar interpretation, see Norbert Schneider, *The Art of the Portrait: Masterpieces of European Portrait-Painting, 1420–1670*, trans. Iain Galbraith (Cologne: Benedikt Taschen, 1994), 67.

39. David Rosand, "The Portrait, the Courtier, and Death," in Robert W. Hanning and David Rosand, eds., *Castiglione: The Ideal and the Real in Renaissance Culture* (New Haven: Yale University Press, 1983), 121.

40. Palucchini and Canova, *Lotto*, 90. For similar interpretations, see Humfrey, *Lotto*, 20–21.

41. Huse and Wolters, *Art of Renaissance Venice*, 241.

42. Pope-Hennessey, *Portrait in the Renaissance*, 228.

43. Huse and Wolters, *Art of Renaissance Venice*, 245–47.

44. So, for example, Freedberg remarks that the sitter's "movement, gesture, and quality of gaze compel an immediate and penetrating communication with the spectator" that "tends to strain a classical conception of behavior" (*Painting in Italy*, 314).

45. In a vein at once Vasarian and stethoscopic, Bernard Berenson proclaims it "characteristic of Lotto to make one feel . . . that we know the precise measure of the sitter's pulse and just how he draws his breath" (*Lorenzo Lotto* [London: Phaidon, 1956], 100). I find Berenson's general emphasis on the way Lotto concentrates his psychological effects within the boundaries of the scopic encounter more valuable than the diagnostic probes into the health of sitters instantiated by this comment.

46. Schneider, *Art of the Portrait*, 69

47. Robert Latham and William Matthews, eds., *The Diary of Samuel Pepys*, Vol. 7, 1666 (Berkeley: University of California Press, 1976), 74–75.

48. For a brief survey of the paw's iconographic possibilities, see Humfrey, *Lotto*, 104–6.

49. Palucchini and Canova, *Lotto*, 110.

50. Following another of Berenson's diagnostic insights: the sitter presses "his side as if in pain" (*Lotto*, 100). "His left hand appears to point explicitly to his spleen, traditionally regarded as the seat of his debilitating humor" (Humfrey, *Lotto*, 137).

51. Pope-Hennessey, *Portrait in the Renaissance*, 228. Berenson adds jasmine petals and is even more sanguine than Pope-Hennessey about the portrait's diagnostic power: "the representation of the sitter's physical condition makes us instantly aware of his mental state" (*Lotto*, 100).

52. Humfrey, *Lotto*, 2 and passim.

53. "[T]he rather awkward, demonstrative pose . . . combines with the intense, brooding melancholy of the face to convey a sense of deep empathy with the sitter's inner thoughts and feelings" (Humfrey, *Lotto*, 2).

54. For details, see John Shearman, *The Early Italian Pictures in the Collection of Her Majesty the Queen* (Cambridge: Cambridge University Press, 1983), 144–46.

55. For these and other speculations, see Humfrey, *Lotto*, 107.

56. Shearman, *Early Italian Pictures*, 147.

57. Huse and Wolters, *Art of Renaissance Venice*, 243.

58. Pope-Hennessey, *Portrait in the Renaissance*, 231. Pietro Zampetti finds pretty much the same elegiac thought indexed by Odoni's "completely sincere, and almost abandoned, if somewhat melancholy" expression: catalogue entry in Jane Martineau and Charles Hope, eds., *The Genius of Venice 1500–1600* (New York: Harry N. Abrams, 1984), 177. According to Johannes Wilde,

Odoni's "gesture expresses his fondness for these works and his devotion to his noble hobby" (*Venetian Art from Bellini to Titian* [London: Oxford University Press, 1974], 223).

59. "Despite the abundance of the visual evidence, the precise meaning of the picture remains elusive" (Humfrey, *Lotto*, 107).

60. Huse and Wolters, *Art of Renaissance Venice*, 243; Humfrey, *Lotto*, 107.

61. Shearman, *Early Italian Pictures*, 147.

62. Huse and Wolters, *Art of Renaissance Venice*, 243.

63. Shearman, *Early Italian Pictures*, 147.

64. Berenson, *Lotto*, 98.

65. David Summers, *The Judgment of Sense: Renaissance Naturalism and the Rise of Aesthetics* (Cambridge: Cambridge University Press, 1987), 110. See Chapters 1 and 3, above.

66. Personal communication.

67. Shearman, *Early Italian Pictures*, 146.

68. Huse and Wolters, *Art of Renaissance Venice*, 243.

69. See Joel Fineman, "The History of the Anecdote: Fiction and Fiction," in H. Aram Veeser, ed., *The New Historicism* (New York: Routledge, 1989), 49–76

70. See, for example, the interesting comments by Patricia Simons on Lotto's *Portrait of a Man in His Study*: "Homosociality and Erotics in Italian Renaissance Portraiture," in Woodall, ed., *Portraiture*, 34.

71. Roland Barthes, *Camera Lucida: Reflections on Photography*, trans. Richard Howard (New York: Hill & Wang, 1981), 13–14.

72. Joan Copjec, "The Orthopsychic Subject: Film Theory and the Reception of Lacan," in *Read My Desire: Lacan Against the Historicists* (Cambridge: MIT Press, 1994), 27.

73. Rab Hatfield, "Five Early Renaissance Portraits," *Art Bulletin* 47 (1965): 325.

Chapter 10: Local Matters

1. Michel Foucault, personal communication, cited in Hubert L. Dreyfus and Paul Rabinow, *Michel Foucault: Beyond Structuralism and Hermeneutics* (Chicago: The University of Chicago Press, 1982), 187.

2. Personal etymology. Derived from the Brazen Rule: take others before others take you.

3. Barbara Correll, *The End of Conduct: Grobianus and the Renaissance Text of the Subject* (Ithaca: Cornell University Press, 1996), 45–46.

4. Simon Schama, *The Embarrassment of Riches: An Interpretation of Dutch Culture in the Golden Age* (New York: Alfred A. Knopf, 1987), 370–71. See also pp. 334–38 and 343.

5. This coupling was the leitmotif of Pieter de la Court's mercantile and anti-dynastic defense of republicanism, *The True Interest of Holland* (1662, 1669), trans. John Campbell (New York: Arno Press, 1972; orig. pub. 1746). See, for example, pp.17–18 and 195–99. For the complicated details of the treatise's composition and publication see Herbert H. Rowen, *John de Witt, Grand Pensionary of Holland, 1625–1672* (Princeton: Princeton University Press, 1978), 391–98.

6. One northern province, Drenthe, was not represented in the States General, while the "Generality Lands" just south of the United Provinces, lands taken from Spain between 1629 and 1637, were treated as conquered territories under the jurisdiction of the States General. "Generality" designates the administrative authority and federal functions of the States General. For a brief survey of Generality institutions, see Jonathan Israel, *The Dutch Republic: Its Rise, Greatness, and Fall, 1477–1806* (Oxford: Clarendon Press, 1995), 291–97.

7. J. H. Huizinga objects to the tendency to discuss "the political structure of the United Provinces in terms of centralization or decentralization," in part because "there was no center to begin with." But centralized monarchies existed, and as Huizinga notes shortly after, Charles V had articulated and implemented a "new political doctrine of centralization" in the 1530s and 1540s. Thus it makes sense to speak of decentralization as a term of contrast that distinguishes the Republic's structure from those of its neighbors. See Huizinga, *Dutch Civilization in the Seventeenth Century and Other Essays*, selected by Pieter Geyl and F. W. N. Hugenholtz, trans. Arnold J. Pomerans (New York: Harper & Row, 1969), 26–27.

8. No doubt, the *OED*'s "Originally" cued the *AHD*'s "formerly" and "former," but where "Originally" merely casts an innocuous glance at a subsequent history, "former(ly)" is a more relational and retrospective term that leaves hanging the pedantic questions it all but asks: "What happened next?"; "Former(ly) in relation to what?" Does the *AHD* sense 1 point to the time before the Hapsburg property became a republic? Does sense 2 point to the time before the republic became a monarchy? Is this a carefully coded lesson in high school civics?

9. In a practice dating back to the thirteenth century, each Netherlands provinces had its representative assembly, called "States" (that is, representatives of the different estates), composed of delegates from town councils. In the early fifteenth century the dukes of Burgundy began convening delegates from the States in the States General, which was later taken over by the Hapsburgs. A pan-Netherlands institution, the States General was located for a long time in Brussels and Antwerp until, in 1583, it moved first to Middelburg, then to Delft, and finally to The Hague.

10. The *OED* makes all the words it defines proper by capitalizing their first letter, whereas its younger cousin, true to our American heritage, democratically embraces the common or lowercase.

11. Israel, *Dutch Republic*, 138–39, 302.

12. Mariët Westermann, *The Art of the Dutch Republic 1585–1718* (London: Weidenfeld and Nicolson, 1996), 21.

13. Schama, *Embarrassment of Riches*, 65.

14. Maurice didn't succeed to the Principate of Orange until he was fifty-one (1618), when his older brother died only seven years before Maurice's own death.

15. Israel, *Dutch Republic*, 306.

16. Gary Schwartz, *Rembrandt, His Life, His Paintings* (New York: Viking Press, 1985), 14.

17. Schama, *Embarrassment of Riches*, 62.

18. K. H. D. Haley, *The Dutch in the Seventeenth Century* (New York: Harcourt Brace Jovanovich, 1972), 76.

19. Ibid., 65.

20. I use Weberian terminology with a certain amount of latitude, though I note that for a long time scholars have recognized that his concept of charismatic authority was always more normative, less restricted to abnormal or personalistic phenomena, than it had seemed. See, for example, Edward A. Shils, "Charisma, Order and Status," *American Sociological Review* 30 (1965): 199–213, and S. N. Eisenstadt, Introduction to his edition of selected papers by Weber, *Max Weber: On Charisma and Institution Building* (Chicago: University of Chicago Press, 1968), ix–lvi. "Lineage-charisma" is the translation of Weber's *Gentilcharisma*, given by Talcott Parsons while noting the normative aspect of Weber's analysis in his Introduction to Max Weber, *The Sociology of Religion*, trans. Ephraim Fischoff (Boston: Beacon Press, 1964), xxxiv.

21. Schama, *Embarrassment of Riches*, 65, 66–67.

22. Israel, *Dutch Republic*, 259.

23. In a personal communication, Sarah Whittier pointed out that the sharp creases in the table covering behind Maurice make it appear to have been recently unfolded—presumably after being packed away in a storage chest.

24. Israel, *Dutch Republic*, 304.

25. Schama, *Embarrassment of Riches*, 253, 238.

26. For a detailed account of the significance and consequences of the Twelve Years' Truce, see Israel, *Dutch Republic*, chapters 18–20 (pp. 421–77). Since the Thirty Years' War goes unmentioned in the chapters that follow, perhaps I should glance briefly at it here. Depending on one's interpretation, its onset coincided either with the beginning of Maurice's aggression against the Remonstrants in 1617–18 or, according to S. H. Steinberg's revisionist argument, with the first year of the truce. Steinberg insists that the term "Thirty Years' War" had and has less significance for the Dutch "than for any other European country. Dutch historians and the Dutch people rightly speak of the 'Eighty Years' War'" (*The Thirty Years' War and the Conflict for European Hegemony, 1600–1660* [New York: W. W. Norton, 1966], 9). A more recent and

considered opinion that explores the significance for other countries of the Dutch input may be found in Israel, *Dutch Republic*, 465–74. Israel argues that the effect of the Calvinist revolution spearheaded by Maurice's campaign against the Remonstrants was no less important to "the making of the Thirty Years War" than it was to "the outbreak of the second part of the Eighty Years War" (465). He focuses on the influential role played by Maurice's political and military maneuvers, maneuvers motivated by his efforts, chiefly through secret diplomacy, to put pressure on Spain while advancing the Counter-Remonstrant cause within the Dutch Republic. On the meaning of "Counter-Remonstrant," see below.

27. See Israel, *Dutch Republic*, 393–95. The controversy first spread to ecclesiastical politics because students of Arminius and Gomarus competed for ministries in Calvinist parishes, hence the dispute was amplified by pulpit wars that threatened to divide the Reformed Church and that invariably, therefore, affected parishioners' broader political interests.

28. This brief overview digests information from several sources, but I have relied most heavily on the extended account in Israel, *Dutch Republic*, chapters 16–20 (pp. 366–477). On the Remonstrance in particular, see 425–26.

29. Haley, *The Dutch in the Seventeenth Century*, 106.

30. For details, see Israel, *Dutch Republic*, 485–505.

31. Ibid., 604.

32. Westermann, *Art of the Dutch Republic 1585–1718*, 23, my italics.

33. Schama, *Embarrassment of Riches*, 67.

34. My use of the term "mythologize" is motivated by the implications of Roland Barthes's "semiological definition of myth in a bourgeois society: myth is depoliticized speech," speech that "transforms history into nature" and thus realizes it in the sense of imparting the effect of the real (*Mythologies*, trans. Annette Lavers [New York: Hill and Wang, 1975], 143, 129). Barthes of course extends the definition from verbal to visual phenomena in his famous analysis of the *Paris Match* cover (116–31). This notion of realization impinges on the view that Dutch portraiture is the example par excellence of bourgeois realism. See further Chapter 11.

35. Herman Roodenburg, "The 'Hand of Friendship': Shaking Hands and Other Gestures in the Dutch Republic," in Jan Bremmer and Herman Roodenburg, eds., *A Cultural History of Gesture* (Ithaca: Cornell University Press, 1992), 152–89.

36. Marjolein C. 't Hart, *The Making of a Bourgeois State: War, Politics, and Finance During the Dutch Revolt* (Manchester: Manchester University Press, 1993), 6, 18. Hart's densely researched history of what might be called sub-cultural negotiations is a useful supplement or even complement to Schama's narrative, but in her brief references to his approach she ignores both his acknowledgments of the limits of cultural history (see pp. 8–11) and his

pointed if brief references to the causes and perils of decentralization (see the many references in the second part of his first chapter, especially pp. 34–50, and within that, pp. 39–40, which connect decentralization to the problems of water management created by the need to keep the collective maritime head of Holland above water). In general, she seems not to have appreciated the extent to which his often circumlocutory reliance on metaphorics, analogy, narrative amplification, and epigrammatic abbreviation inscribes the effects of the political anomalies she discusses in his cultural history.

37. Recoded in gender terms, this risk was often transported from distant and public places to the leaky vessels in the merchant's household.

38. Jonathan Israel, *Dutch Primacy in World Trade, 1585–1740* (Oxford: Clarendon Press, 1991; orig. pub. 1989), 16.

39. Hart, *Making of a Bourgeois State*, 5–6. Israel, whose study preceded Hart's, dismissed "the erroneous notion that the Dutch were saddled with an exceptionally weak and inefficient state which did not intervene to any great extent in economic activity" (411). This is not, of course, Hart's notion, and in his later and more comprehensive study, Israel's characterization of the Dutch state is closer to Hart's: *Dutch Republic*, 246–47, 276–77, 450.

40. Hart, *Making of a Bourgeois State*, 121.

41. Hart cites the complaint of Admiral van Dorp that "he had so many masters—the Prince, the Estates General, the Estates of Holland, his admiralty board—that he did not know who or how to serve" (*Making of a Bourgeois State*, 62).

42. The most obvious and famous example of this was Prince Maurice's taking his war against Remonstrants into city politics.

43. Hart, *Making of a Bourgeois State*, 208.

44. Schwartz, *Rembrandt*, 14. Schwartz's study is full of sharply focused cameos of the divisive impact of republican politics on local affairs. For an especially good example, see pp. 202–3.

45. On Goffman see Chapter 6, note 38, above.

46. Simon Schama, "Wives and Wantons: Versions of Womanhood in 17th Century Dutch Art," *The Oxford Art Journal* 3.1 (April 1980): 12–13.

47. Schama, *Embarrassment of Riches*, 10–11.

48. "Housewives and Hussies," ibid., 375–480.

49. Norman Bryson, *Looking at the Overlooked: Four Essays on Still Life Painting* (Cambridge: Harvard University Press, 1990), 96–135.

50. "At the center of the Dutch world was a burgher, not a bourgeois. There is a difference, and it is more than a nuance of translation. For the burgher was a citizen first and homo oeconomicus second. And the obligations of civism conditioned the opportunities of prosperity" (Schama, *Embarrassment of Riches*, 7). This comment is part of Schama's critique of Wallerstein, and suggests another reason why Hart should not have lumped them so easily together in her own introductory critique.

51. Lena Cowen Orlin, *Private Matters and Public Culture in Post-Reformation England* (Ithaca: Cornell University Press, 1994), 3.

52. Schama, *Embarrassment of Riches*, 400.

53. Orlin, *Private Matters and Public Culture*, 141.

54. Richard Helgerson, "Soldiers and Enigmatic Girls: The Politics of Dutch Domestic Realism, 1650–1672," *Representations* 58 (Spring 1997): 52–53. The painting is dated 1662–63 and Helgerson persuasively demonstrates the significance of the appearance of many such ambivalent paintings during the 1650s and 1660s, the period of the "True Freedom."

55. H. K. F. van Nierop, *The Nobility of Holland: From Knights to Regents, 1500–1650*, rev. ed. (1990), trans. Maarten Ultee (Cambridge: Cambridge University Press, 1993), 225–26.

56. Charles Wilson, *The Dutch Republic* (New York: McGraw-Hill, 1968), 57.

57. Jacques Lacan, *The Four Fundamental Concepts of Psycho-Analysis*, trans. Alan Sheridan (New York: Norton, 1981), 84.

58. Ibid., 96, 75.

59. Ibid., 73. In the Lacanian archeology of the subject, the gaze as the scopic and visual dimension of ideology is a slant, reductive condensation of the discourse networks it represents: in Lacan's terms, an Imaginary reduction of the Symbolic, which is structurally similar to an iconic reduction of the symbolic in the Peircean scheme I have been deploying in this study. As I suggest in Chapter 7, Lacan makes clear that the scenic, pictorial, and diagrammatic analogies he employs are conspicuously inadequate to the discursive processes of subjectification they denote. That inadequacy stages and imitates the ontological inadequacy or reductiveness of scopic form, in which the temporal, discursive, ambiguous, and dialectical operations of the Symbolic are compressed, frozen, anchored in the episodic medium of spatial representation Lacan calls the Imaginary. The explanatory diagrams borrowed from the "geometral" demonstrations of perspective theory are cordoned off in scare quotes that mark them as anamorphic figures of a referent they gesture toward ("desire") but fall short of, for example: "what was elided in the geometral relation—the depth of the field, with all its ambiguity and variability, which is in no way mastered by me. It is rather it that grasps me, solicits me at every moment. . . . I am not simply that punctiform being located at the geometral point from which the perspective is grasped" (ibid. 96).

60. Ibid., 99.

61. Ibid., translation altered from Sheridan's "[m]imicry reveals something" so as more closely to approximate the key Lacanian idiom in "Le mimétisme *donne à voir* quelque chose": *Les quatre concepts fondamentaux de la psychanalyse*, vol. 11 of *Le séminaire de Jacques Lacan*, ed. Jacques-Alain Miller (Paris: Editions du Seuil, 1973), 114.

62. Lacan, *Four Fundamental Concepts*, 107, my italics. The italicized phrase replaces Sheridan's "it shows to the other." Although my substitution is more awkward, once again it better conforms to the key idiom repetitively featured in the original: "qu'il offre à voir" (*Quatre concepts*, 122). In this instance, *offrir* replacing *donner* makes the performance seem more flamboyant and sacrificial.

63. Lacan, *Four Fundamental Concepts*, 101. Again varied from Sheridan, whose "offers his picture to be seen" misses the sense of the original, "donne à voir son tableau" (*Quatre concepts*, 116): he gives his picture to be seen as if it were himself.

64. Lacan, *Four Fundamental Concepts*, 112–13.

65. For *points de capiton*, upholstery studs or buttons, see Jacques Lacan, *Écrits: A Selection*, trans. Alan Sheridan (New York: Norton, 1977), 154, 303. My use of this term is cruder and simpler than that of Slavoj Žižek in his elegant discussion in *The Sublime Object of Ideology* (London: Verso Books, 1989), 87–111. On the agency or insistence of the signifier, see Lacan, "The Agency of the Letter in the Unconscious or Reason since Freud," in *Écrits*, 146–78.

66. Lacan, *The Four Fundamental Concepts of Psycho-Analysis*, 95–96.

67. On this, see Roodenburg, "'Hand of Friendship,'" 156–57.

68. Schama, *Embarrassment of Riches*, 319. I express a reservation because Schama asserts this as a fact but cites no supporting statistical evidence, while in Alan Chong's statistical studies of average prices of seven different genres during the seventeenth century, portraits ranked consistently low. Indeed, between 1600 and 1650 they ranked lowest. See Alan Chong, "The Market for Landscape Painting in Seventeenth-Century Holland," in Peter C. Sutton, ed., *Masters of Seventeenth-Century Dutch Landscape Painting* (Boston: Museum of Fine Arts, 1987), 104–20.

69. Schama, *Embarrassment of Riches*, 8.

70. Israel, *Dutch Republic*, 125. Israel's reference to the emergence of a closed patrician oligarchy encapsulates the thesis of the gradual aristocratization of burgher society put forth by H. van Dijk and D. J. Roorda in "Sociale mobiliteit onder regenten van de Republiek," *Tijdschrift voor Geschiedenis* 84 (1971): 306–28, and *Het patriciaat in Zierikzee tijdens de Republiek* (n.p. 1979). See also Roorda, "The Ruling Classes in Holland in the Seventeenth Century," in J. S. Bromley and E. H. Kossman, eds., *Britain and the Netherlands* (Groningen: J. B. Wolters, 1964), 109–32. A major objective of the important essay by Joanna Woodall discussed below in Chapter 11 is to show that this thesis is wrong, in part because it is based on an innocent or naturalizing construal of the meaning of realism: "There is no evidence from fields of representation other than 'realist' painting (portraiture and genre) that the Amsterdam citizenry was opposed to nobility per se during the first half of the century, then rapidly reconciled to an aristocratic lifestyle around 1650" (Joanna Woodall,

"Sovereign Bodies: The Reality of Status in Seventeenth-Century Dutch Portraiture," in Joanna Woodall, ed., *Portraiture: Facing the Subject* [Manchester: Manchester University Press, 1997], 96).

71. David R. Smith, *Masks of Wedlock: Seventeenth-Century Dutch Marriage Portraiture* (Ann Arbor, Mich.: UMI Research Press, 1982), 27. Smith's view of the dangers of embarrassment confronting painters and patrons early in the seventeenth century is balanced and nicely nuanced, and lays out the problematic to be explored in my next chapter. He argues that they preferred images "rooted . . . in the ideals of the Renaissance court" in spite of the gulf separating that court from "the social ideals of the Dutch middle classes": "Dutch portrait painters, in giving their patrons the poses of princes and kings, sought at the same time to moderate the image in ways that made it credible to a middle-class audience. . . . But it is well to remember . . . that the Dutch burghers who posed in this manner may often have thought themselves to be imitating the citizens of Venice rather than Spanish grandees" (35, 23, 31).

72. Roodenburg comments in general terms on the oppositional process by which Dutch elites distinguished their manners from those of Italian and Spanish elites ("'Hand of Friendship,'" 160–61). He also comments on the contribution of the low-life genre painters of Haarlem to class self-definition: the unruly postural catastrophes that appear as peasants in the paintings of Brouwer, van Ostade, "and their many predecessors and contemporaries . . . offer a caricature of lower-class life. They depict the exact opposite of life among the upper urban classes," and the contrast focuses on representations of "comportment and gestures" (159–60). Roodenburg here follows the lead of Svetlana Alpers, whose essays on Netherlandish representations of peasants appeared in *Simiolus* in the 1970s. See, for example, her "Realism asa Comic Mode: Low-life Painting Seen Through Bredero's Eyes," *Simiolus* 8 (1975–76): 137–38.

73. The problematic of the embarrassment of a self-made class is beautifully captured by Roland Barthes in his essay on Dutch painting. Barthes metaphorically depicts van Ostade's peasants and the rich burghers portrayed in individual and group portraits as the objects of "two anthropologies, as distinctly separated as Linnaeus' zoological classes." All faces in guild or militia portraits "are isomorphic," and what unifies them "consists not of a community of intentions, but of an identity of blood and food . . . —the very order of biology separates the patrician caste" from the peasants ("The World as Object," in *Critical Essays*, trans. Richard Howard [Evanston: Northwestern University Press, 1972], 7, 9). Barthes's biological metaphors dramatize the desire of a "social class unequivocally defined by its economy" (9) to naturalize and depoliticize class differences, and in this context the phrase "patrician *caste*" functions momentarily as free indirect discourse expressing the objective of that desire.

Chapter 11: The Posography of Embarrassment: Representational Strategies in a Decentralized Class Society

NOTE: I would like to express my appreciation to Dr. Sarah Whittier for numerous insightful contributions to the posographical studies that appear in this chapter and Chapter 13. Her comments illuminated and refined and often led me to alter my interpretations of many of them

1. Joanna Woodall, ed., "Introduction: Facing the Subject," in Woodall, ed., *Portraiture: Facing the Subject* (Manchester: Manchester University Press, 1997), 5.

2. Seymour Slive, *Dutch Painting 1600–1800* (New Haven: Yale University Press, 1995), 44–45. This book is a revised version of the sections on painting written jointly with Jakob Rosenberg in *Dutch Art and Architecture 1600–1800* by Slive, Rosenberg, and E. H. ter Kuile (Baltimore: Penguin Books, 1966).

3. Following Peter Sutton's account of "the High-Life Interior" in *Masters of Seventeenth-Century Dutch Genre Painting* (Philadelphia: Philadelphia Museum of Art, 1984), xxxii–xxxiv.

4. Seymour Slive, *Frans Hals*, 3 vols. (London: Phaidon Press, 1970), 1.52–53. For more details about the sitter and the dating of the portrait, see 3.20.

5. Claus Grimm, *Frans Hals: The Complete Work*, trans. Jürgen Riehle (New York: Harry N. Abrams, 1990), 119. My comments on Hals in this chapter rely heavily on the observations of Slive and Grimm. Over a period of almost twenty-five years, they have consistently and at times vociferously disagreed on issues of attribution, with Slive resisting the subtractive efforts of the Grimm Shrinker. This doesn't affect the value of their interpretive insights, which often overlap and reinforce each other. For Slive's early and late views of the disagreement, see *Frans Hals*, 3.78–79, and *Dutch Painting*, 330–31.

6. See Joneath Spicer, "The Renaissance Elbow," in Jan Bremmer and Herman Roodenburg, eds., *A Cultural History of Gesture* (Ithaca: Cornell University Press, 1991), 84–128. There are several such elbows in elegant merry company scenes by van de Velde and Buytewech.

7. Grimm, *Frans Hals*, claims that "[t]he military pose of resting the outstretched hand on a cane or sword also occurs in several of Hals's single portraits" (138), but in his purged catalogue no more than three sitters (nos. 61, 73, and 75, the second one doubtful) hold canes. Slive's more generous catalogue adds only two others (188 and 235), in addition to the smaller Brussels portrait of van Heythuyzen holding a whip (disattributed by Grimm). I am still looking for a second sitter resting his hand on what is unambiguously a sword.

8. Slive, *Frans Hals*, 1.53.

9. Grimm, *Frans Hals*, 119.

10. Slive observes that "although Heythuyzen is shown in a garden there is a strong impression of studio rather than outdoor light on the figure" (*Frans Hals*, 3.20).

11. One length even seems to end in a tassel, but a tassel the color of straw.

12. Slive, *Frans Hals*, 1.54. See also Grimm, *Frans Hals*, 119: "the transitoriness of the pleasures of life, glory, and wealth."

13. Slive, *Frans Hals*, 1.53.

14. Ibid. For information on van Heythuyzen and other Hals patrons, see Pieter Biesboer, "The Burghers of Haarlem and Their Portrait Painters," in Seymour Slive, ed., *Frans Hals* (Munich: Prestel, 1989), 23–44.

15. Slive, *Frans Hals*, 1.53.

16. Slive, *Dutch Painting*, 45. The last observation refers to urban homes, not to the country estates possessed by wealthier merchants like van Heythuyzen. Slive speculates that the background vista in the portrait may be imaginary (*Frans Hals*, 1.53).

17. Simon Schama, *The Embarrassment of Riches: An Interpretation of Dutch Culture in the Golden Age* (New York: Alfred A. Knopf, 1987), 311, 386. See also p. 400: "Customary male markers of patriarchal dynasticism, the residue of a feudal warrior ethos or the accumulation of a territorial estate all being less important in the Republic, the aura and status of a family household assumed correspondingly more significance."

18. Gary Schwartz, *Rembrandt, His Life, His Paintings* (New York: Viking Press, 1985), 204.

19. Peter Burke, *Venice and Amsterdam: A Study of Seventeenth-Century Elites*, 2d ed. (Cambridge: Polity Press, 1994), 27, 29–30. Gary Schwartz's blanket assertion that the Amsterdam patricians were all "enmeshed in large clan groupings" so that "their fates were tied to those of their relatives, near and far" and "[f]ew aspects of their lives did not reflect clan politics in one way or another" (*Rembrandt*, 9) is misleading in this respect. Schwartz is concerned primarily with the way political and social factions affected patronage, and he has little or nothing to say about the social, cultural, and political importance of the household.

20. Richard Goldthwaite's attempt to make the case for the breakdown of lineages and the emergence of nucleation in Renaissance Florence—an application of Philippe Ariès's argument about the enervating effect of domesticity on lineage—did not stand up against the counterarguments of several other historians.

21. Burke, *Venice and Amsterdam*, 12.

22. Ibid., 11. Such broad structural comparisons always need qualification when one considers smaller-scale diachronic phenomena. See, for example, Stanley Chojnacki's account of Venetian changes in the relation of status to political power, mentioned in Chapter 3 above.

23. Jonathan Israel, *The Dutch Republic: Its Rise, Greatness, and Fall, 1477–1806* (Oxford: Clarendon Press, 1995), 344.

24. Jonathan Israel, *Dutch Primacy in World Trade, 1585–1740* (Oxford: Clarendon Press, 1991; orig. pub. 1989). Israel's revisionary argument begins with a critique of Braudel's over-emphasis on the importance of bulk freightage to the Dutch economy.

25. Israel, *Dutch Republic*, 344.

26. Burke, *Venice and Amsterdam*, 16.

27. Israel, *Dutch Republic*, 337. On the decline of the nobility in Holland, see the measured assessment on pp. 337–41.

28. Ibid., 480.

29. K. H. D. Haley, *The Dutch in the Seventeenth Century* (London: Thames and Hudson, 1972), 83. The implied equation of the regent class with the existing social order upheld by aristocrats is misleading because it is based on the necessary but not sufficient qualifier "dominant." The bases of regent dominance are very different from those of aristocratic dominance.

30. Eugène Fromentin, *Les maîtres d'autrefois Belgique-Hollande*; *The Masters of Past Time: Dutch and Flemish Painting from Van Eyck to Rembrandt*, trans. Andrew Bogle, ed. H. Gerson (London: Phaidon Press, 1948). For the logic behind the connection of portraiture with realism, see Richard Brilliant, *Portraiture* (Cambridge: Harvard University Press, 1991), 46, and the essay he cites by Wendy Steiner, "The Semiotics of a Genre: Portraiture in Literature and Painting," *Semiotica* 21 (1977): 111–19.

31. Joanna Woodall, "Sovereign Bodies," in Woodall, ed., *Portraiture*, 76.

32. Ibid., 91–92. Discussing the lighter tonality of Hals's late portraits, Slive attributes it to a "change in men's fashions rather than a pronounced shift in the artist's late palette. . . . After wearing predominantly black costumes for about a generation, Dutchmen had begun to choose lighter and brighter clothes," and artists "were prepared to make the most of the change" (*Frans Hals*, 1.204–5). Woodall supplies a more specific political context for this observation: "The historical moment at which Amsterdam citizens abandoned conservative, black and white portraiture supports the view that their previously distinctive portrayed identity resulted from competition with the Stadholder for sovereignty. From the mid-1640s they increasingly began to have themselves portrayed according to the [more colorful] pictorial conventions which had prevailed for some two decades at the Hague court. . . . The adoption of these modes coincides with the negotiation of the Peace of Münster (1648)" and their "complete acceptance followed the defeat and death of the Stadholder Willem II in 1650, inaugurating a Stadholderless period during which the Amsterdam regents for the first time openly dominated the political arena" (92–93).

33. Joanna Woodall, "Sovereign Bodies," in Woodall, ed., *Portraiture*, 82.

34. Wayne E. Franits, *Paragons of Virtue: Women and Domesticity in*

Seventeenth-Century Dutch Art (Cambridge: Cambridge University Press, 1993), 13, 196.

35. Walter S. Melion, *Shaping the Netherlandish Canon: Karel van Mander's Schilder-Boeck* (Chicago: University of Chicago Press, 1991), 64.

36. Joanna Woodall, "Sovereign Bodies," in Woodall, ed., *Portraiture*, 96.

37. For one thing, "marital pendants were more characteristic of burgher portraiture than images of illustrious princes." For another, the effect of the pendant (produced several years later) was to domesticate the depicted space and undercut the iconography: "the covered table became a piece of household furniture as well as a courtly prop, the helmet [on the table] an anachronistic ornament as well as a serious military accoutrement" (ibid., 82).

38. The flattening effect is partly produced by the contrastive plasticity of the sword handle (a displaced codpiece) and table, the latter jutting forward with its conspicuously modeled drapery.

39. On the conditions that produce performance anxiety, see the excellent discussion by David R. Smith, *Masks of Wedlock: Seventeenth-Century Dutch Marriage Portraiture* (Ann Arbor, Mich.: UMI Research Press, 1982), 13–24. Smith observes that "middle-class Dutchmen wear swords in their portraits much less often than do their aristocratic contemporaries from elsewhere in Europe. In a country where soldiers (though not sailors) usually found little favor and where the nobility was weak and uninfluential, most patrons probably felt uncomfortable with the weapon's princely and military connotations" (17).

40. Smith, *Masks of Wedlock*, 6. Gary Schwartz comments that Soolmans's costume "gives us some idea of what the Mennonites meant when they accused the Calvinists of sinful frivolity in dress" (*Rembrandt*, 159). See also Christian Tümpel's remark that "Puritan severity and the claims of social position were not always easy to reconcile in liberal Amsterdam. Portraits such as Rembrandt's of the Soolmanses make it clear that considerations of social status often took precedence over the strict observance of religious principles" (Christian Tümpel, with Astrid Tümpel, *Rembrandt*, trans. Edmund Jephcott and others [Antwerp: Fonds Mercator, 1993; orig. pub. 1986], 107).

41. RRP, 2.549. See Introduction, n. 1, for complete reference.

42. Smith, *Masks of Wedlock*, 108–9.

43. In *Rembrandt's Enterprise*, Alpers extends the idea of performance from the act of painting to the characteristic look of Rembrandt's subjects: figures are represented theatrically as if their gestures were "performed or acted" (Svetlana Alpers, *Rembrandt's Enterprise: The Studio and the Market* [Chicago: University of Chicago Press, 1988], 37), as if the models and sitters were actors performing roles (36–40). She argues that Rembrandt's interest in posing as performance led to a disenchanted, quasi-Shakespearean emphasis on the theatricality of all actions, and to metasocial or metatheatrical representations in which "the question and the ambiguity of social performance were very much in pictorial play" (48, 57).

44. For the purposes of this discussion, I am ignoring the fact that the portrait of Soolmans is a pendant whose full effect is produced by its relation to its partner. But a reading of that relation would only reinforce what I say about Soolmans. If his wife, Oopjen Coppit, is similarly overdressed, her pose and address to the beholder are, in my opinion, more sympathetically rendered. For criticism of both the treatment of Soolmans and the relation between the pair portraits, see Slive, *Dutch Painting*, 62–63.

45. Kenneth Clark, *An Introduction to Rembrandt* (New York: Harper & Row, 1976), 66, 70. The tone of Clark's comment on Rembrandt's enjoyment of the garters and shoes is rendered mischievous by the sentence preceding it: "The furthest he went in that direction [high fashion] is a full-length portrait of an unknown man in a Van Dyck pose, which makes him look slightly ridiculous" (66).

46. See Smith's interesting discussion of the iconography of the glove, *Masks of Wedlock*, 72–81. Something might be said on the subject of wrinkled white stockings. They appear in genre images of peasants and drunken soldiers, but I don't find them featured in many "proper" portraits. One is Jacob van der Merck's dandified *Portrait of a Man* (Smith, *Masks of Wedlock*, Figure 25, whereabouts unknown). Two others seem more innocent: Pieter Codde's 1634 *Portrait of a Couple* in the Mauritshuis (which may, it has been suggested, have been influenced by the Soolmans portrait) and G. Donck's *Portrait of Jan van Hensberck and Maria Koeck with Their Child* in London (ibid., Figures 52 and 53). In Rubens's famous portrait of himself with Isabella Brandt (1609; Munich), the white stockings are skintight. I suspect that Soolmans's wrinkles have an aesthetic function—setting horizontals against the vertical accent of the trousers—but they still seem remarkably silly to me. For a real problem with white socks see Vermeer's *Artist in the Studio*.

47. Michael North, *Art and Commerce in the Dutch Golden Age*, trans. Catherine Hill (New Haven: Yale University Press, 1997), 56–57.

48. The perspective design is anomalous. In the male pendant it steps up to a higher level behind the sitter—chiefly, it seems, to imply a higher viewing point, which places the observer closer to Soolmans's face than his feet, so that even though the body appears foreshortened and thus to lean backward, the oversized and graphically contoured moonface pushes forward and demands that the observer treat it as if it were a bust. Note also that the tiled flooring in the two pendants does not converge toward a vanishing point between the pendants; both floors recede toward the left, further accentuating the dominance of the slightly larger male pendant.

49. Michael Fried, *Absorption and Theatricality: Painting and Beholder in the Age of Diderot* (Berkeley: University of California Press, 1980), 100.

50. Ann Jensen Adams, *The Paintings of Thomas De Keyser (1596/7–1667): A Study of Portraiture in Seventeenth-Century Amsterdam*, 4 vols. (rpt. in two vols., Ann Arbor, Mich.: UMI, 1995; orig. pub. 1985), 1.103–4.

51. The *schutterstukken*, or portraits of civic militia companies, allow members of nonhereditary elites and other urban classes to adopt the military bearing that had since feudal times been the representational prerogative of aristocrats.

52. Adams, *Paintings of De Keyser*, 1.111.

53. J. R. Hale, "The Soldier in Germanic Graphic Art of the Renaissance," in Robert I. Rothberg and Theodore K. Rabb, eds., *Art and History: Images and Their Meaning* (Cambridge: Cambridge University Press, 1988), 87.

54. Adams, *Paintings of De Keyser*, 1.112.

55. Christopher Brown, Jan Kelch, and Pieter van Thiel, *Rembrandt: The Master and His Workshop/Paintings*, trans. Elizabeth Clegg, Michael Hoyle, and Paul Vincent (New Haven and London: Yale University Press and National Gallery Publications, 1991), 200, 202.

56. Gary Schwartz, ed., *Rembrandt: All the Etchings Reproduced in True Size* (London: Oresko Books, 1977). "B" designates Adam Bartsch, whose 1797 catalogue supplies the numbering Schwartz uses. There is no pagination, only Bartsch numbers, in Schwartz's edition.

57. H. Perry Chapman, *Rembrandt's Self-Portraits: A Study in Seventeenth-Century Identity* (Princeton: Princeton University Press, 1990), 42.

58. Adams, *Paintings of De Keyser*, 1.112.

59. E. Haverkamp-Begemann, *Rembrandt:* The Nightwatch (Princeton: Princeton University Press, 1982), 28.

60. Slive, *Frans Hals*, 1.43.

61. For the former, see Hale, "Soldier in Germanic Graphic Art of the Renaissance," 87. Even here the textual and visual evidence is marked by heroizing tendencies. On this, see Keith Moxey, *Peasants, Warriors, and Wives: Popular Imagery in the Reformation* (Chicago: University of Chicago Press, 1989), 69–72.

62. See, for example, Haverkamp-Begemann, *Rembrandt*, 48–50, 109–10, 112–13. In spite of his emphasis throughout on "antique costumes and out-of-date arms and pieces of armor" (90), he insists that the companies continued to have some "military or paramilitary responsibilities. Officially, their duties were even quite heavy"—guarding the city, keeping the peace, putting out fires—but reality "was not always that grim. The day-to-day routine work was taken care of by hired soldiers and by other bodies of citizens" (48). Even though he stresses the symbolic—historical and allegorical—meaning of military action in the *Nightwatch*, Haverkamp-Begemann tries to make it more functional: Rembrandt "demonstrated the viability of arms and armor as symbols of virtuous defense of freedom and order by letting them be used" (109). "*The Nightwatch* expressed forcefully the preparedness of the individual men represented and thereby of Amsterdam's citizens to defend the independence of the city against any adversary, including the Dutch republic itself" (112–13).

63. Chapman, *Rembrandt's Self-Portraits*, 39–40.

64. Slive, *Frans Hals*, 1.42. A similar view is expressed by Schama in *Embarrassment of Riches*, 181–82 and 244–45. But the question of their military character is far from settled. For versions of the opposite opinion, see Koos Levy-van Halm and Liesbeth Abraham, "Frans Hals, Militiaman and Painter: The Civic Guard Portrait as an Historical Document," in Slive, ed., *Frans Hals*, 87–102, and the essays collected in M. Carasso-Kok and J. Levy-van Halm, eds. *Schutters in Holland: kracht en zenuwen van de stad* (Haarlem: Frans Halsmuseum, 1988). Margaret D. Carroll argues that the military activity of the companies increased after the Twelve Years' Truce: *Rembrandt's 'Nightwatch' and the Iconological Tradition of Militia Company Portraiture in Amsterdam*, Ph.D. dissertation, Harvard University, 1976, 38–58. Certainly the civic guard companies—like our National Guard—were occasionally called to action, as when an Amsterdam company was involved in Zwolle in 1622 and when, during the Haarlem butter tax uprising of 1624, as Israel wryly notes, "the militia, in which the great portraitist Frans Hals was then serving, fired on the demonstrators, killing five and wounding many more" (*Dutch Republic*, 484).

65. Richard Helgerson, "Soldiers and Enigmatic Girls: The Politics of Dutch Domestic Realism, 1650–1672," *Representations* 58 (Spring 1997): 55–56.

66. Spicer, "The Renaissance Elbow," 102. On the development of the *schutterij* and *schutterstukken* in Amsterdam starting in 1575 and their relation to Dutch military history, see Christian Tümpel, "De Amsterdamse schutterstukken," in Carasso-Kok and Levy-van Halm, eds., *Schutters in Holland*, 74–103.

67. Helgerson, "Soldiers and Enigmatic Girls," 56.

68. Israel, *Dutch Republic*, 265–66.

69. Ibid., 266. "Garrisons and their commanders spent the money transferred from the core provinces not only on construction, food, munitions, boots, and saddles, but wine, and elegant attire, for officers and great quantities of beer for the men. Even in small garrison towns, taverns, gambling, and prostitution proliferated" (ibid., 265).

70. Helgerson, "Soldiers and Enigmatic Girls," 58.

71. Several examples are not easily categorizable, and the ambiguity is itself worth thinking about.

72. Schama, *Embarrassment*, 244. Of the concluding sentence, Schama mordantly observes that this, "at least, was the received wisdom," and it turned out to be wrong when in 1672 the armed civilians were totally ineffectual "in withstanding the shock of the French invasion" and the Hague militia "delivered the brothers up to the mob" (245). The militiaman, in short, was too benign.

73. Pieter de la Court, *The True Interest of Holland* (1662, 1669), trans. John Campbell (New York: Arno Press, 1972; orig. pub. 1746), 7. On the dangers of "soldiery" and its intimate connection to monarchy, see pp. 314–17.

74. Or most of it: a pommel is visible, wedged in the crook of his arm.

75. Slive, *Dutch Painting*, 44–45. For the history of the portrait's reception, see Slive, *Frans Hals*, 3.19–20.

76. Grimm, *Frans Hals*, 118.

77. Slive, *Frans Hals*, 1.121.

78. This effect is not unlike the one produced by some of the Lotto poses I discussed in Chapter 9, above.

79. Slive, *Frans Hals*, 1.21.

80. Slive, *Dutch Portraiture*, 42.

81. Grimm, *Frans Hals*, 104.

82. On this, see Slive's excellent observations in *Dutch Painting*, 41. He contrasts Hals's treatment of light to "the artificial, static light of the Caravaggio tradition" and "the rather idealizing light of Rubens."

83. Woodall, Introduction to Woodall, ed., *Portraiture*, 5.

84. Grimm, *Frans Hals*, 70, 103.

85. Slive, *Frans Hals*, 1.21; Christopher Wright, *Frans Hals* (Oxford: Phaidon Press, 1977), 8.

86. Slive, *Frans Hals*, 1.54.

87. Ibid., 1.54–55 and 202. Slive immediately qualifies this assertion, noting that Mannerist artists and others "who wanted to show a transitory aspect of a patron rather than a more characteristic one" had already "made some attempts in this direction," but that the portrait of Massa far surpasses them in liveliness of motion (1.55). Grimm (*Frans Hals*, 119) mentions other sources for the format. For a profile of Massa's career as merchant, traveler, diplomat, author, and cartographer, see Slive, *Frans Hals*, 1.56 and 3.25–26.

88. The "unusual seated pose," Grimm writes, "might be borrowed from the tradition of genre painting" (*Frans Hals*, 118).

89. Slive, *Frans Hals*, 1.55; my italics.

90. Grimm, *Frans Hals*, 119; my italics.

91. For a marvelous and complicated variant on this format, see the pair portraits of Nicolaes Hasselaer and his wife, dated four years after the Massa portrait. Here, as Slive notes in his excellent remarks, the sitters pose as if momentarily interrupted from posing by the intrusion of the observer: "It seems as if the seated husband and wife were turned toward each other when the beholder suddenly caught their attention. Each of them now looks at the person whose presence has just been discovered" (*Frans Hals*, 1.120).

92. Grimm, *Frans Hals*, 119.

93. Six in Grimm's version of the oeuvre; nine in Slive's. Three are pendants, and two of these (the portraits of Nicolaes Hasselaer and Stephanus Geraerdts), along with one late individual portrait, are the only hatless sitters in this group.

94. The most elegant of the sitters in this group has been identified as a member of the Coymans family, and the most relaxed and amiable figure as that of the landscape painter Frans Post. The others are unidentified.

95. Slive, *Frans Hals*, 1.202; Wright, *Frans Hals*, 14.

96. This is one of three dangerously tilted slouch hats in Hals's late portraits. Another barely hangs on to the head of one of the sitters in *The*

Regents of the Old Men's Alms House. The third, which is balanced with more panache by its sitter (Slive, *Frans Hals*, plate 338 and cat. 218), was restored in 1949 after have been overpainted; probably, Slive speculates, "because it did not suit the taste of another generation" (1.192), a comment that testifies to the fashion power of hats.

97. Slive's comparison of the late works of Hals and Rembrandt remains by far the most compact and illuminating account of their significance: *Dutch Painting*, 51–54.

98. Woodall, "Sovereign Bodies," in Woodall, ed., *Portraiture*, 93–94.

99. Helgerson, "Soldiers and Enigmatic Girls," 60.

100. Slive, *Dutch Painting*, 356, 47.

101. Alpers, *Rembrandt's Enterprise*, 3, 58.

102. Quoted by Schwartz, *Rembrandt*, 308.

103. Alpers, *Rembrandt's Enterprise*, 82.

104. Schwartz, *Rembrandt*, 305.

105. Alpers, *Rembrandt's Enterprise*, 85–86.

106. Schwartz, *Rembrandt*, 308, 312. To be fair to Schwartz, the full context of his argument makes it less invidious. He is discussing a split between the emergent institutionalization of art and its standards in the Amsterdam Brotherhood of Painters, which "distinguished itself from the old guild" in order to "sever the association of painting with the crafts and to establish the rule of science and order of art" (309). Rembrandt "showed himself, with his half-lengths, to be a man of the guild" because, although he produced better "balanced" works during this decade, "their effect was overshadowed by the half-lengths" (312)—many of which, as Schwartz goes on to suggest, could have been studies for evangelists, apostles, or saints. For a good example of classicist criticism of Rembrandt, see Tümpel, *Rembrandt*, 299.

107. J. M. Nash, "Speculating on Rembrandt," *Art History* 12 (1989): 232–40. This is an unduly hostile review, so full of unsupported denigrations and unmotivated transitions that it verges on incoherence.

108. Ibid., 237–38. Of the three examples Nash considers in these pages, two—Susanna and Bathsheba—are familiar "historical" figures, while the assertion that Titus is not daydreaming seems entirely arbitrary. These instances can't possibly support the claim that Rembrandt *regularly* (Nash's term) establishes what the many anonymous subjects in the half-lengths are thinking about.

109. Schwartz, *Rembrandt*, 305.

110. Tümpel (*Rembrandt*, 299) attributes most of these to followers of Rembrandt and classifies them as "picturesque studies of heads and historical figures."

111. F. W. J. Schelling, *Philosophy of Art*, ed. and trans. Douglas W. Stott (Minneapolis: University of Minnesota Press, 1989), 146. Quoted in Brilliant, *Portraiture*, 130.

112. Schwartz, *Rembrandt*, 312.

113. Christopher White, *Rembrandt and His World* (New York: Viking Press, 1966), 32–34. For two examples, see Chapter 4 and notes 3 and 4 above. For others, see Horst Gerson, *Rembrandt Paintings*, trans. Heinz Norden (Amsterdam: Meulendorf International, 1968), 104, 130, 386; Jakob Rosenberg, *Rembrandt: Life and Work*, 3d ed. (London: Phaidon Press, 1968), 79–81; Carl Neumann, *Rembrandt*, 2 vols., 4th ed. (Munich: F. Bruckmann, 1924), 2.533.

114. Slive, *Dutch Painting*, 87.

115. Personal communication.

116. Alpers, *Rembrandt's Enterprise*, 93; my italics.

117. This interpretation of the painting is overdetermined by its context: Alpers has just summarized the archival traces of the uneasy patron/client relation between Six and Rembrandt, and she is concerned to show how the painting may be used dramatically to condense and encapsulate the relation. What Six did in the studio and Rembrandt recorded is thus an extension of the archival text.

118. The full effect is spatially more dialectical and nuanced: the brightness and cubic plasticity of the hand and the lovely detailed contouring of its sleeve, the textural accents of the former and the graphic delineation of the latter, bring them closer to the surface of the canvas, especially when compared to the impressionistic brushwork on the cloak. But the hue and mass of the cloak, and the runnels of shadow coursing down it and billowing it forth, reassert its claim to the surface and even take on a *repoussoir* function.

119. Slive, *Dutch Painting*, 87. This interpretation, which first appeared in Slive's contribution to the 1966 *Pelican History of Dutch Art* (p.72), is probably the target statement from which Alpers demurs in her comment that Six's head and eyes "could suggest inwardness and withdrawal" but probably don't.

120. Alpers, *Rembrandt's Enterprise*, 92–93.

121. Schwartz, *Rembrandt*, 206. See Eddy de Jongh, review of Bob Haak's *Hollandse schilders in de gouden eeuw*, *Simiolus* 15 (1985): 67–68.

122. Six had connections to this faction through his marriage to Nicolaes Tulp's daughter. On the de Graeff portraits, see Joanna Woodall, "Sovereign Bodies," in Woodall, ed., *Portraiture*, 86–90. See also Rembrandt's 1639 portrait in Kassel, the identification of which as Andries de Graeff by Schwartz and others has been rejected by the RRP (3.303–304) and renamed *Portrait of a Man, Standing*. For details, see van Thiel's catalogue entry in *Rembrandt and Workshop*, 210.

123. The identification was made by the indefatigable I. H. van Eeghen, "De vaandeldrager van Rembrandt," *Maandblad Amstelodamum* 58 (1971): 173–81. Soop was fifty at the time of the portrait. The attribution of the portrait to Rembrandt was challenged in 1976 by a former member of the RRP, whose present members persist in assigning it to Rembrandt. See Walter Liedtke's entry in Liedtke, Carolyn Logan, Nadine M. Orenstein, and Stephanie S. Dickey, *Rembrandt / Not Rembrandt in The Metropolitan Museum of*

Art: Aspects of Connoisseurship, vol. 2, *Paintings, Drawings, and Prints: Art-Historical Perspectives* (New York: The Metropolitan Museum of Art, 1996), 72.

124. Haverkamp-Begemann, *Rembrandt*, 28.

125. Slive, *Frans Hals*, 1.43.

126. Soop *appears* to be older than any of the other ensigns depicted in militia portraits I have seen in Amsterdam, Haarlem, Leiden, Delft, and Alkmaar. Admittedly my survey was casual and incomplete, and appearances can be deceiving, especially in the category of relative age.

127. Haverkamp-Begemann, *Rembrandt*, 104.

128. Van Thiel, *Rembrandt and Workshop*, 202. "The plume in the hat and the tooled leather baldric," Walter Liedtke observes, "belong to the regalia of the office of ensign" (*Rembrandt / Not Rembrandt*, 72). Neither van Thiel nor Liedtke comments on the pole.

129. Schama, *Embarrassment of Riches*, 244.

130. Slive, *Dutch Painting*, 256.

131. Van Eeghen, "De vaandeldrager van Rembrandt," 179. On the basis of the information available to her, van Eeghen was able to place Soop in the company of his father's nephew, Dirck Geurtsz van Beuningen, who died in 1648, but she wasn't able to fix the date of his appointment as standard-bearer.

132. These are Haverkamp-Begemann's suggestions for locale. He notes the resemblance to the archway depicted in *The Nightwatch* (*Rembrandt*, 104).

Chapter 12: Methodological Interlude I: Toward Group Portraiture

1. Francis Barker, *The Tremulous Private Body: Essays on Subjection* (London: Methuen, 1984), 52.

2. William S. Heckscher, *Rembrandt's Anatomy of Dr. Nicolaas Tulp* (New York: New York University Press, 1958).

3. Ibid., 99. See also pp. 59, 105, and 115.

4. Barker, *Private Body*, 81, 75, 77. Even as Tulp and the surgeons participate in "the fatal virulence of Rembrandt's depicted . . . science" (110), "the scientific gaze" is "organized around the corpse" precisely "in order not to see it" (77).

5. Ibid., 75, 77, 73. See p. 76 for a Foucauldian litany of residual and emergent transgressions against humanity in which the painting as agent participates.

6. Barker calls the sitters "surgeons" several times and "scientists" once (82); occasionally he names individuals among them. He also refers to them as "spectators" who remind us of "the performative context"—not, however, of posing but of "the public setting of this ritual dissection" (75). He never calls them "sitters."

7. Ibid., 73, 75. Why unwittingly? Because when we pay to enter the

Mauritshuis and stand before the painting we support the same capitalist regime and continue to celebrate its harsh justice? But our consciousness has now been raised; our complicity with our bourgeois predecessors finally exposed; if we're still weak enough to buy tickets we can always avert our gaze from the anatomy of Dr. Tulp.

8. Ibid., 78–79. On this see William Schupbach's influential iconographic study, *The Paradox of Rembrandt's 'Anatomy of Dr. Tulp,'* *Medical History*, supplement no.2 (London: Wellcome Institute for the History of Medicine, 1982).

9. A. B. de Vries, Magdi Tóth-Ubbens, W. Froentjes, *Rembrandt in the Mauritshuis*, trans. James Brockway (The Hague: Stichting Johan Maurits van Nassau, 1978), 101. In future references this work will be cited as de Vries, and the author as "he"—partly to avoid problems of grammatical number and partly because de Vries is credited in the Foreword with "the responsibility for the criticism of style in respect of all . . . paintings discussed" (6).

10. For details, see Heckscher, *Rembrandt's Anatomy*, 115, 191, and the cited documentary and secondary sources he relies on. In addition to Heckscher and Schupbach, the most important commentaries on the painting are two group projects bound together by strong scholarly affiliations (evident in the similarity of their critical reactions to Heckscher): de Vries, *Rembrandt in the Mauritshuis*, 82–113, and the findings of the RRP, 2.172–89.

11. Heckscher, *Rembrandt's Anatomy*, 115. See Gary Schwartz, *Rembrandt, His Life, His Paintings* (New York: Viking Press, 1985), 143–45, for an analysis of the politics of this rivalry. Whereas Schwartz flatly asserts that "the cadaver is that of Adriaen Adriaensz (Aris) 't Kint of Leiden" (145), de Vries's caption under a photographic detail of the corpse is more cautious: "The corpse (Adriaan Adriaansz 't Kint?)" (de Vries, *Rembrandt in the Mauritshuis*, 99).

12. Jonathan Sawday, *The Body Emblazoned: Dissection and the Human Body in Renaissance Culture* (New York: Routledge, 1995), 149–50, my italics. Sawday cites Barker, the RRP, and Schwartz, but oddly doesn't acknowledge the source of the idea in Heckscher, the sole mention of whose book appears in a subsequent footnote, where it is judged "important" but superseded by Schupbach's study (297).

13. De Vries, *Rembrandt in the Mauritshuis*, 99. This might not affect Barker's general diatribe against bourgeois (in)justice, but it would render his more interesting and suggestive resolution of the two anomalies nugatory.

14. The event only "served as the basis for the painting" (ibid., 99). While the RRP accepts the assumption "that the commission for the painting arose from . . . [Tulp's] second anatomy demonstration," it rejects the idea that the painting is in any sense the record of that event (2.182–83).

15. RRP, 2.183. See de Vries, *Rembrandt in the Mauritshuis*, 102 and 108–9. To be fair to Heckscher, his view is more complex, or perhaps inconsistent. He denies that Rembrandt shows the surgeons "as he had

casually observed them on a specific day at their work" (24), and he devotes a chapter to the anomalies and their iconographic significance (65–76).

16. De Vries, *Rembrandt in the Mauritshuis*, 102. Rembrandt's "Amsterdam precursors . . . did not attempt to record an anatomy demonstration, but used this solely as a thematic formula for a group portrait," and, allowing for his innovative turn to dramatic depiction, his project was the same (RRP, 2.183).

17. RRP, 2.183; de Vries, *Rembrandt in the Mauritshuis*, 102.

18. Barker, *Private Body*, 74.

19. "The authors of the present study believe that the artist's prime intention was to achieve a *group portrait* and at the same time to satisfy Tulp's desire to be shown as '*Vesalius redivivus*.' As such, the painting can also be regarded as interpreting an event of the past" (de Vries, *Rembrandt in the Mauritshuis*, 16).

20. Christian Tümpel, with Astrid Tümpel, *Rembrandt*, trans. Edmund Jephcott and others (Antwerp: Fonds Mercator, 1993; orig. pub. 1986), 80–81.

21. RRP, 2.1283.

22. De Vries, *Rembrandt in the Mauritshuis*, 16, 109, 102.

23. Recall Walter Melion's paraphrases of van Mander, which I cited in the preceding chapter: "[p]icturing *nae t'leven* involves recording something seen at the moment of viewing it" and "working *nae t'leven* conferred immediacy guaranteeing the documentary value of an image." (Walter S. Melion, *Shaping the Netherlandish Canon: Karel van Mander's* Schilder-Boeck [Chicago: University of Chicago Press, 1991], 63).

24. Heckscher, *Rembrandt's Anatomy*, 39.

25. De Vries, *Rembrandt in the Mauritshuis*, 102. I suspect that de Vries may have misread Riegl, who clearly refers not to the observers outside the painting but to "die Hörergruppe," that is, the sitters listening to the praelector: Aloïs Riegl, *Das holländische Gruppenporträt* (Vienna: Österreichische Staatsdruckerei, 1931; orig. pub. 1902), 182. Riegl repeats this reference several times in the ensuing pages.

26. RRP, 183.

27. Heckscher, *Rembrandt's Anatomy*, 14.

28. Barker, *Private Body*, 73.

29. In this they follow H. van de Waal, whose scornful dismissal of Riegl's deployment of the observer first appeared in *Oud-Holland* 71 (1956): 61–107: "The *Syndics* and Their Legend," subsequently reprinted in van de Waal, *Steps Towards Rembrandt: Collected Articles 1937–1972*, trans. Patricia Wardle and Alan Griffiths (Amsterdam: North-Holland, 1974), 247–92, esp. 249, 253–56, 259.

Chapter 13: Rembrandt's Embarrassment: An Anatomy of Group Portraiture

1. William S. Heckscher, *Rembrandt's Anatomy of Dr. Nicolaas Tulp* (New York: New York University Press, 1958), 24.

2. Richard Brilliant, *Portraiture* (Cambridge: Harvard University Press, 1991), 92–93, my italics. See also Gary Schwartz, *Rembrandt, His Life, His Paintings* (New York: Viking Press, 1985), 143: "There was a built-in conflict between the desire of the individual sitters to show up clearly and handsomely, and that of the various corporate bodies to decorate the walls of their meeting places with worthy pieces of art. The conflict was complicated by the circumstance that the sitters usually paid the entire cost of the painting, while the guild or city would own it."

3. This hypothesis or fantasy doesn't preclude moments in which the painter and sitters may have assembled together to block out the scene, or moments in which they were assembled for other purposes and the painter took group impressions. The point is simply that since the group portrait represents an improbable if not unimaginable event, it must be assumed to construct what it pretends only to represent.

4. Aloïs Riegl, *Das holländische Gruppenporträt* (Vienna: Österreichische Staatsdruckerei, 1931; orig. pub. 1902), 2, my italics.

5. Ibid., 180, 21.

6. Ibid., 14.

7. Michael Podro, *The Critical Historians of Art* (New Haven: Yale University Press, 1982), 83. H. van de Waal's opposition to Riegl's introduction of the observer centers on the latter's "novelistic" account of the observer as interested party (*Partei*) in Rembrandt's *Syndics*; see Chapter 12, n. 29, above.

8. Riegl, *Gruppenporträt*, 180.

9. For the distinction between indicator and interlocutor, see note 29 below.

10. *De pictura* 2.42, in Leon Battista Alberti, *On Painting and On Sculpture*, ed. and trans. Cecil Grayson (London: Phaidon Press, 1972), 83. On Alberti's interlocutor, see my *Second World and Green World: Studies in Renaissance Fiction-Making*, ed. John Patrick Lynch (Berkeley: University of California Press, 1988), 22–24.

11. Margaret Iversen, *Alois Riegl: Art History and Theory* (Cambridge: MIT Press, 1993), 101–2. The best and most compact accounts I have seen of Riegl's exposition of these relations are in Podro, *Critical Historians*, 81–95, and Richard Wollheim, *Painting as an Art* (Princeton: Princeton University Press, 1987), 176–83.

12. Leo Steinberg, "The Philosophical Brothel," *October* 44 (1988): 13, my italics; first published in *Art News* 71 (September and October 1972). On the question of "the beholder's subjective experience," Wollheim argues that Riegl recognized the distinction between virtual or internal and actual or empirical observers, and that he was concerned only with the first (*Painting as an Art*, 181–82).

13. Podro, *Critical Historians*, 88.

14. Wollheim, *Painting as an Art*, 178.

15. Riegl, *Gruppenporträt*, 12.

16. Brilliant, *Portraiture*, 93.

17. Heckscher, *Rembrandt's Anatomy*, 33.

18. I don't feel as confident about the third figure, third from the right in the upper row, but compared to the direct glances of his neighbors, his seems not to hit the external target of subordination.

19. Norbert Schneider, *The Art of the Portrait: Masterpieces of European Portrait-Painting, 1420–1670*, trans. Iain Galbraith (Cologne: Benedikt Taschen, 1994), 164.

20. Ann Jensen Adams, *The Paintings of Thomas De Keyser (1596/7–1667): A Study of Portraiture in Seventeenth-Century Amsterdam*, 4 vols. (rpt. in two vols., Ann Arbor, Mich.: UMI, 1995; orig. pub. 1985), 1.54–55. For an example that fails in spite of head-turning, see Nicolaes Eliasz. Pickenoy's *Anatomy of Dr. Joan Fonteyn* (1625), in which three of the seven figures look off to the right and four eye the observer, including the praelector pointing to a skull. The latter is depicted in half-length, while the others are busts arranged in two groups of three, one on each side of the doctor. The effect of *désagrégation* is intensified by two features: the busts are placed like individual cutouts against a dark background, but the cutouts are allowed to interrupt and jostle against each other in order to suggest volume and depth. One has to allow for the fact that this work is a fragment of a larger painting, but it remains a good example of how not to overcome the problem.

21. Heckscher, *Rembrandt's Anatomy*, 35; Adams, *Paintings of De Keyser*, 1.54–55.

22. Or at least one of the two does—the one on our left. The other's gaze is lower and its trajectory less easily definable; it could just as well terminate in the *repoussoir* figure at bottom as pass beyond it into observer space. (*Repoussoir*: a foreground figure used to draw the observer's eye beyond it into the deeper space of a picture.)

23. See H. van de Waal, *Steps Towards Rembrandt: Collected Articles 1937–1972*, trans. Patricia Wardle and Alan Griffiths (Amsterdam: North-Holland, 1974), 247–75.

24. Jonathan Sawday, *The Body Emblazoned: Dissection and the Human Body in Renaissance Culture* (New York: Routledge, 1995), 151. There are, of course, sumptuary and positional ways of denoting hierarchy, and Adams has determined that "persons portrayed on the left side of a painting often have higher status than those on the right" (*Paintings of De Keyser*, 1.52–53).

25. See Riegl, *Gruppenporträt*, 169–71, 183. I follow Adams in assigning it this title rather than the more usual *The Anatomy Lesson of Dr. Sebastiaen Egbertsz de Vrij*—who is also the praelector in Petersz.'s 1603 anatomy—partly because, according to the documentation, at least three of the sitters in addition to the doctor were indeed officers, and partly because, insofar as the picture feints in the direction of an event, it is a lesson not in anatomy but in osteology.

See Adams, *Paintings of De Keyser*, 1.53–54, 57–58 and 3.7–10. For the possible change of attribution from de Keyser to Pickenoy, see Seymour Slive, *Dutch Painting 1600–1800* (New Haven: Yale University Press, 1995), 336, n. 6. I shall continue to refer to it as de Keyser's work.

26. And toward the tickled skeleton, whose pose and rictus make it all but dance and whose curvature accentuates the graceful rhythmic counterpoint of the figures in space.

27. Adams points out that de Keyser's painting is "unique in the history of Surgeons' Guild portraits" because it depicts an osteology lesson with a skeleton "rather than an anatomy lesson with a corpse." Skeletons occasionally appear in illustrations of anatomy lessons, but only as "part of the setting" or as a secondary teaching aid in dissection. Whereas "the more spectacular dissection of a corpse . . . was open to the public," she adds, the lecture in osteology was an in-house affair, "the most basic and frequently presented lesson offered to an assembly of guild members" and thus the event that "most often brought the guild membership as a body together" (*Paintings of De Keyser*, 1.57–58).

28. This directional distinction is more obvious in the presence of the painting than it is in small photographic reproductions.

29. Though I have been using the word "interlocutor" for years to describe the Albertian function, this point makes its inappropriateness glaringly obvious, which is why I have decided to distinguish interlocutors, whose engagement with observers is general, from indicators, whose engagement is specifically deictic. For an example of the difference between visual and rhetorical presentation, compare the gestures depicted in these group portraits to the allocutionary gesture depicted by Titian and the Vesalian illustrator presumed to belong to Titian's workshop.

30. Adams, *Paintings of De Keyser*, 1.59. Slive differs from Adams in distinguishing between the total absorption of the four standing figures and the seated figures' "total disregard of the surgeon's demonstration lessons." But he agrees that, although the latter's engagement with the spectator helps "establish the outer unity between the sitters and the spectator," it "lessens the structural and psychological unity of the group" (*Dutch Painting*, 250).

31. In a weird spatial sarabande, a flaccid version of his left elbow and curved hand dangles from the skeleton's left scapula.

32. Sawday, *Body Emblazoned*, 152–53.

33. RRP, 2.172, 183; Heckscher, *Rembrandt's Anatomy*, 35; Michael Bockemühl, *Rembrandt 1606–1669: The Mystery of Revealed Form*, trans. Michael Claridge (Cologne: Benedikt Taschen, 1993), 60.

34. Riegl, *Gruppenporträt*, 182–83. "Sightless gaze" is Podro's very loose but helpful translation of Riegl's puzzling characterization, "gleichsam entsinnlichtes Schauen" (182), "a look as if of recollection." The phrase occurs during Podro's sensible resolution to this issue (*Critical Historians*, 88).

35. The RRP comments on the sketchy treatment that sets him off from the others: "the contrast is reduced to a cast shadow, with little internal detail, set against the dull flesh color" (2.177).

36. The gesture is unostentatious enough to produce such cautious interpretations as the following RRP paraphrase of William Schupbach's comment: "he *appears* to point at the corpse" (RRP, 2.183, my italics; Schupbach, *The Paradox of Rembrandt's 'Anatomy of Dr. Tulp,'* *Medical History*, supplement no.2 [London: Wellcome Institute for the History of Medicine, 1982], 27).

37. Sawday, *The Body Emblazoned*, 151.

38. And a portrait not collectively commissioned by the guild—thus not an official guild portrait—but privately commissioned by Tulp and the others portrayed in it (Heckscher, *Rembrandt's Anatomy*, 188–91; RRP, 2.182–83).

39. Perhaps the anatomical illustration over which the names of the sitters were written is held up to the observer as a cue that identifies, if not the source of Rembrandt's depiction of the arm, then, more generally, the fictiveness of the imaginary event.

40. Bockemühl, *Rembrandt*, 41. In line with his dialectical and progressivist argument, he goes on to add that the tendency was "one which Rembrandt was only to overcome later—albeit then completely."

41. Kenneth Clark, *An Introduction to Rembrandt* (New York: Harper & Row, 1976), 66.

42. Slive, *Dutch Painting*, 62.

Chapter 14: Methodological Interlude II: On Self-Portraits

1. Leon Battista Alberti, *On Painting*, trans. John R. Spencer (New Haven: Yale University Press, 1956), 64.

2. Horst Gerson, *Rembrandt Paintings*, trans. Heinz Norden (Amsterdam: Meulendorf International, 1968), 88.

3. Jacques Lacan, *Écrits: A Selection*, trans. Alan Sheridan (New York: Norton, 1977), 4.

4. Svetlana Alpers, *Rembrandt's Enterprise: The Studio and the Market* (Chicago: University of Chicago Press, 1988), 33, 61, 85, 83.

5. I remain amused and bemused by the concept of a self-portrait of Rembrandt executed, for example, by Govaert Flinck.

6. See Mieke Bal's brief but characteristically generous profile of Alpers's work and its significance in *Reading "Rembrandt": Beyond the Word-Image Opposition* (Cambridge: Cambridge University Press, 1991), 28–29.

7. Gary Schwartz, *Rembrandt, His Life, His Paintings* (New York: Viking Press, 1985).

8. Alpers, *Rembrandt's Enterprise*, 93. This criticism isn't entirely accurate. Schwartz briefly and casually makes a similar point in the preface to the

English edition of his book, and in the same context as Alpers, that is, in responding to the RRP. See *Rembrandt*, 10.

9. Alpers, *Rembrandt's Enterprise*, 99, 104.

10. Some methodological refinements that aren't crucial to the self-portraits I shall discuss deserve at least a footnote glance.

From the assumption that what we see in a self-portrait corresponds roughly to what the painter saw in the mirror, it follows that the completed picture situates the observer in either or both of two positions. When the painting replaces the mirror as the locus of the image, the observer (1) replaces the painter as the locus or source of the gaze directed at the image, and (2) replaces the mirror as the object of the gaze directed by the painter at his specular image. The first position maintains the fiction of the mirror: the observer upholds the primacy of the normative act of production; since the picture represents the mirror image, the observer replaces—appropriates the position formerly occupied by—the mirror-gazing painter at work. But the second position jeopardizes the primacy of the normative fiction because it introduces the possibility of what may be called *specular bypass*: since the observer replaces the mirror, the mirror easily gives way to the representation of the sitter himself engaging observers in unmediated eye contact. Instead of the object the painter saw in the mirror, we confront the subject who, in terms of the normative specular fiction, gazes at the mirror but who also, as a result of the specular bypass, gazes at the observer. The fiction of the pose is complicated because self-portraiture always allows for both possibilities. Does the image represent the painter looking at himself in the mirror or looking at the virtual observer? Obviously it may always be imagined to do both. That might well render the distinction trivial, except that in some of the paintings to be discussed in the following sections we'll see that the two readings may clash and modify each other—somewhat as meanings do in puns—in ways that enrich the total effect.

I should mention a further refinement that supervenes on recognition of the difference between these two constructions of the sitter's image as specular object and as mirror-gazing subject: to choose the former entails compensating for lateral reversal so as to place the reflected sitter's left (the mirror image of the subject's right) on our left, whereas we would place an unmirrored sitter's right on our left. This distinction is sometimes useful in the interpretation of self-portraits, especially those in which the painter poses as a painter, though the usefulness depends on our ability to determine whether the painter is right-handed or left-handed. For a set of interesting reflections on these conundrums of specularity see Richard Brilliant's chapter on self-portraiture in *Portraiture* (Cambridge: Harvard University Press, 1991), 141–74, esp.144–47 and 156–58.

I note in passing that in *Courbet's Realism* (Chicago: Chicago University Press, 1990), Michael Fried determines right- and left-handedness only in terms of the subjective or unmirrored image and ignores the possibility that the

self-portraits he discusses may represent the mirror image (see pp. 74, 80, 81, 83, and 95). In at least one of these cases, *The Man with the Leather Belt*, this weakens his argument.

11. Joseph Leo Koerner, *The Moment of Self-Portraiture in German Renaissance Art* (Chicago: University of Chicago Press, 1993), xv, xii.

12. An effect sartorially reinforced by the way the outer sleeves are divided to reveal the elegantly slashed and puffed sleeves of the undergarment.

13. Alpers, *Rembrandt's Enterprise*, 41. The problem, that is, of the difficulty of trying to figure out "who, or what event, is depicted" in so-called history paintings, especially since Rembrandt had a "penchant for eccentric subjects" (7).

14. Ibid., 121.

Chapter 15: Good Boys and Bad: Orthopsychic Comedy in the Early Self-Portraits

1. Svetlana Alpers, *Rembrandt's Enterprise: The Studio and the Market* (Chicago: University of Chicago Press, 1988), 33, 18, 39. See also 16–22 passim.

2. For the distinction between facture and texture, which is my own (not Alpers's), see Chapter 1 above and Chapter 18 below.

3. Alpers, *Rembrandt's Enterprise*, 22, 32.

4. The nineteenth-century Italian physician Ivan Lermolieff, pseud. Giovanni Morelli, developed a graphological system for identifying artists by their habits of drawing, manifested in such minutiae as pen strokes indicating earlobes and fingernails. See his *Italian Painters: Critical Studies of Their Works*, trans. C. J. Ffoulkes (London, 1892–93).

5. A. J. P. Laurie, *The Brushwork of Rembrandt and His School* (Oxford: Oxford University Press, 1932).

6. RRP, 1.xiv. The gist of the critique is that Laurie's comparative method led him to slight the way the context of the individual painting affects the significance of the brushwork.

7. Contained subversion might be the moral of Gary Schwartz's study (*Rembrandt, His Life, His Paintings* [New York: Viking Press, 1985]); it isn't the moral of mine.

8. Alpers, *Rembrandt's Enterprise*, 81.

9. Ibid., 39, 21.

10. H. Perry Chapman, *Rembrandt's Self-Portraits: A Study in Seventeenth-Century Identity* (Princeton: Princeton University Press, 1990), 17. For a critique of this distinction, and a general assessment of Chapman's book, see my review essay in *Clio* 23 (1994): 285–94.

11. Schwartz, *Rembrandt*, 363.

12. Chapman, *Rembrandt's Self-Portraits*, 40.

13. See the narrative of these years and conflicts in Jonathan Israel, *The Dutch Republic: Its Rise, Greatness, and Fall, 1477–1806* (Oxford: Clarendon Press, 1995), 506–15.

14. Shakespeare, *King Henry V*, 3.2.125, ed. J. H. Walter, Arden Edition (London: Methuen, 1954), 65.

15. Chapman, *Rembrandt's Self-Portraits*, 40.

16. Schwartz, *Rembrandt*, 61.

17. Norbert Schneider, *The Art of the Portrait: Masterpieces of European Portrait-Painting, 1420–1670*, trans. Iain Galbraith (Cologne: Benedikt Taschen, 1994), 114. For Christian Tümpel, the sitter "presents himself in the role of an Old Testament prophet," whose weapons and dog "underline the stately pose" (*Rembrandt*, trans. Edmund Jephcott and others [Antwerp: Fonds Mercator, 1993; orig. pub. 1986], 69). The translator's choice of "underline" is risky; changing one letter would undermine it.

18. Since the RRP rejects Rembrandt's hand in this painting, Alpers places it in her category of "portraits done in the manner of Rembrandt self-portraits" (*Rembrandt's Enterprise*, 121).

19. Or perhaps as he seems not to realize: the indeterminacy of physiognomic analysis allows the reading to go either way, toward admiring self-perusal or toward consternation.

20. See the extensive argument for deattribution in RRP, 3.625–33. Acknowledging that the pose formula is standard for self-portraits, the authors question the signature, the manner of painting, and the resemblance of the sitter's features to those of authenticated self-portraits. They reassign it to "an unknown artist in Rembrandt's immediate circle" and conclude that it "may be seen as a self-portrait" (625)—presumably (one hopes) of the unknown artist. But that only makes it more interesting in view of the fact that the features are similar to those of the more restrained and genuinely stylish figure depicted in the painting in Berlin that the RRP considers an authentic self-portrait (RRP, 2.519–24). See Schwartz, *Rembrandt*, 189, where the two appear side by side. Instead of a self-portrait by Rembrandt posing as a bravo, a comic Capitano, a *miles gloriosus*, we would then have a self-portrait by someone else posing as Rembrandt posing as a bravo.

21. Schwartz, *Rembrandt*, 189.

22. Ben Broos, *Mauritshuis The Hague: Guide to the Royal Cabinet of Paintings*, trans. Jantien Salomonson and Peter Black (Hague: SDU Uitgeverij, 1988), 171.

23. Kenneth Clark, *An Introduction to Rembrandt* (New York: Harper & Row, 1978), 16–17, reads the fancy dress as a reaction to the restrained fashion of Rembrandt's Amsterdam patrons.

24. Some amazing hats: Uccello's *Nicholas da Tolentino at the Battle of San Romano* in London, Raphael's *Castiglione* in Paris, Titian's *Duke of Atri* in Kassel,

Moroni's portrait of a gentleman and two others by Moretto da Brescia, all in London.

25. David R. Smith, *Masks of Wedlock: Seventeenth-Century Dutch Marriage Portraiture* (Ann Arbor, Mich.: UMI Research Press, 1982), 35.

26. Ibid., 31, 35. The influence of Castiglione in the period Smith concentrates on was necessarily indirect: though he fails to mention it, the *Cortegiano* was not translated into Dutch until 1662, which doesn't mean it wasn't consulted in the original, or in any of the various translations published much earlier. On the text's history, see Peter Burke, *The Fortunes of the 'Courtier'* (Cambridge: Polity Press, 1995), 61–66, 129–30, and passim. Before 1662, of course, the Dutch had other means of access to new fashions of conduct and civility. See the discussion by Herman Roodenburg in "The 'Hand of Friendship': Shaking Hands and Other Gestures in the Dutch Republic," in Jan Bremmer and Herman Roodenburg, eds., *A Cultural History of Gesture* (Ithaca: Cornell University Press, 1992), 154–56.

27. Alpers, *Rembrandt's Enterprise*, 89–90, 116.

28. The profile self-portrait also exists in an undated independent pencil sketch in the Uffizi. Carlo del Bravo speculates that Dolci may have copied it and added the date in the painting: "Carlo Dolci, devoto del naturale," *Paragone* 163 (1963): 40. But it makes a better story to imagine that he copied the pencil sketch from the painting just in case La Sua Altezza Regissima should ask for the real thing.

Chapter 16: Marking Time: Revisionary Allusion in Specular Fictions

1. For more on the gold chain see Chapter 23 below.

2. H. Perry Chapman, *Rembrandt's Self-Portraits: A Study in Seventeenth-Century Identity* (Princeton: Princeton University Press, 1990), 49–50.

3. Chapman makes much of the beret as a symbol of "the artist as *pictor doctus* or learned painter, whose knowledge is the foundation of the art of painting and the basis for its claim to be one of the liberal arts" (*Rembrandt's Self-Portraits*, 90). Repeatedly she connects the symbolism of the *pictor doctus* with the upward mobility of artists trying to dissociate themselves from craftsmen. But when she explores Rembrandt's deployment of the symbolism, she minimizes the possibility that the iconographic focus is less on the intellectual status of painters and painting than on the social pretensions that valorize the traditional apparatus and ideology of patronage. For an interesting account of the role played by learning and letters in the strategies of courtership developed by painters, see Clark Hulse, *The Rule of Art: Literature and Painting in the Renaissance* (Chicago: University of Chicago Press, 1990), 77–114. See also Loren Partridge and Randolph Starn, *A Renaissance Likeness: Art and Culture in Raphael's "Julius II"* (Berkeley: University of California Press, 1980).

4. In *Rembrandt and the Italian Renaissance* (New York: New York University Press, 1966), Kenneth Clark includes among the "current formulae" Rembrandt tried out in the 1630s "the hand on the breast of Van Dyck (although with a very different effect)" (123). Svetlana Alpers comments on "how often the prominent hands in Rembrandt's paintings are not deployed in expressive gestures, nor described—as Van Dyck's attenuated and uselessly aristocratic ones are, for example—as a sign of social class" (*Rembrandt's Enterprise: The Studio and the Market* [Chicago: University of Chicago Press, 1988], 25). But the Count's somewhat attenuated gloved hand is an obvious exception to this practice because—to take advantage of Clark's ambiguous genitive construction—Rembrandt's hand rests "on the breast of Van Dyck" and gives it a gentle shove.

5. By the members of the RRP, who casually assume that the hand is the sitter's left—that is, that the figure in the picture is the sitter himself rather than his mirror image (2.340). Suppose that the question whether the hand is right or left is in this case undecidable, underdetermined, and that the painter is right-handed. Then, the more telling and thematically appropriate effect of self-alienation—the painter posing as the painted—would be produced by imagining that the gloved hand is the painting hand, for this more conspicuously and archly dissimulates the labor of painting.

6. Exotropy appears repeatedly in self-portraits. John Pope-Hennessey discusses it in relation to mirror surfaces and Dürer's self-portraits (*The Portrait in the Renaissance* [New York: Pantheon Books, 1966], 125–29). To me, it indicates the duality of the specular and postspecular focus.

7. The cited phrase is from RRP, 2.343.

8. Ibid., 2.337.

9. Jacques Foucart, *Les peintures de Rembrandt au Louvre* (Paris: Editions de la Reunion des musées nationaux, 1982), 32. The quoted phrase translates "les diaprures épaisses."

10. Consider, for example, Horst Gerson's reaction to the contrast between these self-portraits and one dated a year earlier: struck by the "startling" change Rembrandt's "expression and pose" have undergone, he attributes this to the effects of rapid aging—the painter "has not only become graver—he has visibly aged" (*Rembrandt Paintings*, trans. Heinz Norden [Amsterdam: Meulendorf International, 1968], 58). Even Christopher Wright, who is commendably skeptical of such conjectures, fails to avoid them. He too notices aging in these "rather worried looking pictures" and, refusing to link the worry to "an impending crisis" in Rembrandt's life, seeks instead to associate it with the painter's formal development: Rembrandt's mastery of diffused light and elaborate poses increased during the following years and "the unease of the Louvre pictures evaporates" as he gains in self-confidence (*Rembrandt Self-Portraits* [New York: The Viking Press, 1982], 23). But this, no less than the reference to aging, suggests a genetic motivation: the unease, the worried look,

is attributed to Rembrandt's not yet having attained the artistic "self-fulfillment" toward which he was gradually moving. Wright's usage makes "unease" denote both the sitter's less confident appearance and its correspondence to the state of mind of the still-unfulfilled painter. Genetic inferences of this sort conflate the now of the observer's relation to the painting with the then of the painter's relation to the painting. They may sometimes be recuperated by being pried loose from the painter's life and redirected to the apparatus of portraiture, and I submit that the way to do this is to pass them through the screen of the various constituents of the fictions of the pose. We may then indeed discover in the Count and the General something like "an impending crisis," a crisis of self-representation, but one that is itself represented as an ironic commentary on the forms of desire inscribed in the prevailing model of patron/painter relations.

11. For an extended discussion of practices and varieties of conspicuous allusion, see Richard Wollheim's splendid chapter on borrowing in *Painting as an Art* (Princeton: Princeton University Press, 1987), 187–248. Though I'm a little bewildered by and not sympathetic to Wollheim's psychologistic use of "the mind of the artist" and "what the [borrowed] text means to the artist"(188) as criteria of genuine allusion, I don't think they're essential to his argument, whose elaboration is powerfully persuasive even if one ignores them. As Wollheim describes it, a particular borrowing works like the trope of metonymy in that it is introduced into an image as part of the context from which it is borrowed; in standing for that context, it picks out aspects that are relevant to the meaning of the image.

12. Lorne Campbell, *Renaissance Portraits: European Painting in the 14th, 15th, and 16th Centuries* (New Haven: Yale University Press, 1990), 107.

13. Chapman, *Rembrandt's Self-Portraits*, 67.

14. Sheldon Nodelman, "How to Read a Roman Portrait," *Art in America* 63 (1975): 27. This conceptualization is further discussed in Chapter 9 above.

15. It is indeed a discourse and an instituted process, not merely a tacit cultural practice. Its records are a heterogeneous ensemble of texts: legal documents, contracts, correspondence, biographies, iconography, memoirs, inventories, bills of sale, treatises on painting—a veritable "network of writing" (Foucault) that enables scholars to reconstruct the articulate context of understandings, expectations, criteria, interests, and values in which portraiture is inscribed and of which it "speaks."

Chapter 17: Rembrandt as Burgher: Waiting for Maerten Soolmans

1. Kenneth Clark, *An Introduction to Rembrandt* (New York: Harper and Row, 1978), 14–18.

2. RRP, 2.234.

Chapter 18: Methodological Interlude III: Texture Versus Facture

1. Peter and Linda Murray, *The Penguin Dictionary of Art and Artists*, 5th ed. (Harmondsworth, Middlesex: Penguin Books, 1983), 308–9.

2. Even the most inconspicuous traces of facture in tempera and fine oil painting can be detected by looking at the painting from the wrong angle or in the wrong light; that they are difficult to pick out is itself part of the statement the painting makes. I think the case of fresco is different because in *buon fresco* (in which facture disappears in the absorptive process of chemical bonding with wet *intonaco*), the most visible traces tend to be those of the *giornate*, the patches that record the work done in discrete sessions of painting, and I don't yet see how giving these patches representational status would enable them to modify the meaning of the image.

3. RRP, 2.232.

Chapter 19: Specular Fictions in Two Etchings

1. J. M. Nash, "Speculating on Rembrandt," *Art History* 12 (1989): 240.

2. The sources of these views are: (1) the traditional title, and also Kenneth Clark, *An Introduction to Rembrandt* (New York: Harper and Row, 1976), 21; (2) Svetlana Alpers, *Rembrandt's Enterprise: The Studio and the Market* (Chicago: University of Chicago Press, 1988), 115; (3) Nash, "Speculating," 240; (4) Gary Schwartz, *Rembrandt, His Life, His Paintings* (New York: Viking Press, 1985), 349.

3. The sources here are: (1) David R. Smith, *Masks of Wedlock: Seventeenth-Century Dutch Marriage Portraiture* (Ann Arbor, Mich.: UMI Research Press, 1982), 138; (2) Eva Ornstein–van Slooten, *Rembrandthuis Amsterdam*, guide to the Rembrandt collection, trans. E. Willems-Treeman (Amsterdam: De Volharding, 1977), 8; (3) Alpers, *Rembrandt's Enterprise*, 67; (4) Nash, "Speculating," 240. H. Perry Chapman thinks he is drawing with his left hand and speculates that he may have drawn the portrait on paper before transferring it to the plate. "Or perhaps," she adds, "he wanted the viewer to see him as he saw himself in the mirror, thereby emphasizing that this is a self-portrait" (*Rembrandt's Self-Portraits: A Study in Seventeenth-Century Identity* [Princeton: Princeton University Press, 1990], 158).

4. Nash, "Speculating," 240.

5. Smith, *Masks of Wedlock*, 139–40.

6. A collar similar to that worn by the sitters in Rembrandt's portraits of Jan Six and of the art dealer Abraham Francen.

7. Smith, *Masks of Wedlock*, 139.

8. My reading is based on the second of five states. See Chapman, *Rembrandt's Self-Portraits*, 82–83 for a brief account of the changes from state to state.

9. Nash, "Speculating," 240.

10. "Most likely he is drawing not on loose sheets of paper but on a copper plate, which we cannot see and which rests on a folded cloth and a thick book" (Chapman, *Rembrandt's Self-Portraits*, 158).

11. Nash, "Speculating," 240.

12. Since I view the interplay of these alternatives as an oscillatory ambiguity rather than a paradox, I can even imagine an interpretation that produces a hybrid: the sitter portrays himself portraying the imaginary observer (who stands near the mirror), and the act of portrayal yields two different images, of which we see only one. Such absurdities can easily be multiplied beyond necessity; perhaps this fantasy should be razed.

Chapter 20: Married, with Peacock: Saskia in Rembrandt's
Looking-Glass Theater

1. Christian Tümpel, with Astrid Tümpel, *Rembrandt*, trans. Edmund Jephcott and others (Antwerp: Fonds Mercator, 1993; orig. pub. 1986), 116.

2. David R. Smith, *Masks of Wedlock: Seventeenth-Century Dutch Marriage Portraiture* (Ann Arbor, Mich.: UMI Research Press, 1982), 137. For a thorough and compact survey of the prodigal son motif, see H. Perry Chapman, *Rembrandt's Self-Portraits: A Study in Seventeenth-Century Identity* (Princeton: Princeton University Press, 1990), 114–20.

3. Smith, *Masks of Wedlock*, 138.

4. Chapman, *Rembrandt's Self-Portraits*, 114.

5. Jakob Rosenberg, *Rembrandt: Life and Work*, 3d ed. (London: Phaidon, 1968), 23.

6. Ludwig Goldscheider, *Rembrandt: Paintings, Drawings, and Etchings*, 2d ed. (London: Phaidon Press, 1964), 164.

7. Christopher White, *Rembrandt and His World* (New York: Viking Press, 1966), 32–34.

8. Diane Kelder, *Rembrandt* (New York: McGraw Hill, 1970), 13–15.

9. Seymour Slive, *Dutch Painting 1600–1800* (New Haven: Yale University Press, 1995), 63.

10. Robert Wallace, *The World of Rembrandt* (New York: Time-Life Books, 1968), 66.

11. Horst Gerson, *Rembrandt Paintings*, trans. Heinz Norden (New York: Reynal and William Morrow, 1968), 56.

12. Kenneth Clark, *An Introduction to Rembrandt* (New York: Harper & Row, 1978), 73.

13. Jakob Rosenberg and Seymour Slive, in Rosenberg, Slive, and E. H. ter Kuile, *Dutch Art and Architecture: 1600–1800* (Harmondsworth, Middlesex: Penguin Books, 1967), 55.

14. Chapman, *Rembrandt's Self-Portraits*, 114, 119.

15. Leonard J. Slatkes, *Rembrandt* (New York: Abbeville Press, 1980), 46.

16. RRP, 3.146–47.

17. Quoted by Madlyn Kahr, "Rembrandt and Delilah," *Art Bulletin* 55 (1973): 257. See Carl Neumann, *Rembrandt* (Berlin: W. Spemann, 1905), 1:73.

18. Richard Helgerson, "Soldiers and Enigmatic Girls: The Politics of Dutch Domestic Realism, 1650–1672," *Representations* 58 (Spring 1997): 51.

19. See the detailed technical description in RRP, 3.136–42, and the commentary that follows on pp. 142–46.

20. Smith, *Masks of Wedlock*, 152.

21. See, for example, Esaias van de Velde's *Fête Champêtre* of 1615, which also features the raised glass, the white plume, and the intimate tangle of bodies and limbs.

22. Chapman, *Rembrandt's Self-Portraits*, 117. In *Romola*, George Eliot describes the "crowning glory of a well-spread table" at the supper in the Rucellai gardens: "a peacock cooked according to the recipe of Apicius for cooking partridges, namely, with the feathers on, but not plucked afterwards, . . . [and] so disposed on the dish that it might look as much as possible like a live peacock taking its unboiled repose. . . . In fact, very little peacock was eaten; but there was the satisfaction of sitting at a table where peacock was served up in a remarkable manner, and of knowing that such caprices were not within reach of any but those who supped with the very wealthiest of men." (*Romola*, ed. Andrew Sanders [Harmondsworth: Penguin Books, 1980], 412–13. I'm grateful to Beth Pittenger for bringing this passage to my attention.) The passage from Horace is present in Eliot: "Tito quoted Horace and dispersed his slice in small particles over his plate" (412).

23. Kahr, "Rembrandt and Delilah," 258.

24. Alpers, *Rembrandt's Enterprise*, 40–41.

25. Christopher White—see note 7 above.

26. Helgerson's historical thesis leads him to focus on genre paintings of the 1650s and 1660s, but, as we saw in Chapter 11, the motif of domestic invasion by solders and bravos spoke as well to such earlier concerns as the danger of insufficiently occupied soldiers in unoccupied cities during the years of the Truce.

27. Schwartz, *Rembrandt*, 189.

28. Ibid., 76–77, based on the Dutch translation of Huygens's Latin by A. H. Kan and L. Schwartz. On Huygens, the secretary of Prince Frederick Henry, see Schwartz, *Rembrandt*, 72–77.

29. Alpers, *Rembrandt's Enterprise*, 142. Alpers suggests that the painting "could be Rembrandt's view" of the incident involving his libel suit against the gossip of Saskia's relatives (142). Even if "could be" were changed to "could represent," the suggestion still treats the painting as a "document" parallel to, and reinforcing, the text of the legal document. I would prefer to keep the two documents more completely insulated from each other in order to maintain

interpretive equity between them—in order, that is, to allow an interpretation of the painting to proceed unprejudiced by its context before it is recoupled to the context as a comment on the libel suit.

30. Smith, *Masks of Wedlock*, 140.

31. Ibid., 140. Alpers doesn't agree that the etching is a testimony to friendship (see *Rembrandt's Enterprise*, 67, 142), and—for the reasons cited in the preceding chapter—neither do I.

32. Simon Schama, "Wives and Wantons: Versions of Womanhood in 17th Century Dutch Art," *The Oxford Art Journal* 3.1 (April 1980): 12–13.

33. Schwartz, *Rembrandt*, 192.

34. Schama, "Wives and Wantons," 13.

35. Alpers, *Rembrandt's Enterprise*, 56.

36. Kenneth Clark, *Rembrandt and the Italian Renaissance* (New York: New York University Press, 1966), 137–38.

37. Julius S. Held, *Rembrandt's 'Aristotle' and Other Rembrandt Studies* (Princeton: Princeton University Press, 1969), 97. On the authenticity of the attribution to Rembrandt, see Held's brief bibliographical note, p. 85, n.1. See pp. 85–93 for Held's assessment of the documentary evidence, which both supports the attribution and testifies to the general agreement, from Rembrandt's time on, that the figure is indeed (as its iconography suggests) Juno. Gary Schwartz observes, a little tendentiously, that the painting "bears a closer resemblance to a sixteenth-century *St. Catherine Enthroned* after Quentin Massys than to any of the sources yet cited" (Gary Schwartz, *Rembrandt, His Life, His Paintings* [New York: Viking Press, 1985], 314).

38. Held, *Rembrandt's 'Aristotle,'* 85.

39. See, for example, figures 24–27. These are the very paintings, we recall, that Rembrandt's contemporaries disapproved of and that Gary Schwartz doesn't like in part because they evoke such sentiments as Held's.

Chapter 21: Methodological Interlude IV: On Revisionary Allusion—Rembrandt Against the Italian Renaissance

1. Aloïs Riegl, Das *Holländische Gruppenporträt* (Vienna: Österreichische Staatsdruckerei, 1931; orig. pub. 1902), 180.

2. On this distinction see Richard Wollheim's discussion of "borrowing" in *Painting as an Art* (Princeton: Princeton University Press, 1987), chapter 4, esp. 187–90. See Chapter 16 note 11 above for a mild critique of Wollheim's reliance on a psychologistic lexicon.

3. The threat posed by the precursor that refuses to remain remaindered has been exhaustively investigated by Harold Bloom in his applications of Oedipal conflict theory to literary history. Derrida sublates the problematic of the remainders produced by the *Aufhebung* in his interpretations of the logics of *différance* and supplementarity. On the general Derridean response to the

problematic of the *Aufhebung*, see the illuminating footnote by Alan Bass in his translation of Derrida's "Différance," in *Margins of Philosophy*, trans. Alan Bass (Chicago: University of Chicago Press, 1982), 19–20. For Derrida's reading of the Hegelian concept via his *Aufhebung* of Bataille's reading of the concept, see "From General to Restricted Economy: A Hegelianism Without Reserve," in *Writing and Difference*, trans. Alan Bass (Chicago: University of Chicago Press, 1978), 251–77. For a brilliant discussion of the *aufgehoben* as remainder in literary history, see Julia Lupton, *Afterlives of the Saints: Hagiography, Typology, and Renaissance Literature* (Stanford: Stanford University Press, 1996), xvii–xxiii and passim.

4. Kenneth Clark, *Rembrandt and the Italian Renaissance* (New York: New York University Press, 1966), 3.

5. Ibid., 144.

6. Clark notes that he uses the terms "classic" and "Baroque" in a "stylistic rather than a chronological sense" (ibid., 28, 22–24), following the distinctions developed by Heinrich Wölfflin. See, for example, Wölfflin's *Renaissance und Barock* (Munich: T. Ackerman, 1888) and *Kunstgeschichtliche Grundbegriffe* (Munich: F. Bruckmann, 1915). I will return to Wölfflin below. "Classic," for Clark, denotes an art that "aims at clarity and economy, both in presentation of subject and in design" (28). Though the word "classicism . . . implies a connection with the art of Greece and Rome," the style recurs through the history of European art, and one of Clark's interests is to determine "how far Rembrandt's classicism was absorbed through the Renaissance, and how far he was inspired directly by works of art of Graeco-Roman antiquity" (76).

7. Clark, *Rembrandt and the Italian Renaissance*, 96. In this book, Clark designates the titles of Rembrandt paintings only by capitalizing first letters. He uses neither italics nor quotation marks. Italics are reserved for foreign titles (as in the Raphael painting mentioned above and the titles of Shakespeare's plays). I follow his style in my citations from his book but not in my mentions of titles he discusses.

8. The etchings are most conveniently available in Gary Schwartz, ed., *Rembrandt: All the Etchings Reproduced in True Size* (London: Oresko Books, 1977). "B" designates Adam Bartsch, whose 1797 catalogue supplies the numbering Schwartz uses. There is no pagination in Schwartz's edition, only Bartsch numbers. The titles are approximate—those given by Clark and Schwartz vary insignificantly—and Schwartz gives no information on their provenance except to note that he usually provides "the traditional title." Ideally, titles should cooperate with their images as they do in the mixed-media genre of emblem books.

9. Kenneth Clark, *The Nude: A Study in Ideal Form* (Garden City, N.Y.: Doubleday Anchor, 1959; orig. pub. 1956).

10. Clark, *Rembrandt and the Italian Renaissance*, 11.

11. Clark, *Nude*, 23.

12. Margaret Miles, *Carnal Knowing: Female Nakedness and Religious Meaning in the Christian West* (New York: Vintage Books, 1991; orig. pub. 1989), 13–14.

13. Clark, *Nude*, 439.

14. Clark, *Rembrandt and the Italian Renaissance*, 10–11. Given the clarity and usefulness of Clark's distinction between nudity and nakedness, I find it odd that in Ann Jensen Adams, ed., *Rembrandt's* Bathsheba Reading King David's Letter (New York: Cambridge University Press, 1998), this etching is entitled and discussed as *Nude Woman Seated on a Mound*.

15. Whatever the range of opinions Rembrandt's contemporaries may have entertained about the female body and its representational conventions, the two that have been preserved and continually re-cited—those of Jan de Bisschop in 1671 and Andries Pel in 1681—agree with Clark in taking a dim view of Rembrandt's anti-classicizing "naturalism." See Clark, *Rembrandt and the Italian Renaissance*, 12, and Ann Jensen Adams, "Introduction: Perspectives on Rembrandt and His Works," in Adams, ed., *Rembrandt's* Bathsheba, 7–8.

16. And rendered more moving by Mieke Bal's sensitive analyses of the different relations to the observer constructed by this and several other drawings of naked women. See Mieke Bal, *Reading "Rembrandt": Beyond the Word-Image Opposition* (Cambridge: Cambridge University Press, 1991), 141–48.

17. Svetlana Alpers notes the emphasis in this etching "on modeling itself as a demanding act": "The Painter and the Model," in Adams, ed., *Rembrandt's* Bathsheba, 156.

18. Of the sitters in both etchings, Eric Jan Sluijter asserts that they "appear to be undressed not because they function as nude models, but because they are bathing in the countryside." But if one agrees, as I do, with the opinion cited in the preceding note, the disjunction makes no sense. The woman is posing naked in the countryside. Sluijter argues that because the second figure is "transformed into a Diana" by the inclusion of the quiver, "the associations with illicit spying . . . [become] more pronounced" (Sluijter, "Rembrandt's Bathsheba and the Conventions of a Seductive Theme," in Adams, ed., *Rembrandt's* Bathsheba, 62). This makes the sitter's attitude all the more interesting because, although she appears to be blandly and patiently attentive to a "demanding" pose (Alpers) in one perspective, in the other she may be interpreted as having just noticed the voyeur and turned protectively away toward her weapons.

19. Many Rembrandt portraits of undressed women center on the feint toward and critique of nudity, both appealing to and interrogating voyeuristic desire (or its puritanical repression). The paintings of Bathsheba, Danae, and Susanna have been read in these terms. The 1630 *Andromeda* in the Maurits-huis performs the same set of moves. It is a very small painting—only 13.58 by 9.84 inches. Ample Andromedas had been chained to their rocks in much

larger paintings by Titian (68.9 by 75.6 inches) and Rubens (72.4 by 76.4 inches). Rembrandt's figure is shorter and rounder in proportion, but it is at first glance a quotation of nudity. The piece of drapery loosely encircling or slipping down from her hips is a touch of classical chic. Yet if the desaturated skin tones remind observers of marble or creamy flesh, the harsh light raking the body makes the marble glare rather than glow. The result is that what in another context would be a classicizing tone is here transformed into pallor, the signifier of fear. Andromeda's head and arms are twisted, her breasts uplifted, to show the strain of being manacled. The motif is familiar enough so that we know what isn't being shown. The conspicuous exclusion of both Perseus and the monster demands the observer to imagine a context for her look of fear. From what does she flinch? The approach of the monster? The battle? The approach of the triumphant Perseus? *Is* this Andromeda? Is it the demythologizing picture of a model rehearsing her Andromeda role (the equivalent of a preparatory oil sketch)? Or is it a smartly half-clad naked woman manacled for display as a nude and not too happy about it? For comments on the *Andromeda*, see Sluijter, ibid., 66–69, and for a varied set of responses to the interplay of nakedness with nudity in the 1654 Louvre *Bathsheba* and other images of women by Rembrandt, see Adams, ed., *Rembrandt's* Bathsheba, passim.

20. Whether the shock of revulsion arcs from Rembrandt through the painting to Clark or the other way round is undecidable. Perhaps that's only the standard dilemma of the hermeneutic circle, but I doubt it. The rhetoric of intentionality is what gets Clark in trouble, or at least in trouble with me. It also gets him in trouble with Gary Schwartz, and the following episode instructively highlights the problems that lurk in two competing modes of intentional criticism, one directed toward the painter and the other toward the patron.

Schwartz emphatically dismisses Clark's aesthetico-moral reading of the *Ganymede* because it ignores the context of patronage that alone—in Schwartz's version of reception theory—controls the range of possible interpretation. He gives two reasons why the *Ganymede* couldn't possibly express Rembrandt's "protestant-Christian revulsion against" homosexuality. First, since the only other "bare-bottomed baby Ganymede in Dutch art" is reproduced in a de Hooch genre scene as "the mantelpiece painting in a high-class brothel," those who saw it are "likely to have taken it as a joking apology for pederasty," therefore "not everyone in Holland" shared the revulsion Clark displaces to Rembrandt. This is a good point because it allows some Dutch observers to appreciate the lighter-spirited if heavier-handed effect of parody in Rembrandt's *Ganymede* than the one Clark notes. Schwartz's second reason is, to put it euphemistically, less compelling: "one of the three collectors in Utrecht to have owned a painting by Rembrandt" also owned an Italian treatise, "objected to by many Papists, on temperate sodomy." This doesn't

prove that the collector "was a homosexual or that Rembrandt painted *Ganymede* for him. What it does show is how vital the identity of the patron can be to the understanding of a work of art" (Schwartz, *Rembrandt, His Life, His Paintings* [New York: Viking Press, 1985], 128).

21. Clark, *Rembrandt and the Italian Renaissance*, 2, 96, 99, 144, 2. As my citations of Clark indicate, his use of capitalization is inconsistent, and he gives no clue as to why the *m* is lower-case in three incidences of the name of the ocean and upper-case in one.

22. Richard Helgerson, *Forms of Nationhood: The Elizabethan Writing of England* (Chicago: University of Chicago Press, 1992), 23.

23. Ibid., 296; for a compact summary of the thesis, see 295–97. To these hierarchic polarities we may add Latin vs. vernacular, and, in Plantagenet England, French vs. English. See Helgerson, 29–30, for an interesting comment on linguistic polarity.

24. Tacitus, *Germania*, in *Cornelii Taciti Opera Minora*, ed. M. Winter-bottom and R. M. Ogilvie (London: Oxford University Press, 1975). Future references in the text are to section numbers in this edition. The same section numbers are used in the bilingual Loeb Library edition and in the Library of Liberal Arts translation, *Tacitus: Agricola, Germany, Dialogue on Orators*, trans. Herbert W. Benario (Indianapolis: Bobbs-Merrill, 1967).

25. *Germania* appeared in 98 A.D., after the death of Domitian. Other classical authors who preceded Tacitus also, of course, contributed to the discourse—the geographers Strabo and Pomponius Melo, Julius Caesar, Pliny the Elder, Martial, Lucan, and Seneca, to name only a few—but no one had presented so detailed an anthropology with such epigrammatic power, hence the form given the discourse by Tacitus was definitive for subsequent ages. In addition, the project of displacement produced the outlines of the ideal of the "noble savage" that would appeal to German humanists in the Renaissance.

26. Scott Davis has suggested to me that *Germania* stages a reversal of Benjamin's "any document of civilization is at once a document of barbarism" (personal communication).

27. Tacitus is nothing if not umbrageous about the origin, reference, and extension of the name *German*. The fictiveness of a single autochthonous *natio* is suggested in section 2 and gets more conspicuous in the last eighteen of *Germania*'s forty-six sections, which consider differences among the customs and origins of various individual peoples (*singularum gentium*). In section 2, after speculating that "the Germans themselves" were indigenous and minimally affected by intermingling with other peoples, he launches into an explanation of the name that undercuts or at least obfuscates the claim. The passage is so slippery it has been considered a textual crux and frequently revised. See 2.13–18 in the Oxford text, whose editors call the passage a "locus conclama-tus" (*Opera Minora*, 38).

28. *Tacitus*, trans. Benario, 44; 9.6–10 in the Oxford lineation.

29. The cultural impact of urban development was more recent in the northern plains and forests of Europe, its tempo was more rapid, it was informed by a sharper split between town and country, and it was superimposed on a more vivid cultural memory of the tribal past and of life lived, in T. S. Eliot's words, "On the edge of a grimpen, where is no secure foothold, / And menaced by monsters, fancy lights, / Risking enchantment" (*Four Quartets,* "East Coker"). Relative to the continuity of the Mediterranean epoch of urbanism, going back at least to Jericho in the eighth millennium B.C.E., the Germans were projected into urbanism so rapidly, dramatically, and brilliantly that they never lost their sense of its alien and anomalous relation to what they felt or had been told was their indigenous tribal state. They always retained their self-image as *das Volk.* The mystical conception of a folk-soul, the organic myth of a transcendental group mind, appealed to the Romantics as a national Idea and to the Nazis as a strategy.

Vasari attributed Gothic architecture to the rude barbarians and Germans who conspired with Christianity to destroy the classical style indigenous to Mediterranean culture. "Scholarship on the Gothic" during the nineteenth century "focused on a Germanic culture from the dawn of history, seducing many . . . into believing that Gothic architecture had something to do with the ancient Goths" (Hans Belting, *The Germans and Their Art: A Troublesome Relationship,* trans. Scott Kleager [New Haven: Yale University Press, 1998], 27).

30. See, for example, the texts collected in Gerald Strauss, ed. and trans., *Manifestations of Discontent in Germany on the Eve of the Reformation* (Bloomington: Indiana University Press, 1971), especially selections 6–10. For a useful survey, see Frank L. Borchardt, *German Antiquity in Renaissance Myth* (Baltimore: The Johns Hopkins University Press, 1971), and, for more detail, see *inter alia* Ulrich von Hutten et al., *Letters of Obscure Men,* trans. Francis Griffin Stokes (Philadelphia: University of Pennsylvania Press, 1972; orig. pub. 1909), and Hajo Holborn, *Ulrich von Hutten and the German Reformation,* trans. Roland H. Bainton (New York, Harper & Row, 1966; orig. pub. 1937). *Germania,* which was printed in Venice in 1470 and in Nuremberg in 1473, first appeared in Italy in 1455.

31. F. M. Dostoevsky, *The Diary of a Writer,* trans. Boris Brasol, 2 vols. (New York: Scribner's, 1949), 2: 26.

32. The revolt of Julius Claudius Civilis is the subject of the most Northern of Rembrandt's paintings, now housed, appropriately, in Sweden.

33. Erasmus, *Adagiorum Chiliades,* 4.6.35, from the 1508 edition; trans. Margaret Mann Phillips in *Erasmus in His Times: A Shortened Version of the Adages of Erasmus* (Cambridge: Cambridge University Press, 1967), 32–33, my italics.

34. Heinrich Wölfflin, *The Sense of Form in Art: A Comparative Psychological Study,* trans. Alice Muehsam and Norma A. Shatan (New York: Chelsea Publishing Company, 1958); *Italien und Das Deutsche Formgefühl* (Munich:

F. Bruckmann 1931). Art historians who refer to Wölfflin's work often seem embarrassed by this book, or at least they don't mention it. It's interesting that the 103 entries for Wölfflin listed on-line in the University of California catalogue include copies of the translation only, not of the original German text. Hans Belting devotes a few pages to Wölfflin and a sentence or two to *The Sense of Form in Art* in the context of a more general critique of "Art Historians and the 'German Question'" (*The Germans and Their Art*, 52). For my purposes, the most interesting aspect of Belting's essay is not merely the durability of the barbarian self-understanding derived from Tacitean discourse but the empirical level of scholarly debate at which the Tacitean bipolarity is engaged.

35. See Heinrich Wölfflin, *Principles of Art History*, translated by M. D. Hottinger (New York: Dover Publications, 1932) from the seventh German edition of *Kunstgeschichtliche Grundbegriffe* (Munich: F. Bruckmann, 1929); the first edition appeared in 1915. For Wölfflin's developmental account of Italian Renaissance art and ideals of beauty, see *Die klassische Kunst: Eine Einführung in die italienische Renaissance* (Munich: F. Bruckmann, 1899), translated by Peter and Linda Murray from the eighth German edition (1948) as *Classic Art: An Introduction to the Italian Renaissance* (London: The Phaidon Press, 1952).

36. Wölfflin, *Sense of Form in Art*, 87. The flutes of white marble gleam against the shades of the Black Forest.

37. Ibid., 18. It is no doubt for this reason that Wölfflin uses the term *Italian* rather than the broader concept *Mediterranean*, invoked by Clark. The examples he uses to illustrate "the principles of Antique art" that Italian art follows (203) are drawn exclusively from ancient Roman art. The absence of references to Greek art is notable, especially since the nude arising from the depths of the Hellenic sense of form first appears on Aegean shores.

38. Wölfflin was born Swiss (in Basel), studied in Munich, and taught in Basel, Berlin, and Munich. According to his theory, his own way of seeing may therefore have been hybrid.

39. See Wölfflin, *Sense of Form*, 222, for a comment on the German's painterly "feeling for the material nature of things" and its opposition to Italy's love affair with space and plastic form: "The more plasticity is emphasized, the more the feeling for matter recedes into the background."

40. Ibid., 228, 184–89, 209–10, 213–14, 218.

41. Michael Podro, *The Critical Historians of Art* (New Haven: Yale University Press, 1982), 83. "Thus," Podro adds, in a comment that suggests a Northern source for the insights of both Riegl and Wölfflin, "Riegl continues in his account of Dutch art an eighteenth-century notion of the sublime and its Hegelian derivative, the notion of painting as an art which imitates a spiritual content for which there could be no adequate sensory realization" (ibid.). On Riegl, see Chapter 13 above.

42. Erwin Panofsky, "Der Begriff des Kunstwollens," *Zeitschrift für*

Ästhetik und allgemeine Kunstwissenschaft 14 (1920): 321–39; "The Concept of Artistic Volition," trans. Kenneth J. Northcott and Joel Snyder, *Critical Inquiry* 8 (1981): 17–33.

43. Wölfflin, *Sense of Form in Art*, 223.

44. *Germania* 9, trans. Benario, 44; my brackets indicate a periphrastic addition on the translator's part. Compare: "neque in ullam humani oris speciem adsimulare ex magnitudine caelestium arbitrantur . . . deorumque nominibus appellant secretum illud quod sola reverentia vident" (9.6–10; *Opera Minora*, 42).

45. Wölfflin, *Sense of Form in Art*, 188.

46. *The Writings of Albrecht Dürer*, trans. and ed. William Martin Conway (New York: Philosophical Library, 1958), 244–45, 247. Originally published in 1889 as *Literary Remains of Albrecht Dürer*. For the original text, see Albrecht Dürer, *Schriftlicher Nachlass*, 3 vols., ed. Hans Rupprich (Berlin: Deutscher Verein fur Kunstwissenschaft, 1956–1969), 3.293, 295. On Panofsky's more or less neo-Kantian analysis of Dürer's statements and their relation to Italian aesthetics and art theory, see Panofsky, *The Life and Art of Albrecht Dürer*, 4th ed. (Princeton: Princeton University Press, 1955), 242–84, especially 274–82.

47. Joseph Leo Koerner, *The Moment of Self-Portraiture in German Renaissance Art* (Chicago: University of Chicago Press, 1993), 187.

48. During a discussion of Hans Baldung Grien's misogynist drawings of witches as examples of the male viewer's "lies and deceptions," Koerner mentions Dürer's assertion that absolute beauty was unavailable to him because of "the lie . . . in our understanding" and offers a more up-to-date explanation in terms of the social construction of gender: "Today, . . . these paradoxes of visual experience seem rather the ironies of an unequal society" produced by "contradictions between, for example, patriarchy's dream of self-sovereignty and the realities of [male] desire" (*Moment of Self-Portraiture*, 356). Wölfflin's alternative—inscribing Dürer's view in the North/South discourse—is ignored but not disabled by this move.

49. Koerner, *Moment of Self-Portraiture*, 172. For Koerner's incisive critique of previous interpretations that minimize the self-portrait's ambivalences, see ibid., 72–79, and for a brief, equally incisive critique of historicist readings, see ibid., 40–42.

50. Ibid., xvi, 90–91. Koerner finds it indicative of "the achieved coherency of Dürer's projects," the "monologism" with which they elicit "all-encompassing interpretations" and direct them to "the unifying terminus of the originary artistic self," that the only "artists' monographs" produced by the formalist Wölfflin and the iconologist Panofsky were on Dürer (238).

51. The Prado self-portrait is a more obvious candidate for analysis in these terms because, as Koerner reads it, it both alludes to and critically revises Dürer's Italian longings (social, cultural, and aesthetic).

52. Martin Luther, "The Pagan Servitude of the Church," trans. Bertram Lee Woolf, in *Martin Luther: Selections from His Writings*, ed. John Dillenberger (Garden City, N.Y.: Anchor Books, 1961), 275. For the reason given above, I prefer the alternative title of this treatise, "The Babylonian Captivity of the Church."

53. Ibid., 263–64.

54. Ibid., 350. In response to the Donatist heresy, which states that if a priest is wicked his ability to transmit the sacrament from God to the worshiper is impaired, Catholic theologians developed the notion of a divine second nature, an indelible character. "Character" in this usage refers not to the priest's "moral qualities" but to "the indelible and unrepeatable stamp that baptism, confirmation, and ordination conferred, regardless of moral qualities." Jaroslav Pelikan, *Reformation of Church and Dogma (1300–1700)*, vol. 4 of *The Christian Tradition: A History of the Development of Doctrine* (Chicago: University of Chicago Press, 1984), 96–97.

55. Luther, "Pagan Servitude," 264–70.

56. Ibid., 270–74.

57. Hans Jantzen, *High Gothic: The Classic Cathedrals of Chartres, Reims and Amiens*, trans. James Palmes (New York: Pantheon Books, 1962), 70.

58. Wölfflin, *Sense of Form in Art*, 21.

59. Luther changed his position later in life and became more conservative—more "Southern"—in acknowledging the need for some sacramental structures mediated through the visible offices of the Church. For a stimulating account that traces his changing relation to the polarity of spirit vs. structure, see Jaroslav Pelikan, *Spirit versus Structure: Luther and the Institutions of the Church* (London: Collins, 1968).

60. Wolfflin's ethnic concept is already in place in this earlier book, published in 1899: the classic art of the High Renaisance is "the natural continuation of the Quattrocento and a completely spontaneous expression of the Italian people." If its monumental forms were used to idealize reality, "the idealizing was the heightening of an essentially Italian reality" (*Classic Art*, xvi).

61. The idealism is almost too conspicuously idyllic, as if *Classic Art* was the author's pastoral retreat from the bitter vision of his predecessor at the University of Basel: in Burckhardt's story, "Renaissance man" sallies forth into an Italy that had "become a school for scandal, the like of which the world cannot show"—sallies forth to join "the crowd of suitable victims, that countless assembly of highly and characteristically developed human beings, celebrities of every kind, . . . all of whom . gave the fullest and freest play to their individuality[.] This host existed in the fifteenth and sixteenth centuries, and by its side the general culture of the time had educated a poisonous brood of impotent wits, of born critics and railers, whose envy called for hecatombs of victims; and to all this was added the envy of the famous men among themselves" (Jakob Burckhardt, *The Civilization of the*

Renaissance in Italy, trans. S. G. C. Middlemore, 3d ed. rev. [London: Phaidon Press, 1950], 98).

62. The Stanza della Segnatura was a library in which the papal tribunal of the seal met to adjudicate matters of canon and civil law.

63. Wölfflin, *Classic Art,* 92–93.

64. Ibid., 89. Wölfflin ascribes the title to Vasari, but John Pope Hennessey notes that although Vasari (in the 1550 edition) describes the figures around the altar writing the Mass and disputing about the host, the actual title dates only to 1610 (John Pope-Hennessey, *Raphael* [New York: New York University Press, 1970], 249 n. 44). S. J. Freedberg reminds us that the fresco portrays not a dispute but a disputation: Freedberg, *Painting in Italy, 1500 to 1600,* rev. ed. (Harmondsworth, Middlesex: Penguin Books, 1975), 54.

65. In the 1908 German edition two details of the fresco on facing pages depict the clusters of figures to the left and to the right of the altar, respectively, and each also contains an image of the altar with the monstrance on it. But the same details in the eighth edition and the English translation based on it omit both the altar with the round host in the monstrance and the fulfillment of its meaning in the amplified heavenly roundels above it. What remains are people who appear to read and talk. Thus the word supersedes the image, and the eighth edition transforms the Northern art historian who genuflects before the Italian commitment to form into a closet protestant performing a de facto act of iconoclasm. Compare *Die klassische Kunst* (Basel: Benno Schwabe, 1948), 102–3 and *Classic Art,* 90–91, to *Die klassische Kunst* (Munich: F. Bruckmann, 1908), 90–91.

66. Pope-Hennessey, *Raphael,* 59.

67. Hajo Holborn, *A History of Modern Germany: The Reformation* (Princeton: Princeton University Press, 1982; orig. pub. 1959), 123–24. For a thoughtful and compendious account of the problems of the papacy in the early sixteenth century, centered on Julius II and Raphael's portrayal of him, see Loren Partridge and Randolph Starn, *A Renaissance Likeness: Art and Culture in Raphael's 'Julius II'* (Berkeley: University of California Press, 1980).

68. Freedberg, *Painting in Italy,* 54–56.

69. In 1890 Rembrandt was claimed for the North as a German by another self-proclaimed German: Julius Langbehn, *Rembrandt als Erzieher, von einem Deutschen* (Leipzig: C. L. Hirschfeld, 1890).

70. Clark, *Nude,* 400. Clark argues that the alternative convention evolved during the later Middle Ages in France, Burgundy, the Low Countries, and, taking a different form under Dürer's influence, in Switzerland and Germany (400–35). Though he describes it as a convention that applies to men and women, most of his comments and illustrations focus on the development of the female of this Gothic species.

71. These strategies are thoroughly canvassed in Schwartz, *Rembrandt, His Life, His Paintings,* passim.

72. Wölfflin, *Sense of Form in Art*, 17.

73. Clark, *Rembrandt and the Italian Renaissance*, 130, my italics.

74. For arrogant externality, nothing beats Titian's marvelous portraits of Doge Andrea Gritti (1535–40) and Vincenzo Capello (1540) in Washington.

75. S. J. Freedberg, "*Disegno* versus *Colore* in Florentine and Venetian Painting of the Cinquecento," in *Florence and Venice: Comparisons and Relations*, vol. 2: *Cinquecento*, ed. Christine Smith with Salvatore I. Camporeale (Florence: La Nuova Italia Editrice, 1980), 320. Such binary oppositions as rough vs. smooth, textural vs. graphic, and *colorito* vs. *disegno* reappear in various contexts: Venetian vs. Florentine, North vs. South, Baroque vs. Renaissance, Dutch vs. Italian, and anticlassicism vs. classicism. I note in passing that oppositions of this sort escape the net cast by Wölfflin's categorical scheme: because his concept of the painterly is keyed more to ways of seeing than to ways of painting, it leads him to abstract painterliness from the material representations of brushwork and paint.

76. Ibid., 310, 313, 314, 315, 315, 319.

77. Carlo Ginzburg, "Titian, Ovid, and Sixteenth-Century Codes for Erotic Illustration," in Ginzburg, *Clues, Myths, and the Historical Method*, trans. John and Anne C. Tedeschi (Baltimore: The Johns Hopkins University Press, 1989), 92–93.

78. Roger Ascham, *The Schoolmaster*, ed. Lawrence V. Ryan (Ithaca: Cornell University Press, 1967), 62–63, 69, 73.

79. Daniel Arasse, "The *Venus of Urbino*, or the Archetype of a Glance," trans. Rona Goffen, in Goffen, ed., *Titian's* Venus of Urbino (New York: Cambridge University Press, 1997), 101–3. I suppose it's obligatory at this point to explain or confess in the face of this painting that we are dealing with a "male gaze."

80. Ginzburg, "Titian, Ovid, and Sixteenth-Century Codes for Erotic Illustration," 80. See, for example, Rembrandt's paintings of Ganymede and Andromeda (discussed above), Europa, Actaeon and Callisto, and the Rape of Proserpina. The *Danae* may be a revisionary allusion of Titian's Danaes, but it is not a parody. Many passages in the series of mythological paintings dated between 1630 and 1636 display the kind of Italianate palette, colorito and chiaroscuro, and handling of paint made popular in the Netherlands by painters from Utrecht and Flanders. Rembrandt dresses the classical motifs in clothing or nudity conspicuous enough to evoke the "Mediterranean" tradition. At the same time, the small scale of the figures in the Actaeon/ Callisto conflation and in the panels depicting the rapes of Proserpina and Europa combine with poses that are not only awkward but also comically exaggerated to produce the effect of parody Clark notes in the *Rape of Ganymede*.

81. Wölfflin, *The Sense of Form in Art*, 17.

Chapter 22: Rembrandt as Courtier

1. Kenneth Clark, *Rembrandt and the Italian Renaissance* (New York: New York University Press, 1966), 123.

2. Kenneth Clark, *An Introduction to Rembrandt* (New York: Harper & Row, 1978), 19.

3. Jakob Rosenberg, *Rembrandt: Life and Work*, 3d ed. (London: Phaidon, 1968), 41. See also Leonard J. Slatkes, *Rembrandt*, Abbeville Library of Art (New York: Abbeville Press, 1980), 60.

4. See, e.g., Clark, *Introduction*, 21; Christopher Brown, *Second Sight* (London: National Gallery, 1980), 3–4; Horst Gerson, *Rembrandt Paintings*, trans. Heinz Norden (Amsterdam: Meulendorf International, 1968), 86, 366.

5. David Rosand, *Painting in Cinquecento Venice: Titian, Veronese, Tintoretto* (New Haven: Yale University Press, 1980), 78. See Rosand's interesting comments on the iconography of the parapet in "The Portrait, the Courtier, and Death," in Robert W. Hanning and Rosand, eds., *Castiglione: The Ideal and the Real in Renaissance Culture* (New Haven: Yale University Press, 1983), 91–129.

6. This is the most interesting aspect of the story indexed by the sketch and its inscription: as H. Perry Chapman notes (*Rembrandt's Self-Portraits: A Study in Seventeenth-Century Identity* [Princeton: Princeton University Press, 1990], 73), Rembrandt converted the image of Castiglione to a self-portrait on the spot, as if the specular thematics was already operating, touched off by the chance to efface and replace both Castiglione and Raphael at a single blow. The pugnacity of the image bespeaks that desire.

7. Chapman thinks this etching is "a kind of pictorial criticism" of the Titian that rejects the sitter's "haughty sidelong glance in favor of a more assertive direct gaze" (ibid.,75). But the gaze is more than assertive and direct; it is impish in its "pictorial criticism" of courtly machismo. The Bad Boy struts his stuff.

8. A distinction applies here that is roughly comparable to the one Kenneth Clark makes between nudity, the embodiment of mimetic idealism, and nakedness, the plight of the poor body stripped of concealing clothes and idealizations.

9. Cecil Gould, *Titian* (London: Hamlyn, 1969), 36; David Rosand, *Titian* (New York: Abrams, 1978), 78; Brown, *Second Sight*, 16–17; Kenneth Clark, *Rembrandt and the Italian Renaissance* (New York: New York University Press, 1966), 125; Gerson, *Rembrandt Paintings*, 336.

10. Loosely translated from Baldinucci's *Cominciato* by Seymour Slive in *Rembrandt and His Critics, 1630–1730* (The Hague: Martinus Nijhoff, 1953), 113.

11. Rosand, *Titian*, 78.

12. David Bomford, Christopher Brown, and Ashok Roy, *Art in the Making: Rembrandt* (London: National Gallery, 1988), 84.

13. Jacques Lacan, *Écrits: A Selection*, trans. Alan Sheridan (New York: Norton, 1977), 4.

14. Ibid., 2.

15. Joan Copjec, *Read My Desire: Lacan Against the Historicists* (Cambridge: MIT Press, 1994), 37.

Chapter 23: Rembrandt in Chains: The Medici Self-Portrait

1. Julius S. Held, *Rembrandt's "Aristotle" and Other Rembrandt Studies* (Princeton: Princeton University Press, 1969), 35, 43–44. The whole discussion is instructive (32–44), especially the brief reference to the negative value attached to gold in More's *Utopia* (35). For an account of this inverse valuation that may have some bearing on Rembrandt's use of gold chains, see my "Utopian Folly: Erasmus and More on the Perils of Misanthropy," in Berger, *Second World and Green World: Studies in Renaissance Fiction-Making*, ed. John Patrick Lynch (Berkeley: University of California Press, 1988), 247.

2. H. Perry Chapman, *Rembrandt's Self-Portraits: A Study in Seventeenth-Century Identity* (Princeton: Princeton University Press, 1990), 54; Svetlana Alpers, *Rembrandt's Enterprise: The Studio and the Market* (Chicago: University of Chicago Press, 1988), 67–69.

3. Alpers, *Rembrandt's Enterprise*, 68.

4. Chapman, *Rembrandt's Self-Portraits*, 53–54.

5. Ibid., 130; Ernst van de Wetering, *Rembrandt: The Painter at Work* (Amsterdam: Amsterdam University Press, 1997), 281 and 265–81 passim.

6. Chapman, *Rembrandt's Self-Portraits*, 130. Jakob Rosenberg, who judges the sitter's mood to be "gloomy," also comments on the "ornate costume," which, together with the "broad frontal arrangement," reminds him of "Renaissance portraits of the time of Mabuse and Holbein" (*Rembrandt: Life and Work*, 3d ed. [London: Phaidon, 1968], 53–54).

7. Kenneth Clark, *An Introduction to Rembrandt* (New York: Harper and Row, 1978), 35.

8. Varying degrees of containment, or of rapprochement between the mask of seniority and the naked face of senility, may be illustrated by the following examples. Their numbers refer to A. Bredius, *Rembrandt: The Complete Edition of the Paintings*, rev. H. Gerson (London: Phaidon, 1968). Among early histories and portraits, see *St. Paul in Prison* (Bredius 601), *Jeremiah Lamenting the Destruction of Jerusalem* (Bredius 604), and *An Old Woman Reading* (Bredius 69), the double portrait of Jan Rijksen and Griet Jans (Bredius 408), and the pendants of Johannes Elison and Maria Bockenoll (Bredius 200 and 347). Among portraits of the 1640s and after, see the 1645 portrait of an old man (Bredius 236), *The Apostle Paul* of the 1650s (Bredius 297), the portrait of Dirck van Os (Bredius 315), and the pendants of Jacob Trip and Marguerite de Geer (Bredius 314 and 394). Among the self-portraits of the 1650s and 1660s,

see those dated 1652 (Bredius 42), 1655 (Bredius 49), 1657 (Bredius 48), 1658 (Bredius 50, discussed in Chapter 24 below), 1659 (Bredius 51), 1660 (Bredius 54), ca. 1661–62 (Bredius 52, discussed in Chapter 25 below), and 1669 (Bredius 61, discussed in Chapter 26 below).

9. As often in Rembrandt's late portraits, the effect of the mask is accentuated by a severe and sharply demarcated hairline.

10. Christopher Wright, *Rembrandt Self-Portraits* (New York: The Viking Press, 1982), 33.

11. Alpers, *Rembrandt's Enterprise*, 68.

Chapter 24: Rembrandt in Venice: The Patriarch

1. I borrow this idea from H. Perry Chapman, who notes the self-portrait's "unprecedented grandeur" and "patriarchal quality": *Rembrandt's Self-Portraits: A Study in Seventeenth-Century Identity* (Princeton: Princeton University Press, 1990), 90.

2. Gary Schwartz, *Rembrandt, His Life, His Paintings* (New York: Viking Press, 1985), 350.

3. Chapman, *Rembrandt's Self-Portraits*, 91, 98. Horst Gerson, *Rembrandt Paintings*, trans. Heinz Norden (Amsterdam: Meulendorf International, 1968), 106, made the connection between mahlstick and cane; he added that the Patriarch's beret becomes "his crown."

Chapman describes the cane as silver-knobbed and situates it in the sitter's left hand. Though I can't see the knob as silver, it does evoke a mahlstick, which, in Rembrandt's four painted images of it (Boston, Paris, London, Cologne), is also knobbed. There is no such knob on Jacob Trip's cane nor on that of Dirck van Os, Rembrandt's other cane-bearing sitter (if, as Gerson doubts, Rembrandt painted this portrait).

As to which hand holds the cane, it is left only if one interprets the image as the painting subject rather than the specular object the subject gazes at. The painting tends rather to obfuscate than enlighten on this point: the illuminated hand is smaller, the larger hand holding the symbolic object is in shadow, but if the object symbolizes a mahlstick, presumably it belongs in the left hand of a right-handed painter.

4. Chapman, *Rembrandt's Self-Portraits*, 93–94, 91.

5. Chapman's genetic account of Rembrandt's development is in fact inconsistent. The thesis about his fashioning himself "not as an honored gentleman but as an artist of Honor" during the 1630s, when he emulated Rubens (ibid., 68–69), is later repeated as if it described a new development in the 1640s (97). The need to fill out the narrative of self-quest and self-discovery drives Chapman's story of the career, and imposes itself on the particular interpretations that provide the evidence of that story.

6. Chapman herself notes that both paintings are formal and dignified

(ibid., 77, 94), and that in both "Rembrandt looked beyond his immediate milieu for a standard against which to measure himself" (95). The chief motive for her insistence on the differences between the Courtier and the Patriarch lies less in formal considerations than in her story of Rembrandt's career of continual self-transformation and emergent independence. The Patriarch's vaunted air of autonomy and majesty is usually treated as an oppositional response to bankruptcy (which is the reason behind Chapman's emphasis on independence). As Pascal Bonafoux pithily puts it, "Rembrandt bankrupt; Rembrandt pontiff" (*Rembrandt: Self-Portrait* [New York: Rizzoli, 1985], 112).

7. Chapman, *Rembrandt's Self-Portraits*, 94, 91.

8. Ibid., 89. Kenneth Clark, *Rembrandt and the Italian Renaissance* (New York: New York University Press, 1966), 123–30.

9. Clark, *Rembrandt and the Italian Renaissance*, 130.

10. Chapman, *Rembrandt's Self-Portraits*, 92. Both Chapman (92–94) and Clark (130) are careful to qualify their accounts of Rembrandt's debt and similarity to Venice and Titian. I note in passing that the terms Chapman uses on p. 92 to describe Rembrandt's relation to Titian don't clearly differentiate influence from allusion. Terms and phrases like "assimilation," "he drew . . . on Venetian painting techniques," "affinities with . . . Titian's late works," tilt toward influence and are at best noncommittal about the difference. The verb "approximate" in the passage quoted above is initially noncommittal but draws decisively toward allusion when Chapman adds that the Frick self-portrait "seems intentionally to imitate . . . Titian's limited color scheme."

11. Ernst van de Wetering, *Rembrandt: The Painter at Work* (Amsterdam: Amsterdam University Press, 1997), 164–65.

12. Ibid., 162–65.

13. "Pictorial criticism" is Chapman's term (*Rembrandt's Self-Portraits*, 75).

14. Svetlana Alpers, *Rembrandt's Enterprise: The Studio and the Market* (Chicago: University of Chicago Press, 1988), 15, 126–27. Alpers acknowledges van de Wetering's earlier work through the RRP volumes. Most of his subsequent publications postdated *Rembrandt's Enterprise*, and in the work he published during the 1990s he does not mention, much less examine or criticize, her argument. Like Alpers, however, he acknowledges the important work of Gridley McKim-Smith, "Writing and Painting in the Age of Velazquez," in McKim-Smith et al., *Examining Velazquez* (New Haven: Yale University Press, 1988), 1–33.

15. Van de Wetering, *Rembrandt*, 169–79.

16. Alpers, *Rembrandt's Enterprise*, 72, 73, 75. Note how the consistent use of the past tense in these passages keeps attention focused on genetic inferences and a speculative scenario about Rembrandt's desire and practice in the past. The scenario is then installed as an interpretive *donnée* governing our response to "the look of" Rembrandt's paintings today. This is not, however, an arbitrary or purely deductive decision. "We have ample evidence," she writes, "from his 'teaching' drawings to the great majority of his late paintings, that it was the

model in the studio, not the art of the past, that Rembrandt wanted before his eyes" (77). My chief quarrel with her interpretation of this evidence is that she insists on an either/or construal whereas I prefer a more ambivalent both/and construal.

As exceptions that prove her rule, Alpers cites the Courtier and Rembrandt's "repeated use of the table motif of Leonardo's Last Supper," noting of the latter that "[t]he viewer is meant to recognize the source and perhaps even see Rembrandt's use of it in a competitive vein" (73). During this discussion she mentions Clark's *Rembrandt and the Italian Renaissance* but doesn't deal with the contrary argument he develops in its first four chapters, which focus on Rembrandt's conscious borrowing from Florentine and Venetian art.

17. James Elkins reminds us that "oil painting methods have always been semi-secret, like alchemical recipes," so that "when certain ways of painting went out of fashion, the methods tended to be forgotten along with them." Among the victims of such losses was "the famous Venetian technique practiced by Titian, Giorgione, Veronese, and Cima: it died slowly over several generations as painters used methods that were less and less like the original techniques" (Elkins, *What Painting Is: How to Think about Oil Painting, Using the Language of Alchemy* [New York: Routledge, 1999], 170–71). The challenge for Rembrandt, who (unlike Dürer) didn't make the Italian journey, could well have been to represent the representational effects of the Venetian technique without actually using it—to produce the effects of numerous blended glazes via the very different technique described by van de Wetering as the "interaction of sharp and blurred elements" (*Rembrandt*, 220–22). For different reasons, both Elkins (*What Painting Is*, 171–73) and van de Wetering (*Rembrandt*, 194–95) have criticized Max Doerner for what the latter calls his "glazing-myth," but the question remains whether one can speak of a fiction or quotation of glazing technique, an effect of glazing. See Max Doerner, *The Materials of the Artist, and Their Use in Painting with Notes on the Techniques of the Old Masters*, trans. Eugen Neuhaus (New York: Harcourt, Brace, 1934), 344–48.

18. Alpers, *Rembrandt's Enterprise*, 77. To be fair to Alpers, her emphasis on Rembrandt's autonomy is part of a more general quarrel with "[t]he normal working assumption of the historian of Renaissance art who looks for sources"—the assumption, which she calls "the law of imitation," that one can trace "a mode of picture-making and a tradition" only by examining the artist's sources. She finds it "characteristic of art historians . . . that they offer no alternative" to this law, which, she insists, doesn't hold for Rembrandt: "a large number of the sources that have been cited for works by Rembrandt are not compelling, not because Rembrandt did not look at earlier art, but because he did not declare or reveal his model" (73).

19. Titian's half-length portraits of Ranuccio Farnese in Washington and of the sitter known as the "Young Englishman" in Florence (Palazzo Pitti) play

subtle variations on full frontality, as does Rembrandt in the portrait of the Pa-
triarch, the effect of whose laterally expanding figure resembles that produced
by Titian in several of the ducal and ecclesiastical portraits mentioned above.

20. Clark, *Rembrandt and the Italian Renaissance*, 130, my italics.

21. "Some Vanity of His Art: Conspicuous Exclusion and Pastoral in
Vermeer," in Berger, *Second World and Green World: Studies in Renaissance Fiction-
Making*, ed. John Patrick Lynch (Berkeley: University of California Press,
1988), 462–509. Prospero's reluctance to abandon the pleasurable power of his
magic art and return to the uncertain world of ducal politics reaches a climax
in his decision to present the masque celebrating his daughter's betrothal in
act 4, scene 1, an entertainment that diverts him from more serious business
and that he abruptly and quite unexpectedly tells Ariel he has promised to
present: "I must / Bestow upon the eyes of this young couple [Miranda and
Ferdinand] / Some vanity of mine art" (*The Tempest* 4.1.39–41). The
gratuitousness of this announcement and its imperative form, together with
the labored attempt to sound dismissive and self-deprecating about his art
("*Some* vanity"), betray his surrender to its charms.

22. Quoted in slightly altered form from ibid., 465.

23. Roger Ascham, *The Schoolmaster*, ed. Lawrence V. Ryan (Ithaca:
Cornell University Press, 1967), 63, 73, and 60–75 passim.

24. Chapman, *Rembrandt's Self-Portraits*, 94.

25. Ibid., 88.

26. To produce this effect, the arm on the right would have to be much
longer than the other arm; it is the observer's tendency to deny this in the
interest of size constancy that makes the side on the right appear closer when
we focus on the smaller hand.

27. Christopher Wright, *Rembrandt Self-Portraits* (New York: The Viking
Press, 1982), 32.

28. Horst Gerson, *Rembrandt Paintings*, 106.

29. I'm grateful to Sarah Whittier for pointing out this detail and
emphasizing the importance of the cues to vulnerability.

30. Jakob Rosenberg, *Rembrandt: Life and Work*, 3d ed. (London: Phaidon,
1968), 47.

31. Leonard J. Slatkes, *Rembrandt*, Abbeville Library of Art (New York:
Abbeville Press, 1980), 98.

32. Chapman, *Rembrandt's Self-Portraits*, 90; Bonafoux, *Rembrandt*, 110.

33. Kenneth Clark, *An Introduction to Rembrandt* (New York: Harper and
Row, 1978), 28; Chapman, *Rembrandt's Self-Portraits*, 90, 88.

34. Bonafoux, *Rembrandt*, 112.

35. The 1636 Dresden double portrait is an obvious but somewhat
special exception. In the 1663 London self-portrait, the folded hands are
sketchily rendered. The hands in the 1652 arms-akimbo pose in Vienna are
also cursorily treated, and I can't tell from reproductions whether or not they

are gloved. There are of course several self-portraits with gloved hands (usually one rather than two), a few with hands concealed in a proto-Napoleonic pose, and the self-portraits as artist with hands holding tools of the trade. The Courtier's bare hand is, as I noted, blocklike, the back of a fist, while the folded hands of the 1659 self-portrait in Washington and the 1669 self-portrait in London are sketchy and dim.

36. Michael Fried, *Courbet's Realism* (Chicago: University of Chicago Press, 1990), 81.

37. Chapman, *Rembrandt's Self-Portraits*, 92.

38. Anecdote reported or invented by Arnold Houbraken in *De groote schouburgh der nederlantsche konstschilders en schilderessen*, 3 vols. (Amsterdam: B. M. Israel, 1976), 1: 269.

39. Bonafoux, *Rembrandt*, 112.

40. I note in passing that true specularity, an unambiguous reproduction of a mirror image, may be definitively indicated only when the reproduction registers specular distortion. In *The Portrait in the Renaissance* (New York: Pantheon Books, 1966), 124–30, John Pope-Hennessey briefly discusses this effect in some of Dürer's self-portraits, treating them as defects caused by the painter's inexperience. To my knowledge, only Parmigianino's self-portrait in a convex mirror represents mirroring and indeed dramatizes specular truth. Relative to this limiting case, all the self-portraits I have seen are "scientifically" defective, which is to say that they are idealized in the same way the transparent Albertian window is idealized.

For a discussion of convex mirrors, see Heinrich Schwarz, "The Mirror in Art," *Art Quarterly* 15 (1952): 111–15. Schwarz claims that most fifteenth-century mirrors were convex and that "the black convex mirror" or "Claude glass" was an important aid to painters in the seventeenth century. According to Lucien Dällenbach "examples of the use of a convex mirror are rare in painting" (*The Mirror in the Text*, trans. Jeremy Whitely with Emma Hughes [Chicago: Chicago University Press, 1989], 10), but the context suggests that he means "representation" rather than "use."

Chapter 25: (Ef)facing the Hand

1. Svetlana Alpers, *Rembrandt's Enterprise: The Studio and the Market* (Chicago: University of Chicago Press, 1988), 115, 116.

2. H. Perry Chapman, *Rembrandt's Self-Portraits: A Study in Seventeenth-Century Identity* (Princeton: Princeton University Press, 1990), 98–99.

3. I am grateful to Beth Pittenger for suggesting this analogy.

4. Alpers, *Rembrandt's Enterprise*, 28.

5. J. M. Nash, "Speculating on Rembrandt," *Art History* 12 (1989): 239.

6. Alpers, *Rembrandt's Enterprise*, 117–18.

7. Nash, "Speculating on Rembrandt," 239. Alpers specifically rejects this

possibility at one point (115–16), though at another she claims that Rembrandt penetrated the meaning of theatricality early in his career and sustained his interest in representing it in his "mature works" (34–35). Nash's reading was confusedly anticipated by Kenneth Clark, who observes that Rembrandt here "is not looking for character, he is simply painting, and his mastery of the medium has made him feel detached and at ease" (*An Introduction to Rembrandt* [New York: Harper and Row, 1978], 34). Clark's "he" conflates the sitter the portrait represents with the painter being represented by Clark. Nash's reading allows us to distinguish the two figures as well as the different approaches that produce them.

8. Christopher Wright, *Rembrandt Self-Portraits* (New York: The Viking Press, 1982), 32.

9. Ibid., 33. Indeed, as the observer draws closer to the painting, its conspicuous texture and the subordination of graphic clarity to optical haziness combine to preserve the Giorgionesque effect of distant vision. The reference to melancholia anticipates Chapman's extended exploration of the theme.

10. "For the first time," Horst Gerson writes of the Louvre portrait, "the brow is covered by a light-colored cap, its pure white emitting an unreal radiance. White pigment as such generally introduces a mood of the abstract," which here, he claims, "counteracts the portrait's pictorial unity and realism" (*Rembrandt Paintings*, trans. Heinz Norden [Amsterdam: Meulendorf International, 1968], 140). Perhaps "abstract" is an appropriate term if understood in its specific art-historical sense, but it tends to distract attention from the conspicuously casual and violent flashes of impasto that trap and emit the light.

11. See Jacques Foucart, *Les peintures de Rembrandt au Louvre* (Paris: Editions de la Reunion des musées nationaux, 1982), 75. Foucart's emphasis on the contrast between the prosaic white linen "en négligé sur la tête" and "la majesteuse dignité de l'attitude" (75) supports this interpretation, which suggests that what "counteracts the portrait's pictorial unity and realism" (see the preceding note) is not so much "a mood of the abstract" as an effect of the symbolic.

12. Chapman, *Rembrandt's Self-Portraits*, 96–97.

Chapter 26: The Last Laugh; or, Something More

1. Jacques Lacan, *The Four Fundamental Concepts of Psycho-Analysis*, trans. Alan Sheridan (New York: Norton, 1981), 144, 268, trans. altered. Original texts are in Jacques Lacan, *Les quatre concepts fondamentaux de la psychanalyse*, vol. 11 of *Le séminaire de Jacques Lacan*, ed. Jacques-Alain Miller (Paris: Seuil, 1973), 162 and 299. In the first phrase of the first passage, the French ("le sujet se constitue comme idéal") is better rendered as "the subject constitutes itself," which is more in accord with Lacan's notion of agency; the reflexive form is repeated in the next phrase. I have changed the gender of personal pronouns

from masculine to neuter. In the second passage, I elided a reference to the specific character of "quelque chose plus," the all-important *objet petit* a, mainly to keep from disheartening readers so early in the chapter.

2. Joan Copjec, *Read My Desire: Lacan Against the Historicists* (Cambridge: MIT Press, 1994), 37.

3. Lacan, *Four Fundamental Concepts*, 84.

4. The pre-existence of the gaze means that "the subject becomes an object" for itself (Lacan, *The Seminar of Jacques Lacan, Book I: Freud's Papers on Technique, 1953–54*, ed. Jacques-Alain Miller, trans. John Forrester [New York: Norton, 1991], 220).

5. The kernel phrase and idea is carefully worded to accentuate the wrap-around effect of reflexive or middle-voice (as opposed to passive) agency: "the preexistence to the seen of a given-to-be-seen" (Lacan, *Four Fundamental Concepts*, 74).

6. See Louis Althusser, "Ideology and Ideological State Apparatuses," in *Lenin and Philosophy and Other Essays*, trans. Ben Brewster (New York: Monthly Review Press, 1978), 170–83. See also my *Making Trifles of Terrors: Redistributing Complicities in Shakespeare* (Stanford: Stanford University Press, 1997), 321–23 and 326–28, and Judith Butler, *The Psychic Life of Power: Theories in Subjection* (Stanford: Stanford University Press, 1997), 106–31.

7. Whether imagined as a mythical event or as a continuous practice of self-subjectification, the concept implicates the middle voice of shared responsibility: "to be produced" is the equivalent of "to *be* inscribed"; "to be interpellated" is the equivalent of "to *get oneself* inscribed." As I noted above, the middle voice is also emphasized in Lacan's account of the gaze: to be the subject of the gaze is not "to be seen" but "to give oneself to be seen."

8. Copjec, *Read My Desire*, 30.

9. Ibid., 36.

10. Lacan, *Four Fundamental Concepts*, 115. Sheridan's translation smoothes out the rhetorical archness of the original: "Telle est la véritable envie. Elle fait pâlir le sujet devant quoi?—devant l'image d'une complétude qui se referme" (*Quatre concepts*, 131).

11. Ibid., 100–101, slightly altered so as to substitute "gives . . . to be seen" for Sheridan's "offers . . . to be seen." The original, "donne à voir son tableau," echoes the kernel phrase cited in note 5 above and encourages the reader to imagine for a moment that the painter identifies giving the picture to be seen with giving himself to be seen—and correlatively, that he gives himself to be seen as if he were in a picture (*Quatre concepts*, 116). Having planted this suggestion, Lacan immediately backs away from it ("Je ne le crois pas"), but reverts more than once in subsequent pages to the idea that the painter wishes to make his gaze *the* gaze (see 124–29). The elided passage, untranslated by Sheridan, is the italicized portion of the following sentence: "On pourrait croire, que, tel l'acteur, le peintre *vise au m'as-tu-vu*, et désire

être regardé" (116). The painter "aims his have-you-seen-me, and desires to be looked at"—or, in the context of Lacanian puns, desires to be "en-gazed" (*regardé*), that is, turned into the gaze. The weaponry metaphor is taken up in the quotation that follows.

12. Lacan, *Four Fundamental Concepts*, 101; *Quatre concepts*, 116.

13. Copjec, *Read My Desire*, 37.

14. Lacan, *Four Fundamental Concepts*, 118.

15. Lacan, *Quatre concepts*, 116.

16. William Shakespeare, *Othello*, 1.3.19–20. The reference is not entirely arbitrary. The Venetian Senator in *Othello* is expressing his suspicion about the Turkish fleet's apparent change of course from Cyprus to Rhodes. When Lacan discusses the conflicts between artists and patrons for control of the gaze, one of his examples is "the great hall of the Doges' Palace in which are painted all kinds of battles, such as the battle of Lepanto, etc.," and what "les peuples" who visit the palace see in these frescoes is "the gaze of those persons [*des gens*] who, when the audience [*les peuples*] are not there, deliberate in this hall. Behind the picture it is their gaze that is there" (Lacan, *Four Fundamental Concepts*, 113; *Quatre concepts*, 129). Lacan's casual mention of the Battle of Lepanto "ou d'ailleurs" is mischievous. The defeat of the Turks at the Battle of Lepanto in 1571 was a kind of Pyrrhic interlude in a campaign that eventuated in Venice's loss of Cyprus (1573) and ultimate decline as a naval power. Thus the gaze behind that picture is a mythologizing and perhaps self-mystifying gaze. What is celebrated in monumental form, with the painter's help, is the loss and absence of the power for which the fresco's monumentality is forced to compensate, or apologize. This is the absence Lacan elsewhere describes as castration and as the *objet* a: see *Four Fundamental Concepts*, 85–89, and *Quatre concepts*, 98–103.

17. Lacan's comments on painting in *Four Fundamental Concepts* are predictably mystifying. The reason for this is not merely that he enjoys mystifying readers (which he does) but that his remarks about the observer's relation to the picture are not offered as reflections on painting. On the contrary, his comments on painting contribute to an extended analogy that plays variations on the mirror-stage theme: just as an observer and a painter imagine their relation to portraits and self-portraits, so the subject sees itself as, seeks itself in, an *I that gets looked at*, an exemplary other: "in the scopic field, the gaze is outside, I am looked at, that is to say, I am a picture" (106). Throughout this study I have reversed the polarity of Lacan's metaphor, making portraiture its tenor rather than its vehicle. This has enabled me to frame the interpretation of portraits within the narcissistic problematic of orthopsychic self-representation and anxiety I associate with the regime of the graphic gaze.

18. Copjec, *Read My Desire*, 36.

19. Lacan, *Four Fundamental Concepts*, 117.

20. James Elkins, *What Painting Is: How to Think about Oil Painting, Using*

the Language of Alchemy (New York: Routledge, 1999), 114–15. Elkins is describing the 1659 self-portrait in Washington, but to some extent his remarks apply equally well to the Joker.

21. John Pope-Hennessey, *The Portrait in the Renaissance* (New York: Pantheon Books, 1966), 8–9.

22. What Richards actually wrote was "what a word means is the missing parts of the contexts from which it draws its delegated efficacy": I. A. Richards, *The Philosophy of Rhetoric* (New York: Oxford University Press, 1936), 35, and, more generally, 32–43.

23. For an interesting and strategically inconclusive inquiry into the relation between Rembrandt's "golden tone" and varnish yellowed by age, see Ernst van de Wetering, *Rembrandt: The Painter at Work* (Amsterdam: Amsterdam University Press, 1997), 245–63.

24. Horst Gerson, *Rembrandt Paintings*, trans. Heinz Norden (Amsterdam: Meulendorf International, 1968), 142. He notes that X-rays show the painter's hand resting on "the breast of the blurred sculpture."

25. See, inter alia, Christian Tümpel, with Astrid Tümpel, *Rembrandt*, trans. Edmund Jephcott and others (Antwerp: Fonds Mercator, 1993; orig. pub. 1986), 368. For a convenient listing of the sources of these identifications, see H. Perry Chapman, *Rembrandt's Self-Portraits: A Study in Seventeenth-Century Identity* (Princeton: Princeton University Press, 1990), 102, 162.

Plates and Figures Discussed in Text

Frontispiece. Rembrandt Workshop (?), *Half-Length Figure of Rembrandt*, 1–5

Plates

Figures

Library of Congress Cataloging-in-Publication Data

Berger, Harry.
 Fictions of the pose : Rembrandt against the Italian Renaissance /
Harry Berger, Jr.
 p. cm.
 Includes bibliographical references and index.
 ISBN 0-8047-3323-6 (cloth : alk. paper). — ISBN 0-8047-3324-4
(paper : alk. paper)
 1. Portrait painting—Psychological aspects—History.
 2. Rembrandt Harmenszoon van Rijn, 1606–1669 Self-portraits.
 I. Title.
ND1309.B47 2000
757—dc21 99-39775

 ∞ This book is printed on acid-free, archival quality paper.

Original printing 2000

Last figure below indicates the year of this printing:
09 08 07 06 05 04 03 02 01 00

Designed by Janet Wood
Typeset in 11/15 Bembo by James P. Brommer